DATE DUE

06-11-04			
NO-15-04			

DEMCO 38-296

Les Fauves

R

Les Fauves
A Sourcebook

Russell T. Clement

Art Reference Collection, Number 17

Greenwood Press
Westport, Connecticut • London

Library of Congress Cataloging-in-Publication Data

Clement, Russell T.
 Les Fauves : a sourcebook / Russell T. Clement.
 p. cm.—(Art reference collection, ISSN 0193–6867 ; no. 17)
 Includes indexes.
 ISBN 0–313–28333–8 (alk. paper)
 1. Fauvism—France—Bibliography. 2. Painting, French—
Bibliography. 3. Painting, Modern—20th century—France—
Bibliography. 4. Fauvism—France—Biography. I. Title.
II. Series.
ND548.5.F3C59 1994
759.4—dc20 94–2848
 [B]

British Library Cataloguing in Publication Data is available.

Library of Congress Catalog Card Number: 94–2848
ISBN: 0–313–28333–8
ISSN: 0193–6867

First published in 1994

Greenwood Press, 88 Post Road West, Westport, CT 06881
An imprint of Greenwood Publishing Group, Inc.

Printed in the United States of America

The paper used in this book complies with the
Permanent Paper Standard Issued by the National
Information Standards Organization (Z39.48–1984).

10 9 8 7 6 5 4 3 2

Contents

Preface

To mega biblion ison tōi megalōi kakōi
Callimachus
Epigrams

The making of large books is a great evil

Big books often have small beginnings. This one was conceived following a Fall, 1990 visit to the Musée Municipal d'Art moderne at the Palais de Tokyo in Paris. Still bibliographically hungry after completing a bio-bibliography on Paul Gauguin (Greenwood Press, 1991) and under the lash of rank advancement, Matisse's lyric *La Dance* and Dufy's immense *La Fée électricité* provided the spark of inspiration needed to commence a research guide and sourcebook on the major French Fauve painters.

Work began in earnest in late 1990. As sources multiplied and the database grew, it became apparent that the Fauve literature was far too extensive for a single large volume. Certain Fauve painters merited individual treatment, particularly after the decision was reached to detail entire careers and œuvres. In 1992, Marilyn Brownstein, former Senior Editor, Humanities at Greenwood Press, enthusiastically threw her support behind the prompt completion of a separate volume on Henri Matisse (Greenwood Press, 1993). A separate volume on Georges Braque was also published by Greenwood Press earlier this year.

This sourcebook compiles and organizes the literature on Fauvism in general as well as sources on eleven individual French Fauve artists—Raoul Dufy, Georges Rouault, Maurice de Vlaminck, André Derain, Kees van Dongen, Albert Marquet, Emile-Othon Friesz, Charles Camoin, Henri Manguin, Jean Puy, and Louis Valtat. Each individual Fauve section includes a biographical sketch, chronology, primary and secondary bibliographies, and exhibition lists (individual and group). Entire careers are covered in the sourcebook, not just their Fauve periods.

To produce the sourcebook, from 1990 to 1993 relevant literature was gleaned from computer and card catalogues and from printed indexes and guides to the library and archival collections of major art museums, universities, and scholarly and artistic institutes in the United States and Western Europe. Standard art indexes and abstracting services, such as *Bibliography of the History of Art; Art Index, ARTbibliographies MODERN; International Repertory of the Literature of Art; Répertoire d'art et d'archéologie;* Chicago Art Institute, Ryerson Library's *Index to Art Periodicals; Frick Art Reference Library*

Original Index to Art Periodicals; Arts and Humanities Citation Index; Humanities Index; Religion Index; MLA Bibliography; Worldwide Art Catalogue Bulletin; and *Répertoire des catalogues de ventes* were consulted, along with pertinent bibliographic databases such as RLIN, SCIPIO, Carl UnCover, FirstSearch, and OCLC. The sourcebook attempts to be as comprehensive as possible within time, travel, budget, and length constraints. It should not, however, be construed as exhaustive.

This guide is intended as a briefly and partially annotated bibliography, not as a critical one. Annotations are provided for entries where titles give incomplete or unclear information about works and their content. Monographs and dissertations are annotated with more regularity than periodical articles. Annotations are of necessity brief and are intended only to note the subject matter discussed, the general orientation, or the conclusion of the study. Obviously, a few sentences can hardly hope to represent fairly and adequately describe even a short article, to say nothing of a major book.

My apologies to authors who may feel that the annotations have misrepresented, misconstrued, misunderstood, or even distorted their work in this process of radical condensation. My own opinion and critical judgment have in no case been conscious criteria for inclusion or exclusion. Foreign language titles abound, particularly in French. Since a reading knowledge of French is essential for serious Fauve research, with few exceptions only titles in other foreign languages are occasionally translated.

How to Use the Primary and Secondary Bibliographies

The bibliographies are divided into sections, accessible by the Contents. Entries are numbered consecutively throughout. In every section, books are listed first, followed by periodical articles. Within each section, citations are listed alphabetically by author or chronologically, when noted. Anonymous works are alphabetized by title. When several entries are credited to the same author, they are arranged chronologically. Authors whose surnames have changed and those who have rearranged their given names or initials are generally listed as they appear in print. They may, therefore, be found in the Personal Names Index in more than one location.

To some degree any system of classification is arbitrary, and this one is no exception. I have attempted to organize a great variety of material under headings most useful for art historical study rather than placing them in what at first may have seemed a most appropriate place. This arrangement is not always satisfactory. Hopefully, users perplexed by omissions in certain sections will be compensated by finding titles that they were unaware of in other sections.

Ideally, some titles should be listed in more than one section. In most instances, however, this was not practical. The division of the Secondary Bibliographies into many categories is intended to serve as a simple subject index. Citations in the "Mentions" sections concentrate on major sources deemed historically significant. These entries are interesting as a reflection of the critical evaluation of Fauvism and its individual artists at the time of publication. The Exhibitions sections contain information and publications about exhibitions, including a few sales catalogues and reviews, arranged chronologically in individual and group exhibition categories.

The most effective use of the Secondary Bibliographies is by means of the Contents and Art Works and Personal Names Indexes. Entries are indexed with reference to their citation numbers. Particular publications may be located in the Personal Names Index under the author or any other persons associated with the work.

Acknowledgments

This sourcebook reached fruition through the gracious assistance, generous support, and unflagging encouragement of many remarkable individuals. Numerous library colleagues, art historians, and Fauve specialists provided invaluable assistance in identifying, correcting, and organizing sources. Brigham Young University and the Harold B. Lee Library in particular rendered exceptional institutional support. Profound gratitude is expressed to A. Dean Larsen, Martha M. Peacock, and Madison U. Sowell, BYU colleagues who critiqued the expository sections and provided helpful suggestions about overall organization. Also at BYU, Annick Houzé proofread and edited the French citations and Richard D. Hacken edited the German, Italian, and Scandinavian entries. Kathleen Hansen and her able Interlibrary Loan staff procured important books and journals essential to the project. Katherine Bond, Michelle Kushlan, Kelly Hong, Christy Cobia, Julie Roueché, and Aleisha Ann Cheney—all deftly supervised by Erva Rieske—performed the laborious tasks of data entry, word processing, correcting, and formatting. Without their cheerful assistance and dogged persistence, this work would never have been realized. Appreciation is likewise extended to Mary M. Blair, Marilyn Brownstein, and Alicia S. Merritt, editors at the Greenwood Publishing Group, for believing in the project, offering helpful directions along the way, and skillfully shaping the final products. Funding of three research trips to Europe was supplied by Brigham Young University and the National Endowment for the Humanities Travel to Collections Program. The work is dedicated to my children—Esther, Jon, Sam, and Ben—gentle *fauves* all.

Introduction

The scandal of the Parisian art world in 1905 was Salle VII of the third annual Salon d'Automne in the Grand Palais. Its walls throbbed with raw color—color squeezed straight out of tubes, ravishing the eye and senses, clashing in dreamy harmonies flung directly on the canvas; color that dared to tint human flesh pea green and tree trunks a violet red; color that not only refused to initiate nature, but was used to suggest form and perspective. The public was confused. Angry critics ridiculed the paintings and their makers. In jest, one critic dubbed these artists "*les fauves*" or wild beasts. The name stuck.

The signatures on the paintings bore the names of men, some of whom, surviving notoriety, would soon become more or less famous. Henri Matisse (1869-1954), the oldest and the unlikely center of this radical new style, flourished into his eighty-fifth year as one of the masters of the twentieth century. André Derain (1880-1954), for a time, produced works of breathtaking originality and virtuosity. Albert Marquet (1875-1947) and Henri Manguin (1875-1949), lesser-known names today, were the bestsellers of the group because they turned out tamer work that was gentler to unschooled eyes. Maurice de Vlaminck (1876-1958)—tall, strong and muscular, already a larger-than-life figure and a fabulous fabulist—would later claim with exaggeration that he was really the first to embrace the new style, and then the first to abandon it.

Seminal moments like this are prey to myth. By one account, probably apocryphal, one of the organizers of the enormous Automne show—1,625 works in all—decided to group most of the chromatically intense pictures in a single room for the sake of consistency. Commerce may have been another motive for grouping these high-color paintings together. Parisians frequented the salons not only to inspect new works offered by artists, but also to gossip and gasp over the excesses and, occasionally, to buy a picture. Two such fall annuals had already been held, in 1903 and 1904. Although certain pre-Fauve painters had participated, their works had not been collectively shown in special rooms and the full impact of the new style had not been exerted. If, instead of being concentrated in one room, the paintings had been scattered throughout the hall, the claim for the first revolutionary art movement of the 20th century could still be made. But would anyone have thought to call its practitioners *les fauves*?

Fauve means wild beast. It was a critic's tag, a derisive moniker of Louis Vauxcelles, art critic for the daily newspaper *Gil Blas* who also coined the term "Cubism" in 1908. Vauxcelles, the champion of French Impressionism, was generally an appreciative and sympathetic votary of avant-garde work. Naturally, there are several versions of the christening, but Matisse's seems as plausible as any. As the artist later told the story, Vauxcelles walked into Room VII, spotted a bronze neo-Renaissance bust of a

child by sculptor Albert Marque (1872-1939), surrounded by the carnival of colors blazing on the walls, and wisecracked, *"Donatello parmi les fauves"*—"Donatello among the wild beasts." Another version has it that the remark was inspired by Matisse's heavy, hairy overcoat, which made him look like a bear. Vauxcelles was so pleased with the line that he repeated a slightly modified version the next day in his review for *Gil Blas*, published October 17, 1905. Other critics proved more vitriolic. Camille Mauclair indignantly protested in *Le Matin* with a borrowed phrase first used by Ruskin about Whistler in 1877—"They have flung a pot of paint in the public's face." Others derided or dismissed the pictures as mere "daubs" and "raving madness or a bad joke." One critic compared them to "the naive and brutal efforts of a child playing with its paintbox."[1]

While the eccentricities of the Fauve painters aroused the protest of most critics and the ire of the public, the painter Maurice Denis (1870-1943), though no friend of the new movement, astutely described the impressions of a perceptive viewer:

> When one enters the gallery devoted to their work, at the sight of these landscapes, these figure studies, these simple designs, all of them violent in color, one prepares to examine their intentions, to learn their theories; and one feels completely in the realm of abstraction. Of course, as in the most extreme departures of van Gogh, something still remains of the original feeling of nature. But here one finds, above all in the work of Matisse painting outside every contingency, painting in itself, the act of pure painting. All the qualities of the picture other than the contrasts of line and color, everything which the rational mind of the painter has not controlled, everything which comes from our instinct and from nature, finally all the factors of representation and of feeling are excluded from the work of art. Here is, in fact, a search for the absolute. Yet, strange contradiciton, this absolute is limited by the one thing in the world that is most relative: individual emotion[2]

The "wild beasts" themselves did not use the name. "Matisse tells me that he still has no idea what 'Fauvism' means," reported Georges Duthuit in 1950.[3] Fauvism was glorified pure color. The movement did not constitute a school with a particular system and theory; rather, it resulted from a brief association of young French painters, impelled by an occasional commonality of aims in the face of a cacophony of mixed styles, clashing palettes, and opposing personalities. The term "affinities" used by John Elderfield in New York's Museum of Modern Art's 1976 *The "Wild Beasts": Fauvism and its Affinities* exhibition catalogue, more accurately describes this loose federation of painters. Janet Hobhouse, among other scholars, questions Fauvism's very existence: "Does Fauvism exist at all? or is it merely a convenient term by which art historians explain certain friendships, shared aims, and shared exhibition space of a certain period?"[4]

Because of its impassioned character and the large number and varying abilities of its adherents, Fauvism lacked the coherence and methodical progression of other, more clearly defined movements, such as Cubism. It did not evolve through a disciplined exploration of its own possibilities, but rather through a succession of extended experiments, manifested in a series of somewhat sporadic and isolated explosions, which merged to give Fauvism its short but flamboyant burgeoning before its sudden dissipation. Although the chief center of Fauvism was in France, parallel currents appeared in Germany; and the movement assumed international importance before being supplanted by Cubism and various types of abstraction in the years after 1906. Fauvism had, however, a great effect on the evolution of modern art, exemplifying its subjective qualities, its unbridled freedom, and its striving for public acceptance.

Few radical movements in art have had so brief a life span. Beginning when the work first provoked widespread interest in the Salon d'Automne of 1905, it lasted approximately two years, at which time critics realized that the group was disintegrating. The last important Fauve salon was the 1907 Salon des Indépendants. Given its fevered intensity of style, the uneasy equilibrium of Fauvism—order and passion, fire and austerity—could not long sustain its original high state of tension. Burnout was inevitable. Georges Braque (1882-1963), who came late to Fauvism and left early, had a reasonable rationale for its swift decline: "You can't remain forever in a state of paroxysm."[5] The pursuit of the new that followed Fauvism—the unnerving plunge into Cubism, the spin into Futurism, the eeriness of Dada and then Surrealism—seized the public audience for art so completely that years slipped by before any serious notice was given to that first, once-shocking moment in the infancy of modern painting.

The course of Fauvism was crucially affected by the interaction of personalities. The group crystallized around the dominant personality of Matisse, whose ideas were adopted during the pioneering years by three fairly distinct circles: first, Matisse and his fellow students from Gustave Moreau's studio and the Académie Carrière, including Albert Marquet, Henri Manguin, Charles Camoin (1879-1960), Louis Valtat (1869-1955), and Jean Puy (1876-1960), and, somewhat apart from these, Georges Rouault (1871-1958); second, the so-called "school of Chatou" (a Parisian suburb), namely André Derain and Maurice de Vlaminck; and third, the latecomers to the group from Le Havre: Emile-Othon Friesz (1879-1949), Raoul Dufy (1877-1953), and Georges Braque. There was also the Dutchman, Kees van Dongen (1877-1968), who met the others at the salons and galleries where they exhibited. Relationships between these artists found a common denominator in the prestige and strenuous activity of Matisse, who, except for Valtat, was the oldest (thirty-six in 1905) of them all. Matisse was the recognized leader and innovator of the movement.

Matisse and the Formation of Fauvism

The initial contacts that led eventually to the creation of Fauvism date to 1892. In that year, Henri Matisse, twenty-two years old and having just spent his first year in Paris in the stifling and frustrating atmosphere of William Adolfe Bouguereau's class at l'Académie Julian, joined the studio of the celebrated symbolist Gustave Moreau at the Ecole des Beaux-Arts. Ironically, Bouguereau's vast studio on the Left Bank, in the rue Notre-Dame-des-Champs, was taken over after his death in 1905 by the Fauve painter Othon Friesz.

Unquestionably one of this century's most sensuous artists and one of the greatest colorists of all time, Henri Matisse was born on December 31, 1869, in Le Cateau-Cambrésis, a village in the north of France. His childhood, spent in the nearby village of Bohain-en-Vermandois, was relatively happy. His father was a grain merchant and his mother, who had trained as a milliner, was sensitive and artistic. Matisse was educated at the lycée in Saint-Quentin, the nearest town, where he was solidly grounded in the classics. He left to study law in Paris in 1887, returning with a diploma in 1888, and took up a post as a lawyer's clerk. In *Jazz* (1947), Matisse recalled those days, spent filling "pages with the fables of la Fontaine, preparing official dossiers which no one read, not even the judge." These were devised to "use up a certain amount of official paper in accordance with the importance of the trial." Diversion was provided by attending drawing classes before work at l'Ecole Quentin Latour. This was a region famed for its textiles, and many workers spent the winters weaving. The drawing school Matisse attended was for the training of textile designers; there he conceived a sense of decorative patterns and a love of textiles and tapestries that would last all his life.

In 1890, stricken with appendicitis, Matisse faced a long convalescence. His mother gave him a small box of paints as a distraction. Matisse started copying "chromos" or anodyne landscape scenes and studied a painting manual by F. A. Goupil. He would later remark, "Once bitten by the dream of painting, I never wanted to give it up." His first two original paintings of 1890 were still lifes with books, curiously signed with his name back-to-front: "essitaM. H." Parental permission to go to study painting in Paris was at last forthcoming and by early 1891, Matisse found himself once more in the metropolis, where he enrolled at l'Académie Julian—a coaching establishment for l'Ecole des Beaux-Arts, under the prestigious academic salon artist, Bouguereau. Matisse also attended evening classes at l'Ecole des Arts Décoratifs. Academic training proved a shock and a disappointment to the aspiring artist. Throughout his life Matisse would rail against the rigidity that he had experienced there.

The academicians' insistence on accurate drawing from models, visible in Matisse's own *Standing Nude* (1892), however, would be repeated by Matisse when he himself became a teacher in 1908. In the models themselves, Matisse confronted the naked human figure which, he said in 1908, "best permits me to express my almost religious awe towards life." Failing the entrance exam to l'Ecole des Beaux-Arts in February, 1892, Matisse started to frequent the Cours Yvon, a glass-enclosed courtyard of l'Ecole, where, drawing from plaster casts, he hoped to attract the attention of a passing *maître*.

Gustave Moreau (1826-98), sheltered from need through inherited wealth, lived and worked in seclusion, caring neither to exhibit nor to sell his paintings. Moreau created heavily symbolic and imaginative works and was equally daring and unconventional in his pedagogy. Moreau's studio offered Matisse a congenially liberal approach. Unique among the academicians, Moreau endeavored to develop the individualities of his pupils and never attempted to impose his own exotic, orientalist reveries upon them. Rather, he gave intelligent encouragement, made no fetish of academic drawing, awakened their interest in color, urged them to study the masters in the Louvre but also insisted that they go out into the city streets to paint. The tracery with which Moreau overlaid his female bodies would find its way into Matisse's fine-line drawings of embroidered blouses in the 1930s. Orientalism would also be central to Matisse's work for many decades. In more immediate terms, both Moreau's abstract oil sketches and certain pen and ink drawings demonstrated a freedom of technique that would be adopted by the future Fauve. Having worked informally with Moreau for almost three years, Matisse was finally admitted to l'Ecole des Beaux-Arts and enrolled on April 1, 1895.

In this stimulating atmosphere, Matisse met artist Georges Desvallières (1861-1950), who would be one of the organizers of the famous Salon d'Automne of 1905. Other artists who would be represented there included Georges Rouault, two year's Matisse's junior; and Albert Marquet, then only seventeen and attending evening classes at l'Ecole des Arts Décoratifs. Except for Valtat, who exerted only a minor influence, all of Matisse's future collaborators in Fauvism were younger than he. Manguin and Camoin, who joined Moreau's studio in 1895 and 1896, were seven and ten years younger, respectively. For all of them, with the exception of the silent and somewhat sullen Rouault, who followed an independent path, Matisse was the leader from the start. In 1896, he sent several of his student paintings to the recently founded Société Nationale des Beaux-Arts; sold one of them to the state; was elected an associate member of the society, nominated by its president, Puvis de Chavannes; and seemed set upon a respected academic painting career. A year later, however, the situation was reversed. Matisse had begun to investigate Impressionism and his painting *The Dinner Table*, exhibited at the Nationale in 1897, provoked hostile reaction. Moreau courageously defended *The Dinner Table*, and Matisse appreciated his master's support.

Despite Moreau's brilliance as a teacher, his studio was isolated and hermetic. The Fauves-to-be discovered modernism on their own and one by one began to practice it. They saw the Impressionists at the Caillebotte Bequest: Cézannes, Gauguins, Lautrecs, and van Goghs at Ambroise Vollard's gallery; paintings by Vuillard, Denis, Vallotton, Bonnard, and other Nabis; works by Signac, Cross, and the Neo-Impressionists at the Salon des Indépendants. In the summer of 1897, Matisse met van Gogh's English friend, John Russell, who further acquainted him with Impressionist and Post-Impressionist painting. He frequented Rodin's studio and, sometimes accompanied by Manguin, visited Camille Pissarro, whom he fervently admired.

Following his marriage in January, 1898, Matisse took Pissarro's advice to study Turner's paintings in London on a short wedding trip. He then spent six months in Corsica, where he discovered with astonished delight the Mediterranean atmosphere that was to prove his true spiritual milieu; then he stayed for six months in the vicinity of Toulouse. 1898 was a joyful year of relaxation following an arduous apprenticeship. He abandoned himself to his new freedom, reveling in painting outdoors and creating sketches in vivid pure colors—yellows, greens, and bright reds—which he executed in vibrant strokes that in some instances swept in continuous lines (such as *Coucher de soleil en Corse*) and in others were applied in dots (such as *petite porte du vieux moulin*).

Following his return to Paris in February, 1899, Matisse remained there until 1907— his entire Fauve period. In Paris, Matisse found that Moreau had died and the highly conservative and uninspiring Fernand Cormon had succeeded him. Matissse was soon asked to leave Cormon's studio. He began to attend the live class of a free academy where Eugène Carrière occasionally offered corrections to those who wished them.

Matisse's enrollment at l'Académie Carrière enlarged his circle of artist-friends to include other Fauves-to-be—Jean Puy and, most important, André Derain. He continued to keep in contact with earlier friends, especially Albert Marquet, who lived in the same apartment he occupied. Matisse began to be regarded as a leader although he still considered himself essentially a student. His immediate circle was greatly attracted by his painting in which they sensed a new departure, as well as by the ideas which he expounded, including the importance of Cézanne. Matisse's early success as a conservative painter was long forgotten as he struggled with new problems. The numerous nudes he painted at Carrière's (for examples, *L'homme nu, Modèle début, Académie bleue,* and *Nu aux souliers roses*) were bold in design and color, with simplified planes, decisive drawing, and an emphasis on structural elements which reveals Cézanne's influence. But their most startling feature was the free use of color, his figures being modeled in green, violet, or blue in conjunction with complementaries. Marquet, though less bold, worked along similar lines. Together they would go on summer afternoons to Arcueil on the outskirts of Paris to paint outdoors. Intensifying local colors in his landscapes, Matisse painted in broad masses with heavy accents of light and shadow but using the same intensity of color throughout his painting, so as to pull all elements together in spite of their forceful contrasts.

La Belle Epoque

It was through André Derain that Matisse met Maurice de Vlaminck. Derain lived in the suburbs of Paris at Chatou on the banks of the Seine and traveled into the city by train to attend Carrière's academy. During a minor train derailment in June, 1900, he met his Chatou neighbor Vlaminck. They went out painting together the very next day and shared a studio together the following year in an abandoned and dilapidated restaurant on an island in the Seine where they could work in peace. In 1901, at the first large van Gogh exhibition held at Bernheim-Jeune's, Derain introduced Matisse to his friend

Vlaminck. Van Gogh's pure colors and vibrant brush strokes profoundly impressed the Fauves. Matisse admired the bright colors and the confident, handling of the work of Derain and Vlaminck when he visited their studio at Chatou. The essential triangle of Fauvism was thus established.

It was, however, almost immediately broken. Derain was conscripted into the army that same year and Vlaminck remained in Chatou, apart from Matisse and his friends, until Derain's return three years later. From 1899 to 1902, Charles Camoin also served in the army. He was stationed first at Arles, where he sought out souvenirs of van Gogh, and then at Aix-en-Provence, where he was cordially received by Cézanne. Meanwhile, Matisse and Marquet resumed their joint expeditions and experimentation. In the daytime they worked directly from nature at Arcueil or in the Luxembourg Gardens, making powerful studies saturated with pure colors. At night they sketched in music halls and cabarets, where like Toulouse-Lautrec they developed sensitive and perceptive graphic styles. Among the many influences that affected Matisse at this time, the dominant stimulus was Cézanne, not solely for his use of pure colors but also for the vitality and structure of his composition. It was also from Cézanne that Matisse learned that color relationship had to be carefully balanced and their graduations painstakingly worked out.

Matisse and his circle came together at the height of *la belle époque*. All of the Fauves-to-be were in Paris at the time of the Exposition Universelle of 1900, the last of the great world fairs that celebrated the prestige of the *haute bourgeoisie* and catered to its tastes for conspicuous consumption in the nineteenth century. Matisse and Marquet prepared for the exposition by painting laurel leaves on the cornice of the Grand Palais for poor wages. Vlaminck played the violin in the cafés and cabarets surrounding the exposition complex and, finding himself appalled at just how few Parisians were in fact able to enjoy *la belle époque*, began to write novels of social criticism. He had read Marx and Kropotkin while serving in the army and had joined an anarchist group, contributing to their journal, *Le Libertaire*. If Matisse was the sturdy bourgeois gentleman, Vlaminck was the polar opposite—a raw, oversized personality with oversized appetites, a cartoon figure of the stereotypical artist. "He painted as other men throw bombs," one critic commented.[6]

Likewise, André Derain developed left-wing sympathies. Raoul Dufy was basically apolitical, but when he lived in Montmartre in 1902-03, he was close to anarchist circles and even subject to police attention. Van Dongen was an active anarchist in his early years. He contributed illustrations to the satirical anti-establishment journal, *L'Assiette du beurre*. The Neo-Impressionist circle of Signac, Cross, Luce, and Fénéon, who befriended him in Paris, was composed of fully committed anarchists. Félix Fénéon was even implicated in an anarchist bombing. Favorite gathering places for artists in Montmartre, such as the Lapin Agile frequented by Picasso and Guillaume Apollinaire's circle, were visited by social as well as artistic radicals. The tradition of cooperation between the two groups was an important feature of the late nineteenth century artistic and literary Parisian scene. It is not surprising that new and controversial art, such as Fauvism, would find itself attacked in terms partly derived from the political controversies of the past, and that the avant-garde should find the public's attitude toward their paintings colored by that fact.

Havrais Fauves

Matisse and Marquet began to exhibit together in 1901. Around them the other Fauve artists began to gather. It was their paintings that the final group of Fauves-to-be saw when they arrived in Paris from Le Havre the far north in 1900. These latecomers to the group included Dufy, Friesz, and Braque. They, too, were much younger than Matisse: eight, ten, and thirteen years respectively. Braque was only eighteen when he

arrived in Paris to take his diploma as a house painter, shunning the academies and learning about painting directly from the Vollard and Durand-Ruel galleries and from the Louvre. Dufy and Friesz had met in the mid-1890s in the studio of Charles Lhuillier in Le Havre. Lhuillier, by all accounts, was as liberal and as sympathetic to new art as Moreau. By 1900 the Le Havre Fauves were in Paris on municipal scholarships to Bonnat's studio at l'Ecole des Beaux-Arts. Matisse was still being talked about in the school. Soon his paintings could be seen in public exhibitions, at the Indépendants from 1901 and at Berthe Weill's gallery from 1902.

Initially, the Le Havre artists, as newcomers to Paris, were not in contact with Matisse's circle, but they began to exhibit at the same institutions and were gradually attracted to his direction and style. So, too, were Kees van Dongen, who had reached Paris from Holland in 1887, and André Derain, when he returned from military service in 1904 (a three-year interruption to his career that he strongly resented). Derain was also influential in ending Vlaminck's isolation at Chatou. Although the Fauves were never a coherent, unified group, but rather a series of fluctuating constellations (as the *Chronology* attests), they came temporarily to settle their orbits around Matisse, creating for a few brief years a dazzling combination of energy and color before dispersing to follow their own paths once again.

Development of Fauvism

Exactly when this process created what is known as Fauvism is widely debated. The Fauvist group, the Fauvist movement or affinities, and the Fauvist style (more accurately styles) did not emerge simultaneously. The group was largely a matter of asssociation, cooperation, and encouragement among the artists. It developed very gradually from the first contacts in 1892 to the establishment of the core group in 1900 and continued until 1906, when the youngest Fauve, Georges Braque, began to work with the others and the group was finally complete.

Scholars generally agree that the earliest Fauve style began to emerge in the summer of 1904. It has long been recognized, however, that even before this time members of the original Matisse circle had practiced a form of high-color painting that presaged their Fauve styles. "From around 1900," Derain later explained, "a kind of fauvism held sway. One has only to look at the studies from the models that Matisse made at that time."[7] This early "kind of fauvism" has subsequently become known as "pre-Fauvism" or "proto-Fauvism." Marquet dated its beginnings to "as early as 1898 [when] Matisse and I were working in what was later called the fauve manner. The first showing of the Indépendants in which, I believe, we were the only painters to express ourselves in pure colors, took place in 1901."[8]

Marquet is correct both as to the creators and duration of what is generally designated proto-Fauvism, since it did not immediately precede Fauvism but was, instead, a short-lived and circumscribed episode involving Matisse and Marquet and lasting only from the end of 1898 to 1901. In 1901, Matisse turned away from bright colors, Marquet following him, and did not return to them consistently until the summer of 1904. By then, the other Fauves-to-be in Matisse's immediate circle, together with Derain and Vlaminck, had heightened their palettes, having in fact begun to do so at the very time Matisse and Marquet were darkening theirs. This second Fauvist prelude, between 1901 and 1904, which must be distinguished from the first since it occurred independent of Matisse's leadership (though not of his earlier example), might well be called pre-Fauvism.

Matisse and his circle were not the only ones using the lessons of established high-key Impressionist color, nor were they (with the exception of Matisse himself) the most daring or inventive in how they were using their sources. In March, 1899, the Durand-

Ruel Gallery held an important survey of contemporary painting that displayed in depth the two principal camps of late Impressionist colorists, the Neo-Impressionists and the Nabis. Between them, in the room of honor, was an exhibition of the little-known pastels of Odilon Redon (1840-1916). Matisse met Redon, became friendly with him, appreciated his subtle use of intense colors, and bought two pastels at the exhibition.

The pointillism of Georges Seurat and his followers, particularly Paul Signac and Henri-Edmond Cross, likewise played a decisive role in the development of several modern colorists, including Matisse and his friends. The pointillists attempted to put some order into the spontaneous sensations of the Impressionists. Gauguin, van Gogh, and Toulouse-Lautrec all went through a pointillist phase before finding their respective styles. Matisse and Marquet experimented with pointillism around 1900; Matisse would spend a pivotal summer in Saint-Tropez with Paul Signac in 1904. Matisse's circle also admired Gauguin's strong colors, rich contrasts, his willful renunciation of modeling, and his powerful and decorative opposition of flat planes. Yet, it was van Gogh's emotional use of pure colors, his vivid brushstroke, his rich application of pigment—as well as Cézanne's conscious effort to express spatial relations through color alone—that most deeply affected them. From these sources the pre-Fauves derived whatever principles they could or wished to assimilate, whatever elements suited their own purposes. Certainly the strongest factor in their evolution came from Matisse himself.

From late 1901 to the end of 1903, Matisse, whose goal was to master every means of expression by successively attempting various techniques, devoted himself to the study of volume and mass and worked in intentionally muted colors. He himself later came to regard this as a transitional phase between values and hues. The record of the circle's joint exhibitions from 1901 onward clarifies how the Fauve group was consolidated. In the spring of 1901, Matisse sent a group of paintings to the Salon des Indépendants, the first time he had publically exhibited since the Nationale in 1899. By 1901, the Nationale had become far more conservative in approach, particularly since the death of its liberal president Puvis de Chavannes in 1898. Although the Indépendants was non-selective and engulfed serious artists among amateurs, it was the obvious place for Matisse to show among the moderns, especially since it was presided over by Signac, whose work had provoked his first real experiments with high color. Marquet and Puy were also represented at the Indépendants of 1901.

Pioneer Fauve Dealers

The official salons were closed to the Fauve painters because of their experimentations. Therefore, exposure through independent dealers was crucial. In the winter of 1901-02, the critic Roger Marx, who had previously helped Moreau's students sell their copies from the Louvre to the state, introduced Matisse to the dealer Berthe Weill. Weill, a tiny woman from Alsace with enormous flair and a sharp eye for discerning talent in completely unknown painters, ran a small second-hand shop at 25, rue Victor-Massé, not far from Degas' house. At first, her stock consisted entirely of objects donated by friends. In 1900 she bought from Picasso, who had just arrived in Paris, three bullfighting scenes for which she paid 100 francs and which she resold to Adolphe Brisson for 150, a sum which delighted her. Generally, she was content with modest profits—if she sold a Matisse for 130 francs, she would only take 30 francs commission. As late as 1908 she sold a van Gogh for 60 francs, having paid 40 for it herself. Most of the time she sold lithographs by Toulouse-Làutrec, Daumier, and Redon.

From 1902 on, Weill began to mount exhibitions. She started with Matisse and Marquet, then Camoin, Dufy and Puy, and, in 1905, Friesz, Derain, Vlaminck, and van Dongen. On the recommendation of Dufy, she took an interest in the Fauves and later the

Cubists. For a quarter of a century, many young painters of note were represented in her galleries in rue Victor-Massé, rue Taitbout, and rue Lafitte. After the Fauves, she represented Metzinger, Modigliani, Roger de la Fresnaye, Fauconnet, Gromaire, Lhote, Favory, Dufresne, Dunoyer de Segonzac, Waroquier, Bissière, Yves Alix, and Gernez. All left her once they were established, for she lacked the prestige and capital of men like Vollard and Druet, who stole her painters one after the other. When she died in 1951 at age 86, she was subsisting only on gifts from her former protegés.

In February 1902, a group of Moreau's students, including Matisse and Marquet, exhibited at her gallery. Marquet sold one of his works to the architect Frantz Jourdain, the first president of the Salon d'Automne at its founding the following year. At the Indépendants of 1902, Manguin was represented with Matisse, Marquet, and Puy. In 1903, Camoin exhibited there too, as did Dufy and Friesz, though as yet the Le Havre painters were not in contact with Matisse's circle. It is certain, however, that they knew each other's work. Dufy had shown at Weill's in February, 1903, and Matisse and Marquet in the same gallery in May.

Early Salons and Exhibitions

The main event of 1903 was the establishment of the Salon d'Automne. The Fauves-to-be had a vested interest in the Salon from its beginning. Jourdain was president. Among the founders were Desvallières, Rouault and Marquet, who had been friends since their time at Moreau's studio, and Eugène Carrière, the second teacher of the Fauves, as well as the critics Roger Marx and J. K. Huysmans and the artists Redon and Vallotton. There was some conservative representation—the critic Camille Mauclair, who was to attack the Fauves at the 1905 Salon, was among the founders. The first Salon d'Automne (1903) at which Matisse, Marquet, and Rouault all showed, was dominated by former Nabis—Bonnard, Vuillard, Denis, and Serusier—and by the first retrospective of the work of Gauguin, who had died earlier that year in the Marquesas. But Matisse and his friends still had their first loyalties toward the Indépendants, especially from 1904 when Matisse and Paul Signac became friends, a friendship leading to Matisse's visit to Signac's house at Saint-Tropez that summer. The visit led to Matisse's production of *Luxe, calme et volupté*, exhibited at the 1905 Indépendants, where Matisse, as president of the hanging committee, helped orchestrate the first group exhibition of the Fauves.

By then, the Fauve group was almost complete. In 1904, at the Indépendants in the spring, at Berthe Weill's in April, and at the Salon d'Automne, Matisse, Marquet, Manguin, Camoin, Valtat, and Puy all showed together. By then they were also painting together, often at Manguin's studio, where they shared the same models.

This period in Matisse's life came to a satisfactory close with his first one-man exhibition, a retrospective of forty-six paintings at Ambroise Vollard's gallery in June, 1904. Matisse had known Vollard since 1899, when he bought from him a Bathers by Cézanne and a Rodin plaster and traded one of his own paintings for a Gauguin portrait. Vollard had been following the work of Matisse's circle without making any commitment toward it. It was once again the well-known critic Roger Marx who urged that Matisse deserved an exhibition. He wrote a complimentary catalogue preface, praising Matisse's rejection of fashionable success at the Nationale for "the challenge of struggle and the bitter honor of satisfying himself. The more one ponders the more it becomes evident in this case that the constant growth of his talent was caused by endlessly renewed efforts which stimulated the artist to make the most ruthless demands upon himself."[9]

Welcomed by the dealer of Cézanne, van Gogh, and Gauguin, Matisse's vocation was now confirmed. The exhibition did not bring Matisse any monetary success, but it undoubtedly raised Matisse's reputation among his colleagues, as well as increasing

Vollard's interest in the Fauves-to-be. That November, he gave van Dongen his first one-artist show. The following February, Vollard visited Derain on Matisse's advice and bought the entire contents of his studio. He did the same for Vlaminck a year later.

After his exhibition at Vollard's, Matisse spent the summer of 1904 with Henri-Edmond Cross in Le Lavandou and Paul Signac in nearby Saint-Tropez on the Mediterranean. Since Seurat's death, Signac was regarded as the grand old man of Post-Impressionism, as well as a notorious anarchist. At first, still influenced by Cézanne, Matisse found Signac rather dogmatic but greatly admired Cross, who at his best was an excellent colorist. As Matisse yielded to the spell of the Mediterranean sunshine, his colors brightened and blossomed anew. Following his lead, other Fauves spent time in search of the *pays enchanté* of the south, migrating there like a flock of birds each summer.

Matisse's chief work of that summer, which he exhibited at the Salon des Indépendants of 1905, had the Baudelarian title *Luxe, calme et volupté*. This methodically organized, scintillating and rainbow-colored mosaic is the masterpiece of Matisse's pre-Fauve period, the summary and concentration of his efforts in the Neo-Impressionist style, and his first version of the classical pastoral theme. Signac was delighted at this confirmation of his color theories and bought *Luxe, calme et volupté* immediately, taking it straight from the Salon des Indépendants back to Saint-Tropez, where it remained until 1943.

Fauvist World

Returning to Paris for the second Salon d'Automne, which opened October 15, 1904, Matisse showed fourteen works, including several Saint-Tropez landscapes and two sculptures, *Le Serf* and *Madeleine (I)*. Friesz was overcome by Matisse's paintings and renounced Impressionism to throw himself into what he called "color orchestrations" and "emotional transpositions." It was also in the fall of 1904 that the other Fauves joined Matisse. Dufy and Friesz exhibited at the Indépendants in the spring, as they had done the previous year, and Dufy, who was soon to become Weill's favorite Fauve, showed twice at her gallery in 1904. Also back in the circle, having completed his military service though not yet exhibiting again, was Derain. With Derain's return, Vlaminck met Matisse again, and he, too, was brought into the group. Matisse invited the pair from Chatou to exhibit at the 1905 Indépendants. As chairman, Matisse co-opted onto the hanging committee Camoin, Manguin, Marquet, and Puy. Van Dongen, Dufy, and Friesz submitted paintings and were accepted. Except for Braque, the Fauvist circle was now complete.

At the Indépendant of 1905, Matisse's new direction was corroborated by a retrospective of the works of Georges Seurat, but challenged by a retrospective of forty-five of van Gogh's works, with their flatter, bolder, and more sinuous approach. André Derain's *Port au Pecq* and *The Old Tree*, Vlaminck's paintings of the Seine at Bougival, and Dufy's flag-bedecked yachts and harbor scenes from Honfleur, exhibited along with *Luxe, calme et volupté*, all used a bright palette of contemporary colors and a mixed technique.

Although the Fauves were not so named until the fall of 1905, Fauvism (as a group if not as a movement) preceded its title, which in any case did not become widely used until 1907. It was clear enough, at least to informed opinion, that at the 1905 Indépendants there was a burst of new talent, though no one could find common denominators there. Louis Vauxcelles began his front-page review of the show with the claim that "we possess today a luxuriant generation of young painters, daring to the point of excess, honest draftsmen, powerful colorists, from who will arise the masters of

tomorrow."[10] Moreover, he noted Matisse's prominence among the former Moreau pupils. Charles Morice, in the influential *Mercure de France,* cryptically noted "we are at the beginning of 'something else.'"[11]

André Derain increasingly showed himself ready to match Matisse in ambition and style. At times, Derain was even ahead of Matisse. Fauvism is as widely thought of as Matisse's invention as Cubism was at one time seen as Picasso's alone; but just as it was Braque who arguably, produced the first true Cubist paintings, so Derain's work was more purely Fauvist before Matisse's. By the winter of 1904-05, at the latest, when Matisse was deep in Neo-Impressionism, Derain's painting had entered a new phase. Derain's greatest advances came in landscape. The *Snowscape at Chatou,* probably one of the paintings Vollard acquired from Derain's studio in February, 1905, and *The Old Tree* and *Port au Pecq,* both exhibited at the 1905 Indépendants, are both Fauve paintings.

Derain's *Port au Pecq* has a flat and tense surface composed of mixed stylistic devices that Matisse would not match until the summer of that year at Collioure. The combination of large Nabi derived color areas and Neo-Impressionist infilling with Impressionist handling in the background is especially striking. Moreover, such typically Fauvist forms as the broken-color divisions of the trees on the right-hand side and Derain's admixture of van Gogh's flecked brushstrokes over broad color zones and *japonisme,* clearly demonstrate Derain's mature Fauve synthesis. If Derain did initiate Fauvism in the winter of 1904-05, he lacked the confidence to pursue it alone. Having seen *Luxe, calme et volupté* in the spring Indépendants, he followed Matisse into Neo-Impressionism with a series of paintings executed in London of the Thames, its bridges, and the buildings surrounding it.

Collioure: Summer 1905

Matisse was joined by André Derain in Collioure, a fishing village near the Spanish border, in the summer of 1905. Here, Matisse and Derain painted the same motifs in friendly competition. This little Catalan port played the same role for Matisse and Derain that Céret in the same Rousillon region was destined shortly after to serve for Braque and Picasso. Collioure was the birthplace of Fauvism—sun-filled paintings of pure color in a brilliant new style that would create such a sensation when exhibited at the Salon d'Automne a few months later. It was an astonishingly productive period of cooperation between the two artists that took them beyond the confines of Neo-Impressionism. Matisse's new friendship with Derain, and his subsequent association with Vlaminck and the Havrais Fauves, meant a disruption of the original circle of 1900. There is real justification for speaking of that circle as a pre-Fauve grouping, which gradually was replaced by a truer Fauvism from late 1905 onward. If such is the case, then Camoin and even Manguin must also be counted pre-Fauves for, as with Puy, their experiments with color climaxed in 1905. Although Camoin, Manguin, and Puy continued to exhibit with Matisse's circle, there was less and less in common between their work and that of Matisse's newer, more adventurous friends.

Derain found Matisse's methodical experimentation a complete contrast to Vlaminck's frenzied improvisation and realized the extent to which his own talents might develop under the discipline of compositional structure and constant application to work. Derain's paintings, including many views from the heights overlooking the bay, show his rapid powers of assimilation and his individual advance over the methods of Cross and Signac. He employed a mixed technique, sometimes painting in flat areas and at other times using a rainbow-hued pointillism. His palette was light and flowerlike, rich and varied in its intensities and nuances with cool tones of lavender, green, and violet and warm ones of orange, vermilion, and pink. Works such as *La japonaise au bord de l'eau*

and *Paysage de Collioure* - less sketchy and impetuous than those done at Chatou - were executed directly in color, vividly applied in small strokes, threadlike filaments, or curving spirals that developed into turbulent whorls.

Matisse, intoxicated with the climate, recaptured the ectasy he had known in Corsica and Toulouse (he would return faithfully for about ten years to this region). He dashed off numerous small, scintillating sketches that sparkled brillantly with pure color. Like Derain, he enhanced the pointillist technique by means of cross hatchings and swirls. Matisse allowed the bare white canvas to act as color and texture in his versions, which appeared even more unfinished than Derain's.

At this moment, the art of Paul Gauguin came as an unexpected revelation. Matisse and Derain often visited their neighbor, the sculptor Aristide Maillol, at Banyuls. Maillol shared personal recollections of Gauguin and imbued the visitors with his own ardent admiration for Gauguin's work. Maillol also took them to the nearby village of Corneilla-de-Conflent where Daniel de Monfreid, the faithful and solitary friend of Gauguin, preserved magnificent and completely unknown high-color paintings done in the South Seas. All of the Fauves profited by the fundamental lesson of Gauguin—pure color applied flatly to the surface of the canvas. Gauguin's paintings encouraged Matisse and Derain to adopt a more synthetic approach. The large Gauguin retrospective held at the Salon d'Automne of 1906 would confirm their new direction.

The final works Matisse painted at Collioure in the summer of 1905 led toward the exuberant coloring that constitutes the very essence of Fauvism. They reveal an unprecedented and transitory medley of pointillism and flat patterning. The mixing of techniques and this new flatness appears in *La fenêtre ouverte*, Matisse's complex development of the window theme that would provide the motif for so many important later canvases, such as his Nice interiors. *La fenêtre ouverte* is one of the clearest yet most delicate statements on color complementaries and reflected light: one flanking wall green, balanced by the red frame, and salmon-colored reflection; the opposite wall pink, with patches of green reflected in the window frames, which appear to swing into the room. The unbroken flat surfaces of the casement and the wall, seen against the light, enframe with their calm masses the central area that looks out upon the sun and the sea, flecked with more vivid, turbulent colors. The pigment is applied in a thin, fluid manner, as freely as watercolor.

Paris: Fall 1905

On his return to Paris, Matisse resumed painting from models and in a few days completed a large portrait of his wife Amélie, *Woman With a Hat*. Called "the nastiest smear of paint I have ever seen"[12] by its ultimate purchaser, the American collector Leo Stein, this veritable eruption of fantastic colors—a plaintive face mottled with green, pink, and yellow, topped by a coiffure of brick red and cobalt blue—culminates in the purple of a hugely overdecorated hat, its burden of colorful fruit and feathers indistinctly rendered by Matisse's energetic brush strokes. The same flamboyant colors that enliven the highly decorated fichu and waisted blouse are spread over the background. The figure does not predominate over the accessories; each is an equal and independent element, each developed for its own sake, yet they operate harmoniously and are integrated into a rhythmic whole. *Woman with a Hat* was the most sensational painting at the famous Salon d'Automne of 1905 and was soon followed by an even more fantastic second portrait of Mme Matisse.

Madame Matisse: The Green Line, created later the same year, is emphatically calmer, a work with a much greater sophistication and confidence. The division of the background into decorative flat planes, pink above orange on the left, dark green on the

right, is extraordinarily daring. The frontality of the painting possibly owes something to Derain's series of full-face portraits, but the strong "green line" that gives the painting its title is a device typical of Matisse's inventiveness. In complementary fashion, Amélie's face is divided literally in half by a thick green line running straight down the nose, each half a different color (purple and vermilion on one side, emerald green on the other) and with a distinctly different experession, balancing the overall mask-like effect. These colors, laid on in flat areas enlivened by dark accents, deprive the face of its character of deep seriousness and create a kind of dissonant, clashing harmony the intensity of which results from the purity of the compound elements and the simple tension between them. Going beyond his earlier efforts and violating the principles of complementaries, Matisse instinctively used color in this way. As he later wrote, "Fauvism for me was a tryout of means: to place side by side blue, red, green and combine them in an expressive and structural fashion. It was the result of an inbred necessity within myself rather than an conscious intention."[13]

When Matisse was working on *The Green Line*, the reverberations of the Salon d'Automne were beginning to have their effect on the younger Fauve painters. Matisse's *La fenêtre ouverte* and *Woman with a Hat* were his most important submissions. Derain was represented by nine paintings, including *The Drying of the Sails*. *La cage centrale*—Salle VII—included works by Matisse, Derain, Manguin, Marquet, Camoin, and Vlaminck. Puy was in Salle III with the older Nabis, including Vuillard and Bonnard; Rouault in Salle XVI with a number of Cézanne-derived realists. Valtat appeared in Salle XV, with the then unknown Jawlensky and Kandinsky, who were deeply influenced by the Fauve canvasses they saw there. Friesz, still working in the Impressionist tradition, also showed, though not in Salle VII. While Matisse and Derain were at Collioure, Camoin, Manguin, and Marquet had spent the summer at Saint-Tropez. These three produced bold, high-color Impressionistic works without the flat quality of mature Fauve paintings. Only Braque, who first exhibited with the Fauves at the 1906 Indépendants, did not show.

Following their *succès de scandale* at the 1905 Salon d'Automne, contacts among the members of the group multiplied. The Fauves regrouped in November at Berthe Weill's, where Camoin, Derain, Dufy, Marquet, Matisse, and Vlaminck were represented. At the 1906 Indépendants, held in March and April, they were joined by Friesz, Puy, van Dongen, and Braque. The financial station of the Fauve painters, which up to that time had been very difficult, improved considerably. In 1905 Marquet signed a contract with Druet. Vollard, who formerly had been interested only in Valtat and Camoin, followed Matisse's advice and contracted with Derain in February, 1905; with Puy a few months later; and with Vlaminck in April, 1906. Derain, before renting a studio in the rue Tourlaque in Montmartre, frequented the Bateau Lavoir, where van Dongen and Picasso had been among the first residents. Vlaminck, who settled comfortably with his family at Rueil, was able to give up music and devote himself entirely to painting.

Although Matisse did not sign a regular contract until September, 1909, he was able to support himself through purchases by a small but influential coterie of collectors. Among these were the Americans Gertrude and Leo Stein, who adorned the walls of their cosmopolitan salon with an increasing number of his paintings. It was at their Paris apartment that Matisse, late in 1906, met his young Spanish rival, Pablo Picasso. In March, 1906, Matisse's second private exhibition opened at the Galerie Druet, where Marquet and van Dongen were later shown. Although it was a very important exhibition, including paintings, watercolors, sculptures, and a new series of lithographs and woodcuts, Matisse's works were somewhat eclipsed by the opening of the Salon des Indépendants the next day.

Le Bonheur de vivre

The 1906 Indépendants marked the first time the complete Fauve group appeared together. The highlight of the exhibition proved to be Matisse's monumental canvas, *Le Bonheur de vivre* (The Joy of Living). In this one masterpiece, Maatisse separated himself from his fellow Fauves, who each exhibited over half a dozen small *plein-air* views. *Le Bonheur de vivre*, painted in the expropriated convent of Les Oiseaux in Paris where Matisse and Friesz set up studios late in 1905, pays tribute to Stéphane Mallarmé's poem, *L'Après-midi d'une faune* (Afternoon of a Faun). Indeed, the opening line, "*Ces nymphes, je veux les perpetuer*" ("I wish to perpetuate these nymphs") could serve as the *leitmotif* for the rest of Matisse's career: the dance of nymphs and satyrs would be perpetuated from *The Dance* to the Barnes murals of 1930-32 and through to the drawings and paper cut-outs of the 1940s and 1950s.

The summation and logical outcome of Matisse's work at Collioure (as *Luxe, calme et volupté* had been of his activity in Saint-Tropez), *Le Bonheur de vivre* the painting combines in an extraordinary synthesis the two traditionally contrasting themes of the bacchanal and the pastoral, thus simultaneously exalting Dionysiac frenzy and Apollonian calm, rhythm, and melody. The colors shine bright, almost acid, with expanses of lime green and lemon. Contours in scarlet and viridian around the two central figures create a vibrant aura. The overall triangle of the composition relates to Cézanne's Bather pictures, a source for Picasso's *Demoiselles d'Avignon* at roughly the same time. Equally strong elements of linear arabesque and pure color combine to organize space and form. A figure from Ingres' *Turkish Bath* (exhibited in his 1905 retrospective at the Salon d'Automne) is recalled by the nude female figure on the left? The dancing circle of figures recalls Ingres' own *Golden Age* of 1862? Other figure groupings evoke Poussin's *Bacchantes*, and, in particular, an engraving by Agostino Carracci, *Reciprocal Love*. But these references are obscured by the flatness, the thin, luminous paint, and conventions for rendering trees and tufts of grass and flowers taken from Persian miniatures. While Claude Debussy's music for *L'Après-midi d'une faune* was written in 1894 and there was an established tradition of pastoral, Golden-Age painting in the nineteenth and earlier centuries, Matisse's painting is an extraordinary anticipation of the modern visualisation of the theme danced so sensually by Nijinsky for the Ballets Russes against decor by Léon Bakst in 1912.

Critics were aghast at the stylistic and mixed-technique eclecticism of *Le Bonheur de vivre*, although Leo Stein eventually bought it. Matisse, with proceeds from his successful second exhibition at Druet's gallery, set off to discover North Africa: Algiers, Constantine, Botha and Biskra, inspired by the traditions of artists such as Delacroix and the exotic and sensuous literature of his own contemporary, André Gide. He would return there often, drawn by the sunlight and fascinated by Moslem art, the stylizations and bright colors of which had already left their imprint on *Le Bonheur de vivre*.

After his return in May, 1906, Matisse spent the summer in Collioure. Matisse's growing interest in primitive art was expressed on his return, not only by a collection of artifacts from North Africa—carpets, bowls, jugs, and textiles—but also by a simplicity, clearly visible in *Pink Onions* and other works, close to children's art. With unflagging energy he produced a series of landscapes, figure studies, and still lifes, experimenting in various manners—sometimes employing massive architectonic forms boldy inscribed within dark contours; at other times creating delicate, decorative linear passages either without outlines or enclosed in fluid arabesques.

Expression and Decoration

Fauvism offered Matisse the possibility of free experimentation in color and line, always used in an attempt to attain maximum conciseness and expressive power. Matisse, the first Fauve to use pure colors, was also the first to revert to shading, which he did while Fauvism was still at its height. He was the only one of the group who could subdue his palette without diminishing its luminosity. The brilliance of his color was, in fact, often less the result of its actual intensity than of its careful placement within the painting and its interplay with its surroundings. While clashes and dissonance appear in his paintings, there are also incredibly subtle nuances. The forcefulness of his expression is always tempered by a lyrical freshness and exquisite harmonies.

The years 1905 to 1907, the zenith of Fauvism, produced a rich complex of canvasses that still appear brilliant and modern. Matisse's interiors and landscapes of Collioure and the renowned *Green Line* portrait of Mme Matisse brought to vivid maturation his daring palette of saturated green, vermilions, and blues. He continued in 1906-07 with equally brilliant compositions, some with arabesque structuring suggesting the flowing patterns of Gauguin and even the decorative style of Art Nouveau. Vlaminck was a younger and especially daring exponent of Fauvist extravagant of color and dashing brush texture. Derain, and later Braque, painted brilliantly but with a certain discipline of compostion that suggests the influence of Cézanne. Friesz, van Dongen, and Dufy also colored their landscapes and figure compositions with powerful flat planes and passages of ultramarine, vermilion, greens, oranges, and yellows. Marquet, Camoin, Valtat, and Puy were to varying degrees more reserved in their tonalities, off-setting resonant notes of pure hues by distributing them among gray zones. The aesthetic principles of Fauvism may be summed up as follows: color constructs space and is the equivalent of light; the whole plane surface should flame with color without modeling or illusionist *chiaroscuro*; purity and simplification of means; an absolute correspondence between expression (emotive suggestion) and decoration (the formal order of the picture). In short, a dynamic sensualism disciplined by synthesis and subordinated to a basic economy of means. Fauvist subjects, like certain aspects of the Fauvist style, follow those of Impressionist and Post-Impressionist sources. Beaches, ports, seascapes, carnivals, interiors, and, somewhat less commonly, figure compositions and portrait studies are the principal themes. Georges Rouault, a fringe Fauve, chose more serious subjects—sinister judges, prostitutes, somber clowns and acrobats.

Maurice de Vlaminck

Matisse's *Le Bonheur de vivre* and the 1906 Indépendants, strengthened the group identity of the Fauves. From the time of the 1906 Indépendants, the Havrais painters began to develop their more mature Fauve styles, working together from the same motifs as first Matisse and Marquet and later, Matisse and Derain, had done before. Although Marquet contributed to this new period of Fauve activity, Matisse and Derain generally did not. Having worked together at Collioure in 1905, they now went their separate ways. Derain continued to paint for a while with Vlaminck at Chatou, but since Collioure he seemed to have had less in common with his exuberant colleague. In late 1906, Derain left Chatou for Paris. While Vlaminck continued to pursue an emotional, charged style; Derain, like Matisse, came to appreciate the virtues of the classical and the calm.

Lacking his usual partner, Vlaminck did not contribute significantly to the collaborative activity of 1906. From the fall of 1905 Vlaminck's move to artistic maturity was swift and decisive. By the next spring he had become the third major Fauve painter. With ever-increasing ardor, Vlaminck continued to apply his colors, dominanted by

combinations of the three primaries, especially the cobalts and vermilions, just as he squeezed them out of the tube, producing flat color zones as pure and vibrant as possible. After the unexpected contract with Vollard in early 1906, Vlaminck's enthusiasm was unbounded. The summer of 1906 was probably the most productive and happiest of his entire career. He set up his easel on the banks of the Seine near Chatou and achieved, with the sheer spontaneity of the original Fauve vision and the ebullient force of his color, the emphatic pictorial openess and expansive flatness characteristic of the mature Fauve synthesis. Forms seemed to grow spontaneously out of the pure, vivid hues—blood reds, sunny yellows and oranges, and electric blues brought to their highest pitch and unified in masterly, dynamic harmonies. The paint was applied in thick, glossy strokes and slapped on with gusto to create canvasses drenched in light, their extreme violence tempered by delicate shadings.

Friesz, Braque, Dufy, and Marquet

While Vlaminck spent the summer of 1906 working around Chatou, Friesz and Braque were in Antwerp. Dufy and Marquet were on the Channel coast at Trouville, Honfleur, Sainte-Adresse, and Le Havre. From 1901 to 1904, Dufy had regularly spent his summers in the area, painting the striped bathing tents on the beach and the boardwalk of the Marie-Christine casino at Sainte-Adresse. Dufy's paintings from 1902 show a refined Boudin-like harmonious style. By 1904, the same subject was treated in a spontaneous Impressionist manner. Dufy's 1906 paintings of the casino boardwalk reveal his version of colorful and flattened mixed-technique Fauvism. In the summer of 1906, Braque and Friesz were not even at the stage of color subjects. Their views of Antwerp have only occasional touches of intense color, nervous brushstrokes, and a tentative Fauve boldness of design. It was only when the pair traveled south, as their colleagues had done before, that their color was fully liberated from atmospheric Impressionism and their Fauve styles matured.

Georges Braque

Leaving Antwerp, Braque stopped in Paris in September and October, 1906, where he viewed the Salon d'Automne. Among the highlights of the exhibition were powerful Fauve landscapes by Vlaminck and Derain. Vlaminck's paintings of Chatou and Derain's paintings produced in London that spring and in L'Estaque that summer showed that he, like Matisse, had consolidated the flat, high-color and decorative high Fauvist manner. There was also a major Gauguin retrospective at the 1906 Salon, far larger than those at the 1903 Salon d'Automne and at Vollard's in 1905. This display of 227 of Gauguin's works must have hastened the younger Fauves to follow Matisse and Derain on the path of decorative, high-color art.

In October, 1906, Braque left Paris for L'Estaque, probably on Derain's suggestion. Like the previous Fauve visitors to the Midi, he immediately heightened his palette. His more sturdily structured version of Neo-Impressionist Fauvism produced some of his most uninhibited paintings, of a vigor and intensity matched only by Vlaminck. He continued this style into the spring of 1907, thus lagging over a year behind his colleagues. Braque exhibited his late 1906 paintings of L'Estaque at the Indépendants of 1907 and, encouraged by their reception, returned immediately to the south to La Ciotat where he was joined for the summer by Friesz. By then, Braque had put Divisionism behind him. At La Ciotat, the two friends created their own decorative Fauvist style—Braque keeping to the golden-toned base of the spring painting but simplifying the forms into soft undulating patterns and Friesz taking the curvilinear to the restless

arabesques of Art Nouveau. Both artists' work was flat, constructed in height but not depth. Moreover, intimations of Braque's interest in stylized drawing and the beginning of an equalized distribution of lights and darks began to appear. This direction toward Cubism would decisively terminate his short affiliation with Fauvism. Other Fauve painters did not remain static either. Raoul Dufy developed a peculiarly dashing post-Fauvist mode that soon became fashionable among commercial illustrators and fabric designers. Vlaminck, once one of the most consistent Fauves, turned to brown-and-gray-toned works of a systematized vivacity. Rouault continued his comparatively independent line of development, repeating somber themes and turning more and more to religious expression.

André Derain

While Braque and Friesz were working at La Ciotat, Derain was at nearby Cassis, writing enviously to Vlaminck about his two happy colleagues and of the crisis that had beset his own art. Compared with his vivid Gauguinesque paintings of the previous summer, Derain's Cassis work is somber and restrained. Large flat areas bounded by outlining remain in some paintings, but the color is naturalistic, the shapes angular, the lines heavy and thick. The mood is far from the exuberance of his Fauve style. Indeed, Derain's Cassis landscapes may be referred to as post-Fauve paintings. Early in 1907, he turned to figure painting. At the Indépendants that year, he exhibited the *Dancer at the 'Rat Mort'* painted in late 1906, the final masterpiece of his flat-color Fauve manner, and a large, dramatic *Bathers* of early 1907, which still had some of the intense coloring of Fauvism, but was linked to tonally modeled and angular forms derived from Cézanne. This was Derain's final act of rivalry with Matisse, whose *Blue Nude* with its blue contours, the sketchy rendering of ferns in the background, and the uncomfortable, unnatural *contrapposto*—appeared in the Indépendants as well. Matisse's *Blue Nude* was seen to be so ugly that when the painting was exhibited in Chicago in 1913, at the second venue of the notorious Armory Show, it was burned in effigy by students.

Dissolution of Fauvism

By the spring 1907 Indépendants, the Fauvism of Matisse and Derain was as good as over. By the fall 1907 Salon d'Automne, it had ended for the others as well. The spate of figure compositions produced by the Fauves that year is as good a sign as any that the focus of their art had radically changed, turning away from landscape and from the joyful celebration of its light and color to something more calculated, conceptual, and classically restrained. The Indépendants of 1907 marked both the high point of Fauvism and the moment when it began to disintegrate. It was, paradoxically, the first time that the name *les fauves* became popular. After its first use in 1905, it had not been applied to the group again until the Salon d'Automne of 1906, when Vauxcelles and Maurice Guillemot both briefly mentioned the *salle des fauves*.[14] By 1907, however, it was in common use. Realizing that his quip had caught on, Vauxcelles counted twenty-five painters at the Indépendants who he considered had been touched by Fauvism, among them:

M. Matisse, fauve-in-chief, M. Derain, fauve-deputy; MM. Othon Friesz and Dufy, fauves-in-attendance; M. Girieud, irresolute, eminent Italianate fauve; M. Czobel, uncultivated, Hungarian or Polish fauve; M. Béreny, apprentice-fauve; and M. Delaunay (fourteen year old—pupil of M. Metzinger) infantile fauvelet[15]

Vauxcelles's inclusions and omissions, surprising today, show not only how broad the outlines of Fauvism could seem, even to a seasoned observer, but more particularly that the Havrais Fauves (Derain, Friesz, and Dufy) were now attracting more attention than Matisse's colleagues from Moreau's studio, who had become increasingly conservative. Furthermore, Fauvism itself had been recognized as enough of a movement and had received enough publicity to attract new converts.

Other converts were noted by Jean Puy in the 1907 Salon d'Automne, including Le Fauconnier and Braque. By the end of the year the first full-length study of Fauvism had appeared by Michel Puy (Jean's brother and an art critic) in the November, 1907 issue of *La Phalange*. In the December issue of the same magazine there was an interview with Matisse by the new critic of the avant-garde, Guillaume Apollinaire. Matisse was represented by his blue nude, the first of his paintings of large-scale figures, and Derain by the first of his large Bathers compositions. Matisse's blue nude began the move in his art toward the development of a grand decorative style. Derain's direction was opposite to the decorative—more barbaric and Cézannesque. It would not be long before Matisse had separated himself from his former collaborators and before Apollinaire, who attributed the invention of Fauvism to Matisse and Derain, would be linking Derain's name with that of Picasso in the invention of Cubism.

Fauvism and Cubism are usually viewed as the two opposite poles of early twentieth century art—the instinctive versus the reasonable; color versus monochrome; free form versus structure; the fragmented versus the stylistically coherent; wildness versus sobriety. Certainly, they led in opposite directions. They had, however, common sources, the most important of which was Cézanne. The last phase of Fauvism and the first of Cubism overlapped in the Cézannism of 1907. Bathed in the 1907-08 rediscovery of Cézanne, Derain, followed by Braque, turned almost entirely away from curvilinear forms and Fauvist color toward emphatically regularized drawing, hatched diagonal brushstrokes, a restricted palette, and a flattened architectonic surface. Matisse, for his part, extended the lessons of Fauvism to a post-Fauvist classicism and idealism.

Fauvism ended as a style in 1907 as amorphously as it had emerged. It ended as a movement and as a group in as public a way as it had begun: "The feeling between the Picassoites and the Matisseites became bitter," Gertrude Stein later recalled. "Derain and Braque had become Picassoites and were definitely not Matisseites."[16] The polarization of the avant-garde in Paris that took place from 1908 left Matisse isolated from his former colleagues. This was not, however, entirely a one-sided move. Clearly, the growth in esteem and popularity of Picasso contributed to the demise of Fauvism, but Matisse himself had also been developing away from his Fauve style. Whereas those who abruptly abandoned Fauvism in pursuit of the classical were not, with the single exception of Braque, as successful in their new styles as in the ones they had left, Matisse independently realized the very ambition to which the others aspired—a revived classicism and a timeless, monumental, and ideal art.

Matisse After Fauvism

After exhibiting *the Blue Nude* at the 1907 Indépendants, Matisse appears to have taken stock of his artistic position. The *Brook with Aloes*, painted at Collioure that summer, was Matisse's last Fauve landscape, but one whose flattened decorative style and subdued color turned from the excited handling of previous Collioure landscapes towards a calmer and more deliberately harmonic style. The results of this new preoccupation with fundamentals were evident in the large paintings (labeled *esquisse*, or sketch in the catalogue) he exhibited at the 1907 Salon d'Automne. One of these, *Le Luxe, I*, is nearly seven feet high. A Bathers composition in theme and motif, it is similar to the *Le Bonheur*

de vivre and *Luxe, calme et volupté* before it. It is, however, far more tentative in draftsmanship than either of these and potentially even anti-Fauve. The color is muffled and varied in its application, combining flat, nearly even zones with scrubbed, sketchy areas and sections of broken strokes. It has a new grandness of design and a new decorative clarity. A second version, *Le Luxe, II,* probably from early 1908, exaggerated these characteristics to achieve a newly direct calmness and simplicity, compared with which even *Le Bonheur de vivre* seems an energetic painting.

Turning once more to Puvis de Chavannes for subject, method, and materials, Matisse began to create other life-sized figure compositions in a grand decorative style. Another sketch shown at the 1907 Salon d'Automne, *Music,* points directly to the painting *Music* of 1910 and marks the beginnings of Matisse's post-Fauve period of high decorative art. At this time he started painting still lifes again, combining and testing the decorative against deepening pictorial space but emphasizing patterning, avoiding the decorative for the sculptural, and collapsing sculptural forms with the pressure of the decorative patterns on which they are placed. In *Harmony in Blue,* modeling and perspective are almost banished. The pictorial space is flattened and patterned to set up a tense equilibrium between the horizontal plane of the table and the vertical one of the wall. In *Harmony in Red,* table and wall are joined in one vivid surface of color.

Matisse's *Harmony in Blue* was one of the highlights of the retrospective exhibition (thirty paintings, drawings, and bronzes in a section of his own) that Matisse received at the Salon d'Automne of 1908. Even as late as this, he was not immune to vicious criticism for his Fauve attributes. Writing in *La Revue hebdomadaire,* M. J. Péladan, who had been a founder of the Rosicurcian Salons of the 1890s, accused the Fauves as a whole of charlatanism, of being "ignorant and lazy [trying] to offer the public colorlessness and formlessness," and Matisse himself of not having any respect for the "ideal and the rules."[17] Moreover, Péladan attacked the jury of the Salon for allowing the paintings to be hung. The morgue, Péladan noted, had recently been closed to public view. In his opinion, the same should happen to the Salon d'Automne: "The spectacle of unhealthy shams constitues a danger of infection. One ought not to make a spectacle of epilepsy, likewise feigning, likewise painting."[18]

Notes of a Painter

Georges Desvallières asked Matisse to reply to Péladan both as the leader of the Fauves and as a jury member. Matisse's reply was "Notes of a Painter,"[19] his earliest theoretical statement. "Rules," he insisted, "have no existence outside of individuals." Matisse emphasized the rules he himself believed in and spoke of his own ideal, of

> "an art of balance, of purity and serenity, devoid of troubling or depressing subject matter, an art which could be for every mental worker, for the businessman as well as the man of letters, for example, a soothing, calming influence on the mind, something like a good armchair which provides relaxation from physical fatigue."

This famous passage is hardly the manifesto of a *fauve.* Indeed, "Notes of a Painter" confirms that, by the end of 1908, Matisse's Fauve period was over: "I do not think exactly as I thought yesterday," he wrote.

In the essay Matisse stressed his reliance on expression, the repudiation of anything violent or excessive (a rejection of one side of Fauvism), his dissatisfaction with the sketch-like manner of his early Fauve style, his discontent with the fleeting character of Impressionism, and his preference for the calm and equilibrium of classical art. Matisse's change of direction is confirmed by a story told by Maurice Sterne of Matisse's first day

of teaching at the school he opened at the beginning of 1908. "When Matisse entered the room he was aghast to find an array of large canvases splashed with garish colors and distorted shapes. Without a word he left the atelier, went to his own quarter in the same building, and returned with a cast of a Greek head [he] told his students to turn their half-baked efforts to the wall and start drawing 'from the antique.'"[20] This was how the King Fauve treated those would-be Fauves.

It was from the Salon d'Automne of 1908, which provoked "Notes of a Painter," that Matisse excluded Cubist pictures and confirmed the dissolution of the Fauve group. The *Harmony in Blue* was sold to Sergei Shchukin. In March, 1909, Shchukin commissioned from Matisse the panels *Dance* and *Music*, which mark the consolidation of his grand decorative style. By the end of 1909, Matisse had left Paris and was living in Issy-les-Moulineaux. His period of cooperation with the Parisian avant-garde had ended, and with it the final chapter of Fauvism was closed.

The Fauve Legacy

"You can't remain forever in a state of paroxysm," Braque insisted, explaining his abandonment of the Fauvist style.[21] Matisse concurred: "Later," he said, "each member denied that part of Fauvism we felt to be excessive, each according to his personality, in order to find his own path."[22] The post-Fauvist work of its adherents had in common a rejection of the excessive for something more rational and classical in form. To all except Matisse, this meant a repudiation of color as well. With the emergence of the Cubist tradition and its entrenchment as the dominant pictorial style of the first half of the twentieth century, color took second place to form in most paintings. The logic of form created through color—of design in color—that Fauvism made possible seems not to have been fully accessible at once, except to an artist as utterly obsessed with pictorial purity as Matisse. He realized immediately that color alone could evoke the complete range of pictorial attributes that other components of painting convey separately—depth as well as flatness, contours as well as planes, the substantive as well as the illusory. For many Fauve and non-Fauve artists alike, Fauvism catalyzed their understanding of earlier art, offering an example of how it could be revitalized, while showing that the ideas which paralleled their own had already found artistic resolution. Before Fauvism had been dismissed as an evolutionary dead end, it provided a joyful, even Dionysian experience, which many of its active participants later disavowed at great length. Manguin, for example, burned many of his canvases from the period around 1920.

Various Fauvist affinities spread to Russia, Belgium, Italy, the Netherlands, England, and America, where they were welcomed as the first clear demonstration of a new artistic liberation at the beginning of the twentieth century. In Germany, two groups in particular were affected by it—the Brücke movement during its Dresden period and the Neue Künstler Vereinigung in Munich before the secession of the Blaue Reiter group. Max Pechstein, Jawlensky, and Kandinsky were all greatly influenced by Fauvism. Van Dongen, for example, exhibited with the Brücke group in 1908. Jawlensky made frequent trips to France where he came into contact with Matisse and Rouault. Kandinsky lived in Sèvres, near Paris, precisely at the height of Fauvism. He frequented the Steins's salon and especially admired the art of Matisse.

It would be wrong to overstate the radical nature of the Fauve achievement. That it became so immediately popular and was so readily assimilated by ambitious painters only shows that Fauvism was as much a summation of the past as the spearhead of a new sensibility. Unlike most subsequent modern movements, Fauvism was never really autonomous. This lack of autonomy and clearly defined identity presents itself in several striking ways, chief among which is that even within the most narrowly defined Fauve

period, between the Indépendants of 1905 and 1907, and even at its height, between the Salons d'Automne of 1905 and of 1906, not all paintings produced by the so-called Fauves can truly be described as Fauve paintings. This applies particularly to the more conservative members of Matisse's original circle, such as Manguin, Camoin, Marquet, Valtat, and Puy, but also to Matisse himself.

What finally requires emphasis is that the cooperative group status was absolutely essential to Fauvism, though it demonstrates its fugitive character at the same time. So much depended on the interactions of personalities and on the key role that Matisse played as advisor and example to the others. This explains how Fauvism developed from a movement centered around Matisse and his friends from Gustave Moreau's studio and l'Atelier Carrière to one formed around the triangle of Matisse, Derain, and Vlaminck. The Matisse-Derain association became the linchpin of Fauvism. When it broke after the Indépendants of 1907, Fauvism soon declined. Even at its height, however, Fauvism was not a single coherent group but a grouping of several allegiances, of pairs of painters following a similar vision—Matisse with Marquet, Matisse with Derain, Derain with Vlaminck, Marquet with Dufy, and so on. For little more than two brief years they pursued broadly similiar aims, stimulated by each other's examples and above all by Matisse's, until that "paroxysm" of which Braque spoke had passed, which was nothing less than the convulsion during which twentieth-century art was born.

Notes

1. For documentation of the critical reception of the notorious 1905 Salon d'Automne, see the Fauve Exhibitions section.

2. Quoted by Rewald (1952):12.

3. Duthuit (1950):35.

4. Hobhouse (1976):47.

5. Recorded by Duthuit (1950):26.

6. Quoted by Dudar (1990):68.

7. Duthuit (1929):260.

8. Duthuit (1929):23.

9. Quoted by Barr (1951):45.

10. *Gil Blas* (March 23, 1905).

11. *Mercure de France* (April 15, 1905).

12. Quoted by Sarah Wilson (1992):12.

13. Quoted in Matisse (1971):16

14. Vauxcelles, *Gil Blas* (October 6, 1906); Guillemot, *L'art et les artistes* (November 1906):296.

15. *Gil Blas* (March 20, 1907).

16. *Autobiography* (1933):79.

17. *La Revue hebdomadaire* (October 17, 1908):361.

18. *La Revue hebdomadaire* (October 17, 1908):370.

19. *La Grande revue* (December 25, 1908):731-45; Flam (1973):32-40.

20. Quoted by Barr (1951):118.

21. Recorded by Duthuit (1950):26.

22. Tériade, "Matisse Speaks," p. 43; Flam (1973):132.

Bibliographic Overview

Fauvism did not receive detailed scholarly study until the 1960s. For over fifty years after the movement dissolved, most books, journal articles, and exhibition catalogues repeat general information—the legendary events of the Salon d'Automne of 1905 and how the term *Fauves* was coined; a survey of Henri Matisse's initiative as the leader of the group and the roles that Matisse, André Derain, and Maurice de Vlaminck played in the formation of the movement; the group's exhibitions and corresponding public and critical reactions; and its sudden disintegration and replacement by Cubism in 1907-08.

The Salon des Indépendants of 1907 marked both the high point of Fauvism and the moment when it began to disintegrate. By the end of the year the first full-length study of Fauvism had appeared, by Michel Puy (Jean Puy's brother) in the November, 1907 issue of *La Phalange*. In the December, 1907 issue of the same magazine there was an interview with Matisse by Guillaume Apollinaire. Michel Puy wrote a second essay on Fauvism, "Le Dernier état de la peinture" in 1910. Puy's two essays, reprinted in *L'Effort des peintres modernes* (Paris: A. Messein, 1933), pp. 61-126, are among the most thoughtful early evaluations of Fauvism and Matisse. Gelett Burgess's article, "The Wild Men of Paris," *The Architectural Record* (May 1910):400-10, based on interviews of several Fauve painters in 1908, warrants special mention. Burgess, an American writer, humorist, and illustrator, describes stepping into the hall that housed the Salon des Indépendants of 1908 to be assaulted by "shrieks of laughter coming from an adjoining wing." He tells of seeing spectators "lurching hysterically in and out of the galleries," and relates his own shock upon encountering this strange new world, "a universe of ugliness."

In 1929-31, Georges Duthuit published a series of articles on Fauvism in *Cahiers d'art*. This material was expanded into book form in 1949 and published in English in 1950. Duthuit's comprehensive annotated bibliography is an important landmark in Fauve research. The book remained the most influential study for another decade. Its drawbacks, however, are readily apparent—its poetic, evocative style lacks documentation, logical organization, and a critical apparatus. Written by a son-in-law of Matisse, it is blatantly biased in favor of Matisse and his friend Albert Marquet and openly hostile to Maurice de Vlaminck. Duthuit's initial series of *Cahiers d'art* articles generated much material for the first ambitious survey of the modern movement, *Histoire de l'art contemporain* (Paris: Editions Cahiers d'Art, 1935), edited by René Huyghe from articles published in *L'Amour de l'art*. These lively accounts and sympathetic evaluations were primarily written by friends and close associates of the artists and are based more on memory than on scholarly research. Huyghe's anthology became the source book for subsequent works, including the prerceptive three-volume study by Bernard Dorival, *Les*

Etapes de la peinture Française contemporaine (Paris: Gallimard, 1943-46), whose value, however, is diminished by the lack of proper documentation and illustrations.

Post-World War II books on Fauvism compensated for this absence of visual material. Duthuit's book is lavishly illustrated, as was the large, popular volume by Jean-Paul Crespelle, *Les Fauves* (Neuchâtel: Ides et Calendes, 1962); published immediately in translation as *The Fauves* (Greenwich, CT: New York Graphic Society, 1962). Two other surveys should be cited: Jean Leymarie, *Fauvism* (Geneva: Skira, 1959) and Joseph-Emile Muller, *Fauvism* (New York: Praeger, 1967). Although prepared by art historians and museum advisors, these brief surveys are directed at a popular audience and lack the necessary documentation. Several group exhibitions of Fauvism during the early 1950s—in Venice and Berne in 1950, Paris in 1951, and New York in 1952-53—were accompanied by small, summary catalogues that added little new information or sources.

Finally, the exhibition catalogue, *Le Fauvisme français et les débuts de l'expressionisme allemand* (Paris and Munich, Spring, 1966), included considerable documentation and an informative introduction by Dorival and Michel Hoog. Beginning in the late 1960s, and particularly apparent in the last fifteen years, Fauvism is at last receiving critical scholarly attention. Ellen C. Oppler's well-documented and meticulously researched Ph.D. dissertation (Columbia University, 1969) argues that the Fauvist painters were not really the revolutionaries of popular legend but rather that they continued previous developments, basing their expressions on the synthesis of nineteenth-century traditions found in Post-Impressionism and a continuing interest in Impressionism. John Elderfield, in his catalogue for the 1976 Museum of Modern Art's (New York) *The "Wild Beasts": Fauvism and its Affinities* exhibition, concentrates on the stylistic evolution of each member of the group, provides insightful comparisons, and summarizes past scholarship. Oppler's and Elderfield's works focus on the roles of Matisse, Derain, and Vlaminck in their efforts to survey Fauvism in general. Research on the Le Havre group—Georges Braque, Raoul Dufy, and Othon Friesz—was initiated by Kim Younga in his 1980 Ph.D. dissertation (Ohio State University).

The most significant recent work on Fauvism is Judi Freeman's authoritative catalogue for the 1990-91 traveling exhibition *The Fauve Landscape: Matisse, Derain, Braque and Their Circle, 1904-08* (Los Angeles County Museum of Art). One of the largest international loan shows of Fauve art ever assembled (175 works) and the first to concentrate on outdoor vistas, Freeman surveys the landscapes of eleven Fauves. The exhibition was dominated by Derain, whom Freeman considers "the quintessential Fauve." Freeman interviewed the aged surviving children and other relatives of some of the artists and included translations of letters, many unpublished, that the Fauves had written one to another. Turn-of-the-century postcards of the small tourist Provençal towns that the Fauves frequented and the vistas they painted are also included. The catalogue's absorbing 63-page chronology of the period provides considerable new information and sources.

Chronology, 1904–1908

This chronology is based on chronologies and information found in Judi Freeman, *The Fauve Landscape* (Los Angeles: Los Angeles County Museum of Art; New York: Abbeville Press, 1990), pp. 59-121 (see pages 116-21 for documentation); John Elderfield, *The 'Wild Beasts': Fauvism and its Affinities* (New York: The Museum of Modern Art, 1976); Alfred H. Barr, Jr., *Matisse: His Art and His Public* (New York: The Museum of Modern Art, 1951); André Derain, *Lettres à Vlaminck* (Paris: Flammarion, 1955); Ellen C. Oppler, *Fauvism Reexamined* (New York, 1969); Gaston Diehl, *The Fauves* (New York: Abrams, 1975); Pierre Schneider, *Matisse* (New York: Rizzoli, 1984); Jack Flam, *Matisse: The Man and His Art, 1869-1918* (Ithaca, NY and London: Cornell University Press, 1986); and Sarah Wilson, *Matisse* (New York: Rizzoli, 1992); among other sources.

Events not associated with a particular day, month or season are placed at the beginning of the year. Unless noted, all exhibitions took place in Paris and all other events took place in France. Francs are converted to dollars by using the average exchange rate of the period: 5.0 francs equaled 1 dollar.

Birth and Death Dates and Places of the Fauve Painters

Louis Valtat. Born August 8, 1869, Dieppe. Died January 2, 1952, Paris.

Henri Matisse. Born December 31, 1869, Le Cateau (Nord). Died November 3, 1954, Cimiez.

Georges Rouault. Born May 24, 1871, Paris. Died February 13, 1958, Paris.

Henri Mangugin. Born March 23, 1874, Paris. Died September 25, 1949, Saint-Tropez.

Albert Marquet. Born March 27, 1875, Bordeaux. Died June 14, 1947, Paris.

Maurice de Vlaminck. Born April 4, 1876, Paris. Died November 10, 1958, Revil-la-Gadelière.

Jean Puy. Born November 8, 1876, Roanne (Loire). Died 1960, Roanne.

Kees van Dongen. Born January 26, 1877, Delfshaven (near Rotterdam). Died May 28, 1968, Monte-Carlo.

Raoul Dufy. Born June 3, 1877, Le Havre. Died March 23, 1953, Forcalquier.

Emile-Othon Friesz. Born February 6, 1879, Le Havre. Died January 10, 1949, Paris.

Charles Camoin. Born September 23, 1879, Marseille. Died May 20, 1965, Paris.

André Derain. Born June 10, 1880, Chatou (Seine-et-Oise). Died September 8, 1954, Garches (Seine-et-Oise).

Georges Braque. Born May 13, 1882, Argenteuil (Seine-et-Oise). Died August 31, 1963, Paris.

The Fauves in 1904

At the beginning of 1904, Henri Matisse lived in his fifth-floor studio at 19, quai Saint-Michel, Paris, where he had lived since 1899. Matisse later recalled:

> I had two windows which looked straight down from the fifth floor on to the channels of the Seine. A fine view: on the right Notre-Dame, on the left the Louvre, the Préfecture [of Police] and the Palais de Justice opposite. On Sunday mornings there was always terrific activity on the *quai*; barges were moored there, fishermen came and planted their little rods, people browsed in the boxes on the bookstalls. It was the real heart of Paris. [quoted in Nigel Gosling, *Paris 1900-1914: The Miraculous Years* (London: Weidenfeld and Nicolson, 1978):85]

Maurice de Vlaminck lived in his native Chatou, painting Paris landscapes along the banks of the Seine. André Derain was engaged in military service in eastern France. Prior to Derain's departure, Vlaminck and Derain had leased a studio at 7, place de l'Hôtel de Ville, Chatou. Most of the other Fauve painters lived in Paris. Albert Marquet resided at either 38, rue Monge or 25, quai de la Tournelle. By February, 1904 Marquet lived at 211 bis, avenue de Versailles. Henri Manguin and Jean Puy also lived in Paris; Manguin at 61, rue Boursault and Puy at 69, rue Lepic. Georges Braque was an art student in Paris, living at 48, rue d'Orsel. Raoul Dufy and Othon Friesz were dividing their time between Paris and Le Havre. Friesz's Paris address was 86, rue de Sèvres; Dufy's 31, quai Bourbon. Charles Camoin lived at 3, rue des Pyramides. Louis Valtat resided on the rue Girardon. Kees van Dongen had lived permanently in Paris since 1900, having first visited in 1897.

1904

Camoin and Marquet travel together to Marseille and Cassis.
Dufy visits Marseille and Martigues.
Wilhelm Unde, the German art dealer, settles in Paris.
Valtat visits the painter Paul Signac in Saint-Tropez.

1904

20 January-20 February
Seven works by Dufy (paintings, pastels and watercolors) are exhibited in Paris at Galerie Berthe Weill. Weill had opened her gallery at 25, rue Victor-Massé on December 1, 1901.

31 January
Puy writes to Manguin that he is hoping that they will work together for a week, starting next week.

February
Fifty paintings and approximately the same number of drawings by Paul Gauguin are exhibited at Galerie Vollard, 6, rue Laffitte, Paris.

17-27 February
Forty-six works by Emile Bernard are displayed at Galerie Bernheim-Jeune, 8, rue Lafitte, Paris.

21 February-24 March
Twentieth Salon des Indépendants, Grandes Serres, Grand Palais. Among the 2,395 works in the exhibition are those by Camoin (six), Kees van Dongen (six), Dufy (six), Friesz (five), Pierre Girieud (six), Manguin (six), Marquet (five), Matisse (six), Jean Metzinger (six), Puy (six), Félix Vallotton (six), and Valtat (three). A special Cézanne exhibition includes thirty paintings, two drawings, and photographs of about twenty seven other works.

This salon, organized by the Société des artistes indépendants, accepted all entries without restriction. As published in the 1904 exhibition catalogue, the official policy stated: "The Society of Independent Artists, based on the suppression of admission juries, has as its goal to permit artists to freely represent their works for the judgment of the public." Participants who paid a nominal entrance fee could exhibit at least two
works of art. Matisse had been on the hanging committee since 1903; Manguin and Marquet joined the committee in 1904.

25 February-29 March
Peintres Impressionnistes, eleventh exhibition of La Libre Esthétique, Brussels, includes three works by Valtat along with works by Impressionist and Post-Impressionist artists. Catalogue by Octave Maus. La Libre Esthétique had been established in 1893 by Maus, an amateur painter and an attorney at the appeals court in Brussels, as the successor to the Belgian group of avant-garde artists, Les XX.

April
Accompanied by Sebastián Junyer Vidal, Pablo Picasso moves to Paris, to a building nicknamed the Bateau-Lavoir ("floating laundry") at 13, rue Ravignan, facing place Emile-Goudeau. Picasso takes the top-floor apartment vacated by Paco Durio, a Spanish sculptor and friend of Gauguin's, and lives there intermittently through 1909.

1904

2-30 April
Galerie Berthe Weill exhibited works by Camoin (six), Manguin (eight), Marquet (six), Matisse (six), and Puy (eight). The catalogue text by Roger Marx identifies them as students of Gustave Moreau.

13 April
Matisse begins copying Raphael's *Portrait of Balthazar Castiglione* at the Louvre. Manguin had registered on 15 March to copy Titian's *Portrait of a Man*, and Marquet had on 5 April to copy Chardin's *House of Cards*. Louis Vauxcelles, the art critic who would later coin the name "Fauves," met the three artists at the Louvre and described the encounter in an article in *Gil Blas* on May 4.

20 April-15 May
Forty-six paintings by Friesz are exhibited at a Galerie des Collectionneurs, 338, rue Saint-Honoré.

1-18 June
Forty-five paintings and one drawing by Matisse are exhibited at Galerie Vollard, Paris. Catalogue text written by Roger Marx. Matisse had known Ambroise Vollard since 1899, when the artist had purchased a painting of bathers by Cézanne and a sculpture by Rodin. Matisse had also traded one of his own paintings for a portrait by Gauguin. The exhibition, largely unsuccessful, was Matisse's first one-man show. Shortly afterward, however, Vollard purchased one of the exhibited works, *La Desserte* (*The Sideboard*, 1897).

10 June-13 October
Manguin and his family are in La Percaillerie at the tip of Cotentin (Manche) in Normandy, where he and fellow artist De Mathan had spent the summer of 1896.

late Spring-Summer
Marquet and Dufy paint together in Fécamp.

Summer
Braque leaves Paris and vacations in Brittany and Normandy. He spends some time in Le Pouldu, near Point-Aven, where Gauguin and his circle had painted.

Camoin visits Naples and Capri.

early July
Marquet, in Paris, does not paint landscapes despite good weather. He works instead on illustrations for Charles-Louis Philippe's *Bubu de Montparnasse*, published in October.

12 July-late September
Matisse, his wife Amélie, and their son Pierre spend the summer with the Signacs (at the Signacs' suggestion) at their villa in Saint-Tropez. Matisse had met Paul Signac earlier that year in Paris. Marquet had intended to accompany the Matisses, but he lacked sufficient funds and was busy illustrating *Bubu de Montparnasse*. Matisse does not paint Pointillist works in Saint-Tropez, which displeases Signac, the leading practitioner and

1904

12 July-late September
proponent of the Pointillist style. Stung by criticism, Matisse paints *Le Goûter (Golfe de Saint-Tropez)*, one of the first studies for *Luxe, calme et volupté*.

mid-July-early September
Art dealer Berthe Weill vacations in Le Havre and Saint-Adresse. Dufy takes her to visit Trouville.

16 July
Marquet writes to Manguin that Manguin's painting, *La Baigneuse, Jeanne* (1904), exhibited at the 1904 Salon des Indépendants, has been accepted for acquisition by the state.

17 August
Manguin writes a long letter to Matisse complaining of the incessantly changeable weather in Normandy, which makes it difficult to paint landscapes. He mentions that Marquet has reported that the Salon d'Automne promises to be outstanding.

early September
Matisse writes to Manguin describing the intense heat and how difficult it has been to work. He has been able to complete only one painting, probably *Le Goûter (Golfe de Saint-Tropez)*. In the same letter Matisse worries that painting may drive him crazy and acknowledges that he is never happy with the results. Funds are desperately low.

8 September
Marquet writes to Manguin that his illustrations for *Bubu de Montparnasse* had been rejected by the publisher, who chose another illustrator. He also refers to Puy, who has just returned to Paris after summer travels through Brittany, during which he produced a large body of work.

early Fall
Matisse begins work on the final version of *Luxe, calme et volupté*, using a title inspired by Charles Baudelaire's poem "L'Invitation au voyage":

> Là, tout n'est qu'ordre et beauté,
> Luxe, calme et volupté.

> There, all is nothing but order and beauty,
> Luxury, calm and voluptuousness.

The painting is completed in the winter of 1905.

Fall
Amélie Matisse visits Collioure, contemplating a future stay there with her family.
Derain completes his three years of military service, chiefly stationed in Commercy, and returns to Chatou, where he and Vlaminck resume their work together. The two artists had first met on a train from Paris in 1900. Derain resides at his studio at 7, place de l'Hôtel de Ville, Chatou. Derain decides to frequent the Académie Julian in Paris, despite Vlaminck's disdain for it. Derain begins to paint, often in Vlaminck's company, in

1904

Fall
Chatou, Le Pecq, Montesson, and Marly-le-Roi, all northwestern suburbs of Paris along the Seine. During the fall Derain becomes friendly with the poet and critic Guillaume Apollinaire, who lives nearby at Le Vésinet. Derain also visits the Musée d'Ethnographie du Trocadéro (now the Musée de l'Homme) in Paris.

Friesz moves to 18, impasse du Maine.

Picasso and Fernande Olivier move in together. The two artists remain together intermittently for the next seven years.

1 October
Having received a letter dated 22 September from Roger Marx declaring that the state wants to purchase Matisse's copy of *Balthazar Castiglione*, Matisse writes to him to accept the offer of 300 francs.

4 October
Manguin writes to Marquet from Saint-Tropez, after visiting Marseille. He has found the Villa Demière in Malleribes (near Saint-Tropez) and is enthusiastic about staying there the next year.

13 October
The Manguins return to Paris.

15 October-15 November
Second Salon d'Automne is held at the Petit Palais, Paris. 1,317 paintings and sculptures by 324 artists are exhibited. Individual galleries are devoted to Cézanne (forty-two works), Puvis de Chavannes (forty-three paintings, drawings, pastels, cartoon and caricatures), Odilon Redon, Pierre-Auguste Renoir, and Toulouse-Lautrec. Also represented are Camoin (seven works), van Dongen (two), Friesz (four), Marquet (ten), Matisse (thirteen paintings and two sculptures, all made before his summer in Saint-Tropez), Puy (five), Rouault (forty-four), and Valtat (three). The state purchases paintings by Camoin, Marquet and Matisse. This is the first year that the Salon includes photography. At the Salon, Matisse begins to hyphenate his name, Henri-Matisse, to distinguish himself from the painter Auguste Matisse.

Leo Stein, who had moved to Paris in 1902 and lives with his sister Gertrude at 27, rue de Fleurus, visits the Salon d'Automne regularly and finds that Matisse's work makes a strong impression.

24 October-20 November
Paintings, watercolors and drawings by Dufy (eleven), Picasso (twelve works from 1901-04), and others are exhibited at Galerie Berthe Weill. Catalogue text by Maurice Le Sieutre.

15-25 November
105 paintings and twenty drawings by Kees van Dongen are exhibited at Galerie Vollard. Catalogue text by Félix Fénéon.

1904

early December
Camoin writes to Cézanne from Martigues, requesting permission to visit him in Aix-en-Provence. Cézanne, responding on 9 December, invites him to have lunch at his studio. Cézanne encourages Camoin to respond to influences that interest him.

14 December
Manguin writes to the critic and historian Elie Faure, indicating that he will attend the banquet for the painter and teacher Eugène Carrière, as will Amélie Matisse and Marquet.

17-31 December
Paul Signac holds a one-man show at Galerie Druet, Paris.

19 December
The *Assemblée générale* meets to elect the members of the jury for the next Salon des Indépendants. In a letter dated 1 December, the painter René Piot had urged Manguin to bring friends and colleagues so that all would be represented. Piot is friendly with Manguin, Marquet, Matisse, and Puy.

Winter 1904-05
Manguin, Marquet, Matisse, and Puy paint companion paintings in Manguin's Paris studio.

1905

Hans Purrmann, the German artist who becomes one of Matisse's students in 1908, arrives in Paris.

Vollard purchases from Puy all the work he has available.

16 January-15 February
Van Dongen exhibits eight paintings at Galerie Berthe Weill, along with works by other artists. Text signed by "Place aux 'Jeunes'."

before February
Derain invites Matisse (whom he has known since 1899 when they were students in Eugène Carrière's studio) to visit him and Vlaminck in Chatou. Matisse visits the two artists and encourages them to exhibit at the Salon des Indépendants. Derain had introduced Matisse to Vlaminck in March 1901, during the van Gogh retrospective at Bernheim-Jeune. Matisse reacts strongly to Vlaminck's absolutely pure colors.

February
Matisse introduces Vollard to Derain. Vollard purchases the entire contents of Derain's Chatou studio and signs him to a contract.

10-25 February
First exhibition of the Ensemble d'intimistes (peintres d'interieurs) (Group of Intimist Painters [Painters of Interiors]), Galerie Henri Graves, 18 rue de Caumartin, includes works by Matisse.

1905

25 February-25 March
Watercolors, drawings and paintings by van Dongen (ten), Dufy (five) and others are exhibited at Galerie Berthe Weill.

March
The first issue of *Vers et prose*, the Symbolist journal founded by the poet Paul Fort, is published. Matisse is among the subscribers.

Camoin lives at 13, carrefour de l'Odéon. Friesz is back at 15, place Dauphine. Marquet resides at 25, quai des Grands-Augustins, not far from Matisse. Puy is at 56, avenue de Clichy. Vlaminck lives at 21, boulevard des Ormes in Rueil.

7 March
Vollard writes to Marquet, offering 1,000 francs ($200.00) for six canvases without frames.

24 March-30 April
Twenty-first Salon des Indépendants is held at Grandes Serres, Grand Palais in Paris. Among the 4,269 works by 669 artists are included retrospectives of work by Georges Seurat (serre B) and Vincent van Gogh (serre A). Matisse lends one of his van Gogh drawings (probably *Hayricks*) to the retrospective, which includes forty-five paintings and drawings. The Seurat retrospective included forty-three paintings and drawings. Cézanne is represented with ten paintings.

The following Fauves and artists associated with them participate: Camoin (seven), Delaunay (eight), Derain (eight), Desvallières (seven) van Dongen (seven), Dufy (eight), Friesz (eight), Girieud (one), Manguin (eight), Marquet (eight), Matisse (eight, including *Luxe, calme et volupté*), Metzinger (eight), Puy (eight), Rouault (eight), Valtat (three), and Vlaminck (eight).

Matisse is *Secrétaire adjoint* and Signac serves as one of the vice presidents of the Salon. Supported by Signac, Matisse is placed in charge of the hanging committee, assisted by Bonnard, Camoin, Laprade, Luce, Manguin, Marquet, Metzinger, Puy, and Vallotton. Purchases worth 81,000 francs ($16,200.00) made by the state, the city, and individuals. Leo Stein buys a Manguin and a Vallotton. The state buys Matisse's *Vue de Saint-Tropez* (1904) and Marquet's *Notre Dame (Soleil)* (1904). Derain sells four of the eight paintings he exhibits, three to the Russian collector Ivan Morosov, for 150 francs ($30.00) each: *Le vieil arbre* (1904), *Solitude*, and *La pluie*. Vlaminck sells *Les bords de la Seine à Nanterre* (1905) for 100 francs ($20.00). Camoin, van Dongen, and Manguin sell paintings for 150 francs ($30.00). The Fauves receive negative comments from critics such as Maurice Denis and Charles Morice. Dufy, in particular, is awestruck by Matisse's *Luxe, calme et volupté*.

6-29 April
Exhibition at Galerie Berthe Weill includes works by Camoin (one), Manguin (seven), Marquet (five), and Matisse (six). Weill comments that Camoin leads in sales, followed by Marquet.

1905

1 May
Following Leo Stein's purchase of one of his paintings at the Salon des Indépendants, Manguin meets Leo and Gertrude Stein at their apartment.

12 May
Marquet leaves Paris for the Côte d'Azur, traveling via Marseille en route to Saint-Tropez.

12 May-10 June
Paintings and pastels by Friesz (twelve) and others at Galerie Berthe Weill.

15 May
Matisse, en route to Collioure, stops in Perpignan. He writes to Manguin, who is living with his family at the Villa Demière in Malleribes near Saint-Tropez, that he is anxiously awaiting 150 francs ($30.00) from Weill. In response, Manguin sends Matisse 100 francs ($20.00).

mid-May
The painter Francis Jourdain writes to Manguin from Nice, complaining about the poor weather and mentioning that Matisse's close friend Simon Bussy is there. He alludes to political problems surrounding plans for the Salon d'Automne.

16 May-week of 4 September
Matisse arrives in Collioure, takes a pension in an inexpensive boarding house close to the train station, and plans to be at work in a few days. Amélie Matisse had suggested that the family go to Collioure, as she is in nearby Toulouse and has family living in the region.

20 May
Matisse writes to Manguin, thanking him for the money. He remains very angry with Weill and her failure to send funds. He says that he has rented a room on the quay with a view of the water where he can work easily. Matisse also mentions that he is friendly with Etienne Terrus, a local landscape painter who exhibits at the Salon des Indépendants and is a friend of the Pointillist painter Maximilien Luce. Terrus lives in Elne, twelve miles from Collioure. Terrus becomes a constant companion of Matisse during this and subsequent trips to Collioure. He later introduces Matisse to the sculptor Aristide Maillol. Matisse encourages Manguin to visit him in Collioure.

25 May-1 June
Camoin visits Marseille and is enthusiastic about the sun and the light there. He helps Théo van Rysselberghe, the Belgian Pointillist, find a model.

27 May
Francis Jourdain visits Manguin and his guest Marquet at the Villa Demière, Malleribes.

1 June
Marquet stays at the Hôtel Sube near the port in Saint-Tropez, with a spectacular view that he can paint from his balcony. This is better for him than staying with the Manguins at the Villa Demière, where he did not generally have easy access to a model.

1905

6 June
Matisse writes to Marquet from Collioure, delighted to learned that he is staying at the Hôtel Sube. Matisse discusses his oil sketches and watercolors. He finds the region stunning and encourages Marquet to visit. Thanks to Terrus, they have met Maillol, whom Matisse helped with a sculpture he was making.

9 June
Manguin writes to Matisse about his sketches and problems with consistent light. He remains enthusiastic about the region but wishes he was closer to the water and Saint-Tropez. Manguin also notes that he has seen Signac, van Rysselberghe, and Edmund Cross.

Summer
Signac writes to Matisse about Marquet, Manguin, and van Rysselberghe. He cannot understand their complaints about the weather.

Braque stays in Honfleur and Le Havre with the sculptor Manolo (Manuel Martínez Hugué) and the critic Maurice Raynal. Braque reportedly acquires an African mask from Gabon, from a sailor.

Friesz visits Antwerp.

Summer-Fall
Dufy visits Marseille and Martigues.

28 June
Camoin, in Saint-Tropez, writes to Matisse that he and Marquet have been working together, painting women. Camoin finds Saint-Tropez expensive and he hopes to finish some studies before moving to Agay. He mentions that, like Matisse, he continues to wait for money owed him by Weill.

July
Works by Friesz and others are exhibited at Prath et Magnier, Paris.

early July
Camoin and Marquet depart Saint-Tropez for Cassis, where they stay at the Hôtel Cendrillon.

5 July
Marquet visits Saint-Raphael.

8 July-September
Derain works with Matisse in Collioure.

13 July-at least 24 July
Marquet and Camoin stay at the Grand Hôtel, Agay. Marquet writes to Manguin, urging him to visit them in Agay.

1905

14 July
Matisse writes to Signac about *Luxe, calme et volulpté*. Matisse has been making sketches and watercolors that will later be useful in Paris.

15 July
Amélie Matisse writes to Jeanne Manguin and describes Matisse and Derain's work. She reports that they enjoy Collioure and have made many trips, including a visit to Spain.

Matisse writes to his friend Bussy expressing his satisfaction with his (Matisse's) progress in painting and recent work.

mid-July
Terrus and Joachim Gasquet (Cézanne's confidant and biographer) visit Manguin in Saint-Tropez.

25 July-about 15 August
Marquet and Camoin visit Anthéor, which Marquet describes as stunning.

before 28 July
Maillol takes Matisse and Derain to visit Georges-Daniel de Monfreid, who lived in Leucate (a village near Maillol's town of Banyuls-sur-Mer), so they can examine his archives and collection of paintings by Paul Gauguin.

28 July
Derain writes to Vlaminck that a new concept of light is the negation of shadow and that he can experiment with the division of tones to obtain a harmonious and luminous image. He indicates that he is no longer strongly interested in anarchist politics. Derain also mentions that he has gone to Spain and visited several potteries.

31 July
Matisse writes to Manguin that they are doing well despite the intense heat. He sends greetings from Derain and asks about the submission deadline for the Salon d'Automne.

late July-early August
Following a trip to Italy, Francis Jourdain writes to Manguin from Paris about summer in the city, which is filled with English tourists. He offers to assist Camoin, Manguin, and Marquet with their submissions to the Salon d'Automne by handling transportation, framing, and registration.

August
In Pont-Aven for the summer, Maurice Denis discusses Matisse's work with fellow artists Paul Sérusier and Pierre Hepp. Sérusier is highly critical.

5 August
Derain writes to Vlaminck that he hopes to make thirty paintings, twenty drawings and fifty sketches before returning to Paris around 1 September.

1905

mid-August
The Manguins and the Signacs bicycle east along the Côte d'Azur, visiting Anthéor, Agay, and Menton. The Manguins continue to Cannes, Antibes, Saint-Jean, Beaulieu-sur-Mer, and Nice, returning to Malleribes via the inland route through the Var valley. Manguin finds the inland gorges and the mountains stunning, although he writes to Matisse on 22 August that he prefers the sea.

Marquet travels alone along the Mediterranean coast, toward Menton, staying at the Hôtel des Négocients near the port.

22 August
Manguin writes to Matisse expressing his disappointment at not having completed more paintings this summer. Although short of funds, he plans to stay in Malleribes until late September or early October. Manguin reports that he has seen Signac regularly and that he could not have been kinder. However, Signac does seem somewhat on the defensive regarding Matisse. According to Manguin, Signac plans to be in Paris in October, but he doubts that Cross will be well enough to go.

25 August
Marquet leaves Menton for Nice. He returns to Saint-Tropez by 28 or 29 August.

week of 28 August
Storms in Collioure delay completion of some of Matisse's paintings.

week of 4 September
Matisse and his family return to Paris. Derain probably returns by this date as well, traveling via L'Estaque, Agay, and Marseille.

by 8 September
Marquet immediately sells three paintings upon his return to Paris. He has seen the paintings that Matisse and Derain made in Collioure and writes to Manguin that they have made some stunning things.

13 September
Fénéon visits Matisse and sees the artist's work from Collioure--fifteen oil paintings, forty watercolors and about one hundred drawings.

14 September
Matisse writes to Signac that Marquet and Camoin have returned from the Côte d'Azur. He notes differences in their work from his, although he still admires it.

18 September
Matisse writes to Manguin that Signac has purchased *Luxe, calme et volupté* for 1,200 francs ($240.00). He sends Manguin 60 francs ($12.00) of the 100 francs ($20.00) he owes him. Matisse writes to Simon Bussy that he is painting a large canvas (now generally agreed to be *Le Port d'Avall*), which he intends to exhibit at the Salon d'Automne. The painting is not exhibited until March 1906, in Matisse's exhibition at Galerie Druet. He tells Bussy that he has received an extension from the Salon d'Automne to complete the

1905

18 September
painting (an indication of Matisse's standing within the Salon committee). He adds that
he has sold an important painting that he is calling "Luxe, calme et volupté."

21 September
Manguin writes to Matisse that he is intrigued by his news but that he had already known
of Signac's purchase of *Luxe, calme et volupté*. He mentions that Signac has also obtained
from Cross one of his earlier paintings, predominantly yellow in tone and featuring
women. The Matisse and Cross paintings are to be installed in Signac's dining room in
Saint-Tropez, and Manguin hopes to see them hanging before he leaves the Midi. He
expresses his appreciation of the natural beauty of the region and how it has influenced his
work.

27 September
Derain signs a receipt with Vollard for 3,300 francs ($660.00) for eighty-nine paintings
and eighty paintings.

28 September
Matisse writes to Signac that works by Camoin, Manguin, and Marquet have been accepted
at the Salon d'Automne and that Vauxcelles has already mentioned Manguin's paintings
of Saint-Tropez in *Gil Blas*. Regarding his own works, Matisse notes that if he had not
been on the committee and strongly supported by friends, they would not have been
accepted.

Autumn
Derain visits London for several days.

October
Matisse rents a studio at the Couvent des Oiseaux, 56, rue de Sèvres (at the corner of
boulevard de Montparnasse), which he retains through Spring 1908. Matisse begins to
paint *Le Bonheur de vivre*.

1 October
The Manguins return to Paris, traveling via Marseille in order to view murals by Puvis de
Chavannes in the Musée des Beaux-arts at the Palais de Longchamps. Signac accompanies
them to Marseille, where he stays to make some watercolors.

18 October-25 November
The Third Salon d'Automne is held at the Grand Palais, Paris. Among the 1,625 works
by 397 artists are included retrospectives of works by Ingres, Manet, and Renoir, who
is honorary president of the Salon. Works by Camoin (five), Derain (nine, including
views from Collioure), Manguin (five), Marquet (five), Matisse (ten), and Vlaminck (five)
are featured in room 7. Puy's works (four) are in room 3 with those by the older Nabis
artists and by Bonnard and Vuillard. Rouault (three) is represented in room 16; Valtat
(five) is in room 15 with Alexei Jawlensksy (six) and Wassily Kandinsky (12). Friesz
exhibits four works. Dufy does not exhibit, although many later references erroneously
indicate that he did. Emile Loubet, president of the Republic, refuses to open the Salon
because some of the paintings are considered radical compared to those at the more
conservative Salon of the Société Nationale des Artistes Français.

1905

18 October-25 November
From the press commentary prompted by this Salon emerges the term *les fauves*. The critic Louis Vauxcelles coins the phrase in his review for *Gil Blas*, published on 17 October 1905. Critics had been aware of a change in contemporary painting during the preceding year, but they did not identify it as a movement or group of artists until this Salon.

Generally, critics for *Gil Blas*, *L'Ermitage*, *Le Figaro*, and *Mercure de France* respond positively to the Salon, which is dominated by the Fauve artists. André Gide writes: "I stayed quite a while in this gallery [the one dominated by works by the Fauve artists]. I listened to the visitors and when I heard them exclaim in front of a Matisse: 'This is madness?' I felt like retorting, 'No sir, quite the contrary. It is the result of theories....'" ["Promenade au Salon d'Automne," *Gazette des Beaux-arts* ser. 3:34(1 Dec. 1905):483]. Maurice Denis describes Matisse's work as "an emotion from nature" ["De Gauguin, de Whistler, et de l'excès des théories," *L'Ermitage* (15 Nov. 1905)]. The critic for *Le Radical* writes: "There is much better than just hopes and promises [in this Salon]. And these youths' names, now unknown by the snobs who rush to society openings, will be celebrated tomorrow." [quoted in Jeanne Warnod, *Le Bateau-Lavoir* (Paris: Editions Mayer, 1986):77].

Vauxcelles comments: "M. Derain is going to alarm people; he alarms them at the Indépendants. I think he is more of a poster designer than an artist. The decided character of his virulent imagery, the facile juxtaposition of his complementaries will seem willfully puerile to some; let us recognize nevertheless that his *Boats* would happily decorate the wall of a child's room. M. Devlaminck [*sic*] makes naïve images: his painting, which really looks terrible, is really very good-natured." [Le Salon d'Automne," *Gil Blas* (17 Oct. 1905)]. M. Nicolle writes, "That which we are presented with does not have, aside from the materials used, any connection with paintings; presenting some odd medleys of color; of blue, of red, of yellow, of green; touches of crude colorings juxtaposed haphazardly; barbaric and naïve games of a child who is playing with the 'box of colors'..." [Le Salon d'Automne," *Journal de Rouen* (20 Nov. 1905)].

after 18 October-before 25 November
Braque is impressed with Matisse's and Derain's works at the Salon d'Automne. Friesz, Braque's friend from Le Havre, exhibits four paintings at the Salon but not in room 7, designated the "Fauve" room by the critics. Hans Purrmann, the German painter and later a pupil of Matisse, goes to Paris from Munich to see the Manet retrospective at the Salon. Overwhelmed by Matisse's work at the Salon, he goes to see more of it in Gertrude and Leo Stein's collection, a visit arranged by the American painter Maurice Sterne. Leo Stein introduces him to Matisse. Alexei Jawlensky also sees the Salon and meets Matisse.

21 October-20 November
Paintings by Camoin (six), Derain (five), Dufy (fifteen), Manguin (seven), Marquet (six), and Vlaminck (five) are exhibited at Galerie Berthe Weill. According to Weill's memoirs, Dufy's inclusion infuriated Matisse and she had to place Dufy's works in a small separate room to appease Matisse.

1905

23 October
Having attended the vernissage (varnishing) of the Salon d'Automne, Gertrude Stein and Etta Cone return to the Salon. Claribel Cone, who visited the Salon separately, later described her impressions of the Fauve room:

> The walls were covered with canvases--presenting what seemed to me then a riot of color--sharp and startling, drawing crude and uneven, distortions and exaggerations--composition primitive and simple as though done by a child. We stood in front of a portrait--it was that of a man bearded, brooding, tense, fiercely elemental in color with green eyes (if I remember correctly), blue beard, pink and yellow complexion. It seemed to me grotesque. We asked ourselves are these things to be taken seriously. [quoted in Barbara Pollack, *The Collectors: Dr. Claribel and Miss Etta Cone* (Indianapolis, New York: Bobbs-Merrill, 1962):70].

23 October-11 November
Van Dongen exhibits nineteen works at Galerie Druet, Paris.

25 November
Camoin arrives in Martigues, where he will spend the winter.

29 November
Leo Stein writes to a friend, Mabel Foote Weeks: "The Autumn salon is over and has left two pictures stranded in our atelier. All our recent accessions are unfortunately by people you never heard of, so theres [*sic*] no use trying to describe them, except that one of those out of the salon made everybody laugh except a few who got mad about it [Matisse's *Femme au chapeau* (*Women with a Hat*, 1905, private collection, San Francisco), for which Stein paid 500 francs ($100.00)], and two other pictures are by a young Spaniard named Picasso whom I consider a genius of very considerable magnitude and one of the most notable draughtsmen living." [quoted in *Four Americans in Paris: The Collection of Gertrude Stein and her Family*, exhibition catalogue (New York, Museum of Modern Arts, 1970):27].

Following the Salon, Leo takes his brother, Michael Stein, and his brother's wife, Sarah, to visit Matisse in his studio. A close friendship develops between the Matisses and the Steins.

2 December
Camoin writes to Matisse from Martigues and refers to a recent mishap in Marseille, about which he believes Marquet has told Matisse. Camoin had been painting outdoors when some youths threw his painting to the ground, stole his easel, and hit him on the head. Camoin reports seeing Cézanne painting outdoors "before his subject." He also mentions that he hopes to see Matisse during March, at the time of the Salon des Indépendants.

1905-06 Winter
Picasso begins to paint Gertrude Stein's portrait. He had met her and Leo Stein at Clovis Sagot's secondhand shop.

end of the year
Marquet signs a contract with Eugène Druet, who is also his chess partner.

1905

end of the year
Signac writes to Manguin, indicating that he has been following the intense debates in the press surrounding the Salon d'Automne. He also mentions that the paintings in his dining room, including Matisse's *Luxe, calme et volupté*, are in place.

On his return from London, Derain's future wife, Alice Princet, leaves her husband, Maurice Princet (a mathematician and theorist on the fourth dimension who influenced the Cubists), to live with Derain. Derain and Picasso meet.

1906

Derain mentions in a letter to Vlaminck that he has been reading and thinking about Friedrich Wilhelm Nietzsche, whose work he finds "astonishing."

A Russian artist, Elizabeth Epstein, takes Jawlensky to visit Manguin, whose paintings Jawlensky admires.

Sergei Shuchukin asks Vollard for Matisse's address. Shuchukin is a wealthy Russian businessman and art collector who has built a large collection of art and antiques and placed it on public display, first in his home and later in the Museum of Imperial History in Moscow.

Van Dongen moves to the Bateau-Lavoir (where the Spanish painter Juan Gris also lives from 1906 to 1922). Van Dongen lives there for one year with his wife, Guus, and there one-year-old daughter, Dolly. While there, van Dongen meets the critic Félix Fénéon, who, according to van Dongen, frequents the same group of anarchists as van Dongen.

Valtat visits Algeria.

3 January
Marquet writes to Faure that he is flattered by his invitation to exhibit (it is not clear to what exhibition he is referring). He encourages Faure to invite also "my friend Matisse, with whom I always exhibited and would bring honor, certainly, to your exhibition."

13 January
Manguin and other Fauve artists attend one of the Saturday gatherings regularly held at Gertrude and Leo Stein's apartment.

14 January
Manguin, Matisse, and Leon Stein visit a large private collection of Cézanne paintings.

Signac writes to Angrand about *Le Bonheur de vivre*: "Matisse, whose work I have liked until now, seems to have gone to the dogs. Upon a canvas of two and a half meters he has surrounded some strange characters with a line as thick as your thumb. Then he has covered the whole thing with flat, smooth colors which, however pure, seem disgusting." [quoted in Jack Flam, ed. *Matisse: A Retrospective* (New York: Hugh Lauter Levin, 1988:51].

1906

15 January
Sarah Stein takes Etta Cone to meet Matisse. Cone purchases two drawings.

20 January
Vlaminck writes to Marquet, inquiring about the plans for the annual exhibition of La Libre Esthétique.

21 January
Octave Maus, in Paris to select works for La Libre Esthétique exhibition, notifies Manguin that he has chosen three of Manguin's paintings from Galerie Druet. He invites Manguin to attend the opening festivities on 24 February in Brussels. Maus is encouraged to invite Matisse, Manguin, Camoin, and the other Fauves by his friend and fellow Belgian, Théo van Rysselberghe.

29 January-mid-March
In London for his second trip, Derain resides in the middle-class Holland Park section of the city.

30 January
Derain writes to Matisse about the works by Claude Lorrain, Joseph Mallord William Turner, Diego Velázquez, and Hans Holbein that he has seen in London museums. For Derain, Rembrandt's works are the most impressive.

18 February
Etta Cone purchases a watercolor (*Le Port de Collioure*, 1905) and a drawing from Matisse.

22 February-25 March
Thirteenth exhibition of La Libre Esthétique in Brussels includes Camoin (four), Manguin (three), Marquet (six), Matisse (seven), Puy (six), and others. Catalogue by Octave Maus.

March
Vollard purchases 150 paintings from Manguin.

7 March
Derain writes to Vlaminck that he has seen Turner's work in the National Gallery and has been to the British Museum.

8 March
Derain writes to Matisse that he has been thinking a great deal about Turner's and Claude's work, particularly the relationship of tones in Turner and the massing of colors and the sense of construction--analogous to the Italian and French Primitives--in Turner and Claude. He also writes about the strong emotions aroused in him by Velázquez's work and about the humanity of Rembrandt's paintings. It is evident from this and other letters that Derain has spent considerable time at the National Gallery studying works by these artists plus El Greco, Anthony van Dyck, Ferdinand Bol, Paolo Uccello, and Bartolomé Esteban Murillo. He was also fascinated by Maori statues at the British Museum. Derain mentions that he will return to Paris in time for the 19 March opening of Matisse's exhibition at Galerie Druet.

1906

9 and 10 March
Submissions are due for the Salon des Indépendants.

19 March
Braque probably meets Matisse and Derain at the opening of the Salon des Indépendants.

19 March-7 April
Fifty-three paintings, three sculptures, and several watercolors, lithographs, and woodcuts from 1897-1906 by Matisse are exhibited at Galerie Druet. Sales are very slow. In a review of the exhibition Léon Rosenthal writes, "M. Henri-Matisse is preoccupied with astonishing and disconcerting the public." [*La Chronique des arts* (31 March 1906):100].

between 19 March and 7 April
Derain, back in Paris, sees Matisse's exhibition and writes to Vlaminck that it is "really not bad. He is very gifted. That is undeniable." Derain also expresses his admiration for Claude Monet.

20 March-30 April
Twenty-second Salon des Indépendants is held at Serres de la Ville, Grand Palais. 5,552 works by 842 artists are shown. Cézanne is represented by ten paintings. Matisse shows only Le Bonheur de vivre. Also included are Braque (seven, which he later destroyed), Camoin (eight, many painted in Corsica), Béla Czobel (eight), Delaunay (eight), Derain (three), van Dongen (eight), Dufy (eight), Friesz (eight), Auguste Herbin (eight), Manguin (eight), Marquet, (eight, all of which belong to Druet), Matzinger (eight), Valtat (eight), and Vlaminck (eight). The opening is dedicated to more than 1,200 victims of a catastrophe in the coal mines near Courrières (Pas-de-Calais). The hanging committee, elected at the Salon's general assembly, consists of Laprade, Lebasque, Luce, Manguin, Albert Marque, Marquet, Matisse, Metzinger, Signac, and others. Friesz is on the executive committee.

Concerning *Le Bonheur de vivre*, Morice comments: "The large canvas of M. Henri Matisse, the *Bonheur de vivre*, is the 'question' of the Salon. A good many people have made merry before this strange work. I have not shared their hilarity. Indeed, it is rather with disquiet, with sadness, that I see an admirable gifted artist squander his energies..." [*Mercure de France* 61 (15 April 1906):535-6]. Weill later called the painting "the biggest laughing stock of any time in his career." [*Pan! Dans l'oeil!* (Paris: Lipschutz, 1933):124].

In the Salon catalogue Dufy lists his address as Sous-les-Rochers-Falaise.

Spring
About the time of the Salon, Gertrude Stein introduces Matisse and Picasso. Ferdinand Olivier described this meeting:

> There was something very sympathetic about Matisse. With his regular features and his thick, golden beard, he really looked like a grand old man of art. He seemed to be hiding, though, behind his thick spectacles, and his expression was opaque, gave nothing away, though he always talked for ages as soon as the conversation moved on to painting. He would argue, assert and endeavor to persuade. He had

1906

Spring

an astonishing lucidity of mind: precise, concise and intelligent. I think he was a good deal less simple than he liked to appear. He was already nearly forty-five [*sic*: Matisse was 30-seven and Picasso was twenty-five] and very much master of himself. Unlike Picasso, who was usually rather sullen and inhibited at occasions like the Stein's Saturdays, Matisse shone and impressed people. They were the two painters of whom the most was expected. [*Picasso and His Friends* (New York: Appleton-Century, 1965):88].

In his copy of the Indépendants catalogue, Apollinaire noted by Matisse's name, "At the moment Stein speaks only of two painters, Matisse and Picasso."

Picasso erases the head from his portrait of Gertrude Stein, leaving it unfinished until he returns from Gósol in the Spanish Pyrenees, later this summer. Archaic Iberian reliefs from Osuna, Spain (excavated in 1903) are on exhibit at the Musée du Louvre.

27 March
Eugène Carrière, who was known by many of the Fauves from their studies in his atelier, dies.

5 April
While in Nice during a trip of several weeks along the Mediterranean coast, Puy and his wife, Jeanne, write to the Manguins (in Paris), after spending some time in Saint-Tropez, where the weather was cold and gray and the sea rough.

23 April-7 May
Signac is in Rotterdam for "a change of scenery," as he puts it in a letter to Manguin, who is in Cavalière through mid-July.

late April
Vollard goes to Rueil and purchases the entire contents of Vlaminck's studio for 6,000 francs ($1,200.00), also reserving the right of first refusal on all future paintings. This arrangement allows Vlaminck to devote himself entirely to his painting, though he continues to give violin lessons to supplement his income.

early May
Friesz writes from Paris to Manguin in Cavalière, asking him which two of his paintings at Bernheim-Jeune and Druet he wants to send to the exhibition that Friesz is organizing for the newly established Cercle de l'Art Moderne in Le Havre. Friesz also asks Manguin to choose two drawings for an exhibition (location unknown) of drawings by Derain, Friesz, Manguin, Matisse, and Puy that Friesz is organizing.

May
Vollard purchases at least twenty paintings from Picasso for 2,000 francs ($400.00). Picasso will use the funds to travel to Spain that summer.

May-mid-August
Picasso and Olivier go to Barcelona and then to Gósol, where Picasso studies Iberian masks.

1906

1 May

Puy writes to Manguin, where he plans to stay through 1 June. He describes his travels through Saint-Tropez, Le Lavandou, Cavalière, Agay, Cannes, Antibes, and Nice as difficult and disruptive. It is hard to work, he observes, when he is somewhere for only eight days. Matisse, reports Puy, has been selling his works for 2,000 ($400.00) each--to Druet, to Vollard, and to a private collector. This is later confirmed by Matisse in a letter to Manguin, in which he indicates that he sold older paintings to Vollard and recent ones to Druet for that amount.

4 May-October

Matisse spends the summer in Collioure, making various side trips. Amélie and the children arrive slightly later and return to Paris on 10 September. Matisse probably returned in early October.

8 May

Leon Stein writes to Manguin that Michael Stein's family has survived the San Francisco earthquake (18 April). Although much of the city was destroyed by fire, the Stein family's properties in the city are still standing. Michael Stein leaves Paris for New York on 12 May. After he arrives and sends word about the situation in San Francisco, Leo and Gertrude plan to go to Italy.

10-26 May

Matisse, who has been in Perpignan since 5 May, visits Algeria. He goes to Algiers, then travels to Biskra for a short stay, returning to Algiers and then proceeding to Constantine and Biskra. His letters describe his fascination with the North African landscapes and, to a lesser extent, with the people.

12 May

Manguin writes from Cavalière to Matisse in Algeria. He much prefers the area around Saint-Tropez and misses the Villa Demière. Manguin mentions that Lebasque had settled in Saint-Tropez the previous week and is enchanted with it. Lebasque travels to Italy later in the year.

15 May

Marquet's father dies.

18 May

Matisse is in Biskra, "feasting his eyes."

From Paris, Friesz writes to Manguin telling him that he has taken two of Manguin's paintings from Vollard's gallery for the Cercle de l'Art Moderne exhibition (opening 26 May), along with works by Bonnard, Puy, and Valtat. All of the artists that Friesz had invited to participate will be included, with the exception of van Rysselberghe and Vuillard.

22 May

Wassily Kandinsky and Gabriele Münter arrive in Paris. Kandinsky had known Hans Purrmann, a close friend of Matisse, since their student days in Franz von Stuck's atelier. It is possible that Kandinsky meets the Steins in Paris through Purrmann.

1906

24 May-17 June
Seventy-three paintings and drawings by van Dongen are exhibited at the Kunstkring, Rotterdam.

25 May
Friesz writes to Marquet from Le Havre that the exhibition of the Cercle de l'Art Moderne features a "stunning group of work." He has various offers for Marquet's works.

26 May-30 June
Paintings by Braque, Derain, Dufy, Friesz, Manguin, Marquet, Matisse, Puy, Vlaminck, and others are exhibited at the Hôtel de Ville, Le Havre. Organized by Friesz for the Cercle de l'Art Moderne. Catalogue text by Le Sieutre. Matisse's two paintings--*La Plage rouge* (*The Red Beach*, 1905) and *La Marine de Collioure* (*Seascape of Collioure*) sell for a total of 550 francs ($110.00). The Cercle de l'Art Moderne had been founded in the spring. Charles Braque, Georges Braques' father, was among the nine founders, as was Georges Jean-Aubry, a close friend and biographer of Eugène Boudin. Braque, Dufy, and Friesz served in the painting committee.

late May
Camoin's paintings of negresses are in the *Exhibition Coloniale*, Marseille.

late May-early June
Matisse writes to Manguin that *Le Bonheur de vivre* (he calls it his "grand tableau") is hanging on the loft wall of Leo and Gertrude Stein's studio, at a height of twelve to fifteen feet. Also installed in that room is Picasso's *Boy Leading a Horse* (1905). The Steins have not yet purchased Matisse's painting, pending the effects of the San Francisco earthquake on their finances. Matisse encourages Manguin to go see it and give him his opinion. Matisse also reports that he has sold to Shchukin a large still life, which he had found in the attic of his studio, plus a drawing and two lithographs.

31 May
Friesz writes to Manguin from Le Havre that the exhibition there had been popular, with one hundred and fifty people visiting the first day and twenty-five to thirty daily thereafter. The press has been critical. Friesz, Manguin, Marquet, and Matisse have sold works. Offers have been made for Redon's and Vlaminck's paintings. Friesz writes that there are many interesting things to paint in Le Havre but that is difficult to work and he is going to Antwerp soon.

June
Signac urges Manguin to move to Saint-Tropez on a permanent basis. He offers to sell Manguin his Peugeot automobile for 4,500 francs ($900.00).

1 June
Sarah Stein writes to the Manguins from San Francisco that the family's affairs in the city are complicated. She and Michael will remain there for several months to settle them.

12 June-11 September
Braque and Friesz are in Antwerp.

1906

18 June-early July
Puy is in Doëlan (Finistère).

Summer
Derain is in the Midi. He first visits the Auvergne, then Béziers, then Marseille, after which he discovers the port of L'Estaque, where he spends the rest of the summer. En route he loses all his baggage. L'Estaque at this time is a coastal tourist town with at least six hotels. In a letter to Vlaminck in Chatou, he calls the landscape stunning.

late June
Matisse writes to Manguin, urging him to visit Collioure. He has found a house for the Manguin family with a kitchen and a terrace that has a panoramic view of the boats, the sea, and the mountains. The rent is 200 francs ($40.00) for three months, which Matisse feels is reasonable. Matisse pays 185 francs ($37.00) per month for himself, his wife, and their three children at a hotel in Collioure.

Matisse describes his routine in Collioure: he and Amélie leave at six each morning to go to a forest near the mountain. There she poses peacefully and they have not been disturbed. He can work only until ten or eleven in the morning because of the intense heat.

late June-early July
Manguin writes to Matisse that he will not go to Collioure right away as he is in the midst of making several paintings. He thinks that he and his wife might be able to leave Cavalière either sometime in July or spend September and October with the Matisses.

early July
Marquet is in Paris, caring for his mother who has fallen ill following the death of his father. He is eager to go to Le Havre and to paint.

Signac, having driven his car from Saint-Tropez, visits with Camoin in Marseille. Later in the summer Camoin travels to Corsica.

10 July
Mathan writes to Manguin from Paris that Rouault and Georges Desvallières (both of whom had been in Moreau's studio in the 1890s with Marquet) have left Paris but that Girieud remains. Mathan has been drawing at the Palais de Justice and at executions and attending debates about Alfred Dreyfus at the Cour de Cessation. Mathan observes that Camoin has decided to specialize in the study of boxing, following Cézanne's advice. According to Mathan, Matisse has written telling him that he is producing a significant number of paintings in Collioure.

12 July
Matisse writes to Manguin, inquiring again whether he will come to Collioure. Matisse has been unable to paint for two weeks because of bronchitis.

12 July-14 August
Manguin and his family are in Collioure.

1906

13-17 July
Marquet joins Dufy in Le Havre and stays at the Hôtel du Ruban Bleu, place d'Arme. Dufy's interest in the coast at Sainte-Adresse encourages both artists to paint there together. Sometime in July or early August, Dufy and Marquet travel to Trouville, Honfleur, Dieppe, and Fécamp.

14 July
Friesz sends greetings to Matisse and Manguin from Antwerp.

16 July
Puy writes to Manguin from Bénodet (Finistère), complaining of his inability to paint. He had moved to Bénodet from Doëlan because he found Doëlan unsuitable for painting and an unpleasant place to stay. In Bénodet, he writes, he has found some exceptional motifs to paint, particularly views to be made on a boat in the Atlantic. He has decided not to submit any works to the Salon d'Automne.

20 July
Derain signs a receipt for 1,800 francs ($360.00) for Vollard in exchange for twelve paintings of London.

10-end of August
Marquet is in Fécamp because he could not work easily in Le Havre, though he enjoyed being there. He wants to produce some paintings to show at the Salon d'Automne, but the bad weather is making that difficult.

26 August
Etienne Terrus writes to Manguin in Cavalière (where the Manguins remain until mid-September), regretting that he will not be able to visit Manguin in the Midi this summer and meet all of the painters who are working there. He mentions that Gustave Fayet, a collector with particularly strong holding of works by Gauguin, and a M. Fabre (presumably another collector) have visited Collioure. Terrus plans to be in Paris in October.

end of Summer
Writing in 1929 [see *Tournant dangereux: souvenirs de ma vie*, p. 88; and *Portraits avant décès*, pp. 105-6, 212], Vlaminck recalled that he discovered *art nègre* at this time. He acquired two Dahomey statuettes and one from the Ivory Coast in exchange for buying drinks for customers in an Argenteuil café. Vlaminck also asserted that he received a statue from the Ivory Coast from a friend of his father. He sold the mask to Derain for 50 francs ($10.00) after Derain had seen it over his bed.

before the end of August
Picasso returns from Gósol and replaces the face on Gertrude Stein's portrait with a mask.

late Summer-early Autumn
After returning from the Midi, Derain leases a studio in Montmartre at the famed Villa les Fusains, 22, rue Tourlaque. This building had been a popular site for artist's studios since the late nineteenth century.

1906

10 September
Amélie Matisse and the Matisse children return to Paris.

15-21 September
Manguin learns from Marquet that Manguin is to serve on the Salon d'Automne jury. Manguin plans to submit only six paintings to the Salon. Marquet urges Manguin to return to Paris as soon as possible, but Manguin is unable to get there in time to serve as a juror.

mid-September-October
Braque is in Paris, after staying with Friesz in nearby Durtal at the home of the painter Alexis Axilette.

20 September
Matisse writes to Manguin, concerned about getting Manguin elected a juror at the Salon d'Automne. Since Matisse was in Collioure, he was unaware that this had already happened. Now that Matisse's family has left Collioure, he has been spending two nights a week with Terrus.

Matisse also writes to Marquet about Manguin's inability to return to Paris to be elected to the jury, feeling that his reluctance is foolish.

21 September
Marquet reports to Manguin about the submissions to the Salon d'Automne. Manguin's, Matisse's, and his own paintings met with great success, but Camoin had two paintings returned for retouching. Van Dongen, Dufy, and Friesz are also reworking most of their paintings, which Marquet found very attractive. Matisse had submitted five paintings.

24 September-late October
First Die Brücke exhibition of paintings, held at Lampen-Fabrik Seifert (a lamp factory) in Dresden. The founders of Die Brücke were Fritz Bleyl, Erich Heckel, Ernst Ludwig Kirchner, and Karl Schmidt-Rottluff. In early 1906, Cuno Amiet, Emil Nolde, and Max Pechstein joined the group.

28 September-7 October
Manguin stops in Menton, en route to Paris.

October
Dufy moves to 15, quai Conti; Vlaminck resides at 20, avenue Victor-Hugo, Rueil.

Dufy exhibitions at Galerie Berthe Weill.

October-February 1907
Braque stays in L'Estaque at the Hôtel Maurin.

6 October-15 November
Fourth Salon d'Automne, Grand Palais. 1,805 works by 532 artists are shown. Includes retrospectives of Carrière, Gustave Couret, and Gauguin, as well as an exhibition of contemporary Russian art organized by the emerging impresario Sergei Diaghilev.

1906

6 October-15 November
Among the Fauves and associated artists are Camoin (five), Czobel (six), Delaunay (two), Derain (eight, including one painting of London and five paintings of L'Estaque), Desvallières (eight), van Dongen (three), Dufy (seven), Friesz (four), Manguin (six), Marquet (eight), Matisse (five), Metzinger (two), Puy (ten), Valtat (ten), and Vlaminck (seven).

after 6 October
Derain carves two wooden bed panels after seeing the Gauguin retrospective at the Salon d'Automne. He also begins carving stone from the front steps of his family's home in Chatou.

22 October
Cézanne, age 67, dies in Aix-en-Provence.

early November-end of 1906
Derain, back in L'Estaque, writes to Vlaminck and asks him to purchase a copy of Alfred Jarry's play *Ubu roi* (1896) and send it to Derain. He notes that Braque, Friesz, and Girieud are in L'Estaque and that most of the artists from the Salon des Indépendants are working in the region. Matisse spends eight days there en route to Collioure. Derain observes that Friesz and Braque are content and working well. Derain complains about difficulties with his own paintings.

November-Spring 1907
Matisse returns to Collioure. Amélie and their daughter, Marguerite, join him in November. He frequently sees Maillol in neighboring Banyuls-sur-Mer. Matisse paints *Nu bleu (Souvenir de Biskra)*.

9-20 November
Pierre Bonnard exhibits forty-one works at Galerie Bernheim-Jeune.

23 November
Critic Félix Fénéon, who serves as director of contemporary art at Bernheim-Jeune from November 1906 to 1924, buys a body of van Dongen's works.

December
Second Die Brücke exhibition, consisting of woodcuts, is held at Lampen-Fabrik Seifert, Dresden.

4-30 December
Braut, Desvallières, Laprade, Rouault and others exhibit at Galerie Berthe Weill.

14 December
Matisse writes from Collioure to Manguin, who is in Paris for the winter, offering his frank opinion of Manguin's recent work. Matisse evaluates the use of color and tone in Manguin's paintings and urges him to discuss his comments with Derain and Puy, who are well acquainted with his views.

1906

30 December
Manguin thanks Matisse for his evaluation. He discusses his goal of obtaining harmony and luminous expression in his paintings.

Manguin also mentions that Fénéon has associated himself with Bernheim-Jeune. His first project at the gallery will be to show the Neo-Impressionists. According to Manguin, Druet is disturbed by this, and he plans to show work by Manguin, Matisse, and their colleagues in a group exhibition the following March and to present an exhibition of work by Bonnard and his associates. Druet has also guaranteed Marquet 4,000 francs ($800.00) per year in order to have first choice of Marquet's works, which have sold well through Weill and in Le Havre. Marquet's paintings will be priced at 4,000 francs ($800.00) each for at least three years.

end of 1906
Marquet moves to 29, place Dauphine. His mother lives with him through April.

1907

During the year Derain spends twenty-eight days in the army.
Friesz signs a contract with Druet.
Apollinaire moves to 9, rue Léonie, Montmartre, near the Bateau-Lavoir.
Valtat moves to a new studio in the place Constantin-Pacqueur.

21 January-2 February
Eighty works by Paul Signac are exhibited at Galerie Bernheim-Jeune. Catalogue text by Paul Adam.

February-April
Von Dongen, accompanied by Luce for a portion of the trip, visits Holland for two months.

2 February
Matisse and Terrus visit Prades (Pyrénées-Orientales).

by 4 February
Vollard purchases much of Picasso's Rose period work for 2,500 francs ($500.00).

5-25 February
Fourth exhibition of the conservative Société des Peintres du Paris Moderne, Grand Palais.

7 February
Matisse writes to Manguin from Narbonne about a frame for a nude he has painted (*Nu bleu*). He wants the frame to be three or four inches larger than that and a trefoil Louis XVI frame. Manguin secures a Louis XVI frame, and in a letter of about 12 February he promises that it will be ready by 5 March.

Matisse plans to return to Paris in early March, but is back in Collioure in mid-April.

1907

11-23 February
Thirty-nine works by Marquet are exhibited at Galerie Druet. Sales are strong. Many works are already in private collections and have been borrowed for the exhibition.

12 February
Matisse, Amélie, and Terrus are in Vernet-les-Bains, where there is over eight feet of snow.

15-28 February
Luce exhibits works at Bernheim-Jeune. Catalogue text by Gustave Geffroy.

16 February
Manguin reports to Matisse that Manet's *Olympia* is now on view next to Ingres' *Odalisque* in the Salle des états at the Louvre and that it looks stunning. He also mentions that Weill has sold one of Matisse's landscapes with red rocks.

late February
Gertrude and Leo Stein buy six paintings by Matisse from Druet, exchanging their paintings by Maurice Denis, Henri Fantin-Latour, and Adolphe Monticelli as part of the transaction. Druet, Fénéon, and Vollard argue over who will show Matisse's work.

22 February
Daniel-Henry Kahnweiler arrives in Paris from his native Mannheim, having spent several years working in London for his uncle, a financier with extensive South African investments. He intends to open an art gallery and begins meeting the Fauve artists.

early March
Picasso purchases two Iberian sculptures from Gery Pieret, Apollinaire's secretary. In August 1911 Picasso learns that they had been stolen from the Louvre.

March
Paintings and ceramics by Vlaminck are exhibited at Galerie Vollard.

March-April
Galerie Miethke, Vienna, exhibits works by Gauguin (seventy-two), Marquet (seven), Matisse (four), Puy (seven), Signac (four), Valtat (eight) and others. Catalogue text by Rudolf Adalbert Meyer.

March-late May or early June
Matisse makes ceramics with André Méthey at his atelier in suburban Asnières; Derain and Vlaminck have been doing so since 1904. Some later accounts indicate that Vollard urged the artists to work with Méthey; others suggest that Méthey invited the artists himself. Matisse may have completed the ceramic triptych for Karl-Ernst Osthaus' Haus Hohenhof in Hagen, Germany, at this time.

3 March-3 April
Fourteenth exhibition of La Libre Esthétique, Brussels, includes Derain (four views of London later shown at the Toison d'Or, Moscow), Friesz (five), Girieud (six), Laprade (four), Vlaminck (five), and others. Catalogue by Octave Maus.

1907

20 March-30 April
Twenty-third Salon des Indépendants, Serres au Cours la Reine, Grand Palais. 5,406 works by more than 1,055 artists are shown. Includes a memorial exhibition honoring Cézanne. Matisse is on the hanging committee.

Matisse exhibits *Nu bleu* under the title *Tableau no. III*, along with five works on paper. Louis Vauxcelles writes about *Nu bleu*: "I admit to not understanding. An ugly nude woman is stretched out upon grass of an opaque blue under the palm trees....This is an artistic effect tending toward the abstract that escapes me completely." [*Gil Blas* (20 March 1907)].

Derain exhibits his *Baigneuses I* (1907), along with three paintings of L'Estaque and a portrait. Derain and Vlaminck (six) sell particularly well. Braque exhibits six paintings, five made at L'Estaque the previous autumn; five are purchased by Uhde, the sixth by Kahnweiler. Dufy exhibits six works, including four landscapes made in Normandy. Marquet shows three paintings, all of which belong to Druet. Delaunay is represented by a landscape study and five other works. Other artists included are Camoin (six), Auguste Chabaud (six), Czobel (six), Girieud (six), Herbin (six), Metzinger (six), Puy (six), and Valtat (six).

Vauxcelles describes the Fauve group within the Salon:

> A movement I consider dangerous (despite the great sympathy I have for its perpetrators) is taking shape among a small clan of youngsters. A chapel has been established, two haughty priests officiating, MM. Derain and Matisse; a few dozen innocent catechumens have received their baptism. Their dogma amounts to a wavering schematicism that proscribes modeling and volumes in the name of I-don't-know-what pictorial abstraction. This new religion hardly appeals to me. I don't believe in this Renaissance.... M. Matisse, fauve-in-chief; M. Derain, fauve deputy; MM. Othon Friesz and Dufy, fauves in attendance; M. Girieud, irresolute, eminent, Italiantate fauve; M. Czobel, uncultivated, Hungarian or Polish fauve; M. Bérény, apprentice fauve; and M. Delaunay (a fourteen-year-old--pupil of M. Metzinger...), infantile fauvelet. [*Gil Blas* (20 March 1907)].

Spring
After possibly traveling to Le Havre to prepare for the Cercle de l'Art Moderne exhibition that is to open in early June, Braque and Friesz go to the south of France.

Derain convinces Picasso to visit the ethnographic museum at the Palais du Trocadéro.

30 March
Camoin, Cézanne, Derain, Dufy, Friesz, Manguin, Marquet, Matisse, and Puy exhibit works at Galerie Berthe Weill.

April
Vlaminck publishes his third novel, *Ames de mannequins* (*Souls of Mannequins*) in collaboration with Fernand Sernada and a new editor, Pierre Douville, at the publisher Frères Offenbach, who accepted the manuscript but rejected Derain's illustrations.

1907

April
Vlaminck's two earlier novels, *D'un lit dans l'autre* (*From One Bed to Another*, 1902) and *Tout pour ça* (*All for That*, 1903), were very successful. Both were illustrated by Derain.

Braque meets Kahnweiler; Kahnweiler had already met Picasso.

2 April-10 May
Camoin, Friesz, and Marquet visit London. Marquet returns for another trip later that summer.

14 April-30 June
Seventeenth Salon, Société Nationale des Beaux-Arts, Grand Palais.

17 April
Derain writes to Kahnweiler, as he has heard that the dealer offered 100 francs ($20.00) for his painting *La Jetée de L'Estaque* (*The Jetty at L'Estaque*). Derain says that 150 francs ($30.00) is his lowest price. Kahnweiler replies on the back of this letter that he accepts the price. Kahnweiler tells Derain that he saw at Puy's studio some of Derain's watercolors. He finds them "passionate" and would like to acquire one.

22 April
Back in Collioure, Matisse writes to Kahnweiler that he agrees to sell him a drawing exhibited at the Salon des Indépendants (no. 1242) for the price listed. Kahnweiler may take the drawing at the close of the salon.

22 April-8 May
Eighty-five works by Edmund Cross are exhibited at Bernheim-Jeune. Catalogue text by Maurice Denis.

27 April
Picasso invites Gertrude and Leo Stein to see his *Demoiselles d'Avignon* (1906-07).

May
Galerie Kahnweiler opens at 28, rue Vignon in Paris.

May-early September
Braque and Friesz are in La Ciotat.

14 May-about 20 October
The Manguins are in Saint-Tropez and at the Villa Demière in nearby Malleribes.

mid-May-before 15 September
The Matisses are in Collioure, accompanied by a nineteen-year-old cousin of Matisse's who has been diagnosed as having a brain tumor and is paralyzed. Matisse paints *Les Aloès*.

23 May
Puy is in Bénodet.

1907

26 May
Matisse visits Amélie-les-Bains.

early June
Second exhibition of the Cercle de l'Art Moderne opens in Le Havre at the Hôtel de Ville. Included are Braque (two), Derain (two), Dufy (two), Manguin (two), Marquet (two), Matisse (two), Vlaminck (two), and others. Catalogue text by Ferdinand Fleuret.

June
Camoin travels to Seville and Grenada in Spain.

6 June
Marquet is in Fontainebleau, where he is disappointed by the weather. He hopes to leave by the end of the month.

11 June
Manguin writes to Matisse that Fayet is selling many of the paintings that he has bought; the Steins have bought several through Fénéon. He also mentions that there is a new dealer, "a new German" (Kahnweiler), on the rue Vignon, who is paying the prices asked for paintings by Braque, Friesz, Marquet, and Puy. Manguin adds that Cross's exhibition at Bernhaim-Jeune sold well.

13 June
Matisse writes to Fénéon from Collioure that he is sending him four canvases on which several small areas of red are not yet dry. He says that the weather has been bad in Collioure since his arrival from Paris.

17-29 June
Watercolors by Cézanne are shown at Bernheim-Jeune.

17 June-end of Summer
Derain stays at the Hôtel Cendrillon, Cassis. He enjoys the area, attends bullfights in Marseille, and finds the landscapes more beautiful than those in Collioure. During his stay he writes to Vollard to settle their account. A subsequent letter tallies the 6,100 francs ($1220.00) owed Derain for twenty-six paintings of London, his work at the Salon d'Automne, the bed he carved for Vollard, and ceramics.

about 20 June
Matisse writes to Manguin that he is sending three or four paintings to Fénéon.

Summer
Kahnweiler buys several paintings from Vlaminck and Braque. Derain signs a contract with Kahnweiler about this time. Dufy paints his *Pêcheurs à la ligne* (*Fishermen Angling*) series during his summer stay in Sainte-Adresse. Valtat travels to Normandy, Port-en-Bessin, and Arromanches.

Summer-late October
Drawings by Rodin are exhibited at Bernheim-Jeune.

1907

July-August
Van Dongen and others exhibit at Kunsthandel C. M. van Gogh, Amsterdam.

9 July
Braque and Friesz are at the Hôtel Cendrillon, Cassis. They visit Derain during their stay.

12 July
Matisse signs a receipt for Fénéon, indicating that he has been paid 1,800 francs ($360.00) for four paintings.

13 July
Matisse writes to Fénéon that he is sending him several paintings, including *Les Aloès*, a *Baigneuse* of the same price, and *La Musique* (probably *Music* [*Sketch*], 1907) for 400 francs ($80.00) each.

14 July-about 14 August
Matisse and Amélie visit Italy, at the urging of Leo Stein. En route to the Steins in Fiesole, they visit Derain and Girieud at Cassis; Braque and Friesz at La Ciotat; Cross at Saint-Clair (Var); and Manguin at Saint-Tropez. Derain describes Matisse's visit to Vlaminck: "I saw Matisse for the second time. He came here with his wife, here, en route to Italy. He showed me photos of his canvases; they are completely stunning. I believe that he is crossing the threshold of the seventh garden, that of happiness." [*Lettres à Vlaminck* (Paris: Flammarion, 1955):149].

While in Fiesole (about 26-29 July) the Matisses stay at the Hôtel Italia. They tour Florence, Siena (about 2 August), Arezzo, and Padua, then travel up the Adriatic coast to Ravenna and Venice (about 6 August). Matisse later recalled:

> Leo was at [my] heels all the time except in front of great works of art. He would then move a few steps away and come back with the question: 'What do you think of it?' 'I could not reply,' Matisse continues. 'This manner of visiting museums paralysed me completely; so much so that I couldn't see anything anymore, I looked at things with the one idea that I'd have to talk about them.'" [Quoted in Pierre Schneider, *Matisse*, p. 135].

During his stay with the Steins in Fiesole, Matisse meets the aesthetician Walter Pach. At the conclusion of this trip the Matisses return to Collioure.

15 July-mid August
Marquet is in London, staying at 44 Dean Street in Soho.

8 August
Terrus is in Elne, awaiting Matisse's return.

19-26 August
Marquet visits his ailing mother in Le Teich (Gironde). She dies 25 August and Marquet spends a short time in Saint-Jean-de-Luz before returning to Paris.

1907

21 August
Matisse writes to Fénéon about "the many beautiful things I saw in Italy."

29 August
Matisse writes to Vlaminck that he is concentrating on his paintings. He plans to stay in Collioure until the end of October, though his wife will return in mid-September (in fact, he returns with her). He urges Vlaminck to show quality work at the Salon d'Automne.

late August
Kahnweiler receives recommendations from Derain (in Cassis), Friesz (in La Ciotat), and Braque (in L'Estaque) for their submissions to the Salon.

September
Braque and Friesz return to Paris from the Midi. Braque may have seen Picasso's *Demoiselles d'Avignon* (1906-07) at the Bateau-Lavoir shortly after returning to Paris, between 23 and 25 September. Braque is probably accompanied by Apollinaire. According to Ferdinand Olivier, Braque tells Picasso, "You paint as if you wanted to force us to eat rope or drink paraffin." [*Picasso and His Friends*, p. 97].

3 September
Manguin writes to Vallotton from Saint-Tropez that he has sent four paintings to Fénéon for the Salon d'Automne and that he plans to spend the winter in Saint-Tropez.

4 September
Puy writes to Manguin that Vollard has taken care of Manguin's submissions to the Salon d'Automne. Puy says that he has had difficulty painting all summer and has been relatively unproductive.

8 September
Alice B. Toklas (who later becomes Gertrude Stein's companion) arrives in Paris.

11 September
Jeanne Manguin reports to Amélie Matisse that Manguin is sending four paintings to the Salon d'Automne and that Marquet has nothing to submit, as his mother has just died.

by 15 September
The Matisses return to Paris, where they plan to stay until the end of December. While in Paris, Matisse makes faiences with Méthey.

15 September
Matisse writes to Manguin that Fénéon has bought two of Matisse's most recent paintings. He also mentions that he sold a large painting to the Steins, as well as composition he calls *La Musique* (*Esquisse*) (*Music* [*Sketch*], 1907), a still life and a landscape.

19 September
Marquet returns to Paris from the west coast of France following his mother's funeral.

1907

Autumn
Matisse paints the second version of *Le Luxe* (*Le Luxe II*) and exchanges paintings with Picasso, giving him his *Marguerite* (1907).

Dufy travels to Martigues and Marseille.

Mercure de France publishes Cézanne's correspondence with Emile Bernard, which serves as the clearest statement published to date of Cézanne's ideas about composition and form.

Autumn-Summer
Max Pechstein, a member of Die Brücke in Dresden, lives in Paris and makes contact with Purrmann and van Dongen.

by 28 September-mid-November
Braque goes to L'Estaque, following the Cézanne retrospective at the Salon d'Automne.

October
Derain marries Alice Princet, and she moves to Villa les Fusains, 22, rue Tourlaque, in Montmartre, where Derain has already been living.

October-November
Marquet (two), Valtat (three), and others exhibit at Gallery Manes, Prague.

1-22 October
Fifth Salon d'Automne, Grand Palais. 1,748 works are shown by more than 571 artists. Includes a retrospective of Cézanne's work, as well as a Belgian art exhibition and a group of Rodin's drawings. Matisse and Marquet serve as the Fauves on the jury. Many ceramics made by the Fauve painters at Méthey's are displayed in a vitrine. Derain shows five paintings, among them three landscapes, including those painted at Cassis. Braque exhibits only one painting. Matisse shows *La Musique (Esquisse)* (1907); *Le Luxe I* (early 1907); and *La Coiffure* (*The Hairstyle*, 1907), all of which he labels as *esquisse* (sketches), as well as four other paintings. Apollinaire refers to Matisse as the "fauve of fauves" [*La Phalange* 2(15-188 Dec. 1907):481-5]. Works by Matisse and Derain are criticized for the ugliness of the models. Dufy is represented by two paintings, Camoin (seven), Chabaud (five), Czobel (two), Delaunay (one), Friesz (five), Girieud (three), Herbin (two), Henri Le Fauconnier (two), André Lhote (three), Manguin (four), Marquet (two), Metzinger (two), Valtat (six), and Vlaminck (six). By this time the critic Michel Puy (brother of Jean Puy) considers the Fauve group to include Braque and Le Fauconnier.

11 October
The Manguin plan to return to Paris around 17 or 18 October and stay there through mid-November.

18 October
Vlaminck is invited to serve as *sociétaire* (full member) at the Salon d'Automne, but the invitation is rescinded three days later, with considerable embarrassment on both sides.

1907

20 October
Dufy writes to Berthe Weill from Marseille. He has taken a room on the port with a splendid view and is enjoying the good weather. He asserts that Matisse, Vlaminck, Derain, Friesz are on the avant-garde, with an intensity of life and thought far beyond the "boredom and uselessness contained in most other paints."

24 October-10 November
Camille Claudel, Manguin (eight), Marquet (ten), and Puy (fourteen) exhibit at Galerie Eugène Blot, rue Richepanse. Catalogue text by Louis Vauxcelles.

November-December
Matisse and Derain probably see *Les Demoiselles d'Avignon* (1906-07) at Picasso's studio.

4-16 November
Thirty-nine works by Friesz (all painted in Normandy, Belgium, or near Marseille) are exhibited at Galerie Druet. Catalogue text by Fernand Fleuret.

14-30 November
Matisse (two) and others participate in a group exhibition of flowers and still lifes, Bernheim-Jeune.

15 November
La Phalange publishes the first full-length study of the Fauves, written by Michel Puy.

December
La Phalange publishes an interview with Matisse by Guillaume Apollinaire.
Braque begins painting *Nu*, which he completes by June 1908.
Matisse (eight drawings) and others exhibit at the fourteenth Berliner Secession, Berlin.

8-15 December
Maillol exhibits at Galerie Druet.

8 December-Summer 1908
Manguin returns to Saint-Tropez, traveling via Lyon, Orange, and Arles. Bonnard stays at the Villa Demière, Malleribes during the summer.

28 December
Cross, writing to Angrand, mentions that he owns three Matisse oils, which he has had since 1906.

1908

Matisse takes Sergei Shchukin to Picasso's studio. Shchukin acquires Matisse's *Panneau décoratif* (*La Desserte, harmonie rouge*) (*Decorative Panel* [*The Sideboard*], 1908).

6-18 January
Works by van Gogh are exhibited at Bernheim-Jeune (one hundred paintings) and Galerie Druet (thirty-five).

1908

10 January
Matisse opens his academy at the former Couvent des Oiseaux, where he has rented a studio since October 1905. The academy exists until the summer of 1911, although its activities diminish after Matisse moves to the Paris suburb of Issy-les-Moulineaux in the fall of 1909. Among his students are the American painters Patrick Henry Bruce, Max Weber, and Sarah Stein.

The photographer Edward Steichen writes to Alfred, owner of the Little Galleries of the Photo-Secession (known as 291) in New York, praising an exhibition of Matisse's drawings. He calls Matisse "The most modern of the moderns" and ranks him with Rodin and Cézanne.

27 January
Marquet moves into Matisse's former apartment on the fifth floor at 19, quai Saint-Michel, which Matisse had vacated because he needed larger quarters for his family.

18 February
Braque and Picasso make drawings of a deaf female model.

Marquet urges Manguin to return to Paris from Saint-Tropez to serve as vice president at the Salon des Indépendants and to work on the placement of paints. Marquet wants this exhibition to be outstanding, because it will be the last at the Grand Palais. The Serres, where the Salon has been held, is begin torn down, and subsequent salons will be held in the Jardin des Tuileries.

March
Seascapes, landscapes, and still lifes by Vlaminck are exhibited at Galerie Vollard.

1 March-5 April
Fifteenth exhibition of La Libre Esthétique in Brussels includes three paintings by Valtat, among others. Catalogue by Octave Maus.

2-28 March
Twenty-seven paintings by van Dongen are exhibited at Galerie Kahnweiler. Catalogue text by Saint-Georges de Bouhélier.

20 March-2 May
Twenty-fourth Salon des Indépendants, Serres au Cours de la Reine, Grand Palais features 6,701 works by more than 1,314 artists, including Braque (four plus one not shown in the catalogue), Camoin (six), Chabaud (six), Derain (eight), van Dongen (six), Dufy (six), Friesz (six), Manguin (six), Marquet (six), Vlaminck (six), and others. Derain is a member of the executive committee. Matisse does not exhibit. In his review in *La Revue des lettres et des arts* (1 May 1908), Apollinaire contends that Braque's work is the most original effort of the Salon. Even though Matisse nor Picasso exhibit, Vauxcelles refers to them as "barbarous 'schematizers.' The primary school Metaphysicians who want to create an ' abstract art.'...The two excellent painters that MM Matisse and Picasso were-- and will be (for nothing has been lost)--have truly brought about ravages in the naïve brains of their young successors." [*Gil Blas* (20 March 1908)].

1908

after 20 March
The American writer Gelett Burgess begins conducting interviews with individual Fauve artists, others associated with them, and Picasso. These interviews and Burgess' impressions form the basis of an article published in *Architectural Record* in May 1910.

Spring
The state closes the Couvent des Oiseaux. Matisse and Rodin move to the Hôtel Biron at 33, boulevard des Invalides (which later became the Musée Rodin). The Hôtel is available to artists because the government had seized the property (formerly the Couvent du Sacré Cœur) in 1904.

6-18 April
Twenty-seven paintings and drawings by Camoin are exhibited at Galerie Kahnweiler.

6-25 April
Drawings, lithographs, watercolors and etchings by Matisse are shown at Little Galleries of the Photo-Secessions (Known as 291), 291 Fifth Avenue, New York. This is Matisse's first exhibition in the United States.

9 April
Valtat leaves Saint-Raphaël to go to Paris.

18 April-24 May
Salon de la Toison d'Or, Moscow, exhibits work by Braque (five), Derain (six paintings, including four views of London), van Dongen (four), Friesz (three), Girieud (seven), Manguin (two), Marquet (three), Matisse (five), Metzinger (five), Puy (three), Valtat (two), and others.

27 April-16 May
Van Rysselberghe exhibits at Bernheim-Jeune.

May-late November
Derain is in Martigues, staying at the Maison Chassaigne, rue Lamartine. He writes to Vlaminck in Chatou about how his work is progressing. Derain much prefers painting here than in Paris. Derain goes to Paris at least once during the period, visiting Picasso in La Rue des Bois (a town approximately twenty-seven miles north of Paris) sometime between August and early September.

after 2 May
Braque goes to Le Havre to help organize the Cercle de l'Art Moderne exhibition.

mid-May-by 25 September
Braque makes his third trip to L'Estaque. According to Kahnweiler, Braque went south by bicycle, sending his belongings and painting supplies by mail.

27 May
The Belgian architect Henry van de Veld, who is designing Osthaus' house in Hagen, Germany, writes to Osthaus that he will soon design the installation of Matisse's tile triptych, which had already arrived in Hagen.

1908

June
Third exhibition of Cercle de l'Art Moderne is held at the Hôtel de Ville, Le Havre. It includes works by Braque (two), Derain, van Dongen, Dufy, Friesz, Marquet, Matisse, and Vlaminck. Catalogue text by Apollinaire. A conference on music is held in conjunction with the exhibition.

1-20 June
Girieud and others exhibit at Galerie Berthe Weill.

6 June
Matisse is in Dieppe. Marquet and Manguin are visiting Gertrude and Leo Stein and Signac in Fiesole. They travel on to Naples and throughout Italy through mid-July.

mid-June
Matisse makes an eight-day trip to Germany with Purrmann, now one of the students in Matisse's academy. They visit Speyer (Purrmann's native city), Munich, Nuremberg, and Heidelberg. Amélie is in Perpignan with her ailing mother.

about 15 June-early December
Cross and his wife travel to Italy.

Summer
Dufy joins Braque in L'Estaque. Braque possibly visits Derain in Martigues.

July
Druet is in Naples

3-20 July
Camoin (two), Friesz (three), Girieud (three), Francis Jourdain, Laprade, Manguin (three), Marquet (three) and others exhibit at Galerie Druet. According to the catalogue, this exhibition was to be held at Druet's new gallery on 20, rue Royale, but the new space was not yet finished.

17 July
Derain writes to Vollard, requesting that the dealer send him money.

18-27 July
Puy is in Brittany, then returns to Paris.

27 July-late August
Matisse is in Paris and has been frequenting the Bal Tabarin, a popular café and dance hall. Amélie is back in Perpignan for her mother's funeral.

August-early September
Picasso and Olivier visit La Rue des Bois.

12-13 August
Marquet is in Cassis, on his way back to Paris.

1908

22 August
Vollard writes to Vlaminck, asking the artist to let Vollard know if he has paintings ready and needs money. Vollard has arranged for Vlaminck's submissions to the Salon d'Automne to be framed about 10 September, and he asks Vlaminck to give the framer the paintings' titles prior to the Salon.

24 August
Marquet and Matisse visit the Bal Tabarin together.

from 28 August
Marquet paints for several days in Poissy, staying at the Hôtel de Rouen.

September
According to Gertrude Stein, Matisse takes Shchukin to Picasso's studio, where he sees *Les Demoiselles d'Avignon.*

Paintings and prints of Die Brücke artists are exhibited at Richter Art Salon, Dresden. Includes at least sixteen works by Fauve artists, including van Dongen, Friesz, Marquet, and Vlaminck.

1 September
Druet's new gallery on the rue Royale is nearly complete. It is scheduled to open 28 September.

2-5 September
Matisse joins Marquet in Poissy to fish, go boating, and ride horses.

20 September
Marquet and Matisse are in Bordeaux, en route to Dakar. Marquet writes to Manguin, "We are going to attend the opening of the Salon d'Automne with negresses."

24 September-by 3 October
Marquet and Matisse are in Dakar.

1 October-8 November
Sixth Salon d'Automne, Grand Palais includes 2,107 works by more than 644 artists. Special exhibitions at the Salon include several works by El Greco, a group of works by Maurice Denis, a retrospective devoted to the work of Monticelli, and a number of frescoes by Piot. Matisse has his own section, exhibiting eleven paintings, six drawings, and thirteen sculptures that are not for sale. Matisse's section elicits a generally positive response from the critics. Also included are Camoin (five), Chabaud (two), Derain (six), Friesz (six), Girieud (seven), Le Fauconnier (one), Manguin (one), Marquet (six), Puy (five), Valtat (six), and Vlaminck (six).

Matisse and Marquet (vice president) served as jury members, and the number of works that Matisse was permitted to show was unlimited. Among the works rejected were six by Braque, although Marquet, as the jury's vice president, chose to save one Braque from rejection. Matisse was among the jurors voting against them; he had seen many of Braque's most recent paintings of L'Estaque at Picasso's studio. Although two were

1908

1 October-8 November
subsequently admitted, Braque removed all of his entries from the Salon and showed them later that fall at Kahnweiler's.

4 October
Marquet and Matisse are in Fontainebleau.

10 October
Marquet returns to Paris.

12-24 October
Twenty-three works by Toulouse-Lautrec are exhibited at Bernheim-Jeune.

19 October
Apollinaire writes to Braque, telling him that Kahnweiler has asked him to write the preface to the catalogue of Braque's forthcoming exhibition. He asks whether Braque agrees. Apollinaire declares, "I will be very happy to say the best that I think of an artist whose talent and character I admire."

25 October-14 November
Paintings by Girieud and others are exhibited at Galerie Kahnweiler. Catalogue text by Charles Morice.

26 October-8 November
Paintings, drawings, and watercolors by Francis Jourdain are exhibited at Galerie Druet.

9-21 November
Paintings, pastels, drawings, and lithographs by Odilon Redon, Galerie Druet.

9-28 November
Twenty-seven works from 1906-08 by Braque are exhibited at Galerie Kahnweiler. Catalogue text by Apollinaire. Matisse's remark about Braque's painting "cubes" appears in Vauxcelles' review of the exhibition. Vauxcelles calls Braque "a very daring man....He creates metallic and deformed figures that are terribly simplified. He despises form, reducing everything, site and figures and houses, to some geometric schemes, to cubes." [*Gil Blas* (14 Nov. 1908)].

21 or 28 November
At Picasso's studio, Picasso and Olivier host a banquet honoring Henri (le Douanier) Rousseau. Apollinaire, Braque, Friesz, Marie Laurencin, André Salmon, Gertrude Stein, and many others attend. Rousseau tells Picasso, "You and I are the greatest painters of our time, you in the Egyptian style, I in the modern." [as quoted in Ferdinand Olivier, *Picasso and His Friends* (New York: Appleton-Century, 1965):929].

by 22 November late November
Braque is in Le Havre.

1908

25 November-12 December
Eighty-nine works by van Dongen are exhibited by Bernheim-Jeune. Catalogue text by Marius-Ary Leblond.

26 November
Matisse writes to Fénéon regarding a canvas of a bacchante and a faun, priced at 2,500 francs ($500.00). He is waiting for Fénéon to respond before he gives him prices on several other canvases.

late November-before 4 December
A farewell banquet given by Rousseau in honor of Max Weber is attended by Apollinaire, Picasso, and Olivier.

by December
Matisse discusses Henri Bergson's *L'Evolution Créatrice* (Paris: F. Alcan, 1907) with Matthew Stewart Prichard, an English student of philosophy who worked for the Museum of Fine Arts in Boston.

11-31 December
Manguin, Marquet, Matisse, and Puy exhibit works at Galerie Berthe Weill.

14 December-9 January 1909
One hundred-and-seven works by Georges Seurat are exhibited at Bernheim-Jeune.

21 December-end of month
Matisse is in Berlin with Purrmann to install an exhibition at Paul Cassirer's gallery. Negative advance criticism in the press prompts Cassirer to refuse to hang some of Matisse's paintings; he puts the others in the vestibule. The Leipzig *Kunstchronik*'s critic comments, "I stand speechless in front of these extravaganzas and, I confess it openly, have only one feeling in response to them: a huge, irrepressible impulse to laugh!" The paintings are taken down as soon as Matisse and Purrmann leave Berlin. Before the removal of the paintings occurred, however, the German Expressionist painter Ernst Ludwig Kirchner, in Berlin in January, 1909, sees Matisse's exhibition. During this trip Matisse meets Henry van de Velde and the German painter Max Liebermann. Liebermann calls Matisse and Purrmann Don Quixote and Sancho Panza. En route back to Paris, Matisse and Purrmann stop in Hagen to see Osthaus, then spend Christmas with Oskar and Grete Moll. Shortly after his return to Paris, Matisse receives a laurel wreath with a card, "To Henri-Matisse, triumphant on the battlefield of Paris," from Thomas Whittemore, an American professor who subsequently would unearth the mosaics at the Hagia Sophia in Constantinople.

21 December-15 January 1909
Exhibition at Galerie Notre-Dame-des-Champs, 73, rue Notre-Dame-des-Champs, includes works by Braque (six), Derain (three), Dufy (four), Herbin (four), Metzinger (two), Picasso (two), and others.

Friesz, Manguin, Marquet, Matisse, and Puy exhibit works at Galerie Druet.

1908

25 December
Matisse publishes "Notes of a Painter" in *La Grande revue* 52 (25 Dec. 1908):731-45; at Desvallières' request and partly motivated by M. J. Péladon's negative review of his work at the Salon d'Automne. Péladon wrote: "Each year it becomes more difficult to speak of these people who are called *les fauves* in the press. They are curious to see beside their canvases. Correct, rather elegant, they might be taken for department-store floorwalkers. Ignorant and lazy, they try to offer the public colorlessness and formlessness." [*La Revue hebdomadaire* 12 (17 Oct. 1908):361].

Matisse's essay explains that he sought expression in his work above all else. He discusses the organization of his compositions and especially the tonalities and modeling of his forms. He demonstrates the lessons he has applied from the art of the past to his own work.

Common Abbreviations

cat.	catalogue
col.	color
diss.	dissertation
dist.	distributed
ed(s.)	edition(s) or editor(s)
exh.	exhibition
illus.	illustrations
min.	minutes
no. or nos.	number(s)
p. or pp.	pages(s)
pl.	plate(s)
ser.	series
supp.	supplement
vol(s.)	volume(s)

Fauvism in General

I. Fauvism in General

Books

1. APOLLONIO, UMBRO. *Fauves e cubisti.* Bergamo: Instituto Italiano d'Arti Grafiche, 1959. 95 p., illus., some col.

a. French ed.: *Fauves et cubists.* Paris: Flammarion, 1959. 93 p., illus.
b. U.S. ed.: *Fauves and Cubists.* New York: Crown, 1959. 93 p., illus.
c. English ed.: *Fauves and Cubists.* London: Batsford, 1960. 93 p., illus.
Reviews: *Connoisseur* 147(May 1961):202; N. Lynton, *Burlington Magazine* 104(May 1962):220.

2. CANNATÀ, ROBERTO. *Il Fauvismo e l'Espressionismo.* Contributi de F. Menna, U. Artioli, M. Manieri-Elia, F. Catalano, [et al.]. Milan: Fratelli Fabbri, 1976. 125 p., illus. Volume in "L'Arte nella società" series.

3. CHASSE, CHARLES. *Les Fauves et leur temps*. Avec la collaboration de Pierre Labracherie. Lausanne: La Bibliothèque des Arts, 1963. 188 p., 16 col. pl.

4. COWART, WILLIAM JOHN III. *'Ecoliers' to 'Fauves': Matisse, Marquet, and Manguin Drawings, 1890-1906*. Ph.D. diss., Johns Hopkins University, 1972; Ann Arbor, MI: University Microfilms, 1984. 355 p., illus.

5. CRESPELLE, JEAN-PAUL. *Les Fauves*. Neuchâtel: Ides et Calendes, 1962. 365 p., 100 illus., some col. Volume in "Les Grands mouvements" series.

Illustrated survey of the paintings and graphics of the Fauves. At the time of its publication this work was perhaps the most exhaustive and comprehensive survey on Fauvism.
a. English ed.: *The Fauves*. Trans. by Anita Brookner. London: Oldbourne Press, 1962. 351 p., 100 col. pl.
b. U.S. ed.: *The Fauves*. Trans. by Anita Brookner. Greenwich, CT: New York Graphic Society, 1962. 351 p., 100 col. pl.
c. German ed.: *Fauves und Expressionisten*. Munich: Bruckmann, 1963. 365 p., illus.
Review: G. Habasque, *L'Œil* 96(Dec. 1962):85.

6. DENVIR, BERNARD. *Fauvism and Expressionism*. London: Thames & Hudson, 1975. 128 p., 70 illus., some col. Volume in "Dolphin Art Book" series.

Expressionism was characterized by the ecstatic use of color and the emotive distortion of form, reducing the dependence on objective reality to an absolute minimum, or dispensing with it entirely. Its genesis can be retraced to the revolt against rationalism and the accompanying cultivation of the sensibilities initiated by the Romantics, and to the scientific acknowledgment of man as an instinctual being. But above all Expressionism owes its appearance in modern painting to the Symbolists' liberation of color during the 1880s and 1890s that culminated in Fauvism. Matisse, Derain, and Vlaminck rank among the foremost protagonists of Fauvism, which drew its themes from Gauguin and its stylistic characteristics particularly treatment of color from van Gogh. Expressionist developments took place throughout Northern Europe, represented in the work of Edvard Munch, of Ensor and his Flemish successors, and of two German groups: Die Brücke and Der Blaue Reiter.
a. U.S. ed.: Woodbury, NY: Barron's, 1978. 128 p., col. illus., 32 pl.

7. DIEHL, GASTON. *Les Fauves: œuvres de Braque-Derain-Dufy-Friesz-Marquet, Matisse-van Dongen-Vlaminck*. Introduction de Gaston Diehl. Paris: Editions du Chêne, 1943. 6 p., col. illus., 12 pl.

a. Another ed.: 1948.

8. DIEHL, GASTON. *Les Fauves*. Paris: Nouvelles Editions Française, 1971. 190 p., illus.

a. U.S. ed.: *The Fauves*. New York: H. N. Abrams, 1975. 168 p., illus., col. pl.

9. DORIVAL, BERNARD. *Le Fauvisme et le cubisme (1905-1911)*. Paris: Gallimard, 1944. Vol. 2 (pp. 9-144) of Dorival's *Les Etapes de la peinture française* (4 vols., 1943-48).

10. DUTHUIT, GEORGES. *Les Fauves: Braque, Derain, Van Dongen, Dufy, Friesz, Manguin, Marquet, Matisse, Puy, Vlaminck*. Geneva: Editions des Trois Collines, 1949. 254 p., illus., some col. Cover designed by Henri Matisse.

Enlarged version of texts published in *Cahiers d'art*, 1929-31. Bibliography by Bernard Karpel, pp. 237-44.
a. U.S. ed.: *The Fauvist Painters*. Trans. by Ralph Manheim. New York: Wittenborn, Schultz, 1950. 126 p., pl., some col.
b. Swedish ed.: Stockholm: Galerie d'Art Latin.
Reviews: *Canadian Art* 82(1950):87; *Magazine of Art* 44(Dec. 1951):337-8; *Art Bulletin* 34(Dec. 1952):328.

11. DUTHUIT, GEORGES. *Répresentation et présence. Premiers écrits et travaux*. Paris: Flammarion, 1974.

Reprints Duthuit's 1929-31 series of articles on Fauvism in *Cahiers d'art* (pp. 195-231).

12. FERRIER, JEAN-LOUIS. *Les Fauves, le règne de la couleur. Matisse, Derain, Vlaminck, Marquet, Camoin, Manguin, van Dongen, Friesz, Braque, Dufy*. Paris: P. Terrail, 1992. 223 p., illus.

13. FONTIER, JAAK, et al. *Expressionisme en Fauvisme*. Nijmegen: B. Gottmer; Beveren-Melsele: Orion, 1981. 2524 p., illus., 16 pl. Volume in "Grote ontmoetingen" series.

14. FREEMAN, JUDI, ed. *The Fauve Landscape* [exh. cat.] Los Angeles County Museum of Art. New York: Abbeville Press, 1990. 350 p., illus., some col.

15. GIRY, MARCEL. *Le Fauvisme: ses origines, son évolution*. Préface de René Jullian. Neuchâtel: Ides et Calendes, 1981. 271 p., 103 illus., 722 col. Volume in "Collection des grandes monographies" series.

On Fauve painting, 1905-07, and the precursors of the movement. Artists discussed include Matisse, Marquet, Derain, Vlaminck, van Dongen, Dufy, Friesz, and Braque.
a. German ed.: *Der Fauvismus: Ursprünge und Entwicklung*. Würzburg: Popp, 1982.
b. U.S. ed.: *Fauvism: Origins and Development*. Trans. by Helga Harrison. New York: Alpine Fine Art Collections, 1982. 275 p., illus.
Review: R. Schiebler, *Weltkunst* 53:1(Jan. 1983):46-7.

16. GOLDING, JOHN. *Fauvism and the School of Chatou: Post-Impressionism in Crisis*. London: British Academy, 1982, pp. 86-102, illus., 10 pl.

Lecture on Aspects of Art, Henriette Hertz Trust of The British Academy, 1980. Reprinted from *Proceedings of the British Academy* 66(1980).

17. GOYENS DE HEUSCH, SERGE. *L'Impressionnisme et le Fauvisme en Belgique*. Préface par Philippe Roberts-Jones. [exh. cat.] Anvers: Fonds Mercator; Paris: Albin Michel, 1988. 473 p., illus., some col. In French and Dutch.

Thoroughly examining the crosscurrents of Impressionism, Neo-Impressionism, Post-Impressionism and Fauvism in Belgian art of the late 19th and early 20th centuries, this lavishly illustrated catalogue surveys 196 paintings by 88 artists, among them many lesser-known figures as well as such noted painters as Ensor, Van de Velde, Permeke, Wouters, and Van Rysselberghe. An introductory discussion of the connections between French and Belgian art of the period is supplemented by biographical commentaries on the artists and by five concise essays prefacing the stylistically arranged groups of works.
a. Another ed.: Ludion: Musée d'Ixelles-Museum van Elsene, 1990. 320 p., 207 illus., 192 col.

18. HAHNLOSER, HANS ROBERT. *Vom Impressionismus zu den 'Nabis' und 'Fauves'*. Soundeerdruck für unsere Freunde. Kempen-Ndrh.: Dr. te Neues, 1964. 13 p., 12 pl. Portfolio of paintings.

19. HERBERT, JAMES D. *Fauve Painting: The Making of Cultural Politics*. New Haven, CT and London: Yale University Press, 1992. 224 p., 18 col. pl., 75 illus.

Revealing his enthusiasm for the Fauve painting of the first decade of the 20th century, Herbert admittedly "cobbles together . . . [a] negotiation across time" through his interpretations of various audiences and associations contemporary with Fauvism. Concentrating on the works of Matisse, Derain, and Vlaminck, he enters into a detailed factual discussion comparing their paintings with various other movements from Impressionism to Cubism, interspersing critical and literary references and snippets of the history surrounding the period.

20. JEDLICKA, GOTTHARD. *Der Fauvismus*. Zurich: Büchergilde Gutenberg, 1961. 173 p., illus., some col., pl.

21. KIM, YOUNGNA. *The Early Works of Georges Braque, Raoul Dufy and Othon Friesz: The Le Havre Group of Fauvist Painters*. Ph.D. diss., Ohio State University, 1980. 434 p., 265 illus.

Detailed stylistic examination of the early work of these three artists who grew up together in Le Havre and studied together in Paris, and of their Fauvist works from 1906 to 1907. It is shown that Braque was the more innovative member of the group, his movement towards Cubism being compared with that of Picasso. Youngna concludes that the two artists mutually created the style and that Fauvism and the influence of Cézanne on Braque in 1907 and 1908 played a fundamental role in its formation.

22. LAUDE, JEAN. *La Peinture française, (1905-1915) et l'art cubisme*. Paris: Editions Klincksieck, 1968. 2 vols. in 1, illus. Plate volume subtitled "Documents." Volume in "Collection d'esthétique" series.

23. LEYMARIE, JEAN. *Le Fauvisme; étude biographique et critique*. Geneva: A. Skira, 1959. 166 p., 71 col. illus. Volume in "Le Goût de notre temps" series.

Survey of Fauve paintings with emphasis on the major personalities. Bibliography (pp. 149-52) lists major books and periodicals in English and French.
a. English ed.: *Fauvism; Biographical and Critical Study*. Paris: Skira, 1959. 163 p., col. illus.
b. U.S. eds.: *Fauvism: Biographical and Critical Study*. Trans. by James Emmons. New York: Skira, 1959. 163 p., col. illus.; *Fauves and Fauvism*. New York: Skira/Rizzoli, 1987. 120 p., illus., some col.
Reviews: A. Werner, *Arts Magazine* 33(June 1959):14; J. Grenier, *L'Œil* 55-56(July-Aug. 1959):70; J. Melquiot, *Apollo* 71(June 1960):211.

24. MARUSSI, GARIBALDO. *I "Fauves"*. Venice: Edizioni del Cavallino, 1950.

25. MATHEWS, DENIS. *Fauvism*. With 24 illustrations, chosen by Heinrich Neumayer. London: Metheun, 1956. 62 p., 24 col., illus.

a. German ed.: *Fauvismus*. Vienna, 1956.

26. MULLER, JOSEPH-EMILE. *Le Fauvisme*. Paris: Fernand Hazan, 1956. 95 p., illus., some col. Volume in "Bibliothèque Aldine des arts" series.

Review: Werk 44(Jan. 1957): supp. 9.

27. MULLER, JOSEPH-EMILE. *Le Fauvisme*. Paris: Hazen, 1967. 256 p., illus., some col.

History of the French Fauves, with emphasis on the movement's influence on major painters like Matisse and Dufy.
a. U.S. ed.: *Fauvism*. Trans. by Shirley E. Jones. New York: Praeger, 1967. 260 p., 216 illus., some col.
b. English ed.: *Fauvism*. Trans. by Shirley E. Jones. London: Thames & Hudson, 1967. 260 p., 54 col. pl.

28. NEGRI, RENATA. *Matisse e i Fauves*. Milan: Fratelli Fabbri, 1969. 100 p., illus., 30 pl. Volume in "Mensili d'arte" series.

29. OPPLER, ELLEN CHARLOTTE. *Fauvism Reexamined*. Ph.D. diss., Columbia University, 1969; New York, London: Garland, 1976. 461p.; 413 p., 112 illus.

According to the legendary story of Fauvism, some venturesome young men shocked the Parisian art world in 1905 by exhibiting paintings of such unprecedented, brilliant color that they were condemned as wild beasts. The young Fauves, however, continued their courageous attack on the art that had gone before—the formless, delicately tinted Impressionism, and the literary, oversophistictaed work of the Nabis. When the great art of Cézanne, however was revealed to them at a retrospective in October, 1907, they recognized that their youthful exuberance had led them astray. They soon returned to a naturalistic palette and to more carefully structured compositions. Like most popular legends,

this one contains several glaring falsehoods. This study shows that the Fauves were not the embattled revolutionaries of pouplar legend. They admired rather than rejected Impressionism and they had been studying the work of Gauguin and Cézanne long before the alleged impact of 1907. Draws on primary sources (including French newspapers, literary texts, and pictorial materials) and places the movement within thhe larger cultuural and historical context. Oppler documents the contradictory aspects of the movement, analyzes its stylistic transformations in relation to Impressionist and Post-Impressionist traditions, and explains the artistic and personal reasons for its brief life span.
Review: C. Baldwin, *Art Bulletin* 60:1(March 1978): 187-8.

30. PAYRÓ, JULIO E. *Qué es el 'fauvismo.' Un arte feliz: la pintura de las fieras.* Buenos Aires: Columba, 1955. 62 p., 2 col. pl. Volume in "Colección Esquemas" series.

31. POPP, JOSEPH S. *An Investigation of the History and Significance of Fauvism.* M.S. thesis, Northern Illinois University, 1966. 61 p.

32. RAYNAL, MAURICE, ARNOLD RUDLINGER, HANS BOLLIGER, JACQUES LASSAIGNE, and GEORG SCHMIDT. *Histoire de la peinture moderne. Matisse, Munch, Rouault, Fauvisme et expressionnisme.* Geneva: Skira, 1950.

33. SALMON, ANDRE. *Le Fauvisme.* Paris: A. Somogy, 1956. 64 p., illus., some col. Volume in "Tendances de la peinture moderne" series.

34. SOTRIFFER, KRISTIAN. *Expressionismus und Fauvismus.* Edited by Walter Koschatzky. Vienna and Munich: Verlag Anton Schroll, 1971. 139 p., illus., pl.

a. U.S. ed.: *Expressionism and Fauvism.* New York: McGraw-Hill, 1972. 139 p., illus., some col.

35. TASSI, R. *Fauvismo, Expressionismo, Realismo Sociale.* Milan: Fratelli Fabbri. Volume in "I Maestri del colorer" series.

36. VAUXCELLES, LOUIS. *Le Fauvisme.* Geneva: Pierre Callier, 1958. 115 p., 11 col. illus. Volume in "Peintres et sculpteurs d'hier et d'aujourd'hui" series.

37. WHITFIELD, SARAH. *Fauvism.* London: Thames and Hudson, 1988. 216 p., 171 illus., 24 col. Volume in "World of Art" series.

Examines the art of the group of painters led by Henri Matisse knows as the Fauves. Whitfield discusses the artists (including Albert Marquet, Henri Manguin, Charles Camoin, André Derain, Maurice Vlaminck, Raoul Dufy, Othon Friesz, and Georges Braque), their work, their influences and the response to their style of painting which involved the use of strong colors and bold brush strokes.
a. U.S. ed.: New York: Thames and Hudson, 1991. 216 p., illus.

Articles

38. ANDREAE, CHRISTOPHER. "Light Shining Through Darkness." *Christian Science Monitor* (20 Sept. 1993):16-7.

Concerns the influence of Fauvism and Gustave Moreau on Georges Rouault.

39. AUST, VON GÜNTER. "Yon den 'Nabis' 24 den 'Fauves'" in *Das Von der Heydt-Museum in Wuppertal*. Recklinghausen: A. Bongers, 1977. 332 p., illus., some col.

40. BANJEAN, JACQUES. "Le Fauvisme ou la nature." (1938).

41. BASCHET, JACQUES. "Au temps des Fauves." *L'Illustration* 93:4801(3 March 1935):281-4. Col. illus.

For a critique of this article, see Jacques Guenne, "Les Fauves au musée." *L'Art vivant* 192(April 1935):3.

42. BAZIN, GERMAIN. "Historique du Fauvisme" in René Huyghe, *Histoire de l'art contemporaine* (Paris: Félix Alcan, 1935), pp. 105-6.

43. BEARD, DORATHEA K. "A Modern Ut Pictura Poesis: The Legacy of Fauve Color and the Poetry of Wallace Stevens." *The Wallace Stevens Journal: A Publication of the Wallace Stevens Society* 8:1(Spring 1984):3-17.

Mentions the Fauves and Matisse.

44. BEERLI, CONRAD-ANDRE. "Couleur et société" in *Mélanges d'histoire économique et sociale en hommage au professeur Antony Babel*. Geneva, 1963. Vol. 2, pp. 625-79.

45. BERNARD, EMILE. "L'Anarchie artistique: Les Indépendants." *La Renovation* 1(June 1905):91-6.

46. BERNARD, EMILE. "Du culte de la personalité." *La Renovation esthétique* 3(Sept. 1906):260-4.

47. BERNARD, EMILE. "Les Renovateurs de l'art." *La Renovation esthétique* 1(Sept. 1905):267-74.

48. BERTHOUD, DORETTE. "Les Fauves" in her *La Peinture française d'anjourd'hui* (Paris: Editions d'Art et d'Histoire, 1937), pp. 9-32.

49. BRION, MARCEL. "Le Fauvisme." *Art d'aujourd'hui* 7-8(March 1950):7-9.

50. BROUSSE, PAUL. "Provençaux et Roumains." *La Nouvelle revue* 40(15 May 1906):213-34.

51. BRUNHAMMER, Y. "Art Deco 1925." *L'Œil* 256(Nov. 1976):42-7. In French. 12 illus.

Examines the decorative art produced in France in the aftermath of the 1900 Exposition and exhibited at the 1925 Exposition. Brunhammer charts the main influences which affected the decorative arts in this period including Mackintosh's chair designs: Fauvist and Expressionist use of color and the discovery of "Black art"; the geometry of cubism and its derivatives; Futurist focus on movement; the palette of the Russian artists as revealed in Diaghilev's *Ballets russes*; and Le Corbusier's designs.

52. BURGESS, GELETT. "The Wild Men of Paris." *Architectural Record* 37:5(May 1910):401-14.

Burgess, an American writer, and his friend Inez Haynes Irwin visited Matisse's studio on April 20, 1908. This early article on Fauvism was based on interviews with Matisse, Braque, Derain, Friesz, Auguste Herbin, and Picasso. See also Edward F. Fry's article, "Cubism, 1907-1908: An Early Eyewitness Account," *Art Bulletin* 48(March 1966):70-3.
Reprint: *Architectural Record* 140(July 1966):237-40.

53. CARCO, FRANSIS. "Le Nu dans la peinture moderne: les Fauves." *Les Nouvelles littéraires* (May 1924). See also Carco's *Le Nu dans la peinture moderne* (Paris: G. Crès, 1924), pp. 64-76.

54. CATONNNE, AMEDEE. "Aux Indépendants." *Les Temps nouveaux* (15-21 April 1905).

55. "Ces pauvres Fauves de 1905." *Beaux-arts* (25 June 1937):2.

56. CHARPONNEL, GEORGES LE and CHARLES VELLAY. "Enquête." *Gil Blas* (1904).

57. CHASSE, CHARLES. "L'Histoire du fauvisme revue et corrigée." *Connaissance des arts* 128(Oct. 1962):54-9. 9 illus., some col.

58. CHASTEL, ANDRE. "Le Fauvisme ou l'été chaud de la peinture." *Le Monde* (21 Aug. 1959).

59. CHASTEL, ANDRE. "Au seuil du XXᵉ siècle: Seurat et Gauguin" in *Art de France* (Paris, 1962), vol. 2, pp. 297-305.

60. CHERVET, HENRI. "Le IVᵉ Salon d'Automne." *La Nouveau revue* 43(1 Nov. 1906):97-102.

61. CLOUZOT, HENRI. "Le Père Soulier." *Le Carnet des artistes* 21(1 Dec. 1921):17-8.

Soulier was a pioneer amateur dealer in Fauve paintings. Mentions that Galerie Clovis, Sagot, 46, rue Lafitte was also, according to an advertisement in *Maintenant* (1914), offering Fauve and Cubist canvases.

62. COCHIN, HENRI. "A propos de quelques tableaux impressionnists." *Gazette des Beaux-arts* 3:32(1 Aug. 1904):101-12.

63. COGNIAT, RAYMOND. "Du Fauvisme à l'après guerre." *L'Amour de l'art* 15(Jan. 1934):271-6.

Also published in René Huyghe, *Histoire de l'art contemporain: la peinture* (Paris: Félix Alcan, 1935), pp. 271-6. Essay on Charles Dufresne and Henri de Waroquier.

64. COLOMBIER, PIERRE DU and MANUEL ROLAND. "L'Epoque du Fauvisme" in their *Les Arts* (Paris: Denoël et Steele, 1933), pp. 44-60. Illus.

65. CONSTANTINI, VINCENZO. "La Pittura del 'fauves'." *La Fiera Letteraria* (Milan) (8 July 1928).

66. COSTA, VANINA. "La Nature fauve." *Beaux-arts magazine* 85(Dec. 1990):76 87. 15 col. illus.

Referring to the exhibition *The Fauvist Landscape: Matisse, Derain, Braque, and Their Circle*, held at the Los Angeles County Museum of Art (4 Oct.-13 Dec. 1990), Costa sees the brief Fauvist period beginning in 1905 as painting's last great preoccupation with landscape. She gives a brief history of the movement, and looks at its themes and techniques—rudimentary drawings and the use of color are considered its chief characteristics. The work of Derain, Braque and Matisse is examined, and particular attention is paid to the way that landscape, free from established dimensions, facilitates the destruction of geometric perspective and evokes a total experience of the world. Some space is given to the legacy left by Fauvism.

67. COURTHION, PIERRE. "Les Grandes étapes de l'art contemporain 1907-1917." *XXᵉ siècle* 28(May 1966):79⁺.

68. CUNNE, KARL. "Fauvisme och Kubismen i Frankrike." *Ord och Bild* (Sweden) (1927):655-70.

69. DAVIDSON, MORRIS. "The Fauves and Henri Matisse" in his *An Approach to Modern Painting* (New York: Coward-McCann, 1948), pp. 82-9.

70. DECAUDIN, MICHEL. "Apollinaire et les peintres en 1906 d'après quelques notes inédites." *Gazette des Beaux-arts* (Feb. 1970).

71. DENIS, MAURICE. "La Réaction nationaliste." *L'Ermitage* (15 Nov. 1905).

72. DENIS, MAURICE. "La Peinture." *L'Ermitage* 16:1(15 May 1905):310-20; 16:2(15 Nov. 1905):309-19; 17:1(15 June 1906):321-6.

73. DENIS, MAURICE. "Sur l'exposition des Indépendants." *La Grande revue* 48(10 April 1908):545-53.

74. DIEHL, GASTON. "Le Fauvisme." *Beaux-arts* 70(20 June 1942):5.

75. DORIVAL, BERNARD. "Le Fauvisme au Musée d'Art moderne." *Musée de France, Bulletin* 12(April 1947):17-24. 6 illus.

76. DORIVAL, BERNARD. "Fauves: The Wild Beasts Tamed." *Art News Annual* 22(1952-53):98-129, 174-6. Illus.

77. DORIVAL, BERNARD. "L'Art de la Brücke et le Fauvisme" in *Art de France* (Paris, 1961), vol. 1, pp. 381-5.

78. DORRA, HENRI. "'The Wild Beasts': Fauvism and its Affinities at the Museum of Modern Art." *Art Journal* 36:1(Fall 1976):50-4. 4 illus.

Despite its distance from today's avant-garde, this exhibition justifies itself by its excellent catalogue by John Elderfield and the quality of its content. Included were many important and rarely seen works, such as Matisse's *Luxe, calme et volupté*. Elderfield places a number of artists outside the Fauvist canon as being pre-Fauvist, notably Puy, Camoin, and Manguin. He follows Barr in distinguishing two phases in the development of Fauvism, the first characterized by a technique combining vestiges of Neo-Impressionist brushwork and flat color areas, while the second is referred to as "flat color Fauvism." Elderfield feels that important influences affecting the style's development are underplayed, such as van Gogh's brushwork and use of color, Japanese sources, and the influence of neo-Impressionist theory. However, attention is paid to works with Symbolist themes.

79. DOSCHKA, ROLAND. "Art Cannot be Made with Theory" in *Terra scultura, terra pictura: Keramiek van de 'Klassicke modernen'* [exh. cat.] 's-Hertogen-bosch, Netherlands: Kruithuis Museum, 1992.

Discusses the versatility of the Fauves and Cubists who combined skills in both sculpture and painting.

80. DUDAR, HELEN. "In Turn-of-the-Century Paris, An Explosion of Brash Art." *Smithsonian* 21:7(Oct. 1990):64-77.

81. DUFRESNE, CHARLES., et al. "Du Fauvisme à l'après-guerre." *L'Amour de l'art* 15(Jan. 1934):271-6. illus.

Includes contributions by Henri de Waroquier, Raymond Cogniat, and Fritz Neugass.

82. DUTHUIT, GEORGES. "Le Fauvisme." *Cahiers d'art* 4:5(1929):177-92; 4:6(1929):258-68; 4:10(1929):429-35; 5(1930):129-34; 6:2(1931):78-82. Illus. Reprinted in Duthuit, *Répresentation et présence. Premiers écrits et travaux*. Paris: Flammarion, 1974), pp. 195-231.

83. DUTHY, ROBIN. "Buy Fauves (if you can)." *Connoisseur* 210(May 1982):126-7.

84. EARP, THOMAS W. "From Fauve to Cubist" in his *The Modern Movement in Painting* (London, New York, 1935), pp. 21-7.

Special Spring number of *Studio* (1935).

85. EDDY, ARTHUR JEROME. "Les Fauves" in his *Cubists and Post-Impressionism* (Chicago: A. C. McClurg, 1914), pp. 43-48.
a. 2nd ed.: 1919.

86. *L'Esprit nouveau: revue internationale illustrée de l'activité contemporaine, arts, lettres, sciences.* Numbers 1-28, 1920-25.

Includes articles on Fauvism, Derain, and Matisse.
a. Reprint: New York: Da Capo Press, 1968-69. 8 vols.

87. EVENEPOEL, HENRI. "Gustave Moreau et ses élèves: lettres d'Henri Evenepoel à son Père." *Mercure de France* 1:15(1923):1+.

88. ["Les Fauves."] *Zolotoe runol/La Toison d'or* (April 1908).

Reproduces Matisse's five paintings shown at the first Salon de la Toison d'or (Salon of the Golden Fleece) in Moscow. The Fauvist group was well represented at the three Toison d'or exhibitions sponsored by Nicolai Riabushinsky.

89. "Les Fauves et les contemporains." *Le Moment* (16 Dec. 1935).

90. FEURRING, MAXIMILIEN. "Henri Matisse und die Fauvisten." *Prisma* (Munich) 1:1(Nov. 1946):15-6.

91. FIERENS, PAUL. "Le Fauvisme." *Cahiers de Belgique* (Brussels) 4:4(April-May 1931):118-29.

92. FIERENS, PAUL. "Matisse e il Fauvismo." *Emporium* 88(Oct. 1938):195-208 16 illus.

93. FOSKI. "Carnet de Paris: Aux Indépendants." *La Nouvelle revue* 39:1-2(1 April, 15 April 1906):417-9, 560-3.

94. GAGNON, MAURICE. "Fauvisme" in his *Peinture moderne* (Montréal: Bernard Valiquette, 1940), pp. 109-28.

95. GARVEY, ELEANOR M. "Cubist and Fauve Illustrated Books." *Gazette des Beaux-arts* 63, ser. 6(Jan. 1964):37-50. 8 illus.

96. GEORGE, WALDEMAR. "Le Mouvement Fauve." *L'Art vivant* 3:54(15 March 1927):206-8.

97. GEORGE, WALDEMAR. "The Fauves Exhibition." *Drawing and Design* (London) 2:12(June 1927):180-1.

98. GEORGE, WALDEMAR. "Dualité de Matisse." *Formes* 16(June 1931):94-5.

99. GEORGES-MICHEL, MICHEL. "Les Fauves" in his *Les Grandes époques de la peinture 'moderne'* (New York, Paris: Brentanos, 1944), pp. 124-41.

100. GERBE, LEON. "La Peinture française—le mouvement fauve." *Le Peuple* (1 March 1939).

101. GIDE, ANDRE. "Promenade au Salon d'Automne." *Gazette des Beaux-arts* 34(1905):475-85.

102. GILLET, LOUIS. "L'Atelier de Gustave Moreau: M. Henri Matisse." *Revue des deux mondes* (Summer 1937). Reprinted in his *Essais sur l'art français* (Paris: Flammarion, 1938), pp. 141-50.

103. GILLET, LOUIS. "Les Fauves." *Revue des deux mondes* (Summer 1937). Reprinted in his *Essais sur l'art français* (Paris: Flammarion, 1938), pp. 152-4.

104. GINDERTAEL, R. V. "Le Fauvisme ou les grandes vacances." *L'art d'aujourd'hui* ser. 2(Oct. 1951):32.

105. GIRY, MARCEL. "Fauvism, the Source of Cubism" in *Le Cubisme* (Saint-Etienne: Université de Saint-Etienne, 1973). Centre Interdisciplinaire d'etudes et de recherche sur l'expression contemporaine, travaux, IV. 238 p., 13 illus.

Texts presented at the First Conference of the History of Contemporary Art, held at the Museum of Art and Industry, Sainte-Etienne, in 1971. The twelve essays are: "Fauvism, the Source of Cubism" by M. Giry; "Contacts Between Braque and Picasso and the Dubois: "Cubism and Problems of Color" by M. Hoog; "Space and Cubism (Architectural Problems)" by G. Sargent; "Transformation of Signs" by J. Laude; "The Letter in Cubist Painting" by F. Will-Levaillant; "Robert Delaunay and Cubism" by B. Dorival; "Mondrian and Cubism" by M. Le Bot; "Cubist Sculpture" by D. Milhau; "Henri Laurens" by M. Menier; and "Cubism and the Russian Avant-Garde" by J.-P. Bouillon.

106. GIRY, MARCEL. "Le Style géometrique dans la peinture vers 1907" in *Le Cubisme* (Saint Etienne: Université de Saint Etienne, 1973). Centre Interdisciplinaire d'etudes et de recherches sur l'expression contemporaine, travaux IV, 1973, pp. 29-34.

107. GIRY, MARCEL. "Ingres et le Fauvism." *Actes du Colloque international Ingres et son influence* 55-60. 3 illus.

Deals with the influence of Ingres on Fauvism via the exhibition of 68 works by him including a drawing of the *Golden Age* at the Salon d'Automne of 1905, and in particular his influence on Matisse's *Joy of Life* (Barnes Foundation, Merion, PA).

108. GIRY, MARCEL. "Le Salon d'Automne 1905." *L'Information d'histoire de l'art* (Jan.-Feb. 1968):16-25.

109. GIRY, MARCEL. "Le Salon des Indépendants de 1905." *L'Information de l'histoire de l'art* (May-June 1970):110-4.

110. GIRY, MARCEL. "Matisse et la naissance du Fauvisme." *Gazette des Beaux-arts* ser.6, 75:1216-7(May-June 1970):331-44. 4 illus.

111. GOETZ, THALIE and MANUEL JOVER. "From Fauvism to the Post-War Period." *Beaux-arts magazine* (1991):40-65.

Special issue devoted to the Troyes Museum of Modern Art and its Pierre and Denise Lévy collection, which is particularly strong in works by Derain and Braque.

112. GOLBERG, MECISLAS. "Axiomes et dilemmes." *La Plume* (15 March 1904).

113. GOLDIN, AMY. "Forever Wild: A Pride of Fauves." *Art in America* 64:3(May-June 1976):90-5. 5 illus.

Article occasioned by the large exhibition, *Fauvism and its Affinities* held at the Museum of Modern Art, New York, Spring 1976. Historical perspective attributes increasing importance to Matisse and the Fauves, now that color and space have taken priority over natural forms. Derain is given considerable emphasis in the exhibition, and is seen as the motive force behind Matisse's interaction with the Fauves. Fauvism took its themes from Gauguin but its handling from van Gogh, at least in the use of strong colors; the substitution of color for line and composition as a means to pictorial structure and unity is the essence of Fauvist paint-handling techniques. Goldin disputes the assertion that the instinctive, emotional Fauvist style gave way to the measured form and sobriety of Cubism—this is only applicable to the Fauves' use of color and the Cubists' lack of it. The movements were in fact united in their daring use of techniques, the integration of form and ground, and in the search, common to artist everywhere, for a method which would confirm art's tie to a deeper reality while loosening its bondage to nature and to inappropriate conventions.

114. GOLDING, JOHN. "Fauvism and the School of Chatou: Post-Impressionism in Crisis." *British Academy Proceedings* 66(1980):85-102. 16 illus.

Discusses the Fauvism of Vlaminck and Derain following their 1900 meeting and subsequent association; the influence of van Gogh and Cézanne; and Vlaminck's paintings, 1900-1908, in the context of contemporary aesthetic problems and cross-currents. *Aspects of Art* lecture, read February 7, 1980.

115. GOLDWATER, ROBERT JOHN. "The Primitivism of the Fauves" in his *Primitivism in Modern Painting* (New York, London, 1938), pp. 74-86.

116. GOLDWATER, ROBERT JOHN. "The Fauves, Brücke, Blaue Reiter" in *Major European Art Movements, 1900-1945: A Critical Anthology* (New York: Dutton, 1977). 396 p., 143 illus.

117. GROSSMAN, RUDOLF. "Dômechronik." *Kunst und Künstler* (1922):29-32.

118. GUENNE, JACQUES. "Les Fauves au musée." *L'Art vivant* 192(April 1935):3.

Critique of Jacques Baschet's derogatory article in *L'Illustration* (3 March 1935):281-4.

119. HEPP, PIERRE. "Sur le choix des maîtres." *L'Occident* (Dec. 1905):263-5.

120. HERBERT, PIERRE L. and W. EUGENIA HERBERT. "Artists and Anarchism: Unpublished Letters of Pissarro, Signac and Others." *Burlington Magazine* (Nov.-Dec. 1970).

121. HOBHOUSE, JANET L. "The Fauve Years: A Case of Derailments." *ART News* 75:6(Summer 1976):47-50. 7 illus.

The Museum of Modern Art, New York, exhibition, *'The Wild Beasts': Fauvism and its Affinities*, presents a definition of Fauvism as, in the author's opinion, "a form of post-Impressionism (and pre-Cubism) practiced chiefly by Matisse, Derain and Vlaminck between 1905 and 1907." In view of the extreme contrasts of style, personality and preoccupation of the artists involved, and of the divergent ways taken by them after this period, Hobhouse questions whether Fauvism can justifiably be termed a "movement." She compares the achievements of Derain and Matisse, noting particularly the contrast between the fundamental serenity and harmony of works such as Matisse's *Bonheur de vivre* and *Luxe, calme et volupté* (1904-05) and the restless, searching unresolved quality of Derain's *Composition* (*L'Age d'or*) of 1905. In her opinion, the exceptional quality of the works in the exhibition merely adds to the confusion over terminology.

122. HOLL, J.-C. "Salon d'Automne." *Les Cahiers d'art et de littérature* 5(Oct. 1906):67-114.

123. HONEYMAN, THOMAS J. "Les Fauves—Some Personal Reminiscences." *Scottish Art Review* 1(1969):17-20.

124. HOOG, MICHEL. "La Direction des beaux-arts et les fauves, 1903-1905. Notes et documents." *Art de France* 3(1963):363-6. 3 illus.

125. HOOG, MICHEL. "La Peinture et la gravure; Fauvisme et expressionisme" in *Encyclopédie de la Pléiade*, vol. 4: *Histoire de l'art. Du réalisme à nos jours* (Paris: Nouvelle Revue Française, 1969), pp. 526-612.

126. HOOG, MICHEL. "Fauves" in *Album no. 7 de la Collection Pierre Lévy* (Paris: Mourlot, 1972). Reprinted in Pierre Lévy, *Des artistes et un collectionneur* (Paris, 1976), pp. 294-305.

127. HUMBERT, AGNES. "Les Fauves et le Fauvisme." *Jardin des arts* 12(Oct. 1955):713-20.

128. HUYGHE, RENE. "Le Fauvisme: les coloristes." *L'Amour de l'art* 14(1933):97-102.

129. HUYGHE, RENE. "Le Fauvisme: les peintres pathétiques." *L'Amour de l'art* (June 1933).

130. HUYGHE, RENE. "Le Fauvisme: le réveil des traditions." *L'Amour de l'art* 7(July 1933):153-6. Reprinted in *Histoire de l'art contemporain* (Paris: Félix Alcan, 1935), chapter 6.

131. HUYGHE, RENE and JEAN RUDEL. "Le Fauvisme" in *L'Art et le monde moderne*, vol. 1: *1880-1920* (Paris: Larousse, 1969), pp. 188-97.

132. JACOB, MAX. "Souvenirs sur Picasso." *Cahiers d'art* (1927):199-202.

133. JAMOT, PAUL. "Le Salon d'Automne." *Gazette des Beaux-arts* 3:36(1 Dec. 1906):456-84.

134. JEDLICKA, GOTTHARD. "Le Fauvisme." *XXe siècle* (1970):35-8.

Special number devoted to Fauvism.

135. JOSEPHSON, RAGNAR. "Kvinnorna frán Colliouve och Kvinnorna frán Avignon." *Tidskrift for konstvetenskap* 26(1947):9-46.

136. KAHNWEILER, DANIEL-HENRY. "Du temps que les cubistes étaient jeunes." *L'Œil* (15 Jan. 1955):27-31.

137. KALLEN, HORACE M. "Gauguin and the 'Fauves'" in his *Art and Freedom* (New York: Duell, Sloan and Pearce, 1942), vol. 2, pp. 723-6.

138. KATZ, LEO. "Fauvism" in his *Understanding Modern Art* (Chicago: Delphian Society, 1940), vol. 2, pp. 299-305.

139. KRAMER, HILTON A. "Fauvism sans Matisse." *Modern Painters* 4:2(Summer 1991):18-21. 4 col. illus.

Kramer uses the *Fauve Landscape* exhibition at the Royal Academy in London (18 June-1 Sept. 1991), to argue that the period of influence of Fauvism, 1904-08, was less of a movement than a moment, and one that has been misunderstood from its inception. The concentration on landscape means that the exhibition was less than a complete account of Fauvism, for which he blames academic orthodoxy which privileges "socially significant" subject matter while neglecting "bourgeois" questions of aesthetics. The Fauve painters were not lead by patriotism in their choice of motifs or personal culture and the exhibition was further harmed by the virtual absence of Matisse, the most influential of the Fauve painters. This means that the influence of the Fauves on abstract painting of the future was lost as Matisse's progress towards the abstract, figurative and decorative was neglected.

140. LASSAIGNE, JACQUES. "Les Origines du Fauvisme" in *Panorama des arts 1947* (Paris: Somogy, 1948), pp. 60-5.

141. LASSIUS, JEAN DE. "Les Fauves." *L'Amour de l'art* 8:6(June 1927):209-11.

142. LEBENSZTEJN, JEAN-CLAUDE. "Sol" in *Scolies, Cahiers de recherches de l'Ecole Normale Supérieure* (Paris: P.U.F., 1971), vol. 1, pp. 95-122; vol. 2 (1972), pp. 89-114.

143. LEHMANN, LEON. "L'Art vécu: souvenirs du temps des Fauves." *Beaux-arts* 134(July 1926):2; 135(2 Aug. 1935):2.

Mentions Matisse and Rouault in particular.

144. LEYMARIE, JEAN. "Il Fauvismo: la fase preparatoria," "La Formazione del movimento," "La Piena maturità" (L'Espressionismo e il fauvismo) in *L'Arte moderna* (Milan, Fratelli Fabbri, 1967-68-69). 3 vols., pp. 201-320.

145. LEYMARIE, JEAN. "Fauvismus" in *Die Kunst des 20. Jahrhunderts 1880-1940* [20th Century Art, 1880-1940]. Edited by Giulio Carlo Argan. (Berlin: Propyläen Verlag, 1977). 420 p., illus.

146. LINNEBACH, G., et al. "Expressionisme: die Brücke, der Blaue Reiter" [Expressionism: die Brücke, der Blaue Reiter] in *Paris-Berlin: rapports et contrastes France-Allemagne 1900-1933*, edited by Pontus Hulten (Paris: Centre Georges Pompidou, Gallimard, 1978), pp. 58-117. 75 illus.

Includes five essays on difference aspects of Expressionism. Linnebach compares and contrasts die Brücke with Fauvism.

147. MADSEN, HERMAN. "Expressionismen och 'les fauves'" in his *Från Symbolism till Surrealismen* (Stockholm: Ahlén soners Förlag, 1939), pp. 64-81.

148. "Les Maîtres de l'art indépendant, 1895-1925. Portraits d'artistes." *Le Point* (Lanzac) 2:3(1937):1-143.

Includes essays on Matisse, Marquet, Puy, Dufy, van Dongen, Vlaminck, and Derain.

149. MARTIN, ALVIN and JUDI FREEMAN. "The Distant Cousins in Normandy" in *The Fauve Landscape* [exh. cat., Los Angeles County Museum of Art] Judi Freeman, ed. (New York: Abbeville Press, 1990), pp. 215-39. 33 illus., 20 col.

Concerns Braque and Friesz.

150. MATISSE, HENRI. "Notes d'un peintre." *La Grande revue* 52:24(25 Dec. 1908):731-45.

Matisse's famous essay on Fauve principles in his art, with a preface by Georges Desvallières, unofficial editor of the journal's art pages, who is said to have initiated the article. The essay is a defense and justification of his art for the general public and a response to his rivals and critics. It is accompanies by six illustrations of his paintings of 1906-08, including *Marguerite Reading; Standing Nude; Portrait of Greta Moll; Nude, Black and Gold;* and *Game of Bowls.* Within a year, "Notes d'un peintre" was translated into Russian and German. In this important statement about the purposes of his art, Matisse stresses six broad points: his aim is a form of expression inseparable from his pictorial means; he seeks to condense his sensations received from nature, thereby to produce a more lasting and stable art than that of the Impressionists; he transposes colors until their juxtaposed areas create an intuitively found unity that does not copy nature but realizes its essential character; clarity and order are necessary to a picture and will convey its significance to the viewer even before its illustrated subject is recognized; his art is

intended to have a soothing, calming influence on the mind; by basing his art on nature, he avoids precoception and rules, but is nevertheless bound to the expression of his time. (See Elderfield, 1992, p. 181).

a. Other eds.: Complete English translation by Margaret Scolari in Museum of Modern Art, 1931 and 1951 catalogues. Separately published under French title by Scheiwiller (Milano, All'Insegna del Pesce d'Oro, 1942); Russian translation in *Toison d'Or* (Zolotoye Runo)6:(1909). German translation in *Kunst and Künstler* 7(1909):335-47. Frequently reprinted in whole or part.

151. MAUCLAIR, CAMILLE. "Les Fauves." *La Grande revue* (15 Dec. 1905).

152. MILLARD, CHARLES W. "Fauvism." *Hudson Review* 29:4(Winter 1976-77):576-80.

Article occasioned by the exhibition *Fauvism and its Affinities* held at the Museum of Modern Art, New York, from March 26 to June 1, 1976.

153. MOLLET, "LE BARON". "Les Origines du cubisme: Apollinaire, Picasso et cie." *Les Lettres françaises* (3 Jan. 1947).

154. MONOD, FRANÇOIS. "Le Salon d'Automne." *L'Art et décoration* 18(1905):198-210.

155. MORICE, CHARLES. "Enquête sur les tendances actuelles des arts plastiques." *Le Mercure de France* (1 Aug. 1905):346-59; (15 Aug. 1905):538-55; (1 Sept. 1905):61-85. On the fourth question: "Quel état faites-vous de Cézanne?" see Lionello Venturi, *Cézanne* (Paris, 1936), vol. 1, p. 370.

156. MULLALY, TERENCE. "Fauves." *Apollo* 64(Dec. 1956):184-9.

157. NAKAYAMA, KIMIO. "The Dawn of Modern Painting: Fauvism and its Affinities." *Mizue* (Japan) 855(June 1976):21-9. 9 illus. In Japanese. Summary in English.

Fauvism appeared in Japan in the 1920s as the result of combining elements from Impressionism, neo-Impressionism and Art Nouveau, prevalent in Europe at the beginning of the century. As a movement it tried to find ideals and hopes in a concrete manner. Discusses the background of the movement and its practitioners in France and Japan.

158. NATANSON, THADEE. "Deux élèves de Gustave Moreau: Marquet et Matisse" in his *Peints à leur tour* (Paris: Albin Michel, 1948), pp. 197-205.

159. OZENFANT, AMEDEE [Vauvrecy, pseud.]. "Les Fauves, 1900-1907." *L'Esprit nouveau* 16:2(1922):1871-2.

160. PAYRÓ, JULIO E. "El post-impresionismo: los fauves" in his *Pintura moderna, 1800-1940* (Buenos Aires: Poseidon, 1942), pp. 136-64.

161. PERATE, ANDRE. "Salons de 1907." *Gazette des Beaux-arts* 38(1907).

162. PHILLIPS, JONATHAN. "The Fauve Landscape." *American Artist* 55:591(Oct. 1991):48-53[+].

163. POMPEY, FRANCISCO. "La Pintura moderna en francia: los 'fauves'." *Haz* (Madrid) 4:17(Dec. 1944):43-5.

164. PRACHE, ANNE. "Souvenirs d'Arthur Guéniot sur Gustave Moreau et son enseignement à l'Ecole des Beaux-arts." *Gazette des Beaux-arts* (April 1966):229-40.

165. PURRMANN, HANS. "Aus der Werkstatt Henri Matisses." *Kunst und Künstler* (Feb. 1922):167-76.

166. PUY, MICHEL. "Les Fauves." *La Phalange* (15 Nov. 1907):450-9. Reprinted in his *L'Effort des peintres modernes* (Paris: A. Messein, 1933), pp. 61-78.

167. ROMERO BREST, JORGE. "Los Fauves." *Saber Vivir* (Bueños Aires) 7:86(Aug.-Sept. 1949):32-5.

168. ROSSET, DAVID. "Les Fauves dans les collections suisses." *La Galerie des arts* 16(May 1964):22-6. 7 illus., some col.

169. ROUAULT, GEORGES. "Gustave Moreau." *L'Art et les artistes* 20:66(April 1926):217-50.

Special number, with an additional letter by André Suarès. On p. 249 is reproduced a photo of "Les Elèves de l'atelier de Gustave Moreau en 1894."

170. ROUAULT, GEORGES. "Evocations." *Chroniques du jour* 2:9(April 1931):8-9.

171. ROUVEYRE, ANDRE. "Souvenirs de mon commerce: dans la contagion de Mécislas Golberg." *Mercure de France* (15 April 1922):297-323.

172. RUSSOLI, FRANCO, ed. "L'Expressionismo e il Fauvismo" in *L'Arte Moderna* (Milan: Fratelli Fabbri Editori, 1967), vol. 3.

173. SALMON, ANDRE. "Les Fauves" in his *La Jeune peinture française* (Paris: Albert Messein, 1912), pp. 9-40.

174. SALMON, ANDRE. "Les Fauves et le fauvisme." *L'Art vivant* 3(1 May 1927):321-4.

175. SALMON, ANDRE. "Letter from Paris." *Apollo* 6(Nov. 1927):220-2.

On Fauvism and Vlaminck.

176. SALMON, ANDRE. "Naissance du Fauvisme." *L'Amour de l'art* (May 1933). Reprinted in René Huyghe, ed., *Histoire de l'art contemporain: la peinture* (Paris: Alcan, 1935), pp. 103-5.

177. "Le Salon d'Automne." *L'Illustration* 63:3271(4 Nov. 1905):294-5.

Brief comments by critics on works exhibited by Guérin, Cézanne, Rousseau, Le Beau, Vuillard, Matisse, Manguin, Rouault, Derain, Volta, and Puy. Reprinted in Rene Huyghe, ed., *Histoire de l'art contemporain: la peinture* (Paris: Félix Alcan, 1935), p. 98 and in *Cahiers d'art* 6:5-6(1931):252.

178. SALVINI, ROBERTO. "Poetica e poesia. I: Simbolisti e fauves" in his *Guida all'arte moderna* (Florence: L'Arco, 1949), pp. 155-68.

179. SCHEFFLER, KARL. "Der Kanon" in his *Geschichte der europäischen malerei vom Impressionismus bis zur Gegenwart* (Berlin: Bruno Cassirer, 1927), pp. 199-205. Volume in "Die Europäische Kunst" series.

180. SCHNEIDER, PIERRE. "Four Fauves." *Art News* 61:15(Sept. 1962):49-50.

181. SCHNEIDER, PIERRE. "Dans la lumière de Matisse." *L'Express* (12 Aug. 1968).

182. SEROUYA, HENRI. "Les Fauves" in his *Initiation à la peinture d'aujourd'hui* (Paris: La Renaissance du Livre, 1931), pp. 108-14. Volume in "A travers l'art français" series.

183. SEVERINI, GINO. "Souvenirs sur Reverdy." *Mercure de France* (Jan.-April 1962):293-7.

184. SUTTON, DENYS. "Aspects of the Venice Biennale: The Fauves." *Burlington Magazine* (Sept. 1950):263-5.

185. SUTTON, DENYS. "The 'Fauves'." *World Review* (London) (May 1947):48-54.

186. SUTTON, DENYS. "The Nature of Fauvism." *Country Life* (30 Mar. 1951):955. 2 illus.

187. TERIADE, EMMANUEL. "Constance du Fauvisme." *Minotaure* (15 Oct. 1936).

188. TERRASSE, CHARLES. "Le Fauvisme" in his *Histoire de l'art* (Paris: Henri Laurens, 1946), vol. 3, pp. 186-7.

189. VAUXCELLES, LOUIS. *Gil blas* (4, 18, 23 March 1905; 17 Oct. 1905; 20 March 1906; 9, 14 Nov. 1908).

Articles and reviews on Fauve painters, paintings, and exhibitions.

190. VAUXCELLES, LOUIS. "Les Fauves, à propos de l'exposition de la *Gazette des Beaux-arts* 12:86(Dec. 1934):273-82.

191. VERONESI, GIULIA. "I 'Fauves'." *Emporium* 136(July 1962):3-9.

192. VIAZZI, GLAUCO. "Fauvismo." *Domus* 203(Nov. 1944):419-22.

193. VLAMINCK, MAURICE DE. "Fauves et cubistes." *L'Art vivant* (1929).

194. VLAMINCK, MAURICE DE. "Avec Derain, nous avons crée le Fauvisme." *Jardin des arts* (June 1955):473.

195. VOGT, PAUL. "Das Museum Folkwang in Essen" [The Folkwang Museum in Essen]. *Kunst und das schöne Heim* 85:11(Nov. 1973):697-704,740. Summary in English. 6 illus.

Description of the current programs of the Folkwang Museum in Essen, with a short historical summary. The 1969 museum catalogue lists about 250 works of the 19th and 20th centuries. A text from the museum guide by Paul Vogt, the museum's director, is included, in which he describes developments in European art in the first decade of the 20th century with particular reference to Fauvism and German Expressionism.

196. WHITFIELD, SARAH. "Fauvism" in *Concepts of Modern Art*. T. Richardson and Nikos Stango, eds. (Harmondsworth, England: Penguin Books, 1974). 281 p., 111 illus.

Art of the present century embodies a wide range of concepts and ideologies, often emerging concurrently, and making a linear history of the period impossible. This collection of sixteen authoritative essays examines the key ideas to emerge in the art of the last seventy years, as represented by its movements.

197. "The 'Wild Beasts': Fauvism and its Affinities." *Mizue* (Japan) 855(June 1976):5-20. 171 illus.

Portfolio of illustrations of paintings by Matisse, Derain, Braque, Vlaminck, Dufy, and van Dongen, drawn from the exhibition with the above title held at The Museum of Modern Art, New York, 26 March-1 June 1976. Contains no text.

198. ZERVOS, CHRISTIAN. "Le Fauvisme" in his *Histoire de l'art contemporain* (Paris: Cahiers d'Art, 1933), pp. 113-38.

199. ZIMMERMAN, P. "De laatsten en de eersten" [The Last and the First]. *Hollands maandblad* 27:459(Feb. 1986):39-42. 1 illus. In Dutch.

On the Nabis versus the Fauves in France.

II. Fauve Influences On Other Artists

Books

200. BARJAVEL, RENE. *Neillot*. Paris: Linéal, 1975. 160p., 159 illus. In French and English.

Contends that Louis Neillot (Vichy, 1898-Paris, 1973) is to be classed as one of the Fauves, whose joyousness and explosive vigor he shares by virtue of his powerful use of color. However, his insistence on balance, strict discipline and properly organized space, which is bound up with his admiration for Cézanne, enabled him to give his Fauvism a richer content and to progress beyond Fauvism itself. Neillot's structural power, whether in landscape or in still life painting, is impressive in black and white as well as in color. The book contains a biographical note, numerous extacts from criticisms, a bibliography and particulars of works in museums and collections, and illustrates fifty years of research on the part of the painter, while also offering a picture of Neillot's personality as it emerges from the testimonies of his contemporaries.

201. BORRAS, MARIA LUISA. *Picabia*. Barcelona: Poligrafa, 1985.

This study of Francis Picabia (1879-1953) both as painter and polemicist, the outcome of fifteen years research, offers a comprehensisve survey of the artist and his times, from his early Post-Impressionism and Pointillism, through Fauvism and his own version of Cubism, to his hermetic Dada works and Surrealism. Borras notes that some of his literal and realistic paintings of the mid-1930s are prophetic of Pop and Photo-Realism, yet with his own brand of the parodic and sinister. A catalogue of Picabia's works is included.
a. English ed.: London: Thames and Hudson, 1985. 549 p., 1153 illus.
b. French ed.: Trans. by Robert Marrast. Paris: Albin Michel, 1985. 549p., illus.

202. Brussels, Fondatiton pour l'art belge contemporain. SERGE GOYENS DE HEUSCH. *Foundation pour l'art belge contemporain: apperçu d'une collection* [Foundation for Countemporary Belgian Art: Glance at a Collection]. Brussels: Fondation pour l'Art Belge Contemporain, 1988. 240 p., 114 illus., 59 col.

Presents a selection of paintings, drawings and prints from this collection, grouped into the following sections: touches of Fauvism; towards a purity of form; the great wave of abstraction after 1945; referential abstraction or allusive figuration; post-War figuration; and the generation 1970-90. There is a brief introduction by the author to each section. More than nine artists are represented.

203. CAMFIELD, WILLIAM A. *Francis Picabia: His Art, Life and Times*. Princeton: Princeton University Press, 1979. 366 p., 473 illus., 20 col.

Picabia played a key role in the history of modern art, particularly in Dada and the development of abstract art. This study interprets Picabia's art in the context of his life as a painter, poet, polemicist, and *bon vivant*. The paintings reflect the artist's fascination in turn with Impressionism, Fauvism, Cubism, Dada, and diverse modes of abstract and figurative art. Camfield has consulted Picabia's documents, and has interviewed his wives and colleagues. Reference is made to his collaborations with avant-garde periodicals, the cinema, and the Swedish Ballet, and to friendships with Duchamp, Apollinaire, Gertrude Stein, Stieglitz, André Breton, Isadora Duncan, Erik Satie, and others. The text is based not only on Picabia's paintings but also on documents, visits to over 300 private and public art collections, and interviews with his family, colleagues and critics.

204. CARTER, ERNESTINE. *The Changing World of Fashion—1900 to the Present.* Introduction by Diana Vreeland. London: Weidenfeld & Nicolson; New York: G.P. Putnam's, 1977. 256p., 229 illus., 40 col.

Pre-World War I dress designers are discussed. Analyzes the influence on international fashion of the fashion centers of Paris, London and the U.S., incorporating profiles of Gabrielle Chanel, Elsa Schiaparelli, Christian Dior, Cristóbal Balenciaga, Yves Saint-Laurent, Mary Quant, Zandra Rhodes, Claire McCardell, among others. Fashion is viewed in relation to the arts (Léon Bakst, Les Fauves, Cubists, Surrealists); the dance (Isadora Duncan to discotheques); politics (demonstration headbands and fringes); social change (black stockings, jeans, anti-fashions); technological developments (increased speed of locomotion, test-tube fabrics); as interpreted in literature and by photographers (Cecil Beaton, Martin Munkacsi), illustrators, and journalists.

205. CHABERT, PHILIPPE. *Hommage à Charles Dufresne (1876-1938)* [exh. cat.] Lausanne: Galerie Paul Vallotton (16 March-22 April 1989). Catalogue par Philippe Chabert. 14p., 11 col. illus.

Catalogue to an exhibition of paintings by Charles Dufresne, with an account of his career and an analysis of his œuvre. Chabert examines the development of an influences on his style, asserting that he adopted the bold colors of the Fauves and the spatial techniques of the Cubist without adhering to either movement.

206. CHARMET, RAYMOND. *Auguste Chabaud.* Paris, Lausanne: Bibliothèque des Arts, 1973. 171 p., 104 illus. In French.

Auguste Chabaud is generally known either as a Fauve painter or as the solitary painter of Provence. However, these merely correspond to two phases within a complex and varied œuvre. A careful study of Chabaud's career reveals five pre-1914 phases: post-Impressionism, Fauvism, pre-Cubism, Cubism, and the maturation of his individual style; and three post-1919 phases: his blue period, his return to a more austere style, and the final harmony of his latest works. Charmet describes the succession of these phases through a study of the artist's personality and the events which marked his life, particularly the decisive effect of his experiences during the First World War. A chapter is also devoted to Chabaud's writings and humanist beliefs. A catalogue of his work, which also includes drawings and sculpture, a list of his main exhibitions, a biographical note, and a bibliography complete the study.

207. CLAIRE, STEPHANIE and ANNA WALDMANN. *Salvatore Zofrea.* Sydney: Hale & Iremonger, 1983. 144 p., 67 illus., 29 col. In English.

Autobiographical account by the Italian painter Salvatore Zofrea (b. 1946), who emigrated to Australia at the age of 10, is followed by Waldmann's assessment of his work. He painted part-time until a serious illness in 1975. While convalescing, Zofrea discovered the Psalms and did a series of paintings inspired by them which were exhibited and led to some success. In 1979 Zofrea was commissioned to create a mural for the *Sydney Morning Herald* building, which he sees as a turning point in his life. Stressing his originality as an artist, Waldmann describes some of the influences on his style, from Hieronymous Bosch to the Fauves, and assesses the

impact on him of his rediscovery of Christianity in 1975. Lists of his solo and group exhibitions and prizes are appended.

208. FINEBERG, JONATHAN DAVID. *Kandinsky in Paris, 1906-1907.* Ph.D. diss., Harvard University, 1979; Ann Arbor, MI: UMI Research Press, 1984. 14 p., illus.

209. FLOREA, VASILE. *Romanian Painting* Trans. by Sergiu Celac. Bucharest: Meridiane Publishing House, 1982. 154 p., illus.

Traces the history of Romanian painting from the earliest cave paintings ot the present day, including sections on Art Nouveau, the Group of Four, artists distantly influenced by Impressionism, Fauvism or Expressionism, the avant-garde of the inter-War years, and developments since Romania's liberation in 1944, especially the changing definition of realism and experimentation with new styles and techniques.
a. U.S. ed.: *Romanian Painting.* Trans. by Sergiu Celac. Detroit: Wayne State University Press, 1983. 154 p., 105 illus., 51 col.

210. HOBBS, RICHARD JAMES. *Odilon Redon.* London: Studio Vista, 1977. 192 p., 119 illus., 19 col.

Account of the whole range of the work of Redon (1840-1916) in relation to the Symbolist context that affected its development: the nature and history of the Symbolist movement, literary background, critical reaction, exhibitions and artistic organizations, *cenicles* and patrons, conditions and fashions of the time. Includes discussions of Redon in relation to early influences, notably Rodolphe Bresdin; themes ranging from fantasy and mythology to Flaubert and flowers; the Decadents, e.g., Huysmans; Redon's awareness of Poe, Wagner and Symbolist taste; Belgian Symbolism; Mallarmé and his circle; Symbolist theorists; the Nabis painters; conditions and events prior to the First World War (including the Fauves, Redon's patrons, etc.). Describes the evolution of Redon's art chronologically by demonstrating the mutual influences that took place between it and this Symbolisit context.
a. U.S. ed.: Boston: New York Graphic Society, 1977. 192p., illus.
Review: M.A. Steveens, *Times Literary Supplement* 3928(24 June 1977): 762.

211. HULTEN, KARL GUNNAR PONTUS, NATALIA DUMITRESCO, and ALEXANDRE ISTRATI. *Brancusi.* Paris: Flammarion, 1986. 335p., illus., some col.

Catalogue raisonné of the work of Constantin Brancusi (1876-1957), presenting his sculpture and the furniture and utensils he made for his own use. Dumitresco and Istrati provide a detailed chronology of his life and career, drawing on his correspondence with family, friends, dealers and critics. Hulten discusses Brancusi's sculptural œuvre, identifying the impact of Fauvism and Cubism on his work and commenting on his use of photography and his concept of environmental sculpture. He examines the function of the base, discusses the size, scale, symmetry and simplicity of his sculptures, and evaluates Brancusi's influence on contemporary art.
a. Italian ed.: Milan: A. Mondadori, 1986. 335p., illus., some col.

b. U.S. ed.: New York: H.N. Abrams, 1987. 336p., illus., some col.
c. English ed.: London: Faber and Faber, 1988 (c. 1987). 336p., 614 illus., 51 col.

212. KOSTIN, VLADIMIR IVANOVICH. *OST Obschchestvo stankovistov* [OST The Society of Easel Artists]. Leningrad: Khudozhnik RSFSR, 1976: 157p., 71 illuus., pl.

Devoted to the history, origins and activity of one of the most significant groups in Soviet art of the 1920s. Analyzes the works and artistic method of the group's members, who were young artists recently graduated from Vkhutemas, and notes the influence on the OST members of German Expressionism and French Fauvism.

213. *Leo Gestel als modernist: werk uit de periode 1907-1922.* [Leo Gestel as a Modernist: Work from the Period 1907-22]. Exhibition at Haarlem, Netherlands: Frans Halsmuseum (4 June-31 July 1983); also shown S-Hertogenbosch, Netherlands: Noordbrabants Museum (20 Aug.-16 Oct. 1983). Text by Aleida Betsy Loosjes-Terpstra.

Catalogue to an exhibition of paintings by Leo Gestel (1881-1941), concentrating on his abstract period of 1914-22 and the ways in which he applied various abstract qualities to his work. In his introduction, the author explores a chronological development in these paintings: luminism (Pointillism), post-luminism (Fauvism), and the return to realism; he describes the characteristics of each, and gives details of the painters who influenced Gestel. This is followed by a summary of the documentary evidence regarding Gestel's views on his own work, on his first atelier, on Dutch expressionist, on friendship, and on encouraging young artists.

214. MORGAN, ANN LEE. *Arthur Dove: Life and Work, With a Catalogue Raisonné.* Cranbury, New Jersey; London; Toronto: Associated University Presses, for the University of Delaware Press, 1984. 380 p., 425 illus., pl.

Study of the life and art of Arthur Dove (1880-1946), who spent his formative years in upstate New York but developed a modernist outlook in response to his experiences of New York and Europe. Having experimented with Impressionism and Fauvism, Dove postulated his own vision which accommodated a nonillusionistic pictorial structure and representational elements.

215. MYERS, JANE, ed. *Stuart Davis: Graphic Work and Related Paintings with a Catalogue Rainsonné of the Prints.* Exhibition at Fort Worth, Texas: Amon Carter Museum of Western Art (29 Aug- 26 Oct 1986). 96 p., 93 illus., 9 col.

Catalogue to an exhibition of a selection of prints, drawings and paintings by Davis (1892-1964), with a catalogue raisonné of his prints by the author and Sylvan Cole, divided into four periods: 1915-29, 1931, 1936-39, and 1949-64. A selection from Davis's notebooks and sketchbooks, 1922-38, is included, as well as an essay, "Stuart Davis: Methodology and Imagery." In this, Diane Kelder traces the evolution of Davis's style, from his early realism, and the radical effect on him of the Armory Show (1913), which led to his realization that his artistic training had been inadequate, to his gradual break with the Ash Can School, and emulation of Post-Impressionist, Fauvist, and Cubist styles.

216. O'BRIAN, JOHN *David Milne and the Modern Tradition of Painting.*
Toronto: Coach House Press, 1983. 141p., 60 illus.

Study of the Canadian painter David Milne, who trained in New York and was
influenced by Post-Impressionism and the Fauves. O'Brian's aim is to show that
Milne's Canadian experience had a strong impact on him, as well as the movement
of anti-traditionalism which started in Europe.

217. STILIJANOV-NEDO, INGRID. *Max Pechstein 1881-1955: Druckgraphik*
[exh cat.]. Regensburg: Ostdeutsche Galerie (6 July-10 Sept. 1989). 89p., 53
illus.

Catalogue to an exhibition of prints by Max Pechstein (1881-1955), with an extract
from the book *Das graphische Jahr* by Fritz Gurlitt (Berlin, 1921) in which
Pechstein talks about his motivation for making prints and relates how his
experiments with the medium developed over the years. Also included is an essay
in which Stilijanov-Nedo discusses Pechstein's prints and traces his artistic
development focusin on his involvement with the group Die Brücke, the influence
of Art Nouveau on his work, and his stay in Paris in 1907 where he came into
contact with Nabis and the Fauves. Also considered is his production of prints after
his years as a soldier in First World War. The author concludes with a discussion
of several of Pechstein's works.

218. STUMP, JEANNE A. GASS. *The Art of Ker Xavier Roussel.* Ph.D. diss.,
University of Kansas, 1972. 417 p., illus.

Covers the French painter's entire career, with special attention to the forty years
after 1900 which have received little documentation. Roussel's early works
reflected the stylistic innovations and Symbolist content of the Nabis, the patterned
forms of Art Nouveau, and his use of hcightened, unrealistic color links him with
the Fauves. His Nabi origins were displayed in his propensity for the mural; those
painted for the stairway of the Kunstverein, Winterthur reveal his interest in spatial
distortion. Roussel's iconography and recurring motifs are discussed.

219. VISSCHER-D'HAEYE, BERNADETTE DE. *Hippolyte Daeye 1873-1952:
genèse d'une peinture* [exh. cat.] Ostend, Belgium: Provinciaal Museum voor
Moderne Kunst, 1989. 304 p., 410 illus., 64 col.

Catalogue of an exhibition of the work of Hippolyte Daeye (1873-1952) dating from
1898 to 1946, and including both paintings and drawings. The author traces his life
from his birth at Gand, Belgium and his education, details his travels and his years
in England, and the influence of the Fauves and the Diaghilev ballet. Between 1927
and 1930 his work became freer and more expressive and from 1931 to 1936 he
conducted a deeper investigation into the relationship between color and space.
Visscher-d'Haeye traces the development and influences on Daeye's later work and
discusses the evolution of Belgian art, with particular reference to art in Anvers and
Brussels, and Daeye's role in promoting artistic activities and in organizing and
selecting exhibitions.

Articles

220. ADAM, GEORGINA. "Art Deco Cachet." *Antique Collector* 61:5(May 1990):90-5. 9 illus., 8 col.

Examines the recent surge of interest in Art Deco furniture, which went completely out of fashion in the 1950s and 1960s. Adam traces the history of Art Deco design and comments on the founding of the Société des Décorateurs in 1901 in Paris, influenced by Fauvism, Cubism, and oriental fabrics and ornament, the creation of ensembles by members of the society, and subsequent developments in other countries. She reviews current prices of Art Deco furniture, considers the related problems of copies and fakes, and lists the most common practices involved.

221. ADAMS, PHILIP R. "Walt Kuhn's *Salute*." *Arts in Virginia* 25:2-3(1985):2-11. 14 illus., 2 col.

Traces the career of American painter Walt Kuhn (1877-1949). Adams describes some of the influences on him, which included the Armory Show of 1913 of which he was one of the organizers, although Cubism did not finally affect his style as much as Fauvism. He describes the fruitful year of 1934 in which Kuhn completed seventeen paintings and kept all of them, including *Salute* which, however, he never exhibited. He discusses the preliminary sketch for *Salute* which has survived, and concludes by suggesting that Kuhn concentrated his circus pictures on the "anonymous proletariat of show business" rather than the big stars since he regarded them as "metaphors" or symbols of larger realities.

222. BARSCH, B. "Henri Gaudier-Brzeska." *Bildende Kunst* 12(1980):609-12. In German. 9 illus.

Henri Guadier-Brzeska was killed in the First World War and only spent three years on the development of his sculpture, but his work and theoretical ideas had a profound influence on British sculptors like Barbara Hepworth and Henry Moore. Barsch considers that his importance lies in the fact that he prepared the way for the development of English sculpture which in turn became so important to European sculpture as a whole from the mid-1950s onwards. He moved to London in 1910 with Sophie Brzeska, whose name he took. There he met many of the most important literary and artistic personalities of the period and became involved with the two main intellectual groups, the Vorticists and the Bloomsburg Group. Gaudier-Brzeska's work comprised around forty sculptures and hundreds of sketches, experimenting with all the contemporary trends and being influenced by Rodin's sculpture, Expressionism, Cubism, Fauvism, and African and Asiatic art. However, he always remained true to his principles: three-dimensional representation, suitability of material, and rhythm. His sculpture can be divided into two groups: the modelled sculptures, mostly in bronze based on the work of Rodin; and his tone sculpture often fashioned from a single block. His theoretical ideas were published in various periodicals and had a great influence on future sculptors.

223. BAUR, JOHN IRELAND HOWE. "John Marin's 'Warring, Pushing, Pulling' New York." *ARTnews* 80:9(Nov. 1981):106-10. 6 illus.

Traces the development of Marin, who stands at a crossroads in American art. He began painting in the late 1880s and his artistic origins lie in the tonal Impressionism of Whistler, but he was among the first Americans to feel the impact of modernism, playing a major role in the group around Alfred Stieglitz which established the American equivalents of international Cubism, Fauvism, and Futurism. Concludes that Marin's importance to American art transcends his personal achievement, for he showed that the language of international modernism could be given both an individual and an American accent. Several of his depictions of life in New York City are illustrated.

224. BENNINGTON, JOHN. "From Realism to Expressionism: The Early Career of Roderic O'Conor." *Apollo* (U.K.) 121:278(April 1985):253-61. 19 illus.

Roderic O'Conor (1860-1940) is increasingly recognized as one of the most innovative British artists of his generation. Bennington traces the development of his painting style from realist beginnings through Impressionism, Synthetism, and Symbolism to a precursory form of Fauvism. A checklist of works by O'Conor in public collections dating from the period up to 1903 is appended.

225. BUCKBERROUGH, SHERRY A. "A Biographical Sketch: Eighty Years of Creativity" in *Sonia Delaunay: A Retrospective* [exh. cat.] (Seattle: University of Washington Press, 1979), pp. 13-99. 91 illus.

Describes Sonia Delaunay's childhood in Russia, her arrival in Paris in 1905 and contact with the Impressionists, the Post-Impressionists, and the Fauvists, her transition from canvas to fabrics, her marriage to Robert Delaunay and their creation of the theory and art of simultaneity. Sonia Delaunay's costume designs for the Russian ballet under Sergei Diaghilev, her experiments with Dada and Surrealism in the 1920s, her success in the fashion world and in designs for living and her projects celebrating the machine and the working man are all discussed. Finally, the solitary war years, followed by a renaissance of simultaneity, are charted.

226. BUSCH, G. "Louis Anquetin: 'Der Windstoss auf der Seinebrücke'" [Louis Anquetin: 'The Gust of Wind on the Seine Bridge']. *Niederdeutsche Beiträge zur Kunstgeschichte* 12(1973):59-68. 9 illus.

An improvised exhibition by young artists was held in Paris in 1889. Among those who took part were Gauguin, Charles Laval, Emile Bernard, and Louis Anquetin. These artists had come together as a "Group impressionniste et synthétiste." Anquetin being a particular friend of Bernard. The color sense of the Fauves was already beginning to emerge at this time and Anquetin's art shows the influence of their ideas. His life and work is traced from his birth in 1861, and one of his paintings, *Le Coup de vent sur le Pont des Saintes-Pères*, is given close attention. It is in many ways a modern picture, with the rush of traffic, the fear and the danger, and in its style it anticipates Futurism and Pop Art.

227. CHARTRAIN-HEBBELINCK, MARIE-JEANNE. "Henry [sic] Evenepoel face à Manet" [Henri Evenepoel Confronts Manet]. *Revue Belge d'archéologie et d'histoire de l'art* 54(1985):71-84. 9 illus. Summary in English.

Discusses the extent of Manet's influence on the painter Henri Evenepoel (1872-99). He discovered the work of Manet at an exhibition in Brussels in May, 1894. In a letter of this time he expresses his enthusiasm for Manet's painting, although he questions whether Manet is really an Impressionist. The author believes Manet's influence is most clearly seen in Evenepoel's portraits and groupings of figures, and that his assimilation of Manet's influence continued throughout the rest of his brief career. In the paintings he did in Algeria (in 1897 and 1898) he goes beyond Manet to a style that can almost be called Fauvist.

228. COLEMAN, JOHN. "A Painter of Living Art: Jack T. Hanlon, 1913-1968." *GPA Irish Arts Review Yearbook* (1988):222-8. 5 illus., 3 col.

Examines Fr. John Thomas Hanlon's career and discusses the relationship of his work to Cubism and Fauvism. Notes his participation in the founding of the Irish Exhibition of Living Art in 1943.

229. COOPER, HELEN A. "The Watercolors of Charles Demuth." *Antiques* 133:1(Jan. 1988):258-65. 12 col. illus.

Traces the career of Charles Demuth (1883-1935), with particular reference to the watercolors that show his brilliant technique to best advantage. His early figure studies show the influence of Rodin, while a series of landscapes he did in France echo John Marin's robust brushwork and the saturated palette of the Fauves. In 1915 he began to paint flowers, exploring the emotional density of color to achieve effects similar to those of Redon or the French Symbolists. In 1916 and 1917 he did a series of architectural watercolors in which the earlier expressionism was replaced by a more intellectual structure of lines and planes, and this change in style marked all his work thereafter. Towards the end of the 1920s Demuth's watercolors became less abstract, although they were still dominated by the brilliant colors and shapes—"the dynamic interplay of object and space." Includes texts by Matisse.

230. DELLAMORA, RICHARD J. "Canadian Artists in Venice." *Arts Magazine* 58:10(June 1984):18. 1 illus.

Having discussed the Canadian public's lack of awareness of its own national art, Dellamora reviews the exhibition *Canadian Artists in Venice 1830-1930* at Queen's University, Kingston, Ontario (19 Feb.-1 April 1984). Dellamora examines the response of Alexander Young Jackson and James Wilson Morrice to the Venetian scene, noting that they represent the two opposed aspect of anglophone tradition in Canadian painting; the one dealing with unpeopled landscapes painted in a style in which the Fauvist influence is repressed, the other more clearly acknowledging its debt to France.

231. EAUCLAIRE, SALLY. "Victor Higgins." *Southwest Art* 20:11(April 1991):54-60. 11 illus., 9 col.

Reassesses the artistic career of Higgins (1884-1949), who sold his paintings from coast to coast during the "golden age" of the Taos Society of Artists in the early 1900s. Unlike fellow artists, after about 1920 Higgins refused to paint cliched themes such as comely Indian maidens in the moonlight. Instead he flirted with Fauvism, Cubism, Synchromism, and other European avant-garde art movements.

These he methodically adapted to distinctly American landscapes and portraits. Currently, his reputation is rising.

232. EGGUM, ARNE. "Fauvism and Edvard Munch" in *Edvard Munch: schilderijen 1900-1906 en grafiek* [Edvard Munch: Paintings 1900-06 and Prints]. Exhibition at Brussels, Bibliothèque Royale Albert 1er, 1981. Organized under the Belgian-Norwegian Cultural Accord by the Ministries of Netherlandish and French Culture. Catalogue by Arne Eggum and Gerd Woll. 128 pp., 111 illus.

Catalogue to an exhibition of paintings (1900-06) and of prints from throughout his career by Edvard Munch. In "Fauvism and Edvard Munch," Arne Eggum examines the relationship to Fauvism of Munch's paintings of the period, including *Christmas in the Brothel*, the similarity of his use of colors to that of Matisse and Picasso, and the decorative and emotional aspects of the paintings.

233. EGGUM, ARNE. "Edvard Munch: hans liv og kunst" [Edvard Munch: His Life and Art]. *Louisiana Revy* (Denmark) 28:2(Feb. 1988):4-19. 26 illus. 16 col.

Biographical sketch of Munch, published on the occasion of an exhibition of his paintings and photographs at the Louisiana Museum, Humlebaek, Denmark (20 Feb.-15 May 1988), the catalogue of which is included in this issue of *Louisiana Revy*. Eggum focuses on the transmutation of traumatic personal experiences into a language of private symbolism. Selected paintings illustrate various phases in his career, especially the Paris and Berlin periods, and demonstrate Munch's ability to absorb and blend impressionistic and naturalistic features. Munch is seen in the whole context of contemporary European painting, and his relationship to the Fauves and artist of Die Brücke is examined.

234. George Hopper Fitch Collection. COOPER, HELEN A. "Maurice Prendergast: *'Rising Tide, St. Malo'*" in *American Watercolours from the Collection of George Hopper Fitch* (New Haven, CT: Yale University Art Gallery, 1980), pp. 10-12. 3 illus.

Dates Prendergast's watercolor *Rising Tide, St. Malo* to 1907 and recognizes in its bold brushstrokes and brilliant colors the influence of the Fauvists. Prendergast's treatment of crowds, sea, sky, and buildings is considered and his principle of rhythmic composition examined.

235. FONTBONA, FRANCESC. "Marian Pidelaserra à Paris (1899-1901)." *Gazette des Beaux-Arts* 120:1317(Oct. 1978):141-6. 8 illus.

Marian Pidelaserra (1877-1946), one of the foremost post-modernist Catalan painters, lived in Paris during the period 1899-1901. In Paris his art underwent a radical change of style as the orthodox realism that he had learned form his master Père Borell in Barcelona gave way to a style influenced by the Impressionists, Evenepoel, and Corinth. Pidelaserra's canvases contained elements of Expressionism, especially in the distortion of forms in rainy scenes, and there were also elements of Fauvism and Constructivism which were absorbed into his style. The development of his work was towards barbarism and the exhibition of his canvases in Barcelona in February, 1902 created a sensation in the Catalan art

world. Fontbona concludes that Pidelaserra's stay in Paris provided him with the necessary direct contact with new European art.

236. FORT, IRENE SUSAN. "John Marin." *Arts Magazine* 56:4(Dec. 1981):4. 1 illus.

States that the oil and watercolor paintings in the John Marin exhibition at the Kennedy Gallery, New York (13 Oct.-6 Nov. 1981) show the importance of the theme of New York City in his work from 1910 to the end of his life, and the various ways he experimented with it in successive decades. The influences of Fauvism and Orphism were followed by those of Cubism and Socialist Realism during the Depression.

237. FRANK, J. "The Centenary of Béla Czóbel, the Painter." *New Hungarian Quarterly* 25:94(1984):173-6. 10 illus.

With reference to the Budapest commemorations of the centenary of the artist's birth in 1983, Frank traces and evaluates the career of the Paris-trained Hungarian painter Béla Czóbel (1883-1974), focusing on his introduction of Fauvism into the Hungarian art world in 1906.

238. GARCÍA-OCHOA, LUIS and ISABEL VAQUERIZO (Interviewer). "Luis García-Ochoa: de la Real Academia de Bellas Artes de San Fernando" [Luis García-Ochoa: From the Royal Academy of Fine Art of San Fernando] *Correo del Arte* (Spain) 69(March 1990):42-3. 4 illus., 1 col.

In this interview painter and draughtsman Luis García-Ochoa of Madrid's Real Academia de Bellas Artes de San Fernando discusses his background and development, the influence on him of Fauvism, Symbolism and Neo-Romanticism, and his interest in literature, philosophy, and music.

239. GIRY, MARCEL. "Fauvisme, la source de cubisme" in *Le Cubisme* (Saint-Etienne: Université de Saint-Etienne, 1973).

Essay presented at the First Conference of the History of Contemporary Art held at the Museum of Art and Industry, Saint-Etienne, in 1971.

240. GORDON, DONALD E. "Kirchner in Dresden." *Art Bulletin* 48(Sept.-Dec. 1966):373.

241. GUERRICCHIO, LUIGI. "Leonardo De Santis." *Le Arti* (Italy) 24:7-8(July-Aug. 1974):262. In Italian. 2 illus.

Short appreciation of De Santis's painting which provides brief details of his artistic formation, his admiration for the Fauves and Matisse, and possible influences on his art.

242. GÜSE, ERNEST-GERHARD. "Fauvism" in *August Macke: Gemälde, Aquarelle, Zeichnungen* [August Macke: Paintings, Watercolors, Drawings]. Exhibition shown Münster, Westfälisches Landesmuseum für Kunst und Kulturgeschichte (7 Dec. 1986-8 Feb. 1987); Bonn, Städtisches Kunstmuseum (10

March-10 May 1987); Munich, Städtische Galeria im Lenbachhaus (27 May-26 June 1987). Edited by Ernst-Gerhard Güse. Munich: Bruckmann, 1986. 527 p., 728 illus., 151 col.

Catalogue to an exhibition of paintings and drawings by August Macke (1887-1914), with ten essays. Irene Kleinschmidt-Altpeter discusses aspects of Macke's early work; Ernst-Gerhard Güse assesses the influence on Macke of the French Impressionists and Fauves.

243. HARYU, ICHIRO. "The Avantgarde Art Movement in Japan." *Mizue* (Japan) 857(Aug. 1976):5-43, 69 illus. In Japanese. Summary in English.

Illustrated survey of the paintings presented in the exhibition *Japan's Avant-Garde*, Tokyo Metropolitan Art Museum, from May, 1976. The show is described as representing the progress of Japanese avant-garde art over fifty years from the time when Fauvism and Cubism were introduced there and developed in uniquely Japanese ways. The major difference in the development from that of Europe is that it is an effort to transplant into Japanese terms the European ideology and its maintenance. However, during the period of fascism in Japan it was finally destroyed. Also presented is an essay by Ichiro Haryu entitled "Light and Shade of the Avant-Garde Art Movement."

244. HELLBRANTH, ROBERT. "Alcide Le Beau: ein vergessener Fauve" [Alcide Le Beau: A Forgotten Fauve]. *Weltkunst* 58:2(15 Jan. 1988):107. 1 col. illus.

Discusses the life and work of the Breton painter Alcide Le Beau (1872-1943), relating his work to that of the Fauves, and analyzing the lyrical, romantic quality that set him apart from them and inspired his greatest work, a series of forty paintings based on the operas of Richard Wagner. Hellbranth argues that Le Beau has been neglected by history and deserves to be rediscovered.

245. HOOG, MICHEL. "Les *Demoiselles d'Avignon* et la peinture à Paris en 1907-1908." *Gazette des Beaux-arts* (Oct. 1973):209-16.

246. HOOPER, GEORGE and SARAH WILSON (Interviewer). "On Colour: George Hooper." *Artist* (U.K.) 102:6(June 1987):4-7. 9 illus., 6 col.

Transcript of an interview with the painter George Hooper, in which he discusses his memories of his childhood in India, particularly the bright colors and the greyness of England where he went to school. Hooper describes the development of his attitude to color during the 1930s and his attachment to the Fauvists. In conclusion, Hooper discusses the links between music and color in his paintings.

247. "Insight/On Site." *Bulletin of the Cleveland Museum of Art* 78:8(Oct. 1991):261-3.

Discusses Cleveland artist Penny Rakoff's installation, *The Fauve Landscape* (twelve sycamore trees wrapped in brightly colored lyrca), inspired by the colors of the Fauve painters.

248. KOTALIK, JÍŘÍ. "On the Exhibition of Works by František Kupka" in *Frank Kupka* edited by K. Rubingere (Cologne: Galerie Gmurzynska, 1981), pp. 13-32. Also in German. 15 illus.

Examines chronologically the places and events which influenced Kupka's development at key periods in his life. His work stemmed from the contradictory atmosphere and Symbolism of the Belle Epoque, adapted itself partially to Fauvism and involved itself decisively in the "romantic change of representational art of the years 1910-14." After the War he rejected figuration and moved towards geometrical seventy and a formal purism. It is noted that Kupka's work was outside the mainstream of Bohemian avant-garde art and was therefore not completely understood in his homeland.

249. KOVTUN, EUGENI'I FEDOROVICH. "Kazimir Malevich." Translated by C. Douglas. *Art Journal* 31:3(Fall 1981):234-41. In English. 6 illus.

Survey of recent research which has shown Malevich's work to be much richer and more varied than scholars previously thought. Between 1903 and 1913 he went from Impressionism to the varying forms of Russian Fauvism, Cubism, and Suprematism. But the objectless canvases were not the last phase in his creative development; there are later, almost unknown works, begun in the 1920s, in which Malevich returns to a figurative style, but one that has memories of Suprematism. This last period up to the early 1930s is discussed against the background of earlier developments.

250. KRUTY, PAUL. "Mirrors of a 'Post-Impressionist' Era: B. J. O. Nordfeldt's Chicago Portraits." *Arts Magazine* 61:5(Jan. 1987):27-33. 18 illus.

Kruty champions Nordfeldt (1878-1955) as a painter of "advanced" style in American art prior to the Armory Show, with reference to a group of portraits painted in Chicago in 1912-13 which have not been studied adequately. The Swedish-born Nordfeldt, who emigrated to the U.S. in 1891, had just returned from Europe and was influenced by Munch, Jawlensky, Manet, and the Fauves. He carried concepts of European avant-garde styles to the American midwest and can be seen as Chicago's "own Post Impressionist."

251. KUWABARA, SUMIO. "Mizu to kami no vissionnaires stachi: John Marin 1870-1953" [Visionaries with Water and Paper: John Marin 1870-1953]. *Mizue* (Japan) 936(Autumn 1985):12-13. 2 col. illus.

Discusses the watercolor paintings of John Marin and the characteristics of American watercolors in general. Marin studied painting in the Philadelphia College of Art and in Paris, being influenced by Cubism and Fauvism. After *Municipal Building, New York* (1912), his paintings began to show a sense of strong movement, backed by his study of Delaunay's Orphism and Futurism.

252. LANDAU, ELLEN GROSS. "The French Sources for Hans Hofmann's Ideas on the Dynamics of Color-Created Space." *Arts Magazine* 51:2(Oct. 1976):76-81. 4 illus.

Landau believes that Hofmann's ideas were formulated during his period in Paris (1904-14) and later solidified in Germany and America. Hofmann was very much concerned with color and its spatial implications. He was influenced by such French theorists as Delaunay and the Fauves.

253. LEMAIRE, GERARD-GEORGES. "Jean Lamore: figures perdues dans une forêt de symboles" [Jean Lamore: Faces Lost in a Forest of Symbols]. *Opus international* 112(Feb.-March 1989):39-41. 2 illus.

Analyzes Jean Lamore's *Nu reversé* (Upsidedown Nude), the first key work to emerge from his decision to turn to sculpture on a monumental scale, for which he uses enormous tree trunks. Lemaire notes its erotic and primitive connotations, and its recall of both the archaic and modern and of Mannerist, Baroque, Romantic, Fauve, and Vorticist elements. Lamore is described as "corrupting language by the brutal yet subtle reversal of languages which he refines and remodels." His pictorial work is briefly discussed, and details of his participation in recent collective exhibitions are appended.

254. LENZ, D. "Images of Landscape 1900-1916" in *Max Beckmann: Retrospective*, edited by Carla Schulz-Hoffman and Judith C. Weiss (St. Louis: Saint Louis Art Museum, 1984), pp. 111-19. 12 illus.

Beckman's fame rests on his figure paintings, but 220 out of 835 paintings are landscapes of cityscapes and the theme runs throughout his career. His landscapes have been virtually ignored by critics who seek significance in Beckmann's imagery rather than beauty in his presentation. Lenz analyzes Beckmann's early landscapes, tracing the influence of Cézanne, van Gogh and the Fauves, and showing that Beckmann differed from most 20th century artists in that he created an image of the beauty and order of nature. The war transformed Beckmann's view, however, and barren landscapes appear alongside city streets as the scene of the ultimate existential decisions. Even in exile Beckmann continued to paint German landscapes.

255. LIBBY, GARY RUSSELL. "An American Impressionist: Daniel Putnam Brinley 1879-1963." *Southwest Art* 11:2(July 1981):84-91. 16 illus.

Born in Newport, Rhode Island of aristocratic New England stock, this artist is probably best known for his active participation in the Armory Show of 1913, where avant-garde European art was formally introduced to the American public. His career can be divided into two major periods, with the Armory Show as the turning point. Brinley's first period contained soft muted tonal paintings followed by more vigorous, colorful impressionist work. This gave way, during the second period, to a flatter style of bright color areas boldly outlined. Libby notes the latent influences of Art Nouveau, Fauvism, and van Gogh in his paintings.

256. MARGERIE, EMMANUEL DE and MICHEL HOOG. "La Donation Pierre Lévy." *Revue du Louvre et des musées de France* 27:4(1977):241-52. 18 illus.

Discussion of some of the works in the Collection Pierre Lévy, bequeathed to the French nation. Two recent exhibitions at Troyes have revealed the importance of the collection, mainly devoted to French painting from 1880. The most celebrated

part of the collection is the work by the Fauves, while the oldest work is a canvas by Daumier, *Au bord de l'eau.*

257. METKEN, GÜNTER and CAMILLE DEROUET. "Regards sur la France et l'Allemagne: le climat des rapports artistiques—contacts personnels, voyages, publications" [Looks at France and Germany: The Climate of Artistic Relations—Personal Contacts, Journeys, Publications] in *Paris-Berlin: rapports et contrastes France-Allemagne 1900-1933,* edited by P. Hulten (Paris: Centre Georges Pompidou, Gallimard, 1992), pp. 20-57. 75 illus.

Summary by Metken of the interchange of ideas between French and German artists, from the isolation of the first decade of the 20th century, through the German interest in Fauvism and Cubism and the emergence of international Dada, to the evolution of the Bauhaus and Surrealism. The influence of Matisse, Delaunay, and Picasso is discussed in detail and the survey is followed by documents relating to the cultural interchange, including writings by Apollinaire, Tzara, Kandinsky, and Grosz. A second essay, by Derouet, traces the building up of Cubist art in Germany, particularly by Uhde and Kahnweiler, and is followed by documentary evidence and comments on the transactions. The section concludes with an alphabetical list of Parisian artists who had links with Germany and brief notes on their activities.

258. "Mondrian: l'abstraction en ligne droit." *Point art* 5(Spring-Summer 1991):11. 4 illus., 1 col.

Outlines the stages that took Piet Mondrian further and further towards the logic of the abstract. After a fairly conventional beginning to his career, Mondrian flirted with Luminism and Fauvism before, in 1917, setting up the De Stijl group with van der Leck, van Doesburg, and Huszár. Mondrian's essay, published under the title *Neo-plasticism,* advocated a move to denaturalization to reveal a new depth in art. Concludes by briefly considering critical reaction to Mondrian's art.

259. NORA, FRANÇOIS. "Picabia fauve et dadaîste" [Picabia as Fauvist and Dadaist]. *Revue du Louvre et des musées de France* 23:3(1973):189-92. 2 illus.

Before working in the fields of abstract art, Dada and anti-art, Picabia was a successful painter in the Impressionist tradition. Dissatisfied, he went through a transition period. His *Paysage,* misdated 1906, is a brilliant fusion of Fauvist color and Cubist forms. After breaking with the Dada group Picabia produced his "monstrosities" and "transparencies," together with Dadaist collages. Aragon said that Picabia produced pieces most unsuitable for the Louvre, which would nevertheless enter it, a prophecy largely fulfilled through the acquisition by a national museum, the Musée National d'art moderne, of *Y'a bon IA BANA N,* a caricature collage of his mistress Germaine Everling.

260. OREN, MICHEL. "On the 'Impurity' of Group f/64 Photography." *History of Photography* 15:2(Summer 1991):119-27. 1 illus.

Examines the career of the Group f/64 of photographers, active in the San Francisco Bay area in 1932-35 and opposed to the manipulation and photographic prints of Californian Pictoralism. Oren argues that they were paradoxically unable to

maintain their aesthetic ideals, but that there is a close relationship to European avant-garde artists such as the Fauves and Kandinsky. Oren describes the efforts of this extreme Imagism to reconcile itself with the work of Alfred Stieglitz and concludes by assessing the reasons for its decline.

261. REISS, W. TJARK and GEORGE SCHRIEVER. "Winold Reiss: Painter of Plains Indians." *American West* 18:5(Sept.-Oct. 1981):28-37. 8 illus.

German-born artist Fritz Winold Reiss (1886 or 1888-1953) was convinced by the writings of James Fenimore Cooper, Karl May, and Prince Maximilian von Wied, and the engravings of Karl Bodmer that he wanted to paint American Indians. The current schools of Cubism, Futurism, and Fauvism reinforced his strong sense of design and color and he adapted Art Deco to his own needs. He came to the U.S. in 1913. During several summer trips from New York, Reiss painted portraits of Indians in the Glacier National Park vicinity. Many were used for calendars and were exhibited throughout the world. He also decorated interiors of such public places as hotels, restaurants, and railway terminals. George Schriever included a tribute, "A Mover and Skater."

262. RODRIGUEZ, ANTÓNIO and JOSÉ-AUGUSTO FRANÇA. "No atelier de José Guimarães" [In José Guimarães's Studio]. *Colóquio Artes* (Portugal) 32:84(March 1990):14-21, 78-80. 11 illus., 2 col. In Portuguese and French.

A tour of José de Guimarães's Lisbon studio provides a backcloth for a discussion of the many sources of inspiration behind his art and for a characterization of his style and the dominant motifs in his work. Among the aspects discussed by Rodrigues are: the importance of the "making" process in de Guimarães's art; his use of paper which he has made himself as support for his works and his use of natural heavily textured supports which he then paints; the character of his primitivism; the correlations of his works with aspects of Art Nouveau, Expressionism, Fauvism, Cubism, and Kitsch; the body as a key element in his œuvre; and the symbolic and expressive connotations of the totemic qualities of his works.

263. ROI, V. "Era il nostro Van Gogh: geniale e folle" [He was our van Gogh: Genial and Crazy]. *Arte* (Italy) 14:143(July-Aug. 1984):34-41, 103. 7 illus.

Reappraisal of the work of the Venetian painter Gino Rossi on the centenary of his birth. Publicity has up until now centered on Rossi's unhappy and fraught private life; however, recent exhibitions of his work at the Galleria Scudo in Verona and at the Palazzo Vendramin Calergi in Venice and a recent catalogue of his work prepared by Luigi Menegazzi and Claudia Gian Ferrare (Milan: Electa, 1984) have given his work the attention which it deserves. Roi traces Rossi's artistic career, stressing the impact of van Gogh's and Gauguin's work of the Fauves, of the Viennese Secession, and later of Cézanne and the Cubists, on his development.

264. RÖMINGER, RITVA. "Valon Taiteillija August Macke" [The Artist of Light: August Macke]. *Taide* (Finland) 28:5(1987):35-9, 66. 5 illus., 1 col. Summary in English.

Biographical and artistic survey of August Macke (1887-1914), describing his early involvement with music and the theatre, rejection of formal art training, influences on his development (Böcklin, Impressionism, Fauvism, and Matisse), friendships with Robert Delaunay and Franz Marc, and relations with the Blaue Reiter group. Röminger describes the main themes of his work, such as the lost harmony between man and nature, and stresses the independence which characterized Macke throughout his short life.

265. SANDLER, IRVING. "Hans Hofmann and the Challenge of Synthetic Cubism." *Arts Magazine* 50:8(April 1976):103-5. 4 illus.

An exhibition of Hans Hofmann paintings dating from 1947-52, held at the André Emmerich Gallery, revealed how Hofmann sought to "synthesize compacted Cubist drawing with explosive Fauve color and paint handling." Sandler believes that Hofmann's desire to do this was related to currents in American art in the 1940s and to Hofmann's years in Paris from 1903-14 where he participated in the origins of Fauvism and Cubism. Sandler traces the effect of these influences on the development of Hofmann's paintings and argues that in the paintings on exhibition, Hofmann achieved his ambition of "an original synthesis in a non-objective manner of Cubist geometry and Fauve color and texture." Such an exhibition should prompt a re-examination of the value of his painting.

266. SARAB'YANOV, DIMTRY V. "Talent and Hard Work: The Art of Natalia Goncharova" in *Russian Women-Artists of the Avantgarde 1910-1930*, edited by Krystyna Rubinger (Cologne: Galerie Gmurzynska, 1979), pp. 134-43. Also in German. 5 illus.

Brief survey of the life and work of Natalia Goncharova, who played a significant part in the Neo-Primitivist movement in the late 1900s and early 1910s. Her paintings are characterized by the fact that she always chose simple, everyday rural and urban scenes that contained a strong narrative element. Goncharova's paintings can be compared with those of the Fauves and her German paintings and prints with those of the Expressionist, particularly int the way in which the latter used impressions and themes from the First World War.

267. SAURE, WOLFGANG. "Berlin-Paris." *Kunst* 4(April 1987):314-188. In German. 5 col. illus.

Discusses the influence of French literature, fashion, painting and lifestyle on the culture and society of Berlin since the 17th century. Saure describes Berlin as a catalyst and crystallization point between East and West and notes the part played by Berlin in promoting the Parisian avant-garde, Fauves, and Cubists. He comments on the influence of Robert Delaunay, Cézanne, Picasso, and Georges Braque on the Berlin art scene of the early 20th century.

268. SCHLAGHECK, IRMA. "Farbe und Licht: deutsche Impressionistem (5)—Gut für den ersten Platz" [Color and Light: German Impressionists (5)—Good for First Place]. *ART: das Kunstmagazin* 1(Jan. 1990):62-8. 9 col. illus.

Examines the life and work of Albert Weisgerber (1878-1915) and his progression from Impressionism to Expressionism. Weisgerber died before his work was fully

completed and he left a void in the development of art in Munich. He was influenced by Cézanne, Matisse, and the Fauves. From age thirty Weisgerber became obsessed with the idea of his early death and his paintings turned to mythological themes.

269. SCHNEIDER, PIERRE. "The Four Giacomettis." *Artforum* 25:8(April 1987):100-9, 20 illus., 2 col.

Article on the artistic Giacometti family—the brothers Alberto and Diego, their father, Giovanni, and his second cousin, Augusto. Schneider stresses the importance of the family itself, as they all drew, sculpted and painted each other. Augusto and Giovanni are seen as prefiguring the two main avenues of 20th century experimental art; Augusto, moving from Art Nouveau and Symbolism to abstraction, illustrates the "nocturnal" side of the modern; Giovanni, going from realism to Post-Impressionism to a kind of Fauvism, the "solar" side. The characters and works of and influences on each artist are described.

270. SCHULTZE, JURGEN. "Umgang mit Vorbildern: Jawlensky und die französische Kunst bis 1913" [Dealing with Precedents: Jawlensky and French Art to 1913] in *Alexej Jawlensky 1864-1941*, edited by Armain Zweite (Munich: Prestel, 1983), pp. 73-86. 27 illus.

In this study of Jawlensky's work between 1903 and 1914, Schultze documents the influence of the Fauves upon the artist's landscapes, of Kees van Dongen and Marianne Werefkin upon his female portraits, and of Edouard Vuillard and Matisse upon his interiors and still lifes.

271. SINGERMAN, B. "Pablo Picasso." *Kunst und Literatur* 31:1(Jan.-Feb. 1983):98-111. In German.

Translation of an article that was published in Russian in *Teatr* (pt. 10, 1981), which provides a critical analysis of Picasso's artistic development, comparing him to Apollinaire, Meyerhold, and Chaplin in his impact on 20th century culture. Citing specific paintings, the various stages in the development of Picasso's "tragic humanism" are enumerated. Particularly stressed is Picasso's association and break with Fauvism. With the painting *Les Demoiselles d'Avignon* (1907), Picasso rejected the calculating, comfortable approach of the Fauvists and substituted a raw, instinctively more "effective" art. His further success in harmonizing "the laws of classical and modern painting" in seeing man and nature through the "principle of complementarity" is discussed. Singerman concludes that Picasso is as "characteristic" of his times as are Chaplin or Brecht.

272. SYRKUS, HELENA. "Kazimierz Malewicz" [Kazimir Malevich]. *Rocznik historii sztuki* 11(1976):147-58. 16 illus.

Concentrates on the artist's drawings and models for Suprematist architecture and on their fate after his death, pointing out the influence of Malevich's ideas on the architecture of Frank Lloyd Wright (e.g., Gregor Affleck House, Bloomfield Hills, Michigan). Also discussed are the influence of Pointilism, Fauvism, Cubism, and Russian folk art on Malevich's early painting and his role in the development of abstract art.

273. TANAKA, ATSUSHI. "A Study of Tetsugoro Yorozu—The Years 1911-1917." *Bulletin of the National Museum of Modern Art, Tokyo* 1(1987):83-112, 142-3. 20 illus. In Japanese. Summary in English.

Examines the most avant-garde works of the cited period by the painter Tetsugoro Yorozu (1885-1927). Around this time, Yorozu immersed himself in the European Post-Impressionist style and during the next few years he followed trends in Europe—Fauvism, Futurism, abstract art and Cubism—while continually striving for a personal mode of expression. From 1914 Yorozu chose not to work by some newly chosen style, but to look into himself for expression, and his works of this period share abstruseness and tension. Toward the end of this time he became an admirer of traditional Japanese painting, particularly Nan-ga, and this triggered a new direction in his art.

274. TARBELL, ROBERTA K. "Early Paintings by Marguerite Thompson Zorach." *American Art Review* 1:3(Mar.-Apr. 1974):43-57. 155 illus., 8 col.

Examines recently rediscovered Fauvist paintings by Marguerite Thompson Zorach (1887-1968), one of America's most explorative modern painters during the second decade of the 20th century. Executed between 1908 and 1912 in France, Palestine, India, and California's Sierra Mountains, they form the core of an exhibition of her early work held at the National Collection of Fine Arts, the Brooklyn Museum, and Bowdoin College Museum of Art in 1973 and 1974. Because of their high quality, the article singles out the paintings of 1911 and 1912 for a more detailed analysis than was possible in the exhibition catalogue.

275. TERENZIO, STEPHANIE. "Gabriele Münter in 1908." *Bulletin, William Benton Museum of Art, University of Connecticut, Storrs* 1:3(1974):3-17. 5 illus.

The work of Gabriele Münter (1877-19162) is discussed in relation to her painting *Fabrik* of 1908, which marks the transition from an Impressionist style to that of German Expressionism. Münter's relationship with Kandinsky, Alexej Jawlensky, and Marianne Werefkin is analyzed, with reference to their interest in contemporary French Fauvist painting and the style of Pont Aven and "Synthetism." Münter and Kandinsky's travels during the period 1904-08 are outlined, including stays at Sèvres in 1906-07 and at Murnau in 1908. The relationship of motif to style, the interchange of ideas among the group, and the impact on them of the Salon des Indépendents (1907-11) and the Salon d'Automne (1904-06) are discussed.

276. THOMAS, G. "Une recherche permanente" [A Permanent Search]. *Arts* (France) 52(5 Feb. 1982):16. 2 illus.

Argues that Emile Bernard's early work contains in embryo the basic elements used by the Fauvists, the Cubists, and the abstract artists, but that (as with Picasso) what is noticeable about Bernard's work is its diversity. Therefore, if Bernard did not stand up for his position as an innovator it was because he could only be fulfilled through the constant evolution of his own work.

277. TORE, J. A. V. "Galwey (1864-1931)." *Goyá* (Spain) 119(March-April 1974):284-6. In Spanish. 3 illus.

This Catalonian artist came under a variety of influences: that of Vayreda, the Parisian painters of his time, the English landscape school, and his experience in Mallorca with the accompanying release of color in his work. In his final period Galwey returned to classical, dramatic themes, though incorporating some of the lessons learned from the Fauvists. However, his subject matter is predominantly unadorned nature, with the theme of the tree showing exceptional importance. He has passed on these concerns to numerous painters of the new generation.

278. WAGNER, ANNI and GUSTAVE DIEHL. "N. Tarkhoff: die Wiederentdeckung eines grossen Künstlers in unseren Tagen" [N. Tarkhoff: The Rediscovery of a Great Artist]. *Kunst und das Schöne Heim* 95:9(Sept. 1983):609-16, 653-4. 8 illus. Summary in English.

Account of Tarkhoff (1871-1930) and of his special way of painting. His motifs were mothers with their children, street scenes, people at work, still lifes, flowers and animals. He was strongly impressed by Cézanne and the Russian impressionist Konstantin Korovin, and appreciated the Fauvists' demand for rich colors and originality. His own paintings are remarkable for their extreme luminosity, and the warmth and the wide range of colors he applied.

279. WERNER, ALFRED. "Gabriele Münter: Naive Genius." *American Artist* 39:390(Jan. 1975):54-9, 882-3. 9 illus.

Münter is generally considered in terms of her association with Kandinsky, which contributed to her eclipse as a painter since under his influence she worked in a on-figurative style alien to her nature. Later she realized this and destroyed her "Kandinsky style" works. Another major influence on her work was Aleksei Jawlensky, also a self-exiled Russian, whose Fauvist pictures with large areas of luminous color surrounded by simple black lines were emulated by Münter. Münter lived with Kandinsky for a number of years prior to the First World War and acted as secretary to the Blauer Reiter. Following the War and Kandinsky's marriage to another woman, Münter turned to painting in an Expressionist style, and was classified as a "degenerate artist" by the Nazi Régime in 1933. Her pictures are characterized by a balanced calm combined with vivid use of color, very different from the pessimistic works of other Expressionists. She also made use of the Hinterglass technique.

280. WOLF, M. "Herwarth Walden and Der Sturm." *Arts Magazine* 55:9(May 1981):25. 1 illus.

With reference to an exhibition commemorating Herwarth Walden (George Lewin), creator of *Der Sturm*, the German Expressionist art gallery and periodical, held at the Helen Serger La Boetie Gallery, New York (27 Feb.-29 May 1981), Wolf provides an account of the life of this patron of European Expressionism, showing the diversity of his promotional methods and outlining his rebellious expressionist credo. Among the groups he supported and for whom he organized exhibitions were the French Orphists, Belgian Fauvists, Czech Cubists, Dutch and Russian painters, der Blaue Reiter, the Futurists, the French Puteaux Group, and others.

281. ZELLWEGER, HARRY. "Mut als Übermut: der Aufbruch der achtziger Jahre—am Ende?" [Confidence as Overconfidence: The Revolution of the 1908s—Is it Over?]. *Kunstwerk* 41:3(Aug. 1988):5-46. 30 illus., 13 col.

Traces the development of art in the 1908s and its growth in various European, British and American centers. Zellweger emphasizes the importance of an exhibition of contemporary German art held in Basel (March 1982) which he sees as representing an artistic breakthrough and a re-orientation of the international art scene. The intensity and aggression of the new movement is equated with the radical nature of Fauvism, Cubism and Dadaism and other movements dominant at the beginning of the 20th century. Zellweger concludes with a commentary on the disintegration of art in the 1980s and relates this to the *Documenta 8* exhibition in Kassel, Germany (1987) which highlighted the facile desire for innovation that came to dominate the entire movement.

282. ZWEITE, ARMIN. "Jawlensky in München" [Jawlensky in Munich] *Alexej Jawlensky 1864-1941*, edited by A. Zweite (Munich: Prestel, 1983), pp. 47-66. 29 illus.

Argues that Jawlensky's modernity, in contrast to Kandinsky's visionary conceptions of art, is a product not of programmatic experiment or utopian ideals but of his direct experience with form and color and his commitment to the perfection of his technique. Zweite documents Jawlensky's activities in Munich, tracing the process whereby the artist freed himself from the influence of van Gogh and the Fauves and achieved his own style of landscape and portrait painting.

III. Fauve Mentions

Books

283. ALLARD, ROGER. *Baudelaire et 'L'Esprit nouveau'*. Paris, 1918.

284. APOLLINAIRE, GUILLAUME. *Méditations esthétiques: les peintres cubistes*. Edited by Lloyd-Christopher Breunig and J.-Cl. Chevalier. Paris, 1913.

a. Other eds.: Paris: Hermann, 1965. 191 p., pl.; 1980. 237 p., illus.
b. German ed.: *Die Maler des Kubismus: ästhetische Betrachtungen*. Trans. by Oswald von Nostitz and Herbert Molderings. Frankfurt: Luchterhand, 1989. 97 p.

285. APOLLINAIRE, GUILLAUME. *Il y a . . .* Préface de Ramón Gómez de la Serna. Paris: Albert Messein, 1925.

a. Other eds.: 1947, 1949, 1951.
Mentions the Fauve painters in a section entitled "Peintres (1907-1918)." Also includes an essay on Matisse (dated 1907) and another on van Dongen (1918).

286. APOLLINAIRE, GUILLAUME. *Le Flâneur des deux rives*. Paris: Gallimard, Editions de la Sirène, Nouvelle Revue Française, 1928. 107 p.

a. Other eds.: 1949, 1954.

287. APOLLINAIRE, GUILLAUME. *Chroniques d'art (1902-1918)*. Compiled with preface and notes by Lloyd-Christopher Breunig. Paris: Gallimard, 1960. 107 p.

a. Another ed.: 1981. 623 p.
b. U.S. eds.: *Apollinaire on Art: Essays and Reviews, 190-1918*. New York: Viking Press, 1972; New York, London: Da Capa, 1988. 592 p.
c. Italian ed.: *Yonache d'art 1902-1913*. Trans. by Maria Croci Gulí. Palermo: Novecento, 1989. 472 p.

288. ARGAN, GIULIO CARLO. *L'Arte moderna 1770-1970*. Florence: Sansoni, 1970. 774 p., illus., some col.

a. Another ed.: 1980. 523 p., illus., some col.

289. ARP, JEAN and L. H. NEITZEL. *Neue französische Malerei*. Ausgewählt von Hans Arp; eingeleitet von L. H. Neitzel. Leipzig: Verlag der Weissen Bücher, 1913. 8 p., illus., 15 pl.

Discusses the Fauves, in particular Matisse (pl. 3-6), van Dongen (pl. 7-9), and Derain (pl. 10-1).

290. AZCOAGA, ENRIQUE. *El Cubismo*. Barcelona: Ediciones Omega, 1949. 35 p., 54 illus., pl., 3 col. Volume in "Colección Poliedro" series.

Pages 12-3 discuss Fauvism.

291. BAIER, HANS. *Stilkunde* [A Compendium of Styles]. Leipzig: E. A. Seeman, 1976. 343p., 236 illus., some col. Volume in "Taschenbuch der Künste" series.

Introduction to art historical styles, which recognizes the link with art history itself, giving the origins and history, characteristics, key examples and analyzes of the major styles from prehistory to the early 1970s. The second half of the book is concerned with post-1800 styles, linked with the changing fortunes of capitalism and socialism. Includes a chapter on Expressionism and Fauvism.

292. BALDEWICZ, ELIZABETH KAHN. *Les Camoufleurs: The Mobilization of Art and the Artitst in Wartime France, 1914-1918*. Ph.D. diss., University of California, Los Angeles, 1980. 2 vols., 722 p., illus.

During the First World War several hundred painters, decorators and sculptors were enlisted by the military in France to invent and construct a means of hiding men and materials of warfare. Many members of the division of *camoufleurs* made drawings and paintings of the warfront which they sent back to Paris for exhibition. Baldewicz describes how the image of war presented in these private works became a crucial issue in both the Parisian and the warfront press. Despite the key role played by camouflage in the waging of war, modernity in this area was as difficult to get accepted as modernity in the art world—artists who attempted Cubist or

Fauvist styles risked an even more reactionary reading of their work. These traditional attitudes persisted after the end of the war.

293. BARRES, MAURICE. *Œuvres*, vol. 2: *Mes cahiers, 1896-1923.* Textes choisis par Guy Dupré. Préface de Philippe Barrès. Paris: Plon, 1963.

294. BASLER, ADOLPHE and CHARLES KUNSTLER. *La Peinture indépendante en France.* Vol. II: *De Matisse à Segonzac.* Paris: G. Crès, 1929. 2 vols. Volume in "Collection Peintres et sculpteurs" series.

Pages 15-40 discuss the Fauves.
a. U.S. ed.: *Modern French Painting: The Modernists from Matisse to de Segonzac.* New York: Payson, 1931, pp. 9-29.

295. BEACHBOARD, ROBERT. *The Montmartre Colony.* Paris: Collection du Musée du Vieux Montmartre, 1963. 195 p., illus., some col.

296. BELL, CLIVE. *Since Cézanne.* New York: Harcourt, Brace, 1922. 229 p., illus., 8 pl.

Chapter 7: "Matisse and Picasso"; chapter 13: "Marquet"; chapter 16: "Othon Friesz"; chapter 19: "The Authority of M. Derain."
a. Other eds.: 1928, 1969.
b. English eds.: London: Chatto and Windus, 1922; 1923; 1929.

297. BERNIER, GEORGES. *La Revue blanche.* Paris: Hazan Autumn, 1991. 325 p., 410 illus., 110 col.

Founded in 1894 by the Natanson brothers, whose banker father had intended them to take up respectable business careers, *La Revue blanche* had an editorial policy of publishing and promoting the avant-garde in the fields of art, literature, politics, and science. It contributed to the artistic and intellectual ferment of the end of the century, with contributions from: Bonnard, Toulouse-Lautrec, Signac, Vuillard, Valloton, Marcel Proust, Charles Henry, Léon Blum, to name a few. This study traces the history of the *Revue* and is profusely illustrated, most of the illustrations appearing here for the first time.

298. BIEDERMAN, CHARLES JOSEPH. *Art as the Evolution of Visual Knowledge.* Red Wing, MN: Charles Biederman, 1948.

The Fauves are mentioned on pp. 314-6.

299. BILLY, ANDRE. *Max Jacob.* Une étude par André Billy; avec des lettres inédits du poète Guillaume Apollinaire; un choix de poèmes; des inédits; des manuscrits; des portraits; une bibliographie. Paris: P. Seghers, 1947. 211 p., illus. Volume in "Poètes d'aujourd'hui" series.

300. BILLY, ANDRE. *L'Epoque 1900; 1885-1905.* Paris: Tallandier, 1951. 485 p. Volume in "Histoire du la vie littéraire" series.

301. BILLY, ANDRE. *L'Epoque contemporaine, 1905-1930*. Paris: Tallandier, 1956. 365 p. Volume in "Histoire de la vie littéraire" series.

302. BLANCHE, JACQUES-EMILE. *Essais et portraits*. Paris: Porbon-aîné, 1912. 171 p.

303. BLANCHE, JACQUES-EMILE. *Propos de peintre. Deuxième série. Dates*. Paris: Emile-Paul Frères, 1921-28. 3 vols.

304. BLANCHE, JACQUES-EMILE. *Les Arts plastiques: 1870 à nos jours*. Préface de Maurice Denis. Paris: Editions de France, 1931. 529 p. Volume in "La Troisième République, 1870 à nos jours" series.

305. BOWNESS, ALAN. *Modern European Art*. London: Thames and Hudson, 1972. 224 p., 207 illus., some col.

a. U.S. ed.: New York: Harcourt, Brace, Jovanovich, 1972.

306. BRETTELL, RICHARD R. *An Impressionist Legacy: The Collection of Sara Lee Corporation*. Introduction by David Finn. Photography by Geoffrey Clements and David Finn. New York: Abbeville; dist. in the U.K. and Europe by Pandemic, London, 1986. 127 p., 80 col., illus.

Catalogue raisonné of the collection of paintings and sculpture on permanent display at the Chicago headquarters of the Sara Lee Corporation, which were acquired from the personal collection of the company's founder, Nathan Cummings. They are principally French and include works by Matisse, Braque, Dufy, Rouault, and Vlaminck.
a. 2nd ed.: New York: Abbeville Press, 1987. 127 p., col. illus.
b. 3rd ed.: New York: Abbeville Press, 1990. 152 p., col. illus.

307. BRION, MARCEL. *La Peinture moderne de l'impressionnisme à l'art abstrait*. Paris: Gründ, 1957.

308. CALLEN, ANTHEA. *Techniques of the Impressionists*. London: Orbis, 1982. 192 p., illus., some col.

Examines thirty paintings by eighteen artists, 1866-1905, covering French painting from realism to Fauvism and focusing on Impressionism. Reproduces whole compositions, actual size details, and the palette of individual colors used for each painting. Discusses technique and materials (brushes, pigments, supports), and provides information on each artist's background and training.
a. Other eds.: London: New Burlington Books, 1987; London: Tiger Books International, 1988. 192 p., illus., some col.
b. U.S. ed.: Secaucus, New Jersey: Chartwell Books, 1982. 192 p., illus., some col.
c. Italian ed.: *La Tenica degli Impressionisti*. Milan: Rusconi Immagini, 1983. Review: J. Burr, *Apollo* 119:266(April 1984): 305-6.

309. CARCO, FRANCIS, et al. *Les Veillées du 'Lapin Agile'*. Paris: L'Edition Française Illustrée, 1919. 265 p.

310. CARCO, FRANCIS. *Le Nu dans la peinture moderne.* Paris: G. Crès, 1924. 162 p., illus., 33 pl.

Pages 64-76 discuss the Fauves.

311. CARCO, FRANCIS. *De Montmartre au quartier Latin.* Paris: Albin Michel, 1927.

312. CARCO, FRANCIS. *Nostalgie de Paris.* Geneva: Editions du Mileu du Monde, 1941. 246 p.

a. Another ed.: Paris: Gallimard, 1952. 288 p., illus.

313. CARCO, FRANCIS. *L'Ami des peintres. Souvenirs.* Geneva: Editions du Milieu du Monde, 1944.

a. Another ed.: Paris: Gallimard, 1953. 237 p., illus.

314. CARDONNEL, GEORGES LE and CHARLES VELLAY. *La Littérature contemporaine (1905)—opinions des écrivains de ce temps.* Paris: Société du Mercure de France, 1905. 331 p. See also "Enquête," *Gil Blas* (1904).

315. CARRÀ, CARLO. *Pittura metafisca.* Milan: Il Balcone, 1945. 264 p. Volume in "Testi e documenti di arte moderna" series.

Includes Carrà's 1919 essay, "Parere intorno ad Henri Matisse e André Derain," pp. 139-49.

316. CARRIERE, EUGENE. *Ecrits et lettres choisies.* Paris: Mercure de France, 1907. 358 p.

317. CASSOU, JEAN. *Panorama des arts plastiques contemporains.* Paris: Gallimard, 1960. 796 p., illus. Volume in "Le Point du jour" series.

318. CASSOU, JEAN, EMILE LANGUI, and NIKOLAUS PEVSNER. *Les Sources du XX^e siècle: les arts en Europe de 1884 à 1914.* Paris: Editions des Deux Mondes, 1960. 363 p., illus., some col. Volume in "Conseil de l'Europe" series.

a. Another ed.: Paris: Réunion des Musées Natinoaux, 1990. 46 p.
b. English ed.: *The Sources of the XXth Century: The Arts in Europe from 1884 to 1914.* Paris: Musée National d'Art Moderne, 1960, 454 p., illus., 96 pl.

319. CASTELFRANCO, GIORGIO. *La Pittura moderna.* Florence: L. Gonnelli, 1934. 96 p., 58 illus.

Fauvism is discussed on pp. 51-60.

320. CASTLEMAN, RIVA. *Prints of the Twentieth Century; A History.* With illustrations from the collection of the Museum of Modern Arrt. New York:

Museum of Modern Art, dist. by Oxford University Press, 1976. 216 p., illus., some col.

Contends that the present century has seen the print evolve into a new prominence among art media, not only as an expressive medium for artists of widely differing aims but also for the growing numbers of less affluent collectors. The print is set against the historical contexts of the significant movements of the period (Fauvism, Expressionism, Cubism, Surrealism, Abstract Expressionism, and Pop, Op, and Minimal Art) and the most important points in the history of the 20th century printmaking are illuminated. Includes a glossary of printmaking techniques.
a. Another ed.: New York: Thames and Hudson, 1988. 240 p., illus., some col.

321. CHENEY, SHELDON. *The Story of Modern Art*. New York: Viking Press, 1941.

Fauvism is discussed on pp. 347-66
a. Other eds.: 1945, 1947, 1950, 1958, 1969.

322. CHIPP, HERSCHELL BROWNING. *Theories of Modern Art: A Source Book by Artists and Critics*. Contributions by Peter Selz and Joshua C. Taylor. Berkeley and Los Angeles: University of California Press, 1968. 664 p., illus.

323. CLARK, KENNETH. *Landscape into Art*. London: J. Murray, 1952. 147 p., 104 pl.

a. Other eds.: 1956, 1961, 1962, 1976, 1979, 1991.

324. COGNIAT, RAYMOND. *Histoire de la peinture*. Paris: F. Nathan, 1954-55. 2 vols., col. illus.

a. Another ed.: 1964. 2 vols., col. illus.

325. COQUIOT, GEORGES. *Cubistes, futuristes, passéistes; essai sur la jeune peinture*. Paris: Ollendorf, 1914. 277 p., pl.

Essays on Derain, Friesz, Matisse, Manguin, Puy, van Dongen, and Vlaminck.
a. 2nd ed.: 1923.

326. COQUIOT, GUSTAVE. *Les Indépendants, 1884-1920*. Paris: Ollendorf, 1920. 239 p., pl.

Includes sections on Braque, Dufy, Friesz, Manguin, Marquet, Matisse, Puy, van Dongen, Vlaminck, and others. "Appendice: Nomenclature des exposants cités et des Salons auxquels ils prirent part" (pp. 193-211); "Emplacements des expositions successives de la Société des artistes indépendants" (pp. 213-20).

327. COURTHION, PIERRE. *Panorama de la peinture française contemporaine*. Paris: Simon Kra, 1927. 191 p., 2 pl. Volume in "Les Documentaires" series.

Includes essays on Matisse, Dufy, Vlaminck, Derain, and Braque (pp. 18-9, 50-67, 78-92, 106-16).

328. COURTHION, PIERRE. *Montmartre.* Geneva: Skira, 1956.

a. English ed.: Trans. by Stuart Gilbert. Lausanne: Skira, 1956. 142 p., illus., col. pl.

329. COURTHION, PIERRE. *Paris des temps nouveaux.* Geneva: Skira, 1957.

330. CRAVEN, THOMAS. *Modern Arts: The Men, the Movements, the Meaning.* New York: Simon and Schuster, 1934. 378 p., pl.

Chapter 6: "Wild Animals"; chapter 7: "Matisse" (pp. 141-76).
a. Other eds.: 1935, 1940, 1943, 1950, 1976.

331. CRESPELLE, JEAN-PAUL. *Montmartre vivant.* Paris: Hachette, 1964. 286 p., illus.

332. CRESPELLE, JEAN-PAUL. *Les Maîtres de la belle époque.* Paris: Hachette, 1966. 221 p., illus.

333. DAUZAT, ALBERT. *Le Sentiment de la nature et son expression artistique.* Paris, 1914.

334. DELEVOY, ROBERT L. *Dimensions du XXe siècle, 1900-1945.* Geneva: Skira, 1965. 227 p., col. illus. Volume in "Art, idées, histoire" series.

a. English ed.: *Dimensions of the 20th Century: 1900-1945.* Trans. by Gilbert Stuart. Geneva: Skira, 1966. 223 p., illus., pl., some col.

335. DENIS, MAURICE. *Henri-Edmond Cross.* Paris, 1907.

336. DENIS, MAURICE. *Théories, 1890-1910 du symbolisme et de Gauguin vers un nouvel ordre classique.* Paris: Bibliothèque de l'Occident, 1912. 270 p.

a. Other eds.: 1913; Paris: L. Rouart et J. Watelin, 1920. 278 p.

337. DENIS, MAURICE. *Journal.* Paris: La Colombe, Editions du Vieux Colombier, 1957-59. 3 vols, illus.

Volume I, 1884-1904; volume II, 1905-1920.

338. DERAIN, ANDRE. *Lettres à Vlaminck.* Paris: Flammarion, 1955. 233 p.

339. DIEHL, GASTON. *La Peinture moderne dans le monde.* Paris: Flammarion, 1961. 218 p., illus., col. pl.

a. U.S. ed.: *The Moderns: A Treasury of Painting Throughout the World.* Trans. by Edward Lucie-Smith. New York: Crown, 1978. 218 p., col. illus.

340. DORGELES, ROLAND. *Au beau temps de la Butte.* Paris: A. Michel, 1949. 320 p.

341. DORIVAL, BERNARD. *La Peinture française.* Paris: Larousse, 1942. 2 vols., pl. Volumes in "Arts, styles et techniques" series.

Fauvism is discussed on pp. 120-1.
a. Another ed.: 1946. 259 p., pl.

342. DORIVAL, BERNARD. *Contemporary French Painting.* Edinburgh: R. Grant & Son Ltd. for the Society of Scottish Artists, 1946. 24 p., 10 pl.

Pages 10-3, 22 discuss Fauvism.

343. DORIVAL, BERNARD. *Les Peintres du vingtième siècle: Nabis, Fauves, Cubistes.* Paris: Tisné, 1957.

344. D'UCKERMANN, PIERRE. *L'Art dans la vie moderne.* Paris: Flammarion, 1937.

345. EINSTEIN, CARL. *Die Kunst des 20. Jahrhunderts.* Berlin: Propyläen-Verlag, 1926. 655 p., 40 pl., some col.

Covers Matisse (pp. 24-34, 191-206, 557), Derain (pp. 33-46, 207-26, 557-8), and Vlaminck (pp. 227-30, 558).
a. Other eds.: 1928, 1931, 1988.

346. ESCHOLIER, RAYMOND. *La Peinture française, XXᵉ siècle.* Paris: Floury, 1937.

Includes Escholier's essay, "Les Fauves".

347. FEGDAL, CHARLES. *Ateliers d'artistes.* Paris: Dclamain, Boutelleau, Stock, 1925. Illus.

Chapter 3 (pp. 29-38) concerns Marquet; chapter 4 (pp. 39-45) van Dongen.

348. FELS, FLORENT. *Propos d'artitstes.* Paris: La Renaissance du Livre, 1925. 215 p., illus., 32 pl.

Notably on Derain, Friesz, Matisse, Vlaminck, and others.

349. FELS, FLORENT. *L'Art vivant de 1900 a nos jours.* Geneva: Cailler, 1950. 2 vols.

350. FELS, FLORENT. *Le Roman de l'art vivant de Claude Monet à Bernard Buffet.* Paris: Fayard, 1959.

351. FLORIA, GUILLERMO B., C. MALASPINA and R. MESALLES. *Historia de la pintura* [History of Painting]. Barcelona: Plaza & Janès, 1975. 2 vols., 435 p., 220 p., 582 illus., some col.

Comprehensive history of painting starting with the earliest known paintings among early civilizations and culminating in the 20th century. The information is presented

chronologically, with emphasis on Western art. The second volume documents more recent artists and art movements, providing illustrations of representative works and descriptive definitions which cover Impressionism, Post-Impressionism, Realism, Expressionism, Fauvism, Cubism, Naïve painting, Metaphysical painting, and new directions in modern art.
a. Another ed.: 1978.

352. FOCILLON, HENRI. *La Peinture aux XIX^e et XX^e siècles; du réalisme à nos jours*. Paris: H. Laurens, 1928. 524 p., illus. Volume in "Manuels d'histoire de l'art" series.

Chapter 3, "Les Contemporains," mentions the Fauves (pp. 248-321).

353. FONTAINAS, ANDRE and LOUIS VAUXCELLES. *Histoire générale de l'art français de la Révolution à nos jours*. Paris: Librairie de France, 1922.

Pages 264-7 discuss the Fauves.

354. FONTBONA, FRANCESC. *El Paisatgisme a Catalunya* [Landscape in Catalonia]. Fotografies de Ramon Manent. Barcelona: Edicions Destino, 1979. 369p. illus., 280 col. In Catalan.

Survey of 19th and 20th century landscape painting that considers Romanticism, Impressionism, modernism, rural examples, work done by the Colla del Safrà group at Mallorca, Fauvism, Cubism, and Surrealism.

355. FORNERIS, JEAN. *Musée des Beaux-Arts Jules Chéret: catalogue promenade*. Nice: A. C. M. E., 1986. 183 p., 124 illus., 89 col.

Catalogue of the permanent collection of the Musée des Beaux-Arts Jules Chéret, Nice. The collection's earliest donations were works by the early Italian and Flemish schools. In 1903 the Museum was enriched by the important collection of Hercule Trachel and in 1912 by a series of paintings given by Madame Félix Ziem. In 1925 the City of Nice acquired the palace built for Elisabeth Vassilievna Kotschoubey in the years 1878-83 and this became the Palais des Arts Jules Chéret. The collection, which continues to be enriched and modernized, ranges from 15th century paintings to works by the Nabis, the Fauves, and the Cubists.

356. FRANCASTEL, GALIENNE and PIERRE FRANCASTEL. *Le Portrait, cinquante siècles d'humanisme en peinture*. Paris: Hachette, 1969. 207 p., pl. Volume in "Art et pensées" series.

357. FRANCASTEL, PIERRE. *Histoire de la peinture française; du classicisme au cubisme*. Paris: Gonthier-Médiatioins, 1955.

358. FRANCASTEL, PIERRE. *Peinture et société, naissance et destruction d'un espace plastique. De la Renaissance au cubisme*. Lyon: Audin, 1951. 298 p., illus., 48 pl.

a. Other eds.: 1965; 1977, 362., illus.
b. Spanish ed.: *Pintura y Sociedad.* Madrid: Cátedra, 1984. 280 p., illus., 108 pl.

359. GARCÍA MARTÍNEZ, JOSÉ A. *Movimentos artísticos del siglo XX.* Bueños Aires: Centro Editor de América Latina, 1976.

360. GAUSS, CHARLES EDWARD. *The Aesthetic Theories of French Artists from Realism to Surrealism.* Baltimore and London: The Johns Hopkins University Press, 1966. 111 p.

Presents the aesthetic theories of French artists, 1855 to the present. A section entitled "Symbolism and Fauvism: Gauguin, Denis, Matisse" (pp. 53-68) discusses Fauvism.

361. GEE, MALCOLM. *Dealers, Critics and Collectors of Modern Painting, 1910-1930: Aspects of the Parisian Art Market Between 1910 and 1930.* New York: Garland Publishing, 1981. 300 p., 266 p.

362. GENAILLE, ROBERT. *La Peinture contemporaine.* Paris: F. Nathan, 1955. 355 p., illus. Volume in "L'Activité contemporaine" series.

363. GEORGES-MICHEL, MICHEL. *Peintres et sculpteurs que j'ai connus, 1900-1942.* New York: Brentano's, 1942. 286 p.

364. GIDE, ANDRE. *Charles-Louis Philippe; conférence prononcée au Salon d'Automne, le 5 nov. 1910.* Paris: E. Figuière, 1911.

365. GIDE, ANDRE. *Journal 1889-1939.* Paris: La Nouvelle Revue Française, 1939. 1,356 p.

a. Other eds.: Paris: Gallimard, Bibliothèque de la Pléiade, 1940; 1948; 1951. 1,378 p.

366. GIRY, MARCEL. *La Peinture à Paris en 1905.* Ph.D. thesis, Université de Strasbourg, 1967.

367. GLEIZES, ALBERT. *Souvenirs—le cubisme, 1908-1914.* Lyon: Association des amis d'Albert Gleizes, 1957. 36 p., illus.

368. GLEIZES, ALBERT. *Art et religion, art et science, art et production.* Chambéry: Editions Présence, 1970.

369. GOLBERG, MECISLAS. *La Morale des lignes.* Paris: L. Vanier, 1908. 196 p., illus.

370. GOLDING, JOHN. *Le Cubisme.* Paris: Juillard, 1963.

371. GOLDWATER, ROBERT JOHN. *Primitivism in Modern Painting.* New York & London: Harper & Brothers 1938. 210 p., pl.

Includes Goldwater's "The Primitivism of the Fauves" essay on pp. 74-86 and other Fauve mentions.
a. Another ed.: New York: Vintage Books, 1967. 289 p., illus.

372. GORDON, DONALD E. *Modern Art Exhibitions 1900-1916. Selected Catalogue Documentation.* Munich: Prestel-Verlag, 1974. 2 vols.

373. GORDON, JAN. *Modern French Painters.* With Forty Illustrations. New York: Dodd, Mead, 1923. 188 p., illus., 39 pl., 18 col.

Chapter 8 (pp. 74-90) "The Designing Instinct" concerns Matisse and the Fauves; chapter 13 (pp. 121-31) concerns Derain and Vlaminck.
a. Other eds.: 1926, 1929, 1936, 1970.

374. GRAUTOFF, OTTO. *Die Französische Malerei seit 1914.* Berlin: Mauritius-Verlag, 1921. 91 p., pl.

Pages 10-42 cover the Fauves.

375. GUENNE, JACQUES. *Portraits d'artistes: Bosshard, Favory, Gromaire, Guérin, Kisling, Lhote, Matisse, Simon-Lévy, Vlaminck.* Paris: Marcel Seheur, 1927. Volume in "L'Art et la vie" series.

See pages 29-30, 37, 52, 205-19, 265-90 for information on Matisse, Vlaminck, and other Fauves.

376. HAFTMANN, WERNER. *Malerei im 20. Jahrhundert.* Munich: Prestel, 1954-55. 2 vols., illus.

a. Another ed.: 1976
b. U.S. ed.: *Painting in the 20th Century.* New York: Praeger, 1960, 1965.

377. HAMILTON, GEORGE HEARD. *Painting and Sculpture in Europe, 1880 to 1940.* Baltimore: Penguin, 1967.

a. Other eds.: 1972, 1981, 1983, 1990.

378. HERBERT, EUGENIA W. *The Artist and Social Reform: France and Belgium 1885-1898.* New Haven, CT: Yale University Press, 1961. 236 p., illus., 5 pl.

a. Other eds.: New York: Books for Libraries Press, 1971; 1980.

379. HOOG, MICHEL. *Peinture moderne.* Paris: Ed. des Deux Coqs d'Or; Verona: Mondadori-Ogame, 1969.

Fauvism is discussed on pp. 88-9.

380. HOPPE, RAGNAR. *Städer och Konstnärer; Resebrev och Essäer om Kunst.* Stockholm: Albert Bonnier, 1931. 225 p., illus.

Includes the essays "På visit hos Matisse (1920)," pp. 193-99 and "Fran Matisse till Segonzac (1930)," pp. 200-25.

381. HUYGHE, RENE. *Histoire de l'art contemporain: la peinture.* Avec le concours de Germain Bazin et la collaboration de Germain Bazin, Jacques-Emile Blanche, Roger Brielle, Jean Cassou. Préface de Jean Mistler. Introduction par Henri Focillon. Paris: Alcan, 1935. 536 p., illus.

Includes "Le Fauvisme. Les Coloristes" (ch. 4); "Le Fauvisme. Les Peintures pathétiques" (ch. 5); "Le Fauvisme. Le Réveil des traditions" (ch. 6). Reprints André Salmon's "Naissance du Fauvisme" (pp. 103-5) and Germain Bazin's "Histoire du Fauvisme" (pp. 105-6).
a. Reprint: New York: Arno Press, 1968. 536 p., illus.

382. HUYGHE, RENE. *La Peinture française: les contemporains.* Paris: Tisné, Bibliothèque Française des Arts, 1939.

Includes "Le Fauvisme" (pp. 21-30) and "Le Fauvisme, evolution et réaction," (pp. 21-66). Notices on Braque, Derain, Dufy, Friesz, Matisse, Marquet, van Dongen, and Vlaminck.
a. Another ed.: 1949. 160 p., 164 pl., some col.
b. U.S. ed.: *French Painting: The Contemporaries.* New York: French and European Publications, 1939.

383. HUYGHE, RENE and JEAN RUDEL. *L'Art et le monde moderne.* Avec la collaboration de Thérèse Burollet. Paris: Larousse, 1970. 2 vols., illus., some col.

384. HYSLOP, FRANÇOIS E., ed. *Henri Evenepoel à Paris. Lettres choisies 1892-1899.* Avec une introduction et notes. Brussels: La Renaissance du Livre, 1976. 221 p., illus.

385. JACOB, MAX. *Correspondance.* Edited by François Garnier. Paris: Editions de Paris, 1953. Illus.

386. JACOB, MAX. *Chroniques des temps héroiques.* Paris, 1956.

387. JALARD, MICHEL-CLAUDE. *Le Post-impressionnisme.* Lausanne: Editions Recontre, 1966. 207 p., illus., some col. Volume in "Histoire intégrale de l'art" series.

388. JEDLICKA, GOTTHARD. *Begegnungen: Künstlernovellen.* Basel: B. Schwabe, 1933. 249 p., pl.

389. JOURDAIN, FRANCIS. *Né en 1876, souvenirs.* Paris: Editions du Pavillon, 1951.

390. JOURDAIN, FRANCIS. *Sans remords ni rancune; souvenirs épars d'un viel homme 'ne' en 76.* Paris: Corréa, 1953. 313 p., illus. Volume in "Le Chemin de la vie" series.

391. JOURDAIN, FRANTZ and ROBERT REY. *Le Salon d'Automne*. Avec la collaboration de Robert Rey. Paris: Les Arts et le Livre, 1926. 93 p., pl. Volume in "L'Art et la vie" series.

392. JOURDAIN, FRANTZ. *L'Atelier Chantorel, mœurs d'artistes*. Avant-propos de J.-H. Rosny. Paris: Charpentier et Fasquelle, 1893. 339 p.

393. KAHNWEILER, DANIEL-HENRY. *Juan Gris: sa vie, son œuvre, ses écrits*. Paris: Gallimard, 1946.

Pages 138-43 discuss Fauvism.

394. KAHNWEILER, DANIEL-HENRY. *Mes galeries et mes peintures: entretiens avec Francis Crémieux*. Préface d'André Fermigier. Paris: Gallimard, 1961. 223 p.

a. Another ed.: 1982. 217 p.
b. English ed.: *My Galleries and Painters*. Trans. by Helen Weaver, with an introduction by John Russell. London: Thames and Hudson, 1971. 160 p., illus.
c. U.S. ed.: New York: Viking Press, 1971. 160 p., illus.

395. KAHNWEILER, DANIEL-HENRY. *Confessions esthétiques*. Paris: Gallimard, 1963. 244 p. Volume in "Les Essais" series.

396. KELDER, DIANE. *The Great Book of Post-Impressionism*. New York: Abbeville, 1986. 383 p., 413 illus., 236 col.

This study of Post-Impressionism begins with a consideration of how the Impressionists such as Monet, Renoir, Cézanne, and Degas coped with the changing times and their own success, and how an American school of Impressionism developed. In a subsequent chapter Kelder discusses Fauvism, with particular reference to Matisse, Derain, Dufy, and Vlaminck.

397. KLINGSOR, TRISTAN L. *La Peinture*. Paris: Rieder, 1921. Volume in "L'Art français depuis vingt ans" series.

Fauve painters discussed in a section entitled "Indépendants, fauves, et cubistes" (pp. 71-98).
a. Another ed.: 1928.

398. LA HIRE, JEAN DE. *Le Montmartre de nos vingt ans*. Préface de Francis Carco. Paris: Tallandier, 1933. 190 p.

399. LAPAUZE, HENRY. *Le Palais des Beaux-arts de la Ville de Paris (Petit Palais)*. Paris: Lucien Laveur, 1910. 246 illus.

400. LEINZ, GOTTLIEB. *Die Malerei des 20. Jahrhunderts* [20th Century Painting]. Freiburg; Basle; Vienna: Herder, 1988. 380 p., 362 illus., 361 col.

Working on the principle of "comparative seeing," Leinz guides the reader through the artists, groups, and movements of the 20th century in chronological sequence,

from Gauguin, Rousseau, van Gogh, Cézanne, Ensor and Munch through the Fauves, Expressionism, Cubism, Dadaism, and Surrealism to Pop art, Beuys, and the "Neue Wilden." The principles, developments, and trends behind the changing face are set out in detail.

401. LEMAITRE, GEORGES. *From Cubism to Surrealism in French Literature.* London: Oxford University Press, 1941. 247 p., pl.

Fauvism is mentioned on pp. 67-9.
a. Other eds.: Cambridge, MA: Harvard University Press, 1947. 256 p., pl; New York: Russell & Russell, 1967. 247 p., illus.

402. LEROY, ALFRED. *Histoire de la peinture française.* Paris: Albin Michel, 1934-37. 4 vols., illus.

Volume 4, pages 299-307 concern Fauvism.

403. LEVY, PIERRE GEORGES. *Des artistes et un collectionneur.* Paris: Flammarion, 1976. 381 p.

Reprints Michel Hoog's 1972 essay, "Fauves," pp. 294-305, among other mentions.

404. LEYMARIE, JEAN and MICHELE RICHET. *Legs Marguerite Savary au Musée National d'Art moderne.* Paris: Editions des Musées Nationaux, 1970.

405. LHOTE, ANDRE. *De la palette à l'écritoire.* Paris: Editions Corréa, 1946. 436 p., illus.

406. LHOTE, ANDRE. *Traité du paysage.* Paris: Librairie Floury, 1939. 195 p., illus., some col. Volume in "Ecrits d'artistes" series.

a. Other eds.: 1946, 1948.

407. LHOTE, ANDRE. *Traité de la figure.* Paris: Librairie Floury, 1950. 255 p., illus., pl., 8 col. volume in "Ecrits d'artistes" series.

408. LOOSJES-TERPSTRA, ALEIDA. BETSY. *Moderne Kunst in Nederland: 1900-1914.* Utrecht: Haentjens Dekka & Gumbert, 1959-.

409. MAC ORLAN, PIERRE. *Rue Saint-Vincent: images italiennes et françaises* Paris: Editions du Capitole, 1928. 266 p., illus., 7 pl.

410. MAITRON, JEAN. *Le Mouvement anarchiste en France.* Paris: F. Maspero, 1975. 2 vols. Volume in "Bibliothèque socialiste" series.

411. MALPEL, CHARLES. *Notes sur l'art d'aujourd'hui et peut-être de demain.* Avec une préface de Louis Lacroix. Paris: Editions Bernard Grasset; Toulouse: Privat, 1910. 2 vols., illus.

412. MAUCLAIR, CAMILLE. *Trois crises de l'art actuel.* Paris: Fasquelle, 1906.

413. MAUCLAIR, CAMILLE. *L'Art indépendant français sous la Troisième République*. Paris: La Renaissance du Livre, 1919. 170 p.

414. MAUCLAIR, CAMILLE. *Les Etats de la peinture française de 1850 à 1920.* Paris: Payot, 1921. 159 p.

415. MAUCLAIR, CAMILLE. *Le Théâtre, le cirque, le music-hall et les peintres du XVI^e siècle à nos jours.* Paris: E. Flammarion, 1926. 138 p., illus., pl.

416. MAYBON, DANIEL and GERALD SCHURR. *Carnet des arts.* Paris: Editions des Intérêts Privés, 1970.

417. MEYERSON, IGNACE, ed. *Problèmes de la couleur.* Paris: S. E. V. P. E. N., 1957. 372 p., col. pl.

Report and discussions of the Centre de Recherches de psychologie comparative held in Paris on 18, 19, and 20 May 1954, collected by Ignace Meyerson. Bibliothèque Générale de l'Ecole pratique des hautes etudes, Paris.

418. MICHEL, EMILE. *Les Maîtres du paysage.* Paris: Hachette, 1906. 544 p., illus., pl.

419. MOHOLY-NAGY, LASZLO. *Vision in Motion.* Chicago: Paul Theobald, 1947. 371 p., illus.

Fauvism discussion begins on page 141.
a. Other eds.: 1956, 1965.

420. MOULIN, RAYMONDE. *Le Marché de la peinture en France.* Paris: Editions de Minuit, 1967. 616., illus. Volume in "Le Sens commun" series.

a. Another ed.: 1989. 613 p., illus.
b. U.S. ed.: *The French Art Market.* Trans. by Arthur Goldhammer. New Brunswick, NJ: Rutgers University Press, 1987. 227 p.

421. MULLER, JOSEPH-EMILE. *La Peinture moderne de Manet à Mondrian.* Paris: Hazan, 1960.

a. U.S. eds.: *Modern Painting from Manet to Mondrian.* New York: Castle Books, 1960. 159 p., illus., some col.; New York: Tudor, 1966. 191 p., illus.

422. MULLER, JOSEPH-EMILE. *L'Art moderne.* Paris: Hachette; Librarie Générale Française, 1963.

423. MULLER, JOSEPH-EMILE and FRANK ELGAR. *Un siècle de peinture moderne.* Paris: F. Hazan, 1966. 192 p., illus., some col.

Revised and enlarged edition of *La Peinture moderne de Manet à Mondrian* (Paris, 1960). Includes a section on Fauvism by Muller.
a. English eds.: *A Century of Modern Painting.* London: Thames and Hudson, 1972. 192 p., 192 illus., some col.; Trans. by Jane Brenton. London: Eyre

Methuen, 1980. 239 p., illus., some col.; 2nd revised ed.: Joseph-Emile Muller
and Ramon Tio Bellido. London: Eyre Methuen, 1985. 239 p., illus.
b. U.S. eds.: *A Century of Modern Painting.* New York: Tudor Publishing Co.,
1972. 192 p., illus., some col.; New York: Universe Books, 1985. 239 p., illus.,
some col.; 1986.

424. MULLER, JOSEPH-EMILE. *L'Art au XX^e siècle.* Paris: Larousse, 1967.
383 p., illus. Volume in "Le Livre de poche" series.

425. MYERS, BERNARD SAMUEL. *Modern Art in the Making.* New York;
Toronto; London: McGraw-Hill; Whittlesey House, 1950. 457 p., illus., 5 pl.,
some col.

Chapter 17: "Toward the Abstract: Matisse and the Fauves" (pp. 272-94).
a. 2nd ed.: New York: McGraw-Hill, 1959. 486 p., illus., 5 col. pl.

426. NOCHLIN, LINDA. *Impressionism and Post-Impressionism, 1874-1904.
Sources and Documents.* Englewood Cliffs, NJ: Prentice-Hall, 1966. 222 p., 1
illus. Volume in "Sources and Documents in the History of Art" series.

427. OLIVIER, FERNANDE. *Picasso et ses amis.* Préface de Paul Léautaud.
Paris: Stock, 1933. 231 p., illus., 10 pl.

a. Another ed.: 1954.

428. OZENFANT, AMEDEE. *Mémoires 1886-1962.* Préface de Katia Granoff,
introduction par Raymond Cogniat. Paris: Seghers, 1968. 621 p., illus.

429. PACH, WALTER. *The Masters of Modern Art.* New York: Viking Press,
1924. 118 p., illus., 36 pl.

Pages 59-68 concern the Fauves.
a. Other eds.: 1929, 1972.

430. PAULHAN, FREDERIC. *L'Esthétique du paysage.* Paris: F. Alcan, 1931.
248 p., pl.

431. PICHON, YANN LE. *Les Peintres du bonheur.* Préface de Maurice Rheims.
Paris: Editions Robert Laffont, 1983. 285 p., illus. Volume in "Aux Sources de
l'art" series.

Counters the popular idea of the late 19th century French artist as a melancholic,
isolated figure. Pichon concentrates instead on works depicting the "good life,"
seen against backgrounds indissolubly linked with the artists discussed: Barbizon,
Chailly, Honfleur, Montmartre, Pont-Aven, and the Seine around Paris. Chapters
are divided according to these geographical areas. In detailing the friendships
between the painters and the social climates in which they worked, he attempts to
recreate their world. The Fauves are discussed, among other artistic groups.
a. Dutch ed.: *De schilders van het geluk.* Amsterdam; Brussels: Elsevier, 1984.
284 p., illus.

b. U.S. ed.: *The Real World of the Impressionists: Paintings and Photographs 1848-1918*. Trans. by Dianne Cullinane. New York: C.N. Potter; dist. by Crown Publishers, 1984. 284 p., illus., some col.

432. POIRET, PAUL. *En habillant l'époque*. Paris: B. Grasset, 1930. 312 p., pl.

a. Another ed.: 1986. 244 p., illus., 8 pl.

433. POLASEK, JAN. *Drawings: Toulouse-Lautrec*. Introduction by Susan M. Brown. New York: St. Martin's Press, 1975. 112 p., illus., 62 pl., some col.

a. Another ed.: St. Paul: 3M Books, 1985.

Account of the life and career of Toulouse-Lautrec, focusing on the artist's drawings. He enjoyed Parisian nightlife and frequently spent his evenings sketching the scenes and making studies for larger paintings. His drawings were published in *Courrier Français*, *Paris illustré* and *La Plume* and he came to be regarded as one of the major figures of the Belle Epoque. Polasek notes that although influences on Lautrec's work can be traced back to the Impressionists, he laid the foundations of modern poster art and was considered to be influential by the Nabis, the German Expressionists, the French Fauves, Picasso, and Edvard Munch, among others.

434. PUY, MICHEL. *Le Sentiment de la nature*. Paris: Rudeval, 1907. 229 p.

435. PUY, MICHEL. *Le Dernier état de la peinture; les successeurs des Impressionnistes*. Paris: Le Feu, Union Française d'Edition, 1910. 69 p.

Fauves are discussed in Chapter 5, pp. 33-46: "Matisse, Marquet, Puy, Manguin, Derain, de Vlaminck, Friesz, Girieud, van Dongen, Braque, Metzinger, Verhoeven, Mainssieux, Marie Laurencin."

436. PUY, MICHEL. *L'Effort des peintres modernes*. Paris: Albert Messein, 1933.

Reprints Puy's "Les Fauves" essay (pp. 61-78), first written for *La Phalange* (15 Nov. 1907).

437. RAYNAL, MAURICE. *Anthologie de la peinture en France de 1906 à nos jours*. Paris: Editions Montaigne, 1927. 319 p., illus.

"Le Fauvism," pp. 11-12, includes sections on Braque, van Dongen, Derain, Dufy, Friesz, and Vlaminck.
a. U.S. ed.: *Modern French Painters*. Trans. by Ralph Roeder. New York: Brentano's, 1928. 275 p., illus. See pp. 3-4 for Fauve introduction.

438. RAYNAL, MAURICE, HERBERT READ and JEAN LEYMARIE. *Histoire de la peinture moderne. De Baudelaire à Bonnard. Naissance d'une vision nouvelle*. Geneva: Skira, 1949-51. 3 vols., illus., col. pl. Volume in "Peinture, couleur, histoire" series.

Volume 2 includes information on Matisse, Marquet, Vlaminck, Derain, Dufy, Friesz, Braque, Rouault, and Fauvism.
a. English ed.: *History of Modern Painting*. Trans. by Stuart Gilbert (vols. 1-2) and Douglas Cooper (vol. 3). Geneva: A. Skira, 1949-50.

439. RAYNAL, MAURICE. *Peintures du XX^e siècle*. Geneva: Albert Skira, 1947. 38 p., illus., 53 pl. Volume in "Les Trésors de la peinture française" series.

Fauvism is discussed on pp. 14-9.

440. RAYNAL, MAURICE, JACQUES LASSAIGNE, and WERNER SCHMALENBACH. *Peinture moderne*. Geneva: Skira, 1966.

441. READ, HERBERT EDWARD. *A Concise History of Modern Painting*. London: Thames and Hudson, 1959. 378 p., illus.

a. Other eds.: 1968, 1974, 1975, 1985.

442. REAU, LOUIS. *Histoire universelle des arts*, vol. 3: *La Renaissance, l'art moderne*. Paris: Armand Colin, 1936.

Pages 400-2 (vol. 3) include a section on Fauvism.

443. REAU, LOUIS. *Un siècle d'aquarelle de Géricault à nos jours*. Paris: Galerie Charpentier, Editions "Tel," 1942. 124 p., illus., pl., some col.

"Le Fauvisme et le Cubisme," pp. 73-82.

444. REDON, ARÏ and ROSELINE BACOU, eds. *Lettres de Gauguin, Gide, Huysmans, Jammes, Mallarmé, Verhaeren à Odilon Redon*. Introduction par Arï Redon, textes et notes de Roseline Bacou. Paris: José Corti, 1960.

445. REDON, ODILON. *Lettres d'Odilon Redon 1878-1916*. Préface de Marius-Ary Leblond. Paris, Brussels: Van Oest & Cie., 1923. 142 p.

a. Another ed.: Paris: José Corti, 1960. 314 p., 12 pl.

446. REDON, ODILON. *A soi-même, journal (1867-1915)*. *Notes sur la vie, l'art et les artistes*. Introduction de Jacques Morland. Paris: H. Fleury, 1922. 178 p.

a. Another ed.: Paris: José Corti, 1961. 188 p.
b. German ed.: *Odilon Redon Selbstgespräch*. Trans. by Marianne Türoff. Munich: Rogner & Bernhard, 1971. 239 p., illus.

447. REIDEMEISTER, LEOPOLD. *Auf den Spuren der Maler der Ile de France: Topographische Beiträge zu Geschichte der Französischen Landschaftsmalerei von Corot bis zu den Fauves*. Hrsg. in Zusammenarbeit mit den Staatlichen Museen der Stiftung Preussischer Kulturbesitz. Berlin: Propyläen Verlag, 1963. 190 p., illus.

448. REWALD, JOHN. *Studies in Post-Impressionism.* Edited by Irene Gordon and Francis Weitzenhofer. London: Thames & Hudson; New York: H. N. Abrams, 1986. 295 p., 75 illus., 8 col.

Includes the following: a book-length study of the roles of Théo van Gogh and Adolphe Goupil in promoting Impressionist and Post-Impressionist artists; two studies on Degas's sculpture; an essay on Seurat's working method; a study on Gauguin's relationships with the dealer Ambroise Vollard and the critic André Fontainas; a study on Redon; a study on van Gogh's posthumous fate; and an essay with chronology on the Fauve movement.

Review: E. Thaw, *New Republic* 194:26(30 June 1986):40-1.

449. RICHARD, LIONEL. *D'une apocalypse à l'autre: sur l'Allemagne et ses productions intellectuelles de Guillaume II aux années vingt.* Paris: Union Général d'Editions, 1976. 446 p., illus.

Discusses Expressionism and Fauvism.

450. RICHARDSON, EDGAR PRESTON. *The Way of Western Art, 1776-1914.* Cambridge, MA: Harvard University Press, 1939. 204 p., illus.

Pages 172-8 discuss Fauvism.

451. RICHTER, HORST. *Geschichte der Malerei im 20. Jahrhundert: Stile und Künstler* [History of Art in the 20th Century: Styles and Artists]. Cologne: DuMont Schauberg, 1974. 243 p., 123 illus.

Despite the subtitle, the emphasis of this text is on "isms" rather than individuals and "reference to artists and works is restricted to that which is necessary for the characterization of the styles." There are short considerations of Fauvism, Cubism and Futurism, but the bulk of the book is concerned with the inter-War years and particularly with the various subdivisions of Expressionism and Realism, although other styles are briefly considered.
a. Other eds.: 1979. 248 p.; 1981. 291 p.

452. ROEDER, GEORGE H., JR. *Forum of Uncertainty: Confrontations with Modern Painting in 20th Century American Thought.* Ann Arbor, Michigan: UMI Research Press; dist. in the U. K. by Bowker, 1980. 299 p. Volume in "Studies in American History and Culture" series.

Analysis of responses to the challenge of modern art by a wide spectrum of American society, including artists, critics, intellectuals, politicians, journalists and business people. Types of painting covered in this survey include Post-Impressionism, Fauvism, Cubism, German Expressionism, Dadaism, Constructivism, Surrealism, Abstract Expressionism, Pop Art, and Minimal Art.

453. ROUAULT, GEORGES. *Souvenirs intimes.* Orné de six lithographies. Préface d'André Saurès. Paris: Galerie des Peintres Graveurs E. Frapier, 1927. 98 p., illus.

454. ROUVEYRE, ANDRE. *Souvenirs de mon commerce: Gourmont, Apollinaire, Moréas, Soury.* Avec douze bois originaux de l'auteur. Paris: G. Crès, 1921. 255 p., illus.

455. RUBIN, WILLIAM S., ed. *'Primitivism' in 20th Century Art: Affinity of the Tribal and the Modern.* New York: Museum of Modern Art, 1984. 2 vols.

a. Another ed.: 1988.
b. German ed.: *Primitivismus in der Kunst des zwanzigsten Jahrhunderts.* Munich: Prestel, 1984. 742 p., illus.
c. Italian ed.: *Primitivismo nell'arte dell XX secolo: affinità fra il tribale e il moderno.* Milan: A. Mondardori, 1985. 702 p., illus.
d. French eds.: *Le Primitivisme dans l'art du 20ᵉ siècle: les artistes modernes devant l'art tribal.* Paris: Flammarion, 1987. 703 p., illus.; 1991.

456. RUDEL, JEAN. *Beaux-arts encyclopédie.* Paris: L. Amiel, 1974.

General survey of the history and development of art that opens with an introductory essay in which the educational and social importance of art is emphasized and the informative aim of the survey is outlined. Articulated within a chronologically and geographically divided format, the survey ranges from pre-historic times through major European movements and styles up to contemporary art. Contemporary art forms the largest section and contains chapters devoted to Impressionism, Gauguin and the Nabis, Expressionism, van Gogh and Fauvism, Art Nouveau, Picasso and Cubism, Abstract Art, the evolution of architecture from the Bauhaus to the International style, contemporary sculpture, painting and applied arts, and environmental design.
a. English ed.: *Panorama of the Arts: From Megaliths to Op Art.* London: Harrap, 1974. 200 p., 758 illus., some col.

457. RUDLINGER, ARNOLD and HANS BOLLINGER. *Histoire de la peinture moderne; de Picasso au surréalisme.* Geneva: Skira, 1950.

458. SALMON, ANDRE. *La Jeune peinture française.* Paris: Albert Messein; Société des Trente, 1912. 124 p.

"Les Fauves" essay on pp. 19-40.

459. SALMON, ANDRE. *L'Art vivant.* Paris: G. Crès, 1920. 302 p., illus. volume in "Artistes d'hier et d'aujourd'hui" series.

460. SALMON, ANDRE. *Propos d'ateliers.* Paris: Crès, 1922. 275 p. Volume in "Mémoires d'écrivains et d'artistes" series.

Pages 115-35 reprint Salmon's essay, "L'Art nègre," which mentions the Fauves.
a. Another ed.: Paris: Nouvelles Editions Excelsior, 1938.

461. SALMON, ANDRE. *Souvenirs sans fin.* Paris: Gallimard, 1955-61. 3 vols., illus. Vol. 1: *1903-1908.*

462. SAN LAZZARO, GUALTIERI DI. *Cinquant'anni di pittura moderna in Francia*. Rome: Danesi, 1945. 151 p., 19 pl.

a. U.S. ed.: *Painting in France, 1895-1949*. Trans. by Baptista Gilliat-Smith and Bernard Wall. New York: Philosophical Library, 1949. 132 p., illus., pl.
b. English ed.: London: Harvill Press, 1949. 132 p., pl.

463. SAUNIER, CHARLES. *Anthologie d'art français: la peinture au XXᵉ siècle*. 128 gravures. Paris: Larousse, 1912. 156 p., 128 pl.

464. SAUVEBOIS, GASTON. *L'Equivoque du classicisme*. Paris: L'Edition libre, 1911. 142 p.

465. SCHMIDT, GEORG. *Petit histoire de la peinture moderne de Daumier à Chagall*. Neuchâtel: Griffon,

466. SEVERINI, GINO. *Tutta la vita di un pittore*. Milan: Garzanti, 1946-. Volumes in "Vita vissuta" series.

467. SHAPIRO, THEDA. *Painters and Politics: The European Avant-Garde and Society, 1900-1925*. New York: Elsevier, 1976. 341 p., 56 illus.

Study based largely on archival sources of the political activities and wider social attitudes of a generation of avant-garde painters in Western Europe: the French Fauves and Cubists, the German Expressionists, and the Italian Futurists. Set in the period that witnessed the rise of mass left-wing parties, the First World War, the Russian Revolution, and short-lived postwar revolutionary movements in Western countries, it traces the painters' political affinities during their early years and the heroic phase of their careers when abstract and nonobjective art was developed.

468. SHATTUCK, ROGER. *The Banquet Years: The Arts in France, 1885-1918*. London: Faber & Faber, 1958.

a. Other eds.: 1959.
b. U.S. eds.: New York: Anchor Books, 1958; 1961, 1968, 1969.
c. French ed.: *Les Primitifs de l'avant-garde*. Paris: Flammarion, 1974. 402 p.

469. SILVER, KENNETH ERIC. *Esprit de corps: The Art of the Parisian Avant-Garde and the First World War*. Ph.D. diss., 1981; Princeton, NJ: Yale University Press; London: Thames and Hudson, 1989. 504 p., illus., pl.

470. SIZERANNE, ROBERT DE LA. *Les Questions esthétiques contemporanes*. Paris: Hachette, 1904. 274 p.

471. SOTRIFFER, KRISTIAN. *Modern Graphics: Expressionism and Fauvism*. New York, Toronto: McGraw-Hill, 1972. 139 p.

472. STEIN, GERTRUDE. *Autobiography of Alice B. Toklas*. London: John Lane, 1933. 267 p., illus., 17 pl.

Scattered references to various Fauve painters on pp. 35-104. Chapter 3 deals with Stein's years in Paris, 1903-07; chapter 4 with 1907-14.
a. U.S. eds.: New York: Harcourt Brace, 1933; 1960; 1990; 1993.
b. French ed.: 1934.
c. German ed.: 1955.
d. Spanish ed.: 1967.
e. Polish ed.: 1979.
f. Estonian ed.: 1985.

473. STEIN, LEO. *Appreciation—Painting, Poetry and Prose.* New York: Random House, 1947. 175 p.

474. SYLVESTER, DAVID, ed. *Modern Art, from Fauvism to Abstract Expressionism.* New York: F. Watts, 1965. 296 p., col. pl., illus. Also published by Grolier, Inc. as a volume in its "The Book of Art" series.

475. TERRASSE, CHARLES. *La Peinture français au XX^e siècle.* Paris, 1939.

Biographical section, pp. 31-40, refers to Braque, Derain, Dufy, Friesz, Manguin, Marquet, van Dongen, and Vlaminck.
a. U.S. ed.: *French Painting in the XXth Century.* New York: Hyperion, 1939. See pp. 13-8, 31-40.

476. TOKLAS, ALICE B. *What is Remembered.* New York: Holt, Rinehart and Winston, 1963. 186 p., illus.

a. Another ed.: San Francisco: North Point Press, 1985. 186 p., illus., 24 pl.
b. English ed.: London: Michael Joseph, 1963. 192 p., pl.

477. TURPIN, GEORGES. *Panorama de la peinture française.* Paris: Revue Moderne des Arts et de la Vie, 1948. 134 p., illus.

Subtitled *Les Fauves, les cubistes et leurs contemporains.* Contains a vivid description of the appearance of the Fauves at the 1905 Salon des Indépendants, Paris. See also *Courrier de France* (March 1949).
a. Another ed.: 1950.

478. UHDE, WILHELM. *Picasso et la tradition française: notes sur la peintuure actuelle.* Traduit du manuscrit allemand par A. Ponchont. Paris: Editions des Quatre-Chemins, 1928. 105 p., illus., 48 pl.

a. U.S. ed.: *Picasso and the French Tradition: Notes on Contemporary Painting.* New York: E. Weyhe, 1929. 105 p., illus., pl.

479. UHDE, WILHELM. *Von Bismarck bis Picasso; Erinnerungen und Bekenntnisse.* Zurich: Oprecht, 1938. 296 p., 6 pl.

480. VALLIER, DORA. *Histoire de la peinture, 1870-1940. Les Mouvements d'avant-garde.* Brussels: Editions de la Connaissance, 1963. 291 p., illus., some col. Volume in "Témoins et témoignages" series.

481. VALLOTTON, FELIX. *Documents pour une biographie et pour l'histoire d'une œuvre.* Présentation, choix et notes de Gilbert Guisan et Doris Jakubec. Lausanne, Paris: La Bibliothèque des Arts, 1973-75. Vol. 2, 1900-1914 (1974). Volumes in "Publications du Centre de recherches sur les lettres romandes" series.

482. VANDERPYL, FRITZ R. *Peintres de mon époque.* Paris: Librairie Stock, 1931. 228 p.

Includes essays on Vlaminck, Derain, van Dongen, Dufy, Matisse, and Friesz.

483. VENTURI, LIONELLO. *Les Archives de l'impressionnisme; lettres de Renoir, Monet, Pissarro, Sisley, et autres. Mémoires de Paul Durand-Ruel. Documents.* Paris, New York: Durand-Ruel, 1939. 2 vols.

a. Reprint: New York: B. Franklin, 1968. 2 vols.

484. VENTURI, LIONELLO. *Pittura contemporanea.* Milan: Ulrico Hoepli, 1947. 238 p., illus., col. pl.

"Fauves e cubisti," pp. 11-3; "I Fauves," pp. 17-20.
a. French ed.: *La Peinture contemporaine.* Milan: Ulrico Hoepli, 1948.

485. VLAMINCK, MAURICE DE. *Tournant dangereux.* Paris: Stock, Delamain et Boutelleau, 1929. 275 p.

a. German eds.: *Gefahr voraus! Aufzeichnungen eines Malers.* Trans. by Jürgen Eggebrecht. Stüttgart: Deutsche Verlags-Anstalt, 1930. 276 p.; 1959.
b. English ed.: *Dangerous Corner.* Trans. by Michael Ross. Introduction by Denys Sutton. London: Elek Books, 1961. 171 p., illus.
c. U.S. ed.: *Dangerous Corner.* Trans. by Michael Ross. New York: Abelard-Schuman, 1966. 171 p., illus., 9 pl.

486. VLAMINCK, MAURICE DE. *Poliment.* Paris: Stock, Delamain et Boutelleau, 1931. 195 p.

487. VLAMINCK, MAURICE DE. *Le Ventre ouvert.* Paris: R.A. Corrèa, 1937. 239 p.

488. VLAMINCK, MAURICE DE. *Portraits avant décès.* Paris: Flammarion, 1943. 278 p.

a. German ed.: *Rückblick in letzter Stunde: Menschen und Zeiten.* St. Gallen: Erker-Verlag, 1965. 213 p.

489. VLAMINCK, MAURICE DE. *Paysages et personnages.* Paris: Flammarion, 1953. 240 p.

490. VOLLARD, AMBROISE. *Recollections of a Picture Dealer.* Translated from the Original French Manuscript by Violet M. Macdonald. London: Constable, 1936. 326 p., pl.

Memoirs of Ambroise Vollard (1867-1939), the successful Parisian art dealer.
a. U.S. eds.: Boston: Little, Brown, 1936. 326 p., 32 pl.; New York: Hacker Art Books, 1978. 326 p.; New York: Dover, 1978. 326 p.
b. French eds.: *Souvenirs d'un marchand de tableaux*. Paris: Albin-Michel, 1937, 1948, 1957, 1959, 1984.

491. VOLLARD, AMBROISE. *En écoutant Cézanne, Degas, Renoir*. Paris: Grasset, 1938.

492. WACKRILL, H. R. *A Note on Modern Painting*. With a foreword by Roger Fry. London: Oxford University Press, 1934. 48 p., 4 pl.

Pages 16-28 discuss Fauvism.

493. WARNOD, ANDRE. *Les Berceaux de la jeune peinture: Montmartre, Montparnasse*. Avec 121 dessins et 16 hors-textes. Paris: A. Michel, 1925. 288 p., illus., pl.

494. WARNOD, ANDRE. *Visages de Paris*. Préface de Jean de Castellane. Paris: Firmin-Didot, 1930. 372 p., illus.

495. WARNOD, ANDRE. *Ceux de la Butte*. Paris: René Julliard, 1947. 290 p., illus. Volume in "La Petite histoire des grands artistes" series.

Includes early reminiscences of Vlaminck, Derain, Braque, Matisse, van Dongen, Friesz, and Dufy.

496. WARNOD, JEANINE. *Le Bateau-Lavoir 1892-1914*. Paris: Presses de la Connaissance, 1975.

497. WEBER, EUGEN JOSEPH. *The Nationalist Revival in France, 1905-1914*. Berkeley and Los Angeles: University of California Press, 1959. 237 p.

a. Reprint: Millwood, NY: Kraus Reprint, 1980. 237 p.

498. WEBER, EUGEN JOSEPH. *Action Française: Royalism and Reaction in Twentieth-Century France*. Stanford: Stanford University Press, 1962. 594 p.

a. French eds.: *L'Action français*. Trans. by Michel Chrestian. Paris: Stock, 1964. 649 p., illus.; Paris: Fayard, 1985. 665 p., illus.

499. WEILL, BERTHE. *Pan! dans l'œil! ou trente ans dans les coulisses de la peinture contemporaine 1900-1930*. Paris: Librarie Lipschutz, 1933. 326 p., illus., 4 pl.

Sketchy memoirs of the pioneer Parisian art dealer.

500. WESTHEIM, PAUL. *Künstlerbekenntnisse: Briefe, Tagebuchblätter, Betrachtungen heutiger Künstler*. Berlin: Im Propyläen Verlag, 1923. 356 p., illus., pl.

a. Another ed.: 1925.

501. WILENSKI, REGINALD HOWARD. *Modern French Painters.* New York: Reynal & Hitchcock, 1939. 424 p., illus., some col., pl.

Pages 197-8, 200-1, 212-4, etc. mention various Fauve painters.
a. Other eds.: 1940, 1944, 1945, 1947, 1949, 1960, 1963.

502. WILLET, JOHN. *L'Expressionnisme dans les arts 1900-1968.* Paris: Hachette, 1970. Volume in "L'Univers des connaissances" series.

503. WRIGHT, WILLARD HUNTINGTON. *Modern Painting, Its Tendency and Meaning.* New York and London: John Lane, 1915. 352 p., pl., some col.

Pages 233-4 refer to the Fauve painters.
a. Other eds.: 1922, 1930.

504. ZAMAÇOIS, MIGUEL. *Pinceaux et stylos.* Paris: Arthème Fayard, 1948. 396 p. Volume in "C'était hier" series.

505. ZAYAS, MARIUS DE. *African Negro Art: Its Influence on Modern Art.* New York, 1916.

506. ZERVOS, CHRISTIAN. *Histoire de l'art contemporain.* Paris: Editions Cahiers d'Art, 1933. 447 p., illus., pl.

"Le Fauvisme": pp. 113-38; "Henri Matisse": pp. 147-72; "Andre Derain": pp. 173-84. Also refers to Vlaminck, Friesz, Dufy, and Braque.
a. Another ed.: 1938.

Articles

507. AHLERS-HESTERMANN, FRIEDRICH. "Der deutsche künstlerkreis des Café du Dôme in Paris." *Kunst und Künstler* (1921):369-402.

508. AUBERY, PIERRE. "Mécislas Golberg." *Lettres nouvelles* (July-Sept. 1965):60-74.

509. AUBERY, PIERRE. "Mécislas Golberg et l'art moderne." *Gazette des Beaux-arts* (Dec. 1965):339-44.

510. BASLER, ADOLPHE. "Volkerbund der malerei" [The Federation of Painting]. *Kunst und Kunstler* 27(Jan. 1929):149-54.

511. BAZAINE, JEAN. "Recherches des jeunes peintres." *Formes et couleurs* (Lausanne) 5:6(1943). 8 p., illus.

512. BLUMENKRANZ-ONIMUS, NOËMI. "Apollinaire par les peintres—les peintres par Apollinaire." *Médecine de France* 143(1963):17-32.

513. BREUNIG, LLOYD-CHRISTOPHER. "Studies on Picasso, 1902-1905." *Art Journal* (Winter 1958):188-95.

514. CARPENTER, RHYS. "Evolution of Modern Painting" in *Art: A Bryn Mawr Symposium* (Bryn Mawr, PA: Bryn Mawr College, 1940), pp. 117-66.

515. Columbus Museum of Art, Columbus, Ohio. "Columbus Museum of Art Complete Acquisition of Sirek Collection." *McKay Lodge Conservation Report* (1991):3-4.

Mentions Fauve works acquired, including a still-life and a self-portrait by Matisse.

516. COMBE, JACQUES. "L'Influence de Cézanne." *Renaissance* (May-June 1936):23-32.

517. CORK, RICHARD. "Postmortem on Post-Impressionism." *Art in America* 68(Oct. 1980):85-7.

518. DONNE, J. B. "African Art and Paris Studios, 190-5-1920" in *Art and Society: Studies in Style, Culture, and Aesthetics*. Edited by Michael Greenhalgh and Vincent Megaw. New York, 1978.

519. DORIVAL, BERNARD. "Ukiyo-e and European Painting" in *Dialogue in Art; Japan and the West* 27-71. 71 illus., 26 col.

Known in France around 1860, Ukiyo-e prints had an immediate influence on the vision and the craft of painters. First, Théodore Rousseau and Millet and then Whistler, Manet, and mainly Degas were profoundly affected. Asymmetrical compositions, scenes and landscapes represented from above or below, figures shown in close-up, pale palette, flat areas of color, the replacement of Albertian perspective with the system of opposed diagonals: all these innovations were taken up by the Impressionists, particularly Monet, who learned moveover not to reduce the scene he was painting to the limits of the canvas, and absorbed a pantheistic feeling for nature contrary to traditional Western humanism. Japanese graphic art had a continuing influence on French painting from the Post-Impressionists to the Nabis and the Fauves, as well as on the work of Ensor, Munch, Klimt and others. After the Renaissance rediscovery of ancient art, nothing had so influenced European painting as Japanese prints.

520. DRALIN, GEORGES. "Propos." *L'Occident* 5(May 1904):234-9.

521. DUNCAN, CAROL. "Virility and Domination in Early 20th Century Vanguard Painting." *Artforum* 12(Dec. 1973):30-9.

522. ERLANGER, L. "Gabriele Münter: A Lesser Life?" *Feminist Art Journal* 3:4(Winter 1974-75):11-13, 23. 5 illus.

Account of Münter's career and her life with Kandinsky. During 1904-08 she moved from tedious Impressionist landscapes to colored woodcuts which gave her the freedom of larger planes. This practice taught her simplification of contour and plane. About 1909 she was the first to discover, then practice, the art of

"Hinterglasmalerei" (behind glass painting). Between 1908-14 her output was enormous: by limiting her choice of colors she transformed what she saw into highly personalized statements. With Kandinsky, she was part of the Blue Rider group. The Murnau-Munich period is referred to as Kandinsky's "genius period": he probably benefited from Münter's creativity as much as she was stimulated by him. Her love of things kept her a representational painter.

523. FIZ, SIMON MARCHAN. "Impresionismo, postimpresionismo y el retorno a los fenomenos perceptivos" [Impressionism, post-Impressionism, and the Return to the Phenomena of Perception]. *Revista de Ideas Estéticas* (Spain) 22:125(1974):2952[+].

Aims to deal with these two schools in so far as they represent a rejection of the post-Renaissance construction of the world and posit a return to the primacy of perception: an attitude reflected within philosophy by the phenomenological thinkers. The various section in this exposition comprise: (1) the return to phenomena of perception; (2) the different tendencies and experiences; impressionism and feeling, Cézanne and sensation; (3) Expressionism, Fauvism, and the emphasis on chromatic experiences; (4) the return to immediacy; (5) epistemological consequences; (6) modern painting, subjectivity and the practice of painting; (7) modern art as "reflection"; (8) return to phenomena; and (9) semeiotic repercussions. In conclusion Fiz dwells on the modification of iconicity implicit in all these different experiments.

524. FIZ, SIMON MARCHAN. "Architecture y ciudad en la pintura de las vanguardias" [Architecture and the City in the Paintings of the Avant-Garde Artists]. *Goyá* (Spain) 180(May-June 1984):329-41. 19 illus.

Examines the images of architecture and cities in the paintings of the late 19th century and early 20th century. The Impressionists were much influenced by poets' views of the city, especially Baudelaire and Rimbaud. The new Paris of Haussmann also inspired Impressionistic paintings of the boulevards. Fiz describes how the large city as a source of mysterious effervescence gave way to more precise observations, integrating railway stations, chimneys and factories. The Eiffel Tower became the symbolic image of Paris and of new technology in an influential painting by Delaunay. De Chirico offers the most unsettling vision of the city, which he sees as a new artificial landscape, into which man is irreversibly immersing himself. He presents the tension between the antique and the modern by using classical elements mixed into a new imaginary universe. The townscapes of the Expressionists and the Fauves are also discussed.

525. GIDE, ANDRE. "Promenade au Salon d'Automne." *Gazette des Beaux-arts*. 3:34(1 Dec. 1905):475-85.

526. GIRARD, ANDRE. "L'Idéal." *Les Temps nouveaux*. (14 July 1906).

527. GRODECKI, LOUIS. "Berenson, Wölfflin et la critique de l'art moderne." *Critique* 86-7(July-Aug. 1954):657-75.

528. GROTTANELLI, VINIGI L. "The Lugard Lecture of 1961" in *African Images: Essays in African Iconology*. Edited by D. F. McCall, and E. G. Bay.

(New York: Africana Pub. Co. for the African Studies Center, Boston University, 1974), pp. 3-22.

Surveys European interest in and analysis of African art in the 20th century. Grottanelli notes that although much was collected during the 19th century, chiefly housed in ethnographical collections, it was in 1904 that artists can be first seen to be interested in the forms of African sculpture. Thus, European attitudes can be divided into aesthetic and ethnographic; the first, discussed with reference to Expressionism, Fauvism and Cubism, is shown to lack true understanding of African art's complex nature, something which anthropology has demonstrated as being the result of conscious maturity and which requires extensive categorization of style, content, and purpose. African art, despite the effects of imported European technology, is a living act that requires an individual approach unaffected by European aesthetics. It is shown how previous studies have concentrated on analysis of formal structure with fundamental lack of understanding of the underlying cultural structures. What is needed for the study of African art is a many-sided and complex analysis by which the barriers separating cultures may be overcome.

529. HAMMACHER, ABRAHAM MARIE. "The Changing Values of Light-Space-Form Between 1876 and 1890" in *Studies in Western Art*, vol. 4: *Problems of the Nineteenth and Twentieth Centuries* (Princeton, NJ: Meiss, 1963), pp. 104-10.

530. HERBERT, JAMES D. "Matisse Without History." *Art History* 11(June 1988):297-302.

531. HUET, JEAN-CHRISTOPHE. "Gris-gris, fétishes et art moderne." *Beaux-arts magazine* 67(April 1989):64-71. 10 illus., 9 col.

Mentions the influence of African art on Fauvism and Cubism.

532. LADENDORF, HEINZ. "L'Age d'or retrouvé par la peinture du XXᵉ siècle sur la côte de la Méditerranée" in *La Méditerranée de 1919 à 1939* (Nice: Publications de la Faculté des Lettres et Sciences Humaines de Nice, 1969, 1st quarter).

533. LETHEVE, JACQUES. "Les Salons de la Rouge-Croix." *Gazette des Beaux-arts* (Dec. 1960):363-74.

534. MALTESE, CORRADO. "Tra Leonardo e Land: qualche interazione tra arte e scienza" [From Leonardo to Land: Interactions between Art and Science]. *Storia dell'arte* 38-40(Jan.-Dec. 1980):419-23.

In relation to Edwin Land's theory of color vision, reviews the history of color-perception theory and the question of "true" color versus "atmospheric" color as understood or confronted by artist from the Renaissance (Leonardo, Alberti, Fra Angelico, Giorgione) to the 19th century, when the theoretical works of Goethe, Chevreul, Helmholtz and Rood influenced European artists, particularly Runge, Klee, Seurat, Signac, the Impressionists, and the Fauves.

535. MAUCLAIR, CAMILLE. "La Critique d'art: sa mission, son état actuel." *La Revue blanche* 5:10(28 Nov. 1908):681-4.

536. MONOD, FRANÇOIS. "Les Expositions: le 21ᵉ Salon des Indépendants." *Art & décoration* 17(May 1905):1-3.

537. MONOD, FRANÇOIS. "Chronique." *Art & décoration* 23(Feb. 1908):1-3.

538. MORICE, CHARLES. "Le XXIᵉ Salon des Indépendants." *Mercure de France* 54(15 April 1905):536-56.

539. MORICE, CHARLES. "Le XXIIᵉ Salon des Indépendants." *Mercure de France* 60(15 April 1906):534-44.

540. "Notre enquête sur les collections et les collection neurs." *Revue illustrée de la carte postale* 6(25 May 1905):612-3.

541. PAVEL, AMELIA. "Concepte ale expressionismului in evolutie" [Concepts of Expressionisms in Evolution]. *Studii si cercetari de istoria artei. Seria acta plastica* 21:1(1974):75-86. 8 illus. Summary in French.

542. PIGUET, PHILIPPE. "Suzanne Pagé." *L'Œil* 405(April 1989):22-3. 1 illus. In French.

Profile of Suzanne Pagé, newly-appointed chief curator of the Musée d'Art moderne de la Ville de Paris. Pagé's career to date is described and her aims to improved and expand the collections of the Museum are discussed. The Museum's collections currently fail to give any significant representation of avant-garde movements, such as Dada, Surrealism and abstract art; its strengths being Fauvism, Cubism, Léger, Delaunay, and the Paris School.

543. RATCLIFF, CARTER. "Dandyism and Abstraction in a Universe Defined by Newton." *Artforum* 27:4(Dec. 1988):82-9. 12 illus., 3 col.

Attempts to define dandyism in art from the definition of dandyism in life and associates it with an essential insubstantiality. Its history is traced from 19th century France and England to American art of the late 20th century. Manet's portraits are characterized by their self-conscious mocking of the processes of representation, by their knowing hollowness. The Fauves and the Cubists also indulged in dandyish disengagement, while Duchamp is the 20th century dandy par excellence. The works of Robert Rauschenberg, Jasper Johns, and Andy Warhol are inserted into this tradition as works that resist the imposition of interpretations.

544. RAYNAL, MAURICE. "Montmartre au temps du Bateau-Lavoir." *Médecine de France* 35(1952):17-30.

545. ROGER-MARX, CLAUDE. "Le Mouvements dans le paysage de Corot à nos jours." *Arts* (22 Feb. 1952).

546. ROTZLER, WILLY. "Apollinaire und seine Freunde" [Apollinaire and His Friends]. *Du* (Switzerland) 3(March 1982):26-67. 42 illus.

In the artistic milieu of early 20th century Paris, Guillaume Apollinaire was a key advocate of the new. Rotzler comments on his unhappy love life and traces his career as writer and journalist, concentrating on his contacts with artist: the Fauves, Picasso, who during these years inaugurated Cubism, Braque, Robert and Sonia Delaunay, and the Futurists. The relationship between his poetry and developments in art is noted. Apollinaire's literacy and critical activity continued unchecked through war service until his death in 1918.

547. ROUVEYRE, ANDRE. "Souvenirs de mon commerce: dans la contagion de Mécislas Golberg." *Mercure de France* (15 April 1922):297-323.

548. SCHAPIRO, MEYER. "The Reaction Against Impressionism in the 1880's: Its Nature and Causes" in *Studies in Western Art: Problems of the 19th and 20th Centuries* (Princeton, NJ: Millard Meiss, 1963).

549. SHEON, AARON. "Adolphe Monticelli: 'Some People Thought Him Mad.'" *Art News* 77:10(Dec. 1978):100-2. 2 illus., 1 col.

Overlooked almost to the point of oblivion, Monticelli's visionary art is now seen as a crucial link between early 19th century Romanticism and the painting of van Gogh, Fauvism, and Expressionism. Written in connection with the exhibition: *Monticelli: His Contemporaries, His Influence*, held at the Museum of Art of the Carnegie Institute in Pittsburgh, 27 Oct. 1978-7 Jan. 1979.

550. STRYIEUSKI, CASIMIR. "Impressions de la Riviera: maisons d'artistes." *Revue bleue* 5:7(5 Jan. 1907):31-2.

551. VISAN, TANCREDE DE. "La Réaction nationaliste en art: réponse à M. Camille Mauclair." *La Plume* 367-8(1-15 March 1905):131-6.

552. WARNOD, ANDRE. "Ma jeunesse à Montmarte." *Les Œuvres libres* (Sept. 1955).

553. WERTH, LEON. "Le Mois de peinture." *La Phalange* 5(20 June 1910):725-32.

554. ZERVOS, CHRISTIAN. "Un demi-siècle d'art en France; notes sur le renouvellement esthétique de notre époque." *Cahiers d'art* (1955):9+.

IV. Fauve References in Newspapers and Periodicals

555. *Les Annales politiques et littéraires* (1 Dec. 1912)

556. *L'Art et les artistes*

557. *L'Art décoratif*

558. *L'Art et décoration*

559. *L'Assiette au beurre*

560. *Cahiers de Mécislas Golberg* (Nov. 1900-April 1901; Jan.-April 1907; 1908)

561. *La Chronique des arts et de la curiosité*

562. *L'Ermitage*

563. *Le Festin d'Esope* (Nov. 1903-Aug. 1904)

564. *Gazette des Beaux-arts*

565. *Gil Blas*

566. *La Grande revue*

567. *L'Illustration*

568. *L'Intransigeant*

569. *Le Journal*

570. *Le Mercure de France*

571. *Nord-Sud* (1917-18)

572. *L'Occident* (Dec. 1901-10)

573. *La Phalange* (July 1906-10)

574. *La Plume* (1890's-1904; Feb.-July 1905)

575. *Poème et drame* (Nov. 1912-May 1913)

576. *La Renovation esthétique* (1905-09)

577. *La Revue hébdomadaire* (1905-08)

578. *La Revue immoraliste* (April 1905)

579. *Le Rire*

580. *Les Soirées de Paris* (Feb.-Aug. 1914)

581. *Vers et prose* (Mar. 1905-08)

582. *L'Ymagier* (1894-95)

V. Individual Fauve Artists

583. CHARMET, RAYMOND. "Découvrons le XIXᵉ siècle: Chabaud" [Let Us Discover the 19th Century: Chabaud]. *Galerie Jardin des Arts* 132(Dec. 1973):89-93. 5 illus.

In extracts from a book on Auguste Chabaud (1882-1955) written shortly before the author's death, Charmet discusses the art and vision of the Fauvist painter in terms of his period. He sets him in the artistic framework of Paris in the early years of the century, and gives an outline of his various themes, contrasting those drawn from Parisian subjects with his work done in Provence. Charmet describes Chabaud's treatment of circus subjects, of Montmartre scenes and of women, and explains his dual personality as a painter in terms of both his own character and his need to keep from his parents all knowledge of his Parisian subject matter.

584. KONCHALOVSKY, ANDREI. "A Russian Fauve." *Art & Antiques* (Summer 1988):88-93+.

A Soviet director's memoir of his grandfather, Pyotr Konchalovsky.

VI. "New" or "Young" Fauves

585. BONGARD, W. "Pock and Balsa: Criteria of Quality in the Visual Arts in the Twentieth Century." *Studio International* (U.K.) 196:1001(Aug. 1983):28-31. 5 illus.

Using traditional modern art as a basis for argument and indicating some of the problems raised by "non-retinal" art in the search for criteria of quality in the visual arts, the author accepts that innovation has been an over-estimated criterion, but argues that it is a necessary condition of quality. Bongard puts forward such criteria as continuity of artistic creation, social commitment and the mastery of artistic techniques and, considering the work of the "Young Fauves" in the light of these conclusions, suggests that they may have missed their medium. In the last analysis, time decides on the true status of art, but it is the right and prerogative of every generation to make judgments.

VII. Fauve-Related Archival Materials

586. *Artists Collection*, ca. 1902-39. .25 linear ft. Holographs, signed; printed matter. Located at the Department of Special Collections, Stanford University Libraries, Stanford, California.

Summary: Single items and small collections of letters by or about artists, some catalogs and examples of their work. From various sources; unpublished guide available. Includes materials on painters (including Henri Matisse), sculptors, architects, and photographers.

587. BARR, ALFRED HAMILTON, JR. *Papers*, ca. 1915-83. 61 microfilm reels. Originals located at the Museum of Modern Art, New York; microfilm

available at the Archives of American Art, Smithsonian Institution, Washington, D.C.; at all Archives of American Art offices; and through interlibrary loan.

Barr (1902-81) was an art historian, administrator, critic and curator; married to Margaret Scolari Barr, art historian and teacher.

Files kept during Barr's tenure at the Museum of Modern Art, New York, including: files of personal and professional correspondence with museum officials, curators, writers, historians, critics, art associations, foundations, magazines, artists, collectors, and others. Among the correspondents are John Canaday, Stanton Catlin, Camille Gray, René d'Harnoncourt, John Hightower, Roland Penrose, and James Thrall Soby. Also included are files on staff, exhibitions, publications and collections of the MOMA; files on abstract art, cubism and futurism, some related to Barr's book *Cubism and Abstract Art* (1936).

Other files related to the Foundation for Arts, Religion and Culture (ARC); Barr's travels, lectures, speeches, exhibitions, publications, political controversies, artists and collections in the U.S.S.R., and writings, (including travel notebooks regarding his trip to Russia, 1959, his visit with Pablo Picasso in 1956, and his visit with Henri Matisse in 1952). Also included are exhibition catalogs, clippings, printed materials and photographs.

Papers kept by Barr's widow, Margaret, including obituaries, *A Memorial Tribute* (1981); an initiation and guest list to the memorial to Barr; condolence letters, 1981-83; and photocopies of autograph lettres, ca. 1920s-70s, from the Barr's collection sold to Arthur A. Cohen in 1975, are also included.

The Museum of Modern Art was responsible for the selection, organization and arrangement of the papers microfilmed. Documents regarded as of a sensitive nature by MOMA staff were removed form the files before filming.

588. BARR, ALFRED HAMILTON, JR. *Papers*, 1918-75 (bulk 1929-70). 95 linear ft. (55 boxes). Located at the Museum of Modern Art, Archives, New York. Microfilm of some of the originals available at the Archives of American Art, Smithsonian Institution, and at the Museum of Modern Art, New York.

Correspondence, general files, documents, articles, photographs, manuscripts, clipings, and printed material.

Transferred from Barr's office; gifts of Margaret S. Barr, 1975-80; and gift of Andrew W. Barr, 1986.

Organization: Arranged in 15 series: Personal correspondence arranged chronologically, 1928-74; obituaries, tributes, and condolences, 1981, 1983; abstract art, cubism and futurism, 1924-74; Foundation for the Arts, Religion and Culture (ARC), 1963-75; exhibitions and publications; lecture notes; art and politics, 1947-60; Soviet cultural matters, 1948-74; writings, drafts, and travel notebooks; personal items. These series have been microfilmed by the Archives of America Art. Unfilmed series include: Matisse (6 linear ft.); Picasso (7 linear ft.); Russian culture, 1924-74 (6 linear ft.); family letters (2 linear ft.); education (2 linear ft.). Finding aids in the repository.

589. BASS, MADELINE TIGER. *The Red Studio, 1911.* Typed manuscript notes (1976?). 1 item, 1 p.

Includes notation by Bass (1934-) on her poem about Henri Matisse, and on its publication.

590. BRAQUE, GEORGES. *Letter*, 13 July 1905, Honfleur. Holograph, signed. Located at The Getty Center for the History of Art and the Humanities, Archives of the History of Art, Santa Monica, California.

Two-page humorous illustrated letter describing various schools of painting.

591. BRAQUE, GEORGES. *Letter*, 1925. Holograph, signed. Located at The Getty Center for the History of Art and the Humanities, Santa Monica, California.

To an unidentified correspondent regarding a royalty payment.

592. CONE, CLARIBEL and ETTA CONE. *Claribel and Etta Cone Letters*, 1898-1949. 6 microfilm reels. Located at the Baltimore Museum of Art, Maryland. 35-mm. microfilm reels, 3807-3812, available at Archives of American Art offices and through interlibrary loan. Authorization to publish, quote, or reproduce must be obtained from Baltimore Museum of Art, Museum Drive, Baltimore, Maryland 21218.

Claribel Cone (1864-1929) and her sister Etta Cone (1870-) were Baltimore art collectors. Includes correspondence between Claribel and Etta Cone and Cone family members; 40 letters from Henri Matisse, 1928-49; and letters from Marguerite Matisse-Duthuit, Leon Kroll, Walter Pach, Lucien R. Pissarro, Ben Silbert, Gertrude Stein, John Rewald, Jack Tworkov, Vincent van Gogh, William and Marguerite Zorach, and others. Enclosed with the letters are typescripts of essays by Ben Silbert, "Landscape—My First Watercolor" and "Concerning Some of My Drawings"; a draft typescript of a talk by Gertrude Stein, "The Value of College Education for Women"; and clippings. Many of the letters have a typed copy and carbon of the copy. Many are written in French, often with typed translations.

593. COOPER, DOUGLAS. *Papers*, ca. 1933-85. ca. 15 linear ft. Manuscripts (holographs, typescripts); photographs; some printed matter. Located at The Getty Center for the History of Art and the Humanities, Archives of the History of Art, Santa Monica, California.

Cooper (1911-84) was an English art historian, critic, collector, and administrator. The collection embraces all papers relating to Cooper's career as a critic, curator, collector, dealer and historian that remained with his estate at the time of his death. Cooper's career both as a collector and as an historian focused first on french cubist painting, the School of Paris, and their Post-Impressionist antecedents; he maintained personal associations or correspondence with many of the French artists and English critics associated with these movements, including Braque, Picasso, Léger, Herbert Read, Clive Bell, and Francis Steegmuller. As a lecturer, curator and essayist (most particularly) as director of the Mayor Gallery, 1933-36, through which her presented many European modernists to a British audience), his personal

interests ranged more widely, and the collection reflects his relationships with such figures as Graham Sutherland, Henry Moore, Nicolas de Staël, and Renato Guttuso, and his work on Klee, Delacroix and the Impressionists, Cooper was an inveterate controversialist, and a number of files represent issues in the institutional art politics of the day.

Missing from the collection is Cooper's correspondence with or directly related to Picasso (now in the Musée Picasso in Paris), and his working papers for an unfinished catalogue raisonnée for Paul Gauguin. Much personal, business and incidental correspondence was discarded by Cooper during his lifetime.

General reference photo files have been distributed among the Center Photo Archives paintings section, and lightly annotated or presentation copies of books incorporated into the collection of the Center Library. The collection is arranged into sections reflecting different aspects of Cooper's life and work, although it repeats most of his file titles and the structure that he himself imposed upon his papers.

Organization: I. Correspondence, 1939-84; II. Writings, 1934-84; III. Records of the Mayor Gallery, London, 1933-36; IV. Papers relating to Nazi art collections, 1940-46; V. Exhibitions, 1948-83; VI. Records relating to the Douglas Cooper art collection, 1935-85; VII. Miscellaneous records.

Series II includes typescripts for lectures delivered by Cooper in London, Paris, Cambridge, and the United States on the work of Henri Matisse, among other artists. Series III includes business correspondence received when Cooper was director of the London gallery. Correspondents include Henri Matisse, among others. Series VII, vertical files (boxes 52A-52B, 53A) includes notes, correspondence photographs, etc. on Henri Matisse, among other artists.

594. COURTHION, PIERRE. *Papers*, ca. 1925-85. 12 linear ft. Located at The Getty Center for the History of Art and the Humanities, Archives of the History of Art, Santa Monica California.

Courthion (1902-) was a French art critic and historian. From 1933-39 he was director of the Cité Universitaire de Paris. Includes preparatory material and manuscripts for studies of nineteenth and twentieth-century artists and art movements, including Henri Matisse. Also contains documentation of travel for conferences, jury work on exhibitions, preparation of motion pictures and a preliminary collection of material for an autobiography. Shelf list available in repository.

595. DALE, CHESTER. *Papers*, 1897-1971 (bulk 1950-68). 7 linear ft. (on 8 microfilm reels). Located at The Getty Center for the History of Art and the Humanities, Santa Monica, California.

Dale (1883-1962) was a New York collector of 19th and 20th century art works. Contains a photograph album, biographical material, corresopndence, writings, books, printed materials, and clippings. Includes personal photographs of Georges Braque, Diego Rivera, Frida Kahlo, Salvador Dalí, and others.

596. DE CHIRICO, GIORGIO. *Assortimento di verite* [essay], ca. 1950. Manuscript, 6 p. Located at The Getty Center for the History of Art and the Humanities, Santa Monica, California.

De Chirico (1988-78) was an Italian painter. Discusses modernism, Paul Valéry, *La Nouvelle revue française*, and the XXV Venice Biennale (1950). Other references are to Rossini's opera buffa, Braque's paintings and Jean Cocteau's films.

597. FOSTER, JOSEPH. *Letters Received*, ca. 1956. Manuscripts, 4 items. Located at The Getty Center for the History of Art and the Humanities, Santa Monica, California.

Foster was a French writer. Papers relate to a proposal animated film by Georges Braque and other matters.

598. GAUT, PIERRE. *Papers*, 1918-69. Manuscripts (holographs, typescripts); photographs; printed matter. Located at The Getty Center for the History of Art and the Humanities, Santa Monica, California.

Gaut was a French paint manufacturer and art collector.

The collection contains letters and orders from artists, many of them personal friends, including 18 letters from Georges and Marcelle Braque and two orders form Picasso; material relating to Gaut's collections of Braque and Picasso and some architectural files regarding his house in Robinson, including correspondence with Le Courbusier and drawings by A. and G. Perret.

Series I of (VII) contains correspondence arranged alphabetically by correspondent, including the Braques, and letters from dealers, editors and critics about Gaut's collection of Braque and Picasso paintings. Series II contains photographs of works of art and printed material arranged according to artist, including Braque. Series VI contains personal photographs of Braque, Derain, Lipchitz, and Picasso.

599. KAHNWEILER, DANIEL-HENRY. *Daniel-Henry Kahnweiler Archives.* Galerie Leiris, Paris.

600. KATZENBACH, WILLIAM E. *Papers*, 1948-70. 3.7 linear ft. (partially microfilmed on 1 reel). Located at the Archives of American Art, Smithsonian Institution, Washington, D.C. 35 mm microfilm reel, 3891; available at Archives of American Art offices and through interlibrary loan. Use of unmicrofilmed materials requires an appointment and is limited to the Washington, D.C. storage facility. Microfilmed materials must be consulted on microfilm.

New York designer, art administrator, lecturer, William E. Katzenbach (1904-75) was coordinator of the Decorative Arts Exhibition Program of the American Federation of Arts, which was charged to "bridge the gap between art and industry" and to acquaint the public with good design.

Includes exhibition material, correspondence, photographs, financial records, scrapbooks, catalogs, and printed material.

Reel 3891: Four silkkscreened samples of mural scrolls designed by Alexander Calder, Henri Matisse, Roberto Matta, and Joan Miró, undated and 1948; 3 photographs of Worthington Whittredge and one of his wife, Euphemia Foote Whittredge; 5 photographs, including one color transparency, of William and Lois Katzenbach and their children.

601. LABAUDT, LUCIEN. *Lucien and Marcelle Labaudt Papers*, 1906-81. 8 linear ft. (partially microfilmed on 11 reels). Located at the Archives of American Art, Smithsonian Institution, Washington D.C. 35 mm microfilm reels, 1052, 1854 and 3799-3806 are available at Archives of American Art offices and through interlibrary loan. Microfilmed portion must be consulted on microfilm. Use of unmicrofilmed portion requires an appointment and is limited to the Washington, D.C. storage facility.

Lucien Labaudt (1880-1943) was a painter, muralist, costume and set designer. He also ran a commercial art school called the California School of Design. After his death in 1943, on assignment as a war artist's correspondent, his wife, Marcelle Labaudt, established the Lucien Labaudt Art Gallery in San Francisco, California. She specialized in giving younger and relatively unknown artists their first exhibitions and operated the gallery until 1980.

Collection includes correspondence, photographs, exhibition materials, scrapbooks, journals, printed matter, essays, gallery records and other business records, and miscellaneous papers. Reel 1854 contains correspondence with Henri Matisse, among many others.

602. LHOTE, ANDRE. *Letters*, 1907-29, n.d. to Gabriel Frizeau. 82 items. Holographs, signed. Located at The Getty Center for the History of Art and the Humanities, Archives of the History of Art, Santa Monica, California.

André Lhote (1885-1962) was a French painter, illustrator and art critic. The collection consists of letters written by André Lhote to his friend and patron Gabriel Frizeau. Frizeau, an art collector whose tastes and ideas did not agree exactly with Lhote's enlisted the painter as his agent in Paris. The letters focus on the Paris art market, theoretical concerns, and Lhote's writings on art, but also include personal matters. The collection is arranged in chronological order.

In the course of his reports to Frizeau, Lhote, maintains a running commentary on the art market which includes detailed assessments of the value of specific works as sound financial investments (1908, 1917, 1918), and procedures for sending paintings out on approval (1908, 1912, 1926). Lhote acts as mediator between Frizeau and other artists, often obtaining lower prices for the collector because of Lhote's friendships and the poverty of the artist in question.

In early letters, Lhote extensively describes, and provides sketches of paintings by Gauguin that are for sale or which Frizeau is selling (1908, 1910, 1912, 1913, 1916). Often quoting prices, he also recommends that Frizeau buy works by the following artists: Georges Rouault (1908-1910), Pierre Girieud (1908, 1910, n.d.), Emile Bernard (1908), Henri Matisse (1908).

603. MASSINE, LEONIDE. *Papers*, 1932-68 (1940-55 bulk). 337 folders, 8 boxes. Located at the Dance Collection, New York Public Library, New York.

Massine (1896-1979) was a Russian-born choreographer. Series include Personal Correspondence, 1934-52; Professional Correspondence, 1938-58; "Ballet Russe (Suites)" Bookings, November 1944-45; Legal Material; Professional Material; Financial Material; and Memorabilia. Most significant in the personal correspondence are letters from Léonide to his third wife, Tatiana. Correspondents in the Professional Correspondence series include Marc Chagall, Salvador Dalí, Manual de Falla, André Derain, Sir Maynard Keynes, Henri Matisse, Lucia Chase, Sergei Denham, Mastislav Doboujinsky, Nicholas Nabokov, Michael Powell, Leopold Stokowski, Pavel Tchelichev, Ninnette de Valois, Aleksandra Danilova, Irina Baronova, Nina Verchinina, and Rosella Hightower. In English, Russian, Italian, and French. Register and card catalogue available.

604. MATISSE, HENRI. *Letters*, 1904-53. ca. 105 items. Holographs, signed. Typescript. Located at The Getty Center for the History of Art and the Humanities, Archives of the History of Art, Santa Monica, California.

Collection contains letters to several correspondents including André Level, Christian Zervos, André Lhote, Charles Thorndike, Henri Donias, and Olga Meerson. Subjects include the sale of paintings, reproductions of his work, publications about the artist, work in progress, and personal matters.

Organization: I. Letters, 1904-50 (folders 1-3); II. Letters to Charles Throndike and Henri Donias, 1924-1953 (folders 4-10).

Series I. Letters: 1904-50. ca. 50 letters and cards written by Matisse to the dealer André Level (1904); Olga Meerson (1908-10); the psychiatrist Paul Dubois, mostly concerning his opinion of Meerson as an artist (1911); Luc-Albert Moreau (1920); André Lhote, concerning the selection of his paintings for the Salon des Independents (1936); Raymond Escholier (1941); the painter Jean-Claude Sardot (1942); Christian Zervos, concerning an article appearing in *Cahiers d'art* (1949); and Mlle. Luigi commenting on *Jazz* (1943). With one black-and-white photograph of Matisse (n.d.). In chronological order.

Series II. Letters to Charles Thorndike and Henri Donias, 1924-53. Personal letters to close friends Charles Thorndike, Mme. Thorndike, and Henri Donias. The correspondence covers all topics, from the health of Matisse and his wife to his work and other subjects of interest. Two notes to Thorndike are signed "Janet," apparently written by Matisse as a joke. Of particular interest in this series is a 12 p. typescript list of the books in Matisse's personal library (May 1943). In chronological order.

605. MATISSE, HENRI. *Autograph Letter Signed*, 20 June 1934, to George Macy. 1 iem, 1 p. Located at Special Collections Department, Northwestern University Library, Evanston, Illinois.

Concerns Matisse's illustrations of *Ulysses* (1935).

606. MATISSE, HENRI and PIERRE COURTHION (Interviewer). *Interview with Pierre Courthion and Related Papers*, 1940-41. ca. 125 items. Manuscripts (holographs, signed; typescripts); some printed matter. Located at the Getty Center.

Collection consists of correspondence between Matisse and the French writer and art critic Pierre Courthion (1902-) concerning the editing and publication of a series of interviews conducted by Courthion in 1941; a typescript of the nine interviews; and related notes and other materials.

Organization: I. Interview correspondence, 1940-41 (folder 1); II. Interview (folder 13); III. Notes and papers (folders 2-12).

Series I: Interview correspondence, 1940-41. 31 letters between Henri Matisse, Pierre Courthion and Lucien Chachaut concerning the transcription, editing and publication of the interview. One letter is illustrated.

Series II: Interview. 1941. 142 p. typescript of nine interviews with Matisse by Pierre Courthion. The interviews constitute an oral autobiography with information of Matisse's education, travels and major works, and with substantial discussion of Eugène Carrière, Paul Cézanne, Marcel Jambon, Albert Marquet, Gustave Moreau, Auguste Renoir, Auguste Rodin, Georges Rouault, and the Ballets russes. The final interview includes a lengthy conversation about Matisse's perception of the role of the artist as well as his theories of color and light. Index available.

Series III: Notes and papers. Pierre Courthion's papers concerning the Matisse interview, including a hand-edited copy of the text, Courthion's notes for the conversations, his contract with the publisher Skira and printed ephemera on Matisse. Also included are portions of the interview rejected for publication by Matisse which concern Matisse's relationships with Marcel Sembat and American collectors.

607. Pierre Matisse Gallery (New York). *Pierre Matisse Gallery Records*, 1925-43. 300 items (on partial microfilm reel). Located at the Archives of American Art, Smithsonian Institution, Washington, D.C. 35-mm microfilm reel NPMI available at Archives of American Art offices and through interlibrary loan.

The Pierre Matisse Gallery was a commercial art gallery in New York City founded by Pierre Matisse, son of Henri Matisse. Includes exhibition catalogs, photographs of exhibition, a scrapbook containing clippings and reviews of shows at the gallery, and some clippings regarding shows of works by Henri Matisse.

608. MCBRIDE, HENRY R. *Papers*, 1887-1962. ca. 8,000 items (on 16 microfilm reels). Located at the Beinecke Rare Book and Manuscript Library, Yale University, New Haven, Connecticut. Authorization to publish, quote or reproduce msut be obatined from Yale Collection of American Literature, Beinecke Rare Book and Manuscript Library, Yale University, New Haven, Connecticut 06520.

35-mm microfilm rolls, NMcB-1 through NMcB-14, D105, and 372 available for use at Archives of American Art offices through interlibrary loan.

McBride (1867-1962) was an art critic and author in New York. He wrote for *The New York Sun* (1913-49), *The Dial* (1920-29), and authored *Matisse* (New York: Knopf, 1930). Collection includes correspondence, manuscript writings, notes, reviews, articles, clippings, letters, photographs, catalogs, and postcards. Reel 372 includes photographs, ca. 1903-47, of McBride with Matisse, among others.

609. PACH, WALTER. *Papers*, 1883-1980. 6.5 linear ft. (on 6 microfilm reels); ca. 10 linear ft., ca. 1,200 items, 8 photographs. Located at the Archives of American Art, Smithsonian Institution, Washington, D.C.

Microfilmed portion must be consulted on microfilm; use of unmicrofilmed portion requires an appointment and is limited to the Washington, D.C. storage facility.

35-mm microfilmed reels, 4216-4221, available for use at Archives of American Art offices and through interlibrary loan.

Pach (1883-1958) was an artists, critic, hiistorian, writer, art consultant, and curator in New York. He promoted modern art and was instrumental in organizing the Armory Show in 1913. Author of several books and articles on modern art. Includes correspondence, writings and notes, travel diary; financial records; art work; photographs; and printed material.

Biographical material; correspondence with family, including many letters from Pach's son Raymond, artists, critics, writers and collectors; a diary, 1903-04, written when Pach travelled to Europe with William Merritt Chase's class. Pach writes of his life abroad, his fellow classmates, Charles Sheeler and Morton L. Schambert, his early interest in Japonisme, and his active collecting of Japanese art. Also included are financial records; writings by Pach, mainly handwritten and edited versions of manuscripts; lecture notes; drawings; 3 sketchbooks; photographs of Pach, his family, artist-friends, including group pictures of Chase's class and one of Robert Henri's class at the New York School of Art, ca. 1904, of art work, and a group of photos of mural projects done by José C. Orozco and Diego Rivera in Mexico; exhibition catalogs, included Pach's annotated copy of the 1913 Armory Show catalog and others annotated by Pach; clippings; a scrapbook of theatrical programs, ca. 1890-1927; a guestbook; and a list of the retained *Walter Pach Library* which contains annotated and inscribed books. Correspondents include Henri Matisse, among other artists.

610. ROSEN, ISRAEL. *Israel Rosen Collection*, 1968-88. 4.2 linear ft. (6 document boxes, 2 record center boxes). Located at The Johns Hopkins University Special Collections, Milton S. Eisenhower Library, Baltimore. Cited as Israel Rosen Collection, ms. 307. Unpublished register available in the repository.

Rosen was a physician and a collector of modern art. He had a family practice in Baltimore from 1936 until his retirement in 1977. Rosen and his wife Selma began collection art on their honeymoon in 1936 and went on to builld one of Baltimore's best modern art collections.

The collection consists largely of non-book printed material collected by Israel and Selma Rosen to support their modern art collection. Included are newspaper clippings, magazine articles, private gallery invitations and listings, brochures,

fliers, and some exhibit catalogs too ephemeral to be catalogued as books. The material deals with artists, art movements, art exhibits, museums, and private collections. Major topics covered include Abstract Expressionism, Expressionism (in Germany, Austria, other European countries and the United States), Cubism, Surrealism, and Dada, De Stijl, Bauhaus, Futurism, and Constructivism. Individual artists represented include Paul Klee, Pablo Picasso, Georges Braque, and Hans Hofmann.

Israel Rosen donated similar art files covering 1944 to 1971 to the Archives of American Art, Smithsonian Institution, Washington, D.C.

611. RYSSELBERGHE, THEODORE VAN. *Correspondence*, ca. 1889-1926. ca. 225 items. Holographs signed. Located at The Getty Center for the History of Art and the Humanities, Archives of the History of Art, Santa Monica, California.

Van Rysselberghe (1862-1926) was a Belgian painter associated with the Fauves. Collection contains 84 letters of van Rysselberghe to, among others, Madame Rysselberghe, the dealer Huinck, Paul Signac, and Berthe Willière; and 141 letters received from colleagues including Henri Cross, Paul Signac, Camille Pissaro and Henry van de Velde. The letters, many of which are extensively illustrated, are largely theoretical in nature and explore all facets of art theory and practice associated with the Neo-impressionist milieu of the late 19th and early 20th centuries.

Organization: Series I. Letters to Madame Rysselberghe, ca. 1902-20 (folder 1); Series II. Miscellaneous letters, 1900-26 (folders 2-3); Series III. Letters received from Paul Signac, ca. 1892-1909 (folders 4-8); Series IV. Letters received from Henri Cross, 1908-10, n.d. (folders 9-11); Series V. Miscellaneous letters received, ca. 1889-1905, n.d. (folders 12-13).

Series IV: Letters received from Henri Cross, 1908-10, n.d. (53 items). Eleven letters addressed to van Rysselberghe contain discussion of work in progress (illustrated) and working method and include mentions of Félix Fénéon, Signac, and Henri Matisse.

612. SAINT-MAUR. *Letters Received*, 1949-50. 6 items. Holographs, signed. Located at The Getty Center for the History of Art and the Humanities, Archives of the History of Art, Santa Monica, California.

Saint-Maur (1906-) was a French artist. Collection consists of letters from Henri Matisse (1949), Gino Severini (1949), and Albert Gleizes (1950) concerning the 1949 Salon de l'Art Mural, founded by Saint-Maur in 1935. The letters discuss practical matters ranging from accounts of paintings sold to specifications for the installation of mosaics, guoache drawings, and decorative panels.

613. SCHLEMMER, OSKAR. *Journal*, 1928-43. ca. 100 p. Typescript. Located at The Getty Center for the History of Art and the Humanities, Archives of the History of Art, Santa Monica, California.

Schlemmer was a German painter, designer, and stage designer who taught at the Bauhaus School. Consists of transcripts of entries from Schlemmer's journals for

the years 1935-43, except for a single month (September, 1941); with scattered records from 1925. The transcript includes both whole entries that are not reflected in published selections and full entries where only extracts have been published. The journal is in diary form, with notes on daily activities, including his reading, but serves also as a vehicle for extended reflections on art and artists, art theory and techniques, and Schlemmer's own works. There is detailed discussion of color and form in abstraction, portrait and landscape painting, and the effect of the Nazis on art and artists. Artists mentioned prominently in his discussions and notes include Georges Braque, among many others.

614. SNODGRASS, WILLIAM DE WITT. *Matisse: The Red Studio.* 18 items, 26 p. Autograph manuscript (between 1957 and 1961?). Located at The Getty Center for the History of Art and the Humanities, Archives of the History of Art, Santa Monica, California.

Includes 18 versions of a fictional work on Matisse by Snodgrass (1926-), including 8 autograph manuscripts, emended; 5 typed manuscripts, emended; 1 typed manuscript; and 4 typed manuscripts, emended (carbon copies). Not all manuscripts are complete.

615. STEICHEN, EDWARD. *Archive*, ca. 66 cubic ft. Located at the Department of Photography, Museum of Modern Art, New York.

Steichen (1879-1973) was a prominent American photographer. Director of the Museum of Art's Department of Photography, 1947-62, Steichen was instrumental in arranging the first showings in the United States of several innovative European modern artists. He was also a painter and collector of art.

The collection consists principally of printed matter, especially news clippings and articles about Steichen's varied and long career. Some of the numerous subjects dealt with are the Photo-Secession and "291" galleries in which modern artists such as Henri Matisse, Paul Cézanne, Pablo Picasso, Constantin Brancusi, John Marin, and Alfred Maurer were introduced to the United States.

616. STEIN, GERTRUDE. *Gertrude Stein Archives.* Yale Collection of American Literature. Yale University, New Haven, CT.

617. Valentine Gallery (New York). *Valentine Gallery Records*, 1925-48. 1.7 linear ft. (on 6 partial microfilm reels). Located at the Archives of American Art, Smithsonian Institution, Washington, D.C.

35-mm microfilm reels D22, D193, NY59-5, 911, and 3828-3830 available at Archives of the American Art offices and through interlibrary loan.

Art gallery, New York, founded 1924 (?) by Valentine Dudensing (b. 1901) as Dudensing Galleries, 45 W. 44th St. Renamed F. Valentine Dudensing, ca. 1926, and later Valentine Gallery. Closed in 1948.

Includes records relating to artists Louis M. Eilshemius, John Kane, C.S. Price, and Henri Matisse.

Reel D22 (fr. 214-17) includes 2 letters from Henri Matisse, 4 February 1947 and 18 August 1930, both written from Nice. In the first, Matisse thanks Dudensing for the presentation of the exhibition, and expresses his gratitude to Mrs. Dudensing as well. In the second, he announces his return from a long trip to Tahiti, Panama, Martinique, Guadaloupe and the U.S. He plans to return to Paris at the end of the month, and hopes he has a chance to meet up with Dudensing.

618. WILLIAMS, WILLIAM CARLOS. *A Novelette; Marianne Moore; A Matisse; An Essay on Virginia.* Typed manuscript, 1921. 2 items, 21 p. Located at the Williams Collection. Reference: Baldwin, B78.

Williams (1883-1963) was an American poet and author. Includes 2 versions: 1 typed manuscript, emended (19 p.); 1 typed manuscript (carbon copies) (2 p.).

VIII. Audiovisual Materials

619. *The Day of Empires Has Arrived.* New York: Time-Life Multimedia, 1976. Produced by Time-Life Films and the British Broadcasting corporation, Television Service. Videocassette.

Deals with the forces of unrest that threatened the empires in the early 1900s, including the theories of Marx and Engels in Europe, the oppression in the colonies, and revolutionaries in Russia. Also shows how the Fauve artists of Paris and Berlin characterized, through their art, the century's chaotic first decade.

620. *The Landscape of Pleasure.* Robert Hughes. London and New York: BBC-TV in association with Time-Life Video, 1979. 16 mm. film, videocassette, 52 min., col. Shock of the New, no. 3.

Art historian and critic Robert Hughes talks about the liberation of color that began in the late 19th century and was amplified by Matisse, Derain, and Vlaminck as a means of expressing color. Hughes also points out the increasing personalization of art as seen in the work of Braque and Picasso.
Reviews: *Newsday* (1 Feb. 1981); *New York Magazine* (9 Feb. 1981).

621. *Fauvism and Expressionism.* Glenview, IL: Crystal Productions, 1940. 45 min. video tape. Jean Thompson, narrator.

IX. Fauve Exhibitions

1901, 20 April- 21 May	Paris, Grandes Serres de l'Exposition Universelle. *Société des Artistes Indépendants*. Matisse, Marquet, Puy.
1902	Paris, Grandes Serres de la Ville de Paris. *Société des Artistes Indépendants*. Matisse, Marquet, Puy, Manguin.
1902-08	Paris, Galerie Berthe Weill. Matisse (1902-08); Marquet (1902-08); Puy (1903-08); Manguin (1903-08); Vlaminck (1905-1908); van Dongen (1905-08); Dufy (1905-08); Derain (1906-08); Braque (1908).
1903, 20 March- 25 April	Paris, Grandes Serres de la Ville de Paris. *Société des Artistes Indépendants*.
1903	Paris, Grand Palais des Champs-Elysées. *Société du Salon d'Automne*. Matisse, Marquet.
1904, 21 February- 24 March	Paris, Grandes Serres de la Ville de Paris. *Société des Artistes Indépendants*. Matisse, Marquet, Puy, Manguin, Camoin, Friesz, Dufy, van Dongen.
1904, 15 October- 15 November	Paris, Grand Palais des Champs-Elysées. *Société du Salon d'Automne*. Matisse, Marquet, Puy, Manguin, Camoin, Friesz.
1905, 24 March- 30 April	Paris, Grandes Serres de la Ville de Paris. *Salon des Indépendants*. Matisse, Marquet, Puy, Manguin, Friesz, Dufy, van Dongen, Derain, Vlaminck, Camoin. Reviews: L. Vauxcelles, *Gil Blas* (4, 18, 23 March 1905).
1905, 18 October- 25 November	Paris, Grand Palais des Champs-Elysées. *Société du Salon d'Automne*. Matisse, Marquet, Puy, Manguin, Camoin, Friesz, van Dongen, Vlaminck, Rouault. Reviews: L. Vauxcelles, *Gil Blas* (17 Oct. 1905); *L'Illustration* (4 Nov. 1905):294-5; A. Gide, *Gazette des Beaux-arts* 34(Dec. 1905):476-85; F. Monod, *L'Art et décoration* 18(1905):198-210.
1906, 20 March- 30 April	Paris, Grandes Serres de la Ville de Paris. *Société des Artistes Indépendants*. Matisse, Marquet, Puy, Manguin, Friesz, Dufy, van Dongen, Derain, Vlaminck, Braque. Reviews: L. Vauxcelles, *Gil Blas* (20 March 1905); C. Morice, *Mercure de France* (15 April 1906).
1906, 6 October- 15 November	Paris, Grand Palais des Champs-Elysées. *Société du Salon d'Automne*. Matisse, Marquet, Puy, Manguin, Friesz, Dufy, van Dongen, Derain, Vlaminck, Braque. Reviews: L. Vauxcelles, *Gil Blas* (5 Oct. 1906); M. Denis, *L'Ermitage* (15 Dec. 1906);

1907, 20 March- 30 April	Paris, Grand Serres de la Ville de Paris. *Société des Artistes Indépendants*. Marquet, Puy, Manguin, Friesz, Dufy, van Dongen, Derain, Vlaminck, Camoin, Braque. Review: L. Vauxcelles, *Gil Blas* (20 March 1907).
1907	Paris, Grand Palais des Champs-Elysées. *Société du Salon d'Automne*. Matisse, Marquet, Manguin, Friesz, Dufy, Derain, Vlaminck, Braque. Reviews: F. Vallotton, *La Grande revue* (25 Oct. 1907); M. Puy, *La Phalange* (15 Nov. 1907); L. Rouart, *L'Occident* (Nov. 1907).
1908, 1 October- 8 November	Paris, Grand Palais des Champs-Elysées. *Société du Salon d'Automne*. Matisse, Marquet, Puy, Manguin, Friesz, van Dongen, Derain, Camoin, Vlaminck. Reviews: L. Vauxcelles, *Gil Blas* (9, 14 Nov. 1908); L. Lormel, *La Rénovation esthétique* (Nov. 1908):52; M. J. Péladan, *La Revue hebdomadaire* (17 Oct. 1908):361.
1908, 20 March- 2 May	Paris, Grandes Serres de la Ville de Paris. *Sociéte de Artistes Indépendants*. Marquet, Puy, Manguin, Friesz, Dufy, van Dongen, Derain, Vlaminck, Camoin. Reviews: L. Vauxcelles, *Gil Blas* (20 March 1908); M. Denis, *La Grande revue* (10 April 1908).
1912, October	Paris, Galerie La Boëtie. *Salon de 'La Section d'or'*.
1917, April	Paris, Galerie Paul Guillaume. *Sculptures nègres*.
1921, 30 May	Paris, Hôtel Drouot. *Collection Uhde*.
1921-23, 13-4 June, 17-8 Nov., 4 July 1922, 7-8 May 1923	Paris, Hôtel Drouot. *Collection Kahnweiler*.
1926	Paris, Grand Palais. *Trente ans d'art Indépendants*.
1927, 15-30 April	Paris, Galerie Bing. *Les Fauves, 1904-1908*. Catalogue avec préface ("Le Mouvement Fauve") par Waldemar George. Reprinted in *L'Art vivant* 54(15 March 1927):206-8. Reviews: J. de Lassus, *L'Amour de l'art* 8:6(June 1927):209-11; *Drawing and Design* 2(June 1927):180-1.
1931-32, 22 December- 17 January	Chicago, Art Institute. *Exhibition of the Arthur Jerome Eddy Collection of Modern Paintings and Sculpture*. Catalogue issued in *Chicago Art Institute Bulletin* 35:9(Dec. 1931). Works exhibited by Derain and Vlaminck are discussed on pp. 10-2, 24-6.

1933-34, December-January	Paris, *Beaux-arts* and *Gazette des Beaux-arts. Seurat et ses amis: la suite de l'impressionnisme.* Préface de P. Signac.
1934, October-November	New York, Julien Levy Gallery. *8 Modes of Western Painting.* A College Art Association Exhibition. Catalogue and analyses by Agnes Rindge. 20 p.
1934-35, November-March	Paris, *Beaux-arts* and *Gazette des Beaux-arts. Les Fauves: l'atelier Gustave Moreau.* Préface de Louis Vauxcelles. Catalogue par Raymond Cogniat. 32 p., illus. Includes biographical notes on Camoin, Derain, Desvallières, van Dongen, Dufy, Friesz, Manguin, Marquet, Matisse, Puy, Rouault, and Vlaminck. Reviews: *Beaux-arts* (16 Nov. 1934):1; (23 Nov. 1934):1; *Amour d'art* 15(Dec. 1934):7; *L'Art et les artistes* 29(Dec. 1934):102; L. Vauxcelles, *Gazette des Beaux-arts* 12, ser. 6 (Dec. 1934):273-82; A. Watt, *Apollo* 21(Jan. 1935):42; J. Baschet, *L'Illustration* (9 March 1935); M. Zahar, *Art News* 33(29 Dec. 1934):9; 33(6 April 1935):15.
1935	Paris, Petit Palais. *Les Chefs-d'œuvre du Musée de Grenoble.* Préface de J. Robiquet. Catalogue par G. Barnaud. Review: J. Baschet, *L'Illustration* 93:4801(3 March 1935):281-4.
1937, June-October	Paris, Petit Palais. *Les Maîtres de l'art Indépendants 1895-1937.* Préface de Raymond Escholier.
1938	Paris, Galerie Charpentier. *G.-D de Monfreid et son ami: Paul Gauguin.*
1941, 20 October-22 November	New York, Marie Harriman Gallery. *Les Fauves.* Preface by Robert Lebel. 6 p. Included works by Matisse, Manguin, Marquet, Vlaminck, van Dongen, Dufy, Friesz, Derain, and Braque. Reviews: *Art Digest* 16(1 Nov. 1941):9; *Art Digest* 16:3(Nov. 1941):5-7; *Art News* 40:14(1 Nov. 1941):32.
1942, 12 June-11 July	Paris, Galerie de France. *Les Fauves; peintures de 1903 à 1908.* Review: G. Diehl, *Beaux-arts* 70(June 1942):5.
1945-46	Paris, Musées Nationaux. *Maurice Denis: ses maîtres, ses amis, ses élèves.*
1946	Paris, Galerie Charpentier. *Cent chefs-d'œuvre des peintres de l'école de Paris.* Catalogue par Jacques Lassaigne. Parallel English text by Frederic W. Stewart. 205 p., illus. Works by Braque, Derain, Friesz, Rouault, van Dongen, and Vlaminck, among others.

1947, 14 January- 15 February	Paris, Galerie de France. *L'Influence de Cézanne, 1908-1911: œuvres de Braque, Delaunay, Derain, Dufy, Gleize, Juan-Gris, Herbin, La Fresnaye, Léger, Lhote, Marquet, Matisse, Metzinger, Picasso, Vlaminck, 1903 à 1914.* 18 p., illus.
1947, March	Paris, Galerie Bing. *Chatou.* Introduction et illustrations d'André Derain et Maurice de Vlaminck. 10 p., illus. Review: *Werk* 34(June 1947):supp. 69.
1950, 29 April- 29 May	Berne, Kunsthalle. *Les Fauves: Braque, Derain, Dufy, Friesz, Manguin... und die Zeitgenossen, Amiet, Giacometti, Jawlensky, Kandinsky.* Foreword and essay by Arnold Rüdlinger. 26 p., 14 pl. Review: G. Veronesi, *Emporium* 112(Aug. 1950):50-60.
1950, 8 June- 15 October	Venice, *XXV Biennale Internazionale d'Arte: Mostra dei Fauves.* Preface by Roberto Longhi. "Sala IV: Fauves." Record of 59 works exhibited. See catalogue, pp. 42-8.
1950, 1-21 November	Milan, Commune di Milano. *Mostra di Matisse.* Catalogue with an introduction by Raymond Cogniat. Reviews: *Werk* 37(July 1950):supp. 87-8; *Emporium* 114(July 1951):43-4.
1950, 13 November- 23 December	New York, Sidney Janis Gallery. *Les Fauves.* Catalogue, 8 p. Reviews: *Art Digest* 25:5(1 Dec. 1950):15; *Art News* 49(Dec. 1950):46.
1951, June- September	Paris, Musée National d'Art moderne. *Le Fauvisme.* Préface de Jean Cassou. Catalogue par G. Vienne. 44 p., illus. Review: *Emporium* 114(July 1951):25-8.
1952, April-May	Rennes, Musée des Beaux-arts, Hôtel de Ville. *Le Fauvisme.* Préface de Bernard Dorival. 34 p.
1952-53, 8 October- 1 January	New York, Museum of Modern Art. *Les Fauves.* Also shown Minneapolis, Minneapolis Institute of Arts (21 Jan.-22 Feb. 1953); San Francisco, San Francisco Museum of Art (13 March-12 April 1953); Art Gallery of Toronto(1-31 May 1953). Catalogue with text by Andrew Carnduff-Ritchie. 47 p., illus. Dist. by Simon and Schuster. Reviews: *Cahiers d'art* 27:2(1952):82-5; J. Fitzsimmons, *Art Digest* 27:2(15 Oct. 1952):10-1, 30; *Minneapolis Institute of Arts Bulletin* 42(3,17,24 Jan. 1953):2-7,133-4,17-8.
1952, 7-29 November	Paris, Galerie Nina Dausset. *Symbolistes, Divisionnistes, Fauves: Hommage à Gustave Moreau.*

1952	Paris, Musée des Arts décoratifs. *Cinquante ans de peinture française dans les collections particulières de Cézanne à Matisse.*
1955, March	Marseille, Musée Cantini. *Premières étapes de la peinture moderne.* 51 p., illus.
1956	Chicago, Art Institute of Chicago. *Den of Wild Beasts.*
1957, June	Paris, Galerie Charpentier. *Succession A. Vollard.*
1959, 29 January-16 March	Dallas, Museum for Contemporary Arts. *Les Fauves.* Catalogue, 14 p.
1959, June-August	Basel, Galerie Beyeler. *Les Fauves.* Catalogue, 29 p., col. pl. Text in German and French, introduction in English. Review: *Werk* 46(Oct. 1959):supp. 221.
1959, 5 July-15 November	Berlin, Nationalgalerie der ehemals Staatlichen Museen, Orangerie des Schlosses Charlottenburg. *Triumph der Fabre: die Europäischen Fauves.* Also shown Schaffhausen, Museum zu Allerheiligen. Introduction by Leopold Reidemeister. 1 vol., col. illus. Reviews: *Werk* 46(Sept. 1959):supp. 192-3; *Kunstwerk* 13(Oct. 1959):38,41.
1960-61, 4 November-23 January	Paris, Musée National d'Art moderne. *Les Sources du XXe siècle: les arts en Europe de 1884 à 1914.* Introduction et textes de Jean Cassou, textes de G.C. Argan et Nicholas Pevsner. Catalogue par Jean Cassou et André Châtelet. 410 p., illus.
1961, 19 January-26 February	Kansas City, Nelson Gallery and Atkins Museum. *The Logic of Modern Art: An Exhibition Tracing the Evolution of Modern Painting from Cézanne to 1960: Les Fauves, Expressionism, Cubism, Non-Objective Painting, Surrealism, Painting since World War II.* Essay by Ralph T. Coe. 36 p., illus.
1962, 7 March-31 May	Paris, Galerie Charpentier. *Les Fauves.* Préface de Raymond Nacenta. 80 p., illus., 60 pl. 120 works shown. Reviews: A. Humbert, *Arts* 859(7-13 March 1962):16; A. Brookner, *Burlington Magazine* 104:710(May 1962):221; H. Lessore, *Apollo* 76(May 1962):223-5; P. Schneider, *Art News* 61:3(May 1962):44$^+$.
1962, 26 June-1 September	Marseille, Musée Cantini. *Gustave Moreau et ses élèves.* Préface de Jean Cassou.
1963	Paris, Galerie Romanet. *Deux cents aquarelles et dessins de Renoir à Picasso.* Texte de A. Romanet.

1963	Paris, Huguette Berès Galerie. *Francis Jourdain et quelques-uns de ses amis.* 25 p., illus.
1963	Strasbourg, Château des Rohan. *La Grande aventure de l'art du XX^e siècle.* Introduction par H. Haug.
1964, February-April	Turin, Galleria civica d'arte moderne. *80 pittori da Renoir a Kisling* (Modern Art Foundation Oscar Ghez, Geneva). Textes de François Daulte et Oscar Ghez.
1964, 27 June-20 September	Colmar, Musée d'Unterlinden. *Fenêtre ouverte sur une collection privée* (Pierre Lévy, Troyes). Textes par A. Dunoyer de Segonzac.
1964, August-September	Besançon, Musée des Beaux-arts. *Valtat et ses amis, Albert André, Charles Camoin, Henri Manguin, Jean Puy.* Préface de George Besson.
1964, 7 September-31 October	Tokyo, Takashimaya. *Les Fauves.* Also shown at Osaka, Takashimaya (5-17 Oct., 1965) and Fukuoka, Iwataya (26-31 Oct., 1965).
1964-65, December-February	Paris, Musée du Louvre. *Collection George et Adèle Besson.* Préface de Jean Cassou.
1964	Lausanne, Palais de Beaulieu. *Chefs-d'œuvres des collections suisses de Manet à Picasso.*
1964	Duisburg. *Pariser Begegnungen, 1904-1914: Café du Dôme 10/25/85—Académie Matisse—Lehmbrucks Freundeskreis.*
1965, July-October	Besançon, Musée Beaux-arts. *Collection George et Adèle Besson.* Préface de J. Vergnet-Ruiz.
1965, 12 October-6 November	Paris, Galerie de Paris. *La Cage aux Fauves et des œuvres du Salon d'Automne 1905.* Préface de Jean Cassou, texte de Pierre Cabanne. 16 p., illus.
1965	Paris, Galerie M. Knoedler & Cie. *Quarante tableaux d'une collection privée* (Pierre Lévy, Troyes). Texte de Waldemar George.
1965-66, September-January	Paris, Musée du Louvre. *Chefs-d'œuvre de la peinture française dans les musées de Leningrad et de Moscou.*
1966, 15 January-10 July	Paris, Musée National d'Art moderne. *Le Fauvisme français et les débuts de l'expressionnisme allemand.* Also shown Munich, Haus der Kunst (26 March-15 May); Hamburg, Kunsthalle (24 May-10 July). Préface de Bernard Dorival et Leopold Reidemester. Texte sur le

Fauvisme par Michel Hoog. 370 p., illus., pl. Reviews:
M. Hoog, *Revue du Louvre et des musées de France*
15:6(1965):286; R. McMullen, *Art News* 65(March
1966):26; G. Metken, *Kunstwerk* 19(March 1966):21; A.
Sheon, *Burlington Magazine* 108(May 1966):277.

1966, March-April	Paris, Musée National d'Art moderne. *Paris-Prague: 1906-1930.* Préface de Bernard Dorival.
1966, 25 May- 10 July	Hamburg, Kunstverein. *Matisse und seine Freunde— les Fauves.* Catalogue with introduction by Hans Platte. 105 p., 84 illus., 24 pl. Review: S. Whitfield, *Burlington Magazine* 108(Aug. 1966):439.
1966, June-July	Basel, Galerie Beyeler. *Autour de l'impressionnisme.*
1966, October	Paris, Musée Galliéra. *60 maîtres de Montmartre à Montparnasse, de Renoir à Chagall* (Modern Art Foundation Oscar Ghez, Geneva). Catalogue par Oscar Ghez, François Daulte, E. Gribaudo.
1966	Bordeaux, Galerie des Beaux-arts. *La Peinture française dans les collections américaines.*
1966	Paris, Orangerie des Tuileries. *Collection Jean Walter Paul Guillaume.*
1966	Paris, Galerie La Palette Bleue. *Cent dessins et aquarelles de Renoir à Picasso.* Also shown Galerie Romanet-Rive Gauche.
1967	Paris, Orangerie des Tuileries. *Chefs-d'œuvres des collections suisses de Manet à Picasso.* Catalogue par François Daulte. Textes de J. Chatelain, François Daulte, Hélène Adhémar.
1967, February- March	Saint-Germain-en-Laye. *Chefs-d'œuvre des collections privées.*
1967, June	Paris, Galerie Romanet-Rive Gauche. *Fauves et Cubistes.* Also shown Galerie La Palette Bleue.
1967-68, 25 November- 1 January	Charleroi, Palais des Beaux-arts. *Autour du Fauvisme: Valtat et ses amis.* Sous le patronage de l'Institut de la Vie; Modern Art Foundation Oscar Ghez, Geneva. Textes de R. Rousseau et G. Peillex. 59 p., illus., 44 pl.
1968, February	New York, Solomon R. Guggenheim Museum. *Neo-impressionism.* Catalogue by Robert L. Herbert. 261 p., illus., some col.

1968, 18 April- 12 June	New York, Leonard Hutton Galleries. *Fauves and Expressionists*. Catalogue by Leonard Hutton-Hutschnecker, Bernard Dorival, Leopold Reidemeister. 64 p., illus. Reviews: H. Rosenstein, *Art News* 67:3(May 1968):46-7[+]; A. Werner, *Arts Magazine* 42:7(May 1968):36-9.
1968, 10 October	New York, Parke-Bernet Galleries. *School of Paris Paintings; Including Major Works by Cross, Dufy, van Dongen, Friesz, Luce, Pascin, Signac, Utrillo, Vlaminck. From the Collection of Doctor Roudinesco*. Sold by his order, public auction October 10. 121 p., illus., some col. Sale no. 2742.
1969	Basel, Galerie Beyeler. *Les Fauves*.
1969, 7 May- 27 June	Paris, Galerie Schmit. *Cent ans de peinture française*.
1969, September- November	Malines, Cultureel Centrum Burgmeester Antoon Spinoy. *Fauvisme in de Europese Kunst*. Essays by Jean Leymarie, Em. Langui, and D. Van Daele.
1969	Geneva, Galerie du Théâtre. *Peintres français*.
1970, 26 May- 27 July	Paris, Musée National d'Art moderne. *L'Expressionnisme européen*. Textes de Jean Leymarie, P. Vogt, L. J. F. Wijsenbeck.
1970, 13 November- 23 December	New York, Sidney Janis Gallery. *The Fauves*. Essays by Georges Duthuit and Robert Lebel.
1970-71, 19 December- 1 March	New York, Museum of Modern Art. *Four Americans in Paris: The Collections of Gertrude Stein and her Family*. Also shown Baltimore Museum of Art and San Francisco Museum of Art.
1971, May- November	Paris, Musée Delacroix. *Delacroix et le Fauvisme*.
1972, 6-26 April	Paris, Grand Palais, Société des Artistes Indépendants. *Fauves et cubistes; rétrospective*. 83ème exposition, Société des Artistes Indépendants. Review: *Connoisseur* 179:722(April 1972):295.
1973, 23 September- 11 November	Winterthur, Switzerland, Kunstmuseum. *Künstlerfreunde um Arthur und Hedy Hahnloser-Bühler*. Catalogue with texts by R. Koella, M. Hahnloser-Ingold, Hans R. Hahnloser, Rudolph Steiner. 228 p., 102 illus. Exhibition held to celebrate jointly the 100th birthday of Hedy Hahnloser-Bühler and the 125 years of existence of the

Kunstmuseum in Winterthur. Hedy Hahnloser-Bühler was a collector of Impressionist and Fauvist paintings. Works exhibited included examples by Picasso, Rouault, Bonnard and Hodler. The exhibition sought to capture the atmosphere of the private collection and the close relationship felt by the collector to the artists.

1973 Geneva, Musée d'Art et d'histoire. *L'Art du XX^e siècle.*

1973 Paris, Galerie Schmit. *Tableaux de maîtres français, 1900-1955.* Texte de J. Bouret.

1974 Paris, Caisse nationale des monuments historiques et des sites. *La Collection Germaine Henry-Robert Thomas; peintures, sculptures et objets d'art, XIX^e-XX^e siècles.*

1974, 1 February-
15 April
Paris, Grand Palais. *Jean Paulhan à travers ses peintres.*

1974, 15 August-
8 December
Exposition les Fauves [cover titles; Japanese title]. Also shown Osaka, Seibu Takatsuki Galleries (15 Nov.-8 Dec.). Organisée par le Yomiuri Simbun Osaka Honsha. Catalogue par François Daulte. 150 p. In Japanese and French. Review: *L'Œil* 230 (Sept. 1974):67.

1974-75,
22 November-
20 January
Paris, Musée National d'Art moderne. *Dessins du Musée National d'Art moderne 1890-1945.* Textes de D. Bozo et P. George.

1975, 11 April-
11 May
Toronto, Art Gallery of Ontario. *Les Fauves.* Catalogue by Richard J. Wattenmaker. 45 p., 29 illus., 12 col., 29 works shown. Account of the Fauves' reception at the Paris Salon d'Automne of 1905 is followed by a discussion of Fauvism's basic constituent pictorial features and the traditional sources upon which the Fauve painters drew. The interrelationships and influences within the group of Matisse, André Derain, Maurice de Vlaminck, Albert Marquet, and Henri Manguin, and the individual stylistic development of each artist in the period, ca.1898-ca.1906, are traced. Works by Raoul Dufy, Othon Friesz, Georges Braque, Louis Valtat, and Kees van Dongen are also illustrated and analyzed.

1975 Paris, Musée Jacquemart-André. *Le Bateau-Lavoir, berceau de l'art moderne.* Textes de René Huyghe et Jeanine Warnod.

1976, 26 March-
31 October
New York, Museum of Modern Art. *The 'Wild Beasts': Fauvism and its Affinities.* Also shown Museum of Modern Art, San Francisco (29 June-15 Aug.); Kimbell Art Museum, Fort Worth (11 Sept.-31 Oct.). Catalogue

with text by John Elderfield. 167 p., 206 illus., 24 col. 210 works shown. Texts provide a definition of Fauvism—as a movement, a group, and a style—describing its origins and development, the philosophies and intellectual backgrounds of the Fauvist painters, and the works of art they produced. Elderfield sees Matisse as the movement's common denominator: "The history of Fauvism is largely the history of this essentially private artist's single sustained period of cooperation with the Parisian avant-garde, albeit for a very short period." Discussed in detail are the Fauve works of Matisse, Derain, and Vlaminck, the principal artists of the movement, as well as works by Dufy, Braque, Friesz, Marquet, Manguin, and van Dongen. Contents: Introduction: The Formation of Fauvism; The Fauvist World; The Pastoral, the Primitive, and the Deal; Postscript; Fauvism and its Inheritance. Bibliographical references included in Notes, pp. 149-60. Bibliography (general references and references on individual artists), pp. 161-66. Reviews: J. Russell, *New York Times* (26 March 1976):20; H. Kramer, *New York Times* (4 April 1976):29; C. Baldwin, *Art Bulletin* 60:1(March 1978):187-8; A. Goldin, *Art in America* 64:3(May-June 1976):90-5; C. Baldwin, *Arts Magazine* 50:10(June 1976):99-102; F. Spalding, *Connoisseur* 192:773(July 1976):241; *Apollo* 104:173(July 1976):64-5; C. Lampert, *Studio International* 192:982(July-Aug. 1976):78-9; N. Bremer, *Pantheon* 34:3(July-Sept. 1976):265; J. Hobhouse, *Art News* 75:6(Summer 1976):47-50; D. Ashton, *Colóquio: Artes* 29(Oct. 1976):14-19,83-4; H. Dorra, *Art Journal* 36:1(Fall 1976):50-4.

1976,
6-28 November

Troyes, Hôtel de Ville. *A la découverte de la collection Pierre Lévy.*

1976-77, 24
November-
16 January

Cologne, Wallraf-Richartz-Museum und Museum Ludwig. *Unmittelbar und unverfälscht: frühe Graphik des Expressionismus* [Direct and Undiluted: Early Expressionist Prints]. Hella Robels und Dieter Ronte, eds. 45 p., 162 illus., 165 works shown. Exhibition and catalogue focus on prints by the Dresden "Die Brücke" artists, in particular Hecken, Kirchner, Nolde, Pechstein, and Schmidt-Rottluff. The woodcuts, lithographs and etchings shown date from 1906-13; most were selected from an anonymous private collection. A few works by non-German expressionists and the Fauves were included.

1976

Paris, Musée d'Art moderne de la Ville de Paris. *La donation Germaine Henry-Robert Thomas; peintures, sculptures et objets d'art, XIXe-XXe siècles.*

1977, 11 May- 25 June	Paris, Galerie Schmit. *Choix d'un amateur.*
1977, 18 June- 29 August	Troyes, Hôtel de Ville. *Donation Pierre Lévy, deuxième exposition.*
1977, 9 September- 30 October	Edmonton, Alberta, Edmonton Art Gallery. *The Fauve Heritage.* 29 p., illus.
1977	Düsseldorf, Städtische Kunsthalle. *Vom Licht zur Farbe.*
1978, 16 February- 16 April	Paris, Orangerie des Tuileries. *Donation Pierre Lévy.* Introduction par Michel Hoog.
1978, 21 February- 20 May	Paris, Musée d'Art moderne de la Ville de Paris. *La Collection Thyssen-Bornemisza. Tableaux modernes.*
1978, 10 May- 30 June	Paris, Galerie Schmit. *Aspects de la peinture française, XIX^e-XX^e siècles.*
1978, 1 July- 16 September	Saint-Tropez, Musée de l'Annonciade. *D'un espace à l'autre: la fenêtre. Œuvre du XX^e siècle.* Textes de Alain Mousscigne, A. M. Lecoq, P. Georgel, Pierre Schneider, Daniel Milhau, J. Vorelle, J. M. Royer.
1978, 12 July- 6 November	Paris, Centre Pompidou. *Paris-Berlin: Rapports et contrastes France-Allemagne, 1900-1933.* Introduction by Werner Spies. 576 p., 727 illus. 60 col. Cross-cultural exhibition devoted to an examination of art, architecture, graphic arts, literature, industrial design, film, theater and music in Germany and France, with emphasis on influences and interrelationship between the art of the two countries. The catalogue is divided into five sections, each containing numerous essays and reprints of pertinent letters, documents, books, catalogues, manifestoes and articles. Major movements covered included Expressionism, Fauvism and Die Brücke, Der Blaue Reiter, Dada, Neue Sachlichkeit-Nouvelle Objectivité, Contructivism-Bauhaus. Exhibited works, borrowed from many collections in Europe and America, include paintings, sculpture, photographs, prints, collages, posters, drawings and decorative arts. a. German ed.: Munich: Prestel, 1979. Reviews: J. Gallego, *Goyá* 145(July-Aug. 1978):35-6; R. Henry, *Du* 38:451(Sept. 1978):24-5; D. Ashton, *Arts Magazine* 53:4(Dec. 1978):106-7; W. Saure, *Kunstwerk* 31:6(Dec. 1978):59-60; C. Friday Paul, *Art News* 78:1(Jan. 1979):48-51; M. Brenson, *Art in America* 67:1(Jan.-Feb. 1979):46-7; T. Gaehtgens, *Pantheon* 37:1(Jan.-Mar. 1979):11-4; S. Spender, *New York Review of Books* 26:5(5 Apr. 1979):22-7.

1978, 16 November- 21 December	London, Lefevre Gallery. *Les Fauves.* Catalogue by Denys Sutton. 32 p., 11 illus. 11 paintings. Exhibition of paintings by Braque, Derain, Matisse, and Vlaminck. Introduction discusses the current state of information about the Fauves and suggests some of the avenues which still remain to be explored.
1979, November	Paris, Grand Palais. *Salon d'Automne. La Grande aventure du Salon d'Automne; 75 ans d'ardeur: Les Fauves.* Texte de Gaston Diehl.
1980, 19 January- 21 March	Aachen, Neue-Galerie-Sammlung Ludwig. *Die neuen Wilden; Les Nouveaux Fauves.* Catalogue by Wolfgang Becker. 2 vol., pl.
1982, Summer	Saint-Tropez, Musée de l'Annonciade. *Fleurs de Fantin-Latour à Marquet.*
1982-83, 29 October- 3 July	Zurich, Kunsthaus. *Nabis und Fauves: Zeichnungen, Aquarelle, Pastelle aus Schweizer Privatbesitz* [Nabis and Fauves: Drawings, Watercolors, Pastels in Swiss Private Collections]. Also shown Bremen, Kunsthalle (27 Feb.-10 April 1983); Bielefeld, Kunsthalle (8 May-3 July 1983). Catalogue by J. Schultze, Rudolf Koella, Margrit Hahnloser-Ingold, Gizella Götte, edited by Ursula Perucchi. 180 p., 244 illus. Exhibition of a selection of drawings, watercolors and pastels by artists of the Nabis and Fauves groups. In two introductory texts, Perucchi discusses the drawings of the Nabis and Schultze the drawings of the Fauves. The catalogue is divided into ten sections as follows, each with introduction placing the exhibited works in the artist's total œuvre: Pierre Bonnard, Edouard Vuillard (Ursula Perucchi); Aristide Maillol, Odilon Redon, Félix Vallotton (Rudolf Koella); Henri Manguin, Albert Marquet, Henri Matisse, Georges Rouault (Margrit Hahnloser-Ingold); Ker-Xavier Roussel. Reviews: F. Baumann, *Du* 10(1982):65-6; H. Zellweger, *Kunstwerk* 36:1(Feb. 1983):30-2; D. Nicholson, *Artscribe* 40(April 1983):20-67; F. Porzio, *D'Ars* 24:101(April 1983):34-43; C. Verna, *Flash Art* 111(March 1983):67; M. Perlman, *Art News* 82:4(April 1983):135+; F-J. Verspohl, Ref *Kunstforum International* 4(April 1983):151-9; R. Micha, *Art International* 26:2(April-June 1983):3-14; K. Berger, *Du* 3(1983):82-3.
1983, 4 June- 2 October	Martigny, Switzerland, Fondation Pierre Gianadda. *Manguin parmi les Fauves.* Catalogue par L. Manguin, Pierre Gassier, M. Hahnloser. 175 p., 107 illus. 24 works shown. Exhibition of 24 paintings and drawings by Henri Manguin (1874-1949) and ten members of the Fauves: Braque, Charles Camoin, Dufy, Emile-Othon

Friesz, Albert Marquet, Matisse, Jean Puy, Louis Valtat, Kees van Dongen, and Maurice de Vlaminck. Gassier gives an account of Fauvism from its origins in meetings of Manguin, Matisse, and Marquet in the studio of Gustave Moreau, to its "official" birth at the Salon d'Automne in 1905, tracing the interest of its members in Cézanne and the decline of the movement as Cézanne's work became more widely known. Hahnloser describes the importance for Manguin of his visits to Switzerland, especially Lausanne. Manguin's daughter gives her recollections of his personality. The exhibit was divided into Fauvist works and works by Manguin from the post-Fauvist period (1908-49). Thirteen French posters of the period were also shown.

1983, 17 November-December New York, Wildenstein Galleries. *La Revue blanche: Paris in the Days of Post-Impressionism and Symbolism.* 97 p., illus., some col.

1984, 13 July-1 October Saint-Tropez, Musée de l'Annonciade. *Le Fauvisme des provençaux.* 95 p., 56 illus., some col. 48 works shown. Paintings by six artists from Provence associated with the Fauve movement: Charles Camoin, August Chabaud, Pierre Girieud, Alfred Lombard, René Seyssaud, and Mathieu Verdilhan. Catalogue contains a separate essay on each artist.

1985, 2 July-8 September Albi, Musée Toulouse-Lautrec. *Du réalisme au surréalisme en Belgique.* Sponsored by Le Crédit Communal de Belgique. Catalogue par Marie-Madeleine Spehl-Robeyns. 88 p., 97 illus., 25 col. Exhibition of Belgian painting and sculpture intended to show developments in Belgian art from 1850 to 1940, focusing on the transition from Realism to Surrealism. Spehl-Robeyns provides a commentary on this transition, discussing the dominating role of Impressionism at the turn of the century and identifying the various influences of Fauvism, Symbolism, Expressionism, Cubism, and abstract art on Belgian art. She mentions important proponents of each and concludes with a brief analysis of Surrealist painting as represented by René Magritte.

1988 Ixelles, Musée d'Ixelles. *L'Impressionnisme et le fauvisme en Belgique/Het impressionisme en het fauvisme in Belgie* [Impressionism and Fauvism in Belgium]. Catalogue par Serge Goyens de Heusch. Préface de Philippe Roberts-Jones. 473 p., illus., some col. In French and Dutch.
a. 2nd ed.: Brussels: Musée d'Ixelles; Ludion, 1990. 320 p., 207 illus., 192 col. In French and Dutch. Review: B. Grauman, *Art News* 90:5(May 1991):165.

1989	Paris, Galerie Berggruen. *Gravures fauves et expressionnistes*. Préface de Fabrice Hergott. 11 p., 45 pl. 52 works shown. Included works from Valtat to Kirchner.
1989-90, 12 December- 1 April	New York, Metropolitan Museum of Art. *Twentieth-Century Modern Masters*. Edited by William S. Lieberman, Foreword by Philippe de Montebello and Sabine Rewald. 355p., 281 illus., 95 col. Exhibition of the Jacques and Natasha Gelman Collection, shown in public for the first time at the Metropolitan Museum of Art, New York. The collection comprises 81 masterpieces, mainly of the art of the School of Paris, by artists including Bonnard, Braque, Dalí, Dubuffet, Matisse, Miró, and Picasso. The entries examine each work both individually and in its broader cultural context. Also inlcuded are essays on art currents such as Fauvism, Cubism, and Surrealism, and appreciations of the artists considered to be among the main proponents of these major developments in the history of 20th century art. An illustrated checklist and an index area appended.
1990-91, 4 October- 1 September	Los Angeles, Los Angeles County Museum of Art. *The Fauve Landscape: Matisse, Derain, Braque, and Their Circle, 1904-1908*. Also shown New York, Metropolitan Museum of Art (19 Feb.-5 May 1991); London, Royal Academy of Arts (10 June-1 Sept. 1991). Catalogue by Judi Freeman with contributions by Roger Benjamin, James D. Herbert, John Klein, Alvin Martin. 350 p., 210 col. illus., col. pl. 345 works shown. Reviews: R. Bernier, *House & Garden* 162:9(Sept. 1990):181-5+; G. Stuttaford, *Publishers Weekly* 237:39(28 Sept. 1990):90; *Time* 136:26(17 Dec. 1990):86; S. Thomas, *Library Journal* 116:1(Jan. 1991):100; S. Young, *Travel-Holiday* 174:1(Jan. 1991):76; J. Pissarro, *Burlington Magazine* 133:1055(Feb. 1991):144-6; R. Fisher, *American Artist* 55:586(March 1991):10; K. Larsen, *New York* 24:12(25 March 1991):71-2; J. Flam, *New York Review of Books* 38:8(25 April 1991):40-2); R. Thomson, *Times Literary Supplement* 4604(28 June 1991):16; G. Auty, *Spectator* 266:8504(6 July 1991):39.
1991, 5 June- 28 December	Boston, Museum of Fine Arts. *Pleasures of Paris: Daumier to Picasso*. Also shown New York, IBM Gallery of Science and Art (15 Oct.-28 Dec.). Catalogue by Barbara Stern Shapiro, with the assistance of Anne E. Havinga. Essays by Susanna Barrows, Philip Dennis Cate, and Barbara Wheaton. Boston: Museum of Fine Arts and David R. Godine, Publisher. 192 p., illus., col. pl. 215 works by 70 artists shown. Included 1 painting by van

Dongen, 1 watercolor by Derain, and 3 watercolors by Rouault.

1993-94, November-February	Houston, Museum of Fine Arts. *Van Gogh to Matisse: Masterpieces from the Cone Collection of the Baltimore Museum of Art.* Included Matisse's *Large Reclining Nude* (1935), *Blue Nude* (1907), and *Purple Robe and Anemones* (1937), among other works. The Cone collection includes some 3,000 objects acquired by the Baltimore sisters Dr. Claribel and Miss Etta Cone between 1898 and 1949. In its entirety the collection includes important works by American artists; hundreds of prints and drawings; illustrated books; a large group of textiles; eighteenth-and nineteenth-century jewelry; furniture and other decorative arts, including Oriental rugs; objects of African art and adornment; Japanese prints; and antique ivories and bronzes. The collection was bequeathed to the Baltimore Museum of Art in 1949 by Etta Cone, who had inherited it at her sister's death in 1929.

Raoul Dufy

Biographical Sketch

Although influenced by both Fauvism and Cubism, Dufy is not generally associated with a particular artistic movement. Critics note that he used various techniques suited to whatever problems he was addressing in his work. Dufy's primary concern was the expression of his imaginative perception rather than an accurate representation of reality. His painting is praised for its apparent spontaneity, elegance, and bold mixture of colors. In addition to painting, Dufy was involved in numerous textile and ceramic projects, claiming the artist has a responsibility to beautify utilitarian objects. His *œuvre* consists of more than 2,000 paintings, as many watercolors, and almost 1,000 drawings. He made more than 200 ceramic pieces. There are almost fifty tapestry cartoons and some 5,000 watercolor and gouache fabric designs. Dufy's stage sets, murals, and monumental decorations are among the most important of his time. When asked to describe his role as an artist, he said: "My eyes were made to efface that which is ugly."

Dufy was born in Le Havre in 1877, a port city on the English Channel. His family's financial difficulties required him to leave school at the age of fourteen to work as a clerk for an importing company, and he began to attend evening classes at the Municipal School of Fine Arts. In 1900 he won a scholarship to l'Ecole des Beaux-Arts in Paris, where he studied under Léon Bonnat for four years. Though right-handed, Dufy began painting with his left hand to moderate his natural dexterity and to express a more elemental vision. His early paintings, mostly landscapes, reveal an adherence to pictorial realism and a strong Impressionist influence. Dufy learned technique from Bonnat, but learned still more from frequent visits to the Louvre, where he was chiefly interested in Claude Lorrain and Giorgione. "Claude Lorrain is my god," he could still say fifty years later.

In 1905 he attended the controversial Salon d'Automne in Paris, which featured the works of Henri Matisse and other Fauve painters. Dufy was particularly impressed with Matisse's *Luxe, calme et volupté*. He later claimed: "At the sight of this picture I understood the new *raison d'être* of painting, and Impressionist realism lost all its charm for me as I beheld this miracle of creative imagination at play, in color and drawing." Dufy felt freed from strict representation by Matisse's use of pure intense color as an expression of emotion, and he immediately adopted a style of painting similar to that of the Fauves. However, he has been described as the tamest of the so-called "wild beasts," restraining the violence of his colors and relying on silhouettes to add structure to his work. During this time Dufy began to develop his distinctive technique of freeing color and line from their traditionally dependent relationship, allowing the color to overflow its boundaries to create a sense of motion. This technique later became known as " The Dufy

style." Dufy also relied on what he called "*le jamais-terminé*", an appearance of unfinishedness that gave his paintings their delicate style.

Dufy's exposure to the works of Paul Cézanne in 1907 heightened his interest in the representation of spatial relationships on a two-dimensional surface, and he embarked on a short-lived Cubist phase. His abandonment of Fauvism momentarily damaged his popularity and after being dropped by his dealer, Berthe Weill, he turned to applied arts. From 197 to 1911 he practiced woodcutting and was commissioned by Guillaume Apollinaire to illustrate his collection of poems, *Bestiaire*. Although the engravings attracted little critical attention, they interested Paul Poiret, founder of the decorative arts school, l'Ecole Martin. Poiret thought that Dufy's woodcuts, with their clarity of detail, would be ideal for printing on fabric. He hired Dufy to design textile patterns and together they created brightly colored clothes with floral and animal patterns. Dufy's work with Poiret eventually led to a long collaboration with the fashion designer Bianchini-Férier, during which he revolutionized the appearance of patterned textiles. Towards 1909 success came quickly and Dufy was able to travel widely over Europe. He paid numerous visits to England, Italy, and, in later years, to Africa.

In the 1920s Dufy began to paint again. His works of this period depict regattas and horse races, nudes, and landscapes. Further developing his characteristically delicate and colorful style, Dufy used physical reality as a springboard for his imagination. From his observations he would extract forms which were rearranged in designs that suggest rather than define. For the 1937 Exposition Internationale in Paris, he painted the mural *La Fée électricité*, which was at that time the largest painting ever completed. This work, which depicts the history of the invention of electricity, is the culmination of Dufy's experiments in color and technique. The success of this painting helped to confirm Dufy's position in French culture and his importance in the development of modern art. In later years Dufy suffered from arthritis, which seriously impeded his work. The range of Dufy's artistic creation was revealed to the public by a major exhibition devoted to him by the Musée d'Art et d'histoire, Geneva, in 1952, and by an important retrospective held in Paris at the Musée d'Art moderne in 1953, a few months after his death by a stroke.

Despite Dufy's efforts to temper his natural skill, early critics frequently viewed his approach as facile and discussed his paintings as spontaneous creations. Noting his preference for depicting scenes of genteel leisure, many also dismissed his work as frivolous and lacking in social relevance. However, later critics recognized Dufy's serious artistic intention, noting he achieved his final vision through numerous sketches and revisions and insisting that while Dufy's subject matter is clearly unsophisticated, his treatment displays a profound awareness of formal concerns. As a result, recent assessments have emphasized the importance of Dufy's experiments with color and composition in the development of modern art.

Raoul Dufy

Chronology, 1877-1953

Information for this chronology was gathered from Dora Perez-Tibi, *Dufy* (New York: Harry N. Abrams, 1989), pp. 319-22; *Œuvres de Raoul Dufy: peintures, aquarelles, dessins.* (Paris: Musée d'Art Moderne de la Ville de Paris, 1976), pp. 77-8; and *Raoul Dufy, 1877-1953* (London: Arts Council of Great Britain, 1983), pp. 2-9; among other sources.

1877 Born at Le Havre, June 3. Othon Friesz is born there in 1879; Georges Braque's family settles there in 1890. Dufy's father works in a metals business but is a keen organist. Dufy develops an early passion for Beethoven, Chopin, and Mozart. There are nine children. Despite a sound education including Latin and Greek, Dufy is forced to leave school at fourteen. First drawing prize at this time.

1891 Joins the Swiss firm of Luthy and Hauser, Brazilian coffee importers. Impressed by products from the colonies. Develops fluency in German language at work.

1892 Takes evening classes at the l'Ecole Municipale des Beaux-arts, and copies Greek and Roman casts. Taught by Charles Lhullier, a pupil of Cabanel, admirer of Ingres, friend of Boudin's, and "a real artist, a great classical draughtsman." Meets Friesz. They rent a "chambre de bonne" for a studio.

1895-98 Plein-air painting on Sundays: the quais at Le Havre and Falaise. Dufy paints a Honfleur on family trips to his mother's birthplace and does small family portraits. With Friesz he studies Boudin at the Musée du Havre, and Poussin, Corot, Géricault, and Delacroix at the Musée des Beaux-arts, Rouen.

1898 Military service for one year until Dufy's brother Gaston enrolls as a flautist, releasing his brother.

1900 Wins a 1,200 franc annual scholarship from the Le Havre authorities for l'Ecole des Beaux-arts, Paris. Rejoins Friesz who started there in 1897.

Taught by Léon Bonnat, the most famous official painter of the period. However, the academic atmosphere is uninspiring. "Terrified" by the Louvre—apart from the works of Giorgione and Claude, Dufy is impressed by Gauguin, van Gogh, and above all Pissarro, Monet and the Impressionists, on view at the Vollard and Durand-Ruel Galleries. His own early drawings of real-life scenes are close to Toulouse-Lautrec; his "Impressionist" style is closest to Guillaumin. May have visited Gustave Moreau's studio and encountered the work of Matisse. Dufy lives in the rue Cortot, Montmartre. Picasso, Derain, and Utrillo are neighbors.

1901
Fin de journée au Havre shown at Salon des Artistes Françaises. First *Plage à Sainte-Adresse*. Van Gogh retrospective at the Galerie Bernheim-Jeune.

1902
Berthe Weill buys a pastel: *La Rue Norvins*. Dufy figures in six group shows at her gallery between 1903 and 1909 and in 1925. Matisse, Marquet, Derain, Vlaminck, and Picasso also show pictures at the gallery.

1903
Lives at 15, rue Victor Massé. Two paintings exhibited at the Salon des Indépendants, one bought by Maurice Denis. Exhibits there regularly until 1911, then in 1913 and sporadically in 1920s and 1930s. Paints at Martigues.

1904
Visits Fécamp with Marquet and makes second visit to Martigues. Braque arrives in Montmartre. Dufy and Friesz introduce him to their circle. Studio at 31 quai Bourbon, 1904-05.

1905
Dufy recalled in 1925 his revelation at the sight of Matisse's *Luxe, calme et volupté* at the 1905 Salon des Indépendants: "I understood the new *raison d'être* of painting and impressionist realism lost all its charm for me as I looked at this miracle of creative imagination at work in colour and line." Paints the market at Marseille. Critic Louis Vauxcelles christens "les Fauves" at the Salon d'Automne where the Manet retrospective emphasizes the formal properties of color. Friendship with Marquet. Dufy is dropped by his dealer Blot on account of his new Fauvist style.

1906
First one-artist show at Berthe Weill's. Works with Friesz at Falaise, with Braque at Durtal, and with Marquet at Trouville where both compete to paint a billboard. Exhibits seven works at the Salon d'Automne, including two *Rues pavoisées*. A large Gauguin retrospective and Derain's views of London are also on exhibit.

1907
Summer in Normandy at Sainte-Adresse. *Pêcheurs* series shows Japanese influence. Martigues and Marseille in fall. Cézanne retrospective of fifty-six works at the Salon d'Automne.

1908
Spends summer in close collaboration with Braque at L'Estaque. Abandons Fauvism for a Cézannesque palette, composition, and facture. *Décorations scolaires* exhibited at the Salon d'Automne. Experiments with a deliberately naive, "childish" style.

1909	Heavy nudes show contact with Braque and primitivism. Frequents the Bateau Lavoir, Picasso, Braque, and Gris. Great material difficulties. Sells drawings for five francs each along with Lhote and van Dongen to *Paris Journal*. Studio in the rue Séguier. Journeys to Munich with Friesz to see the "Art Munichois" style. The Ballets Russes arrive in Paris.
1909-10	With Fernand Fleuret in Provence and then Marseille. First woodcuts for Fleuret's *Friperies* (published 1923) and for Apollinaire's *Bestaire*. Wins a place at the Villa Medicis Libre founded by Bonjean for impoverished artists. Fellow boarders include André Lhote and Jean Marchand. Studies thoroughbred horses on the farm. Impressed by the sculpture and stained glass at Evreux Cathedral.
1910	Completes *Bestiaire* woodcuts in his new studio, rue Linné, and sees Guillaume Apollinaire daily. Five plates shown at the Salon d'Automne, along with prints of *La Danse, L'Amour, La Chasse,* and *La Musique.* Matisse shows *La Danse* and *La Musique.* L'Exposition des Arts décoratifs de Munich dominates the Fall Salon.
1910-11	Paul Poiret commissions Dufy to decorate the Pavillon de Butard and his notepaper at the Maison de Couture.
1911	Poiret founds l'Ecole Martine in April followed by the "Petite Usine," Boulevard de Clichy, where Dufy experiments with textile printing. Paints awning for *La Mille et Deuxième Nuit,* the Persian fête held in Poiret's garden. Dufy marries Emilienne Brisson and rents a studio in Montmartre, 5 Impasse de Guelma, which he retains until his death. Exhibits at the Berlin Secession and in Amsterdam. His *Bestiaire* is published by Delplanche and eventually remaindered at 25 francs a copy.
1911-12	First of four hangings made for Paul Poiret including *La Danse* and *La Chasse.* Execution of several primitive woodcut series for Emile Verhaeren's *Poèmes Légendiares de France et de Brabant* (1916), Poiret's *Almanach des lettres et des arts* (1917), Remy de Gourmont's *M. Croquant* (1928), and the *Almanachs de Cocaigne* (1920, 1921, and 1922). First *Baigneuse.*
1912	Works at Petite Usine. Contract with Bianchini-Férier begins in March. In two group shows at Der Sturm Gallery, Berlin. Visits Salzburg.
1913	Visit to Hyères. Exhibits at the Neue Secession in Berlin, the Armory show in New York, and in Chicago, Boston and Paris.
1914	War declared. Dufy drives a van for the military postal service. His work is exhibited in Vienna and Prague and at l'Exposition des Arts décoratifs de Grande Bretagne et d'Irlande.
1915	Illustrations in Cocteau's journal *Le Mot.* Between 1915 and 1919 he creates over one hundred fabric designs assisted by Gabriel Fournier.

1916	Poiret allows André Salmon to hold L'Art moderne in France at the Galerie Barbazanges, whose premises Poiret owns and where he is allowed to hold an annual exhibition.
1917	Dufy supervises paintings and drawings at the Musée de la Guerre, under Camille Bloch, and purchases work by Dunoyer de Segonzac and Luc-Albert Moreau. *Les Peintres de la guerre au camouflage* shows their work at the Galerie Barbazanges. Dufy's woodcuts are published in Poiret's *Almanach des lettres et des arts* and Roger Allard's *Les Elégies martiales*, ed. Bloch.
1918	Dufy resumes work for Bianchini-Férier. André Robert becomes his assistant.
1919	Regularly attends Joachim Gasquet's dinners at the Café des Tourelles in Passy and meets Paul Valéry. Works for Poiret's Oasis Theatre during summers of 1919 and 1920.
1920	Scenery with Fauconnet for Cocteau's *Le Boeuf sur le toit*, Théâtre des Champs-Elysées and London Coliseum. Summer in Venice affects development of Dufy's painting of the 1920s. Poiret's summer collection with Dufy's fabrics appears in the *Gazette du Bon ton*. The "toiles de Tournon" are published here and in other magazines. Illustrates six publications, including Marcel Willard's *Tour de l'horizon*, Remy de Gourmont's *Des Pensées inédites*, and Mallarmé's *Madrigaux*.
1921	Seven fabrics exhibited at the Salon des Artistes décorateurs, where he exhibits in 1922, 1923, 1939 and 1947. First one-artist show of over ninety works at the Galerie Bernheim-Jeune, where he exhibits again in 1922, 1924, 1926, 1927, 1929, and 1932. Lithograph of Paul Claudel for the latter's *Ode jubilaire pour le six centième anniversaire de la mort de Dante*.
1922	In June meets Dr. Rodinesco, one of his greatest future collectors. They dine with Gustave Coquiot and his wife. Décors for the ballet *Frivolant*.
1922-23	Journeys to Florence and Rome. Joins Pierre Courthion in Taormina, Sicily, and meets D. H. Lawrence at Caltagirone. Becomes a successful Parisian figure and divides his time henceforth between Paris and the Midi.
1923	Collaborates with Artigas on ceramics until 1930. First tapestry commission, Manufacture de Beauvais. In March, Dufy and J.-E. Laboreur organize the first Exposition du Groupe des peintres-graveurs indépendants at the Galerie Barbazanges (repeated in 1924). Later in the year *La Collection particulière de M. Paul Poiret* held there includes many Dufys, including the 1915 watercolor *Hommage à Mozart*. Success of exhibition at the Galerie Le Centaure Brussels attracts Belgian collectors and museum curators. Project for décors for *Romeo et Juliette*. First visit to London.

1925 Exposition des Arts décoratifs, Paris. Dufy creates fourteen wall hangings, *tentures* for Poiret's barge *Orgues* in mordant colors. These are later exhibited at the Galerie Barbazanges-Hodebert. Ceramic fountain for "La Renaissance" pavilion. Substantial sale of Poiret's collection at Hôtel Drouot in November. Designs backdrop for René Kerdyck's ballet *Adieu Paris*. Illustrates Gustave Coquiot's *La Terre frottée d'ail* (exhibited at the Galerie Pierre, 1926). Strong series of *Marne* paintings precede 1935-36 treatment of theme. Portraits of Cocteau and Remy de Gourmont. Visits London.

1926 With Poiret and Poiret's son Colin to Morocco. Entertained by the Sultan. Views of Fez, Tlemcen, and Marrakesh; returns in May to exhibit them at Bernheim-Jeune's. Describes his experiences to Christian Zervos for the new *Cahiers d'art*. Thirty-six lithographs for Apollinaire's *Le Poète assassiné*.

1927 Works at Nice, Vallauris, and Golfe Juan. *Hommage à Claude Lorrain*. Individual show at Galerie la Portique, Brussels (Coquiot illustrations, oils, and watercolors). Ceramic gardens and *tentures* exhibited at Bernheim-Jeune's. Included in first retrospective of Fauvism at the Galerie Bing. Begins continuous decoration for Dr. Viard's dining room depicting an imaginary route from Paris to the sea.

1928 Special Dufy number of *Sélection* in Antwerp and first monograph by Christian Zervos. Dufy's only known terra cotta sculpture of a female nude published in *Cahiers d'Art*. Dufy entertains grandly at his villa at Villerville.

1928-29 Mural decorations for Arthur Weisweiller's villa *L'Altana* at Antibes.

1929 Paints at Nice, Cannes, and Deauville. First trip to Cowes for regatta. Contract with Bernheim-Jeune, Etienne Bignou, and Marcelle Berr de Turique.

1930 Exhibition at Galerie la Portique celebrates publication of Marcell Berr de Turique's monograph. Ninety-four etchings for Eugène de Montfort's *La Belle Enfant* published by Vollard. Two portrait vases of Vollard. Portraits of M. Bignou and of his son. Paints at Deauville and in England: "I've done the Henly regatta and I've still to see the Cowes regatta and the Goodwood races. After that I think England will be satisfied" (letter of June 25). In August stays with Mrs. Workman at Hayling Island, when the Kessler family portrait is commissioned. Begins collaboration with Marie Cuttoli for tapestries (to 1940) and with the Maison Onondaga, New York, for fabric designs (to 1933).

1931 Monographs by Fernand Fleuret and René Jean. Dr. Roudinesco founds "Scripta et Picta," a society of bibliophiles and chooses Daudet's *Tartarin de Tarascon* for Dufy to illustrate—a project that will occupy him until 1937. Individual shows in Brussels, Zurich, and twenty-one works in an "Ecole de Paris" exhibition in Prague. Returns to England to continue

work on the Kessler family portrait. Completes first version: *Les Cavaliers sous bois*.

1932 Dufy's first suite of furniture exhibited at Bernheim-Jeune's. Back in London and he draws the world heavyweight boxer Primo Carnera at a championship match in the Albert Hall. Second version of the Kessler family portrait.

1933 Finishes Dr. Viard's dining room. Décors for *Palm Beach*, music by Jean Français, Ballets du Comte de Beaumont, Théâtre des Champs-Elysées. Works in Langres, Normandy (first *Champ de blé* series), the Riviera, and England (Epsom races).

1934 Visits Brussels for an important exhibition at the Palais des Beaux-Arts of drawings, watercolors, and *tentures*. First *Chateaux de la Loire* watercolors (1934-38). Décor for René Kerdyck's *Oeuf de Colombe* at the Comédie Française and for *Romeo et Juliette* again at the Théâtre de la Cigale. Trip to Cowes. First *Royal Yacht Club*.

1935 Proposes to decorate the swimming pool of the luxury liner *Normandie* with amphytrites, the statues at Versailles, fountains of the Place de la Concorde, beach scenes, etc. Withdraws when project is thrown open to competition. Meets Jacques Maroger whose "medium" revolutionizes Dufy's painting technique after 1936.

1936 First London exhibition at Reid and Lefevre includes a *Nogent sur Marne* of 1935, a *L'Atelier de l'artiste*, the *Portrait of Mme. Dufy*, and *Les Deux modèles*. Publication of *Mon Docteur le vin* with nineteen watercolors by Dufy for the wine firm Nicolas.

1937 Exposition Universelle, Paris: *La Fée Electricité*, commissioned and begun in 1936, is exhibited in the Palais de la Lumière. Dufy refuses to exhibit it in a New York department store, but travels to Pittsburgh as a member for the Carnegie Prize Jury. Important exhibition of thirty-four works at *Maîtres de l'art indépendant*, Petit Palais. First attack of polyarthritis.

1937-40 Mural decoration for the Palais de Chaillot theatre bar: *La Seine, l'Oise et la Marne*, showing the course of the Seine from Paris to its estuary at Le Havre.

1938 Replica version of *La Fée Electricité*. Exhibitions in New York, Chicago, Basel, and London where Alex, Reid and Lefevre show *The Chateaux of the Loire* including Mrs. Kessler's *Champ de blé*. Designs for *Epsom*, choreography by Massine, Ballets Russes de Monté-Carlo.

1939-40 Decorative panels for the Singerie at the Jardin des Plantes, Paris, showing outstanding French explorers and Kipling, etc. When war is declared, Dufy continues to work on this and the Palais de Chaillot murals at Saint-Denis-sur-Sarthon.

1940 Goes to Nice, then to Céret where he is joined by the poet Pierre Camo and Artigas. To Aix les bains to take a cure, where he meets Gertrude Stein and visits her at Culoz. Increasingly crippled by arthritis, Dufy finally settles at Perpignan, where he has a studio in rue Jeanne d'Arc until 1946. Two Aubusson tapestry cartoons.

1941 Meets Louis Carré. First exhibition of watercolors at his gallery. First copies of Renoir's *Moulin de la Galette*—main version 1943. *Le Bel eté* tapestry woven at Aubusson.

1942 Short trip to Occupied Paris. Exhibits at the Galerie de France in *Les Fauves, 1903-1908*. Décors for Jean Anouilh's *Antigone*.

1943 Paints at Vernet-les-Bains. Summer at Montsaures, Haute-Garonne, with Roland Dorgelès where he watches threshers at work and creates the first "dépiquages" series. At the height of the Occupation, the Palais des Beaux-arts, Brussels organizes an important Dufy exhibition with local resources.

1944 Scenery for *Les Fiancés du Havre* by Armand Salacrou at the Comédie Française. Carré publishes a luxury facsimile edition of his drawings and sketches.

1945 Trip to Vence. Paints the first of the *Cargo noir* series.

1946 The cellist Pablo Casals often plays while Dufy draws and paints. Chamber music and orchestra series continues. Suite of furniture for Marie Cuttoli and two Aubusson Tabard tapestries are exhibited at the Musée National d'art moderne in *La Tapisserie française du moyen age à nos jours*. Gertrude Stein's text, "Raoul Dufy," appears in a Brussels art journal. Dufy exhibits at the Salon des Tuileries, as he would in 1948, 1949, 1950, 1951, and 1953.

1947 Watercolors and drawings exhibited at the Galerie Louis Carré, preface by Claude Roger-Marx: *Raoul Dufy, ou les miracles de la main gauche*. Shows at the Salon de Mai, the Salon des Artistes décorateurs and at the Palais des Pâpes, Avignon.

1948 Cocteau publishes a monograph on Dufy. *Tapisseries de haute-lisse* shown at the Galerie Louis Carré. May 2, 1948-April 11, 1950: conversations with Pierre Courthion in Perpignan that form the basis of his definitive study of 1951. Shows Courthion drawings for Paul Valéry's *Bucoliques* (unpublished). Continues *Cargo noir* series until 1952.

1949 Visit to Spain—Avila and Toledo: bull fight paintings. Watercolors of flowers for Colette's *Pour un herbier* (1950). Exhibits at the Galerie Louis Carré, New York.

1950 Exhibits in four retrospectives of Fauvism at Bern, Copenhagen, New York, and the 25th Venice Biennale. Shows at the Perls Galleries, New York and Lefevre Gallery, London. Opens Othon Friesz posthumous

retrospective. Last view of Le Havre as Dufy sails to the United States for treatment by Freddy T. Homburger at the Jewish Memorial Hospital, Boston. Designs scenery for Anouilh's *Invitation au château*, translated by Christopher Fry as *Ring Round the Moon*, and produced by Gilbert Miller in New York.

1951 Exhibits in New York, Pittsburg, Washington, Richmond, Virginia, and Chicago. Paints jazz bands in Mexico. In September, Lincoln Kerstein commissions *A la Françaix* for the New York City Ballet with music by Jean Françaix and choreography by George Balanchine. Major Fauvism retrospective at the Musée National d'Art moderne. *Tentures* and fabrics shown at international textile exhibition in Lille.

1952 Largest retrospective yet at the Musée d'Art et d'histoire, Geneva. Dufy travels to Venice, where forty-one paintings are exhibited at the 26th Biennale. Awarded the Grand Prix (won by Braque in 1948 and Matisse in 1950). Donates prize money to Charles Lapique for a stay in Venice and to the Italian painter, Vedova, for a trip to France. Settles in Forcalquier, Basse Alpes. Léon-Paul Fargue's *Illuminations nouvelles* is published with Dufy illustrations. The O'Hana Gallery holds an *Exhibition of Raoul Dufy Racecourses*, the first important post-war showing of his work in London.

1953 "Sachez que la vieillesse n'existe pas" had been Dufy's parting words to Dr. Roudinesco in Paris the previous year. Dufy dies on March 23 at Forcalquier and is buried at the Cimiez cemetery, overlooking Nice.
Works are exhibited at three Paris salons. The lithograph version of *La Fée Electricité* with Dufy's retouchings in gouache is shown at the Galerie Charpentier. Important retrospectives—in Paris, where Musée National d'Art moderne shows 266 items including the whole range of decorative work, at the Ny Carlsberg Glyptotek, Copenhagen, in New York, and in Edinburgh.

1953-63 Retrospectives continue in 1954: Madrid, Basel, San Francisco, Los Angeles, Bern, Knokke-le-Zoute, Honfleur, Le Havre, Marseille, and at the Tate Gallery, London, which shows seventy-eight paintings and eleven watercolors. Major retrospectives continue from 1954-57 and notably in 1963, when Mme. Dufy's bequest to the state is exhibited in Paris, Le Havre, and Nice.

Raoul Dufy

Bibliography

I. Statements by Dufy

622. DUFY, RAOUL. "Croquis de modes." *Gazette du bon ton* 1(1920).

623. DUFY, RAOUL. "Robes pour l'été." *Gazette du bon ton* 4(1920).

624. DUFY, RAOUL. "Toiles de Tournon." *Gazette du bon ton* 8(1920):18-9.

625. DUFY, RAOUL. "Les Tissus imprimés." *L'Amour de l'art* 1(May 1920):18-9.

626. DUFY, RAOUL. "Comment je comprends la peinture." *Beaux-arts* 156(27 Dec. 1935):1.

627. DUFY, RAOUL and M. WILMES (Interviewer). "Dufy nous parle de son exposition." *Panorama* (17 June 1943).

Includes "Mes causeries avec la peintre"—conversations from May 2, 1948 to April 11, 1950.

II. Archival Materials

628. DUFY, RAOUL. *Letters*, 1913-50. ca. 30 items. Holographs, signed; typescripts. Located at The Getty Center for the History of Art and the Humanities, Archives of the History of Art, Santa Monica, California.

Letters are addressed to several correspondents and contain discussion of work-in-progress, the sale of watercolors, exhibitions, travel plans, health, personal matters, wartime conditions, musical interests, and book illustration, including Guillaume Apollinaire's *Le Bestiare.* Correspondents include, among others, Gustave and Mauricia Coquiot, Pierre Geismar, Luc-Albert Moreau, Etienne Bignou, Alexandre Roudinesco, Georges Iackowski, and Berthe Weill. In chronological order.

629. DUFY, RAOUL. *Algerie* (sketchbook), 1943. 1 vol. Manuscript. Located at The Getty Center for the History of Art and the Humanities, Archives of the History of Art, Santa Monica, California.

Sketchbook recording impressions of a cruise to Algeria, with shipboard scenes, landscapes, and notes on the colors in nature included.

630. COURTHION, PIERRE. *Correspondence*, ca. 1950-80. ca. 250 items. Holographs signed. Located at The Getty Center for the History of Art and the Humanities, Archives of the History of Art, Santa Monica, California.

Courthion (1902-) was a French art critic and historian, student at l'Université de Genève; Ecole des Beaux-arts, Paris; and Ecole du Louvre. From 1933 to 1939 he was director of the Cité Universitaire de Paris.

Collection consists of general correspondence with numerous scholars and artists, most notable among them: Bonnard, Rouault, Nicolas de Staël, Miró, Maurice Esteve, René Auberjonois, Paul Klee, Raoul Dufy, Alexander Calder, and Ramuz.

631. CROTTI, JEAN. *Papers*, 1910-73. ca. 1,000 items (on 2 microfilm rolls). Located at the Archives of American Art, Smithsonian Institution, Washington, D.C.

Crotti (1878-1958) was a French painter. His papers include biographical material and autobiographical notes; letters to Suzanne Duchamp, Marie and Lysbeth Crotti, and others; letters from Jean Cocteau, Marcel Duchamp, Raoul Dufy, Waldemar George, Albert Gleizes, George Herbist, Pierre de Massot, Henri Matisse, Walter Pach, Clément Pansaers, Francis Picabia, Pierre Renoir, André Salmon, Paul Signac, Jean Villern, Jacques Villon, and others; sketches and a print by Crotti, and sketches of Crotti by Henri Coutour, Paul Guillaume and Picabia; writings by and about Crotti; exhibition announcements and catalogs; clippings; miscellany; photographs of Crotti, Suzanne Duchamp, and others, works of art, and exhibition installations. Also included but not microfilmed are three phonographs records, an etching plate, and miscellaneous printed material.

632. REIS, BERNARD and REBECCA, REIS. *Papers*, ca. 1935-81. ca. 8 linear ft. Manuscripts (holographs, typescripts); printed matter; photographs. Located at The Getty Center for the History of Art and the Humanities, Archives of the History of Art, Santa Monica, California.

Bernard Reis served as a financial advisor and patron to emerging artists: Rebecca Reis, his wife, was an art collector and hostess. Their papers consist of personal records, business and financial records and correspondence, material relating to the Reis art collection, letters received and printed ephemera (catalogues, invitations, announcements, clippings, etc.). The papers present an interesting picture of post-War American art patronage and collection-building, and art law as it relates to the establishment of artists' trusts and foundations.

Series IV, boxes 3-4, includes letters received, ca. 1935-78, from Raoul Dufy, among many others.

633. ROUDINESCO, ALEXANDRE. *Letters Received*, 1918-49. 74 items. Holograph signed. Located at The Getty Center for the History of Art and the Humanities, Archives of the History of Art, Santa Monica, California.

Collection consists of letters to the Parisian art collector Dr. Roudinesco (1883-) from various Fauve painters.

Most date from the 1930s and represent an unusually intimate and informative relationship between artists and patron. Letters include 30 from Maurice de Vlaminck, 1932-48; 28 from Raoul Dufy, 1918-36; 8 from Paul Signac, 1926-34; 6 from Kees van Dongen, 1930; and 2 from Georges Rouault.

III. Biography and Career Development

Books

634. ALLARD, ROGER. *Raoul Dufy*. Paris: *L'Art d'Aujourd'hui;* A. Morancé, 1925. 10 p., illus., 9 pl.

635. BERR DE TURIQUE, MARCELLE. *Raoul Dufy*. Paris: Librarie Floury, 1930. 285 p., illus., some col. 15 pl.

636. BESSON, GEORGE. *Dufy*. Paris: Braun et Cie; New York: Herrmann, 1953. 64 p., illus., pl. Volume in "Palettes" series.

637. CAMO, PIERRE. *Raoul Dufy l'enchanteur*. Lausanne: Marguerat, 1946. 152., pl., some col.

a. Another ed.: 1947.

638. COCTEAU, JEAN. *Dufy*. Paris: Flammarion, 1948. 9 p., illus., 10 pl. Volume in "Les Maîtres du dessin" series.

a. Another ed.: 1949.

639. COGNIAT, RAYMOND. *Raoul Dufy*. Paris: Braun, 1939. 63 p., 60 illus. Volume in "Les Maîtres" series.

a. Other eds.: 1950; Geneva, 1951.

640. COGNIAT, RAYMOND. *Raoul Dufy*. Paris: Flammarion, 1962. 92 p., illus., some col. Volume in "Les Grands maîtres de la peinture moderne" series.

a. Another ed.: 1967. 94 p., illus., some col.
b. U.S. ed.: Trans. by Thomas L. Callow. New York: Crown Publishers, 1962. 92 p., illus., some col.

641. DIEHL, GASTON. *Peintres d'aujourd'hui, les maîtres. Témoignages de Georges Braque . . . Raoul Dufy . . . recuillis par Gaston Diehl*. Paris: Les Publications Techniques, 1943. 35 p., illus. Volume in "Comédia-Charpentier" series.

642. DUFY, RAOUL. *Dufy*. Paris: Louis Carré, 1953.

643. GAUTHIER, MAXIMILIEN. *Raoul Dufy*. Paris: Les Gémeaux, 1949. 22p., illus.

644. GAUTHIER, MAXIMILIEN. *Raoul Dufy (1877-1953)*. Flammarion, 1955. Volume in "Le Grand art en livre de poche" series.

a. Another ed.: 1958.

645. HUGGLER, MAX. *Raoul Dufy*. Basel: Phoebus-Verlag, 1958.

646. HUNTER, SAM. *Raoul Dufy (1877-1953)*. New York: H. N. Abrams, 1954. 20 p., illus., 15 pl, some col. Volume in "Art Treasures of the World" series.

647. JEAN, RENE. *Raoul Dufy*. Paris: G. Crès, 1931. 13 p., illus., 32 pl. Volume in "Les Artistes nouveaux" series.

648. JEDDING, HERMANN. *Raoul Dufy*. Wiesbaden, Berlin: E. Vollmer, n.d.

649. LASSAIGNE, JACQUES. *Dufy, étude biographique et critique*. Geneva: Skira, 1954. 119 p., illus., some col. Volume in "Le Goût de notre temps" series.

a. German ed.: *Dufy; Biographisch-Kritische Studie*. Geneva: Skira, 1954. 119 p., col. illus.
b. English ed.: Geneva: Skira, New York: dist. by Crown Publishers, 1972. 119 p., illus.
c. U.S. ed.: Geneva: Skira, New York: dist. by Crown Publishers, 1972. 119 p., illus.

650. WERNER, ALFRED. *Rousseau/Dufy*. Text and Notes by Alfred Werner. New York: Tudor Publishing Co., 1970. 40 p., 92 col. pl.

651. WERNER, ALFRED. *Raoul Dufy (1877-1953)*. New York: H. N. Abrams; in association with Pocket Books, 1953. 74 p., illus., 34 col. Volume in "The Pocket Library of Great Art."

652. WERNER, ALFRED. *Raoul Dufy*. NewYork: Harry N. Abrams, 1985. 167 p., 121 illus., Volume in "The Library of Great Painters" series.

Presents a selection of his drawings, prints and paintings, the forty-eight oils watercolors, and gouaches illustrated in color being individually discussed in terms of style and content. Werner traces Dufy's life and artistic career from the genteel poverty of his family background and his studies in Le Havre, through a period of Fauvism when he profited from his association with Braque and Matisse. Also influenced by he profited from his association by Cézanne and Cubism, Dufy experimented until he developed his style, deeply rooted in the French decorative tradition, with which to record the fashionable world that was his main theme, though his repertoire included bathers, nudes, circus performers, birds, flowers, and cityscapes.
a. 2nd ed.: New York: Abrams, 1987. 128 p., 97 illus.
b. French ed.: Trans. by Béatrice Perrin. Paris: Editions Cercle d'Art, 1985. 167 p., illus. some col.

Articles

653. ALLARD, ROGER. "De Montmartre au quai de New York." *Nouvelles littéraires* (16 July 1953).

654. ARLAND, MARCEL. "Dufy." *Nouvelle revue frannçaise* 5(1 May 1953):919-20.

655. BAROTTE, RENE. "Raoul Dufy parmi nous." *France-Amerique* (30 April 1950):1,4.

656. BESSON, GEORGE. "L'Adieu à Raoul Dufy." *Les Lettres françaises* (26 March 1953):8.

657. BETTEMS, ANNE. "Raoul Dufy." *Pour l'art* 20(1951):27-8.

658. BOWES, CATHERINE. "Dufy Remembered." *Modern Painters* 3:4(Winter 1990-91):56-8.

Bowes recalls her early experiences as an *au pair* to the Nicolau family who befriended Jean Cocteau and Raoul Dufy. She describes her memories of the two years from 1939 when she lived in the Nicolau's home in the South of France, which became a meeting place for artists after the outbreak of the Second World War and German occupation, mentions the artists who visited and worked with Dufy, and praises those whose work during that period was produced against constraints of illness and political upheaval. The paintings of these artists, who until recently have been neglected, were exhibited at the Hayward Gallery in 1983-84.

659. CABANNE, PIERRE. "Ses carnets intimes montrent: une longue méditation éveillait en lui le miracle de peindre." *Arts* 874(20-26 June 1962):15.

660. *Cahiers d'art. Index général de la revue 'Cahiers d'art', 1926-1960.* Paris: Editions 'Cahiers d'art', 1981.

See page 21 for articles on Dufy.

661. CHARENSOL, GEORGES. "Retour d'amerique, Raoul Dufy nous dit." *Beaux-arts magazine* (3 Dec. 1937):1+.

662. CHASTEL, ANDRE. "La Vraie grandeur de Raoul Dufy." *Le Monde* (26 July 1958).

663. CLAY, JEAN. "He was Too Good with His Right Hand so He Painted with His Left." *Réalities* 242(Jan. 1971):32-7. 7 illus.

664. COGNIAT, RENE. "Les Débuts de Raoul Dufy." *Nouvelles littéraires* (Feb. 1933).

665. COLOMBIER, PIERRE DU. "Au Moulin de Vauboyen, Raoul Dufy. Pensons à lui." *L'Amateur d'art* 420(21 Nov. 1968):16.

666. DAGRON, JEAN. "Raoul Dufy évoqué par son ami Mazaraki." *Nice-matin* (6 Aug. 1953).

667. DAVIDSON, MARTHA. "View of Raoul Dufy, Modern Rococo Master." *Art News* 36(26 March 1938):19, 27.

668. DORGELES, ROLAND. "Raoul Dufy." *Les Lettres françaises* (20 Dec. 1944).

669. "Dufy, années 1940-50: côte bien orchestrée." *Connaissance des arts* 218(April 1970):135.

670. "Dufy at Seventy-Two." *Apollo* 52(Aug. 1950):37.

671. "Dufy, Raoul." *Current Biography* 12:3(March 1951):23-6.

672. ENGEN, J. "Pinning the Butterfly." *Art Book Review* 1:2(1982):93-4.

673. ESDRAS-GROSSE, BERNARD. "De Raoul Dufy à Jean Dubuffet: ou la descendance du 'Pere' Lhullier." *Etudes normandes* (Rouen) 59(1955):18-42.

674. FLEURET, FERNAND. "Eloge de Raoul Dufy." *Mercure de France* (1933).

675. FLEURET, FERNAND. "Raoul Dufy." *Le Point* 3(1937):104-8.

676. FOURNIER, GABRIEL. "Mon ami Raoul Dufy." *Jardin des arts* 5(March 1955).285-92.

677. GAUTHIER, MAXIMILIEN. "Raoul Dufy" *Art vivant* (1930).

678. GAUTHIER, MAXIMILIEN. "Jeunesse de Raoul Dufy." *Art vivant* (1945):38-41.

679. GUENNE, JACQUES. "Sur une image de Raoul Dufy." *Art vivant* (1932):587.

680. GUTH, PAUL. "Un grand artist se penche sur son passé . . . Comment Dufy qui manqua d'être musicien devient l'un des meilleurs peintres de ce tempos. Propos recueillis par Paul Guth." *Le Figaro littéraire* (11 Aug. 1951):4.

681. GUTH, PAUL. "La Vie de Raoul Dufy." *Connaissance des arts* 16(June 1953):48-53.

682. "Happy Genius: Raoul Dufy Whose Art was Exuberant." *American Artist* 32(Dec. 1968):60-6. 12 illus.

683. HEILMAIER, HANS. "Dufy." *Kunst* 61:5(Feb.1930):143-6.

684. HEILMAIER, HANS. "Raoul Dufy." *Kunst* 52(1953-54):286-8.

685. HOMBURGER, FRED. "Raoul Dufy, Artist and Patient." *Postgraduate Medicine* (Dec. 1953).

686. HOMBURGER, FRED and CHARLES D. BONNER. "The Treatment of Raoul Dufy's Arthritis." *The New England Journal of Medicine* 3001:12(20 Sept. 1979):669-72.

687. IMBOURG, PIERRE. "Dufy dans son travail quotidien." *L'Amateur d'art* 420(21 Nov. 1968):16-8.

688. LAFFAILLE, MAURICE. "Les Voyages de Raoul Dufy." *L'Œil* 220(Nov. 1973):34-7. 10 illus.

Account of the part played in Dufy's work by his various travels in Europe, North Africa and America, with particular reference to his visits to Munich in 1909, Sicily in 1922 (the *Taormina* series), and Morocco in 1925. Dufy's racecourse and boating series, executed in France and England, his views done in Italy, and the work of his trip to the United States at the end of his career are also mentioned.

689. LAFFAILLE, MAURICE. "Raoul Dufy: un centennaire escamoté." *Le Quotidien de Paris* (11 Oct. 1977):14.

690. LAFFAILE, MAURICE. "Peintre maudit?" *L'Œil* 269(Dec. 1977):63.

691. LASSAIGNE, JACQUES. "Raoul Dufy et la participation française à la XXVIᵉ Biennale de Venise." *Les Arts plastiques* 6(June-July 1952):445-7.

692. LASSAIGNE, JACQUES. "Raoul Dufy." *Arts* 491(24-30 Nov. 1954).

693. LASSAIGNE, JACQUES. "Raoul Dufy." *Médecines et peintures* 80(ca. 1955-60). 13 p.

Special issue devoted to Dufy, published in Arcueil by Innothéra.

694. "Last of Dufy." *Life* 34(13 April 1953):135-6.

695. LHOTE, ANDRE. "Mon compagnon." *Les Lettres françaises* (23 March 1953).

696. LIEVRE, PIERRE. "Raoul Dufy." *L'Amour de l'art* (May 1921):146-51.

697. MARTIN, ALVIN and JUDI FREEMAN. "The Distant Cousins in Normandy" in *The Fauve Landscape,* edited by Judi Freeman (New York: Abbeville, 1990), pp. 215-39. 33 illus., 20 col.

Claims that the work of Braque, Friesz, and Dufy differs from that of their Fauvist colleagues. These Normandy artists, who were more closely related to Impressionism, portrayed industrial scenes and the life surrounding these. They were all originally from Le Havre and this port provided the subject matter for their paintings. Each artist's work is analyzed, Friesz leading the other two towards Fauvist principles, Braque leading the way away from these.

698. MICHEL, JACQUES. "Dufy l'enchanteur." *Le Monde* (29 Oct. 1976).

699. MICHEL, JACQUES. "Raoul Dufy, imagier de charme." *Le Monde* (23 Aug. 1977).

700. MICHEL, JACQUES. "Le Dernier hommage à Dufy." *Le Monde* (19 Oct. 1977).

701. MOSDYC. "L'Art Kaser." *Au Pilori* (20 May 1943).

Attack on Dufy in the collaborationist journal.

702. Obituaries: *Art Digest* 27(1 April 1953):10; *Art News* 52(May 1953):7; *Studio* 146(July 1953):24; P. Guth, *Connaissance des arts* 16(1953):48-53.

703. "Photograph by S. H. Roth." *Time* 60(1 Sept. 1953):56.

704. "Portrait." *Art News* 40(1 Nov. 1971):25; *Time* 55(26 June 1950):57.

705. "Portrait by R. Lannes." *Beaux-arts Magazine* (6 July 1934):2.

706. "Portrait by Terechkovitch." *Arts Magazine* (9 July 1948):5.

707. PUIG, RENE. "Raoul Dufy" in *Artistes en Roussillon* (Paris, 1943).

Concerns Dufy's career and reputation in the early 1940s.

708. "Raoul Dufy." *Sélection* (Anvers)1(March 1928):1-88. 3ième série, 7ième année; plates, pp. 45-76.

Special issue devoted to Dufy. Contributors: Christain Zervos: "L'Evolution de Raoul Dufy"; Pierre Courthion: "Raoul Dufy, peintre de la vie moderne": Fritz Vanderpyl: "Dufy, force neuve de l'architecture"; René Jean: "L'Activité de Raoul Dufy"; Fernand Fleuret: "Raoul Dufy, illustrateur"; Llorens Artigas: "Raoul Dufy, décorateur"; Paul-Gustave Vann Hecke: "Dufy et la décoration des tissus de l'époque"; Luc et Paul Haesaerts: "Dufy ou l'impression suavée"; Georges Marlier: "Raoul Dufy peintre du plein air"; André de Ridder: "Buvons à la santé de Dufy!"

709. "Raoul Dufy." *Cahiers d'art* (1928).

Special issue devoted to Dufy.

710. "Raoul Dufy." *La Gazette de Lausanne* (10June 1951).

711. "Raoul Dufy." *L'Amour de l'art* (1953).

Special issue devoted to Dufy. Includes contributions by Colette, Jean Cassou, and Marcelle Berr de Turique.

712. "Raoul Dufy." *Apollo* 61(June 1955):189-91.

713. "Raoul Dufy." *La Côte des peintres* 1:6(July 1963):1-5.

714. "Raoul Dufy in America." *Life* 30:4(22 Jan. 1951):62-7. 10 col. illus.

715. "Raoul Dufy (1877-1953)" in *Modern Arts Criticism* (Detroit, London: Gale Research Inc., 1993), vol. 3, pp. 235-54. 4 illus.

Includes biographical information and critical excerpts from art historians.

716. RAYNAL, MAURICE. "Raoul Dufy" in *Anthologie de la peinture contemporaine* (Paris: Editions Montaigne, 1927).

717. REYER, GEORGES. "Dans la chambre où il est mort, Raoul Dufy me livre son secret: la petite fille du Havre." *Paris-Match* 211(28 March-4 April 1953):5-1.

718. RIDDER, ANDRE DE. "Raoul Dufy, le peintre." *Sélection* 7(April 1925):105-28.

719. ROGER-MARX, CLAUDE. "Raoul Dufy." *Byblis* (Spring 1931):25-32.

720. ROGER-MARX, CLAUDE. "Raoul Dufy; le fauvisme, les coloristes." *L'Amour de l'art* 5(May 1933):113-6.

Includes a biographical notice and a bibliography of Charles Sterling and Germain Bazin.

721. ROGER-MARX, CLAUDE. "Raoul Dufy" in René Huyghe, *Histoire de l'art contemporain: la peinture* (Paris: Alcan, 1935). pp. 113-5.

722. ROGER-MARX, CLAUDE. "Raoul Dufy." *Paletten* (1952):116-20.

723. ROGER-MARX, CLAUDE. "Prélude à l'apothéose de Raoul Dufy." *Le Figaro littéraire* (4 July 1953).

724. STEIN, GERTRUDE. "Raoul Dufy" in Louis Réau, *Les Arts plastiques* (Paris: Michel, 1949), pp. 135-45.

a. U.S. ed.: G. Stein, *Reflections on the Atom Bomb*. Robert Bartlett Haas, ed. Los Angeles: Black Sparrow Press, 1974.

725. TERIADE, EMMANUEL. "Raoul Dufy." *Deutsch Kunst und Dekoration* 64(April 1929):18-23.

726. TREVES, ANDRE. "Il y vingt ans mourait Raoul Dufy." *Peintre* 468(1 July 1973):4-10. 4 illus.

The twentieth anniversary of Dufy's death occasions this brief account of his career. Some critics saw his early works as inspired by Degas. Dufy however soon felt obliged to distance himself from the Impressionists and try something new. Again he rapidly rejected Fauvism and barely flirted with Cubism before entering upon the most characteristic phase of his painting career. As early as 1910, Dufy began engraving in order to help himself out of financial difficulties, and the engravings now constitute an important part of his total œuvre.

727. "U.S. Medicos to Aid Dufy." *Art Digest* 24(1 May 1950):31.

728. VERONESI, GIULIA. "Raoul Dufy." *Emporium* 114(1954):51-7.

729. WARNOD, ANDRE. "Ultimate hommage à Raoul Dufy." *Le Figaro* (2 July 1953).

730. WARNOD, JEANINE. "Dufy l'enchanteur." *Le Figaro* (12 June 1981).

731. WASHBURN, GORDON BAILEY. "Raoul Dufy in America." *Carnegie Magazine* 25(Feb. 1951):60-1.

732. WERNER, ALFRED. "Raoul Dufy." *Art and Artists* 5:2(May 1970):20-3. 4 illus.

733. ZERVOS, CHRISTIAN. "Raoul Dufy; übers. von E. Glaser." *Kunst und Künstlers* 30(Oct. 1929):29-35.

IV. Works (Œuvre)

A. Catalogues Raisonnés

734. DORIVAL, BERNARD. *Raoul Dufy*. Paris: Musée National d'Art Moderne, 1953. 63 p., 40 pl.

Exhibition catalogue raisonné.

735. DORIVAL, BERNARD. "Le Legs de Mme. Raoul Dufy au Musée National d'Art moderne." *Revue du Louvre et des musées de France* 13:4-5(1963):209-36.

Includes a catalogue raisonné of works donated.

736. HOOG, MICHEL. "Dessins, tapisseries et ceramiques legués par Mme. Raoul Dufy au Musée National d'Art moderne de Paris." *Revue du Louvre et des musées de France* 13:4-5(1963).

Includes a catalogue raisonné of works donated.

737. ARNOULD, REYNOLD. *Legs de Mme. Dufy au Musée du Havre*. Le Havre: Le Musée, 1963.

Includes a catalogue raisonné of works donated.

738. LAFFAILLE, MAURICE. *Raoul Dufy; catalogue raisonné de l'œuvre peint*. Avant-propos de Maurice Laffaille; préface de Marcelle Berr de Turique, biographie de Bernard Dorival. Geneva: Editions Motte, 1972, 1973, 1976, 1977; 5 vols. 380 p., 391 p., 207 p. [vol. 5] Paris: L. Carré, 1985 (1st supplement with Fanny Guillon-Lafaille); second supplement forthcoming.

Volume 1 covers the twenty years up to 1918, which span the Impressionist influence and the Fauve and Cubist periods and leads to Dufy's mature work. The material is arranged both chronologically and by subject.

739. ABDUL HAK, ANDREE, et al. *Œuvre de Raoul Dufy; peintures, aquarelles, dessins*. Introduction and elogy by Jacques Lassaigne. Paris: Musée d'Art Moderne de la Ville de Paris, 1976. 78 p., 31 illus., 12 col. 92 works shown (61 paintings, 24 watercolors, 7 drawings).

Exhibition catalogue that includes a catalogue raisonné of Dufy's works in the Musée d'Art Moderne de la Ville de Paris. Andrée Abdul Hak was conservator of the Museum.

740. FORNERIS, JEAN. *Raoul Dufy à Nice: collection du Musée des Beaux-arts Jules Chéret. Centenaire de al naissance de Raoul Dufy.* Nice: Direction des Musées de Nice, 1977. 78 p., 275 p., illus., some col.

Exhibition catalogue that includes a catalogue raisonné of works shown.

741. REZE-HURE, ANTOINETTE. *Les Dessins de Raoul Dufy au Musée National d'Art moderne. Catalogue raisonné.* Ph.D. thesis, Histoire de l'art, Université de Paris, Sorbonne, IV, 1978.

742. GUILLON-LAFFAILLE, FANNY. *Raoul Dufy: catalogue raisonné des aquarelles, gouaches et pastels.* Paris: Louis Carré & Cie, 1981-82. 2 vols., 394; 439 p.; 2,027 illus., 48 col., col.

Catalogue of 2,027 works, arranged thematically, giving title, dimensions, exhibitions, bibliography, and history of collections and sales. Includes a biography of Dufy by Bernard Dorival, photographs and documents relating to his life, bibliography, indexes of museums and of titles.
Review: R. Engen, *Art Book Review* 1:2(1982):93-4.

743. GUILLON-LAFFAILLE, FANNY. *Catalogue raisonné des dessins de Raoul Dufy.* Tome I par Fanny Guillon-Laffaille. Paris: Marval/Galerie Guillon-Laffaille, 1991-. 350p., 800 illus.

This catalogue raisonné of Raoul Dufy's drawings will eventually comprise four volumes, one appearing each year. It follows the catalogue raisonné of the paintings by Maurice Laffaille (1972-85) and Fanny Guillon-Laffaille's catalogue (1981-82) of the artist's watercolors. Each volume will contain about 800 drawings, classified thematiclly, the themes following the same order in each volume. Thus, a "paddock" scene whose provenance is sought may be found in one or other of the four volumes, but always in the "races" chapters. Furthermore, each volume will be representative of Dufy's entire output of drawings.

B. Works in General

Books

744. BERR DE TURIQUE, MARCELLE. *Collection Pierre Lévy: Raoul Dufy.* Paris: Mourlot, 1969.

a. Reprint: *Pierre Lévy, des artistes et un collectionneur.* Paris: Flammarion, 1976, pp. 267-87.

745. BERTRAND, GERARD. *Illustration de la poésie à l'époque du Cubisme, 1900-1914: Derain, Dufy, Picasso.* Paris: Editions Klincksieck, 1971. 238 p., illus. Volume in "Collection le signe de l'art" series.

Discusses Dufy and André Derain.

746. BRION, MARCEL. *Raoul Dufy; Paintings & Watercolors.* Selected by René ben Sussan with an Introduction by Marcel Brion. New York: Phaidon; dist. by Garden City Books, 1958. 111p., illus., some col.

a. English ed.: Trans. by Lucy Norton. London: Phaidon, 1959. 111 p., illus.

747. BUCHEIM, LOTHAR-GÜNTHER. *Raoul Dufy. Festliche Welt, Zeichnungen und Radierungen.* Buccheim Verlag Feldating Obb., 1955.

748. CASSOU, JEAN. *Raoul Dufy, poète et artisan.* Geneva: A. Skira, 1946. 12 p., illus., 9 pl., some col. Volume in "Les Trésors de la peinture rançaise" series.

a. Another ed.: Paris: A. Skira, 8 p., illus., pl.

749. COGNIAT, RAYMOND. *Dufy, décorateur.* Geneva: Pierre Cailler, 1957. 50 p., 80 pl. Volume in "Les Maîtres de l'art décoratif contemporain" series.

750. COURTHION, PIERRE. *Raoul Dufy.* Paris: Editions des Chroniques du Jour, 1929. 7 p., illus., 39 pl., some col. Volume in "XXe siècle" series.

751. COURTHION, PIERRE. *Raoul Dufy.* Geneva: Pierre Cailler, 1951. 74 p., 182 pl., some col. Volume in "Peintres et sculpteurs d'hier et d'aujourd'hui" series.

Includes "Mes causeries avec le peintre"—conversations from May 2, 1948 to April 11, 1950.

752. COURTHION, PIERRE. *Dufy, 1877-1953.* With an Introduction and Notes by Pierre Courthion. London: Faber & Faber, 1953. 24 p., 10 col. illus.

a. Another ed.: 1955.

753. DESLANDRES, MADELEINE. *Dufy et le fauvisme.* Thesis, Université de Paris-Sorbonne, 1969.

754. FARGUE, LEON-PAUL. *Raoul Dufy, illuminations nouvelles.* Paris: Textes Prétextes, 1953.

755. FLEURET, FERNAND. *Eloge de Raoul Dufy.* Paris: Manuel Bruker, 1931. Volume in "Les Grands styles du livre moderne" series.

a. De luxe ed.: Paris: Amis du Docteur Lucien Graux, 1945. With original prints.

756. GUICHARD-MEILI, JEAN. *Dufy—musique.* Paris: Ferdinand Hazan, 1964.

a. English ed.: *Dufy, Music.* London: Metheun and Co., 1964. 15 p., illus., 15 pl., some col.
b. U.S. ed.: New York: Tudor Publishing Co., 1964. 15 p., illus., 15 pl., some col.
c. German ed.: *Dufy, Musik.* Gütersloh: S. Mohn, 1964. 14 pl. 15 col. pl.

166 Dufy—Bibliography

757. KIM, YOUNGNA. *The Early Works of Georges Braque, Raoul Dufy and Othon Friesz: The Le Havre Group of Fauvist Painters.* Ph.D. diss., Ohio State University, 1980. 434 p.

On the early work (1900-06) and Fauvist paintings (Fall, 1906-Fall, 1907) of the Le Havre group. Investigates the movement towards Cubism, including the role of Picasso and the influence of Cézanne.

758. KOSTENEVICH, ALBERT GRIGOREVICH. *Raoul 'D'iufi.* Leningrad: Iskusstvo, 1977. 192p., 61 illus., some col.

Study of Dufy's œuvre divided into five chapters dealing with major phases in his art. Particular attention is given to the evolution of Dufy's pictorial style, and such aspects of his work as drawings, woodcuts, textiles and tapestries are discussed. Dufy's imagery is analyzed, the influence of Impressionism and Cézanne is considered, and reference is made to his acquaintance with other artists including Matisse, Marquet, and Braque.

759. LANCASTER, JAN. *Raoul Dufy.* Mount Vernon, NY: Artist's Limited Edition, 1983. 18 p., illus., 10 pl. Volume in "Medaenas Monographs on the Arts" series.

Details Dufy's style and technique as evidenced in the paintings in the Phillips Collection, Washington, D.C.

760. LAPRADE, JACQUES DE. *Dufy.* Paris: Editions Braun, 1942. 2 pl, 30 pl. Volume in "Galerie d'estampes" series.

761. PEREZ-TIBI, DORA. *Dufy.* Paris: Flammarion, 1989. 334 p., illus., some col.

Comprehensive survey of the work of Raoul Dufy encompassing painting, engravings, lithographs, ceramics, murals and designs for tapestries, fabrics, stage-sets, and furniture. Pérez-Tibi draws on Dufy's notes, letters and unpublished writings to provide insights into a man who brought enthusiasm and joy to all the media in which he worked.

a. English ed.: *Dufy.* Trans. by Shaun Whiteside. London: Thames and Hudson, 1989. 335 p., 378 illus., 236 col.
b. U.S. ed.: Trans. by Shaun Whiteside. New York: Harry N. Abrams, 1989. 335 p., illus., some col.

762. PERROCO, GUIDO. *Dufy.* Milan: F. Fabbri, 1966. Volume in "I Maestri del colore" series.

a. French ed.: *Raoul Dufy.* Paris Hachette, 1979.

763. RĂDULESCU, VENERA. *Raoul Dufy.* Bucharest: Editions Meridiane, 1972. In Romanian.

Anthology of texts, selection of illustrations and chronology by Venera Rădulescu.
a. French ed.: Paris: Editions Bellevue, 1972.
b. English ed.: Trans. by Leon Levitki. London: Abbey Library, 1973. 36 p., illus., 31 pl.

764. RAYNAL, MAURICE. *Dufy*. Cleveland: World Publishing Co., 1950.

a. Another ed.: Geneva; A. Skira; New York: Transbook Co., 1950. 6 p., col. illus., 8 pl.

765. ROGER-MARX, CLAUDE. *Raoul Dufy*. Paris: F. Hazan, 1952. 8 pl., 24 col. pl. Volume in "Bibliothèque Aldine des arts" series.

766. ROGER-MARX, CLAUDE. *Dufy aux courses*. Paris: Ferdinand Hazan, 1957. Volume in "Petite encyclopèdie de l'art" series.

a. U.S. ed.: *Dufy at the Races*. New York: Tudor Publishing Co., 1957. 16 p., illus., 15 pl., some col.

767. TAKAHASHI, HIDEO. *Dufy*. Tokyo: Shinchosha, 1975.

768. TELIN, ROBERT. *L'Art de Raoul Dufy*. Paris: A La Belle Image, 1945. 29 p., illus.

769. WERNER, ALFRED. *Dufy*. Gennevilliers: Ars Mundi, 1990. 128 p., illus.

Selected paintings with commentary.

770. WERNER, ALFRED, et al. *Raoul Dufy*. Paris: Nouvelles Editions Françaises, 1970.

Includes an essay by Christian and Nadine Pouillon, "Analyse de l'art de Raoul Dufy."
a. English ed.: London: Thames and Hudson, 1970. 168 p., illus., some col.
b. U.S. ed.: New York: H. N. Abrams, 1970. 168 p., illus., some col.

771. ZERVOS, CHRISTIAN. *Raoul Dufy*. Paris: Editions Cahiers d'Art, 1928. 22 p., 96 pl. Volume in "Les Grands peintres d'aujourd'hui" series.

a. Other eds.: Paris: Henri Floury, 1930; 1938.

Articles

772. "Actualité de Raoul Dufy." *Art & décoration* 43(1954):58.

773. ALLARD, ROGER. "Raoul Dufy et son œuvre." *Le Nouveau spectateur* 607(25 July-10 Aug. 1919).

Special number on Dufy, published in Paris by Camille Bloch Editions.

774. ASHBERY, JOHN. "Dufy: Only the Sunny Hours." *New York Heral Tribune* (31 March 1964).

775. BAROTTE, RENE. "Le Raoul Dufy de Louis Carré" *Le Livre et ses amis* 12(10 Oct. 1946):31-6.

776. BAROTTE, RENE. "A la recontre de Raoul Dufy: Dufy, le peintre de la vraie lumière." *Vision sur les arts* 123(Dec. 1978).

777. BATAILLE, PHILIPPE. "Dufy: la joie des signes." *Journal de l'amateur d'art* 672(June 1981):34-8.

778. BAYÓN, DAMIÁN CARLOS. "El mundo de Dufy." *Torre* 2(1954):121-50.

779. BONNEY, THERESE. "Raoul Dufy rendu à la peinture." *Rapports France—Etats-Unis* 43(Oct. 1950):3-8.

780. BOUVIER, MARGUETTE. "Chez Raoul Dufy, peintre de la joie." *Comœdia* (May 1943).

781. BRISSET, PIERRE. "Raoul Dufy, un hymne à la joie." *Lectures pour tous* (July 1959):46-52.

782. CABANNE, PIERRE. "Raoul Dufy, un hymne à la joie." *Lectures pour tous* (July 1959):46-52.

783. CAMO, PIERRE. "Dans l'atelier de Dufy." *Le Portique* 4(1946):5-26.

784. CASSOU, JEAN. "Les Moyens et la fin de l'art de Dufy" in *Panorama des arts plastiques contemporains* (Paris: Gallimard, 1960), pp. 317-23.

785. CHAMPIGNEULLE, BERNARD. "Dufy, peintre du bonheur. Une gerbe d'hommages pour Raoul Dufy." *France-illustration* 390(4 April 1953):458-62.

786. CHARENSOL, GEORGES. "Raoul Dufy au Louvre." *Revue des deux mondes* (15 March 1963):283-6.

787. CLAY, JEAN. "Dufy en fête au mai de Bordeaux." *Réalitiés* 292(May 1970)60-5, 123, 127.

788. COLOMBIER, PIERRE DU. "Le Monde féerique de Raoul Dufy." *Comœdia* (26 June 1943).

789. COQUIOT, GUSTAVE. "Raoul Dufy." *La Renaissance de l'art française et des industries de luxe* 12(Dec. 1926):1019-25.

790. COURTHION, PIERRE. "Fantaisies de Raoul Dufy." *L'Art vivant* 16(15 April 1925):9-12. Also published in *Couleurs* (Paris: Editions des Chiers Libres, 1926).

791. COURTHION, PIERRE. "Raoul Dufy." *L'Amour de l'art* (1927):240-2.

792. COURTHION, PIERRE. "Raoul Dufy" in *Panorama de la peinture française contemporaine* (Paris: Kra, 1927).

793. COURTHION, PIERRE, "Raoul Dufy." *Plaisir de France* (Sept.-Oct. 1949).

794. COURTHION, PIERRE. "Raoul Dufy ou le plaisir de peindre" in *Un Demi-siècle d'art indépendant* (Paris: Emle Paul, 1950).

795. COURTHION, PIERRE. "Cette main que je ne reverrai plus." *Arts* (3 April 1953):7.

796. COURTHION, PIERRE. "Hommage à Raoul Dufy. *IX^e Salon de Mai* (7-31 May 1953):6-7.

797. COURTHION, PIERRE. "L'Originalité de Raoul Dufy." *La Revue des arts* 3(June 1953):70-6.

798. COURTHION, PIERRE. "Raoul Dufy, ou le plaisir de peindre" in *L'Art indépendant, panorama international de 1900 à nos jours* (Paris: Albin-Michel, 1958), pp. 71-5.

799. CRESPELLE, JEAN-PAUL. "Dufy l'enchanteur." *Journal du dimanche* (6 Nov. 1977).

800. DAULTE, FRANÇOIS. "Marquet et Dufy devant les mêmes sujets." *Connaissance des arts* 69(Nov. 1957):86-93.

801. DAVIDSON, MARTHA. "Renoir and Dufy: Color Carnival." *Art News* 37(26 Nov. 1938):7.

802. DEMETZ, DANIELLE. "Le Legs de Madame Raoul Dufy au plus grand nombre de musées français." *La Revue du Louvre et des musées de France* 18:6(1968):399-402.

803. DORGELES, ROLAND. "Visage inconnu de Raoul Dufy, magicien français." *Erasme* (1947):9-13.

804. DORGELES, ROLAND. "Dufy le magicien." *Le Figaro littéraire* (28 March 1953).

805. DORIVAL, BERNARD. "Le Thème des baigneuses chez Raoul Dufy." *La Revue des arts* 5:4(Dec. 1955):238-42.

806. DORIVAL, BERNARD and MICHEL HOOG. "Le Legs de Mme Raoul Dufy au Musée National d'Art moderne." 42 illus., 1 col. *La Revue du Louvre et des musées de France* 13:4-5(1963):290-36. 42 illus., 1 col.

Includes a catalogue raisonné of works donated.

807. "Dufy Captures Spirit of British Sport." *Art Digest* 8(15 March 1934):16.

808. FERMIGIER, ANDRE. "Amours, délices et orgues. Dufy à Londres." *Le Monde* (18 Jan. 1984):1, 16.

809. FLEURET, FERNAND. "Le Peintre de la joie, Raoul Dufy." *Formes* 10(Dec. 1930):2, 4a-6.

810. "For the Nation." *Illustrated London News* 2(1953).

811. GARÇON, MAURICE. "Raoul Dufy." *Femina* (Summer 1953):93-6.

812. GAUTHIER, MAXIMILIEN. "Raoul Dufy." *Venice di Biennale* 9(July 1952):13-6.

813. GAUTHIER, MAXIMILIEN. "Les Leçons du papillon blanc." *Les Nouvelies littéraires* (28 Feb. 1963):8.

814. "Une gerbe d'hommages pour Raoul Dufy." *France-illustration* 390(4 April 1953):459-62.

815. GINDERTAEL, R. V. "Raoul Dufy tel qu'en lui-meme enfin l'éternité." *Beaux-arts* (Brussels) (25 Aug. 1953).

816. GONZÁLES, MARÍA ROSA. "Raoul Dufy en Paris." *Saber Vivir* 109(July-Sept. 1954):20-1.

817. HAUTECOEUR, LOUIS. "Dufy expriimait le plus avec le moins." *Arts* (Summer 1962).

818. HUMBERT, AGNES. "Comments on the Art of Raoul Dufy." *Scottish Art Review* 8:2(1961):5-8.

819. LAPRADE, JACQUES DE. "L'Œuvre de Raoul Dufy." *Le Figaro* (27 Oct. 1942).

820. LAPRIEUX, JEAN-MARIE. "Harmonieux musicien de la symphonie des couleurs." *Art magazine* 552(June 1981):30-1, 35.

821. LAPRIEUX, JEAN-MARIE. "Dufy: le plus haut style du charme" [Dufy: The Highest Style of Charm]. *Arts* 69(11 June 1982):14. 2 illus.

Consideration of the style of Raoul Dufy (1888-1953) following the publication of two volumes of his watercolor paintings (Paris: Louis Carré 1981-82.) His use of color gradually became more intense, while his forms assume an arabesque elegance. Dufy acquired a taste for movement and was fascinated by the spectacle of multicolored crowds. The watercolor became his favorite form of expression because of its precision and softness. In 1927 Dufy realized that the eye perceives the colors of an object more clearly than its contour, and from then onwards he ceased trying to make form and color coincide, inventing a tri-chromic principle of composition.

822. LE BIHAN, ODILE. "Dufy le magicien et ses visions lyriques." *Le Républicain lorrain.* (26 July 1981).

823. LEVÊQUE, JEAN-JACQUES. "Dufy." *Galerie-Jardin des arts* 131(Nov. 1973):32-5. 10 illus. In French.

Review of the exhibition of paintings by Dufy shown at the Salon d'Automne. Levêque briefly discusses Dufy's role as a painter of happiness and optimism, and states that stylistically he should be seen as extending the boundaries of Impressionism. Six of his paintings are then illustrated and analyzed in terms of content and composition.

824. LEVÊQUE, JEAN-JACQUES. "Le Centenaire de Dufy: va-t-il le rehabiliter?" [Dufy's Centenary: Will it Rehabilitate Him?]. *Galerie-Jardin des arts* 161(Sept. 1976):19-21. 9 illus.

Dufy has touched on all the currents of contemporary art, yet has remained aloof and individual. Paradoxically, the happiness inherent in his work, which often takes the holiday as its theme, is opposed to 20th century art's characteristic preoccupation with anguish. After taking evening classes in art and winning a scholarship to Paris in 1900, Dufy encountered Matisse's work and turned to Fauvism, which for him meant a freer use of color. His discovery of Cézanne in 1906 confirmed his independence of style. Although popular in his lifetime, Dufy has since been neglected, although his art speaks for those who have a personal view of an era and are not bound by its prejuces and preoccupations.

825. LEVÊQUE, JEAN-JACQUES. "Au bon plaisir de Dufy." *Les Nouvelles littéraires* (28 Oct.-3 Nov. 1976).

826. MAISEL, ALBERT. "Le Guérison de Raoul Dufy." *Sélection du Reader's Digest* (Jan. 1951):1-7.

827. MARTIN-MERY, GILBERTE. "Hommage à Raoul Dufy." *La Revue du Louvre et des musées de France* 20:4-5 (1970):305-8.

Article published on the occasion of an exhibition in Bordeaux, 1970.

828. MCEWEN, JOHN. "Raoul Revealed." *The Spectator* (19 Nov. 1983).

829. MCEWEN, JOHN. "The Other Raoul Dufy." *Art in America.* 72(March 1984):120-7.

830. MELEZE, JOSETTE. "Raoul Dufy." *Art in America.* 72(March 1984):120-7.

831. MELLEQUIST, JEROME. "Dufy's Pennant." *The Freeman* (18 May 1953):609.

832. MICHA, RENE. "Trois maîtres: Dufy et Staël à Paris, Kokoschka à Londres" [Three Masters: Dufy and De Staël in Paris, Kokoschka in London.] *Art international* 24:9-10(Aug.-Sept. 1981);151-68. 14 illus., 6 col.

Discusses the work and career of Dufy with reference to the publication of the catalogue raisonné of his paintings and the accompanying exhibition at the Galerie Louis Carré in Paris. Micha then examines the career of de Staël with reference to

the posthumous retrospective and the Musée National d'Art moderne, Paris, tracing the development of his art. Finally, he discusses Kokoschka with reference to the "memorial exhibition" organized by the Marlborough Galleries of New York and London.

833. NEVE, CHRISTOPHER. "Dufy is Pleasure." *Country Life* 158:4084(9 Oct. 1975):900. 1 illus.

Those chic and high style hedonistic overtones of Dufy's paintings, once viewed disparagingly, are now seen as positive assets. The exhibition at the Wildenstein Gallery, London (1975) showed rare pictures from his brief Fauve period before the evolution of his own exquisite shorthand which makes no distinction between periods or places. Dufy never painted a pessimistic picture and his sureness of touch makes even the slightest of his works seductive.

834. OLLIER, NICOLAS. "La Méditerranée de Raoul Dufy." *Médecine de France* 37(1952):31-2.

835. OSCHE, MADELEINE. "Raoul Dufy (1877-1953): le brillant concerto de la vie moderne" [Raoul Dufy (1877-1953): The Sparkling Concerto of Modern Life]. *Jardin des arts* 216(Jan.-Feb. 1973):60-4. 5 illus.

836. PARINAUD, ANDRE. "Dufy et les chances du bonheur." *Le Nouveau journal* (20 June 1981).

837. PAYRÓ, JULIO E. "Une leccion de optimismo, el arte de Raoul Dufy." *La Nacion* (9 Aug. 1953).

838. PEILLEX, GEORGES. "Dans son atelier parisien Raoul Dufy prépare sa grande rétrospective de Genève." *Arts documents* (Geneva) (June 1952).

839. "Un peintre de notre temps, R. Dufy." *Panorama* 25(March 1978):16-8.

840. "Peintres-graveurs contemporains." *L'Amour de l'art* (1924).

841. PERL, JED. "Dufy Among the Pattern Painters." *New Criterion* 3:6(Feb. 1985):25-33.

Comments on the revival of interest in the work of Dufy and on the show *Raoul Dufy* at the Holly Solomon Gallery, New York (Nov. 2-24, 1984). Perl relates this revival to the revisionist view of 19th century art expressed in *19th Century Art* by Robert Rosenblum and H. W. Janson, (New York: Abrams, 1984), and discusses the importance of revivals in general to critical and aesthetic experience.

842. PEROCCO, GUIDO. "Ultima visita a Dufy." *Biennale di Venezia* 16(1953):24.

843. PERSIN, PATRICK-GILLES. "Raoul Dufy." *L'Œil* 431(June 1991):64-5. 4 col. illus.

Brief review of the exhibition *Raoul Dufy*, held at the Galerie Fanny Guillon-Laffaille, Paris, in July 1991, which aimed to give a panoramic view of the artist's

work. The influence of Matisse in the first few years of the 20th century is noted. As Dufy's style developed towards a simplification of form, so success eluded him. From 1909, the composition fo the painting was given greater importance of Dufy, but success continued to evade him and he was forced to earn a living from engravings and other decorative work. In retrospect, Persin observes Dufy's enormous contribution to Fauvism and Cubism and laments the disfavour he found with his contemporary public.

844. PRAT, VERONIQUE. "Raoul Dufy: le frivole qui ne 'rigolait' pas." *Le Figaro magazine* 11450 (27 June 1981):78-83.

845. "Raoul Dufy et son œuvre." *Le Nouveau spectateur* (1919):103-43.

846. "Raoul Dufy, ou le joie de vivre." *France-illustration* 402(Sept. 1953):68.

847. RENE-JEAN. "Dufy portraitiste de la mer." *L'Amour de l'art* (Aug. 1924):268-72.

848. RENE-JEAN. "Raoul Dufy." *Art et décoration* 55(April 1929):97-112. 19 illus.

849. REY, HENRI-FRANÇOIS. "Dufy, peintre de la gaieté." *Vendredi samedi dimanche* 196(4 June 1981).

850. ROGER-MARX, CLAUDE. "Le Nu et la mer." *Jardin des arts* 11(Nov. 1954-Dec. 1955):658-64.

851. ROSTRUP, HAAVARD. "Introduction til Raoul Dufy's methode." *Kunst Kultur* 37(1954):137-52.

852. ROUSSEAU, F. "Raoul Dufy." *Beaux-arts magazine* 3(Dec. 1989):33-41.

With reference to a retrospective exhibition of Dufy's work at the Hayward Gallery, London, Rousseau states that Dufy's earliest canvases were influenced by Impressionism, but with the advent of Fauvism and naturalism with subjects full of bright colors. Picasso's *Les Demoiselles d'Avignon* profoundly influenced Dufy in 1907, but even under this Cubist influence he retained his individuality with his distinctive characteristics of movement, color, and light. Dufy was relatively uninfluenced by the First World War, continuing to paint happy crowds; in the 1920s his mature style was characterized by a distinctive airy grace. Statements on Dufy by five contemporary painters are included.

853. RUSSELL, JOHN. "An Introduction to the Range of Raoul Dufy." *New York Times* (1 Jan. 1984):23-4.

854. S., M. "Dufy." *Cahiers de Belique* (1928).

855. TERIADE, EMMANUEL. "Raoul Dufy et le nu." *Cahiers d'art* 4(May 1929):125-34.

856. TERIADE, EMMANUEL. "Raoul Dufy." *Kunst and Künstler* (1929):125-34.

857. THIRON, JACQUES. "Le Legs Matisse et Dufy." *Art de France* 4(1964):364-9.

858. "Une Belle époque." *Crafts* 102(Jan.-Feb. 1990):34-7.

Details Dufy's diverse contributions to the decorative arts.

859. VIDAL BARNOLA, LUIS DE. "Raoul Dufy y la musica." *Goyá* (1960-61):334-40.

860. VILLEBOEUF, ANDRE. "Raoul Dufy." *Le Figaro littéraire* (16 May 1959).

861. VINCENT, MADELEINE. "Trois œuvres de Raoul Dufy au Musée des Beaux-arts de Lyon." *Bulletin des Musées lyonnais* 3(1958):41-6.

862. WATT, ANDRE. "France Inherits Dufy's Delights." *Studio* 165(June 1963):244.

863. WIGHT, F. S. "U.S. to See U.S. as Dufy Sees it." *Art Digest* 25(1 Feb. 1951):14.

864. ZAHN, LEOPOLD. "Raoul Dufy Zeichnungen." *Kunstwerk* 1:2(1946-47):6-7.

865. ZERVOS, CHRISTIAN. "Raoul Dufy." *Les Arts de la maison* 8(Summer 1925):13-21. 10 pl.

866. ZERVOS, CHRISTIAN. "Raoul Dufy." *Querschnitt* 6(1927).

867. ZERVOS, CHRISTIAN and ANDRE SCHAEFFNER. "Œuvres récentes de Raoul Dufy." *Cahiers d'art* 4-5(1927):131-40.

868. ZERVOS, CHRISTIAN. "Raoul Dufy." *Cahiers d'art* (1928).

869. ZERVOS, CHRISTIAN. "New York—Raoul Dufy (Galerie Dudensing)." *Cahiers d'art* 8-9(1929):422.

C. Individual Paintings

Articles

870. "*Album*: Raoul Dufy." *Arts Magazine* 59(Nov. 1984):44-5.

871. "*Amphirite.*" *Arts Magazine* 59(Nov. 1984):44.

872. "*L'Atelier au bord de la mer.*" *Connaissance des arts* 420(Feb. 1987):37.

873. "*La Baie de Sainte-Adresse.*" *Connaissance des arts* 424(April 1987):27.

874. "*Before the Races.*" *Apollo* 122(Oct. 1985):16.

875. "*Black Cargo.*" *Arts Magazine* 59(Nov. 1984):45.

876. *"Le Boulevard."* *Connaissance des arts* 443(Jan. 1989):125 and *Architectural Digest* 46(Nov. 1989):A38.

877. CHAMBERLAIN, J. B. *"Harvest at Langres* Acquired by St. Louis." *St. Louis Museum of Art Bulletin* 25(April 1940):21-4.

878. *"Le Chat."* *Architectural Digest* 47(May 1990):231.

879. *"Chevaux et touristes au bord de la mer."* *Art & artists* 225(June 1985):32.

880. *"La Corrida."* *Connaissance des arts* 449-50(July-Aug. 1989):49.

881. [*"Couple in a Gazebo"*]. *Arts Magazine* 59(Nov. 1984):45.

882. *"Les Courses à Ascot, l'enclos royal."* *L'Œil* 382(May 19987):72-3.

883. *"Courses à Goodwood."* *L'Œil* 392(May 1987):73.

884. *"Dépicage gris."* *Connaissance des arts* 455(Jan. 1990):inside cover.

885. *"Dessin en pointille noir et blanc."* *L'Œil* 360-1(July-Aug. 1985):63.

886. *"Dessin géometrique noir et blanc."* *L'Œil* 360-1(July-Aug. 1985):62.

887. *"Les Deux modèles."* *Burlington Magazine* 132(June 1990):25 and *Connaissance des arts* 460(June 1990):194.

888. DORIVAL, BERNARD. "Raoul Dufy et le portrait: *J. B. A. Kessler et sa famille."* *La Revue des arts* 5:3(Sept. 1955):175-80.

889. DORIVAL, BERNARD. "Musée National d'Art moderne, acquisition de deux céramiques." *Revues des arts* 6(March 1956):49-50.

Discusses Dufy's *Jardin d'appartement.*

890. DORIVAL BERNARD. "Les *'Affiches à Trouville'* de Raoul Dufy." *La Revue des arts* 7:5(Sept.-Oct. 1957):225-8.

891. ESSAR, GARY. *"La Jetée de Deauville."* *WAG, Winnipeg Art Gallery Magazine* (June 1983):8-9. 2 illus. In English.

Discussion of Dufy's 1933 painting, *Jetty at Deauville,* in the Winnipeg Art Gallery.

892. *"Etude pour un bal champêtre."* *Connaissance des arts* 484(June 1992):127.

893. *"La Famille Kessler."* *Apollo* 125(March 1987):37.

894. *"Farmhouse."* *Antiques* 126(Sept. 1984):848.

895. *"Haying with Blue Sky."* *Arts Magazine* 59(Nov. 1984):44.

896. *"Interieur à la fenêtre ouverte."* *Die Kunst* 5(May 1987):356.

897. *"Londres, le Parlement."* *Apollo.* 135(April 1992):2.

898. *"Monogrammed."* *Art News* 85(Sept. 1986):25.

899. MORANCE, GASTON A. *"La Terre frotté d'ail."* *Cahiers d'art* 2(Feb. 1962):40.

900. *"Mozart."* *Die Kunst* 9(Sept. 1987):696.

901. *"Nature morte au poison et aux fruits."* *Connaissance des arts* 460(June 1990):113.

902. "Notable Works of Art Now on the Market." *Burlington Magazine* 101(Dec. 1959):supp. 6.

Discusses Dufy's *Le Marché à Falaise.*

903. "Notable Works of Art Now on thc Market." *Burlington Magazine* 106(June 1964):supp. 4.

Discusses Dufy's *Le Marché à Falaise.*

904. O'CONNOR, J., JR. "Jury of Award." *Carnegie Magazine* 11(Sept. 1937):107-9.

905. O'CONNOR, J., JR. *"Console with Yellow Violin."* *Carnegie Magazine* 25(March 1951):75.

906. *"L'Orchestre."* *L'Œil* 398(Sept. 1988):11 and *Connaissance des arts* 415(Sept. 1986):33.

907. *"Pagoda."* *Art News* 85(Summer 1986):138.

908. *"Paris, 14 juillet 1901, bal populaire, place du Tertre."* *Connaissance des arts* 410(April 1986):27.

909. *"Les Passants."* *Apollo* 120(Sept. 1984):220.

910. *"Le Paysage de l'Estaque."* *Art in America* 78(July 1990):34.

911. PERL, JED. "Raoul Dufy's *Atelier au carton bleu.*" *Arts Magazine* 52:5(Jan. 1978):110-1. 1 illus.

Affirms the importance of Raoul Dufy's critically neglected paintings. The *Ateliler au carton bleu* (1942, formerly collection of Louis Carré, Paris) is seen to be the classic statement of Dufy's maturity. Dufy painted *Atelier au carton bleu* when he was 65 years old and the painting is a great work of his late period. Although an analytic mind is at work, the result is not something that is apprehended so systematically. It is one of a series that Dufy did depicting the corner of his studio

on rue Jeanne d'Arc, Perpignan, between 1942 and 1946. Secure in the traditions of Corot, Cubism, and the Venetian colorists, the painting locks each element into place, stratagems become echoes of grand necessity, and a day's labor becomes a masterpiece.

912. "Petit dictionnaire des années héroïques (1907-1917)." *XX^e siècle* 28(May 1966):93.

Illustrated with Dufy's *Maison à l'Estaque*.

913. *"Les Phares de Deauville-Trouville."* *Connaissance des arts* 439(Sept. 1988):8.

914. *"La Plage de Sainte-Adresse."* *Connaissance des arts* 433(March 1988):126-7; 428(Oct. 1987):32.

915. *"La Plage et l'Estacade de Trouville."* *L'Œil* 359(June 1985):26.

916. *"Le Pont d'Asnières vers 1900."* *Connaissance des arts* 465(Nov. 1990):184.

917. *"Pont sur la Tamise à Londres."* *Arts Magazine* 59(Dec. 1984):52.

918. *"Le Port 1905."* *Apollo* 124(Oct. 1986):76.

919. *"Le Port du Havre."* *L'Œil* 412(Nov. 1989):2.

920. *"Quintette bleu."* *Art in America* 75(Aug. 1987):2.

921. *"Regatta at Henley."* *Art in America* 72(Aug. 1987):2.

922. ROBERTS, M. F. "Speaking of Art." *Arts and Decoration* 34(Feb. 1931):42-3.

Discusses Dufy's *Marine*.

923. [*"Sailboats in River"*]. *Connaissance des arts* 424(June 1987):49.

924. *"Sainte-Adresse."* *Connaissance des arts* 458(April 1990):132.

925. STEFANI, ALESSANDRO DE. "Matisse e il cubismo: per una nouva datazione del Grand Braque." *Paragone* 39(March 1988):35-61.

Discusses Dufy's two versions of *La Signora in rosa*.

926. *"Vénus au coquillage."* *La Revue du Louvre et des musée de France* 35:1(1985):6.

927. *"View of Nice."* *Apollo* 120(July 1984):65.

928. *"Le Violin jaune, fond rouge et noir."* *Apollo* 125(April 1987):13.

929. *"La Visite de l'escadre anglaise au Havre."* *Connaissance des arts* 484(June 1992):127.

930. "[*Woman in a Landscape*]." *Apollo* 133(June 1991):73.

D. *La Fée Electricité* (1937)

Book

931. DORIVAL, BERNARD. *La Belle histoire de la 'Fée électricité' de Raoul Dufy.* Paris: La Palme, 1953. 29 p., illus., some col.

Articles

932. DALEVEZE, JEAN. "Dufy décorateur." *L'Œil* 255(Oct. 1976):10-5. 8 illus.

Account of the part played in Dufy's œuvre by his commissions for decorations, in which particular reference is made to his *Fée électricité* executed for the Pavillon de la Lumière at the 1937 Exposition Internationale, and his *De Trouville à Paris* mural for Dr. Viard. Dufy's designs and compositions as a textile designer especially remarkable for their use of color and his work in ceramics with Artigas are also mentioned. Includes an appendix, "De Trouville à Paris," by Maurice Laffaille.

933. DORIVAL, BERNARD. "Un chef d'œuvre de Raoul Dufy entre au Musée d'Art moderne." *La Revue des arts—Musées de France* 7:4(July 1957):170-4.

Concerns Dufy's *La Fée électricité* (1937).

934. "Electric Painting." *Time* 62(14 Dec. 1953):84-6.

935. FEGDAL, CHARLES. "Le Palais de l'électricité et de la lumière; la fresque de Raoul Dufy." *Art et artist* 34(June 1937):292-5.

936. GEORGES-MICHEL, GEORGES. "Raoul Dufy, auteur du plus grand tableau du monde, est de retour en France après avoir étonné l'Amérique." *La Presse* (17-23 May 1952).

937. GUICHARAUD, HELENE. "La Fée électricté, Raoul Dufy et Louis Figuier" [The Fairy Electricity, Raoul Dufy and Louis Figuier]. *Gazette des Beaux-arts* ser. 6,110:1424(Sept. 1987):91-8. 17 illus.

Dufy was invited to provide an immense wall décor for the Palace of Electricity at an international festival held in Paris in 1937. His task was to trace the history of electricity, to pay homage to scholars and scientists responsible for it, and to celebrate the role of electricity in society. Incorporating details gleaned from his own visits to a generating station, he depicted electrical machinery; he also showed its impact on the world of work and leisure. Dufy's portraits of scholars and scientists draw heavily on illustrations in a popularizing work, *Les Merveilles de la science* by Louis Figuier, as well as other sources such as photographs in magazines. Despite the diversity of the artist's iconographic sources, Guicharaud believes that Dufy succeeded in organizing his themes into a coherent and instructive composition.

938. HOOG, MICHEL. "Projets pour la Fée électricite de Dufy." *La Revue du Louvre et des musées de France* 37:3(1987):224.

939. NEMECZEK, ALFRED. "Roboter gegen das Bild des Fortschritts" [Robots Against the Image of Progress]. *ART: das Kunstmagagzin* 10(Oct. 1989):112-4. 4 col. illus.

In 1937, Raoul Dufy exhibited his greatest work, *La Fée électricité,* featuring 125 figures associated with light and electricity. In 1989, Nam June Paik exhibited his *Electronic Fairy* in the Church of the Madeleine in Paris. It consisted of a portico leading to five human figures, each three meters high, all built of old television sets to house a video installation. The figures represent Diderot, Voltaire, Rousseau, Robespierre, and Olympe de Gouges. Nemeczek describes Nam June Paik's work, comparing and contrasting it to Dufy's.

940. "Raoul Dufy et la Fée électricité." *Beaux-arts magazine* (95 Feb. 1937):2.

941. SPROVIERI, GIUSEPPE and DOMENICO GUZZI (Interviewer). "Personaggi" [Personalities]. *Arte* 18:185(May 1988):101-2, 104, 106. 4 illus.

In this interview Guiseppe Sprovieri (b. 1890), a central figure of the Italian art work involved in the birth of Futurism, discusses his early career. Dissatisfied with Rome, he went to Paris where he met Raoul Dufy. He describes Dufy's work *Electricity*, in which Marconi appeared at Sprovieri's suggestion. He compares the world of Paris with the provincial Italian art of the early 20th century, suggesting that although there were exciting artists in Italy they were neglected. In 1913 Sprovieri opened the Galleria Futurista Sprovicri in Rome with an exhibition by Boccioni, and in the same year he put on an exhibition of the main Futurists. In 1914 the gallery was closed because of the war.

942. TRONCHE, ANNE. "Vedette du Musée d'Art moderne, la *Fée électricité* a 40 ans." *La Vie électrique* 133(Sept.-Oct. 1978):12-5.

943. "World's Largest Mural to Honor Men and Women who Discovered Important Principles of Electricity." *Architectural Record* 81(June 1937):29.

944. "World's Largest Painting for Paris Exposition: Allegory, Depicting the History of Electricity." *Architecutral Record* 81(June 1937):29.

945. ZAHAR, MARCEL. "Raoul Dufy: un exemple d'art vivant, le Palais de l'Electricité." *L'Art vivant* 211(17 June 1937):131-3.

E. Drawings

Books

946. CARRE, LOUIS. *Dessins et croquis extraits des cartons et carnets de Raoul Dufy.* Paris: Louis Carré, 1944. 18 p., illus., 56 pl.

Review: R. Barotte, *Le Livre et ses amis* 12(10 Oct. 1946):31-6.

947. GIEURE, MAURICE. *Dufy, dessins.* Paris: Editions des Deux Mondes, 1952. 969 p. (pp. 17-96 illus.) Volume in "Dessins des grands peintres" series.

948. ROUNDINESCO, ALEXANDRE and JEAN TARDIEU. *Dessins de Raoul Dufy*. Préface de Jean Tardieu. Biographie du Dr. A. Roudinesco. Lausanne: Mermod, 1958. 84 p. (pp. 1-56 illus.)

Articles

949. BAZAINE, JEAN. "Dessins de Matisse et de Dufy." *Nouvelle revue française* 336(1 Feb. 1942):225-8.

950. CASSOU, JEAN. "Dessins de Raoul Dufy." *Cahiers d'art* 1(1927):17-22.

951. COLOMBIER, PIERRE DU. "L'Expression impérissable de Dufy: ses dessins." *Journal de l'amateur d'art* 109(10 April 1953):3.

952. COMBE, JACQUES. "Raoul Dufy dessinateur." *L'Amour de l'art* (1932):203-11.

953. "Dessins de R. Dufy." *Art et décoration* 57(May 1930):supp. 2.

954. KJEKKBERB, PIERRE. "Comment évaluer un dessin de Dufy." *Connaissance des arts* 187(Sept. 1967):117, 119.

955. O'CONNOR, J., JR. "Souvenir of the International: Pen and Ink Drawings of a Dinner Given for the Jury of the 1937 Exhibition." *Carnegie Magazine* 28(Feb. 1954):52-4+.

956. PARROT, LOUIS. "Les Dessins de Raoul Dufy." *La Nef* (Oct. 1948).

957. REZE-HURE, ANTOINETTE. "Raoul Dufy: le signe." *Cahiers du Musée d'Art moderne* 5(1980):410-23. 23 illus.

Study of Dufy's drawings, focusing on technique. Dufy himself regarded his drawings not as autonomous entities, but as "designs" or plans for a painted work. However, his drawings were usually "recordings of research"—eloquent lines which captured and expressed complex forms and movements. This article examines Dufy's investigations of natural form and the "signs" that resulted from them in drawings produced by him from 1908 to 1936.

958. ZERVOS, CHRISTIAN. "Situation faite au dessins dans l'art contemporain." *Cahiers d'art* (1953).

F. Watercolors

Articles

959. CAMPAGNE, JEAN-MARC. "Raoul Dufy, magicien de l'aquarelle." *Nice-matin magazine* (28 June 1981).

960. REZE-HURE, ANTOINETTE. *"Les Funérailles de Paul Painlevé* par Raoul Dufy." *Bulletin de la Société de l'histoire de l'art français* (1980):269-78. 8 illus.

The Musée d'Art moderne in Paris owns three drawings and thirty-seven notebook pages that constitute the preparation for Dufy's watercolor *Les Funérailles de Paul Painlevé au Panthéon*. As Dufy rarely received official commissions, the work is of interest. Rezé-Huré outlines the circumstances by which Dufy came to create this painting and the importance of Paul Painlevé in French political life at the time; there follows a detailed description of each of the preparatory sketches in the notebooks and of the drawings, and a brief analysis of Dufy's finished work. The paper on which this article is based was delivered in March, 1980.

961. WEISS, LOUISE. "Raoul Dufy, première aquarelle après la guérison." *Paris-Match* 73(12 Aug. 1950).

G. Graphic Works

Book

962. GREET, ANNE HYDE. *Apollinaire et lettres le livre de peintre* [Apollinaire and the Artist's Book]. Paris: Minard, 1977. 161 p., 81 illus., some col. Volume in "Interférences arts lettres" series.

Discusses *Calligrammes* and de Chirico, *Alcools* and Marcoussis, and *Le Bestiaire* (1911) and Raoul Dufy.
Review: J.-L. Gourg, *Peintre* 575(15 Dec. 1978):16-7.

Articles

963. CHRISTIN, ANNE-MARIE. "Images d'un texte: Dufy, illustrateur de Mallarmé," *Revue de l'art* 44(1979):68-86. 30 illus.

In 1920 Raoul Dufy illustrated twenty-five *vers de circonstance* by Stéphane Mallarmé. The ensemble of those poems and images, published under the title *Madrigaux*, is studied here with the purpose of focusing on Dufy's qualities as an illustrator and at the same time proposing a method for analyzing the complex phenomenon of the illustration. It is shown that Dufy not only was inspired by visual suggestions within the texts, but also isolated in each certain motifs in order to combine them into a single image which has no anecdotal relationship to the text but serves as a relay, yet is in itself perfectly autonomous.

964. FAUCHOIX, RENE. "Un livre illustré de Raoul Dufy." *La Renaissance* (1926).

965. FLEURET, FERNAND. "Raoul Dufy, illustrateur." *Arts et métiers graphiques* 3(1 Feb. 1928):143-52.

966. GARVEY, ELEANOR M. "Cubist and Fauve Illustrated Books." *Gazette des Beaux-arts* ser. 6, 63(Jan. 1964):43-5.

Discusses Dufy's drawings and woodcuts for Apollinaire's *Le Bestiaire* (1911).

967. GOURG, J.-L. "A propos du 'livre de peinture'" [On the Subject of the 'Painter's Books'"]. *Peintre* 575(15 Dec. 1978):16-7.

Review of Anne Hyde Greet's book, *Apollinaire and the Painter's Book* (Paris: Minard, 1977). Gourg discusses her appraisal of de Chirico's series of sixty-seven prints illustrating Apollinaire's *Calligrammes*, Marcoussis's illustrations for *Alcools*, and Dufy's prints for *Le Bestiaire ou Cortège d'Orphée*, regarding some of her conclusions as extreme, but concluding that these are three solid studies which should satisfy all of those who love painting and literature equally.

968. HESSE, RAYMOND. *"Le Bestiaire de Guillaume Apollinaire."* Le Livre et ses amis 6(1946):37-40.

969. HOFER, PHILIP. "Four Modern French Illustrated Bestiaries." *Gazette des Beaux-arts* ser. 6, 33(May 1948):301-16.

970. MORNAND, PIERRE. "Raoul Dufy." *Courrier graphique* 42(1949):3-10.

971. RAWNSLEY, BRENDA and DAVID ELYAN. "The Story of School Prints." *Matrix* (U.K.)10(Winter 1990):21-33. 35 illus., 30 col.

Detailed account of the history of School Prints in two parts. In the introductory part David Elyan, then working for *The Observer*, related how the newspaper's plan to publish original graphics in larger-than-normal editions and at comparatively low prices led to a cooperation with Brenda Rawnsley, owner of the School Prints company and of a series of original prints by Picasso, Braque, Dufy, Léger, and Matisse that she had brought back from France with the objective to make prints available to schools and factories.

972. REMON, GEORGES. "L'Habitation d'aujourd'jui." *L'Art vivant* (1925).

Illustrated by Dufy.

973. ROGER-MARX, CLAUDE. "Raoul Dufy, illustrateur." *La Renaissance de l'art française et des industries de luxe* 21:3(June 1938):40-2, 48.

974. ZERVOS, CHRISTIAN and GASTON A. MORANCE. "Les Gouaches morocaines de Raoul Dufy." *Cahiers d'art* 5(June 1926):98-102.

H. Illustrations, 1910-57

975. **1910**
 1 drawing in *La Grande revue*.

976. **1911**
 30 wood engravings, 1 vignette, 3 headings, 3 ornamental bands and tailpieces for Guillame Apollinaire, *Le Bestiaire ou cortège d'Orpheé*. Paris: Deplanche, large 4to. Printed in an edition of 120 (republished in 1919 by La Sirène [Paris] in an edition of 1,050 with plates reduced in size). Facsimile ed.: Translated into English by Lauren Shakely. With new English translations and foreword, from copy 99 in the Department of Prints and Photographs of the Metropolitan Museum of Art. New York: The Museum, 1977. 87 p., illus.

977. **1913**
Typographical woodcut decorations for Reval, *Le Royaume du printemps*. Paris: Mirasol, 8vo.

978. **1916**
Woodcut cover from a drawing by the author for Fleuret, *Falourdin*. Paris: Delphi, at the Pythian Tripod, the 3rd year of the delirium of Lamachus, 6to.

Woodcut for Verjaeren, *Poèmes légendaires de France et de Brabant*. Paris: Société littéraire de France, 6to. 61 de luxe copies and normal printing.

979. **1917**
12 woodcut illustrations within the text and 1 inset plate for *L'Almanach des lettres et des arts*. A. Mary and R. Dufy. Paris: Martine, 16mo.

Les Élégies martiales. Paris: Camille Bloch. 180 copies 16 mo. and 71 8 vo.

980. **1918**
Portrait and 20 woodcut headings for Rémy de Gourmont, *M. Croquant*. Paris: Georges Crès, 16 mo., edition of 160.

981. **1919**
2 woodcuts for the Comtesse de Noailles. *Destinée*. Feuillets d'Art, large 4to edition of 1,200.

Woodcut for *L'Almanach de cocagne pour l'an 1920*. Paris: La Sirène, 16 mo. 1 drawing in *Aujourd'hui*. Paris: Bernouard, 4to.

982. **1920**
4 woodcuts including 1 inset plate for *L'Almanach de cocagne pour l'an 1921*. Paris: La Sirène, 16 mo.

Wood-engraved headings for Georges Duhamel, *Élégies*, Camille Bloch, 4to. Frontispiece for Fleuret, *La Comtesse de Ponthieu*. Paris: La Sirène, small 16 mo.

25 drawings, stencil-colored by Richard, for Stéphane Mallarmé, *Madrigaux*. Paris: La Sirène 4to. 110 copies.

5 drawings for Marcel Willard, *Tour d'horizon*. Paris: Au Sans Pareil, 16 mo. 353 copies.

983. **1921**
Wood engraving for *L'Almanach de cocagne pour l'an 1922*. Paris: La Sirène, 16 mo.

Lithograph portrait for Paul Claudel, *Ode jubilaire pour le six-centième anniversaire de la mort de Dante*. Paris: Nouvelle Revue Française, 12 mo. 525 copies.

984. 1922
Portrait engraved with burin by Gorvel for Boylesve, *Ah! Plaisez-moi . . .* Paris: Nouvelle Revue Française, collection 'Une Œuvre, un portrait', 16 mo. 1,050 copies.

985. 1923
Cover and 30 woodcuts colored by J. Rosoy and L. Petibarat for Fleuret, *Friperies.* Paris: Nouvelle Revue Française, 16 mo. 270 copies.

986. 1924
1 color plate for Hervieu, *L'Ame du cirque.* Paris: Librarie de France, large 4to. 386 copies.

987. 1925
97 drawings including 20 inset plates for Coquiot, *La Terre frottée d'ail.* Paris: Delpeuch, 4to. 116 copies and normal printing 16mo, including only 77 drawings.

Portrait for Coulon, *L'Enseignement de Rémy de Gourmont.* Paris: Editions du Siècle, 12mo. 750 copies.

Portrait for Tailhade, *Poésies posthumes.* Paris: Messein, 12mo. 1,000 copies.

988. 1926
36 lithographs for Guillaume Apollinaire, *Le Poète assassiné.* Paris: Au Sans Pareil, 4to. 470 copies.

3 drawings for Gustave Coquiot, *En Suivant la Seine.* Paris: Delpeuch, 8vo. 235 copies.

989. 1927
Portrait engraved by Georges Aubert for Fleuret, *Falourdin.* Paris: Nouvelle Revue Française, collection "Une Œuvre, un portrait," 16mo. 809 copies.

990. 1928
Wood-engraved portrait for Allard, *Les Élégies martiales, 1915-1918.* Nouvelle Revue Française, collection "Une Œuvre, un portrait," 16mo.

Frontispiece for André Gide, *Les Nourritures terrestres.* Paris: Nouvelle Revue Française, collection "A la Gerbe" 8vo. 125 copies.

Portrait engraved by Gorvel for Gourmont, *Esthétique de la langue française.* Paris: Les Arts et le Livre, collection "L'Intelligence," 8vo. 1,120 copies.

Frontispiece etching for Mallarmé, *Poesies.* Paris: Nouvelle Revue Française, collection 'A la Gerbe', 8vo. 125 copies.

1 engraving for Courthion, *Raoul Dufy.* Paris: Chroniques du Jour, 4to. 375 copies of which only 50 on Arches paper contain the engraving.

991. **1929**
Portrait for Cocteau, Marc Ramo, George, *Maria Lani.* Paris: Editions des Quatre-Chemins, 4to.

992. **1930-32**
Watercolor sketches for *Normandie,* commissioned by Ambroise Vollard for a text by President Edouard Herriot, *Le Forêt normande,* left unfinished after the death of Vollard in 1939.

993. **1930**
1 lithograph for Tharaud, "Georgina," in *D'Ariane à Zoé.* Paris: Librarie de France, 4to. 220 copies.

Frontispiece and 5 etchings for Berr de Turique, *Raoul Dufy.* Paris: Henri Floury, 4to. (Only the first 200 copies on Japan paper contain the 5 etchings.)

94 etchings for Eugène Montfort, *La Belle enfant, ou l'amour à quarante ans.* Paris: A. Vollard, 4to. 340 copies

Montfort (1877-1936) was a critic, essayist, novelist and founder of the journal *Les Marges.* Another of his books was illustrated by Albert Marquet, *Mon brigadier tribolière* (Paris: Société Littéraire de France, 1918).

994. **1931**
1 vignette, plates, 1 heading, and 1 ornamental band enngraved in wood for Guillaume Apollinaire, *Le Bestiare ou cortège d'Orphée. Supplément: les deux poèmes refusés,* produced at the expense of an admirer, 4to. 29 copies, plus 1 containing the scored plates.

Frontispiece etching, ornamental band, heading 2 plates, and tailpiece, color lithographs for Fleuret, *Éloge de Raoul Dufy,* for the friends of Dr. Lucien Graux, undated, folio.

995. **1931-36**
Color lithographs for Alphonse Daudet, *Aventures prodigieuses de Tartarin de Tarascon.* Paris: Sciripta et Picta, 4to. 130 copies. Review: G. Blazit, *Beaux-arts magazine* (18 Feb. 1938):5.

996. **1932**
6 drawings for Courthion, *Suite montagnarde.* Paris: Editions Lumière. 210 copies.

3 portraits for Montfort, *Choix de proses.* Paris: Les Marges.

997. **1936**
Frontispiece for Berthault, *Vaisseaux solaires,* preface by Montherlant. Corréa, 16 mo.

19 watercolors and black-and-white cover for Gaston Dérys, *Mon Docteur le vin.* Paris: Draeger Frères. 40 p., illus., some col. small 4to.

998. **1937**
1 etching for Gérard d'Hauville, *Mes Champs-Elysées,* in Paris 1937. Paris: Daragnès.

999. **1940**
20 etchings for Brillat-Savarin, *Aphorismes et Variètès.* Paris: Les Bibliophiles du Palais, 4to. 200 copies.

1000. **1944**
Portrait for Armand Sallacrou, *Les Fiancés du Havre.* Nouvelle Revue Française, 16 mo.

1001. **1948-49**
1 lithograph and 7 drawings for Gaston Massat, *La Source des jours.* Bordas.

2 watercolors for "La Tentative amoureuse" in *Œuvres illustrées d'André Gide.* Nouvelle Revue Française.

1002. **1950**
12 watercolors for André Gide, *Les Nourritures terrestres et les nouvelles nourritures.* Paris: "Le Rayon d' or," Nouvelle Revue Française.

1003. **1951**
6 etchings and 1 lithograph for Courthion, *Raoul Dufy.* Paris: Pierre Cailler. (Only the first 225 copies contain the 7 illustrations.)

10 watercolors for Colette, *Pour un herbier.* Paris: Mermod.

1004. **1945-51**
Pencil drawings for Virgil, *Bucoliques,* unfinished project for Scripta et Picta.

1005. **1953**
16 original lithographs and 45 illustrations for Léon-Paul Fargue, *Illuminations nouvelles.* Paris: Textes-Prétextes.

1006. **1955**
Jules Verne, *10 heures de chasse-simple boutade.* Liège: P.A.

1007. **1956**
Roland Dorgelès, *Vacances forcées.* Paris: Vailetay. 218 p., col. illus., 24 col. pl.

1008. **1957**
Manuel, *Réflexions sur l'art musical.* Paris.

I. Tapestries

Book

1009. AJALBERT, JEAN. *Les Peintres de la Manufacture Nationale de tapisseries de Beauvais: Raoul Dufy.* Paris: Eugène Fry, 1932.

Articles

1010. CHAMPIGNEULLE, BERNARD. "French Tapestry and the Painter." *Craft Horizons* 9:2(1949)4-7.

1011. COGNIAT, RENE. "Tapisseries de Raoul Dufy pour des sièges de Szivessy." *Art et décoration* 68:1(1939):16-20.

1012. JAKOVSKY, ANATOLE. "*Le Bel été,*' ou comment le titre de lunique tapisserie de Dufy pourrait s'appliquer à l'ensemble de son œuvre." *La Marseillaise* (16-22 July 1947).

1013. "La Manufacture National de Beauvais à Paris." *Beaux-arts* (Feb. 1932):17.

1014. MERYEM, JEAN. "La Manufacture Nationale de Beauvais à Paris." *L'Art et les artist* 125(March 1932):205-7.

J. Works in Other Media

Books

1015. CAIN, JULIEN. *Paul Poiret le magnifique* [exh. cat] (Paris: Musée Jacquemart-André, 1974). 105p., 16 illus.

Julien Cain justifies this exhibition of the work of Paul Poiret, the fashion designer and organizer of spectacles in the late 19th century, which some people might describe as frivolous, by appealing to Baudelaire's definition of art. For Baudelaire the frivolous was a part of art when treated seriously, something Poiret never failed to do. The catalogue text details Poiret's life and work and is divided into six parts: 1) childhood, apprenticeship, and Parisian début; 2) Poiret the couturier; 3) arranger of festivals; 4) the friend of artists, the collector; 5) Poiret and Raoul Dufy; and 6) a decline of grandeur. The exhibition included drawings and paintings, and objects by the artist and by friends and acquaintances.

1016. MACKRELL, ALICE. *Paul Poiret.* London: B.T. Batsford, 1990. 96 illus., 61 illus., 10 col.

Surveys the achievements of French fashion designer Paul Poiret (1879-1944), arranged in the following chapters: Directoire revival, Orientalism, the Martyns and Dufy, the fashions of Poiret after the First World War, and Poiret, artists and photographers. Recognizing the need for the rejuvenation of fashion illustration, he was one of the first designers to combine fashion and other arts, thus also improving the already high standard of fashion illustrations with the help of artists. A glossary and an index of museums with Poiret collections are appended.

Articles

1017. ALEXANDRE, ARSENE. "L'Exposition parisienne de Beauvais; la mobillier de Raoul Dufy." *La Renaissance de l'art français et des industries de luxe* 15:3(1932):42-6.

1018. "Une Belle époque" [Dufy's Diverse Contributions to the Decorative Arts; Portfolio]. *Crafts* 102(Jan.-Feb. 1990):34-7.

1019. BREERETTE, GENEVIEVE. "Dufy créateur d'étoffes." *Le Monde* (27 July 1973).

1020. BROGILE, AXELLE DE. "Dufy pure soie" [Pure Silk Dufy]. *Connaissance des arts* 256(June 1973):110-3. 8 illus.

Account on Dufy's development as a textile designer in the field of silk fabrics. His career in this field began when he was introduced to Paul Poiret, who showed great interest in his color patterns. Bianchini, the textile supplier to many of the Parisian couturiers, acted as agent for Dufy. In his designs, he exhibits perfect unity between the techniques of printing and of free drawing. Dufy's colors are vibrant and have a quality of spontaneity. He also became interested in the techniques of tapestry and produced a number of pieces in this medium.

1021. CLARISSE. "L'Art et la mode—les tissus." *L'Art vivant* (April 1925).

1022. CLOUZOT, HENRI. "Les Tissus modernes de Raoul Dufy." *Art et décoration* (Dec. 1920):177-82.

1023. COGNIAT, RENE. "Pour une piscine, un projet de décoration de Raoul Dufy sur le paquebot *La Normandie*." *Art et décoration* 64(Jan. 1935):17-20.

1024. DAURIAC, JACQUES-PAUL. "Raoul Dufy: His Famous Art Deco Textile Design." *Graphics* 30:176(1974-75):530-3. Also in German and French. 6 illus.

The exhibition *Raoul Dufy as a Textile Designer* at the Musée de l'Impression sur étoffes at Mulhouse illustrated the artist's fabric designs in the Art Deco style. The textile industry offered Dufy material security as well as providing him with the opportunity to research old and abandoned techniques which led in turn to his experiments in printing on silk. Dufy gave textile printing a splendid stylistic and chromatic revival, thanks to the subtelty of his graphics, the cultivated eclecticism of his inspiration, his sensitive, imaginative elegance, and the novelty of his color schemes.

1025. "Les Décorations de Dufy pour le Muséum National d'histoire naturelle." *Art et décoration* 30(1952):43.

Highlights Dufy's *Les Explorateurs.*

1026. "Des écharpes de Raoul Dufy." *Art et décoration* 59(June 1931):supp. 6-7.

1027. FORESTIER, J. C. N. "Les Jardins de céramiques de MM. Raoul Dufy, N. Ma Rubbio et Artigas." *Art et industrie* 8(10 Aug. 1927):27-30.

1028. HERALD, JACQUELINE. "Limited Editions on Silk." *Antique Collector* 59:1(Jan. 1988):58-65. 8 col. illus.

Describes the recurring interest throughout the 20th century in painted silk squares, notably scarves designed by Raoul Dufy, Patrick Heron, Robert Colquhoun, and Barbara Hepworth.

1029. HOOG, MICHEL. "Dessins, tapisseries et ceramiques legués par Mme Raoul Dufy au Musée National d'Art moderne de Paris." *Revue du Louvre et des musées de france* 13:4-5(1963).

1030. LAFFAILLE, MAURICE. "De Trouville à Paris." *L'Œil* 255(Oct. 1976):12.

Brief appendix to Jean Dalevève's article, "Dufy décorateur" (in the same issue of *L'Œil*) which pays tribute to the artist's decorative work on the strength of Laffaille's viewing of his *De Trouville à Paris* fresco, which has so far remained inaccessible to the public.

1031. "New Fabrics Put Modern Art in Fashion." *Life* 39(14 Nov. 1955):140-4.

1032. SCOTT, BARBARA. "Sumptuous Silks." *Antique Dealer and Collectors Guide* 40:2(Sept. 1986):70-2. 10 illus., 6 col.

Traces the history of Prelle, a silk-weaving company based in Lyon. Founded in the late 18th century, the company is still run by descendants of the Prelle family. In this century Prelle silks have been designed by Emile-Jacques Ruhlmann and Raoul Dufy, among other artists.

1033. TISSERAND, ERNEST. "La Céramique française en 1928 . . . Artigas et Raoul Dufy." *L'Art vivant* 88(15 Aug. 1928):648-50.

1034. TUCHSCHERER, JEAN-MICHEL. "Raoul Dufy et la mode." *Canal* 24(Jan. 1979):22.

1035. VAN HECKE, PAUL-GUSTAVE. "Raoul Dufy, le décorateur." *Sélection* 7(April 1925):81-104.

1036. VENDRENNE-CARERI, ELISABETH. "Dufy décoratif." *Beaux-arts magazine* 72(Oct. 1989):98-101. 11 col. illus.

Considers the work of Raoul Dufy (1877-1953). Vendrenne-Careri stresses the way in which Dufy treated all forms of art as equal and the fact that painting and decoration are blended in his work, whether it is a piece of furniture, ceramics or painting. She sketches the evolution of his art and notes some of the influences on it, including Apollinaire and Cocteau. She describes some of the characteristics of his work, which radiates enjoyment of living.

1037. ZERVOS, CHRISTIAN. "Sculptures des peintures d'aujourd'hui." *Cahiers d'art* 7(1928):276-89.

V. Influence on Other Artists

Articles

1038. BERENS, JESSICA. "Scene and Hurd." *World of Interiors* (U. K.) (July-Aug. 1988):86-95. 9 col. illus.

Describes the interior of art director Mick Hurd's London flat, which he took ten years to paint almost exclusively in reds and blues. The inspiration behind some of the painting is attributed to Raoul Dufy, and elsewhere Matisse, classical and strong Medican influences are observed. Various objects that adorn the flat are also noted for their eccentricity.

1039. "Bueb via Dufy." *Art Digest* (15 Dec. 1943):20.

1040. HOCKNEY, DAVID and MILTON ESTEROW (Interviewer). "David Hockney's 'Different Ways of Looking'." *Art News* 82:1(Jan. 1983):52-9. 8 illus.

In these excerpts from an interview, David Hockney discusses painters and paintings he admires. He recalls the Picasso exhibition at The Museum of Modern Art, argues that Picasso did not decline as an artist, and compares his work with that of Matisse. Hockney also discusses the value of an academic training in drawing and his own experiments in photography. Giving more examples of painters he enjoys, including Piero della Francesca, Marquet, and Dufy, he explains that his tendency is to like pictorial art the most and, in the end, feels that "everything is a bit dwarfed by Picasso." Hockney also discusses his attitude to art history and concludes by describing his response to his recent travels including a trip to China in 1981.

1041. NEMECZEK, ALFRED. "Roboter gegen das Bild des Fortschritts" [Robots Against the Image of Progress]. *ART: das Kunstmagagzin* 10(Oct. 1989):112-4. 4 col. illus.

In 1937, Raoul Dufy exhibited his greatest work, *La Fée électricité,* featuring 125 figures associated with light and electricity. In 1989, Nam June Paik exhibited his *Electronic Fairy* in the Church of the Madeleine in Paris. It consisted of a portico leading to five human figures, each three meters high, all built of old television sets to house a video installation. The figures represent Diderot, Voltaire, Rousseau, Robespierre, and Olympe de Gouges. Nemeczek describes Nam June Paik's work, comparing and contrasting it to Dufy's.

1042. PERL, JED. "Paris: Bicentennial Blahs." *New Criterion* 8:2(Oct. 1989):33-7.

Sicne the 1970s, Paris has declined as an international art center to the extent that French curators tend to ignore the work of French artists in favor of that of Americans, Italians, and Germans. The 1989 Bicentennial show, *Magiciens de la terre*, illustrated this tendency showing work from artists throughout the world including Third World countries. The global pluralism espoused by this exhibition was also to be found in Nam June Paik's *La Fée électricité,* held at the same time at the Musée d'Art moderne de la Ville de Paris. This multi-media event, held in front of Dufy's work of the same name, misinterpreted Dufy's œuvre and artistic personality to the extent that it was an insult to him and to French art. Perl considers

this an indication of the extent to which French disregard for the quality of their contemporary painters is now extending backwards towards painters of an earlier generation.

1043. PIAUBERT, JEAN and ANDRE PARINAUD (Interviewer). "Jean Piaubert." *Galerie-Jardin des arts* 169(May 1977):30-4. 6 illus. In French.

On the occasion of a retrospective exhibition at Artcurial, Paris, Piaubert discusses his career in this interview. Through the dressmaker Poiret he met Derain, who influenced him, but he also learned from Dufy whom he sees as the opposite pole. Piaubert discusses the importance of sand as material in his paintings and the problem of spirituality. Sand stands both for art in its infancy and for the permanency for which he is always searching.

1044. PINTILLE, ILEANA. "Ana Tzigara Berz." *Arta* (Romania) 36:9(1989):2-5. 11 illus., 6 col. In Roumanian.

Introduces the paintings of Ana Tzigara Berz (1908-67), setting her in the cultural context of the inter-war years in Bucharest and appending a biographical sketch. Pintille emphasize the importance of the years which the artist spent studying in Paris and the influence of French painters, especially Dufy, on her style particularly notable for its vitality and skillful depiction of animal life. Pintille also discusses the various media employed such as gouache, watercolor and oils, and their place in Berz's work as a whole.

1045. RADU, VASILE. "Tineta eternă a 'bătrînului' şevalet" [The Eternal Youth of the 'Old Man's' Easel]. *Arta* (Romania) 35:11(1988):12-13. 6 illus., 3 col.

Account of the painter Aurel Ciupe (1900-88), who distinguished himself at the School of Fine Arts in Bucharest, his sense of color and ornament creating a harmonious whole of intimate charm. Then he visited France where he was influenced by the neo-classicism of artists such as Dufy. After his return to Romania he studied under Umberto Coromaldi for a year at Rome, where he seems to have been attracted by the Italian expressionists. In 1925 he started teaching at Cluj. In 1928 Ciupe won first place in the official Bucharest salon, but after this his reputation was eclipsed until after the 1950s. Radu briefly discusses his role in forming the Cluj School and his later career.

1046. SPROVIERI, GUISEPPE and DOMENICO GUZZI (Interviewer). "Personaggi" [Personalities]. *Arte* 18:185(May 1988):101-2, 104, 106. 4 illus.

In this interview Guiseppe Sprovieri (b. 1890), a central figure of the Italian art world involved in the birth of Futurism, discusses his early career. Dissatisfied with Rome, he went to Paris where he met Raoul Dufy. He describes Dufy's work *Electricity*, in which Marconi appeared at Sprovieri's suggestion. He compares the world of Paris with the provincial Italian art of the early 20th century, suggesting that although there were exciting artists in Italy they were neglected. In 1918, Sprovieri opened the Galleria Futurista Sprovieri in Rome with an exhibition by Boccioni, and in the same year he put on an exhibition of the main Futurists. In 1914, the gallery was closed because of the war.

VI. Mentions

Books

1047. APOLLINAIRE, GUILLAUME. *Chroniques d'art (1902-1918).* Paris: Gallimard, 1960.

1048. ARLAND, MARCEL. *Dans l'amitié de la peinture.* Paris: Luneau Ascot, 1980. 323 p., illus., 6 pl.

Dufy is mentioned on pp. 199-201.

1049. BASCHET, ROGER. *La Peinture contemporaine de 1900 à 1960.* Paris: Editions de l'Illustration, 1961. 2 vols., illus., some col.

Dufy discussed in vol. 1, pp. 31-6.

1050. BERTRAND, GERARD. *L'Illustration de la poésie à l'époque du cubisme, 1900-1914: Derain, Dufy, Picasso.* Paris: Editions Klinsieck, 1971. 238 p., illus. Volume in "Collection le signe de l'art" series.

Includes information on Dufy and André Derain.

1051. Bradley Collection, Milwaukee. *The Collection of Mrs. Harry Lynde Bradley.* Milwaukee: Milwaukee Art Center, 1968. 210 p., illus., 26 col. pl.

Dufy's works are described on pp. 12-53, 130-1.

1052. BRASSAÏ, RICHARD. *The Artists of My Life.* Trans. by Richard Miller. London: Thames & Hudson; New York: Viking Press, 1982. p., 135 illus.

Reviews: M. Vaizey, *Art Book Review* 1:4(1982):50; A. Berman, *Art News* 82:6(Summer 1982):28.

1053. BRETTELL, RICHARD R. *An Impressionist Legacy: The Collection of Sara Lee Corporation.* Introduction by David Finn. New York: Abbeville; dist in the U.K. and Europe by Pandemic, London, 1986. 127 p., 80 col. illus.

Catalogue raisonné of the collection of paintings and sculpture on permanent display at the Chicago headquarters of the Sara Lee Corporation, which were acquired from the personal collection of the company's founder, Nathan Cummings. They are principally French—works by Camille Pissarro, Berthe Morisot, Henri Matisse, Roger de la Fresnaye, Gauguin, Bonnard, Léger, Toulouse-Lautrec, Eugène Boudin, Renoir, Degas, Braque, Rouault, Dufy, Jean Metzinger, Maillol, Vuillard, and Vlaminck, among others.

1054. CAIN, JULIEN. *Paul Poiret le magnifique* [exh. cat.] (Paris: Musée Jacquemart-André, 1974). 105 p., 16 illus.

Julien Cain justifies this exhibition of the work of Paul Poiret, the fashion designer and organizer of spectacles in the late 19th century, which some people might

describe as frivolous was a part of art when treated seriously, something Poiret never failed to do. The catalogue text details Poiret's life and work and is divided into six parts: 1) childhood, apprenticeship, and Parisian début; 2) Poiret the couturier; 3) arranger of festivals; 4) the friend of artists, the collector; 5) Poiret and Raoul Dufy; and 6) a decline a grandeur. The exhibition included drawings, paintings objects by the artist or by friends and acquaintances.

1055. CARCO, FRANCIS. *Le Nu dans la peinture moderne (1863-1920)*. Paris: G. Crès, 1924. 162 p., 32 pl.

Dufy is discussed on pp. 105-8, 111.

1056. CASSOU, JEAN and PHILIPPE JACOTTET. *Le Dessin français au XX* *siécle*. Préface de Jean Cassou, notices biographiques de Philippe Jacottet. Lausanne: Mermod, 1951. 191 p., illus., 144 pl.

Dufy is discussed on pp. xv-xvi and 162-3.
a. U.S. ed.: *French Drawing of the 20th Century: 149 Reproductions*. New York: Vanguard Press, 1955. 184 p., 149 illus.

1057. CHARENSOL, GEORGES. *Les Grands maîtres de la peinture moderne*. Lausanne: Editions Recontre, 1967.

Dufy is discussed on pp. 32-42.
a. U.S. ed.: *The Great Masters of Modern Painting*. Trans. by Pamela Marwood. New York: Funk & Wagnalls, 1970. 207 p., illus., some col.

1058. CHASSE, CHARLES. *Les Fauves et leur temps*. Lausanne, Paris: Bibliothèque des Arts, 1963. 188 p., col. pl.

Dufy is discussed on pp. 99, 104, 176-7.

1059. CHETHAM, CHARLES and CHARLES RUSSELL MORTIMER. *Modern Illustrated Books: The Selma Erving Collection*. Northampton, Massachusetts: Smith College Museum of Art, 1977. 64 p., 60 illus.

The 20th century saw the revival of a number of earlier techniques of book illustration, including wood-engraving, lithography, and copper-plate engraving. Ambroise Vollard's *Parallèlement* (1900), poems by Paul Verlaine illustrated with lithographs by Pierre Bonnard, was the first true *livre d'artiste* and signalled a revolution in the quality and imagination of book illustration. The Selma Erving collection, consisting of 110 books and four portfolios of prints related to books, is presented in the following order in the catalogue: *Livres d'artiste*; books containing original prints; portfolios containing prints related to specific books; books illustrated with reproductions, and reference books. Artists include Pierre Bonnard, Georges Braque, Chagall, Raoul Dufy, Aristide Maillol, Marquet, Matisse, Picasso, Redon, Rouault, Dunoyer de Segonzac, and Jacques Villon.

1060. CLAY, JEAN. *De l'impressionnisme à l'art moderne*. Paris: Hachette, 1975.

Dufy is mentioned on pp. 29, 144.
a. U.S. ed.: *Modern Art, 1890-1918*. New York: Vendome Press; dist. by Viking Press, 1978. 320 p., illus., some col.

1061.COGNIAT, RAYMOND. *Dessins et aquarelles du XX^e siècle*. Paris: Hachette, 1966. 224 p., illus., some col.

Dufy's works are discussed on pp. 30, 64, 58-9, 97, 112, 161, 178.
a. U.S. ed.: *XXth Century Drawings and Watercolors*. Trans. by Anne Ross. New York: Crown Publishers, 1966. 222 p., illus., some col.

1062. COLOMBIER, PERRE DU and ROLAND MANUEL. *Les Arts: peintures, sculpture, gravure, architecture, cinéma, photographie, musique et danse*. Paris: Denoël et Steel, 1933. 360 p., illus., 35 pl. Volume in "Tableau du XX^e siècle 1900-1933" series.

Dufy is mentioned on pp. 56-8.

1063. COQUIOT, GUSTAVE. *Cubistes, futuristes, passéistes*. Paris: Ollendorff, 1914. 277 p., pl.

Dufy is mentioned on pp. 26-9.
a. Another ed.: 1923.

1064. COQUIOT, GUSTAVE. *Les Indépendants, 1884-1920*. Paris: Librairie Ollendorff, 1920. 239 p., pl.

Dufy is mentioned on pp. 110-1.

1065. COQUIOT, GUSTAVE. *En suivant la Seine*. Paris: A. Delpeuch, 1926. 138 p., pl.

Includes three drawings by Dufy.

1066. CRESPELLE, JEAN-PAUL. *Les Fauves*. Neuchâtel: Ides et Calendes, 1962. 365 p., illus., some col.

Pages 150-6, 304-5 discusses Dufy.
a. English ed.: *The Fauves* Trans. by Anita Brookner. London: Oldbourne Press, 1962. 351 p., illus., some col.
b. U.S. ed.: Greenwich, CT: New York Graphic Society, 1962. 351 p., illus., some col.
c. German ed.: *Fauves und Expressionisten*. Munich: Bruckmann, 1963. 365 p., illus., some col.

1067. DAULTE, FRANÇOIS. *L'Aquarelle française au XX^e siècle*. Paris: Bibliothèque des Arts, 1968. 143 p., illus.

Dufy is discussed on pp. 5, 10, 14, 58-61, 131.
a. U.S. eds.: *French Watercolors of the 20th Century.* Foreword by André Dunoyer de Segonzac. Trans. by Diana Imber. New York: Viking Press, 1968; 1970. 143 p., illus.
b. English eds.: London: Thames & Hudson, 1968; 1969. 143 p., 56 illus., 50 col.

1068. DAVIDSON, MORRIS. "A Note on Watercolor for the Painter of Oils" in *Painting with Purpose* (Englewood Cliffs, NJ: Prentice-Hall, 1964). 170 p., illus., 4 pl. some col.

Dufy is mentioned on pp. 154, 159.

1069. DELHAYE, JEAN. *Art Deco: Posters and Graphics.* London: Academic Editions, 1977. 96 p., illus.

Mentions Dufy's and van Dongen's posters.
a. French ed.: *Affiches et gravures, art deco.* Trans. by Dominique Carson. Paris: Flammarion, 1977. 96 p., illlus.
b. French excerpt: "Histoire de l'affiche: art déco." *Galerie des arts* 177(Feb. 1978):49-51. 4 illus.
c. U.S. ed." *Art Deco: Posters and Graphics.* New York: Rizzoli, 1977. 96.

1070. DIEHL, GASTON. *Les Fauves: œuvres de Braque, Derain, Dufy, Friesz, Marquet, Matisse, van Dongen, Vlaminck.* Paris: Les Editions de Chêne, 1943. 6 p., 12 col. pl.

Dufy is discussed on pp. 81-8.
a. U.S. ed.: New York: Abrams, 1975. 168 p., illus., some col.

1071. DIEHL, GASTON. *Les Fauves: œuvres de Braque, Derain, Dufy, Friesz, Marquet, Matisse, van Dongen, Vlaminck.* Introduction de Gaston Diehl. Paris: Les Editions du Chêne, 1943. 6 p., 12 col. pl.

a. Another ed.: 1948.

1072. DIEHL, GASTON. *Les Fauves.* Paris: Nouvelles Editions Française, 1971. 190 p., illus., some col.

Dufy is discussed on pp. 81-8.
a. U.S. ed.: New York: Abrams, 1975. 168 p., illus., some col.

1073. DIEHL, GASTON. *Les Fauves: œuvres de Braque, Derain, Dufy, Friesz, Marquet, Matisse, van Dongen, Vlaminck.* Introduction de Gaston Diehl. Paris: Les Editions du Chêne, 1943. 6 p., 12 col. pl.

a. Another ed.: 1948.

1074. DORIVAL, BERNARD. *Les Etapes de la peinture française contemporaine.* Tome 2: *Le Fauvisme et le cubisme, 1905-1911.* Paris: Gallimard, 1943-48, 4 vols.

Dufy is discussed in vol. 2, pp. 107-23.

1075. DORIVAL BERNARD. *Les Peintres du vingtième siècle; nabis, fauves, cubistes.* Paris: P. Tisné, 1957. 2 vols., col. illus.

Dufy is discussed in vol. 1, pp. 63-6.
a. U.S. ed.: *Twentieth Century Painters.* New York: Universe Books, 1958. 2 vols., col. illus.
b. German ed.: *Die Französischen Maler des XX. Jahrhunderts.* Trans. by Concordia Bickel. Munich: F. Bruckmann, 1959-60. 2 vols., col. illus.

1076. DORIVAL, BERNARD. *Images de la peinture française contemporaine.* Préface et descriptions commentées par Bernard Dorival. Paris: Editions Nomis, 1956. 123 p., illus., 28 col. pl.

Dufy is mentioned on pp. 69-71.
a. Another ed.: 1955. 147 p., 32 col. pl.

1077. DUTHUIT, GEORGES. *Les Fauves; Braque, Derain, van Dongen, Dufy, Friesz, Manguin, Marquet, Matisse, Puy, Vlaminck.* Geneva: Editions des Trois Collines, 1949. 254 p., illus.

Dufy is mentioned on pp. 65, 67-8, 90, 155.

1078. ESCHOLIER, RAYMOND. *La Peinture française, XXᵉ siècle.* Paris: H. Floury, 1937. 152 p., illus., col. pl. Volume in "Bibliothèque artistique" series.

Dufy is discussed on pp. 63-70.

1079. FANELLI, GIOVANNI and ROSALIA FANELLI. *Il Tessuto moderno: disegno moda architettura, 1890-1940.* [Modern Textiles: Design Fashions, Interiors, 1890-1940]. Florence: Nuova Vallecchi Editore, 1976. 272 p., 887 illus., 143 pl.

Study of textiles of the period 1890-1940 is intrinsic to the understanding of modern art, since analysis of pattern and design structure is its chief concern. Likewise the study of textiles contributes to understanding of the changing fashions in dress and interior decoration—sometimes showing a commitment to ideals of the "modern movement" in the creation of "total space," sometimes following the vagaries of "taste." After taking into account the cnditions imposed by new techniques of production in the 19th century, this work treats the aesthetic, economic, and political aspects and reveal by research and documentation the significant contribution to textile design by many artists, designers, architects, and artistic movements, including Raoul Dufy.

1080. FELS, FLORENT. *L'Art vivant de 1900 à nos jours.* Geneva: Pierre Cailler, 1950. 550 illus. Volume in "Peintres et sculpteurs d'hier et d'aujourd'hui" series.

Dufy is discussed on pp. 187-90.

1081. FOURNIER, GABRIEL. *Cors de chasse, 1912-1954.* Geneva: P. Cailler, 1957. 246 p. Volume in "Les Problèmes de l'art" series.

Dufy is discussed on pp. 62-85.

1082. FRANCASTEL, PIERRE. *Nouveau dessin, nouvelle peinture; L'Ecole de Paris*. Paris: Librairie de Médicis, 1946. 187 p., 40 pl.

Dufy is discussed on pp. 148-52.

1083. FRANCASTEL, PIERRE. *Histoire de la peinture française, la peinture de chevalet du XIVᵉ siècle*. Par Pierre Francastel avec la collaboration de Galienne Francastel et de Pierre Tisné; notices par Maurice Bex. Tome II: *Du classicisme au cubisme*. Paris, New York, Brussels: Elsevier, 1955. 2 vols., illus., some col.

Dufy is mentioned in vol. 2, pp. 162-3, 188-9.

1084. FRANCASTEL, PIERRE. *Peinture et société; naissance et destruction d'un éspace plastique de la Renaissance au cubisme*. Lyon: Audin, 1951. 298 p., illus., 48 pl.

a. Other eds.: Paris: Gallimard, 1965. 246 p. (Dufy is mentioned on p. 216), illus.; Paris: Denoël, 1977. 362 p., illus., some col.
b. Spanish ed: *Pintura y sociedad*. Madrid: Cátedra, 1984. 280 p., illus., 108 pl.

1085. GAFFE, RENE. *Introduction à la peinture française*. Paris: La Nef; Brussels: Editions des artistes, 1954. 292 p., pl.

Dufy is mentioned on pp. 174-7. Covers French painting from Manet to Picasso.

1086. GEE, MALCOLM. *Dealers, Critics, and Collectors of Modern Painting: Aspects of the Parisian Art Market Between 1910-1930*. Thesis, University of London, 1977. 2 vols., 566 p.; New York: Garland, 1981. 266 p.

Analysis of the "support-system" for modern painting. Chapters on salons, the Hôtel Drouot, dealers, the press, and collectors, followed by a chronological survey of modern art on the market, in four sections: the avant-garde 1910-25 and 1925-30, l'Ecole de Paris, and l'Ecole Française 1918-30. Sections on D.-H. Kahnweiler, P. Guillaume, Bernheim-Jeune, W. Uhde, A. Breton, M. Duchamp, A. Ozenfant, P. Eluard, G. Aubry, L. Zborowski and A. Basler, L. Vauxcelles, A. Salmon, W. George, M. Raynal, A. Lefèvre, D. Tzanck, P. Poiret, and J. Doucet. A second volume contains appendices including an annotated catalogue of modern paintings sold at auction 1918-30; analysis of buyers at auction; a detailed study of Uhde and Kahnweiler auctions 1921-23; and a list of modern art exhibitions in Paris 1910-30. Principle artists considered are Braque, Chagall, de Chirico, Derain, Dufy, Ernst, de la Fresnaye, Gris, Kisling, Laurencin, Léger, Matisse, Metzinger, Modigliani, Picasso, Rivera, Segonzac, Severini, Soutine, and Utrillo.

1087. GENAILLE, ROBERT. *La Peinture contemporaine*. Paris: F. Nathan, 1955. 355 p., illus. Volume in "L'Activité contemporaine" series.

Mentions Dufy on pp. 44-5, 95-6, 143-4, 257-8, 271-2.

1088. GEORGES-MICHEL, MICHEL. *Les Grandes époques de la peinture 'moderne' de Delacroix à nos jours*. New York, Paris: Brentano's, 1945. 239 p., pl.

Dufy is mentioned on pp. 140-1.

1089. GUTH, PAUL. *Quarante contre un.* Paris: Corréa, 1947-1952. 3 vols.

a. Other eds.: Paris: Librairie Générale Française, 1973 (mentions Dufy on pp. 113-22); Paris: Filipacchi, 1991. 308 p.

1090. HAUTECOEUR, LOUIS. *Histoire de l'art.* Tome III: *De la nature à l'abstraction.* Paris: Flammarion, 1959.

Dufy is mentioned in vol. 3, pp. 291-2.

1091. *Histoire illustrée de la peinture de l'art rupestre à l'art abstrait.* Paris: Hazan, 1961.

Dufy is mentioned on pp. 273, 276-7.
a. U.S. ed.: New York: Tudor, 1961.

1092. HOBBS, ROBERT CARLETON. *Milton Avery.* Introduction by Hilton Kramer. New York: Hudson Hills Press; dist. by Rizzoli, 1989. 263 p., 150 illus., 125 col.

Discusses the life and work of Milton Avery, a friend and colleague of the Abstract Expressionists, who nevertheless maintained his commitment to representation. Avery's paintings, depicting family and friends, intimated settings and landscapes encountered holidays, reflect the concerns he shared with the French modernists, including Dufy, Matisse, Braque, and Picasso-saturated color, pictorial logic and the retention of the two-dimensional character of the canvas. Hobbs shows how Avery adapted these concerns to create a distinctly American brand of modernism.

1093. HOOG, MICHEL. *Peinture moderne.* Paris: Editions des Deux Coqs d'Or; Verona: Modadoiri-Ogame, 1969.

Dufy is mentioned on pp. 88-9.

1094. JEDLICKA, GOTTHARD. *Der Fauvismus.* Zurich: Büchergilde Gutenberg, 1961.

Dufy is mentioned on pp. 111-3; see also pl. 61-8.

1095. KELDER, DIANE. *The Great Book of Post-Impressionism.* New York: Abbeville, 1986. 383 p., 413 illus., 236 col.

Chapter on Fauvism emphasizes Matisse, Derain, Dufy, and Vlaminck.

1096. KELDER, DIANE. *Masters of the Modern Tradition: Selections from the Collection of Samuel J. and Ethel LeFrak.* New York: LeFrak Organization, 1988. 95 p., 55 illus., 49 col.

Selection includes works by Dufy, Braque, Matisse, Rouault, van Dongen, and Vlaminck, among other artists.

1097. Lasker Collection. *The Albert D. Lasker Collection, Renoir to Matisse.* New York: Simon and Schuster, 1957. 90 p., illus., 60 col.

Dufy's works are described on pp. 43-52, 122-3.

1098. LEVY, PIERRE GEORGES. *Des artistes et un collectionneur.* Paris: Flammarion, 1976. 381 p.

1099. LEYMARIE, JEAN. *Le Fauvisme: étude biographique et critique.* Geneva: Skira, 1959. 163 p., col. illus. Volume in "Le Goût de notre temps" series.

Mentions Dufy on pp. 101-3.
a. U.S. ed.: *Fauvism: Biographical and Critical Study.* Trans. by James Emmons. New York: Skira, 1959, 163 p., col. illus.

1100. LHOTE, ANDRE. *Traité de la figure.* Paris: Librairie H. Floury, 1950. 255 p., illus., pl. 8 col. Volume in "Ecrits d'artistes" series.

Dufy is mentioned on p. 249.
a. English ed.: *Figure Painting.* Trans. by W. J. Strachan. London: A. Zwemmer, 1953. 168 p., illus., pl., 9 col.
b. U.S. ed.: *Theory of Figure Painting.* Trans. by W. J. Strachan. New York Praeger, 1954. 168 p., illus., some col.

1101. LOEB, PIERRE. *Voyages à travers la peinture.* Paris: Bordas, 1946. 144 p., illus., 48 pl.

Mentions Dufy on p. 135.

1102. MACKRELL, ALICE. *Paul Poiret.* London: B. T. Batsford, 1990. 96 p., 61 illus., 10 col.

Surveys the achievements of French fashion designer Paul Poiret (1879-1944), arranged in the following chapters: Directoire revival, Orientalism, the Martyns and Dufy, the fashions of Poiret after the First World War, and Poiret, artists and photographers. Recognizing the need for the rejuvenation of fashion and other arts, thus also improving the aready high standard of fashion illustrationswith the help of artists. A glossary and an index of museums with Poiret collections are appended.

1103. MATISSE, HENRI. *Ecrits et propos sur l'art.* Texte, notes, et index établis par Dominique Fourcade. Paris: Hermann, 1972. 365 p. Volume in "Collection savoir" series.

Mentions Dufy on pp. 114, 116.

1104. MOLLET, JEAN. *Les Mémoires du Baron Mollet.* Paris: Gallimard, 1963. 199 p.

Dufy is mentioned on pp. 151, 153.

1105. MULLER, JOSEPH-EMILE. *Le Fauvisme*. Paris: F. Hazan, 1956. 95 p., col. illus. Volume in "Bibliothèque Aldine des arts" series.

Mentions Dufy on pp. 47-9.
a. Another ed.: 1967. 256 p., illus., some col.

1106. MULLER, JOSEPH-EMILE. *L'Art au XX^e siècle*. Paris: Larousse, 1967. 363 p., illus. Volume in "Le Livre de poche" series.

Mentions Dufy on pp. 49, 53, 199-201, 233-4.

1107. MULLER, JOSEPH-EMILE and FRANK ELGAR. *Cent ans de peinture moderne*. Paris: F. Hazan, 1979. 239 p., col. illus.

Dufy is mentioned on pp. 85-7.

1108. NATANSON, THADEE. *Peints à leur tour*. Paris: Albin Michel, 1948. 388 p., pl.

Mentions Dufy on pp. 228-30.

1109. OURY, MARCELLE, ed., et al. *Lettres à mon peintre: Raoul Dufy*. Paris: Librairie Académique Perrin, 1965. 193 p., illus. 27 pl. some col. Limited edition issued in box.

Includes extracts from Dufy's notebooks, "Les Carnets de Raoul Dufy," (pp. 156-91) and "Souvenirs, hommages et citations."

1110. PACH, WALTER. *Queer Thing; Painting; Forty Years in the World of Art*. New York, London: Harper & Bros., 1938. 335 p., pl.

Mentions Dufy on pp. 173-6.

1111. PERL, JED. *Paris Without End: On French Art Since World War I*. San Francisco: North Point Press, 1988, 146 p., 50 illus.

Series of ten interlinked essays which explore the developments and major personalities of French art since the First World War, focusing on Matisse, Derain, Dufy, Léger, Picasso, Braque, Giacometti, Hélion, and Balthus. In his final essay Perl compares and contrasts Paris and New York as the cultural capitals, respectively, of the early and late 20th century.

1112. PIPER, DAVID. *Artists' London*. London: Weidenfeld & Nicholson, 1982. 160 p., 137 illus.

Survey of artistic visions of London from the Middle Ages to the present. Artists surveyed and illustrated in the chapter on the 20th century include Raoul Dufy, among others. A dominant theme of the book is the constant renewal of visions of London inspired especially by the arrival of foreign artists.
a. U.S. ed.: New York: Oxford University Press, 1982. 160 p., illus., some col.

1113. POIRET, PAUL. *En habillant l'époque*. Paris: B. Grasset, 1930. 312 p., pl.

Mentions Dufy on pp. 150-3, 295.
a. Another ed.: Préface d'Henry Miller. Paris: B. Grasset, 1986. 244 p., illus., 8 pl.

1114. Quinn Collectionn. *John Quinn (1870-1925); Collection of Paintings, Water Colors, Drawings & Sculpture*. Huntington, NY: Pidgeon Hill Press, 1926. 200 p., pl.

Works in the collection of Dufy are discussed on pp. 9-10.

1115. RAYNAL, MAURICE. *Anthologie de la peinture en France de 1906 à nos jours*. Paris: Editions Montaigne, 1927. 319 p., illus.

Discusses Dufy on pp. 137-41.
a. U.S. eds.: *Modern French Painters*. Trans. by Ralph Roeder. New York: Brentano's, 1928. 275 p., pl.; New York: Arno Press, 1969. 275 p., pl.

1116. RAYNAL, MAURICE. *Histoirie de la peinture moderns: Matisse, Munch Rouault*. Textes et documentation par Maurice Raynal [et al.]. Introduction de Georg Schmidt; traductions de S. Stelling-Michaud. Geneva: Skira, 1950. 154 p., illus. some col. Volume in "Peinture, couleur, histoire" series.

Mentions Dufy on pp. 278-9.
a. U.S. ed.: *Modern Painting*. Trans. by Stuart Gilbert. Geneva: Skira; New York: Skira, 1956. 339 p., illus., some col.

1117. ROGER-MARX, CLAUDE. *Le Paysage français de Corot à nos jours, ou le dialoguue de l'homme et du ciel*. Paris: Plon, 1952. 112 p., illus.

Mentions Dufy on pp. 69-70.

1118. ROGER-MARX, CLAUDE. *Maîtres du XIXᵉ siècle et du XXᵉ*. Geneva: P. Cailler, 1954. 327 p., illus. Volume in "Les Problèmes de l'art" series.

Discussion on Dufy on pp. 225-32.

1119. ROY, CLAUDE. *Descriptions critiques, l'amour de la peinture. Goyá, Picasso, et autres peintres*. Paris: Gallimard, 1956. Volume in "Descriptions critiques" series.

Dufy is mentioned on pp. 197-9.
a. Another ed.: 1969.

1120. SALMON, ANDRE. *Le Fauvisme*. Paris: Editions A. Somogy, 1956.

Mentions Dufy on pp. 42, 46, 48, 52, 54.

1121. SAN LAZZARO, GUALTIERI DI. *Cinquant'anni di pittura moderna in Francia*. Rome: Danesi, 1945. 151 p., 2 pl.

a. English ed.: *Painting in France, 1895-1949.* Trans. by Baptista Gilliat-Smith and Bernard Wall. London: Harvill Press, 1949. 132 p. (pp. 47-8 mention Dufy), pl.
b. U.S. ed.: New York: Philosophical Library, 1949. 132 p., pl.

1122. SIMA, MICHEL. *21 visages d'artistes.* Paris: F. Nathan, 1959. 157 p., illus., 16 col. pl.

Dufy is discussed on pp. 13-4, 42-9.
a. U.S. ed.: *Faces of Modern Art.* Trans. by Gloria Lévy. New York: Tudor Publishing Co., 1959. 157 p., illus., some col.

1123. TARDIEU, JEAN. *Les Portes de toile.* Paris: Gallimard, 1969. 161 p.

Information on Dufy is on pp. 110-4.

1124. TRIER, EDUARD. *Zeichner des Zwanzigsten Jahrhunderts.* Frankfurt am Main: Büchergilde Gutenberg, 1956. 165 p., 138 illus.

Mentions Dufy on pp. 45-6.

1125. VANDERPYL, FRITZ R. *Peintres de mon époque.* Paris: Librairie Stock, 1931. 228 p.

1126. VAUXCELLES, LOUIS. *Le Fauvisme.* Geneva: P. Cailler, 1958. 115 p., 11 col. illus. Volume in "Peintres et sculpteurs d'hier et d'aujourd'hui" series.

Dufy is discussed on pp. 85-90.

1127. VERGNET-RUIZ, JEAN and MICHEL LACLOTTE. *Petits et grands musées de France; la peinture française des primitifs à nos jours.* Paris: Editions Cercle d'art, 1962. 261 p., 254 illus., some col.

Mentions Dufy on p. 208.

1128. VLAMINCK, MAURICE DE. *Paysages et personnages.* Paris: Flammarion, 1953. 240 p.

Dufy is mentioned on pp. 127-9.

1129. VOLLARD, AMBROISE. *Recollections of a Picture Dealer.* Translated from the Original French Manuscript by Violet M. Macdonald. London: Constable, 1936. 326 p., pl.

Memoirs of Ambroise Vollard (1867-1939), the successful Parisian art dealer. Mentions Dufy and other Fauve painters.
a. U.S. ed.: Boston: Little, Brown, 1936. 326 p., 32 pl.; New York: Hacker Art Books, 1978; New York: Dover, 1978.
b. French eds.: *Souvenirs d'un marchand de tableaux.* Paris: Albin Michel, 1937, 1948, 1959, 1984.
c. German ed.: *Erinnerungen eines Kunsthändlers.* Trans. by Margaretha Freifrau von Reisfchach-Scheffel. Zurich: Diogenes, 1957. 377 p., illus.

1130. WARNOD, ANDRE. *Ceux de la Butte*. Paris: Julliard, 1947. 290 pp., illus. Volume in "La Petite histoire des grands artistes" series.

Discusses Dufy on pp. 204-5.

1131. WHITE, PALMER. *Poiret*. London: Studio Vista; New York: Clarkson N. Potter, 1973. 192 p., 130 illus., some col.

Paul Poiret made a large contribution to the shaping of life as we know it. Before the First World War he anticipated the greater freedom women would demand and enjoy in their working and social lives and contributed to their emancipation by freeing their bodies. He created the feminine figure, the "look" of the 20th century. Poiret related fashion to the other arts for the first time. In support of the fine arts he befriended beginners and assembled a collection of modern paintings. With Raoul Dufy, Poiret initiated the French modern applied arts. He infused new life into all the minor arts of his times: interior decoration, perfumes, theatrical costume, fashion illustration and photography, textiles. For the greater part of his life he was a household name all over Europe, Russia, and the Americas, yet in 1944 he died in total oblivion.

1132. WILENSKI, REGINALD HOWARD. *Modern French Painters*. London: Faber & Faber, 1947. 424 p., pl., some col.

Articles

1133. "L'Art spontané." *Club des arts* 13(1953).

1134. CHAPON, FRANÇOIS. "Ambroise Vollard." *Gazette des Beaux-arts* 94(July-Aug. 1979):33-47, 95(Jan. 1980):25-38. 9 illus. In French, summary in English.

Art dealers were the first at the beginning of the century, to give economic support to the illustrated book, that modern form of expression in which various ways of apprehending reality mingled in an association of correspondences. Ambroise Vollard was here an innovator. A certain personal nostalgia for creation provided him with a compensation in his publishing work for which he spared neither effort nor expense, employing for classical texts authors like Verlaine, Octave Mirbeau, and Suarès or artists like Bonnard, Dufy, Picasso, Rodin, Rouault, as well as the leading craftsmen of the time.

1135. CHASTEL, ANDRE. "Paris Summer." *Art et News* 4(1953-4).

1136. DAVIS, S. A. "Lucien Vogel." *Costume* 12(1978):74-82. 3 illus. In English.

La Gazette du bon ton was a revue of fashion that presented costume as an art form. Its publisher was Lucien Vogel, who initiated the high quality fashion magazine, the influence of which persists even today. Davis provides details of Vogel's early life before discussing his magazines, including *La Gazette du bon ton, Le Style parisien, Feuillets d'art,* and *Vu,* and the innovations. Vogel brought to fashion publishing, like his recruitment of painters of the calibre of Dufy, Foujita, and Léon Bakst to work on his projects.

1137. DEGAND, LEON. "Pour le plaisir." *Les Lettres françaises* (11 Aug. 1945).

1138. DESCARGUES, PIERRE. "Et ne craignez point de vous révolter contre vos ainés." *Les Lettres françaises* (9 May 1952).

1139. DIOLE, P. "Le Secret de Van Eyck, 'va-t-il bouleverser la peinture?' la découverte de M. Maroger et l'enthousiasme de Dufy." *Beaux-arts magazine* (28 June 1935):1. Reply by J. Maroger, *Beaux-arts magazine* (5 July 1935):1[+].

1140. DORIVAL, BERNARD. "Un an d'activite au Musée d'Art moderne II—les achats des musées nationaux." *Musées de France* (Dec. 1948):296-7.

1141. DUCHEIN, PAUL. "La Région Midi-Pyrénées, source d'inspiration pour les artistes contemmporains" [The Midi-Pyrenees Region, Source of Inspiration for Contemporary Artists]. *Bulletin du Musée Ingres* 36(Dec. 1974): 25-36. 10 illus.

Lists modern artists who painted subjects in the region of Toulouse, including Toulouse-Lautrec, Matisse, Redon, Ernst, Magritte, Dufy, and Dalí.

1142. FREEMAN, JUDI. "Surveying the Terrain" in *The Fauve Landscape,* edited by Judi Freeman (New York: Abbeville, 1990), pp. 13-57. 63 illus., 38 col.

Discusses the origins and nature of Fauvism during 1904-08, examining the way Fauve artists worked in groups, collaborating with each other. Sites painted, often those chosen by the Impressionists, are discussed and Fauvist practice is compared to that of Impressionism. Principal Fauve artists discussed are Henri Matisse, André Derain, and Maurice de Vlaminck. Also associated with these were Georges Braque, Raoul Dufy, Othon Friesz, Henri Manguin, Albert Marquet, and Jean Puy.

1143. GUENNE, JACQUES. "Les Peintres indépendants." *L'Art vivant* 211(17 June 1937):104-5.

1144. HOOG, MICHEL. "La Génération de 1900. La Peinture et la gravure: Fauvisme et Expressionisme" in *Encyclopédie de la Pléiade. Histoire de l'art.* Tome IV: *Du Réalisme à nos jours* (Paris: Gallimard, 1969).

Mentions Dufy in vol. 4, pp. 547-51.

1145. HUYGHE, RENE and JEAN RUDEL. "Le Fauvisme" in *L'Art et le monde moderne* (Paris: Larousse, 1970). 2 vols. Tome I: 1800-1920 (Paris: Larousse, 1969).

Vol. 1, pp. 188-97 discusses Dufy.

1146. JARLOT, GERARD. "Raoul Dufy" in *Les Clés de l'art moderne* (Paris: Le Table Ronde, 1955), pp. 137-8.

1147. LACKER, D. "Notes sur des symboles bleus" [Notes on Blue Symbols]. *Peintre* 579(15 Feb. 1979):15-18.

Study of the symbology of the color blue, as used by painters since antiquity. Lacker quotes the views of Franz Marc and Kandinsky, who founded the Blaue Reiter, and explains the importance of blue for Raoul Dufy.

1148. LASSIUS, JEAN DE. "Les 'Fauves'" *L'Amour de l'art* (1927):209-11.

1149. LEWIS, V. E. "Prints by Five American Contemporaries." *Carnegie Magazine* 25(Feb. 1951):577-9[+].

1150. LISSIM, SIMON. "Paris 1920-1940." *Decorative Arts Society, 1890-1940, Bulletin* 2(19978):14-23. 6 illus.

1920-1940 saw the beginning of Lissim's career as a painter and designer with emphasis on stage design and porcelain design. Discusses the Paris years and his relations with Russian émigré artists, writers and actors, and the French artistic milieu. Among those mentioned are Sergei Diaghilev, Léon Bakst, Natalia Goncharova, Marc Chagall, Dufy, Lalique, Anna Pavlova, and Alexandre Benois.

1151. LÜTGENS, A. "Kein einziger Kopf zerbrochen: Picasso zum 100. Geburtstag" [Not a Single Head Broken: On the 100th Anniversary of the Birth of Picasso]. *Tendenzen* 23:138(April-June 1982):22-4. 3 illus.

Review of the exhibition of this title in the Kunsthalle, Hamburg. Lütgens compares the complexity of Picasso's paintings *Woman in an Easy Chair* with Dufy's *Woman in Red* and Mondrian's *Peasant from Seeland,* concluding that the selection of works was designed to show Picasso's superiority, thereby avoiding difficult aesthetic questions which would have arisen if Matisse or Käthe Kollwitz had been represented.

1152. MAROGER, J. "Le Secret de van Eyck; reply to P. Diolé." *Beaux-arts magazine* (5 July 1935):1[+].

1153. "Petit dictionnaire des années héroïques (1907-1917)." *XXe siècle* 28(May 1966):93.

Illustrated with Dufy's *Maison à l'Estaque.*

1154. PIERRE, J. "Au temps du 'Boeuf sur le Toit'" [In the Time of the 'Boeuf sur le Toit']. *L'Œil* 311(June 1981):52-7. 11 illus.

With reference to the exhibition *Au Temps du Boeuf sur le Toit* at Artcurial, Paris, in July 1981, Pierre describes the activities centering around the "Boeuf sur le Toit," a bar in the Rue Boissy-d'Anglas, Paris, from 1881 to 1926, which acted as a rendezvous for artists and was the site of a fusion of artistic, musical, dance and theatrical talents. Between 1919 and 1925 there was even an "école du Boeuf"—musicians, dancers and artists lead by Jean Cocteau who created and performed some of the most original spectacles ever seen in the city. In 1920, a ballet entitled "Boeuf sur le Toit"—story by Cocteau, music by Darius Milhaud, sets and costumes by Dufy—was performed by La Comédie des Champs-Elysées.

1155. RAGON, M. "Sur lettres et peinture." *Galerie-Jardin des arts* (Jan. 1964).

1156. REUHMAN, HELMUT. "Methods of the Masters." *Studio* 145(March 1933):73-6.

1157. ROGER-MARX, CLAUDE. "Le Mois à Paris." (1953).

1158. SCHAEFFNER, ANDRE. "Jardins des salons." *Cahiers d'art* 6(1927):218-21.

1159. SCHNEIDER, PIERRE. "Four Fauves." *Art News* 61(Sept. 1962):49.

1160. SIPLE, ELLEN S. "A Modern Decorative Style." *The Arts* (1927).

1161. THIRION, JACQUES. "Musées de Nice: l'enrichissement des collections modernes de 1958 à 1964." *La Revue du Louvre et des musées de France* 17:1(1967):61-7. 13 illus.

1162. VAUXCELLES, LOUIS. "Les Fauves à l'exposition de la Gazette des Beaux-arts." *Gazette des Beaux-Arts* 2(1934):273-82.

1163. VERONESI, GUILIA. "Les Fauves." *Emporium* 112(1950):51-60.

1164. ZERVOS, CHRISTIAN. "Nos enquêtes: entretiens avec Mademoiselle B. Weill." *Cahiers d'art* 3(1927):1-2.

VII. Audiovisual Materials

1165. *Emission de Radio-Actualités avec Villeboeuf,* 1940.

1166. *Emission pour les Etats-Unis de la Radiodiffusion française, à propos de l'exposition Raoul Dufy à la Galerie Louis Carré en juin-juillet,* 24 June 1947.

1167. *Emission radiophonique de Marcel Sauvage consacrée à Raoul Dufy:* "En écoutant la peinture." 1952.

1168. *Raoul Dufy.* Réalisé par J.-C. Huisman à la demande de l'Electricité de France. 1963. Film documentary.

1169. *Raoul Dufy.* Réalisé par Robert Mariaud de Serres. Scénario et documentation de Maurice Laffaille d'après un texte de Marcelle Berr de Turique. 1976. 13 minutes. 36 and 16 mm., col.

1170. STRAVINSKY, IGOR. *Double Canon: Raoul Dufy in Memoriam.* London: Boosey & Hawkes, 1960. 1 p. musical score.

VIII. Exhibitions

A. Individual Exhibitions

1906, October	Paris, Galerie Berthe Weill. *Exposition particulière de peintures par Monsieur Raoul Dufy.*
1921	Paris, Galerie Bernheim-Jeune. *Exposition Raoul Dufy.* 57 paintings, 30 watercolors, pastels, drawings.
1922	Paris, Galerie Bernheim-Jeune. *Exposition Raoul Dufy, œuvres récentes.*
1923	Brussels, Galerie Le Centaure. *Raoul Dufy.*
1924	Paris, Galerie Bernheim-Jeune.
1925	Paris, Péniches. *'Orgues' de Paul Poiret.* 14 hangings.
1926	Paris, Galerie Bernheim-Jeune. *Nouvelles céramiques de Raoul Dufy.*
1926	Paris, Galerie Bernheim-Jeune. *Un voyage au Maroc, 40 aquarelles de Raoul Dufy.* 40 watercolors.
1926	Paris, Galerie Pierre. *Exposition de dessins par Raoul Dufy.*
1927	Brussels, Galerie Le Centaure. *Peintures, aquarelles dessins, tentures, céramiques.*
1927	Paris, Galerie Le Portique. *Cent dessins originaux pour la Terre frottée d'ail de Gustave Coquoit. Aquarelles. Peintures récentes.* Review: *Cahiers d'art* 3(1927):4.
1928	Paris, Galerie Le Portique. *Raoul Dufy, quelques œuvres.*
1929	Paris, Galerie Bernheim-Jeune. *Jardins d'appartements en céramique, peintures.* Review: *Cahiers d'art* 5(1929):17.
1929	Paris, Galerie Le Portique. *Raoul Dufy.*
1929	London, Arthur Tooth & Sons Gallery. Review: *Connoisseur* 83(April 1929):252.
1929	New York, Dudensing Gallery. *Raoul Dufy.* Reviews: *Art News* 28(23 Nov. 1989):12-3; C. Zervos, *Cahiers d'art* 8-9(1929):422.

1930	Paris, Galerie Vignon. *Raoul Dufy gouaches et dessins.* Reviews: *Art et décoration* 57(May 1930):supp.2; P. Fierens, *Art News* 28(17 May 1930):25; *Cahiers d'art* 5:2(1930):105.
1930	Paris, Galerie Georges Petit. Review: *Cahiers d'art* 5:2(1930):105.
1930	Paris, Galerie Le Portique. *Raoul Dufy, à l'occasion de la publication del'ouvrage de Marcelle Berr de Turique.* Review: A. Salmon, *Apollo* 13(Feb. 1931):113.
1930-31	New York, Balzac Galleries. Reviews: *Art News* 29(27 Dec. 1930):12; *Art Digest* 51 Jan. 1931):16.
1931	Brussels. *Exposition Raoul Dufy.*
1931	New York, Valentine Gallery. Review: *Art News* 30(14 Nov. 1931):10.
1931	Zurich, Musée de Zurich. *Œuvres récentes de Raoul Dufy.*
1932	Paris, Galerie Bernheim-Jeune. *Exposition du mobilier de salon 'Paris' exécuté en basse lisse à la Manufacture national de Beauvais d'après des cartons de Raoul Dufy.* Reviews: A. Alexandre, *La Renaissance de l'art française et des industries de luxe* 15:3(Feb. 1932):42-6; *Beaux-arts* (Feb. 1932):17; J. Meryem, *Art et artist* 125(March 1932):205-7.
1932	Paris. Review: *Art et décoration* 61(Dec. 1932):supp. 3-4.
1934	Brussels, Palais des Beaux-arts. *Raoul Dufy.* 105 drawings, 42 watercolors, 7 panels. Review: P. Fierens, *Beaux-arts magazine* (19 Jan. 1932):1.
1934	New York, Pierre Matisse Gallery. Review: *Art News* 32(10 March 1934):5.
1934	Prague. *Dufy.*
1936	New York, Sporting Gallery. Reviews: *Art Digest* 10(15 May 1936):16; A. Sayre, *Art News* 34(16 May 1936):8.

1936 Paris, Galerie Bernheim-Jeune. *Raoul Dufy. Peintures et gouaches pour 'Mon docteur le vin.'*
 Review: *L'Amour de l'art* 17(June 1936):229.

1936 London, Lefevre Galleries. *Raoul Dufy.* 37 paintings, 6 watercolors, 1 drawing.
 Review: D. Goldring, *London Studio* 12 (Studio 112)(Oct. 1936):221-2.

1936 Paris, Galerie Max Kaganovitch. *Œuvres récentes de Raoul Dufy.* 38 paintings.

1936-37 Paris, Galerie Jeanne Bucher.
 Review: J. Lane, *Apollo* 25(Jan. 1937):43.

1937 Paris, Galerie Jeanne Bucher.
 Review: *Beaux-arts magazine* (5 Feb. 1937):8.

1938 New York, Bignou Gallery. *Raoul Dufy.* 17 paintings.
 Reviews: *Art News* 36(5 Feb. 1938):15; M. Davidson, *Art News* 36(26 March 1938):19[+]; *Art Digest* 12(1 April 1938):9.

1938 London, Reid and Lefevre Galleries. *Oil Paintings and Watercolours by Raoul Dufy.*
 Review: *Apollo* 27(June 1938):332.

1938 New York, Carroll Carstairs Gallery.
 Review: *Art News* 37(5 Nov. 1938):15.

1938 Chicago, Arts Club. *Exhibition of Watercolors by Raoul Dufy.*

1938 New York, Bignou Gallery. *Castles of the Loire, Watercolors by Raoul Dufy.* 24 watercolors.

1939 New York, Lilienfeld Galleries.
 Review: *Art News* 37(29 April 1939):12.

1939 Washington, D.C., Whyte Gallery. *Raoul Dufy.* 9 paintings, 11 watercolors, drawings, prints.
 Reviews: *Art News* 37(13 May 1939):16; *Art Digest* 13(15 May 1939):14; J. Watson, *Magazine of Art* 32(June 1939):767-7.

1939 London, Reid and Lefevre Gallery. *Raoul Dufy.* 44 works.

1939 San Francisco, Museum of Art. *Raoul Dufy.*

1941	Chicago, Arts Club. *Raoul Dufy, aquarelles, dessins (œuvres récentes).*
1942	Baltimore, Museum of Art. Review: *Baltimore Museum News* 4(June 1942):51.
1943	Paris, Galerie Louis Carré. *Raoul Dufy, peintures récentes.* Review: M. Wilmes, *Panorama* (17 June 1943).
1943	Brussels, Palais des Beaux-arts. *Dufy dans les collections belges.* 92 works.
1944	Washington D.C., Phillips Memorial Gallery. *Exhibition of Paintings by Raoul Dufy.*
1944-45	New York, Niveau Gallery. Reviews: *Art Digest* 19(15 Dec. 1944):12; *Art News* 43(15 Dec. 1944):20; *Pictures* 6(Jan. 1945):22.
1946	Baltimore, Museum of Art. Review: *Baltimore Museum News* 8(Feb. 1946):3.
1947	Paris, Galerie Louis Carré. *Raoul Dufy, aquarelles et dessins.* Review: *Arts Magazine* (20 June 1947):5.
1947	New York, Carroll Carstairs Gallery. Review: *Art Digest* 22(15 Oct. 1947):22.
1948	New York, Niveau Gallery. Review: *Art News* 47(Nov. 1948):57.
1948-49	Paris, Galerie Louis Carré. *Raoul Dufy, tapisseries de haute lisse.* 6 works. Review: *Studio* 137(April 1949):122-3.
1949	New York, Louis Carré Gallery. *Raoul Dufy.* 11 paintings. Reviews: *Art Digest* 24(1 Nov. 1949):11; *Art News* 48(Nov. 1949):418.
1950	London, Lefevre Gallery. *Raoul Dufy.* Foreword by Claude Roger-Marx. 8 p., illus., some col. 12 paintings, 11 gouaches.
1950	New York, Perls Gallery. *Raoul Dufy.* 14 paintings, 6 watercolors. Reviews: *Art Digest* 25(1 Nov. 1956):16; *Art News* 49(Nov. 1950):69.

1951	New York, Niveau Gallery. Review: *Art Digest* 25(1 Feb. 1951):19.
1951	New York, Louis Carré Gallery. Review: *Art News* 49(Feb. 1951):48.
1951	Chicago, Art Club. *Raoul Dufy. Exposition of Work in the U.S.A.* 5 paintings, 28 watercolors.
1951	Pittsburgh, Carnegie Institute.
1951	Richmond, Virginia Museum of Fine Arts.
1951	Washington D.C., Phillips Gallery.
1951-52	Paris, Gallerie Louis Carré. *Dufy, peintures.* Reviews: *Art Digest* 26(15 Dec. 1951):19; *Art News* 50(Jan. 1952):40.
1952, June-October	Paris, Musée National d'Art moderne. *Raoul Dufy.*
1952, Summer	Geneva, Musée d'Art et d'histoire, *Exposition Raoul Dufy.* 114 paintings, 56 gouaches and watercolors, 32 drawings, 59 prints, ceramics, tapestries, books. Reviews: P. Bouffard, *Musée de Genéve* (July-Aug. 1952):2; *Werk* 39(Aug. 1952):supp. 106; G. Peillex, *Arts documents* (June 1953).
1952	Paris, Galerie Louis Carré. Reviews: G. Marester, *Combat* (12 May 1952); *Studio* 144(Aug. 1952):58.
1953	New York, Pierre Berès Gallery. Review: *Art Digest* 27(15 Feb. 1953):23.
1953, June October	Paris, Musée d'Art moderne. *Raoul Dufy, 1877-1953.* Préface de Jean Cassou. Catalogue par Bernard Dorival. Includes a catalogue raisonné. 266 works, including 101 paintings, 42 watercolors, drawings, prints, tapestries, fabrics, ceramics. Reviews: P. Courthion, *Arts Magazine* (26 June 1953); J-P. Cartier, Combat (29June 1953); S. Preston, *New York Times* (12 July 1953); C. Lake, *Christian Science Monitor* (25 July 1953); A. Chastel, *Art News* 52(June 1953):72; *Apollo* 58(Aug. 1953):51; A. Watt, *Studio* 146(Nov. 1953):152-5; Landini, *Paragone* 43(1953):56-9.
1953	New York, Perls Gallery. *Raoul Dufy: Twenty Masterpieces.* 20 paintings.

	Reviews: *Art Digest* 28(15 Oct. 1953):16; *Art News* 52(Oct. 1953):45; *Arts and Architecture* 70(Nov. 1953):35.
1953	Copenhagen, Ny Carlsberg Glyptotek. *Raoul Dufy, Malerier, Akvareller og Tegninger.* 64 paintings, 16 watercolors, 16 drawings.
1953	Edinburgh, Royal Scottish Academy. *Raoul Dufy.* 75 paintings, 11 watercolors, 1 lithograph.
1953	Paris, Galerie Louis Carré. *Dufy, exposition au profit de la sauvegarde du Château de Versailles.* 23 paintings, 9 watercolors.
1953	Paris, Galerie Charpentier. *La Fée électricité, lithographie en couleurs de Raoul Dufy.* Sketches drawings.
1954, 9 January- 7 February	London, Tate Gallery. *Raoul Dufy. An Exhibition of Paintings and Drawings Organized by the Arts Council of Great Britain and the Association Française d'Action Artistique.* Introduction by Raymond Cogniat. 92 works, including 78 paintings and 11 watercolors. Reviews: *Illustrated London News* 224(16 Jan. 1954):99; *Art News* 52(Feb. 1954):49; *Museum Journal* 53(Feb. 1954):293; *Architectural Review* 115(March 1954):201.
1954	Lausanne, Galerie Maurice Bridel et Nane Cailler. Review: *Werk* 41(March 1954):supp. 38.
1954, April	Basel, Kunsthalle. *Raoul Dufy.* 104 paintings, 27 watercolors, 8 drawings, prints, tapestries. Review: *Werk* 41(June 1954):120.
1954, 12 May- 4 July	San Francisco, Museum of Art. *Raoul Dufy, 1877-1953.* Texts by Grace L. McCann Morley, et al. Also shown Los Angeles, Los Angeles County Museum of Art. 253 works, including 89 paintings, 88 watercolors, drawings, prints, tapestries. Review: L. Ferling, *Art Digest* 28(June 1954):6-7.
1954, 12 June- 11 July	Bern, Kunsthalle. *Raoul Dufy.* 62 paintings, 20 watercolors, 6 drawings, tapestries.
1954, July	Honfleur, Hôtel de Ville, Musée de Honfleur. *Hommage à Raoul Dufy.* Société des Artistes honfleurais. 34 paintings, 17 watercolors, 4 drawings.

1954	Knokke-le-Zoute, Casino communal. *Hommage à Raoul Dufy*. 57 paintings, 26 watercolors, 6 drawings, 1 tapestry.
1954	Le Havre, Galerie Jacques Hamon. *Raoul Dufy, fils du Havre*. 30 paintings, 8 watercolors, 6 drawings, 1 ceramic.
1954	Madrid, Institut française en Espagne. *Hommage à Raoul Dufy, 1877-1953*. Drawings, engravings, illustrated books, fabrics.
1954	Nice, Galerie des Ponchettes. *Hommage à Raoul Dufy* 53 paintings, 26 watercolors, 8 drawings.
1954, December	Marseille, Musée des Beaux-arts, Musée Cantini. *Hommage à Raoul Dufy*. 61 paintings, 25 watercolors, 10 drawings, 2 illustrated books.
1955	New York, Perls Gallery. *Raoul Dufy* (1877-11953). 21 paintings, 8 watercolors, gouaches. Reviews: *Art News* 54(March 1955):48; S. Feinstein, *Arts Digest* 29(1 March 1955):24.
1955	Albi, Musée Toulouse-Lautrec. *Exposition Raoul Dufy*. 51 paintings, 22 watercolors, 10 drawings, 5 tapestries. Review: G. Hilaire, *Bulletin de Paris* (2 Sept. 1955).
1955	Bueños Aircs, *Exposition Dufy*. 45 works.
1955	Eindhoven, Stedelijk van-Abb4e Museum. *Raoul Dufy*. 78 paintings, 13 watercolors, 11 drawings.
1955	Nantes, Galerie Mignon-Massart. *Hommage à Raoul Dufy*. Paintings, watercolors, drawings, book illustrations, fabrics.
1956	Arnheim, Gemeentemuscum. *Mozart en Dufy*. 8 paintings, 5 watercolors, 10 drawings, 2 lithographs.
1956	Berlin, Institut Français.
1956	Nancy, Musée des Beaux-arts. *Raoul Dufy*. 69 paintings, 29 watercolors.
1956	Paris, Galerie Louis Carré. *Raoul Dufy*. 9 watercolors, 5 drawings, 3 tapestries.
1956	Paris, Galerie Pétridès. *40 Aquarelles de Dufy*. 40 watercolors.

1956	Stüttgart, *Raoul Dufy*. Also shown in Münster. 55 paintings, 12 watercolors, 9 drawings.
1957	Basel, Galerie Beyeler. *Raoul Dufy* 1877-1953. 25 paintings, 16 watercolors, 1 drawing, prints. Review: *Werk* 44(Aug. 1957):supp. 154.
1957	Geneva, Galerie Motte. *Exposition Raoul Dufy, 1877-1953, dessins-gouaches*. 17 watercolors and gouaches, 41 drawings.
1957	Lyon, Musée de Lyon, Festival de Lyon-Charbonnières. *Dufy*. Texte de René Jullian "Les Tentations de Dufy", catalogue par Madeleine Rocher-Jauneau. 83 paintings, 15 watercolors, 13 drawings, 9 engravings, book illustrations, painted cloth and tapestries, decorated fabrics.
1957	Paris, Salon des Indépendants. *Rétrospective Dufy*.
1957	Vichy, Salle Majestic. *Deuxième festival de peinture et sculpture de Vichy. Hommage à Raoul Dufy*. 20 paintings, 4 watercolors, 2 drawings.
1958	Winterthur, Kunstmuseum. Review: *Werk* 49(May 1958):supp.94.
1959	New York, Marlborough Galleries. Review: *Connoisseur* 143(April 1959):115.
1959	New York, Perls Gallery. Reviews: *Arts Magazine* 33(May 1959):64; *Art News* 58(May 1959):13; M. Schwartz, *Apollo* 69(May 1959):151.
1959	Paris, Galerie Bernheim-Jeune-Dauberville. *Chefs-d'œuvre de Raoul Dufy*. 61 paintings, 47 watercolors, 4 tapestries, 2 ceramics.
1960	Paris, Galerie Jacques Dubourg. *Raoul Dufy*. 7 watercolors, 30 drawings. Review: J. Mock, *Apollo* 72(Sept. 1960):78.
1960	Asnières, Mairie. *Salon d'Asnières. Hommage à Raoul Dufy*. 12 works.
1961	London, Galerie Wildenstein. *Raoul Dufy*. 28 paintings, 17 watercolors, 24 drawings.
1961	Los Angeles, Dalzell Hatfield Galleries. *Homage to Raoul Dufy*. 16 paintings.

1961 Paris, Galerie Motte. *Raoul Dufy.* 1 painting, 2 watercolors, 31 drawings.

1962 New York, Wildenstein Gallery. *Paintings, Watercolors and Drawings by Raoul Dufy, 1877-1953.* 31 paintings, 26 watercolors, 38 drawings. Reviews: *Art News* 60(Feb. 1962):16; V. Raynor, *Arts Magazine* 36(March 1962):446; S. Preston, *Burlington Magazine* 104(March 1962):133.

1962 Paris, Galerie des Beaux-arts. *Raoul Dufy.* 46 paintings, 32 watercolors, 22 drawings. Review: A. Brookner, *Burlington Magazine* 104(Aug. 1962):363.

1963 Paris, Musée du Louvre, Galerie Mollien. *Donations Dufy.* Catalogue de Bernard Dorival. 54 paintings, 9 watercolors, drawings, tapestries, ceramics. Reviews: M. Coonil Lacost, *Le Monde* (1 March 1963); P. Cabanne, *Arts* (6-12 March 1963); G. Charensol, *Revue des deux mondes* (15 March 1963):283-6.

1963 Paris, Galerie Louis Carré, *Tapisseries de Raoul Dufy.* 6 works. Review: A. Watt, *Studio* 166(Aug. 1963):77.

1963 Angers, 57ᵉ Salon. *Hommage à Raoul Dufy.* 13 paintings, 4 watercolors, 7 drawings.

1963 Geneva, Galerie Motte. *Raoul Dufy.* 28 works.

1963 Le Havre, Maison de la Culture du Havre. *Legs de Mme. Dufy au Musée du Havre.* Catalogue par Reynold Arnould. Includes a catalogue raisonné of works donated. 70 works.

1963 Nice, Galerie des Ponchettes. *Hommage à Raoul Dufy.* 118 works, including 50 paintings, 25 watercolors, drawings, tapestries, lithographs.

1964 Lille, Palais des Beaux-arts. *Raoul Dufy.* Also shown Chambéry, Musée des Beaux-arts; Colmar, Musée d'Unterlinden. Texte de P. Quoniam, catalogue de Germaine Viatte. 32 paintings, 11 watercolors, 32 drawings, prints, fabric, tapestries.

1964 Paris, Galerie Georges Bongers. *Aquarelles et dessins de Dufy.* 11 watercolors, 11 drawings.

1965 Gentilly, Salon Annuel d'art plastique. *Exposition de dessins de Raoul Dufy.*

1965	Namur, Maison de la culture. *Dessins de Raoul Dufy*. 71 drawings.
1965	Paris, Musée d'Art moderne de la Ville de Paris. *La Fée électricité et Raoul Dufy*.
1965-66	New York, Hirschl & Adler Galleries. *Raoul Dufy*. Also shown Honolulu, Academy of Arts; Phoenix, Museum of Art. 36 p., 10 illus. 6 col. 33 paintings, 52 watercolors, 24 drawings. Selections (8 paintings, 1 watercolor, 1 drawing) shown at Los Angeles, Dalzell Hatfield galleries. Reviews: A. Werner, *Arts Magazine* 40(Nov. 1965):36; *Art News* 64 (Nov. 1965):39[+]. S. Preston, *Apollo* 83(Jan. 1966):73.
1966	New York, Wiener Gallery. Review: *Art News* 65(April 1966):15.
1967	Paris, Galerie Europe. *Hommage à Raoul Dufy*. 21 paintings.
1967	Tokyo, Galerie Nichido. *Dufy*. 9 paintings, 26 watercolors, 9 drawings, prints.
1967-68 November- February	Tokyo, National Museum of Westerm Art. *Raoul Dufy*. Also shown Kyoto, National Museum of Modern Art (Jan.-Feb. 1968). Preface by Bernard Dorival. 199 works, including 80 paintings, 28 watercolors, drawings, prints, tapestries, ceramics.
1968, 18 February- 14 April	Essen, Museum Folkwang. *Raoul Dufy: Gemälde, Aquarelle, gouachen, Zeichnungen*. Also shown Hamburg, Kunstverein. Texts by André Robert, Marcel Berr de Turique, Hans Platte, and Paul Bogt. 76 paintings, 26 watercolors, 34 drawings. Review: G. Schurr, *Connoisseur* 167(April 968):242.
1968	Belgrad, Musej Savremene Umetnostri. *Raoul Dufy*. 44 works.
1968-69	Bièvres, Moulin de Vauboyen. *Raoul Dufy*. 94 works including 30 paintings, 31 watercolors and gouaches, drawings, stamps, tapestries.
1969	Milan, Galleria del Milione. *Raoul Dufy*. 21 paintings, 13 watercolors, 12 drawings. Review: R. Kenedy, *Art International* 13 (Summer 1969):62.
1969	Paris, Galerie Pétridès. *Raoul Dufy, 40 courses.*

1969	Sochaux, Maison des Arts et des loisirs. *Raoul Dufy.*
1970, 2 May- 1 September	Bordeaux, Galerie des Beaux-arts. *Raoul Dufy, 1877-1953.* Textes de Raymond Cogniat, Jacques Lassaigne, et Gilberte Martin-Méry. 130 paintings, 55 watercolors, drawings, tapestries, painted fabrics, ceramics. Reviews: R. Cogniat, *Le Figaro* (30 April 1970); J. Clay, *Réalités* 292 May 1970):60-5, 123, 127; P.-M. Grand, *Le Monde* (7 May 1970); A. Werner, *Art and Artists,* 5(May 1970):20-3; *Connaiissance des arts* 219(May 1970):23; G. Schurr, *Connoisseur* 174(Aug. 1970):277; G. Martin-Mery, *Revue du Louvre et des musées de France* 20:4-5(1970):305-8; J.-L. Rey, *Jardin des arts* 188-9(July-Aug. 1970):96-9.
1972	Paris Galerie Dina Vierney. *Raoul Dufy, aquarelles et dessins.* 18 watercolors, 15 drawings, 1 tapestry, 1 ceramic. Review: J-P. Dauriac, *Panthéon* 30(Sept. 1972):415.
1972	Paris, Hôtel George-V. 12 *aquarelles de couleurs de Raoul Dufy.* 12 watercolors.
1973, 30 June- 30 September	Munich, Haus der Kunst. *Raoul Dufy, 1877-1953.* Katalog-redaktion: Maurice Laffaille und Fanny Guillon. Foreword by Bernard Dorival. 176 p., 117 illus., 9 col. 68 paintings, 13 watercolors, drawings, prints, tapestries, ceramics. Reviews: *Connoisseur* 183(July 1973):220; J. Morschel, *Kunstwerk* 26(Sept. 1973):73-4.
1973	Paris, Grand Palais, Salon d'Automne. *Raoul Dufy 1877-1953.* Textes de Bernard Dorival et Henri Gaffié. 86 works. Review: J.-J. Lévêque, *Galerie-Jardin des arts* 131(Nov. 1973):32-5.
1973	Mullhouse, Musée de l'Impression sur étoffes. *Raoul Dufy, créateur d'étoffes.* 58 p., 19 illus., 5 col. 241 numbers, 2 watercolors outside catalogue. Review: J.-P. Dauriac, *Graphis* 30:176(1974-5):530-3.
1973	Sochaux, Maison des Arts et des loisirs. *Exposition Raoul Dufy.*
1974	New York, Perls Gallery. Review: *Arts Magazine* 48(March 1974):63.
1974	Mâcon, Galerie des Ursulines. *Raoul Dufy.* 14 paintings, 1 watercolor, 16 drawings. Review: *Connaissance des arts* 267(May 1974):17+.

1974	Monte-Carlo, Sporting club d'hiver. *Raoul Dufy 1877-1953.* Texte par Henri Gaffié. 31 paintings, 82 aquarelles, dessins, oeuvres gravées.
1974	Tokyo, Palais France. *Raoul Dufy.* 19 paintings, 17 watercolors, 1 drawing, 1 printed fabric.
1975, October	London, Wildenstein Gallery, *Raoul Dufy, 1877-1953.* Preface by Henri Gaffié. 40 p., 15 illus., 8 col. 26 paintings, 39 watercolors, 18 drawings. Reviews: C. Neve, *Country Life* 158:4084(9 Oct. 1975):900; B. Wright, *Arts Review* 27:21(17 Oct. 1975):588; *Burlington Magazine* 117 (Nov. 1975):751.
1975, November	Johannesburg. Wildenstein Galleries. *Raoul Dufy, 1877-1953.* Introduction by Henri Gaffie. 39 p., illu., some col.
1975	Leningrad, Hermitage Museum, *Dufy.*
1975	Paris, Galerie du Lion. *Raoul Dufy aquarelles, dessins.* 16 watercolors, 7 drawings.
1976, March-May	Marcq-en-Barœul, France, Fondation Anne et Albert Prouvost, Septentrion. *Raoul Dufy.* Préface de Jacques Lassaigne. 33 paintings, 17 watercolors, 6 drawings, 12 ceramics. Review: *L'Œil* 248(March 1976):43.
1976	Paris, Musée d'Art moderne de la Ville de Paris. *Œuvres de Raoul Dufy; peintures, aquarelles, dessins.* Catalogue par Jacques Lassaigne et Andrée Abdul Hak. 78 p., 31 illus., 12 col. Works from all phases of Dufy's career, including 61 oils (1901-52), 23 watercolors, (1930-53), and 6 drawings. Full catalogue entries and a catalogue raisonné. Reviews: *Connoisseur* 193(Oct. 1976):152; P. Courthion, *Le Quotidien de Paris* (16-17 Oct. 1976); *Revue du Louvre et des musées de France* 26:4 (1976:315); *Art International* 21(Jan. 1977):42.
1976	Tokyo, Wildenstein Gallery.
1977, 28 April-22 May	Paris, Musée d'Art moderne de la Ville de Paris. *Raoul Dufy; créateur d'étoffes 1910-1930.* Textes par Jacques Lassaigne, Jean Michel Tuchscherer, et Raymond Cogniat. 64 p., 217 illus., 217 col. Highlights Dufy's fabric designs in gouache and watercolor made for the Bianchini-Férier silk factory in Lyon. 217 watercolors, fabrics. Review: *Apollo* 105(June 1977):491-2.

1977	Bueños Aires, Museo de Bellas Artes de la Boca. Review: *L'Œil* 262(May 1977):50.
1977	Paris, Musée d'Art moderne de la Ville de Paris, Centre Georges Pompidou. *Raoul Dufy dans les collections de la Ville de Paris.* Review: *Apollo* 105(June 1977):491-2.
1977, 8 July-3 October	Orléans, Musée des Beaux-arts. *Raoul Dufy, 1877-1953: dessins, aquarelles, gouaches.* 75 works, including 10 watercolors. 59 p. Review: *L'Œil* 264-5(July-Aug. 1977):48.
1977	Nice, Galerie des Ponchettes, Collections du Musée des Beaux arts. *Raoul Dufy à Nice: collection du Musée des Beaux-arts, Jules Chéret.* Catalogue par Jean Fornier, et al. ca. 252 p., 45 pl., 25 col. 28 paintings, 14 watercolors, 88 drawings, 1 tapestry, prints, ceramics. Reviews: *L'Œil* 264-5(July-Aug. 1977):48; *Connaissance des arts* 307(Sept. 1977):17.
1977, 29 September-14 November	Paris, Musée National d'Art moderne. *Raoul Dufy au Musée National d'art.* 16 paintings, 3 watercolors, drawings.
1977	Gstaad, Palace Hôtel. *Raoul Dufy, 1877-1953.*
1977	Le Havre, Musée des Beaux-arts André Malraux. *Raoul Dufy.* Catalogue par G. Testanière. 30 p. 4 illus. Exhibition of 39 paintings, 19 watercolors, drawings, tapestries, prints and ceramics by Raoul Dufy. The collection was the gift of the artist's wife to the Museum in 1962. The exhibition commemorated the centenary of Dufy's birth.
1978	London, J. P. L. Fine Arts. *Raoul Dufy.* 7 watercolors, drawings. Review: M. Wykes-Joyce, *Arts Review* 30:22(10 Nov. 1978):622-3.
1978	Caracas, Museo de Bellas artes. *Raoul Dufy.* Also shown Bogota, Museo Nacional. 50 paintings, drawings, prints.
1978	Caracas, Galerie Siete. *Raoul Dufy* 6 paintings, 6 watercolors, drawings.
1978	Paris, Galerie Tamenaga. *Dufy.* 30 paintings, 12 watercolors.

1978-79, 5 December- 25 February	Sarasota, Ringling Museum of Art. *Raoul Dufy: A Retrospective*. Text by William H. Wilson. 43 p., 27 illus., 2 col. Retrospective exhibition of Dufy oils, watercolors, gouaches, drawings and prints borrowed from American public and private collections. Freddy and Regina T. Homburger's entire Dufy Collection, Dufy letters, and memorabilia (documenting Dr. Homburger's treatment of Dufy for arthritis in 1950-51) formed the core of the exhibition. 63 works, including 12 paintings, 20 watercolors.
1978-79	Tokyo, Seibu Museum of Art. *Raoul Dufy*. 44 paintings, 8 watercolors, fabrics, drawings, prints.
1979	New York, A. M. Adler Fine Arts. *Raoul Dufy, 1877-1953. An Exhibition of Drawings from the Artist's Collection*. 66 works, including 10 watercolors.
1979	Nice, Galerie d'Art contemporain des musées de Nice. *100 dessins et gravures de Raoul Dufy*.
1980, 4 May- 29 June	San Antonio, Marion Koogler McNay Art Institute. *Raoul Dufy: A Twenty-Fifth Anniversary Event*. 16 p., 14 illus., 7 col. 6 works. Retrospective loan exhibition of 38 paintings, drawings, 14 watercolors, prints, book illustrations, textiles, and a tapestry.
1980	Liège, Musée Saint-Georges. *Raoul Dufy*. Also shown Copenhagen, Statens Museum for Kunst. 58 paintings, 18 watercolors, drawings, fabrics, ceramics.
1980	Vence, Fondation Emile-Hugues. *Raoul Dufy à Vence*. 3 paintings, 2 watercolors, drawings. Review: J. Mauraille, *Nice-matin* (3 Aug. 1980):18.
1980	Vévey, Galerie D. H. Leresche. *Raoul Dufy, aquarelles et dessins*.
1981	Toronto, Theo Waddington Galleries. *Raoul Dufy 1877-1953*. Also shown London, Theo Waddington Gallery. Review: M. Mills, *Art Magazine* 12:52(Jan.-Feb. 1981):108.
1981	Paris, Galerie Louis Carré et Cie. *Raoul Dufy, aquarelles*. 33 watercolors. Reviews: *L'Œil* 311(June 1981):85; J.-M. Campagne, *Nice-matin magazine* (28 June 1981); J. Caillens, *Le Havre libre* (3 July 1981); R. Micha, *Art international* 24:9-10(Aug.-Sept. 1981):151-68.

1981 London, Theo Waddington Galleries. *Raoul Dufy, 1877-1953*. 5 watercolors, 10 drawings.

1982 Hamburg, Kunsthalle.
Reviews: A. Lütgens, *Tendenzen* 23:138(April-June 1982):22-4.

1983,
4 February-
27 March

Berlin, Nazarethkirche. *Raoul Dufy: Ölbilder—Aquarelle—Zeichnungen* [Raoul Dufy: Oil Paintings—Watercolors—Drawings]. Texts by Peter Hopf and Jacques Lassaigne. Berlin: Kunstamt Wedding; Paris: Musée d'Art moderne de la Ville de Paris. 62 p., 38 illus., 22 col., 46 works shown. Selection of works from the collection of the Musée d'Art moderne de la Ville de Paris.

1983,
25 October-
20 December

London, J. P. L. Fine Arts. *Raoul Dufy Drawings and Watercolours*.

1983 Salzburg, Galerie Salis. *Raoul Dufy*.

1983 Tokyo, Odakyu Grand Gallery. *Exposition Raoul Dufy*. 134p., 120 illus., 55 col. In Japanese.

1983-84,
9 November-
13 May

London, Hayward Gallery. *Raoul Dufy, 1877-1953: Paintings, Drawings, Illustrated Books, Mural Decorations, Aubusson Tapestries, Fabric Designs*. Also shown Plymouth City Museum and Art Gallery (25 Feb.-31 March 1984); and Nottingham Castle Museum and Art Gallery (7 Aprl-13 May 1984). Introduction by Bryan Robertson. Arts Council of Great Britain. Sponsored by Cognac Courvoisier. 185 p., 173 illus., 67 col. 433 works shown.
Exhibition of paintings, drawings, illustrated books, mural decorations, Aubusson tapestries, fabric designs and fabrics for Bianchini-Férier, Paul Poiret dresses, ceramics, posters, and theatre designs. The catalogue is divided into discussions of various aspects of Dufy's life and work as follows: "An Introduction to Dufy" by Bryan Robertson; "Raoul Dufy: Tradition, Innovation, Decoration 1900-1925" by Sarah Wilson; "The Fabrics of Raoul Dufy: Genesis and Context" by René Simon Lévy; "Mural Decorations; 'La Fée électricité 1937'", and "La Seine, L'Oise et la Marne, 1937-40" by Antoinette Rezé-Huré; "Raoul Dufy: the Book Illustrations" and "Dufy and Ceramics" by Dora Perez-Tibi.
Reviews: S. Lavell, *Arts Review* 35:23(25 Nov. 1983):662-3; M. Bartram, *Artscribe* 44(Dec. 1983):58; F. Rousseau, *Beaux-arts* 8(Dec. 1983):33-41; *Art &*

Artists 207(Dec. 1983):33; M. Bartram, *Artscribe* 44(Dec. 1983):58; AD 53:110-11(1983):106; P. de Francia, *Burlington Magazine* 970:126(Jan. 1984):52; *Connaissance des arts* 383(Jan. 1984):20; *Ceramic Review* 85(Jan.-Feb. 1984):22-3; *Das Kunstwerk* 37(Feb. 1984):29-30; *Art in America* 72(Feb. 1984):31; J. McEwen, *Art in America* 72(March 1984):120-7; J. Collins, *Flash Art* 117(April-May 1984):53; J. Wood, *Pantheon* 42(April-June 1984):180-1; M. Amaya, *Studio International* 196:1004(1984):29-31.

1984	New York, Maxwell Davidson Gallery. Review: J. Bell, *Art News* 83(Nov. 1984):167.
1984, 2-24 November	New York, Holly Solomon Gallery. *Raoul Dufy.* Reviews: J. Perl, *New Criterion* 3:6(Feb. 1985):25-33; J. Silverthrone, *Artforum* 23(Feb. 1985):93-4.
1984	Paris, Galerie Marwan Hoss. *Raoul Dufy.*
1985	Paris, I. I. C. Galerie Marcel-Bernheim. *Raoul Dufy et la mode.*
1985, 24 April-June	Montrouge, Centre culturel et artistique. *XXXᵉ Salon de Montrouge; art contemporain, peinture, sculpture, dessin: Raoul Dufy, œuvres de 1904-1953.* 96 p., illus., some col.
1986	Paris, Trianon de Bagatelle Galerie. Review: *L'Œil* 370(May 1986):86-7.
1987, 24 March-8 May	London, J. P. L. Fine Arts. *Paintings, Watercolours and Drawings: Raoul Dufy (1877-1953).* Catalogue by Sargy Mann. 47 p., 46 illus., 22 col. Exhibition of work by Dufy with an introduction describing the evolution of his mature style, especially his extention of expressive possibilities. Review: M. Beaumont, *Arts Review* 39(10 April 1987):230⁺.
1987	Paris, Galerie Daniel Malingue. *Raoul Dufy.* Reviews: R. Erbslöh, *Die Kunst* 5(May 1987):424; N. Alfrey, *Burlington Magazine* 129(July 1987):479-80.
1987	Paris, Orangerie des Tuileries. Review: M. Hoog, *Revue du Louvre et des musées de France* 37:3(1987):224.
1987, 4 July-28 September	Saint-Tropez, Musée de l'Annonciade. *Les Œuvres fauves de Raoul Dufy (1905-1907).* 51 p., 18 col. illus.

1987	Tokyo, Art Point Gallery. *Raoul Dufy Textile Design.*
1987	Tokyo, Tamenaga Gallery. *Raoul Dufy.*
1987	L'Isle-sur-la-Sorgue, Hôtel Donadëi de Campredon. Association Campredon, Art et culture. *Raoul Dufy.* Review: *L'Œil* 390-1(Jan.-Feb. 1988):87.
1988	Shibo. Also shown Osaka, Shizuoko-Miyazaki, Fukuoka.
1989	Tours, Musée des Beaux-arts. *Raoul Dufy et la musique.*
1989	Zaragoza, Centro de Exposiciones y Congresos. *Raoul Dufy, 1877-1953.*
1990, 10 July-3 September	Perpignan, Palais des Rois de Majorque. *Raoul Dufy et le Midi.*
1991, July	Paris, Galerie Fanny Guillon-Laffaille. *Raoul Dufy.* Reviews: P.-G. Persin, *L'Œil* 431(June 1991):64-5; *Connaissance des arts* 472(June 1991):18.
1992	London, J. P. L. Fine Arts. Review: *Arts Review* 44(May 1992):176.

B. Group Exhibitions

1901	Paris, *Salon de la Société des artistes Français.* 1 painting.
1902	Le Havre, *Société des arts du Havre.* 1 painting, 1 watercolor.
1903	Paris, Galerie Berthe Weill. *Dufy, Lejeune, Metzinger, Torent.* 12 paintings, 2 watercolors.
1903	Paris, Grand Palais. *Salon des indépendants.* 7 paintings, 1 watercolor.
1904, 20 January-20 February	Paris, Galerie Berthe Weill. 7 paintings, 4 watercolors, 1 pastel.
1904, 21 February-24 March	Paris, Grand Palais, *Salon des Indépendants.* 6 paintings.
1904	Paris, Galerie Berthe Weill. *Dufy, Duparque, Juste, Torent.* 2 paintings, 5 watercolors.

1904, 24 October- 20 November	Paris, Galerie Berthe Weill. 11 works.
1905, 25 February- 25 March	Paris, Galerie Berthe Weill. *Série des dessins et croquis de 1830 à nos jours.* 5 drawings.
1905, 24 March- 30 April	Paris, Grand Palais. *Salon des Indépendants.* 6 paintings, 2 watercolors.
1905, 21 October- 20 November	Paris, Galerie Berthe Weill. 11 paintings, 4 watercolors.
1906, 20 March- 30 April	Paris, Grand Palais. *Salon des Indépendants.* 8 paintings.
1906, 6 October- 15 November	Paris, Grand Palais. *Salon d'Automne* 7 works.
1906, October	Paris, Galerie Berthe Weill.
1907, 20 March- 30 April	Paris, Grand Palais. *Salon des Indépendants.* 6 paintings, including 4 landscapes made in Normandy.
1907, 30 March	Paris, Galerie Berthe Weill.
1907, June	Le Havre, Hôtel de Ville. *Cercle de l'art moderne.* Catalogue par Ferdinand Fleuret. 2 paintings.
1907, 1-22 October	Paris, Grand Palais. *Salon d'Automne.* 2 paintings.
1908	Le Havre, Exposition du Cercle de l'art moderne. *Friesz et Dufy.*
1908, 20 March- 2 May	Paris, Grand Palais. *Salon des Indépendants.* 1 painting, 5 drawings.
1908, June	Le Havre, Hôtel de Ville. *Cercle de l'art moderne.* Catalogue texte de Guillaume Apollinaire.
1908-09, 21 December- 15 January	Paris, Galerie Notre-Dame-des-Champs. 4 paintings.
1909	Paris, Galerie Berthe Weill.
1910	Paris, *Salon des Indépendants.* 2 paintings.

1910	Paris, *Salon d'Automne.* 5 etchings.
1911	Berlin, *Secession Ausstellungshaus.* 1 painting.
1911	Amsterdam, Stedelijk Museum. *Modern Kunst Kring.* 4 paintings.
1911	Paris, Galerie d'Art ancien et d'art contemporain, *Société Normande de peinture moderne.* 2 paintings, 2 watercolors, 2 lithographs.
1911	Paris, *Salon des Indépendants.* 1 painting, 4 etchings.
1912	Berlin, Der Sturm. 3 paintings.
1912	Rouen, Salon de la Société Normande de peinture moderne. 4 paintings, 2 woodcuts.
1913	New York, Armory of the Sixty-Ninth Regiment.
1913	Chicago, Chicago Art Institute.
1913	Boston, Copley Society. *International Exhibition of Modern Art.* 2 paintings.
1913	Paris, *Salon des Indépendants.* 3 paintings.
1913	Berlin, Neue Galerie. Neue Secession. 5 paintings.
1914	Prague, Mànes Union. 1 painting, 1 drawing, 2 woodcuts.
1914	Vienna, Kunstsalon Pisko. 1 painting.
1916	Philadelphia, McClees Galleries. *Advanced Modern Art.* 2 paintings.
1920	Paris, *Salon des Indépendants.* 1 work.
1921	Paris, *Salon des artistes décorateurs.* 7 fabrics.
1921	Paris, *Salon d'Automne.* 6 works.
1922	Paris, *Salon des artistes décorateurs.* 1 work.
1922	Paris, *Salon d'Automne.* 2 works.
1923	Paris, *Salon des Indépendants.* 1 work.
1923	Paris, Galerie Barnazanges. *La Collection particulière de Monsieur Paul Poiret.* Paintings and watercolors.

1923	Paris, *Salon des artistes décorateurs.* 1 work.
1925	Paris, Galerie Berthe Weill. *Raoul Dufy, J. P. Laglenne, Jean Lurçat, Louis Marcoussis: peintures, gouaches et aquarelles.*
1926	New York, Sculptor's Gallery. *Exposition of Contemporary French Art.* 4 watercolors from the John Quinn collection.
1926	Paris, *Salon des Indépendants.* 6 works.
1927	Brussels, Galerie Bernheim-Jeune. *Expositions des 'Jardins de salons' par Raoul Dufy, Llorens Artigas et Nicolas Ma Rubbio et de sept tapisseries imprimées par Raoul Dufy.*
1927	Paris, Galerie Bing. *Les Fauves, 1904-1908.* 8 paintings.
1927	Paris, Salon d'Automne. 2 works.
1930	Brussels, Galerie Le Centaure. *Trente ans de peinture française.*
1930	Paris, Galerie du Théâtre Pigalle. *Exposition d''Art vivant'.* 4 paintings.
1931	Prague, *L'Ecole de Paris.* 21 works.
1934	Paris, *Salon des Indépendants.* 2 works.
1934	Paris, Gazette des Beaux-arts. *Les Fauves, l'atelier de Gustave Moreau.* 13 paintings, 3 watercolors, 2 engravings. Review: L. Vauxcelles, *Gazette des Beaux-arts* 2(1934):273-82.
1936	New York, Bignou Gallery. *Modern French Tapestries by Braque, Raoul Dufy, Léger, Lurcat, Henri Matisse, Picasso, Rouault.* From the collection of Madame Paul Cuttoli. Foreword by Edouard Herriot. 20 p., illus.
1936	Paris, *Salon des Indépendants.* 2 works.
1937	Paris, Petit Palais. *Les Maîtres de l'art indépendant 1895-1937.* 34 paintings. Review L. Vauxcelles, *Beaux-arts magazine* (2 July 1937):7.
1938	Basel, Kunsthalle. *Vlaminck, R. Dufy, Rouault.* 55 paintings, 30 watercolors, 8 drawings.

1938-39	New York, Bignou Gallery. *Two Colorists, Renoir and Raoul Dufy.* 7 paintings, 1 watercolor. Review: *Art Digest* 13(1 Dec. 1938):10.
1939	Paris, *Salon des Artistes décorateurs.*
1940	New York, Carroll Carstairs Gallery. *Oils and watercolors by André Dunoyer de Segonzac and Raoul Dufy.* Review: *Art News* 38(17 Feb. 1940):18.
1941	Paris, Bibliothèque nationale. *XXIIIᵉ exposition de la Société des peintres-graveurs français.* 4 engravings.
1942	Paris, Galerie de France. *Les Fauves, peintures de 1903 à 1908. 3 paintings.*
1943	Paris, *Salon d'Automne.* 1 painting.
1945-44	New York, Bignou Gallery. *Raoul Dufy and Some of His Contemporaries.* Review: *Art Digest* 18(15 Dec. 1943):21.
1944	Paris, Bibliothèque nationale. *XXXIᵉ exposition de la Société des peintres-graveurs français.* 3 lithographs.
1946	Paris, Musée National de l'Art moderne. *La Tapisserie française du moyen-âge à nos jours.* 2 armchairs, 2 chairs, 1 sofa (atelier Marie Cuttoli), and 2 tapestries.
1946	Paris, *Salon des Tuileries.* 2 works.
1947	Avignon, Palais des Papes. *Exposition de peintures et sculptures contemporaines.* 4 paintings.
1947	Basel, *Quelques œuvres des collections de la Ville de Paris.* Also shown Bern, La Chaux-de-Fonds, Geneva, Zurich.
1947	Paris, *Salon des artistes décorateurs.* Illustrations.
1947	Paris, *Salon de Mai.*
1948	Paris, *Salon des Tuileries.* 1 painting.
1949	Paris, *Salon des Tuileries.* 2 works.
1949	Los Angeles, Dalzell Hatfield Galleries. *A Superb Exhibition: Cézanne, van Gogh, Renoir, Bonnard,*

Vuillard, Matisse, Rouault, Sisley, Dufy, Utrillo. 8p., illus.

1950, 29 April- 29 May	Bern, Kunsthalle. *Les Fauves.* 8 paintings, 1 watercolor, 3 drawings. Review: G. Veronesi, *Emporium* 112(Aug. 1950):50-60.
1950	Paris, Salon des Tuileries. 2 paintings.
1950, 8 June- 15 October	Venice, XXV^e Biennale. *I Fauves.* 5 paintings. Reviews: M. Georges-Michel, *Biennale di Venezia* 2(1950):9-10; G. Veronesi, *Emporium* 112(1950):51-60.
1950	Copenhagen, Charlotteborg. *Levende Farver.* 4 paintings, 1 watercolor.
1950	New York, Sidney Janis Gallery. *Les Fauves.* 6 paintings.
1951	Paris. *Les Peintres témoins de leur temps.* 1 work.
1951	Paris, *XXVI^e Salon de Mai.*
1951	Paris, Musée National d'Art moderne. *Le Fauvisme.* 10 paintings, 1 watercolor, drawings.
1951	Paris, *Salon des Tuileries.* 1 painting.
1952	Berlin, Festival de Berlin. *Werke Französischer Meister der Gegenwart.* 11 works, including 1 watercolor.
1952	Delft, Museum "Het Prinsehof." *Internationale Tentoostelling de Aqaurel (1800-1950).* 3 watercolors, 2 outside of catalogue.
1952	Geneva, Galerie Motte. *Derain, Dufy, Friesz, Marquet, Utrillo, Vlaminck.* 11 works, including 6 watercolors.
1952	Paris, Musée des Arts décoratifs. *Cinquante ans de peinture française dans les collections particulières de Cézanne à Matisse.* 5 paintings, 2 woodcuts.
1952	Rennes, Musée des Beaux-arts, Hôtel de Ville. *Le Fauvisme.* Préface de Bernard Dorival. 34 p. 6 paintings, 1 watercolor.
1952	Venice, *XXVI^e Biennale.* 41 works. Reviews: J. Lassaigne, *Les Arts plastiques* 6(June-July 1952):445-7; J. Gauthier, *La Biennale di Venezia* 9(July 1952):13-6.

1952-53	Minneapolis, Minneapolis Institute of Art.
1952-53	New York, The Metropolitan Museum of Art.
1952-53	San Francisco, Museum of Art.
1952-53	Toronto, Art Gallery. *Les Fauves*. 6 paintings, 3 drawings, 2 watercolors.
1954	New York, Perls Gallery. *Modern French Paintings*. 12 paintings, 8 watercolors.
1954	Paris. *Les Peintres témoins de leur temps*. 1 painting.
1954	Paris, Musée National d'Art moderne. *Le Dessin de Toulouse-Lautrec aux cubistes*. 11 drawings.
1954	Paris, Petit Palais, Collection Girardin. 15 paintings, 2 watercolors, and illustrations.
1954	Stockholm, Modern Museet. *Cézanne till Picasso*. 7 paintings, 2 watercolors, 1 drawing.
1955	Kassel, Musée Fridericianum. *Documenta*. 4 paintings.
1955	Israel, Musées d'Israel. *Ayala and Sam Zacks Collection of Twentieth Century French Art*. 4 paintings, 2 watercolors, 1 drawing.
1955	Lausanne, Musée Cantonal des Beaux-arts. *Le Mouvement dans l'art contemporain*. 4 paintings.
1955	Paris, Galerie des Beaux-arts. *1850-1950: tableaux de collections parisiennes*. 1 painting, 6 watercolors.
1956	New York, Perls Gallery. *The Perls Galleries Collection of Modern French Paintings*. 21 paintings, 13 watercolors and gouaches. Reviews: *Arts Magazine* 30(May 1956):51; *Art News* 55(June 1956):65.
1956	Basel, Galerie Beyeler. *Aquarelle, Zeichnungen, Gouachen, Skulpturen von 1856 bis 1956*. 4 watercolors.
1956	Besançon, Palais Granvelle. *Cent vingt chefs-d'œuvre du Musée National d'Art moderne*. 1 painting, 2 watercolors, drawings, 1 tapestry.
1956	Brussels, Palais des Beaux-arts. *De Toulouse-Lautrec à Chagall: dessins, aquarelles, gouaches*. 5 watercolors, 11 drawings.

1956	Nice, Musée des Ponchettes. *Collections des musées de Nice*. 3 paintings, 7 watercolors, 8 drawings.
1956-57	Toronto. *A Selection from the Ayala and Sam Zacks Collection*. Also shown Ottawa, Winnipeg, Minneapolis, and Vancouver. 4 paintings, 2 watercolors.
1957	Courbevoie, Musée de Courbevoie. *Les Peintres de l'eau, avec un hommage à Raoul Dufy*. 8 paintings, 3 gouaches and watercolors, drawings, fabrics, 1 ceramic.
1957	Castres, Musée Goyá. *Les Plus belles peintures contemporaines des collections privées du Tarn*. 1 painting, 2 watercolors.
1957	Gravenhague, Gemeentemuseum. *Sammlung Ragnar Moltzau, Oslo*. 10 watercolors.
1957	Zurich, Kunsthaus.
1957	Zurich, Swiss Institute for Art Research. *Maîtres de la première génération du vingtième siècle. A Group of Paintings in the Collection of Peter and Elisabeth Rüdel, New York*. 13 paintings, 1 watercolor.
1958	London, Tate Gallery. *From Cézanne to Picasso, the Moltzau Collection*. 13 paintings, 1 watercolor.
1958	Paris, *Salon d'Automne. Rétrospective du 50 salon*. 1 painting.
1958	Rouen, Musée des Beaux-arts. *Paysages de France de l'Impressionnisme à nos jours*. 6 paintings.
1959	Paris, Première Biennale de Paris. *Jeunesse des maîtres*. 1 painting.
1959	Basle, Galerie Beyeler. *Sélection*. 1 painting, 3 watercolors.
1959	Dallas, Museum for Contemporary Arts. *Les Fauves*. 7 paintings.
1959	Hamburg, Kunsthalle. *Französische Zeichnungen des XX Jahrhundrets*. 10 drawings.
1959	Paris, Musée National d'Art moderne. *L'Ecole de Paris dans les collectioins belges*. 7 paintings, 1 gouache.

1959	Schaffhausen, Museum zu Allerheiligen. *Triumph der Farbe, Die Europäischen Fauves.* Also shown Charlottenburg. 6 paintings.
1960	Nice, Palais de la Méditerranée. *Peintres à Nice et sur la Côte d'Azur 1860-1960.* 8 paintings.
1960	Paris, Galerie Charpentier. *Cent tableaux de collections privées de Bonnard à de Staël.* 7 paintings, 3 watercolors.
1960	Paris, Musée Galliéra. *Dix ans de Biennale de Menton. Les Grands prix.* 3 paintings.
1960	Zurich, Kunsthaus. *Thompson Collection.* 4 paintings.
1960-61	Paris, Musée National d'Art moderne. *Les Sources du XX* siècle. Les Arts en Europe de 1884 à 1914.* 6 paintings.
1961	Paris, Munich, Haus der Kunst. *Von Bonnard bis Heute.* 6 paintings, 3 gouaches and watercolors.
1961	Paris. *Les Peintres témoins de leur temps.* 1 painting.
1961	Wolfsburg, Stadhalle. *Frazösische Malerei von Delacroix bis Picasso.* 7 paintings.
1961	Zurich, Galerie Semiha Hubert. *19 und 20 Jahrundert aquarelle und Zeichnungen.* 3 watercolors, 1 drawing.
1961-62	Tokyo, National Museum. *Exposition d'art français au Japon, 1840-1940.* Also shown Kyoto City Museum. 7 works.
1962	Paris, Galerie des Beaux-arts. *L'Aquarelle en France au XX* siècle.* 6 watercolors.
1962	Paris, Galerie Charpentier. *Les Fauves.* 18 works.
1962	Varsovie. *Franncuskie Ryounki XVII-XX*.* 1 Tkaning. 1 watercolor, 2 drawings, 2 printed fabrics.
1962	Venice, Biennale XXXI. 3 paintings.
1963	Paris, Salon d'Automne. 2 paintings.
1963	Paris, Galerie Romanet. *Deux cent aquarelles et dessins de Renoir à Picasso.* 4 watercolors.
1964	Kassel. *Documenta III.* 3 drawings.

1964	Lausanne, Palais de Beaulieu. *Chefs-d'œuvre des collections suisses de Manet à Picasso.* 5 paintings, 3 watercolors.
1965	Paris, Salon d'Automne. 1 painting.
1965	Recklinghausen, Städtische Kunsthalle. *Variationen.* 9 paintings.
1966	Edinburgh, Institut français d'Ecosse. *Paintings from Nice.* 10 paintings, 2 watercolors, 4 drawings.
1966	Hamburg, Kunstverein. *Matisse und sein Freunde; les Fauves.* 10 paintings.
1966	Munich, Haus der Kunst. *Le Fauvisme français et les débuts de l'Expressionnisme allemand.* 16 paintings.
1966	Paris, Musée National d'Art moderne.
1966	Paris, Musée des Arts décoratifs. *Les Années '25'.* 11 works.
1967	Bondues, Château de la Vigne. *Collections privées du Nord. Ecole de Paris.* 7 paintings, 1 watercolor.
1967	La Jolla, Museum of Art. *Louis and Charlotte Bergmann Collection.* 10 paintings, 14 gouaches and watercolors, 8 drawings, 2 fabrics.
1967	Paris, Orangerie des Tuileries. *Chefs-d'œuvre des collections suisses de Manet à Picasso.* 4 paintings.
1968	Milwaukee, Milwaukee Art Center. *The Collection of Mrs. Harry Lynde Bradley.* 4 paintings, 9 watercolors and gouaches.
1970	Basel, Galerie Beyeler. *Collection Marie Cuttoli-Henri Laugier, Paris.* 4 watercolors, 1 drawing.
1971	Cambridge, Fogg Art Museum, Harvard University. *Selections from the Collection of Freddy and Regina T. Homburger.* Includes a text, "Dufy and Dr. Freddy Homburger," describing Dufy's stay in New York from 1950-51. Reprinted in *Raoul Dufy* (Sarasota: Ringling Museum of Art, 1978-79 and San Antonio: McNay Art Institute 1980). 2 paintings, 3 watercolors, 6 drawings, 1 lithograph.
1971	Ottawa, National Gallery. *A Tribute to Samuel J.*

Zacks from the Same and Ayala Zaks Collection. 3 paintings, 1 watercolor.

1971	Toronto, Art Gallery.

1974 — Paris, Musée Jacquemart-André. *Poiret le magnifique.* 64 works.

1974 — Tokyo, Galerie Seibu. *Exposition les Fauves.* Also shown Kanazawa, Musée Départemental d'Ishikawa. 7 paintings.

1975, 5 March–13 April — Hartford, Wadsworth Atheneum. *Selections from the Joseph L. Shulman Collection.* Texts by James Elliott, Joseph L. Shulman, and Mark Rosenthal. 47 p., 22 illus., 3 col. 50 works shown. Works by early 20th century European artists, including Dufy, Braque, Matisse, and Rouault.

1975, 11 April–11 May — Toronto, Art Gallery of Ontario. *The Fauves.* Catalogue by R. J. Wattenmaker. 45 p., 29 illus. 4 paintings. Catalogue gives an account of the Fauves' reception at the Salon d'Automne of 1905 in Paris, followed by a discussion of Fauvism's basic constituent pictorial features and the traditional sources upon which the Fauve painters drew. Traces the interrelationships and influences within the group of Matisse, André Derain, Maurice de Vlaminck, Albert Marquet, and Henri Manguin, and the individual stylistic development of each artist in the period, ca. 1898-ca. 1906. Works by Raoul Dufy, Othon Friesz, Georges Braque, Louis Valtat, and Kees van Dongen are also illustrated and analyzed.

1976, February–April — Pontoise, Musée de Pontoise. *Aquarelles et dessins du Musée de Pontoise (Nouvelles acquisitions).* Catalogue par Annie Caubet, Danielle Demetz, Jacques Foucart, Edda Maillet, Jacques Vilain, et Simone Willard. 20 p., 19 illus., 44 works shown. Works of the 18th-20th centuries, all acquired in the 1970s, by twenty-five French artists. Alexandre Marie Colin, Raoul Dufy, and Georges Paul Leroux were represented in greatest depth. Includes full catalogue entries.

1976 — Deauville, Salle des Fêtes. *Le Fauvisme en Normandie.* 11 paintings, 2 watercolors, 1 drawing.

1976, 26 March- 31 October	New York, Museum of Modern Art. *The 'Wild Beasts':* *Fauvism and its Affinities.* Also shown San Francisco, San Francisco Museum of Modern Art (29 June-15 Aug.); Fort Worth, Kimbell Art Museum (11 Sept.-31 Oct.). Catalogue by John Elderfield. 167 p., illus., some col. 15 works.
1977, 6 May- 19 June	London, National Portrait Gallery. *Portraits of Helena* *Rubinstein.* Foreword by John Hayes, 31 p., 20 illus., 7 col., 20 works shown. Helena Rubinstein—beauty authority, patron of the arts and inveterate art collector—had some twenty-five portraits painted of her over about fifty years. Bérard, Bouché, Dalí, Dufy, Helleu, Laurencin, Lintott, Montenegro, von Pantz, Portinari, Sutherland, Tchelitchew, and Vertès present their interpretations of the same subject. Review: K. Roberts, *Burlington Magazine* 891:119(June 1977):459.
1977-78, August- January	Moscow, Pushkin State Museum of Fine Arts. *Odinadcat* *kartin iz sobranija Nacional'nogo centra sovremennogo* *iskusstva i kul'tury imeni Zorza Pompidu (Francija) v* *Moskve i Leningrade: Katalog vystavki* [Eleven Paintings from the Collection of the Centre National d'Art et de culture Georges Pompidou (France) in Moscow and Leningrad: exhibition catalogue]. Catalogue by M.A. Bessonova. 24 p., 11 illus. 11 works shown. Included paintings by Matisse, Picasso and Derain, who were also well represented in USSR museums, as well as canvases by Modigliani and Dufy, who were less well known to Soviet viewers.
1978, 16 February- 16 April	Paris, Musée de l'Orangerie. *Donation Pierre Lévy.* Introduction par Michel Hoog; les notices du catalogue ont été rédigées par Antoinette Fay-Hall, Patrice Godin, Michel Hoog, Clette Noll, et Gabrielle Salomon. 279 p., 422 illus., 12 col. 395 works shown. Exhibition presented a representative selection of works from the Lévy gift of more than 2,000 items given to the city of Troyes. Paintings sculptures and drawings by 19th and 20th century French artists predominate (276 objects); works range from Millet and Courbet to Balthus, with particular emphasis on works by the Fauves, especially André Derain (107 objects). Roger de La Fresnaye is represented by twenty works from all phases of his career as well as sixteen illustrations for Claudel's *Tête d'Or.* Maurice Marinot is also represented in depth with forty-three examples of glass and several paintings and drawings. Other artists represented by three or more works include Degas, R. Delaunay, Dufresne, Dufy, Dunoyer de Segonzac, Maillol,

Matisse, Picasso, Seurat, Soutine, and Jacques Villon. Also shown are 63 African sculptures, many formerly from the collections of Félix Fénéon and Paul Guillaume. Full cataloue entries with explanatory text and reproductions of each object are included.
Reviews: X. Muratova, *Burlington Magazine* 120:901(April 1978):260; R. Micha, *Art international* 22:4(April-May 1978):48; J.-P. Dauriac, *Pantheon* 36:3(July-Sept. 1978):281.

1978, 1 April-
1 October

New York, Solomon R. Guggenheim Museum. *The Evelyn Sharp Collection.* Preface by Thomas M. Messer; texts by Louise Averill Svendsen aided by Philip Verre and Hilarie Faberman. 96 p., 46 illus., 45 col., 45 works shown. Paintings, sculpture and a few works in other media by eighteen major 20th century artists. The works selected complement and augment the Guggenheim's own collection. Included were eight Picassos, five Modiglianis and Calders and four Archipenko bronzes as well as works by Bombois, Braque, Chagall, van Dongen, Dufy, Léger, Maillol, Matisse, Miró, Pascin, Rouault, Soutine, Utrillo, and Vlaminck.

1978, May

Mexico City, Museo de Arts moderno.
Review: M. Folch, *Artes Visuales* 19(Sept.-Nov. 1978):31-3.

1978, 6 June-
18 September

Paris, Grand Palais. *De Renoir à Matisse: 22 chefs-d'œuvre des musées soviétiques et français.* Avant-propos par Hélène Adhémar. Catalogue par Anne Distel et Michel Hoog. 55 p., 24 illus., 10 col. 22 works shown. This exhibition presented eleven works from the collections of the Pushkin Museum, Moscow, and the Hermitage, Leningrad, and eleven works from the French museum collections, primarily the Jeu de Paume in Paris. The works are illustrated and accompanied by annotations detailing that phase in the artist's work which they reflect, their date, source of inspiration, and other relevant information. Artists included Renoir, Matisse, Gauguin, Dufy van Gogh, and Picasso.

1978, 24 June-
10 September

Flushing, NY, Queens Museum. *Play Ball! A Century of Sports in Art.* Exhibition and catalogue by Susan Bloom; introductory essa by George Plimpton. 24 p., 22 illus., 66 works shown. Exhibition of paintings, prints, drawings, watercolors, and sculptures of sporting subjects by over 50 American and European artists, 19th-20th centuries, including George Bellows, Robert Dash, Raoul Dufy, Sidney Goodman, Red Grooms,

William King, Louise Kruger, Ben Shahn, and John Wesley.

1978, 2 July-31 December

London, Arts Council of Great Britain. *Paintings from Paris; Early 20th Century Paintings and Sculptures from the Musée d'Art moderne de la Ville de Paris.* Also shown Oxford, Museum of Modern Art (2 July-13 Aug.); Norwich, Castle Museum (19 Aug.-1 Oct.); Manchester, Whitworth Art Gallery (7 Oct.-11 Nov.); Coventry, Herbert Art Gallery and Museum (18 Nov.-31 Dec.) Preface by Joanna Drew and Michael Harrison, foreword by Jacques Lassaigne, introduction by Michael Harrison. 48 p., 74 illus., 4 col., 82 works shown.
Exhibition showed the way in which Fauvism, Cubism, and the School of Paris are represented in the museum's collection. Catalogue includes an introduction on the development of early 20th century art in France, and a special section devoted to Marcel Gromaire, who is strongly represented in the Museum's holdings. Other artists shown included Braque, Delaunay, Derain, Dufy, La Fresnaye, Léger, Lhote, Lipchitz, Matisse, Metzinger, Pascin, Picasso, Rouault, Utrillo, Valadon, and van Dongen.

1979

Le Havre, Musée des Beaux-arts André Malraux. *Impression—créations de Raoul Dufy et Paul Poiret.* Catalogue, *L'Art comme utopie*, 47 p., 58 illus.
Presented the work of two designers: Paul Poiret, the couturier who made innovations in fields ranging from high fashion to interios design, and Raoul Dufy, a one-time associate of Poiret, who subsequently changed artistic direction.

1980

Paris, Grand Palais. *Centennaire de Guillaume Apollinaire.* 3 paintings.

1981

Paris, Artcurial. *Au temps du Boeuf sur le toit, 1918-1928.* 1 painting, 2 gouaches, 2 lithographs.

1981, 27 May-14 July

Paris, Centre culturel suédois. *Le Musée des esquisses d'art public Lund Suéde.* Textes par Gunnar Bra-Hammar, Kristina Garmer, et Marin W. Sanderberg. ca. 120 p., illus.
Preliminary sketches and projects for public art in the collection of the Arkiv för Dekorativ Konst, Lund. Among the forty artists represented are Bror Marklund, Siri Derkert, Paul Gernes, Raoul Dufy, and Claes Oldenburg.

1982

Hamburg, Kunsthalle. *Picasso zum 100. Geburstag.* Included Dufy's *Woman in Red*.
Review: A. Lütgens, *Tendenzen* 23:138(April-June 1982):22-4.

1983, 4 June-
2 October

Martigny, Fondation Pierre Gianadda. *Manguin parmi les Fauves*. Catalogue par Lucille Manguin, Pierre Gassier, et Maria Hahnloser. 175 p., 107 illus.
Exhibition of paintings and draings by Henri Manguin (1874-1949) and ten Fauves: Braque, Charles Camoin, Dufy, Emile-Othon Friesz, Albert Marquet, Matisse, Jean Puy, Louis Valtat, Kees van Dongen, and Maurice de Vlaminck. In his essay Gassier gives an account of Fauvism from its origins in a meeting of Manguin, Matisse, and Marquet in the stuio of Gustave Moreau, to its "official" birth at the Salon d'Automne in 1905, tracing the interest of its members in Cézane and the decline of the movement as Cézanne's work became more widely known. Hahnloser describes the importance for Manguin of his visits to Switzerland, especially Lausanne. Manguin's daughter, Lucille, gives her recollections of his personality. The exhibits were divided into Fauvist works, and works by Manguin from the post-Fauvist Period (1908-49).

1985, 15 June-
20 October

Lausanne, Fondation de l'Hermitage. *De Cézanne à Picasso dans les collections romandes*. Catalogue par François Daulte. 200 p., 121 illus., 120 col.
Exhibition of 20th century paintings and sculptures from private and public collections in French-speaking Switzerland, by exponents of Post-Impressionism (specifically the Nabis and Pointillists) Fauvism, and l'Ecole de Paris, including Cézanne, Maillol, Bonnard, Vallotton, Dufy, Derain, Marquet, Matisse, Vlaminck, Rouault, Chagall, Utrillo, Modigliani, and Picasso. Daulte summarizes the history of each of the movements represented—their major members, principle tenets, and most lasting effects on contemporary arts—and profiles the collecting tastes of the French-speaking cantons.

1984,
15 February,
29 April

London, Tate Gallery. *The Mrs. A.F. Kessler Bequest to the Tate Gallery*. Catalogue by Ronald Alley. 31 p., 15 illus.
Exhibition of fourteen French drawings and paintings that were given to the Tate Gallery by Anne Kessler. The provenance and exhibition history of each picture are given. Artists include Daumier, Degas, Renoir, Toulouse-Lautrec, Matisse, Dufy, Picasso, and Modigliani.

1985-86, 23 November- 12 January	Washington D.C., Phillips Collection. *French Drawings from the Phillips Collection.* Sponsored by the National Endowment for the Arts. Catalogue by Sasha M. Newman. 8 p., 5 illus. Exhibition of drawings by French or French-based artists, from the Phillips Collection, including works by Bonnard, Braque, Henri-Edmond Cross, Degas, Derain, Charles Despiau, Dufy, Dunoyer de Segonzac, Fantin-Latour, Gaudier-Brzeska, van Gogh, Marcel Gromaire, Roger de La Fresnaye, Aristide Maillol, Matisse, Modigliani, Jules Pascin, Picasso, Renoir, Seurat, Nicolas de Staël, and Toulouse-Lautrec. In her introduction Newman briefly desribes the collection and analyzes some of the outstanding work it contains.
1987	Rotterdam, Museum Boymans-van Beuningen. *Concours hippique: the Horse in Art.* Foreword by W. H. Crouwel. Catalogue by J. R. ter Molen. 64 p., 77 illus., 11 col. In English and Dutch. Exhibition of art in a variety of media representing the horse, including works by Odilon Redon, Degas, Toulouse-Lautrec, Albert Marquet and Raoul Dufy, among other artists.
1988, 16 June- 30 October	Geneva, Musée d'Art et d'histoire. *Collection Berggruen.* Catalogue avec un essai par Gary Tinterow. Contribution de John Rewald, 272 p., 120 illus., 114 col., 106 works shown. Exhibition of 106 paintings from the private collection of Heinz Berggruen (1914-), including works by Dufy, Braque, Matisse, and other artists. Tinterow's essay concerns Berggruen as a collector. Rewald's essay highlights the twelve paintings by Cézanne in the exhibition.
1989, 23 March- 7 May	Auckland, Auckland City Art Gallery. *The Reader's Digest Collection: Manet to Picasso.* Catalogue by John Rewald. 96 p., 42 col. illus. Catalogue to an exhibition of French Impressionist and Post-Impressionist paintings, drawings and sculptures from the collection started by Lila Acheson Wallace. Rewald riefly discusses the scope of the collection and provides a short commentary on each of the exhibited artists, including Bonnard, Degas, Dufy, Modigliani, Monet, Morisot, Utrillo, van Gogh, Vuillard, and Vlaminck.
1989, 18 May- 3 September	Lyon, Musée des Beaux-arts. *De Géricault à Léger: dessins français des XIX^e et XX^e siècles dans les collections du Musée des Beaux-arts de Lyon.* Sponsored by Direction régionale des affaires culturelles. Catalogue par Dominique Branchlianoff. 164 p., 133 illus., 21 col.

Exhibition of some 130 drawings from the cited collection. The 20th century section includes examples by Léon Bakst, Emile-Antoine Bourdelle, Raoul Dufy, Fernand Léger, Paul Signac, Henri Matisse, and Suzanne Valadon.

1990-91,
4 October-5 May

Los Angeles, Los Angeles County Museum of Art. *The Fauve Landscape*. Also shown New York, Metropolitan Museum of Art (19 Feb.-5 May 1991); London, Royal Academy of Arts (10 June-1 Sept. 1991). Sponsored by Ford Motor Company and the National Endowment for the Arts, Washington, D.C. Catalogue by Judi Freeman. Published in association with Abbeville Press, New York, 1990. 350 p., 409 illus., 210 col.

Exhibition of the diverse landscape images ranging from seascapes, riverscapes, townscapes and cityscapes painted by the Fauvist group of painters, which included artists such as Henri Matisse, André Derain, Maurice de Vlaminck, Raoul Dufy, and Georges Braque. The range and inventiveness of these artists towards nature is apparent. An introduction surveying the work, travels and thoughts of the Fauvists is followed by a documentary chronology of the years 1904-08. The catalogue includes six essays by Freeman, Alvin Martin, John Klein, James D. Herbert, and Roger Benjamin.

1990

Tokyo, Bridgestone Museum of Art. *Masterworks: Paintings from the Bridgestone Museum of Art*. Catalogue by Yasuo Kamon, 102 p., illus. Included works by Dufy, Matisse, Braque, van Dongen, and Rouault, and other nineteenth and twentieth-century French artists.

1991

Munich, Neue Sammlung, Staatliches Museum für Angewandte Kunst. *Künstlerplakate: Frankreich/USA—zweite Hälfte 20. Jahrhundert* [Artists' Posters: France/U.S.A.—Second Half of the 20th Century]. Texts by Hans Wichmann and Florian Hufnagle. Basel, Boston, Berlin: Birkhäuser, 1991. 330 p., 249 illus., 224 col. Presents posters by forty-six French and American based artists on the occasion of an exhibitin of the same title at the Neue Sammlung. Staatliches Museum für Angewandte Kunst, Munich (1991). Posters by artists are described as a medium which bridges the gulf between categories in art, and leads to interesting consequences for museums of modern art. In the two following chapters Hufnagle discusses the work of artists in France and the U.S. in this field since 1945, including Arp. Braque, Buffet, Chagall, Le Corbusier, Delaunay, Dufy, Matisse, Picasso, Christo, Johns, Lichtenstein, Serra, Stella, and

Warhol. The posters illustrated are accompanied by detailed annotations.

1990 Tokyo, Bridgestone Museum of Art. *Masterworks: Paintings from the Bridgestone Museum.* Catalogue by Yasmo Kamon. 102 p., illus. Exhibition of paintings from the holdings of the Bridgestone Museum of Art in Tokyo. Works by the following artists were on show: Camille Pissarro, Edouard Manet, Edgar Degas, Alfred Sisley, Paul Cézanne, Claude Monet, Pierre-Auguste Renoir, Henri Rousseau, Paul Gauguin, Vincent van Gogh, Paul Signac, Pierre Bonnard, Henri Matisse, Georges Rouault, Raoul Dufy, Kees van Dongen, Pablo Picasso, Georges Braque, Maurice Utrillo, Marie Laurencin, Amedeo Modigliani, Giorgio de Chirico, and Chaim Soutine.

1992,
19 January-
12 April

s'Hertogenbosch, Netherlands. Museum Het Kruithuis. *Terra scultura, terra pictura: keramiek van de 'klassieke modernen' Georges Braque, Marc Chagall, Jean Cocteau, Raoul Dufy, Joan Miró, Pablo Picasso* [Sculpted Clay, Painted Clay: Ceramics from the "Classical Modernists" Georges Braque, Marc Chagall, Jean Cocteau, Raoul Dufy, Joan Miró, Pablo Picasso]. Preface by Yvonne G. J. M. Joris, Roland Doschka, and François Mathey. 220 p., 99 illus., 82 col. In Dutch. Summary in English and French.

In the exhibition preface, Joris analyzes how the "classical modernists" such as Braque, Chagall, Miró Picasso, Cocteau and Dufy looked to the past, drawing on past images as well as experimenting with new materials in their exploration of the sculptural and pictorial possibilities of clay. Doschka, in an essay titled "Art Cannot by Made with Theory," discusses the versatility of the Fauves and Cubists who combined skills in both the sculptural and painted medium. The cooperation between painters and sculpturs and the life and work of French ceramicist André Methey, Catalan ceramicist Llorens Artigas and Chagall's ceramic œuvre are examined. Mathey, in "But This is Another Story...," traces the attitude of various artists towards ceramics, particularly Picasso and Miró.

Georges Rouault

Biographical Sketch

Isolated among the artists of his time and a marginal Fauve at best, Georges Rouault produced work that is convincing proof that it is, or was, possible to be an independent yet wholly committed modernist. Rouault was born in 1871 in the cellar of a house in Belleville, a working-class quarter of Paris near Père Lachaise cemetery. The city was at that moment being bombarded by government troops from Versailles who were putting down the Paris Commune. His father was an artisan and carpenter—a finisher and varnisher of pianos in the Pleyel factory. Alexandre was also a follower of the Catholic democrat Félicité de Lamennais who sent his son to a Protestant school in disgust when Lamennais was condemned by the Pope. Rouault's grandfather, Alexandre Champdavoine, was in his own way equally remarkable. He was an employee in the postal service and in a modest way an amateur painter and collector. He purchased Callot engravings, lithographs by Daumier and Forain, and reproductions of paintings by Rembrandt, Courbet, and Manet.

The Protestant school was not a success and, after a harsh punishment, he was transferred to a state school where he excelled. In 1885 Rouault was taken away and apprenticed for two years to a stained-glass repairer and designer named Tamoni. In 1887 he was employed by another stained-glass maker, Georges Hirsch, who did some restoration work on medieval windows, which gave his young assistant the opportunity to examing them firsthand and to realize their superiority to modern work. Beginning in 1885 Rouault also studied at evening classes at l'Ecole des Arts Décoratifs, and in 1891 he transferred to l'Ecole des Beaux-Arts, where he entered Elie Delaunay's studio. Delaunay died the following year and it was Rouault's good luck that his successor was Gustave Moreau, one of the leading symbolists. Moreau immediately became a progressive influence in the school. His pupils included Matisse, Marquet, Camoin, Manguin, Evenepoel, and others, many of whom were to become members of Matisse's Fauve circle in the following decade. But it was Rouault who was Moreau's closest disciple.

At this period Rouault's ambitions were still conventional. He set himself to win the Prix de Rome but failed on two occasions despite Moreau's encouragement. He did, however, manage to win some minor prizes for pictures on religious themes in 1892 and 1894. His religious and mythological canvases were exhibited for the first time at the conservative Salon des Artistes Français. Rouault also worked at landscape during these formative years. In 1898 Moreau died. There was an immediate vendetta within l'Ecole des Beaux-Arts against his more advanced students. Rouault was rescued by being offered the curatorship of the Gustave Moreau Museum which was set up under the terms of his

teacher's will. He still endeavored to maintain links with the academic art world. For example, he exhibited at the Centennial Exhibition of French art held in connection with the Paris Exposition Universelle of 1900 and was awarded a bronze medal.

Nevertheless, the early years of the twentieth century were a period of discouragement and severe psychological strain. In 1901 he spent six months at the Benedictine Abbey of Ligugé in Poitou, where the novelist Joris-Karl Huysmans was attempting to form a religious community of artists. Convalescing in 1902 and 1903, Rouault reacted aesthetically against academicism and developed a blunt, forceful style that connected him with Fauvism. He helped found the first Salon d'Automne in 1903, becoming a target for the invective of the academicians of whom he had only recently been a colleague. Rouault's personality was increasingly shaped by religious and sociological considerations, and his subjects, interpreted in bold washes of darkish reds and blues with powerful linear definitions, became correspondingly somber—images of corrupt juries, prostitutes, and disenchanted clowns and acrobats. Rouault was represented in the renowned and controversial 1905 Salon d'Automne, although his canvases were not shown with the Fauvist collection.

Rouault met the radical Catholic writer Léon Bloy in 1904 and was especially struck by Bloy's novel *La Femme pauvre* (1897). Bloy, as Huysmans had done earlier, strengthened the religious cast of his ideas and helped him discover the significance of his own creativity. The spectacle of humanity expiating original sin aroused both Rouault's pity and anger. He denounced lust in his hallucinatory figures of prostitutes and ripped off the veil from the wretchedness of the world in his series of clowns, itinerant showmen, and vagabonds. His ferocious images thoroughly stigmatized as well the vain, infatuated stupidity of bourgeois parvenus, lawyers, gendarmes, and judges. Imperfections that betrayed themselves in egoism, complacency, pride, hypocrisy, and debauchery filled Rouault with horror, as is evident in *Monsieur and Madame Poulot* (1905), inspired by Bloy's *La Femme pauvre*; in *Prostitute Before a Mirror* (1906); *Massacred Heads* (1907-08); and later in the *Three Judges* (1913).

Rouault avoided modeling, chiaroscuro, and toned color, with the result that his images became even more powerful. Hard, opaque brushstrokes, thick outlines resembling the lead in stained glass, savage slashes of color, and massive caricatural forms set against ominous shadows—these were the technical means Rouault employed in the creation of his highly distinctive and expressive style. Socially significant themes came naturally to him, possibly because of his own humble background, and he treated such themes with genuine sincerity. His workmen worn out with privation and toil (*Suburb of Endless Sorrow*, 1911), the circus clown who suppresses his grief as he makes others laugh (*Old Clown*, 1917), and exhausted peasants witness his compassion for the poor and disinherited. After his vehement condemnation of stupidity and folly, injustice and cruelty, Rouault absolved it all with a gentleness that was wholly Christian. In his youth he had painted religious subjects, and in 1913 he returned to them with greater determination. He continued his religious and morally conscious paintings until 1917, when his dealer, Ambroise Vollard, persuaded him to turn to printmaking and illustration.

The phase immediately before the First World War was one of transition for Rouault. He experimented with glazed ceramics, a medium he did not pursue; he traveled a little, visiting Burges; and he married. His wife was Marthe Le Sidaner, sister of the painter Henri Le Sidaner. Marthe was a constant support throughout his life and the couple had three daughters. Despite a successful individual show at the Galerie Druet in 1910, Rouault was often poor. In 1912 he moved to Versailles where he inhabited a squalid, rat-infested house in an old quarter of town. On one occasion he went to tell his landlord, who was a veterinary surgeon, that he intended to complain to the local Committee for Public Health. "It'll do you no good," said the landlord complacently. "I'm

the chairman." During the Versailles years Rouault completed a series of watercolors of lowlife subjects including several paintings of prostitutes.

In 1916 Rouault left Versailles and in 1917 he signed a contract with the famous dealer Ambroise Vollard that provided him with freedom to work for many years. Rouault agreed to give Vollard everything he produced in return for a salary. Vollard even went so far as to provide him with a studio on the top floor of his own house where Rouault could work undisturbed. As the artist was later to discover, there were certain drawbacks to this arrangement. Vollard was a jealous patron who liked to monopolize the work of artists he favored and keep it from prying eyes. The result in Rouault's case was that for the next twenty years people judged him by old work rather than by what he was currently producing. During the first decade of their association Rouault concentrated mainly on graphic work. His famous series *Miserere*, fifty-eight etchings and aquatints finished in 1927 but unpublished until 1948, is generally considered his finest graphic achievement. In these austerely monochromatic and exceptionally large copperplates Rouault's obsessions and the simplicity of his vision found their most valid expression. His *Fleurs du mal*, based on Baudelaire's poems, were partly done in 1926-27 and completed in the 1930s. Another significant group is *Les Réincarnations du Père Ubu* (1928), consisting of eighty-two wood engravings and seven color etchings.

In 1918 he returned to making paintings of sacred subject, occasionally with more varied and richer coloration. After 1927, when he resumed painting in earnest, Rouault developed the thickly crusted, richly toned style with thickly outlined images for which he is best known. His themes repeated the clowns and religious figures he had done earlier. Some attention did come his way: in 1921 the first book on his work was published (a volume in La Nouvelle Revue Français' "Les Peintres Français Nouveaux" series); in 1924 there was a retrospective at the Druet Gallery and he was awarded the Legion of Honor. In 1926 he published his book *Souvenirs intimes*, and in 1929 Diaghilev commissioned him to design his last major project, *The Prodigal Son*, with music by Prokofiev and choreography by Balanchine. Rouault's art after 1930 became internationally famous through showings in Munich, London, Chicago, New York, and elsewhere. He also won recognition through tapestry designs. His pictures following the early 1930s are difficult to date precisely because he seldom designated the year of completion with his signature. Moreover, he often reworked or finished canvases he had started from about 1910 through the 1920s. His works increased in richness of color and texture from about 1932 on.

In 1937 Rouault's reputation took a great stride forward. Forty-two paintings, all in a style hailed as relatively "new" by the critics and public but long established by the artist, were shown as part of the large Exposition des Artistes Indépendants staged in connection with the Paris Exposition Universelle. In 1939 Vollard was killed in an accident and the artist was thus released from his contract. It left behind an important question—what was to happen to the great mass of unfinished work which was now in the possession of Vollard's heirs? In 1947 Rouault brought suit against them to recover this material.

Rouault had always been very concerned with the artist's rights over his own creation. In 1943 he wrote:

> I sometimes dream, in these last years of my life, of upholding a thesis at the Sorbonne on the spiritual defense of works of art and the artist's rights before the law, and the ways and means of securing these rights, so that those who come after us may be better protected.

He succeeded perhaps better than he had hoped. He asked the court for the return of 800 unfinished and unsigned paintings that had remained in Vollard's possession at the time

of his death, and his right to them was eventually conceded. He only failed to recover those which had already been sold. In November, 1948, to make his point quite clear and, realizing that at age 77 he could not possibly finish them all, he ceremonially burned 315 of the canvases he had recovered before witnesses.

Rouault's reputation was not damaged by the war. He had already had a few exhibitions abroad in the 1930s and in 1940-44 there were Rouault retrospectives in Boston, Washington, and San Francisco. In the immediate post-war period his sometimes somber vision was in tune with the times. There was a retrospective at The Museum of Modern Art in New York in 1945 and another, shared with Braque, at the Tate Gallery in London in 1946. In 1948 he exhibited at the Venice Biennale and traveled to Italy for the first time. Universally acclaimed as one of the major French artists of the twentieth century, he was made a Commander of the Legion of Honor in 1951. His eightieth birthday that same year was celebrated at the Palais de Chaillot. In the 1950s what had been a trickle of retrospective exhibitions became a flood. Following Rouault's death on February 13, 1958 at age 87, he was honored by a state funeral at St.-Germain-des-Près.

Georges Rouault

Chronology, 1871-1958

Information for this chronology was gathered from *Rouault: première période 1903-1920* (Paris: Musée National d'Art Moderne Centre Georges Pompidou, 1992), pp. 155-239; *Georges Rouault, 1871-1958* (Berlin: Kunstamt Wedding, 1988), pp. 8-9; Waldemar George and Geneviève Nouaille-Rouault, *L'Univers de Rouault* (Paris: Henri Scrépel, 1971); and Georges Rouault and André Suarès, *Correspondance* (Paris: Gallimard, 1960), among other sources.

1871	May 21—birth of Georges Henri Rouault in the cellar of a house in Belleville, a working-class quarter of Paris near the Père Lachaise cemetery. The city was being bombarded by government troops from Versailles who were putting down the Paris commune. His father, Alexandre Rouault, a Breton from Montfort, is an artisan—a finisher and varnisher of pianos in the Pleyel factory. He was also a follower of the Catholic democrat Félicité de Lamennais who sent his son to a Protestant school in disgust when Lamennais was condemned by the Pope. His mother is Marie-Louise Champdavoine. She is a seamstress and, later, employed at the Caisse d'épargne. He has one older sister, Emilie. Rouault's maternal grandfather was in his own way equally remarkable. He was an employee in the postal service and in a modest way an art collector—he bought Callot engravings, lithographs by Daumier, and reproductions of paintings by Rembrandt. Rouault spends his childhood in the working-class districts of Belleville and Montmartre.
1881	During visits to his aunts and grandfather, he shows interest in the work of Daumier, Courbet, Manet, and other artists.
1885-90	Apprenticed for two years to a stained-glass maker named Tamoni. Takes evening classes at l'Ecole des Arts décoratifs. Later employed by another stained-glass maker, Georges Hirsch, who did some restoration work on medieval windows which gives his young assistant the chance to example them and to realize their superiority to modern work. Albert Besnard asks him to execute stained-glass windows for l'Ecole de Pharmacie after Rouault's cartoons. Rouault refuses and decides to pursue a career in painting. December 3, 1890—enrolls at l'Ecole Nationale supérieure des Beaux-arts, in the studio of Elie Delaunay.

1891-92 September 5—Delaunay dies and is succeeded on January 1, 1892 by Gustave Moreau, a leading Symbolist who exerts a progressive influence in the school. Pupils include Rouault, Matisse, Marquet, Evenepoel, Marquet, Lehmann, Piot, Baignères, and others who benefit from Moreau's liberal and intelligent instruction. Rouault is regarded his closest disciple. Executes a series of religious subjects in Rembrantesque style.

1893 March 31—enters *Samson tournant la meule* (*Samson at the Mill*) in the Prix de Rome competition, strongly backed by Moreau, but is unsuccessful. August—participates in the Attainville competitive. Near the end of the year he is awarded Moreau's annual studio prize (300 francs) for his religious paintings.

1894 February 6—awarded second place at the Prix Fortin d'Ivry competition for *Coriolan se découvrant devant Tullius*. July—wins the Prix Chenavard for *L'Enfant Jésus parmi les docteurs*, after fellow students protest against its initial award to one of Gérôme's students. Rouault's painting wins a bronze medal in the Exposition Universelle of 1900.

1895 Matisse enters Moreau's studio. Rouault wins second prize in the Prix de Rome for *Le Christ mort pleuré par les saintes femmes*. Moreau advises him to leave the studio and become an independent painter. Completes his first Catholic communion. Shows for the first time two paintings at the Salon des Artistes français, under the name Rouault-Champdavoine

1895-1901 Shows, except in 1897-98, at the Salon des Artistes français paintings inspired by the Scriptures—*L'Enfant Jésus parmi les docteurs* (1894), *Le Christ mort pleuré par les saintes femmes* (1895), *Le Christ et les disciples d'Emmaüs* (1899), *Salomé* (1900), and *Le Christ et Judas*. Also executes landscapes.

1896 Shows *Christ mort pleuré par les saintes femmes* at the Salon des Artistes français. Summer—stays with the Piot family at Vendée in Soullans. Frequent Ambroise Vollard's gallery where he admires the work of Cézanne and Gauguin.

1897 March—exhibits religious works at the 6th Salon de la Rose-Croix. Paints *Le Chantier* (*Night Landscape*).

1898 April 18—Moreau dies of throat cancer. Moreau leaves his paintings to the state for a museum in his name. His passing deeply affects his students, some of whom join Eugène Carrière's academy. Rouault quits l'Ecole des Beaux-arts and establishes himself an independent painter, working in complete solitude.

1899 March—shows *Christ et les disciples d'Emmaüs* and *Orphée* at the Salon des Artistes français. May-June—completes portrait drawings of his parents. Portraiture becomes increasingly important in his work.

Subjects include friends and fellow painters, poets he admires, and a dozen self-portraits.

1900 Participates in the Salon des Artistes français with *Salomé*, a subject he paints often and one of Moreau's favorite subjects. Aids Léon Lehmann, a friend from Moreau's studio who suffers from poor health. Watercolors and pastels influenced by Rembrandt, Seghers, and Millet. Bronze metal at the Centennial Exhibition of French art held in conjunction with the Paris Exposition Universelle.

1901 Shows at the Salon des Artistes français *Christ et Judas* and *Orphée et Eurydice*. Paints romantic landscapes, religious subjects, and scenes of life in Paris. April—joins Antonin Bourbon at the Benedictine Abbey of Ligugé in Poitou, where the novelist Joris-Karl Huysmans is trying to form a religious community of artists. The experiment is brought to an end by the law against religious congregations introduced by the anti-clerical French government of the time. October—returns to Paris. Becomes a regular visitor to Ambroise Vollard's gallery at 6, rue Lafitte.

1902 The state accepts Moreau's bequest and his house and studio (rue La Rochefoucauld) are transformed into a museum. Rouault is appointed conservator for 2,400 francs a year. Participates, with Matisse, Marquet, René Piot, Georges Desvallières, and the critic Y. Rambosson in the creation of the Salon d'Automne. In poor health following a major breakdown, Rouault convalesces at Evian (Haute-Savoie) in the Alps. The isolation renews his vision and inaugurates a new style. Paints mostly watercolors and gouaches on paper. Experiments in other media as well.

1903 January 14—inauguration of Musée Gustave Moreau, presenting a collection of 800 paintings, 350 watercolors, and 5,000 drawings of the master. Rouault makes a second trip to the Alps, at Annécy where he stays with François Hermès, an art-school friend. Meets the aged Edgar Degas in Paris. First circus scenes and parades.

1904 March—meets the radical Catholic writer Léon Bloy through Auguste Marguillier, secretary of the *Gazette des Beaux-arts* and a mutual friend. They become close friends. Rouault is especially struck by Bloy's novel *La Femme pauvre* (1897). November—shows several watercolors anad drawings of clowns, acrobats, prostitutes, and landscapes in his new more somber style. Receives public and critical ridicule (including Bloy) for his "dark" tableaux, with the exception of Elie Faure and Louis Vauxcelles.

1905 April—exhibits circus scenes and *Filles* at the Salon des Indépendants. June—meets Jacques and Raïssa Maritain through Léon Bloy. Jacques Maritain converts to Catholicism and is one of the first to write favorably about Rouault's new style. Summer—Rouault responds to a request by Charles Morice with an article on new trends in art for the *Mercure de France*. October—shows clowns, buffons, actors, and

circus performers in the historic *cage aux Fauves* alongside paintings by Matisse, Derain, Manguin, Valtat, Puy, and Vlaminck. In another room he exhibits a triptych entitled *Filles* and *M. et Mme Poulot*, paintings inspired by characters in Bloy's novel *La Femme pauvre*. Distressed by what he perceives as "modern art," Bloy refuses to acknowledge the inspiration.

1906 February—shows small landscapes, prostitutes, and bathers at the Salon des Indépendants. The theme of dancers reappears in his work, influenced by his admiration of Degas. Summer—visits Marcilly near Avallon in an abbey restored by Stephanie Piot, brother of René Piot, with Desvaillières and the sculptor Albert Marc. Also visits Vézelay. Occasionally revisits Marcilly over the next several years. Shows at the Salon d'Automne and strengthens ties with Matisse. Begins collaboration on ceramics and faïences with the potter André Metthey in Asnières. Vollard sends Matisse, Derain, Vlaminck, and Puy to Metthey as well and commissions plates and vases.

1907 May 12—Huysmans dies. Shows ceramics at the Indépendants and mostly *Clowns, Lawyers*, and *Judges* at Salon d'Automne, which are critically acclaimed. First journey to Belgium with Marguillier. July—Vollard suggests that Rouault make a series of ceramic pieces exclusively for him.

1908 January 27—marries Marthe Le Sidaner, sister of the painter Henri Le Sidaner (1862-1939). She contributes towards household expenses up to the mid-1930s by giving piano lessons. The couple has four children: Geneviève, Isabelle, Michel, and Agnès. Marthe is a pianist who gives lessons to supplement the family income. They live in an apartment at the Musée Moreau. Shows six sketches at the Indépendants, which create a minor scandal and are harshly reviewed. Paints scenes of judges and juries inspired by attending the Tribunal de la Seine. Also paints peasants and laborers. Jacques Rivière (1886-1925), André Lhote (1885-1962), and Henri Fournier (the writer Alain-Fournier, 1886-1914) become close friends. Committee member, Salon d'Automne.

1909 Shows two canvases, *Juges* and *Filles*, at the Indépendants. Watercolors and drawings. Paints grotesque figures (motorists, lecturers, teachers) and his first working-class scenes; also scenes for his *Exodus* and *Miserere* series.

1910 Moves to 51, rue Blanche in Paris, where his parents come to live as well. February 24-March 5—first individual exhibition at Galerie Druet. Shows 121 paintings, eight drawings, forty-three ceramics, and ten terra cottas. Catalogue preface by Jacques Favelle, a pseudonym for Jacques Maritain, edited by Jacques Rivière. The exhibition is well received by critics and the public. Purchases are made by Stéphane Piot, Olivier Saincère, Roger Dutilleul, Henri Simon, Arthur and Hedy Hahnloser, and Marcel Sembat. Jacques Rivière praises him in an article in *La Nouvelle Revue française* (14 April). Also participates in group shows in Russia and Varsovie. A Russian collector, Vladimir Riabouchinsky,

purchases several canvases. March—presents five works at the Indépendants. Also shows in Rome, London, and is invited to participate in the Neue Künstler Vereinigung in Munich in September-October. Exhibits at Berthe Weill's, at Druet's, and at Salon d'Automne. *Christ Among the Doctors* is bought by the State who deposits it with the Musée de Colmar where it is shown for the first time in October, 1917.

1911 Shows at a group exhibition at Druet's (mostly faïences) and at the Indépendants. Befriends the writer André Suarès, with whom he begins a long correspondence. Exhibits at Bernheim-Jeune, Neue Künstler in October, and shows eighteen paintings and ceramics at the Salon d'Automne. December 12-23—second one-artist show at Druet's (forty-five paintings, eleven monochromes, and sixteen terra cottas). Critical opinion is mixed.

1912 January—third individual show at Druet's (ceramics, paintings, drawings, and watercolors gathered together in albums). June—moves to a rat-infested, rundown house in Versailles. Renews friendship with the Maritains, who are neighbors. His father dies and he begins the indian ink drawings which will become the *Miserere*. Begins a book on Moreau, *Souvenir intimes*, which is published in 1926. Publishes a statement on art, "Sur le Métier du peintre," in *Gil Blas* and an article on Ingres in *Mercure de France*.

1913 Begins negotiations with Ambroise Vollard for his entire production. The contract is finally signed in 1917. Detaches himself from the salons, preferring isolation. Ceramics and illustrated books occupy his time. Group exhibition in Marseille. Two paintings and some drawings are included in the Armory Show, New York.

1914-36 Parallel to painting, Rouault devotes a large amount of time to engravings, in particular to *Guerre et miserere* (1917-27), which appears under the title *Miserere* and is generally considered his finest graphic achievement. Illustrates for Vollard *Les Réincarnations du Père Ubu* (1928, published in 1932) and *Passion* (1935-36, published in 1938), among other books.

1914 Josef Florian, an editor in Prague and a fervent admirer of Léon Bloy and Rouault, prints Rouault's first color reproductions. For a long time Rouault considers these the best to have been printed. Moves to 15, impasse des Gendarmes, Versailles. Publishes "Trois petits poèmes" in *Les Soirées de Paris*, a magazine directed by Guillaume Apollinaire. After war is declared the family moves to Saint-Malo-de-la-Lande (Manche). His health makes him unfit for service. Centers his work on paintings of Christ.

1915 Visits Bordeaux and stays at a villa in Arcachon, returning to Versailles in November. December—his fourth and last child, Agnès, his born.

1916 January—recovers from an illness until spring, when he resumes

painting. The American collector John Quinn purchases several paintings of grotesques. May—exhibits at Bernheim-Jeune. June—moves to rue Blomet, Versailles. Accepts Vollard's commission for *Les Réincarnations du Pere Ubu* after Forain and Derain decline. Rouault accepts on the condition that Vollard agrees to publish his *Guerre et Miserere* and allow him to continue with his other painting.

1917

Vollard concludes negotiations for Rouault's entire studio, paying 49,150 francs for 770 unfinished works and becoming his exclusive dealer. The contract provides him with freedom to work for many years. Rouault agrees to give Vollard everything he produces in return for a set salary. Vollard goes so far as to provide him with a studio on the top floor of his own house, where he can work undisturbed. As the artist later discovers, there are certain drawbacks to this arrangement. Vollard proved a jealous patron. He liked to monopolize the work of artists he favored and keep it from prying eyes. The result in Rouault's case was that for the next twenty years most people judge him by his old work, rather than by what he is producing currently. Vollard has a passion for fine illustrated books and he encourages Rouault to turn in this direction for the following decade. Dr. Maurice Girardin purhcases four canvases and one watercolor from Druet's and develops a friendship with the painter. Girardin often invites Rouault to his apartment and secures scarce art supplies for him during the war. August—moves to Vermoiron, near Vault de Lugny (Yonne). Divides time between Saumur, Paris, and Versailles through 1919. November 3—Léon Bloy dies.

1918-30

Returns to oils, painting primarily religious subjects including the Passion of Christ. His palette becomes more varied and brilliant and his figures have serious and concentrated expressions.

1918

Vollard accepts his proposal for an illustrated edition of Baudelaire's *Les Fleurs du mal*. Abandons gouache and watercolor in favor of oil painting.

1919

Continues engraving plates for *Père Ubu* and *Miserere*, allowing scant time for painting. Constantly travels between Paris, Versailles, and Saumur. October 17—Musée d'Unterlinden in Colmar purchases *L'Enfant Jésus parmi les docteurs*, his first museum purchase.

1920

Moves to a small apartment at 20, rue La Bruyère. Marthe gives piano lessons. Rouault works on Miserere in the morning and paints in the afternoon. Religious and circus themes dominate his work. August—spends the month at Marnat in the Puy de Dôme with painters Emile Charmy, George Bouche, and Edmond Heuzé. His family joins him there. November—inaugural exhibition of fifty canvases at Maurice Girardin's Galerie La Licorne, Rouault's first individual show since 1916. The critics are generally favorable.

1921

Michel Puy, brother of the painter Jean Puy, writes the introduction to the first book dedicated to Rouault, published by La Nouvelle Revue

Française in its *Les Peintres français nouveaux* series. Includes writings and illustrations by Rouault.

1922 Shows at Galerie Barbazangues.

1923 Works in solitude on his etchings and paintings. December—André Lhote writes a laudatory article that appears in *L'Amour de l'art*.

1924 Vollard provides a studio on the top floor of his residence at 28, rue Martignac. The Flechtheim Gallery in Berlin shows works from 1897-1924. The exhibition receives favorable reviews. Galerie Druet holds a large retrospective (1897-1919), consisting of eighty-eight paintings and eight ceramics.

1925 Presents work from *Les Réincarnations du Père Ubu* at the Exposition des Arts décoratifs. Paints one of his most important works, *L'Apprenti-ouvrier*, which is also a self-portrait. He retouches it in 1952 before donating it to the Musée National d'Art moderne in Paris. Decorates a fountain in Aix-en-Provence in honor of Cézanne. April—named Chevalier de la Légion d'honneur.

1926 Publishes *Souvenirs intimes*, memoirs that credit the influence of Moreau, Bloy, Huysmans, Baudelaire, Daumier, Cézanne, Renoir, and Degas. Georges Charensol writes his first book on Rouault. Rouault asks Suarès to write the text for an illustrated book entitled *Cirque*. December—in the first and only edition of the magazine *Funambules*, Rouault reiterates his great admiration for Bloy.

1927 Completes the fifty-eight engravings for *Miserere*, although these are not published until 1948 by Editions de l'Etoile Filante.

1928 Reworks the engravings for Vollard's *Les Réincarnations du Père Ubu*.

1929 Diaghilev commissions him to design the decor and costumes for his last major ballet, *The Prodigal Son* (music by Serge Prokofiev, choreography by George Balanchine). The ballet is presented at the Sarah Bernhardt Theatre in Paris in May and June. Visits Montana-sur-Sierre, Valais, Switzerland, staying with the Japanese collector Fukushina. Disguised as Father Christmas to amuse the children, he accidently burns his hands. *Paysages légendaires,* a poem by Rouault illustrated with six lithographs and fifty drawings, is published by Editions Porteret.

1930-39 Executes large paintings on favorite themes—clowns, Pierrots, judges, sacred subjects, biblical passages—in brightly varied and rich colors.

1930 First foreign exhibitions in London (Gallery St. George), Munich (Neumann Gallery), New York (Brummer Galleries), and Chicago (Art Club). Works on colored aquatints for *Cirque* and *Passion*, with texts by André Suarès. An under-secretary of l'Etat aux Beaux-arts refuses

to authorize the purchase of a painting by Rouault already commissioned by the Musée du Luxembourg.

1931 Shows in Paris, Brussels, New York, and Geneva. Illustrates Michel Arland's *Les Carnets de Gilbert* published by La Nouvelle Revue Française. Arland remains a faithful admirer and ardent supporter.

1932 Publication of Vollard's *Les Réincarnations du Père Ubu*, with twenty-two aquatints and 104 wood engravings by Rouault. Suarès' text for *Cirque* displeases Vollard on the grounds it might upset his clientele. Rouault proposes substituting one of his poems, *Cirque de l'étoile filante*. First tapestry, *Tête de femme*. Other tapestry projects, such as *Le Clown blessé* and *La Petite famille*, are executed at Aubusson and directed by Madame Cuttoli.

1933 Mrs. Chester Dale donates *La Sainte face* to the Musée de Luxembourg, his first work to enter what later becomes the Musée National d'Art moderne de Paris. Shows at Pierre Matisse's and Julien Levy's galleries in New York. Galerie Cardo in Paris shows his *Ubu* illustrations.

1934-36 Completes engravings and illustrations for *Passion* and *Le Cirque de l'étoile filante* (seventeen engravings and eighty-two wood engravings), published by Vollard in 1936.

1935 Exhibits at Smith College Museum of Art in Northampton, Massachusetts, at the Mayor Gallery in London, and at Galerie Kaganovitch (Le Portique) in Paris.

1937 June-October—shows forty-two paintings (1905-37) at the Petit Palais, many in a style judged as new by the critics and public but long established by the artist, as part of the large *Exposition des Artistes Indépendants* staged in connection with the Paris Exposition Universelle. The public reacts with amazement adn enthusiasm. Vollard loans about twenty paintings to the exhibit. On viewing Rouault's works, critic Lionello Venturi decides to write a book on the artist which appears in 1940. *La Renaissance* devotes a special issue to Rouault with a text by Waldemar George. Paints *Le Vieux roi*.

1938 Exhibition of graphic works at The Museum of Modern Art in New York. Shows at the Kunsthalle in Basel with Vlaminck and Dufy.

1939 Vollard publishes *Passion*, text by Suarès, illustrated by seventeen colored engravings and eighty-two woodcuts by Rouault. July 22—Vollard is killed in a car accident, releasing Rouault from their contract. Vollard's heirs seal up Rouault's studio. September—when war is declared Rouault leaves Paris for Beaumont-sur-Sarthe.

1940-48 Paints smaller canvases with thick pigments in which blues dominate.

1940 Venturi publishes his work on Rouault in New York. A second edition is published in French in 1948. Joins the refugee exodus to Golfe-Juan.

His studio is ransacked by German forces. Difficulties begin with Vollard's heirs over ownership of his great mass of unfinished paintings, now in their possession.

1941 Shows in Washington D.C., San Francisco, and Boston.

1942 Shows in Paris at Galerie Louis Carré. Returns to Paris to exhibit *Pierrot aristocrate.*

1943 Editions Tériade publishes *Divertissement,* a poem by Rouault accompanied by fifteen color reproductions. August-September issue of *Le Point* is dedicated to the artist.

1945 Large (161 works) and important retrospective at The Museum of Modern Art in New York. Commissioned by Canon Devemy and the Reverend Father Couturier to design five stained-glass windows for the Chapel of Plateau d'Assy (Haute-Savoie), executed by Hébert Stevens Studios.

1946 April—shows with Braque at the Tate Gallery in London. Galerie René Drouin shows seventeen paintings in *Pour un art religieux.*

1947 March 19—wins judgment against Vollard's heirs for 800 unfinished canvases but 119 are missing and already sold. The court decides that the painter is the owner of his own paintings "provided that he has not given them away of his own volition." *Stella Vespertina,* a book of Rouault's aphorisms collected by Abbé Maurice Morel, is published by René Drouin, accompanied by twelve color reproductions. Shows forty paintings at Odette des Garets.

1948-52 Adds greens, yellows, and reds to his palette, while remaining faithful to familiar themes and inspirations.

1948 June—large retrospective (263 works) at the Kunsthaus in Zurich. The State sends twenty-five paintings and twelve engravings to the Venice Biennale. Travels to Switzerland and, for the first time, to Italy. *Miserere,* with fifty-eight engravings, is issued by Editions de l'Etoile Filante. These engravings are first shown at Galerie des Garets and are warmly received. November 5—at the Chaptal Studio in Montreuil-sous-Bois he burns 315 of the 700 unfinished paintings restored from Vollard's heirs before court authorities. At age 77, he realizes he cannot finish them. Begins a series of paintings based on a completely new range of colors—green, yellow and red.

1949 Visits Belgium and, for the first time, Holland. Prepares models for enamels executed by the studio of the Abbey of Ligugé.

1951 June 6—eightieth birthday is celebrated at the Palais de Chaillot, sponsored by the Centre Catholique des Intellectuels Français. Premiere of a film based on *Miserere* series by Abbét Maurice Morel. Awarded

Commandeur de la Légion d'honneur. Declines the invitation to become a member of the Institut Français.

1952 Retrospectives in Brussels, Amsterdam, and Paris. Louis Carré exhibits *Miserere*.

1953 Retrospectives in Cleveland, New York, Los Angeles, Tokyo, and Osaka. Commander of the Order of St. Gregory the Great.

1954 Retrospective in Milan. Girardin Collection, containing works by Rouault, is donated to the Petit Palais, Paris. Corresponding member of the National Academy of St. Luke in Rome.

1955 Retrospective at the Jerusalem Museum.

1956 Shows at the Musée Toulouse-Lautrec in Albi. Commandeur de l'Ordre des Palmes Académiques. Physically exhausted, he quits painting at the end of the year.

1957 *La Sainte face* is reproduced as a tapestry for the altar of the Chapelle de Hem (Nord), decorated by Manessier. Commandeur de l'Ordre des Arts et des Lettres.

1958 February 13—dies at age 87. February 17—state funeral at the church of Saint-Germain-des-Près. Abbot Maurice Morel, Minister of Education Monsieur Billières, and André Lhote offer the addresses.

1963 Madame Rouault and her children donate almost a thousand unfinished works to the State.

1966 Major exhibitions of Rouault's work organized by the Arts Council of Great Britain, shown at Ediburgh Festival and Tate Gallery, London.

1971 May-September—centenary exhibition held at the Musée National d'art moderne, Paris. The review *XX^e Siècle* publishes an issue in homage to Rouault, containing an article by Jacques Maritain. In it, he writes: "How is it that certain works of art seem to make us aware that we are receiving 'an immortal wound' when we see them? Rouault's painting is pure painting, its sole concern the passionate exploration of the demands of the pictorial subject-matter, the sensitivity of the eye, the precise use of the most refined and appropriate technical means at its disposal. At the same time his art springs from the intimate depths of his soul, from the intensity of his interior vision, from his poetic intuition, confusedly embracing, in its emotion, the subjectivity of the painter and the mystery of the visible world. This is Rouault's great lesson to us."

I. Writings, Statements, and Interviews by Georges Rouault

1171. ROUAULT, GEORGES. "Réponse à une enquête sur les tendances actuelles des arts plastiques" de Charles Morice. *Mercure de France* (Summer 1905). Reprinted in Philippe Dagen, *Archives des arts modernes* (Paris: Lettres Modernes, 1986).

1172. ROUAULT, GEORGES. "Notes sur le *Noli me Tangere* de Cézanne, *la Toison d'or* de Carrière et *Le Grand Pan* de Rodin." *Mercure de France* (16 Nov. 1910):654-9.

1173. ROUAULT, GEORGES. "Ingres ressuscité." *Mercure de France* (10 Dec. 1912). Reprinted in *Sur l'art et sur la vie* (Paris: Denoël/Gonthier, 1971), pp. 59-62.

1174. ROUAULT, GEORGES. "Sur le métier de peindre" (réponse à une enquête). *Gil Blas* (1912). Reprinted in *Sur l'art et sur la vie* (Paris: Denoël/Gonthier, 1971), pp. 63-4.

1175. ROUAULT, GEORGES. "Sur Forain." *La Vie* (1913).

1176. ROUAULT, GEORGES. "Trois petits poèmes" ("Mère," "Miserere," "L'Artiste"). *Les Soirées de Paris* 26-7(July-Aug. 1914). Reprinted in *Sur l'art et sur la vie* (Paris: Denoël/Gonthier, 1971), pp. 145-7.

1177. ROUAULT, GEORGES. "Toque noire, robe rouge" in *Georges Rouault* (Paris: Gallimard, Nouvelle Revue Français, 1921). Volume in "Les Peintres français nouveaux" series.

1178. ROUAULT, GEORGES. "Sur l'Ecole française." *l'Eclair* (29 Aug. 1924).

1179. ROUAULT, GEORGES. "Poèmes." *Bulletin de la vie artistique* 17(1 Sept. 1924):381-4.

1180. ROUAULT, GEORGES and GEORGES CHARENSOL (Interviewer). "Georges Rouault." *Paris-journal* (14 Nov. 1924).

1181. ROUAULT, GEORGES and JACQUES GUENNE (Interviewer). "Georges Rouault, entretien avec Jacques Guenne." *Les Nouvelles littéraires* (15 Nov. 1924).

1182. ROUAULT, GEORGES. "Dix poèmes." *Bulletin de la vie artistique* 6(15 March 1925):127-30.

1183. ROUAULT, GEORGES. "Deux poèmes" ("Le Christ de l'Yser" et "Hommage au solitaire"). *L'Amour de l'art* (Nov. 1925):445-6.

1184. ROUAULT, GEORGES. "Les Frontières artistiques" (Les Appels de l'Orient). *Les Cahiers du mois* 9-10(1925):117-82.

1185. ROUAULT, GEORGES. "Lettre-préface à l'ouvrage de Georges Charensol" in *Georges Rouault, l'homme et l'œuvre* (Paris: Editions des Quatre Chemins, 1926).

1186. ROUAULT, GEORGES. *Souvenirs intime*. Préface d'André Suarès. Paris: Editions E. Frapier, 1926.

Memoirs dedicated to Gustave Moreau, Léon Bloy, Cézanne, Baudelaire, Renoir, Daumier, Huysmans, and Degas.

1187. ROUAULT, GEORGES. "Gustave Moreau." *Le Correspondant* (10 April 1926):141-3.

1188. ROUAULT, GEORGES. "Déclaration sur le Musée Gustave Moreau." *Beaux arts* (16 Oct. 1926).

1189. ROUAULT, GEORGES. "Sur Gustave Moreau. Lettres de Georges Rouault à André Suarès." *L'Art et les artistes* 20:66(April 1926):219-49.

Special number on Moreau, with an additional letter by André Suarès. On p. 249 is reproduced a photograph of "Les Elèves de l'atelier Gustave Moreau en 1894."

1190. ROUAULT, GEORGES. "A féal Debureau." *Funambules* 1(Paris: Edition Porteret, 1 Dec. 1926):6-8.

1191. ROUAULT, GEORGES. "Stella Matutina." *Funambules* 1(1 Dec. 1926):49-57.

1192. ROUAULT, GEORGES. "Léon Bloy." *Funambules* 1(1 Dec. 1926):59-70.

1193. ROUAULT, GEORGES. *Misère et guerre*. Paris: Ambroise Vollard, 1927.

1194. ROUAULT, GEORGES. "Claude Monet." *L'Amour de l'art* 6(June 1927):200 1.

1195. ROUAULT, GEORGES. "Georges Rouault" (poème). *L'Art d'aujourd'hui* 17(Spring 1928):5-6.

1196. ROUAULT, GEORGES. "Lettre de Georges Rouault à Christian Zervos." *Cahiers d'art* 3(1928):102.

1197. ROUAULT, GEORGES. "Déclaration à spectateur." (18 June 1928).

1198. ROUAULT, GEORGES. "Sur Huysmans." *Bulletin de la Société Huysmans* 27(1928):113.

1199. ROUAULT, GEORGES. [Poem-preface to] Jules Joëts' book *Flandre* (Paris: Galerie d'art du Montparnasse, 1929).

1200. ROUAULT, GEORGES. "Les Décors du fils prodigue." *L'Intransigeant* (28 May 1929).

1201. ROUAULT, GEORGES. "Quel est votre paysage préféré?" (réponse à une enquête). *L'Intransigeant* (2 April 1929).

1202. ROUAULT, GEORGES. "1830-1930" (réponse à une enquête). *L'Intransigeant* (23 Nov. 1929).

1203. ROUAULT, GEORGES. *Paysages légendaires.* Paris: Editions Porteret, 1929.

1204. ROUAULT, GEORGES. "Pourquoi je me présente à l'Institut." *L'Intransigeant* (27 May 1930).

1205. ROUAULT, GEORGES. "Sur André Derain." *Les Chroniques du jour* (Jan. 1931).

1206. ROUAULT, GEORGES. "Evocations." *Les Chroniques du jour* (April 1931):8-9. Reprinted in *Sur l'art et sur la vie* (Paris: Denoël/Gonthier, 1971), p. 92.

Concerns Henri Matisse.

1207. ROUAULT, GEORGES. "En marge des doctrines." *La Nouvelle revue française* 217(Oct. 1931). Reprinted in *Sur l'art et sur la vie* (Paris: Denoël/Gonthier, 1971), pp. 93-8.

1208. ROUAULT, GEORGES. "Rouault parle de son art." *Demain* (9 Dec. 1931).

1209. ROUAULT, GEORGES. "Poème." *L'Intransigeant* (8 Feb. 1932).

1210. ROUAULT, GEORGES. "La Conception de la beauté." *L'Intransigeant* (8 Feb. 1932).

1211. ROUAULT, GEORGES. "En marge des doctrines." *L'Intransigeant* (15 Nov. 1932).

1212. ROUAULT, GEORGES. "Pouvez-vous dire quelle a été la recontre capitale de votre vie?" (réponse à une enquête). *Minotaure* 3-4(1933):114.

1213. ROUAULT, GEORGES. "L'Art d'aujour'hui" (réponse à une enquête). *Cahiers d'art* 10(1935):11-8.

1214. ROUAULT, GEORGES. "L'Art peut-il utiliser la photographie?" (réponse à une enquête). *Revue de l'art ancien et moderne* (March 1936).

1215. ROUAULT, GEORGES. "Sur le métier" (réponse à une enquête). *Beaux-arts* (Oct. 1936):5.

1216. ROUAULT, GEORGES. "Textes inédits." *Revue de Belles-lettres* (Neuchâtel)1(1936-37).

1217. ROUAULT, GEORGES. "Souvenirs sur Degas." *L'Intransigeant* (9 March 1937).

1218. ROUAULT, GEORGES. "Climat pictural." *La Renaissance* (Oct.-Nov. 1937):3-4. Reprinted in *Sur l'art et sur la vie* (Paris: Denoël/Gonthier, 1971), pp. 101-5.

Special issue of *La Renaissance* devoted to Rouault: "Georges Rouault: œuvres inédites."

1219. ROUAULT, GEORGES. "Anciens et modernes." *Verve* 4(15 Nov. 1938):104.

1220. ROUAULT, GEORGES. *Le Cirque de l'Etoile filante.* Paris: Ambroise Vollard, 1938.

1221. ROUAULT, GEORGES. "Préface à l'exposition d'André Girard" in *André Girard* (New York: Mrs. Cornelius J. Sullivan Galleries, 1938), pp. 3-5.

1222. ROUAULT, GEORGES. "Conceptions picturales." *Verve* (June-March 1939).

1223. ROUAULT, GEORGES. "Visages réels ou imaginaires." *Verve* 5-6(July-Oct. 1939).

1224. ROUAULT, GEORGES. "Visage de la France." *Verve* 8(1940):13 9. Reprinted in *Sur l'art et sur la vie* (Paris: Denoël/Gonthier, 1971), pp. 106-7.

1225. ROUAULT, GEORGES. "L'Oasis." *Verve* 8(1940):20. Reprinted in *Sur l'art et sur la vie* (Paris: Denoël/Gonthier, 1971), p. 146.

1226. ROUAULT, GEORGES. "Pâques 1942" in [exh. cat.] *Georges Rouault: œuvres récentes* (Paris: Galerie Louis Carré, 1942).

1227. ROUAULT, GEORGES. "Divertissement." *Verve* (1943).

1228. ROUAULT, GEORGES. "Souvenirs du jeune âge sont gravés dans mon cœur." *Le Point* 26-7(Lanzac)(Aug.-Oct. 1943):4-59.

1229. ROUAULT, GEORGES. *Soliloques.* Neuchâtel: Ides et Calendes, 1944. Reprinted in *Sur l'art et sur la vie* (Paris: Denoël/Gonthier, 1971), pp. 15-53.

1230. ROUAULT, GEORGES. "Sur Léon Bloy" (lettre). *Les Cahiers du Rhône* (Neuchâtel)1(Jan. 1944):139-42.

Special number devoted to Léon Bloy.

1231. ROUAULT, GEORGES. "Le Drame intérieur" in Gaston Diehl, *Les Problèmes de la peinture* (Paris: Confluences, 1945), pp. 206-10.

1232. ROUAULT, GEORGES. "Sur le métier de peindre." *Art présent* 1(1945).

1233. ROUAULT, GEORGES. "L'Essentiel peindre." *Spectateur* (18 June 1946).

1234. ROUAULT, GEORGES and JEROME SECKLER (Interviewer). "A Talk with Rouault." *Vogue* 109(15 Feb. 1947):198,204.

1235. ROUAULT, GEORGES. "Anciens et modernes, à propos des sculptures romanes du Roussillon." *Le Point* (Lanzac)34-5(March 1947):48-54.

1236. ROUAULT, GEROGES. *Stella Vespertina*. Paris: René Drouin, 1947.

1237. ROUAULT, GEORGES. "Notes de Georges Rouault" in James Thrall Soby, *Georges Rouault* [exh. cat.] (New York: Museum of Modern Art, 1947), pp. 33-6.

1238. ROUAULT, GEORGES. "Commentaire pictural" [introduction] in Edward Allen Jewell, *Georges Rouault* (Paris: Hyperion, 1947).

1239. ROUAULT, GEORGES. "The Art of a Painter" in Wallace Fowlie, *Jacob's Night; The Religious Renascence in France* (New York: Sheed & Ward, 1947). 116 p., illus.

1240. ROUAULT, GEORGES. "Rouault nous parle" (propos recueillis par Waldemar George). *Le Figaro littéraire* (3-10 Jan. 1948).

1241. ROUAULT, GEORGES. "Message aux nordiques Gantois." *La Métropole* (Anvers) (21 March 1949).

1242. ROUAULT, GEORGES. "Sur l'art sacré" (réponse à une enquête de Maurice Brillant). *La Croix* (11-12 May 1952). Reprinted in *Sur la vie* (Paris: Denoël/Gonthier, 1971), pp. 117-20.

1243. ROUAULT, GEORGES. "Lettre à Edouard Schuré." *Le Goéland* (Paramé)(June 1952).

1244. ROUAULT, GEORGES. "Léon Lehmann." *Le Point* (Souillac)53(Jan. 1953):7-8.

1245. ROUAULT, GEORGES. "Letter from Rouault." *Life* 34(16 March 1953):11.

1246. ROUAULT, GEORGES. "Pauvre van Gogh." *Les Arts plastiques* 6(July-Sept. 1953):269-72.

Written by Rouault for an Amsterdam exhibition of van Gogh.

1247. ROUAULT, GEORGES. "Lettre de Rouault à Pierre Matisse" (à propos du tableau *Monsieur X.)* Gallery Notes (Buffalo, Albright Knox Art Gallery) 18(Oct. 1953):2-3. With English translation. Reprinted in *Georges Rouault. Exposition du centenaire* [exh. cat.] (Paris: Musée National d'art moderne, 1971), pp. 49-50.

1248. ROUAULT, GEORGES. "Hommage à la Société auxiliaire des exposition du Palais des Beaux-arts de Bruxelles, 1928-1953." *Les Arts plastiques* (Bruxelles)3(1953):171.

1249. ROUAULT, GEORGES. "Avant-propos." *Kunsten Iday* 2(1954).

Special issue dedicated to Rouault.

1250. ROUAULT, GEORGES. "Léon Lehmann" (poèmes) in *Léon Lehmann, 1873-1953* [exh. cat.] (Besançon: Musée des Beaux-arts, June 1958).

Rouault's text dates to 1954.

1251. ROUAULT, GEORGES. "N'ayant jamais eu . . ." in Isabelle Rouault, *Peintures et gouaches* [exh. cat.] (Paris: Galerie Bernheim-Jeune, 1955).

1252. ROUAULT, GEORGES and PIERRE COURTHION (Interviewer). "La Dernière déclaration de Rouault." *Les Arts* (19-25 Feb. 1958).

Extract of Rouault's last interview with Pierre Courthion.

1253. ROUAULT, GEORGES. *En mémoire de Georges Rouault*. Paris: Edition de l'Etoile filante, 1959.

1254. ROUAULT, GEORGES and ANDRE SUARES. *Correspondance Georges Rouault—André Suarès, 1911-1939*. Introduction de Marcel Arland. Avant-propos de Isabelle et Geneviève Rouault. Paris: Gallimard, 1960. 358 p., illus., 2 pl.

The letters are preceded by a brief biographical essay that describes the friendship of Rouault and Suarès, and a foreword in which Isabelle and Geneviève Rouault describe how the letters came to be preserved. Samples of the handwriting of both men are included.
a. Japanese ed.: Tokyo, 1971.
b. English ed.: *Georges Rouault—André Suarès Correspondence, 1911-1939*. Trans. and edited by Alice B. Low-Beer. Introduction by Marcel Arland. Ilfraicombe, Devonshire: Arthur H. Stockwell, 1983. 139 p., illus., 2 pl.

1255. ROUAULT, GEORGES. *Georges Rouault: peintures inconnues ou célèbres* [exh. cat.] Paris: Galerie Charpentier, 1965.

Includes a text by Georges Rouault.

1256. ROUAULT, GEORGES. "Evocation de Matisse." *XX^e siècle* (1970).

1257. ROUAULT, GEORGES. *Sur l'art et sur la vie*. Préface de Bernard Dorival. Paris: Denoël/Gonthier, 1971. 205 p., illus., 8 pl. Volume in "Bibliothèque méditations" series.

a. Another ed.: 1982. 183 p., illus., 8 pl.
b. Italian ed.: Turin: Societa Editrice Internazionale, 1972.

1258. ROUAULT, GEORGES. "Georges Rouault (1871-1958):une confession ardente et brève." *Jardin des arts* 215(Oct.-Nov. 1972):50-9. 7 illus.

1259. ROUAULT, GEORGES. *Rouault*. Anthology of texts and selection of illustrations and chronology by Irina Fortescu. Translated from Romanian into

English by Richard Hillard. London: Abbey Library; dist. by W. H. Allen, 1975. 32 p., illus., 64 pl., some col.

II. Archival Materials

1260. COURTHION, PIERRE. *Correspondence*, ca. 1950-80. ca. 250 items. Holographs, signed. Located at The Getty Center for the History of Art and the Humanities, Archives of the History of Art, Santa Monica, California.

Consists of general correspondence with numerous scholars and artists, including George Rouault and Raoul Dufy.

1261. COURTHION, PIERRE. *Papers*, ca. 1925-85. 12 linear ft. Manuscripts. Located at The Getty Center for the History of Art and the Humanities, Archives of the History of Art, Santa Monica, California.

Courthion (1902-), a French art critic and historian, was director of the Cité Universitaire de Paris from 1933-39. Collection includes preparatory materials and manuscripts for studies of Rouault, Matisse, and other artists.

1262. LHOTE, ANDRE. *Letters*, 1907-29, to Gabriel Frizeau. 82 items. Holographs, signed. Located at The Getty Center for the History of Art and the Humanities, Archives of the History of Art, Santa Monica, California.

Lhote (1885-1962) was a French painter, illustrator, and art critic. The collection consists of letters written by Lhote to his friend and patron Gabriel Frizeau. Frizeau, an art collector whose tastes and ideas did not agree exactly with Lhote's, enlisted the painter as his agent in Paris. The letters focus on the Paris art market, theoretical concerns, and Lhote's writings on art, but also include personal matters. The collection is arranged in chronological order.

In the course of his reports to Frizeau, Lhote maintains a running commentary on the art market which includes detailed assessments of the value of specific works as sound financial investments (1908, 1917, 1918), and procedures for sending paintings out on approval (1908, 1912, 1926). Lhote acts as mediator between Frizeau and other artists, often obtaining lower prices for the collector because of Lhote's friendships and the poverty of the artist in question (1914, 1916, 1917).

Early letters contain lengthy descriptions, with some critical commentary, of exhibitions at the Salon d'Automne (1908, 1909, 1913, 1920, 1921). Often quoting prices, Lhote recommends that Frizeau buy works by Rouault (1908-10), Henri Matisse (1908), and Maurice de Vlaminck (1918), among others. A second concern in the letters is artistic theory which includes some critical appraisal of individual works and artists. One subject developed in depth is Lhote's ever-changing view on the theory and practice of Cubism.

1263. MATISSE, HENRI and PIERRE COURTHION (Interviewer). *Interview with Pierre Courthion and Related Papers*, 1940-41. ca. 125 items. Manuscripts (holographs, signed; typescripts); some printed matter. Located at The Getty Center for the History of Art and the Humanities, Archives of the History of Art, Santa Monica, California.

Collection consists of correspondence between Matisse and Courthion concerning the editing and publication of a series of the interviews conducted by Courthion in 1941; a typescript of the nine interviews; and related notes and other materials.

Organization: I. Interview correspondence, 1940-41 (folder 1); II. Interview (folder 13); III. Notes and papers (folder 2-12).

Series: I. Interview correspondence, 1940-41. Thirty-one letters between Henri Matisse, Pierre Courthion, and Lucien Chachaut concerning the transcription, editing and publication of the interview. One letter is illustrated.

Series II. Interview, 1941. 142 p. typescript of nine interviews with Matisse by Pierre Courthion. The interviews constitute an oral autobiography with information of Matisse's education, travels and major works, and with substantial discussion of Eugene Carrière, Paul Cézanne, Marcel Jambon, Albert Marquet, Gustave Moreau, Auguste Renoir, Auguste Rodin, Georges Rouault, and the Ballets russes. The final interview includes a lengthy conversation about Matisses's perception of the role of the artist as well as his theories of color and light. Index available.

Series III. Notes and papers, Pierre Courthion's papers concerning the Matisse interview, including a hand-edited copy of the text. Courthion's notes for the conversations, his contract with the publisher Skira and printed ephemera on Matisse. Also included are portions of the interview rejected for publication by Matisse which concern Matisse's relationships with Marcel Sembat and American collectors.

The Metropolitan Museum of Art, New York. *Miscellaneous Collection*, 1781-1949 (bulk 1830-1947). .8 cubic ft. Located at The Metropolitan Museum of Art, Thomas J. Watson Library, New York City.

Summary: Collection contains assorted letters of artists and others as well as a few news clippings, visiting cards, and documents. Individuals represented include Georges Rouault.

1264. NEUMANN, ISRAEL BER. *Papers*, 1921-60. 3.3 linear ft. Located at the Museum of Modern Art, New York.

Neumann (1887-1961) was a German-American art dealer, lecturer, critic, and publisher who gave support to many modern artists.

Papers consist of Neumann's publications, exhibition catalogs, manuscripts, lecture notes, and personal documents as well as copies of correspondence from artists and photonegatives of artwork. Prominent correspondents are Max Beckmann, Wassily Kandinsky, Paul Klee, Edward Munch, and Georges Rouault. A microfilm exists of additional letters from artists. Unpublished manuscripts are "Confessions of an Art Dealer" (chapters on Munch, Beckmann, Rouault, and Klee) and "Klee in America" (largely photographs of artwork). Also includes all issues of Neumann's irregular periodicals: *Bilderhefte* (Berlin, 1920-22) and *Artlover* (New York, 1926-45).

1265. PLAUT, JAMES SACHS. *Papers*, ca. 1929-76. 300 items (partially microfilm), 1.2 linear ft. Correspondence, business files, academic papers,

photographs, clippings, sketchbook, sketches, and miscellaneous notes. Located at the Archives of America Art, Smithsonian Institution, Washington, D.C.

Plaut (b. 1921) held curatorial positions at the Museum of Fine Arts, Boston, and become Director of Boston's Institute of Modern Art in 1939 (later the Institute of Contemporary Art). He was involved in many international exhibitions until his resignation in 1956. He later served as a consultant on industrial design in Israel. Includes correspondence from Georges Rouault.

1266. ROUAULT, GEORGES. *Letters and Manuscripts*, ca. 1906-32. 26 items. Holographs, signed; manuscripts. Located at The Getty Center for the History of Art and the Humanities, Archives of the History of Art, Santa Monica, California.

Letters include those to Louis Vauxcelles, Félix Fénéon, Armand Dayot, Gustave Coquiot, André Suarès, and Rouault's editor Walter, among others, concerning his religious beliefs, personal and business matters, teachers, exhibitions, and work in progress. Manuscript material includes a sheet of poetry.

1267. ROUDINESCO, ALEXANDRE. *Letters Received*, 1918-49. 74 items. Holographs, signed. Located at The Getty Center for the History of Art and the Humanities, Archives of the History of Art, Santa Monica, California.

Collection consists of letters to the Parisian art collector Dr. Roudinesco (b. 1883) from various Fauve painters. Most date from the 1930s and represent an unusually intimate and informative relationship between artist and patron. Letters include 30 from Maurice de Vlaminck, 1932-49; 28 from Raoul Dufy, 1918-36; 8 from Paul Signac, 1926-34; 6 from Kees van Dongen; 1930; and 2 from Georges Rouault.

III. Biography and Career Development

Books

1268. BORCHERT, BERNHARD. *Georges Rouault, 1871-1958*. Berlin: Kunstreihe des Safari-Verlages, 1962. 24 p., col. illus.

1269. BOYD, MARY A. *Georges Rouault: Societal Influences and Response in Early Maturity, 1903-1914*. M.A. thesis, Northern Illinois University, 1987. 103 p., illus.

1270. BRION, MARCEL. *Georges Rouault*. Paris: Braun; dist. in the U.S. by E. S. Herrmann, New York, 1950. 63 p., illus. Volume in "Les Maîtres" series.

1271. CHARENSOL, GEORGES. *Georges Rouault, l'homme et l'œuvre*. Paris: Editions des Quatres Chemins, 1926. 36 p., 40 pl.

1272. COGNIAT, RAYMOND. *Georges Rouault*. Paris: G. Crès, 1930. 14 p., 32 pl. Volume in "Les Artistes nouveaux" series.

1273. COURTHION, PIERRE. *Rouault*. Texte de Pierre Courthion. Paris: Nouvelles Editions Françaises, 1971. 63 p., 97 illus., some col.

Includes an examination of Rouault's personality and influences, an analysis of his prints, which range from the series of etchings produced during the period 1916-27 and published in 1948 under the title *Miserere*, to the many successful lithographs; a biographical outline; and plates with annotations. Rouault remained an individual, "a grand and solitary figure whose work exhibits a compassion and profound sympathy for the human condition."

a. U.S. ed.: *Georges Rouault*. New York: H. N. Abrams, 1977. 160 p., illus., some col.

b. English ed.: *Georges Rouault*. London: Thames and Hudson, 1978. 160 p., 132 illus., some col.

Review: A. Frankenstein, *Art News* 7:8(Oct. 1978):38.

1274. DIEHL, GASTON. *Peintres d'aujourd'hui: les maîtres: Georges Rouault.* Lettre-introduction de Pierre Bonnard; témoinages de G. Braque. Paris: Les Publicatitons Techniques, 1943. .

1275. DIEHL, GASTON. *Rouault*. Milan: Edizione d'Art et Scienza, 1945. 48 p., illus., 74 pl., some col.

1276. DORIVAL, BERNARD. *Rouault*. Paris: Flammarion, 1982.

a. Italian ed.: Naefels: Bonfini Press Corporation, 1983.

b. U.S. ed.: *Rouault*. Norfolk: Easton Press; New York: Crown Publishers, 1984. 96 p., 20 illus., 49 col. pl.

Review: F. Johnson, *American Artist* 49:514(May 1985):19-20[+].

1277. DRYNESS, WILLIAM A. *Rouault: A Vision of Suffering and Salutation.* Grand Rapids, MI: W. B. Eerdmans, 1971. 235 p., illus., 1 col.

1278. ENDO, SHUSAKU, MASATAKA OGAWA, and SHUJI TAKASHINA. *Rouault et le fauvisme.* Tokyo: Chuokoron-sha, 1973. 136 p., 56 pl., some col. In Japanese with title, colophon and captions in French. Volume in "Les Grands maîtres de la peinture moderne" series.

1279. FORTUNESCU, IRMA. *Rouault*. Paris: B. Geauli, 1975.

1280. HAMMER, KLAUS. *Georges Rouault*. Dresden: VEB Verlag der Kunst, 1988, 32 p., 15 illus., 7 col. In German.

Sets Rouault's association with the Fauves in the context of his early history of poverty and deprivation, and the special empathy with the oppressed classes of society which resulted. The development of his style is traced with particular reference to his use of color. A selection of contempoarary critical comments is appended.

1281. HERGOTT, FABRICE. *Rouault*. Paris: Albin Michel, 1991.

a. Spanish ed.: Barcelona: Ediciones Poligrafa, 1991.

1282. *Honoré Daumier, Georges Rouault*. Milan: Electa, 1983. 226 p., illus., some col.

1283. JEWELL, EDWARD ALDEN. *Georges Rouault*. With an introduction ("Commentaire pictural") by Georges Rouault. New York: Hyperion Press; dist. by Duell, Sloan and Pearce, 1945. 48 p., illus.

a. Another ed.: 1947. 48 p., illus.
b. French ed.: Paris: Hypérion, 1947.
Reviews: *Art Digest* 20(1 Jan. 1946):15; *American Artist* 10:2(Feb. 1946):44; *Art Digest* 22(1 April 1948):38; *American Artist* 12:4(April 1948):60.

1284. KIND, JOSHUA. *Rouault*. Text and notes by Joshua Kind. New York: Tudor Publishing Co., 1969. 36 p., 92 col. pl.

1285. MARCHIORI, GIUSEPPE. *Georges Rouault*. Testo de Giuseppe Marchiori. Milan: Fratelli Fabbri; Silvana, 1965. 34 p., illus., 16 pl., some col. Volume in "I Maestri del colore" series.

a. French ed.: Paris-Lausanne: Bibliothèque des Arts, 1965. 34 pl., illus., 44 pl., some col.
b. German ed.: *Georges Rouault*. Trans. by Christa Vaumgarth. Stuttgart: W. Kohlhammer, 1966. 34 p., illus.
c. English ed.: Trans. by David Rosset. Paris, Lausanne: Bibliothèque des Arts, 1966. 51 pl., illus., pl.
d. U.S. ed.: *Rouault*. New York: Reynal, 1967. 120 p.
Review: *Kunstwerk* 20(Dec. 1966):86.

1286. MOREL, MAURICE. *En mémoire de Georges Rouault*. Paris: Editions de l'Etoile Filante, 1959.

1287. POSSENTI-GHIGLIA, NORA, et al. *Rouault*. Paris: Ancône, 1977.

1288. ROULET, CLAUDE. *Georges Rouault: souvenirs*. Neuchâtel: H. Messeiller; La Bibliothèque des Arts, 1961. 337 p., illus., pl.

1289. SOMOS, M. *Rouault*. Budapest, 1965.

1290. VENTURI, LIONELLO. *Georges Rouault*. New York: E. Weyhe, 1940. 76 p., illus., some col., 153 pl.

a. French ed.: Paris: A. Skira, 1948. 116 p., illus., 173 pl., 12 col. Includes a bibliography.
Reviews: A. Neumeyer, *Journal of Aesthetics* 1:6(1942):73-4; A. Rindge *Art Bulletin* 26:1(March 1944):61-2.

1291. VENTURI, LIONELLO. *Rouault, étude biographique et critique*. Geneva: Albert Skira, 1959. 136 p., illus. Volume in "Le Goût de notre temps" series.

a. U.S. ed.: *Rouault; Biographical and Critical Study*. Trans. by James Emmons. Paris: Skira; Distributed Cleveland: World, 1959. 141 p., illus.

Articles

1292. "L'Affaire Rouault-Vollard." *Arts Magazine* (17 May 1946):1.

1293. BELLINI, PAOLO. "Rouault: il messaggero scomodo" [Rouault: The Troublesome Messenger]. *Arte* 18:191(Dec. 1988):90-5, 168, 171. 5 illus., 3 col.

After describing Rouault's rebellious personality, which still generates difficulties of interpretation, the author discusses aspects of his life in order to illuminate this critical difficulty, including an incident in 1947 when he destroyed large quantities of his work in the course of a dispute over them with the heirs of Ambroise Vollard. His reputation was firmly established after the Second World War. Bellini then speculates on how he learned engraving and surveys his œuvre in this medium, discussing in detail the series *Miserere* (1922-27).

1294. BOIME, ALBERT. "Georges Rouault and the Academic Curriculum." *Art Journal* 29:1(Fall 1969):36-9.

1295. BOUVIER, MARGUETTE. "Georges Rouault, expresionista y mistico." *Goyá* 25(July-Aug. 1958):18-24.

1296. CARTIER, JEAN-ALBERT. "Gustave Moreau, professeur à l'Ecole des Beaux-arts." *Gazette des Beaux-arts* ser. 6,61(May 1963):347-58.

1297. "Il Caso Rouault-Vollard." *Emporium* 104(Oct. 1946):186.

1298. CASSOU, JEAN. "Rouault vs. Vollard." *Art News* 45(Nov. 1946):42.

1299. CASSOU, JEAN. "Lawsuit Between Rouault and the Heirs of Vollard." *Art News* 46:3(May 1947):52.

1300. CHABOT, GEORGES. "Georges Rouault." *La Revue d'art* 29(Sept. 1928):101-6, 148.

1301. COUTOT, M. "A propos du procès Rouault." *Arts Magazine* (13 Dec. 1946):1+.

1302. COUTOT, M. "L'Affaire Rouault." *Gazette des Beaux-arts* ser. 6,83:1263(April 1974):2.

1303. CROWNINSHIELD, FRANK. "Georges Rouault, French Painter." *Vogue* 95(15 April 1940):59, 96.

1304. CROWNINSHIELD, FRANK. "Collector's Peace; Memories of a Group of Famous French Artists." *Vogue* 102(15 Oct. 1943):52-3, 129-32. 12 illus.

1305. CROWNINSHIELD, FRANK. "Rouault—Monk of Art." *Vogue* 105(May 1945):136, 182-4.

1306. DESCARGUES, PIERRE. "L'Affaire Rouault—Vollard." *Arts Magazine* (21 March 1947):1+.

1307. DORIVAL, BERNARD. "Georges Rouault." *Bulletin des musées de France* 12(May-June 1947):19-23.

1308. ECK, G. VAN. "Georges Rouault." *Maandblad voor Beeldende Kunsten* 23(Oct. 1947):243-5.

1309. ELLIOT, J. H. "Three Young Artists." *Los Angeles County Museum of Art Quarterly.* 13:2-3(1957):7-10.

1310. "The Face of Rouault." *Vogue* 121(1 March 1953):138-9.

1311. GAUTHIER, MAXIMILIEN. "Georges Rouault." *L'Art vivant* 6(19 May 1930):410.

1312. GEORGE, WALDEMAR. "Georges Rouault." *Arts Magazine* 9(June 1926):317-24.

1313. GEORGE, WALDEMAR and MARIE DORMOY. "Œuvres inédits; numéro spécial." *Renaissance* 20(Oct.-Dec. 1937):1-32. Excerpt in *Beaux-arts* (17 Dec. 1937):1+.

1314. "Georges Rouault." *Kunsten Idag* 28:2(1954). Foreword by Georges Rouault. Text by F. Finne. 57 p., illus., 21 pl. English summary and bibliography.

Special issue devoted to Rouault.

1315. "Georges Rouault et Ambroise Vollard." *Beaux-arts* (16 June 1933):6.

1316. HUMBERT, AGNES. "Georges Rouault." *Scottish Art Review* 6:4(1958):2-6.

1317. LEHMANN, LEON. "Georges Rouault." *Beaux-arts* (9 Aug. 1935):2.

1318. LEJEUNE, R. "Georges Rouault." *Reformatio* 20(Jan. 1971):13-22.

1319. LEMONNIER, P. "Le Procès Rouault." *Arts Magazine* (24 May 1946):1.

1320. LEON-MARTIN, LOUIS. "Georges Rouault." *Art et décorations* 34(April 1930):111-4. pl.

1321. LHOTE, ANDRE. "Georges Rouault." *Der Cicerone* 3:17(Feb. 1925):132-6.

1322. LIBERMAN, ALEXANDER. "Rouault." *Vogue* 124(15 Nov. 1954):98-103.

1323. LIBERMAN, ALEXANDER. "The Artist in his Studio." *Studio* 159(April 1960):117-9.

1324. MARCHIORI, GIUSEPPE. "Profilo di Rouault." *Emporium* 104(July 1946):23-8.

1325. MARITAIN, JACQUES. "Georges Rouault." *Cahiers d'art* 3:3(1928):97-112.

1326. MARITAIN, RAÏSSA. "Rouault." *Art News* 40:17(15 Dec. 1941):14[+].

1327. MARITAIN, RAÏSSA. "Remembering a Friendship." *Art News* 44:5(15 April 1945):17-9[+].

1328. MARTIN, L. L. "Georges Rouault." *Art et décoration* 57(April 1930):111-8.

1329. "Modern with a Message." *Time* 58(10 Dec. 1951):78.

1330. MOSCI, GASTONE. "La Scrittura di Rouault." *Notizie da Palazzo Albani* 12:1-2(1983):328-31.

Concerns Rouault's writings.

1331. Obituary: *Art News* 57:1(March 1958):7.

1332. O'CONNOR, J, JR. "Homage to the Old King." *Carnegie Magazine* 32(April 1958):129-31[+].

1333. PACH, WALTER. "Georges Rouault." *Parnassus* 5(Jan. 1933):9-11.

1334. "Portrait." *Art News* 40:16(1 Nov. 1941):25; *Art News* 45:44(June 1946):17; *Liturgical Arts* 16(May 1948):95; *France illustration* 5(9 July 1949):34; *Time* 55(26 June 1950):57.

1335. "Portrait by J. Joëts." *Beaux-arts* (19 May 1939):2.

1336. "Portrait by L. Lehmann." *Art et artist* 21(Jan. 1931):120.

1337. "Public Favorite." *Time* 65(7 March 1955):72-3.

1338. RAYNOR, V. "Georges Rouault and the School of Paris." *Arts Magazine* 38:6(March 1964):70.

1339. ROTHENSTEIN, J. "Visit to Rouault." *Museum Journal* 54(March 1955):315-6.

1340. "Rouault Case." *Liturgical Arts* 16(May 1948):91-104.

1341. SARGEANT, WINTHROP. "Rouault." *Life* (1953):46-58.

1342. STILLSON, B. "Vollard as a Clown." *John Herron Institute Bulletin* 35(April 1948):12-3.

1343. "Sues Dealer." *Art Digest* 20:17(June 1946):8.

1344. TAPPOLET, WALTER. "Georges Rouault." *Du* 8(Sept. 1948):38-42.

1345. VAUXCELLES, LOUIS. "Rouault et Vollard." *Ere nouvelle* (24 April 1924).

1346. VENTURI, LIONELLO. "Rouault." *Parnassus* 11(Oct. 1939):4-13.

1347. WATT, ANDRE. "Legal Dispute between Rouault and the Inheritors of Ambroise Vollard." *Studio* 134(Oct. 1947):117.

1348. WILENSKI, REGINALD HOWARD. "Georges Rouault." *Apollo* 11(June 1930):473-4. 4 illus.

1349. WIND, EDGAR. "Traditional Religion and Modern Art: Rouault and Matisse." *Art News* 52:3(May 1953):19-22[+].

Examines the relationship between traditional Catholic doctrine and 20th century religious art, with particular reference to the two artists.
a. Reprint: *The Eloquence of Symbols: Studies in Humanist Art.* J. Anderson, ed. (Oxford: Oxford University Press, 1983). 135 p., 61 illus.

1350. ZÁRATE, V. M. G. DE. "Matisse y Rouault frent al mito histórico de la 'Belle Epoque'" [Matisse, Rouault and the Myth of the 'Belle Epoque']. *Revista de Ideas Estéticas* (Spain) 31:123(July-Sept. 1973)):177-99.

Analyzes the contradictions of the Belle Epoque, with its combination of superficial gaiety and underlying tensions, its apparent emptiness and revolutionary new concepts in science and in the arts. In art Zárate sees an overwhelming desire to sweep away the past and impose the artist's personal vision of the world around him. He then selects Rouault and Matisse for particular consideration. In the former he finds an impassioned artist seeking to affirm the fundamental spiritual worth of man beneath his unhappy appearance, capable of translating this in a coherent personal manner which resulted in incomprehension only because of its unpalatable verity. Similarly, the "pleasure" that Matisse sought to convey in his works was equally unacceptable to his contemporaries because he sought a pure enjoyment of form, color and composition that was far more profound than the pre-First World War society was capable of understanding.

IV. Works (Œuvre)

A. Catalogues Raisonnés

1351. ROUAULT, GEORGES. *Georges Rouault: The Graphic Work.* Catalogue by Alan Wofsy. San Francisco: Alan Wofsy Fine Arts, 1976. 104 p., 366 illus., 66 col.

Describes and illustrates at least one state of every published graphic work by Rouault and also includes many unpublished works. Most of the works described are in the collection of Alan Wofsy. The balance is mainly from two major collections in Los Angeles, those of Harry P. and Jane F. Ullman and the Grunwald Center for Graphic Arts at the University of California, Los Angeles. All books illustrated by Rouault with original graphics are fully collated and a number of limited edition books with illustrations by Rouault are also described.
a. English ed.: London: Secker and Warburg, 1976. 104 p., 353 illus., 66 col.
Reviews: F. Woimant, *Nouvelles de l'estampe* 27(May-June 1976):49; E. Rouir, *Print Collector* 7:33-4(Sept.-Dec. 1976):104-5.

1352. CHAPON, FRANÇOIS and ISABELLE ROUAULT. *Rouault, œuvre gravé*.
Texte de François Chapon; catalogue établi par Isabelle Rouault, avec la collaboration
d'Olivier Nouaille-Rouault. Monte-Carlo: André Sauret, 1978-79. 2 vols., illus.,
some col. In French, English and German.

a. Japanese ed.: Iwanami Shoten, 1979.
Reviews: *L'Œil* 279(Oct. 1978):87; F. Woimant, *Nouvelles de l'estampe* 44(March-
April 1979):19-20.

1353. ROUAULT, GEORGES. *Georges Rouault, 1871-1958: catalogue raisonné*.
Paris: Musée d'Art Moderne de la Ville de Paris, 1983. 231 p., 247 illus., 30 col.
Volume in "Collections de la Ville de Paris" series.
Catalogue a été établi et rédigé par Danielle Molinari, assistée de Marie Claire
Anthonioz; texte sur les céramiques a été rédigé par Guillaume Garnier; maquette est
de Jean-Pierre Géremain.

Catalogue raisonné of works on paper including watercolors, oils, pastels, ink, pencil
and crayon drawings, and of ceramics and book illustrations by Rouault in the
collection of the Musée d'Art moderne de la Ville de Paris. Includes extracts from
previously published writings on the artist's career and the time in which he lived and
extracts from Rouault's own writings. The catalogue is divided into themes and
techniques as follows: "Circus," "Girls," "Nudes and Compositions," "Characters,"
"Faubourg des longues peines," "Landscapes," "Christian Art," "Charcoal Drawings,"
"Ceramics," and "Writings and Engravings." A list of exhibitions of Rouault's work
and a chronology of historical and cultural events in France from 1900 to 1950 are
appended.

1354. MOLINARI, DANIELLE. *Rouault*. Paris: Musée de la Ville de Paris, 1983.

Includes a catalogue raisonné of Rouault's works in the museum.

1355. DORIVAL, BERNARD. *Rouault, l'œuvre peint*. Texte de Bernard Dorival.
Catalogue établi par Isabelle Rouault. Monte-Carlo: André Sauret, 1988. 2 vols.,
illus., some col.

a. Another ed.: Tokyo: Iwanami, 1990. In French and English.

B. Works in General

Books

1356. BAGALONI, GILBERTO. *Rouault*. Ancona, 1977.

1357. BECK, RAINER and SIEGFRIED GOHR. *Georges Rouault*. Cologne:
Joseph-Haubrich-Kunsthalle, 1983.

1358. BELLINI, PAOLO. *Georges Rouault: uomo e artista*. Introduzione di M.
Angiola Romanini. In appendice: catalogo di tutta l'opera grafica, a cura di F.
Agustoni. Milan: Salamon e Agustoni, 1972. 245 p., illus., 24 pl.

Approaches Rouault's work within the framework of phenomenological analysis. Bellini traces the complexities of the interrelationship between his difficult solitary life and his work, from the period of study in his youth with Gustave Moreau, and his apprenticeship with a stained-glass painter. The former revealed to him the nocturnal luminism of Rembrandt and also brought him closer to the work of Bosch and Grünewald, El Greco, and Goyá, by dispelling his belief that there should be a chronological order in his influences from the past. Despite these influences, the true inspiration for his work was his inner experience; his painting was a spiritual biography.

1359. BENINCASA, CARMINE. *Georges Rouault.* Turin: Edition Seat, 1988.

1360. CINOTTI, MIA. *Rouault.*

a. English ed.: Trans. by Cesare Foligno. Novara: Uffici, 1954. 36 p., 10 col. illus.

1361. COURTHION, PIERRE. *Georges Rouault, suivi d'un catalogue établi avec la collaboration d'Isabelle Rouault.* Paris: Flammarion, 1962. 492 p., illus., pl.

a. U.S. ed.: *Georges Rouault; Including a Catalogue of Works Prepared with the Collaboration of Isabelle Rouault.* New York: Abrams, 1962. 489 p., illus., some col.; 1977.
b. German eds.: Cologne: Dumont-Schauberg, 1962; 1980.
c. Japanese ed.: Tokyo: Misuzu Shobo, 1962.
d. Italian ed.: Milan: Il Saggiotare, 1964.
Reviews: G. Whittet, *Studio* 165(March 1963): 110-1; E. Sutfin, *Liturgical Arts* 31(Aug. 1963):119-21; *Kunstwerk* 20(Dec. 1966):86.

1362. COURTHION, PIERRE, BERNARD DORIVAL, and MAURICE MOREL. *La Passion du Christ.* Tokyo: Iwanami Shoten, 1976.

1363. COURTHION, PIERRE. *Georges Rouault.* Paris: Cercle d'Art, 1980.

1364. CRISPOLTI, ENRICO. *Georges Rouault.* Milan: Fratelli Fabri, 1965. 7 p., illus., 14 col. pl. Volume in "I Maestri del colore" series.

1365. DORIVAL, BERNARD. *Georges Rouault, 1871-1958.* Images de Roger Hauert. Texte de Bernard Dorival. Geneva: Editions René Kister; Monaco: Diffusion, Union Européenne d'Editions, 1956. Volume in "Les Grands peintres" series.

1366. DORIVAL, BERNARD. *Cinq études sur Georges Rouault.* Paris: Editions Universitaires, 1956. 108 p., illus., 12 pl. Volume in "Témoins du XXᵉ siècle" series.

a. Japanese ed.: Tokyo: Bijutsu Shuppan-Sha, 1961.

1367. DORIVAL, BERNARD. *Rouault.* Paris: Editions Universitaires, 1963.

1368. DORIVAL, BERNARD. *Rouault.* Tokyo: Shinchosha, 1976.

1369. DOUAIRE, RICHARD J. *Georges Rouault, His Art. The Rouault Case.* Translated by Harry Lorin Binesse from the *Gazette du Palais*, Paris. New York: Liturgical Arts Society, 1948. 19 p., illus., 4 pl.

1370. FUKUSHIMA, SHIGETARO. *Georges Rouault.* Tokyo: Shinchosha, 1958.

1371. GEORGE, WALDEMAR [pseud.] and GENEVIEVE NOUAILLE-ROUAULT. *L'Univers de Rouault.* Paris: Scrépel, 1971. 88 p., illus., some col. Volume in "Les Carnets de dessins" series.

a. English ed.: *Rouault.* Trans. by Noël Lindsay. London: Pall Mall Press, 1971. 90 p., illus., some col.
b. U.S. ed.: *Rouault's Universe.* Trans. by Noël Lindsay. Woodbury, NY: Barron's, 1971. 88 p., illus., some col.

1372. GRUTZMACHER, CURT, et al. *Georges Rouault.* Berlin: Kunstamt Wedding, 1988.

1373. ITO, REN. *Rouault.* Tokyo: Atelier-Sha, 1926. 8 p., 36 pl., 6 col. Title-page and text in Japanese. Volume in "Nouvelles éditions selectionnées des grands peintres occidentaux" series.

1374. LASSAIGNE, JACQUES. *Rouault.* Introduction de Jacques Lassaigne. Dix reproductions en couleurs, avec une notice biographique approuvée par l'artiste et une bibliographie sommaire. Geneva: Editions Albert Skira, 1951. 6 p., 10 col. pl. Volume in "Trésors de la peinture française" series.

a. U.S. eds.: New York: Skira, 1951; 1953. 6 p., 10 pl.

1375. LUTX, L. *Dynamic Symmetry as an Archetype: A Reunification of Mathematics and Art.* Ph.D. diss., University of Illinois at Urbana-Champaign, 1973. 262 p.

With the aim of furthering the integration of disciplines in schools, Lutx makes a detailed examination of dynamic symmetry, a system of areal proportioning formulated by Jay Hambridge and subsequently used explicitly in the execution of works of art. Adopting an integrative approach, the author refers to the paintings of Raphaël, Poussin, Cézanne and Rouault, suggesting that these artists have made unconscious use of the elements of dynamic symmetry, and proposing that disciplines now separated were once united, and that this separation has had numerous disadvantages.

1376. MARITAIN, JACQUES. *Georges Rouault.* Notes on Rouault's prints by William S. Lieberman. New York: H. N. Abrams, 1952. 22 p., illus.

a. Portfolio eds.: 1954. 74 pp., 55 illus., some col.; 1969.

1377. NICCOLLS, SAMUEL THOMAS. *Man on the Boundary: The Nature and Significance of the Image of the Clown in Art of Charles Chaplin, Georges Rouault, and Samuel Beckett.* Ph.D. diss., Ohio University, 1970.

Summary in *Dissertation Abstracts International* 31:8(Feb. 1971):4062A.

1378. NOUAILLE-ROUAULT, GENEVIEVE, et al. *Rouault*. A cura di Giancarlo Galeazzi; presentazione di Virgilio Fagone; testi di Geneviève Nouaille-Rouault, et al. Ancona: G. Bagaloni, 1971. 244 p., illus.

a. French ed.: Paris: Henri Screpel, 1971.
b. U.S. ed.: New York, 1971.
c. German ed.: Cologne: Weber, 1971.
d. English ed.: London: Pall Mall Press, 1971.

1379. NOUAILLE-ROUAULT, GENEVIEVE and H. TAKATA. *Rouault*. Tokyo: Zauho Press, Shogakukan, 1979.

1380. OGAWA, MASATAKA and I. YANAIAHARA. *Matisse-Rouault*. Tokyo: Zauho Press, 1967.

1381. PUY, MICHEL. *Georges Rouault*. Trente reproductions de peintures et dessins précédées d'une étude critique par Michel Puy, de notices biographiques et documentaires, et d'un portrait de l'artiste, par lui-même, gravé sur bois par Jules Germain. Paris: Editions de la *Nouvelle revue française*, 1921. 63 p., illus., pl. Volume in "Les Peintres français nouveaux" series.

1382. RAYNAL, MAURICE. *Histoire de la peinture moderne: Matisse, Munch, Rouault; Fauvisme et expressionisme*. Introduction de Georg Schmidt. Traductions de S. Stelling-Michaud. Geneva: A. Skira, 1950. 154 p., illus., some col. Volume in "Peinture, couleur, histoire" series.

1383. ROUAULT, GEORGES. *Rouault*. New York: Abrams, 1954. 6 p., col. illus., 15 pl. Volume in "Art Treasures of the World" series.

1384. ROUAULT, GEORGES. *Rouault*. New York: Abrams, 1954. 6 p., col. illus., 15 pl. Volume in "Art Treasures of the World" series.

1385. ROUAULT, GEORGES. *Ruō*. Tokyo: Kowade shōbo, 1969. 122 p., illus., Volume in "L'Art du monde" series.

1386. *Rouault in The Idemitsu Collection*. Tokyo: Idemitsu Museum, 1991.

1387. SHOBO, KAWADA. *Matisse, Rouault*. Tokyo: The Zauho Press, 1966.

1388. SOBY, JAMES THRALL. *Georges Rouault: Paintings and Prints*. New York: Museum of Modern Art, 1945. 132 p., illus., pl., 3 col.

Based on an exhibition catalogue (held at the Museum of Modern Art) by Soby written in 1945. Contents: "Georges Rouault: Paintings and Prints" by J. T. Soby; "The Techniques of Georges Rouault's Prints" by C. O. Schniewind; "Notes Received from the Artist, February, 1945"; "Bibliography" by Hannah R. Miller.
a. Other eds.: 1947, 141 p.; New York: Arno Press, 1972. 141 p.
Reviews: *Studio* 130(Sept. 1945):96; *College Art Journal* 5(March 1946):259-60; *Art Bulletin* 31:1(June 1949):152-4.

1389. SOTRIFFER, KRISTIAN. *Georges Rouault: Holzstiche*. Einleitung von Kristian Sotriffer. Feldafing: Buchheim.

1390. TAKATA, H. *Rouault*. Tokyo: Zauho Press, 1966.

1391. TOMINAGA, SOICHI. *Georges Rouault*. Tokyo: The Zauho Press; Kawade Shobo, 1969. 122 p., illus. Volume in "L'Art du monde" series.

1392. VENTURI, LIONELLO. *Georges Rouault*. Paris: A. Skira, 1948. 116 p., illus., 173 pl., 12 col.

1393. YANAGI, MUNEMOTO. *Georges Rouault*. Tokyo: The Zauho Press, 1972. Volume in "L'Art moderne du monde" series.

1394. YANAGI, MUNEMOTO. *Georges Rouault, peintre l'âme chrétienne*. Tokyo: Gakken, 1987.

1395. ZVÉRINA, FRANTÍSEK. *Georges Rouault*. Prague: Stání Nakladatelskví Krăsné Literatury a Umění, 1961. 49 p., 64 pl. Volume in "Soûcasné světové umění" series.

Articles

1396. APOLLINAIRE, GUILLAUME. "Georges Rouault." *Je dis tout* (12-9 Oct. 1907).

1397. APOLLINAIRE, GUILLAUME. "Georges Rouault." *La Revue des lettres et des arts* (1 May 1908).

1398. ARBER, A. J. N. "A Survey of Visitors to the Rouault Exhibition at Manchester City Art Gallery." *Museums Journal* 75:1(June 1975):5-8. 4 illus.

Survey of attendance of the Rouault exhibition (5 June-28 July 1974) to discover characteristics of the people who visited it and assess the influence of advertising.

1399. ARLAND, MARCEL. "Rouault." *Le Nouveau Fémina* 29.

1400. ARLAND, MARCEL. "About Georges Rouault." *Formes* 16(June 1931):96-7. 6 illus.

1401. ARLAND, MARCEL. "A propos des dernières œuvres de Rouault, *Pastoral chrétienne*." *Soleils* 1(1947):40-1.

1402. BELL, CLIVE. "Georges Rouault." *Apollo* 58(Oct. 1953):104-6.

1403. BRANSTEN, E. H. "Significance of the Clown in Paintings by Daumier, Picasso and Rouault." *Pacific Art Review* 3(1944):21-39.

1404. BRASSAC. "Georges Rouault." (4 Aug. 1895).

1405. CASSEGRAIN, N. "Rouault-le-drôle" [Rouault the Jester]. *Art Press* 102(April 1986):37-9. 15 illus.

Personal view of the work of Georges Rouault (1871-1958), who has been described as the spiritual brother of Cézanne since their work is so similar. His prints have a grotesque and humorous character, but he also did much religious work since he was a devout Catholic. Rouault's work has a literary bias, illustrated by his letters to friends, some of which are reproduced here; one of his portraits is of the poet Charles Baudelaire.

1406. CHARENSOL, GEORGES. "Georges Rouault." *Paris-journal* (14 Nov. 1924).

1407. CHARLES, ETIENNE. "Georges Rouault." *La Liberté* (28 March 1907).

1408. "Climat pictural." *Renaissance* 20(Oct. 1937):3-4.

1409. COGNIAT, RAYMOND. "Rouault, l'inspiration religieuse et la recherche des signes." *Les Arts plastiques* 5:4(Jan.-Feb. 1952):252-8.

1410. COHEN, ALEXANDRE. "Georges Rouault." *Telegraaf* (Amsterdam) (16 Appril 1907).

1411. "La Collection Bühler." *L'Amour de l'art* (2 Feb. 1925).

1412. COQUIOT, GUSTAVE. "Georges Rouault." *Le 7ᵉᵐᵉ jour* (25 Dec. 1924).

1413. DORIVAL, BERNARD. "Nouvelles œuvres de Rouault au Musée d'art moderne." *Musées de France* 9(Nov. 1950):193-200.

1414. DORIVAL, BERNARD. "Autoportraits et portraits de Rouault." *Revue des arts* 3(Dec. 1953):229-38.

1415. DORIVAL, BERNARD. "Rouault au Salon d'Automne." *L'Œil* 328(Nov. 1982):34-9. 8 illus.

Account of the progression in the works of Georges Rouault, one of the founders in 1903 of the Salon d'Automne, Paris, with reference to his work on show at the current Autumn Salon at the Grand Palais, Paris (6-29 Nov. 1982). Rouault's themes remained constant, but his technical and conceptual treatment of them varied greatly from the spontaneous dynamism in his watercolors to the greater discipline of line and richness of color in his oil paintings. This diversity of style and technique reflected his changing outlook from initial anger through stoicism to peace and ultimately joy. It is concluded that Rouault's paintings convey at once the real and the supernatural, the misery of man and the sacred compassion of Christ. Appended is an account of the aims and programe of the 1982 Salon d'Automne by its president, Yves Brayer.

1416. DORMOY, MARIE. "Georges Rouault." *Kunst und Kunstler* 29(April 1931):280-6.

1417. DORMOY, MARIE. "Georges Rouault." *Arts et métiers graphiques* 48(15 Aug. 1935):23-30.

1418. DOUAIRE, R. J. "Georges Rouault: His Art." *Liturgical Arts* 16(May 1948):72⁺.

1419. DRYNESS, WILLIAM A. "Touch and Texture of Georges Rouault." *Christianity Today* 20(10 Sept. 1976):42-3.

1420. "Evaluation of Rouault." *Art Digest* 8(15 Nov. 1933):12.

1421. FELS, FLORENT. "Georges Rouault." *Les Nouvelles littéraires* (15 March 1924).

1422. FRANTZ, HANS. "Georges Rouault." *Excelsior* (24. Dec. 1910).

1423. FRY, ROGER. "La Peinture moderne en France." *L'Amour de l'art* (May 1924):154-7.

1424. GEOFFROY, GUSTAVE. "Georges Rouault." *Le Journal* (5 May 1907).

1425. GEORGE, WALDEMAR. "Georges Rouault." *Bulletin de la vie artistique* (15 May 1924).

1426. GEORGE, WALDEMAR. "Georges Rouault, ein romantischer französischer Maler." *Das Kunstblatt* 8(Aug. 1925):225-9.

1427. GEORGE, WALDEMAR. "Cinquante ans de peinture française." *L'Amour de l'art.* (1925):271-6.

1428. GEORGE, WALDEMAR. "Georges Rouault and the Birth of Tragedy." *Formes* 13(March 1931):41.

1429. "Georges Rouault." *Fraternité* (4 Aug. 1895).

1430. "Georges Rouault." *L'Eclair* (21 July 1907).

1431. "Georges Rouault." *Les Nouvelles* (26 Dec. 1909).

1432. "Georges Rouault." *Le Petit bleu* (9 Feb. 1912).

1433. "Georges Rouault." *Le Carnet de la semaine* (1 Jan. 1921).

1434. "Georges Rouault." *L'Eclaire* (2 Nov. 1921).

1435. "Georges Rouault." *Le Crapouillot* (1 Dec. 1922).

1436. "Georges Rouault." *Revue mondiale* (1 Sept. 1924).

1437. "Georges Rouault." *Chicago Tribune* (Aug. 1925).

1438. "Georges Rouault." *L'Art vivant* (1925):128.

1439. "Georges Rouault." *Mizue* 782:3(1970):62-5. 4 illus. In Japanese.

1440. "Georges Rouault—Originally a Designer of Stained Glass." *Pictures on Exhibit* 2(Feb. 1939):12.

1441. GRANVILLE. "Georges Rouault." *Paris-midi* (10 Jan. 1925).

1442. GUENNE, JACQUES. "Georges Rouault." *Les Nouvelles littéraires* (15 Nov. 1924).

1443. HJORN, KJELL. "Georges Rouault." *Konstrevy* 37:2(1951):73-8.

1444. HONE, E. "Georges Rouault." *Liturgical Arts* 11(Aug. 1943):87.

1445. HOWE, RUSSELL WARREN. "Impasto Drama: Georges Rouault." *Apollo* 52(Aug. 1950):36-7.

1446. "*In the Blessed Regions.*" *Vogue* 106(1 Dec. 1945):120-1.

1447. JALOUX, EDMOND. "Georges Rouault." *Les Nouvelles littéraires* (17 Oct. 1924).

1448. JEDLICKA, GOTTHARD. "Georges Rouault." *Werk* 31(Nov. 1944):331-5. 5 illus.

1449. KAHN, GUSTAVE. "Georges Rouault." *L'Aurore* (20 March 1907).

1450. KAHN, GUSTAVE. "Georges Rouault." *Le Courrier français* (14 May 1911).

1451. KOCHNITZKY, LEON. "Rouault, Painter and Moralist." *View* 5(Nov. 1945):12-4.

1452. LA PALETTE. "Georges Rouault." *Paris-journal* (20 Oct. 1910).

1453. LA PALETTE. "Georges Rouault." *Paris-journal* (8 July 1911).

1454. LEON-MARTIN, LOUIS. "Georges Rouault." *Le Crapouillot* (16 March 1922).

1455. LESTRANGE, ROBERT. "Georges Rouault." *Le Tintamarre* (31 March and 13 Oct. 1907).

1456. LEWISON, S. A. "Rouault, Master of Dissonance." *Parnassus* 5(Nov. 1933):1-7. 10 illus.

1457. LHOTE, ANDRE. "Georges Rouault." *L'Amour de l'art* (12 Dec. 1923):779-82.

1458. LHOTE, ANDRE. "Sur les compositions religieuses de Rouault." *Der Cicerone* (1 Feb. 1924).

1459. LHOTE, ANDRE. "Georges Rouault." *La Nouvelle revue française* (1 July 1924):126-7.

1460. LHOTE, ANDRE. "Georges Rouault." *Der Cicerone* (1 Feb. 1925).

1461. MALRAUX, ANDRE. "Notes on Tragic Expression in Painting Apropos of the Recent Work of Rouault." *Formes* 1(Dec. 1929):5-6. 16 pl.

1462. MARITAIN, JACQUES. "Georges Rouault." *La Revue universelle* 17:4(15 May 1924):505-8.

1463. MARTINEAU, RENE. "Georges Rouault." *Le Beffroy* (Dec. 1907).

1464. MARX, CARL. "Georges Rouault." *Le Midi* (Montpellier) (4 April 1907).

1465. MARX, CARL. "Georges Rouault." *Le Télégramme* (Toulouse) (21 April 1908).

1466. MORICE, CHARLES. "Georges Rouault." *Mercure de France* (16 Nov. 1910).

1467. NEVE, CHRISTOPHER. "The Lonely Vision of Georges Rouault." *Country Life* 140(13 Oct. 1966):918.

1468. NEVE, CHRISTOPHER. "Rouault's Outrageous Lyricism." *Country Life* 155:4016(20 June 1974):1622-3. 5 illus.

Argues that the work of Rouault differs from much of the art of his period in being concerned with the pursuit of an idea rather than being preoccupied with form. He is an intensely spiritual painter, finding religious experience in unlikely places, painting every shade of suffering in a spirit of Christian pity and humility. Rouault viewed authority as the epitome of evil and made the clown a recurring symbol of the tragedy of human nature. He constantly produced closely similar images, making a head that of a clown, then of Christ, then his own. Neve concludes that even if in the exhibition at Manchester City Art Gallery (4 June-28 July 1974) the images are too familiar to fire the viewer, his color always surprises.

1469. NICOLLE, MARCEL. "Georges Rouault." *Le Journal de Rouen* (17 April 1907).

1470. NICOLLE, MARCEL. "Georges Rouault." *Le Journal de Rouen* (16 April 1908).

1471. PELADAN. "Georges Rouault." *La Revue hebdomadaire* (23 Oct. 1910).

1472. PERATE, ANDRE. "Georges Rouault." *Gazette des Beaux-arts* (May 1907).

1473. PINTURICCHIO. "Georges Rouault." *Le Carnet de la semaine* 2(July 1916).

1474. PINTURICCHIO. "Georges Rouault." *Le Carnet de la semaine* (2 April 1922).

1475. PUY, MICHEL. "Georges Rouault." *La Grande revue* (10 June 1911):569.

1476. RALUFFE. "Georges Rouault." *Gil Blas* (23 July 1907).

1477. RIVIERE, JACQUES. "Georges Rouault." *Nouvelle revue française* (1910):49-51. Reprinted in *Etudes* (Paris: Gallimard, 1924):52-5.

1478. "Rouault and the Middle Ages Spirit." *London Studio* 16; *Studio* 116(Sept. 1938):167-8.

1479. "Rouault nel Texas." *Domus International* 398(Jan. 1963):55.

1480. "Rouault Sacrifices $500,000 Worth of Early Paintings." *Life* 2(July-Dec. 1948):336.

1481. "Rouault sur roues [exposées dans un camion]." *Connaissance des arts* 237(Nov. 1971):33.

1482. SANDSTRÖM, SVEN. "Konstsamlande som Livsbehov: Göran Bergengrens Rouault—och Picasso—samlingar" [Art Collecting as a Necessity of Life: Göran Bergengren's Rouault and Picasso Collections]. *Konsthistorisk Tidskr* 57:3-4(1988):92-5. 1 illus. English summary.

Discusses the collections of work by Rouault and Picasso assembled by Göran Bergengren (1921-72), from their beginnings in 1951-52 to their dispersal after his death. Sandström includes personal reminiscences of Bergengren, and shows how his personal characteristics and circumstances were reflected in the works which he bought, chiefly engravings, from the melancholy and statuesque Rouaults and early Picassos to the exuberant treatments by Picasso of classical myth from the 1930s onward.

1483. SOWERS, ROBERT. "Über die Malerei mit Licht" [Concerning Paintings with Light]. *Kunst und Kirche* 3(1985):154-7. 5 illus.

Attempts to place glass paintings in the context of the history of painting and architecture—in the 13th century architecture was simple whereas glass painting was complex—before discussing the qualities of the light in paintings of Georges Rouault which led them to be compared to medieval glass windows.

1484. TRAPENARD, JACQUES. "Georges Rouault." *Combat* (8 May 1924).

1485. VAUXCELLES, LOUIS. "Georges Rouault." *Gil Blas* (30 Sept. 1907).

Concerns Rouault's *Judges* series.

1486. VAUXCELLES, LOUIS. "Georges Rouault." *Gil Blas* (26 Dec. 1907).

1487. VAUXCELLES, LOUIS. "Georges Rouault." *Le Carnet des artistes* (15 June 1917):9-14.

1488. VAUXCELLES, LOUIS. "Georges Rouault." *Excelsior* (28 July 1921).

1489. VAUXCELLES, LOUIS. "Georges Rouault." *Excelsior* (23 Sept. 1924).

1490. ZERVOS, CHRISTIAN. "Dernières œuvres de Rouault." *Cahiers d'art* 33-5(1960):175-85. 7 illus., 4 col. pl.

C. Individual Paintings

Articles

1491. "*Amazone.*" *Connaissance des arts* 421(May 1991):68.

1492. "Boston Buys a Rouault, Titled *Clown.*" *Art Digest* 25:18(July 1951):6.

1493. "*Le Christ aux outrages.*" *Connaissance des arts* 457(March 1990):23.

1494. "*Cirque-Clown et enfant au chien.*" *Burlington Magazine* 132:1044(March 1990:xiii.

1495. "*Calvary. Tête de Christ. Nude.* Walter P. Chrysler, Jr. Collection." *Richmond, Virginia Museum of Fine Arts* 4(1939-41):354-6.

1496. "*The Circus Dancer*—Painting." *Vanity Fair* (Feb. 1934):28-9.

1497. "Cleveland Museum has Purchased the Paintings *Head of Christ.*" *Pictures on Exhibit* 13(May 1951):54-5.

1498. "*Clown.*" *Nederlands Kunsthistorisch Jaarboek* 32(1981):288.

1499. "*Le Clown.*" *Art in America* 78:6(June 1990):60.

1500. COURTNEY, J. "*Head of a Clown.*" *John Herron Institute Bulletin* 36(April 1949):3-4.

1501. COWART, WILLIAM JOHN III. "*The White Plume* by George Rouault." *Saint Louis Art Museum Bulletin* 12:2 (March-April 1976):26-7. 1 illus.

1502. *White Plume* (1928) was recently given to the Saint Louis Art Museum. Its subject is probably a Parisian prostitute, although it was previously titled *Chantante*, or singer.

1503. "*Les Deux filles.*" *Du* 4(1988):48.

1504. "*Die Drei Richter.*" *Du* 3(1986):30.

1505. EISENDRATH, W. N., JR. "*The Chinese* by Georges Rouault." *St. Louis Museum of Art Bulletin* 44:1(1960):9-10.

1506. FRANCIS, H. S. "*Head of Christ* by Rouault." *Cleveland Museum of Art Bulletin* 38(April 1951):71-2.

1507. FROST, R. "Rouault from Lee Ault: *Woman with Red Hair*, Lent to Museum of Modern Art." *Art News* 45:5(July 1946):18.

1508. GOODALL, D. B. "Rouault's *Passion* Cycle." *Art in America* 50:4(Winter 1962):74-9.

1509. "*Head of a Clown* Acquired by John Herron Institute." *Art News* 48:6(Sept. 1949):42.

1510. HEITZELMAN, ARTHUR W. "Rouault's *Cirque* and *Passion*." *Boston Public Library Quarterly* 2(April 1950):180-4.

1511. HENDRICKS, WILLIAM. "Two Faces of Christ: What Makes Religious Art Good Art" in *Art as Religious Studies*, Doug Adams and Diane Apostolos-Cappadona, eds. (New York: Crossroad Publishing Co., 1987), pp. 149-59.

1512. "Important New Museum Installations and Acquisitions." *Connoisseur* 189(May 1975):72.

Discusses Rouault's *Head of Christ*.

1513. "Indianapolis Acquires *Head of a Clown*." *Art Digest* 23:18(July 1949):15.

1514. "Institute Receives Gift of Two Expressionist Paintings." *Minneapolis Institute of Art Bulletin* 44(Sept. 1955):33-9.

Included Rouault's *Crucifixion*.

1515. JEUDWINE, W. R. "Modern Paintings from the Collection of W. Somerset Maugham." *Apollo* 64(Nov. 1956):140.

Discusses Rouault's *Christ Crucified*.

1516. KEEN, G. "Times-Sotheby Index: Twentieth-Century Paintings." *Connoisseur* 171:687(May 1969):25.

Mentions *Le Chinois*.

1517. "New Works by Rouault, *Christ and the Doctors*." *Pictures on Exhibit* 3(May 1940):8-9.

1518. "Notable Works of Art Now on the Market." *Burlington Magazine* 98(June 1956):3.

Discusses Rouault's *Le Faubourg*.

1519. "Notable Works of Art Now on the Market." *Burlington Magazine* 100(June 1958):4.

Discusses Rouault's *Baigneuses*.

1520. "Notable Works of Art Now on the Market." *Burlington Magazine* 107:747(June 1965):3.

Mentions Rouault's *Le Louchon (vieux cirque Forain)*.

1521. "*Nue aux bras levés*." *Apollo* 126:309(Nov. 1987):80.

1522. O'CONNOR, J, JR. "*Old King* by Rouault." *Carnegie Magazine* 23(Dec. 1949):167-8.

1523. "*The Ordeal of Samson*, or *Samson at the Wheel*." *Art Journal* 44(Fall 1984):282.

1524. "'*The Passion*' as Rendered by Rouault." *Arts Magazine* 37:2(Nov. 1962):24-5.

1525. "*Paysage*." *Connoisseur* 215(Sept. 1985):54.

1526. "Petit dictionnaire des années héroïques (1907-1917)." *XX^e siècle* 28(May 1966):98.

Illustrated by Rouault's *Marocain*, among other reproductions.

1527. "*Pierrot*." *L'Œil* 366(Jan.-Feb. 1986):14.

1528. "*Polycarpe*." *Connaissance des arts* 472(June 1991):29.

1529. REWALD, SABINE. "*Three Judges*." *Metropolitan Museum of Art Bulletin* 49(Fall 1991):64.

1530. "Rouault and Bonnard; Three Heads, Collection George Gershwin." *New York Museum of Modern Art Bulletin* 1(Oct. 1933):4.

1531. "Rouault's Little Passion Rediscovered." *Art News* 61:7(Nov. 1962):32-3+.

1532. "*Satan*." *Art News* 88:4(April 1989):11.

1533. STARCKY, EMMANUEL. "*Verlaine*." *La Revue du Louvre et des musées de France* 41(July 1991):95.

Concerns Rouault's portrait of Paul Verlaine, acquired by the muséee des Beaux-arts, Dijon.

1534. "Stolen: Rouault's *Le Chirurgien* from the Art Gallery of Toronto." *Museum News* 32(1 Nov. 1954):3.

1535. "*Tête de jeune fille*." *Verve* 5-6(July-Oct. 1939):71.

1536. "*Three Judges*." *Life* 25(11 Oct. 1948):60-1.

1537. "[Untitled: Christ Image]." *Art in America* 77:2(Feb. 1989):45.

1538. "*Visage de la France. Jeanne d'Arc. Figure légendaire. Versailles. Vierge et enfant. L'Oasis.*" *Verve* 8(Sept.-Nov. 1940):12-21.

1539. WALLER, BRET. "Rouault's *Abondonné*: Transformations of an Image." *Porticus; The Journal of the Memorial Art Gallery of the University of Rochester* 7(1984):30-6. 5 illus.

Discusses the painting *Abondonné* or *Le Miracle* (1935-39) by Georges Rouault in the Memorial Art Gallery of the University of Rochester, New York. The work is painted in oil over an intaglio print, and was originally one of the scenes in Rouault's *Miserere* series. Waller describes the genesis of this series in 1912 and its gradual evolution over the following three decades. The evolution of the series relates to the *Réincarnations du Père Ubu*, commissioned by publisher Ambroise Vollard, who also promised his support for the *Miserere* series. The painting in Rochester appears to show Christ blessing a kneeling man. This composition is examined and the history of the design of this particular print examined through its known precursors. The Rochester painting is dated to the latter part of the 1930s, on the basis of the death of Vollard and stylistic parallels with other works by Rouault of this time.

1540. WOLFRAM, E. "Look and See." *Arts Review* 24:15(29 July 1972):457.

Brief discussion of Rouault's contributions to 20th century art, with particular reference to his 1935 work in oil and gouache, *Faubourg*.

1541. "*The Wounded Clown.*" *Theatre Arts* 25(May 1941):400.

D. Drawings

Article

1542. BOULEAU-RABAUD, W. "Trois dessins inédits de Rouault à l'Ecole des Beaux-arts." *Gazette des Beaux-arts* ser. 6, 70(Nov. 1967):299-302.

Analyzes three drawings by Rouault: *Samson tournant la meule, Le Christ pleuré par les saintes femmes, Coriolan dans la maison des Tullius.*

E. Graphic Works

Books

1543. BRUSCAGLIA, RENATO. *Incisione calcografica e stampa originale d'arte: materiali, procedimenti, segni grafici* [Chalcographic Engraving and Original Art Printing: Materials, Processes, Graphic Signs]. Urbino: QuattroVenti, 1988. 304 p., 185 illus.

Study of the different printmaking techniques tracing their history in terms of materials and processes used, with reference to their application in the work of famous artists, including Picasso, Klinger, Nolde, Alechinsky, Rops, Degas, Manet, Munch, and Rouault. Chapters are devoted to direct engraving methods including mixed and

experimental techniques such as the use of carborundum and photomechanical processes. There is also a section on the methods and materials used in chalcographic engraving.

1544. STADLER, W. *Georges Rouault: Zirkus Sternschnuppe* [Georges Rouault: Circus of Falling Star]. Introduction by W. Stadler. Freiburg; Basel; Vienna: Herder, 1984. 47 p., 25 illus.

Extracts of text and examples of the seventeen color etchings and eighty-two woodcuts Rouault created for the circus book, *Le Cirque de l'étoile filante*, in the years 1934-35, are introduced by a text describing Rouault's deep understanding and liking of the world of the circus which he expressed in his art.

Articles

1545. AGUSTONI, F. "The Graphic Work of Georges Rouault." *Print Collector* (Autumn-Winter 1972):14-35. 196 illus.

At the time of publication there was no complete catalogue of the graphic work of Rouault; therefore, the author attempts to summarized briefly the extent of all Rouault's published and some of his unpublished work. He provides information about each set of prints including notes on the subject matter, dates, publishers and the number of prints in each edition. There are small black-and-white reproductions of many of the prints mentioned and actual sizes are given.

1546. "Artist and the Book." *Studio* 162:821(Sept. 1961):118-9.

Discusses Rouault's illustrations for Charles Baudelaire's *Les Fleurs du mal*.

1547. BOSTICK, W. A. "Masterpiece of Bookmaking: Rouault's *Cirque de l'étoile filante*." *Detroit Institute of Art Bulletin* 28:2(1949):40-1.

1548. "*Clowns*, Engraving from the Book *Cirque de l'étoile filante*." *Verve* 4(Jan-March 1939):100,105-6.

1549. "*The Dancer*"—The First Photograph Ever Published of Georges Rouault."

1550. DAVIDSON, MARTHA. "Rouault as Master of Graphic Art." *Art News* 37(8 Oct. 1938):10[+].

1551. DORMOY, MARIE. "Cirque de l'étoile filante de Georges Rouault." *Arts et métiers graphiques* 68(15 May 1939):35.

1552. "Etching by Rouault." *Artlover* 2:4(1927):59-73.

1553. JOHNSON, UWA. E. "Georges Rouault and His Prints." *Brooklyn Museum of Art Bulletin* 13:1(1951):6-12.

1554. LEWIS, V. E. "Prints by Five French Contemporaries." *Carnegie Magazine* 25(Feb. 1951):57-9[+].

1555. LIEBERMAN, WILLIAM S. "Notes on Rouault as Printmaker." *Magazine of Art* 46(April 1953):170-6.

1556. RENOIR, E. "An Unpublished Lithograph by G. Rouault." *Print Collector* 36(Dec. 1977):4-7. 4 illus. In English and Italian.

In 1974 a catalogue was published of Georges Rouault's lithographs printed by Edmond Trapier. Among these works were three versions of the same subject, Christ on the Cross. A new variation of this subject has now been found. Rouault, who was particular about the quality of his works, destroyed the proofs which were not perfect and only allowed those he approved of and which he had signed to circulate. Therefore, unsigned proof states and impressions (such as this) are quite rare. The versions are compared.

1557. ROGER-MARX, CLAUDE. "L'Œuvre gravé de Georges Rouault." *Byblis* 10(Autumn 1931):93-100. 3 pl.

1558. "Rouault graveur." *L'Œil* 346(May 1984):85.

1559. ROUIR, EUGENE. "Georges Rouault: A Catalgoue of the Lithographs Published by E. Frapier." *Print Collector* 8(May-June 1974):6-27. 48 illus.

The eight-year (1924-32) collaboration of Georges Rouault and Raymond Frapier produced 52 black-and-white lithographs, often in several states. Previous cataloguing by the author of this article of the various states and editions of these reprints included errors which he here corrects. Information on titles, measurements, states, proffs, and papers used precede details of the prints, which are divided into six categories: Les Saltimbanques; Portraits; Les Thèmes mythiques; Grotesques; Divers; and Ouvrages.

1560. ROUIR, EUGENE. "Georges Rouault: due lithografie poco conosciute. Georges Rouault: Two Apparently Forgotten Lithographs." *Print Collector* 7:30(Jan.-Feb. 1976):6-9. 2 illus. In Italian and English.

Analyzes Rouault's *Christ's Head in Profile to the Left* and *S. Veronica's Veil.*

1561. SANDSTRÖM, SVEN. "Konstsamlande som livsbehov. (Göran Bergengrens Rouault-och Picasso-samlinger). *Konsthistorisk Tidskrift* 57:3-4(1988):92-5. 1 illus. English summary.

Discusses the collections of work by Rouault and Picasso assembled by Göran Bergengren (1921-72), from their beginnings in 1951-52 to their dispersal after his death. Sandström includes personal reminiscences of Bergengren, and shows how his personal characteristics and circumstances were reflected in the works which he bought, chiefly engravings, from the melancholy and statuesque Rouaults and early Picassos to the exuberant treatments by Picasso of classical myth from the 1930s onward.

1562. SMITH, E. "Matisse and Rouault Illustrate Baudelaire." *Baltimore Museum of Art News* 19(Oct. 1955):1-9.

1563. "Two Prints on War: *The Very Dead Are Risen*, Etching by Rouault; *Serenade to Peace*, Lithograph by Daumier." *Design* 48(Dec. 1946):19.

1564. ZAHAR, MARCEL. "Georges Rouault; or the Return to the Dramatic Grotesque. Illustrations for A. Vollard's *Les Réincarnations du Père Ubu.*" *Formes* 31(1933):354-5.

1565. ZERVOS, CHRISTIAN. "Illustrations de Georges Rouault pour les *Réincarnations du père Ubu de A. Vollard.*" *Cahiers d'art* 7:1-2(1932):66-8. 3 illus.

F. Illustrated Books

1566. VOLLARD, AMBROISE. *Le Politique coloniale du Père Ubu.* Croquis par Georges Rouault. Paris: G. Crès, 1919. 19 p., illus.

1567. VOLLARD, AMBROISE. *Les Réincarnations du Père Ubu.* Avec un portrait de l'auteur par Georges Rouault. Paris: Divan, 1925. 240 p., illus., pl.

a. Another ed.: 22 eaux-fortes et 104 dessins sur bois de Georges Rouault. Paris: A. Vollard, 1932. 211 p., illus.

1568. ROUAULT, GEORGES. *Souvenirs intimes: G. Moreau, Léon Bloy, Cézanne, Ch. Baudelaire, Renoir, Daumier, J.-K. Huysmans, Degas.* Orné de six lithographies hors-texte. Préface d'André Suarès. Paris: Galerie des peintres graveurs E. Frapier, 1926. 98 p., illus.

1569. ROUAULT, GEORGES. *Paysages légendaires; poèmes par Georges Rouault.* Illustrés par l'auteur de 6 lithographies originales hors-texte, 50 dessins en reproduction, et 1 lithographic en couleur pour les 12 exemplaires de tête. Paris: Editions Porteret, 1929. 31 p., illus., 8 pl., 2 col.

1570. ROUAULT, GEORGES. *Petite banlieue.* Avec 6 lithographies et 100 reproductions dont 2 colorées à la main par l'artiste. Paris: Editions des Quatre Chemins, 1929.

1571. ARLAND, MARCEL. *Les Carnets de Gilbert.* Illustré par G. Rouault. Avec 1 lithographic originale et 5 gravures en couleurs. Paris: Nouvelle Revue Française, 1931. 59 p., illus., pl.

1572. SUARES, ANDRE. *Cirque.* Eaux-fortes originales et dessins gravés sur bois de Georges Rouault. Paris: A. Vollard, 1936. 77 p., illus., 14 pl., some col.

1573. ROUAULT, GEORGES. *Le Cirque de l'étoile filante.* Avec 17 eaux-fortes originales en couleurs et 82 et dessins gravés sur bois de Georges Rouault. Paris: Ambroise Vollard, éditeur, 1938. 168 p., 3 col. pl. Printed on March 5, 1936.

1574. SUARES, ANDRE. *Passion.* Avec 17 eaux-fortes originales en couleurs et 82 bois dessines par Georges Rouault. Paris: Ambrois Vollard, éditeur, 1939. 143 p., illus., pl., some col.

a. U.S. ed.: *The Passion*. Edited and with an introduction by Timothy Mitchell. Bloomington, IN: Lilly Library of Indiana University in association with Dover Publications, New York, 1982. 76 p., 99 illus., 17 col.

1575. ROUAULT, GEORGES. *Divertissement*. Avec 15 reproductions en couleurs. Paris: Tériade, 1943. 75 p., col. illus., 15 col. pl. Volume in "Editions de la revue *Verve*" series.

1576. ROUAULT, GEORGES. *Soliloques*. Avant-propos de Claude Roulet. Avec 8 reproductions en couleurs. Neuchâtel: Ides et Calendes, 1944. 207 p., col. pl.

1577. ARLAND, MARCEL. *Avec Pascal*. Préface de Raymond Guérin. Frontispièce et hors-texte de Georges Rouault. Paris: Editions du Salon Carré, 1946. 145 p., illus. Volume in "Œuvres et visages d'aujourd'hui" series.

1578. ROUAULT, GEORGES. *Stella vespertina*. Avec 12 reproductions en couleurs. Avant-propos recueillis par M. l'Abbé Maurice Morel. Paris: René Drouin, 1947. 56 p., col. illus., 12 col. pl. Rouault's foreword reprinted in *Sur l'art et sur la vie* (Paris: Denoël/Gonthier, 1971), pp. 108-16.

Review: *Arts Magazine* (21 Nov. 1947):2.

1579. ROUAULT, GEORGES. *Le Miserere de Georges Rouault*. Préface de l'artiste, présentation de l'Abbé Morel. 58 planches gravées (eauux-fortes), par l'artiste. Paris: L'Etoile Filante; aux Editions du Seuil, 1951. 17 p., 59 pl.

a. Another French ed.: Montréal: Musée de l'Oratoire Saint-Joseph, 1979. 32 p., illus. English translations.
b. English ed.: *Miserere*. Foreword by Anthony Blunt. London: Trianon Press, 1950. 10 pl., 60 pl.
c. German ed.: Munich: Prestel Verlag, 1951. 22 p., illus., 58 pl.
d. U.S. eds.: Introduction by Monroe Wheeler. New York: Museum of Modern Art, 1952. 13 p., 60 pl.; Introduction by Anthony Blunt; foreward by Isabelle Rouault. Boston: Boston Book & Art Shop, 1963. 10 p., 74 illus., 64 pl.
Review: *Studio* 142(Dec. 1951):192.

1580. ROUAULT, GEORGES. *Les Fleurs du mal*. 14 planches gravées par l'artiste. Paris: L'Etoile Filante, 1966.

1581. ROUAULT, GEORGES. *Visages: dix études de l'atelier, reproduites en facsimilés*. Présentées par Pierre Courthion. Paris: Daniel Jacomet et l'Etoile Filante, 1969. 6 p., 10 col. pl., portfolio.

1582. ROUAULT, GEORGES. *The Passion*. 99 illustrations, including 17 in full color. Edited and with an introduction by Timothy Mitchell. Bloomington, IN: Lilly Library of Indiana University in association with Dover Publications, New York, 1982. 76 p., 99 illus., 17 col.

Rouault's illustrations reproduced form André Suarès' *Passion* (Paris: Ambroise Vollard, 1939).

G. *Miserere* Series

Books

1583. FEASTER, SCOTT VANDIVER. *Polemic Organizations as Style: An Approach to Flannery O'Connor's Wise Blood and Georges Rouault's Miserere in Terms of a Perspective Provided by the Modern Catholic Novel.* Ph.D. diss., Ohio University, 1982. 176 p.

Seeks to discover what aspects of structure in works in different modes, namely, Flannery O'Connor's *Wise Blood* and Georges Rouault's *Miserere*, receive illumination by means of an approach to the analysis of their respective forms *vis à vis* criteria of style conceived along the lines of a comparative schema: a common basis of style may lie in a conception of organization as both literary and polemical.

1584. GETLEIN, FRANK and DOROTHY GETLEIN. *Georges Rouault's 'Miserere'.* Milwaukee: Bruce Publishing Co., 1964. 149 p., pl.

Review: *Liturgical Arts* 32(May 1964):102.

Articles

1585. AGUSTONI, F. "The Originality of a Print." *Print Collector* 5(Nov.-Dec. 1973):40-9. 6 illus.

Examines the problem of the meaning of the phrase "original print," giving as definition "every proof pulled . . . from a plate . . . and directly worked upon by the artist in such a way that the part engraved or whatever impregnated with ink and transferred to the final support by one or more complex printing operations, the original image . . . conceived by the artist with this end in mind." There are three essential characteristics of printmaking: an "idea phase," in which a graphic project is conceived; a "material phase" in which the artist prepares a plate; and an "instrumental phase," in which the print is produced by specialist printers. Each phase is examined in detail to evaluate its part in the "originality" of a print. The problem of the prints produced by Rouault for his *Miserere*, for which he used photoengravings of his own drawings and paintings, is discussed. The importance of the printing press and its development is examined in relation to the improvement of quality in prints and the work of copiers is considered in relation to their sources and to the extent of their right to the term "original print." Finally, the growing use of modern techniques to produce false prints is mentioned.

1586. BELLINI, PAOLO. "Rouault: il messaggero scomodo" [Rouault: The Troublesome Messenger]. *Arte* 18:191(Dec. 1988):90-5, 168, 171. 5 illus., 3 col.

After describing Rouault's rebellious personality, which still generates difficulties of interpretation, the author discusses aspects of his life in order to illuminate this critical difficulty, including an incident in 1947 when he destroyed large quantities of his work in the course of a dispute over them with the heirs of Ambroise Vollard. His reputation was firmly established after the Second World War. Bellini then speculates on how he learned engraving and surveys his œuvre in this medium, discussing in detail the series *Miserere* (1922-27).

1587. BERRYMAN, LARRY. "Miserere." *Arts Review* 38(20 June 1986):335-6.

1588. BREESKIN, ADELYN D. "*Miserere et guerre.*" *Baltimore Museum of Art News* 20(Dec. 1950):1-2.

1589. LASSAIGNE, JACQUES. "Georges Rouault: *Miserere.*" *Graphis* 5:26(1949):102-11[+]. With German and French texts.

1590. LEWIS, V. E. "Misery and War by Rouault, Fifty-Nine Prints, C. J. Rosenbloom Gift." *Carnegie Magazine* 26(April 1952):114-6[+].

1591. "*Le Miserere* de Rouault." *Art et décoration* 12(1949):51.

1592. "*Miserere et guerre*, Portfolio of Etchings Available." *Art News* 48(Feb. 1950):10.

1593. OLSEN, VALERIE LOUPE. "*Miserere* by Rouault." *Arts Quarterly* 9:3(July-Sept. 1987):13. 1 illus.

Discusses Rouault's *Miserere* intaglio series, 1916-18 and 1922-27, including *Have Mercy Upon Me, O God, According to Thy Loving Kindness* (New Orleans Museum of Art).

1594. QUINN, R. M. "To the Editor [letter]." *Liturgical Arts* 40(Feb. 1972):81-2.

Concerns Rouault's *Miserere*.

1595. ROGER-MARX, CLAUDE. "*Le Miserere* de Rouault." *Gazette des Beaux-arts* ser. 6, 35(April 1949):289-94, 311-2. English translation.

1596. SALMON, ANDRE. "*Le Miserere* de Georges Braque." *L'Amour de l'art* 6(May 1925):182-6.

1597. YEATMAN, J. "Georges Rouault's *Miserere*." *South Australian Bulletin of Art* 20(July 1958):2-3.

H. Ceramics

Articles

1598. APOLLINAIRE, GUILLAUME. "Georges Rouault." *L'Intransigeant* (15 March and 22 April 1911).

Concerns Rouault's ceramics.

1599. FRAPPIER, GEORGES. "Georges Rouault." *La République* (12 Oct. 1911).

Concerns Rouault's ceramics.

1600. LA PALETTE. "Georges Rouault." *Paris-journal* (22 Oct. and 10 Dec. 1911).

Concerns Rouault's ceramics.

1601. SALMON, ANDRE. "Georges Rouault." *Paris-journal* (12 Dec. 1911).

Concerns Rouault's ceramics.

I. Assy Chapel (Nôtre-Dame-de-Toute-Grâce, Plateau d'Assy, France)

Articles

1602. ADAM, GEORGINA. "Assy, miracle d'art sacré modern." *France-illustration* 6(2 Dec. 1950):585-92.

1603. "The Assy Church." *Life* (1950):294-8.

1604. "La Passion et Véronique, vitraux de l'église d'Assy, exécutés par P. Bony, d'après des peintures de Rouault." *Art et décorations* 16(1950):20.

J. Special Issues Devoted to Rouault

1605. "Georges Rouault: œuvres inédites." *La Renaissance* (Oct.-Nov. 1937).

Special issue devoted to Rouault. Edited by Waldemar George. Includes Rouault's contribution, "climat pictural," pp. 3-4. Reprinted in *Sur l'art et sur la vie* (Paris: Denoël/Gonthier, 1971), pp. 104-5.

1606. "Rouault." *Le Point* (Lanzac) 26-7(Aug.-Oct. 1943):1-80.

Special issue devoted to Rouault.

1607. "George Rouault." *Kunsten Iday* 2(1954).

Special issued devoted to Rouault. Includes a foreword by Rouault.

1608. ROUAULT, GEORGES. "Hommage à Henri Matisse." *XXe siècle* (1970):1-126. illus.

Special issue that includes an article on Matisse by Rouault.
a. Another ed.: *Hommage à Georges Rouault.* Paris: Société Internationale d'art "XXe siècle," 1971. 128 p., illus., some col.
b. U.S. ed.: *Homage to Georges Rouault.* New York: Tudor Publishing Co., 1971. 128 p., illus., some col.

K. Audiovisual Material

1609. *Modern Art: Georges Rouault.* Chicago: Life, 196_. Life filmstrip. Includes lecture notes.

Shows twenty-three of the paintings created by Rouault between 1898 and 1952 and the stained glass windows he designed for the Chapel at Assy.

V. Influence and Mentions

A. Influence on Other Artists

Book

1610. LEVINE, JACK and STEPHEN ROBERT FRANKEL. *Jack Levine.*
Commentary by Jack Levine. Introduction by Milton W. Brown. Compiled and
edited by Stephen Robert Frankel. New York: Rizzoli, 1989. 144 p., 198 illus., 62
col.

Presents reproductions of almost all of Jack Levine's paintings to date, including
drawings and studies. Levine (b. 1915), who arrived on the American art scene in
1937 with his painting *The Feast of Reason* and was immediately established in the
ranks of the Social Realists, examines his art and discusses his influences, from Old
Masters like Titian, Rembrandt, and Rubens to early modernist such as Rouault,
Soutine, and Grosz.

Articles

1611. BEAUMONT, MARY ROSE. "Europe Without Borders." *Art Line* 4:4(Dec.
1988-Jan. 1989):26-7. 3 illus.

Examines the work of Jane Langley, a British painter whose work Beaumont places
in the Northern European tradition embodied by Munch, Rouault, and Beckmann.
Beaumont describes some of Langley's most recent paintings, noting her obsession
with the macabre and emphasizing her fascination with symbolism and allegory. She
identifies the sources of some of Langley's most striking imagery.

1612. GUTĂ, ADRIAN. "Ioan Augustin Pop." *Arta* (Roumania) 35:11(1988):21.
5 illus., 3 col.

Review of an exhibition of paintings by Ioan Augustin Pop (b. 1955) held in Oradea,
Romania (Sept. 1988). Guță gives his impressions of the artist, describing him as a
Neo-Expressionist and comparing him with Rouault. Much of the exhibited work
bridged gaps between different styles, for example the figurative and the primitive or
the figurative and the abstract.

1613. VILLANI, D. "Enó Filippini." *Le Arti* 24:7-8(July-Aug. 1974):278-9. 4 illus.
In Italian.

Short article describing the development of Filippini's art and the influence of Utrillo,
Rouault, Miró, and Klee on his pictorial compositions and technique.

1614. WELLING, DOLF. "Zeldzame expositie van beschikbaar werk van Theo
Wolvecamp" [Unusual Exhibition of Available Works by Theo Wolvecamp]. *Tableau*
(Netherlands) 12:1(Sept. 1989):122. 1 col. illus.

With reference to an exhibition of drawings and gouaches by Wolvecamp (b. 1926)
at Kunsthandel Leeman in Amsterdam (15 Sept.-21 Oct. 1989), Welling provides
information about Wolvecamp's background as a self-taught artist, his connection with

the COBRA group, and the extreme self-criticism which led him to destroy much of his work. Welling also stresses his affinity with Rouault, Arshile Gorky, and Asger Jorn, his affection for the Dutch landscape, and the importance of the time in the 1950s which he spent in Paris.

B. Mentions

Books

1615. *Les Appels de l'Orient*. Paris: Emile-Paul Frères, 1928. 396 p. Volume in "Les Cahiers du mois" series.

1616. BERGER, JOHN. *About Looking*. New York: Pantheon, 1980. 198 p., 25 illus.

Reprints twenty-two essays, previously published during the late 1960s and 1970s, most of which appeared in *New Society*. Topics include photography and artists such as Millet, Seker Ahmet, L. S. Lowry, Ralph Fasanella, Courbet, Francis Bacon, Turner, Rouault, Magritte, and Rodin. Includes Berger's essay, "Rouault and the Suburbs of Paris."
a. Another ed.: New York: Vintage International, 1991. 205 p., illus.
b. English ed.: London: Writers and Readers, 1980. 198 p., illus.
c. Spanish ed.: *Mirar*. Trans. by Pilar Vazquez Alvarez. Madrid: Hermann Blume, 1987. 176 p., illus.
Reviews: J. Perrone, *Arts Magazine* 54:9(May 1980):149-58; K. Baker, *Art in America* 68:9(Nov. 1980):21; V. Margolin, *New Art Examiner* 8:4(Jan. 1981):9; M. Levine, *Artweek* 12:8(28 Feb. 1981):5-6; H. Foster, *Artforum* 19:10(June 1981):88-9.

1617. BLOY, LEON. *Journal*. Présentation et notes de Joseph Bollery. Paris: Mercure de France, 1963. 4 vols.

Rouault is discussed in vol. 2, "Quatre ans de captivité à Cochons-sur-mer (1902-1904), pp. 241-3; "L'Invendable" (1904-1907), pp. 36, 60, 65, 69-71, 132, 288; vol. 3, "Le Vieux de la montagne" (1907-1910), p. 197; and vol. 4, "Au Seuil de l'apocalypse" (1913-1915), pp. 119-199; "La Porte des humbles" (1915-1917), p. 71, 116, 190, 278, 286.

1618. BOIME, ALBERT. *Academic Instruction and the Evolution of 19th Century French Painting*. Ph.D. diss., Columbia University, 1968.

1619. BRASSAÏ, GYULA HALASZ. *Les Artistes de ma vie*. Paris: Denoël, 1982. 223 p., illus.

Brassaï's photographs of artists (as well as their works, studios and homes), 1930s-50s, accompanied by his impressions of them and their art. Includes Brassaï's portraits of Braque, Dufy, Matisse, and Rouault, among others.
a. English/U.S. ed.: *The Artists of My Life*. Trans. by Richard Miller. London: Thames and Hudson; New York: Viking Press, 1982. 223 p., 135 illus.
Reviews: M. Vaizey, *Art Book Review* 1:4(1982):50; C. Bedient, *Art in America* 71:5(May 1983):17, 19, 21; A. Berman, *Art News* 82:6(Summer 1983):28.

1620. BRETTELL, RICHARD R. *An Impressionist Legacy: The Collection of Sara Lee Corporation.* Introduction by David Finn. Photography by Geoffrey Clements and David Finn. New York: Abbeville; dist. in the U. K. and Europe by Pandemic, London, 1986. 127 p., 80 col. illus.

Catalogue raisonné of the collection of paintings and sculpture on permanent display at the Chicago headquarters of the Sara Lee Corporation, which were acquired from the personal collection of the company's founder, Nathan Cummings. They are principally French—works by Camille Pissarro, Berthe Morisot, Henri Matisse, Roger de la Fresnaye, Gauguin, Bonnard, Léger, Toulouse-Lautrec, Eugène Boudin, Renoir, Degas, Braque, Rouault, Dufy, Jean Metzinger, Maillol, Vuillard, and Vlaminck—but there are also works by Alfred Sisley, Henry Moore, Chaim Soutine, Chagall, Kandinsky, Alberto Giacometti, and Giacomo Manzù. The descriptive annotations accompany the illustrations, with the technical details and exhibition histories of each work collected at the end.

1621. COQUIOT, GUSTAVE. *Cubistes, futuristes, passéistes.* Paris: Ollendorff, 1914.

See pages 142[+] for information on Rouault.

1622. COQUIOT, GUSTAVE. *Les Indépendants.* Paris: Ollendorff, 1920.

Pages 72[+] discuss Rouault.

1623. COQUIOT, GUSTAVE. *Des gloires déboulonnés.* Paris: Delpeuch, 1924.

See pages 101[+]s for information on Rouault.

1624. COQUIOT, GUUSTAVE. *Des peintres maudits.* Paris: Delpeuch, 1924.

See pages 115[+] for information on Rouault.

1625. CREUZEVAULT, HENRI. *Henri Creuzevault (1905-1971): 14 reliures des années 50.* Paris: C. Creuzevault, 1983. 10 p., 13 pl., some col.

1626. DORIVAL, BERNARD. *Les Etapes de la peinture française contemporaine.* Paris: Gallimard, 1943-47. 4 vols.

Rouault is discussed in vol. 2.

1627. EINSTEIN, CARL. *Werke.* Berlin: Medusa Verlag, 1931.

Volume 2, pp. 289-96 deals with Rouault.

1628. EVENEPOEL, HENRI. *Gustave Moreau et ses élèves; lettres de 1894 à 1898.* Paris: Mercure de France, 1923.

1629. FELS, FLORENT. *Propos d'artistes.* Paris: La Renaissance du Livre, 1925.

See pp. 149[+] for information on Rouault.

1630. FORESTIER, SYLVIE and MARC CHAGALL. *Marc Chagall: di grossen Gemälde der Biblischen Botschaft* [Marc Chagall: The Great Paintings of the Biblical Message]. Gedichte von Marc Chagall; Herausgeber, Sylvie Forestier. Stuttgart, Zurich: Belser, 1986. 68 p., 33 illus., 32 col. In German and French.

Presents the paintings and stained glass by Chagall illustrating themes from the Old Testament, which are on permanent display in the Musée National, message biblique Marc Chagall, in Nice. Forestier notes that the idea of a space devoted to a series of religious paintings is one which has been particularly common in the post-War period, citing similar projects by Picasso, Matisse, Rouault, Léger, and Germaine Richier. Chagall describes his fascination from an early age with Biblical themes, explaining that his paintings represent the dream of the whole of humanity. Illustrated works are accompanied by short inspirational poems by Chagall, in French, with a commentary by Forestier.

1631. FRY, ROGER. *Vision and Design*. London, 1920.

Page 154 concerns Rouault.

1632. FRY, ROGER. *Transformations*. London: Chatto & Windus, 1925.

For information on Rouault, see pp. 25, 207+.

1633. GORDON, JAN. *Modern French Painters*. New York: Dodd, Mead, 1923.

Rouault is discussed on pp. 89-90.

1634. JOHNSON, UNA E. *Ambroise Vollard, éditeur, 1867-1939*. An Appreciation and Catalogue by Una E. Johnson. New York: Whittenborn, 1944. 214 p., illus., 24 pl.

a. Another ed.: *Ambroise Vollard, éditeur: Prints, Books, Bronzes*. New York: Museum of Modern Art; dist. by New York Graphic Society, Boston, 1977. 176 p., illus., some col.

1635. KELDER, DIANE. *Masters of the Modern Tradition: Selections from the Collection of Samuel J. and Ethel LeFrak*. New York: LeFrak Organization, 1988. 94 p., 5 illus., 49 col.

Selection of paintings from the LeFrak Collection, which consists of works by the Impressionists, post-Impressionists and later painters. Includes works by Rouault, Braque, Matisse, Kees van Dongen, and Maurice de Vlaminck, among others.

1636. LEVY, JULIEN. *Memoir of an Art Gallery*. New York: Putnam, 1977. 320 p., illus., 18 pl.

In the fall of 1931, the Julien Levy Gallery opened in New York and in 1932, Julien Levy introduced the United States to Surrealism. In following years, he exhibited the works of Dalí, Ernst, Cornell, Calder, Picasso, Campigli, Atget, Eugene Berman, Man Ray, Pavel Tchelitchev, Georges Rouault, Henri Cartier-Bresson, Giacometti, and others, until closing in 1949. Levy's reminiscences describe his summer travels

in Europe and his friendships with Duchamp, Gorky, and de Chirico, as well as the origin of the Surrealist Pavilion "Birth of Venus" which Dalí designed for the New York World's Fair.
Reviews: G. Glueck, *New York Times* (11 Feb. 1977):C20; J. Hobhouse, *New York Times Book Review* (13 March 1977):28; D. Rosenthal, *Arts Magazine* 51:8(April 1977):10; T. Lask, *New York Times* (20 April 1977):C23; H. Herrera, *Art in America* 65:3(May-June 1977):35, 37; T. Baum, *Print Collector's Newsletter* 8:3(July-Aug. 1977):83-5.

1637. LEWIS, WYNDHAM. *Wyndham Lewis on Art: Collected Writings 1913-1956.* With introductions and notes by Walter Michel and C. J. Fox. London: Thames and Hudson, 1969. 480 p.

Includes essays on Rouault, Matisse, and other 20th century artists and art movements.
a. U.S. ed.: New York: Funk & Wagnalls, 1969. 480 p.

1638. LEYMARIE, JEAN. *L'Aquarelle.* Geneva: Skira, 1984. 139 p., col. illus. Volume in "Le Métier de l'artiste" series.

Traces the development of watercolor painting in the west since Dürer in the 15th century. Later chapters mention Rouault and Derain. Technical notes on the making of watercolor paints, and an anthology of texts about the medium are appended.
a. U.S. ed.: *Watercolors: from Dürer to Balthus.* Trans. by James Emmons. Geneva, New York: Skra; Rizzoli, 1984. 139 p., 141 illus., 123 col.; 1990.
b. English eds.: *Watercolors: From Dürer to Balthus.* Trans. by James Emmons. London: Weidenfeld & Nicholson, 1985. 139 p., 141 illus., 123 col.

1639. LHOTE, ANDRE. *Parlons peinture.* Paris: Denoël et Steele, 1933.

Pages 407-11 deal with Rouault.
a. 2nd ed.: 1936. See pages 257-62 for information on Rouault.

1640. LUBITCH, OSSIP. *Cirque; dix eaux fortes aquatints par Lubitch.* Suivies d'un poème de Georges Rouault. Paris: Editions des Quatre Chemins, 1934. 7 p., 10 pl.

1641. MARITAIN, JACQUES. *Art et scholastique.* Paris, 1927.

See pp. 228+ for information on Rouault.

1642. MARITAIN, JACQUES. *Frontières de la poésie.* Paris: Louis Rouart, 1935.

1643. MARITAIN, JACQUES. *Art and Poetry.* New York, 1943.

Rouault is discussed on pp. 24+.

1644. MARITAIN, JACQUES and RAÏSSA MARITAIN. *Œuvres complètes de Jacques et Raïssa Maritain.* Fribourg: Editions Universitaires; Paris: Editions Saint-Paul, 1982.

1645. MATHIEU, PIERRE-LOUIS. *Gustave Moreau, sa vie, son œuvre: catalogue raisonné de l'œuvre achevé*. Fribourg: Office du Livre; Paris: Bibliothèque des Arts, 1976. 391 p., illus., some col.

Aims to trace the year by year development of Moreau's art. Also evaluates the influence exerted by Moreau both in literature and art, particularly as a teacher at l'Ecole des Beaux-arts in Paris, where Rouault, Matisse, and Marquet were his students. André Breton regarded Moreau as a true initiator of Surrealism and it has only recently been realized that Moreau was one of the first painters to venture into the field of abstract art. The catalogue raisonné includes ca. 500 works.
a. English ed.: *Gustave Moreau: Complete Edition of the Finished Paintings, Watercolours and Drawings*. Trans. by James Emmons. Oxford: Phaidon, 1977. 400 p., 486 illus., 40 col.
Reviews: A. Brookner, *Times Literary Supplement* (18 March 1977):300; F. Calvocoressi, *Connoisseur* 196:787(Sept. 1977):68; A. Frankenstein, *Art News* 76:9(Nov. 1977):64,66; J. Kaplan, *Burlington Magazine* 119:897(Dec. 1977):869-70, 873.

1646. NOUAILLE-ROUAULT, GENEVIEVE and H. TAKATA. *The Book of Great Masters—30*. Tokyo, Shogakenkau: The Zauho Press, 1979.

1647. PFEIFFER, HEINRICH. *Gottes Wort im Bild: Christusdarstellungen in der Kunst* [Images of God's Word: Representations of Christ in Art]. Munich, Zurich, Vienna: Neue Stadt; Wuppertal: R. Brockhaus, 1986. 102 p., 83 illus., 38 col.

Study of the representation of Christ in art from medieval times to the present day, exploring the richness and variety of images in art from different countries, cultures and ages. Pfeiffer explains why the figure of Christ has had such a profound effect on artists, arguing that the problem of how to convey the concept of Christ's presence in all things and at all times, is one which will never be exhausted. Among 20th century artists, Pfeiffer refers to works by Matisse, Corinth, Nolde, Léger, Alfred Manessier, and Georges Rouault, among others.

1648. PUY, MICHEL. *Le Dernier état de la peinture*. Paris: Le Feu, 1910.

1649. PUY, MICHEL. *L'Effort des peintres modernes*. Paris, 1933.

1650. SACILOTTO, DELI. *Photographic Printmaking Techniques*. New York: Watson-Guptill, 1982. 215 p., illus., some col.

History of photographic printmaking, discussing the work of Fox Talbot, Niépcede Saint-Victor, Stieglitz, Curtis, Strand, Rouault, Winslow Homer, James Rosenquist, Rauschenberg, C. J. Yao, Ruscha, Kenneth Price, Richard Graf, Deli Sacilotto, John Cage, Joan Snyder and Donald Saff, is followed by chapters on basic camera work, photolithographic techniques, photo-etching, photogravure, photo-screen techniques and unusual photographic print processes. Appendices are provided for formulae, sources of supply, a glossary, and a bibliography.

1651. SALMON, ANDRE. *La Jeune peinture française*. Paris: Société des Trent, A. Messein, 1912.

See pages 30-2 for information on Rouault.

1652. SALMON, ANDRE. *L'Art vivant*. Paris: Crès, 1920.

Pages 30-2 discusses Rouault.

1653. SHIKES, RALPH E. *The Indignant Eye; The Artist as Social Critic in Prints and Drawings from the Fifteenth Century to Picasso*. Boston: Beacon Press, 1969. 539 p., 405 illus.

The greater part of this book is devoted to the late 19th and early 20th century art, with sections on one hundred artists including Rouault.

1654. SMITH, JOHN. *The Arts Betrayed*. London: Herbert Press; Pitman, 1978. 256 p., 26 illus.

Traces the gradual development of the arts since 1900 through the juxtaposition of artists who, while working in different disciplines, demonstrated fundamental similarities in approach. The groups considered include Rouault and Gustav Mahler, among others.
a. U.S. ed.: New York: Universe Books, 1978. 256 p., illus.

1655. *Stiftung zur Förderung der Hamburgischen Kunstsammlungen: Erwerbungen 82/83* [Foundations for the Promotion of Hamburg's Art Collections: Acquisitions 1982-83]. Hamburg: Stiftung zur Förderung der Hamburgischen Kunstsammlungen, 1983. 44 p., 18 illus., 6 col.

After provididng details of officials and sponsors, this booklet describes the year's acquisitions: in the Hamburger Kunsthalle, Victor Sevrancx's oil paintings *Opus 6* (1924), Rouault's *Two Nudes* (c. 1910) and Otto Freundlich's *Autumn Vision* (1935); in the Museum für Kunst und Gewerbe only pre-1900 works.

1656. USHERWOOD, NICHOLAS. *The Bible in 20th Century Art*. Introduced by Nicholas Usherwood. London: Pagoda, 1987. 11 p., 40 col. illus.

Paintings and prints on biblical themes by forty artists, each accompanied by appropriate quotations from the Bible, and with a general introduction on the relevance and preponderance of Biblical themes in 20th century art history. Works by Rouault are included.

1657. VANDERPYL, FRITZ R. *Peintres de mon époque*. Paris: Librairie Stock, 1931. 228 p.

1658. VARSHAVSKAYA, M. YA, et al. *Iskusstvo Frantsii XV-XX vekov* [French Art from the 15th-20th Centuries]. Leningrad: Avrora, 1975. 232 p., illus.

Collection of articles dealing with various aspects of French artistic culture from the 15th century to the present. Subjects include three French *livres d'heures* in the Hermitage collection, the work of Georges Rouault and the paintings of André Derain in Soviet collections. Includes an article on Matisse's designs for Baudelaire's *Les*

Fleurs du mal (1946-47), donated to the Hermitage in 1965, and an article by A. Kantor-Gukovskaya on Matisse's drawings in the Hermitage.

1659. VOLLARD, AMBROISE. *Recollections of a Picture Dealer.* Translated from the Original French Manuscript by Violet M. Macdonald. London: Constable, 1936. 326 p., pl.

Memoirs of Ambroise Vollard (1867-1939), the successful Parisian art dealer.
a. U.S. eds.: Boston: Little, Brown, 1936. 326 p., 32 pl.; New York: Hacker Art Books, 1978. 326 p.; New York: Dover, 1978. 326 p.
b. French eds.: *Souvenirs d'un marchand de tableaux.* Paris: Albin-Michel, 1937, 1948, 1957, 1959, 1984.

1660. VON BLUM, P. *The Art of Social Conscience.* New York: Universe Books, 1976. 243 p., 162 illus.

Mentions Rouault.

1661. WARNOD, ANDRE. *Les Berceaux de la jeune peinture, Montmartre-Montparnasse.* Paris: Albin Michel, 1925.

Pages 9, 175, and 221 deal with Georges Rouault.

1662. WHEELER, MARION, ed. *His Face: Images of Christ in Art—Selections from the King James Version of the Bible.* New York: Cameleon Books, 1988. 128 p., 95 col. illus.

Presents ninety-five portraying the face of Christ, by artists from the 12th to the 20th century, including Dalí and Rouault. Arranged in four sections—His youth, His ministry, His suffering and His triumph—the paintings are accompanied by appropriate quotations from the Authorized Version of the Bible.
a. English ed.: Wellingborough, England: Equation, 1989. 128 p., 95 col. illus.

1663. CARCO, FRANCIS. *Le Nu dans la peinture moderne.* Paris: Crès, 1924.

Pages 134-6 deal with Rouault.

Articles

1664. "L'Art d'aujourd'hui." *Cahiers d'art* 10:1-4(1935):11-4.

1665. BENSON, E. M. "Of Many Things." *American Magazine of Art* 27(Jan. 1934):20-1.

Mentions Rouault's *Christ at Banlieue* and *Red Corsage*.

1666. BERIIAUT, M. "Musée des Beaux-arts de Rennes: œuvres récentement acquises." *Revue du Louvre et des musées de France* 18:4-5(1968):283-4.

1667. CABANNE, PIERRE. "Landau Collection." *Studio* 168:860(Dec. 1964):244.

Mentions Rouault's *Soleil couchant*.

1668. CHAPON, FRANÇOIS. "Ambroise Vollard, éditeur." *Gazette des Beaux-arts* ser. 6, 94:1326-7(July-Aug. 1979):33-47; ser. 6, 95:1332(Jan. 1980):25-38. 9 illus. Summary in English.

According to the author of this two-part article, art dealers were the first, at the beginning of the century, to give economic support to the illustrated book, that modern form of expression in which various ways of apprehending reality mingle in an association of correspondences. Ambroise Vollard was here an innovator. A certain personal nostalgia for creation provided him with a compensation in his publishing work for which he spared neither effort nor expense, employing for classical texts authors like Verlaine, Mirbeau, and Suarès or artists like Bonnard, Dufy, Picasso, Rodin and Rouault, as well as the leading craftsmen of the time.

1669. DAULTE, FRANÇOIS. "L'Ecole de Paris à la Galerie Daniel Malingue." *L'Œil* 310(May 1981):62-5. 7 illus.

With reference to an exhibition at the cited Paris gallery in the spring of 1981 of paintings by the Paris School, Daulte describes how the school, which originally comprised foreign artists who followed the main directions of contemporary French paintings without sacrificing their deep originality, eventually came to describe generally some French painters whose work fell outside both academic and avant-garde streams, including Soutine, Pascin, Foujita, Modigliani, Chagall, Utrillo, Rousseau, Vlaminck, Matisse, Derain, Rouault, Dufy, and Marquet. Illustrations of works from the exhibition by Rouault, Dufy, Laurencin, Utrillo, and Vlaminck are annotated.

1670. DORR, G. H., III. "Putnam Dana McMillan Collection." *Minneapolis Institute of Art Bulletin* 50(Dec. 1961):42-3.

Mentions Rouault's *Crucifixion*.

1671. EISENDRATH, W. N., JR. "Painting and Sculpture of the School of Paris in the Collection of Mr. & Mrs. Joseph Pulitzer, Jr. of St. Louis." *Connoisseur* 151:607(Sept. 1962):26-35.

Mentions Rouault's *Pierrot* and *Three Clowns*.

1672. "Evocation de Matisse." *XXᵉ siècle* 5(1970).

Special issue devoted to Matisse.

1673. FEINBLATT, EBRIA. "New Acquisitions: Prints." *Los Angeles County Museum of Art Bulletin* 11:4(1959):14.

1674. "Gustave Moreau." *L'Art et les artistes* 201:66(April 1926):217-52.

1675. HUNOKER, THOMAS. "Zivilisation und Prostsitution" [Civilization and Prostitution]. *Du* 4(1988):26-51. 33 illus., 21 col.

Surveys the role of prostitutes in society from the Greeks onwards, describing the system as a matriarchal structure in the service of patriarchy. Relations between church, state and prostitution are also described, as are those between artists and models, and prostitution in the high places of contemporary society. Examples of the subject in the works of Grosz, Dix, Rouault, and Beckmann among others illustrate the text.

1676. HYMAN, TIMOTHY. "The Imagery of Religion at the Turn of a Civilisation" in *Prophecy and Vision*. Edited by P. Burman and K. Nugent. (Bristol: Committee for Prophecy and Vision; dist. by Arnolfini Bookshop, 1982). 78 p., 91 illus.

Hyman's essay discusses the religious dimension in contemporary art, with examples from the work of Georges Rouault, among other late 19th and 20th century artists.

1677. KUSPIT, DONALD BURTON. "Uncivil War" *Artforum* 21:8(April 1983):34-43. 12 illus.

Cites a wide range of examples, including classical reliefs, the Old Masters, David, Delacroix, Goyá, Picasso, Klinger, Rouault, Ernst, Grosz, de Chirico, Lichtenstein, and Oldenburg, to demonstrate that the art of the past did not lose sight of human dignity and individuality in its depiction of war, but that modern totalitarian war, which is in a sense the condition of modern life, has not been adequately interpreted.

1678. LEHMANN, LEON. "L'Art vécu: souvenirs du temps des Fauves." *Les Beaux-arts* 134(26 July 1935):2 and 135(2 August 1935):2.

Emphasizes Matisse and Rouault.

1679. LIGER, C. "André Suarès: critique de Paul Cézanne." *Arts et livres de Provence* 81(1972):11-23. 3 illus.

Drawing on correspondence on the subject of Cézanne and his work between Rouault, Vollard and Suarès, Liger reconstructs the relationship between the four men, evokes the nature of Suarès's admiration for Cézanne, and describes the creation of the publication, *Souvenirs de Vollard sur Cézanne* (1914). A letter from Suarès to Vollard on the subject of his *Souvenirs*, published in the second edition of the book, is appended.

1680. MCBRIDE, HENRY R. "Palette Knife." *Creative Arts* 6(May 1930):111.

1681. MOUTARD-ULDRY, R. "Monks of LiguGé; Medieval Enameling Techniques Restored." *Craft Horizons* 13(Sept. 1953):26-9.

1682. "Œuvres dans le Musée d'Art moderne occidental à Moscou." *Cahiers d'art* 25:2 (1950):347.

1683. "Paintings and Prints." *Portland Museum of Art Bulletin* 4(Feb. 1943):1-2.

1684. PAVEL, AMELIA. "Concepte ale expressionismului in evolutie" [Concepts of Expressionism in Evolution]. *Studii si cercetari de istoria artei. Seria arta plastica* 21:1(1974):75-86. 8 illus. Summary in French.

Considers Expressionism not as a movement expressing an historical experience but as a source of philosophical symptoms. Several basic concnepts distinguished in Expressionist aesthetics and their influence are traced in various forms of artistic expression in the 20th century. Discussion includes analysis of the works of Rouault and Henri Matisse.

1685. PEREIRA, JOSEPH. "Modern Catholic Art." *The Downside Review* 73:231(1954):59-67.

1686. PERROT, FRANÇOISE. "Das junge europäische Glasfenster" [The Young European Glass Window]. *Kunst und Kirche* 3(1985):183-8. 8 col. illus.

Report on developments in glass painting in England, France and Germany in the 20th century. The idea of the glass painter as both craftsman and artist was developed in England by the Arts and Crafts Movement, led by Christopher Whall (d. 1924). In France, the revival of glass painting after 1945 was mainly church inspired and involved artists such as Georges Rouault. In Germany, there has been a group around Stockhausen, the Stüttgart School, as well as those who broke away from its influence.

1687. "Réponse à notre enquête sur le métier." *Beaux-arts* (16 Oct. 1936):5.

1688. RUHEMANN, H. "Methods of the Masters." *Studio* 145(March 1953):73-6.

1689. SCHWEBEL, H. "Die Christus-Identifikation des modernen Künstlers" [The Modern Artist's Identification with Christ] in *Zeichen des Glaubens: Geist der Avantgarde—religiöse Tendenzen in der Kunst des 20. Jahrhunderts.* W. Schmied, ed. (Stuttgart: Electa-Klett-Cotta, 1988), pp. 67-79. 19 illus.

Examines the different forms of identification with Christ found in 20th century art. The study is divided into the following sections: James Ensor's identification of the artist-ego with Christ; Georges Rouault's identification of Christ with the "suffering brother"; Herbert Falken's divided identification with Christ; Alfred Hrdlicka's identification of Christ with contemporary man in *Plötzenseer Totentanz* (1970); Marc Chagall's Christ-artist-identification, involving the portrayal of Christ as a crucified artist or as a lover; Joseph Beuys and his "miraculous" actions; and the theological problem posed by the identification with Christ.

1690. SOBRAL, LUIS DE MOURA. "La Crucifixion vue à travers les âges." *M; A Quarterly Review of the Montreal Museum of Fine Arts* 6:4(Spring 1975):14-22. 14 illus., 1 col. In French and English.

Discusses the iconography of the Crucifixion on the basis of works in the collection of the Montreal Museum of Fine Arts. The pieces include French medieval ivories, an Italian 15th century bronze, a 14th-century Armenian manuscript, an etching by Antoine Wierix, and recent works such as a painting by Rouault and a print by the contemporary Swiss artist Jörg Schuldhess.

1691. STEWART, IAN. "Diaghilev's Magic Lantern: The Work of Some Designers for the 'Ballets Russes.'" *Country Life* 151:3901(16 March 1972):626-7. 6 illus.

The most flamboyant revelation of what artists could do in the theatre was provided by Sergei Diaghilev's "Ballets Russes" when they burst upon Paris in 1909. Here a synthesis of music, dance and decorative design was fully realized. The revolution in décor consisted principally in the abandonment of realistic perspectives in favor of a simplified, brilliantly colored, animated picture. Léon Bakst was the most successful and versatile designer in an exotic vein but the First World War cut Diaghilev off from Russia and impelled him into a search for new artists in Europe: Picasso, Derain, Matisse, Braque, Ernst, Miró, and Rouault all worked for him in this second decade.

1692. SUTTON, DENYS. "Tsar of Ballet: Sergei Pavlovich Diaghilev." *Apollo* 90:92(Oct. 1969):282-291.

1693. WEILEY, SUSAN. "Newman's People." *Art News* 86:10(Dec. 1987):128-34.

Details the life and career of portrait photographer Arnold Newman, including a brief mention of Rouault.

1694. WERNER, ALFRED. "Vollard's Special Genius." *Art and Artists* 12:4(Aug. 1977):8-13. 5 illus.

Believes that the reason why New York's Museum of Modern Art has produced both an exhibition and a book on the dealer Ambroise Vollard is that "Vollard may have had the talents of a manager—an impresario—but he also had the eyes of and even some of the instincts generally attributed to artists." He looks briefly at Vollard's life and career and some of the artists he dealt with, including Cézanne, Chagall, Matisse, Picasso, Redon, and Rouault. One of Vollard's contributions to the world of art was that he "staked his fortune on some of the contemporary masters rather than on safe, classical art, and used modern methods of promotion, without resorting to vulgarity."

1695. WOODS, W. F. "Kamperman Collection." *Detroit Institute of Art Bulletin* 44:11(1965):10-1.

Mentions Rouault's *Tramp*.

1696. ZAHAR, MARCEL. "Les Maîtres de l'art indépendant au Petit Palais." *Beaux-arts* (2 July 1937):2.

V. Exhibitions

A. Individual Exhibitions

1906, February

Paris, Galerie Berthe Weill. *Exposition Rouault.* Reviews: *Gil Blas* (2 Feb. 1906); H. de Pesquidoux, *L'Idée* (15 Feb. 1906).

1906,
4-30 December

Paris, Galerie Berthe Weill. *Exposition Georges Rouault.* Reviews: A. Lantoine, *La Fédération artistique* (Brussels)(9 Dec. 1906); C. Morrice, *Mercure de France* (1 Jan. 1907).

1910,
21 February-
5 March

Paris, Galerie E. Druet. *Exposition Georges Rouault.* Préface de Jacques Favelle (pseud. for Jacques Maritain). 121 paintings, 8 drawings, 44 ceramics "executées chez A. Methey." Reviews: G. Bal, *New York Herald* (22 Feb. 1910); *Journal des arts* (23 Feb. 1910); J. Schnerb, *La Chronique des arts* (26 Feb. 1910); *Le Siècle* (27 Feb. 1910); L. Vauxcelles, *Gil Blas* (27 Feb. 1910); G. Frappier, *La République* (March 1910); L. Rouau, *Les Marges* (March 1910); A. S., *Paris-journal* (March 1910); C. Henri-Gigot, *Les Nouvelles* (1 March 1910); *L'Action* (5 March 1910); S. Bender, *Le Courrier français* (9 March 1910); *Gazette de la capitale* (5 March 1910); *L'Aurore* (7 March 1910); *Les Echos parisiens* (10 March 1910); *Paris-journal* (14 March 1910); *Le Progrès* (15 March 1910); *Les Echos parisiens* (16 March 1910); C. Morice, *Mercure de France* (16 March 1910); G. Apollinaire, *L'Intransigeant* (18 March 1910); Tavier, *Le Feu* (Marseille)(1 April 1910).

1911-12,
December-
January

Paris, Galerie E. Druet. *Exposition Georges Rouault.* 45 paintings, 58 cermaics. Reviews: *Les Nouvelles* (11 Dec. 1911); A. Salmon, *Paris-journal* (12 Dec. 1911); L. Vauxcelles, *Gil Blas* (15 Dec. 1911); *L'Action* (17 Dec. 1911); L'Imagier, *Siècle* (17 Dec. 1911); Le Gay, *L'Univers et le monde* (26 Dec. 1911); J. Burkley, *L'Assiette au beurre* (30 Dec. 1911); Le Gay, *La Gazette de Liège* (5 Jan. 1912); R. Michaud, *La Revue du mois* (10 Jan. 1912); G. Kahn, *Mercure de France* (16 Jan. 1912); R. Allard, *La Revue indépendante* (Jan. 1912); G. Martin, *La Renaissance contemporaine* (24 Jan. 1912).

1920,
10-20 November

Paris, Galerie La Licorne. *Exposition Georges Rouault.* Reviews: L. Vauxcelles, *L'Amour de l'art* 1(1920):243-4; R. de Nereys, *L'Homme libre* (Oct.-Nov. 1920); R. de Nereys, *La Renaissance* (21 Nov. 1920); *Le Monde de l'art* (Nov. 1920); G. Varenne, *Bonsoir* (16 Nov. 1920); *New York Herald* (18 Nov. 1920); René-Jean, *Comœdia* (20 Nov. 1920); A. Salmon, *L'Europe nouvelle* (28 Nov. 1920); F. Vanderpyl, *Le Petit parisien* (28 Novv. 1920); A. Warnod, *L'Amour de l'art* (Nov. 1920); A. Warnod, *L'Humanité* (1 and 15 Dec. 1920); A. Warnod, *Le Calepin* (15 Dec. 1920).

| 1922 | Paris, Galerie Barbazanges. Pastels. |

1924, 22 April-
2 May — Paris, Galerie E. Druet, *Rétrospective Georges Rouault (1897 à 1919)*. 8 p. 88 paintings, 8 ceramics. Reviews: L. Léon-Martin, *Paris-soir* (27 April 1924); René-Jean, *Comœdia* (27 April 1924); A. Warnod, *L'Avenir* (28 April 1924); *Journal des débats* (28 April 1924); R. Chavance, *La Liberté* (29 April 1924).

1925, 15 March-
30 May — Berlin, Galerie Flechtheim. *Georges Rouault*. Also shown Düsseldorf, Galerie Flechtheim (10-30 May 1925). Reviews: C. Einstein, *Der Querschnitt* 5(March 1925):244; G. Charensol, *La Gazette de France* (6 March 1925); C. Glaser, *Berliner Börsen-Couvrier* (18 March 1925); R. Landau, *8 Uhr Abendblatt* (19 March 1925); F. Stahl, *Berliner Tageblatt* (27 March 1925).

1926 — New York, New Art Circle. *Etchings by Rouault, Published by Ambroise Vollard*. Also shown Berlin, Neue Kunstgemeinschaft.

1927 — Paris, Galerie Bing. *Georges Rouault*.

1929 — Paris, Galerie des Quatre-Chemins. *Georges Rouault*. Watercolors and gouaches.

1930 — New York, Brummer Galleries. *Georges Rouault*. Reviews: *Art News* 28(5 April 1930):10; *Art Digest* 4(15 April 1930):16; F. Watson, *Arts Magazine* 16(April 1930):578-9; *Parnassus* 2(April 1930):5.

1930 — New York, J. B. Neumann Galleries. *Exhibition of Rouault Prints*. Also shown Munich, G. Franke. Preface by Will Grohmann. 47 p., illus., pl. Gouaches, pastels, lithographs. Volume in "The Art Lover Library" series. Review: L. Goodrich, *Arts Magazine* 17(Nov. 1930):120.

1930, June-July — London, Saint-George Gallery. *George Rouault*.

1930 — Chicago, Art Club of Chicago. *Georges Rouault*.

1931 — New York, Demotte Gallery.

1931 — Brussels, Galerie Schwarzenberg. *Georges Rouault*. Préface de Paul Fierens.

1931 — Geneva, Musée de l'Athénée. *Exposition Georges Rouault*.

1933 — New York, Julien Levy Galleries. *Rouault Etchings*. Review: *Art News* 31(6 May 1933):5.

1933, December New York, Pierre Matisse Gallery. *Georges Rouault Exhibition.* 40 works. Reviews: *Art News* 32(28 Oct. 1933):5; *Art Digest* 8(1 Nov. 1933):13; *Studio News* 5(Dec. 1933):1,3.

1935 Northampton, MA, Smith College Museum of Art. *Georges Rouault.*

1935 Mayor Gallery. *Rouault.* Review: E. Holding, *Axis* 4(Nov. 1935):26.

1936, March Paris, Galerie Kaganovitch (Le Portique). *Exposition Georges Rouault.* Reviews: J. de Laprade, *Beaux-arts* (14 Feb. 1936):8; *Art News* 34(7 March 1936):12.

1937 Philadelphia, *Georges Rouault Prints.* Review: *Philadelphia Art Alliance Bulletin* (April 1937):3.

1937,
9 November-
4 December New York, Pierre Matisse Gallery. *Georges Rouault: A Selection of Early Paintings, Water Colors, Tempera Paintings and Gouaches from the Year Nineteen Hundred and Four, to the Year Nineteen Hundred and Seventeen.* Reviews: *Art Digest* 12(15 Nov. 1937):13; M. Davidson, *Art News* 36(20 Nov. 1937):8[+]; M. Breuning, *Parnassus* 9(Dec. 1937):22-4.

1938 New York, Museum of Modern Art. *The Prints of Georges Rouault.* Catalogue by Monroe Wheeler. 24 p., illus., pl. Reviews: *Art Digest* 14(15 May 1940):6; G. Lo Duca, *Emporium* 88(Oct. 1938):223.

1939 New York, Pierre Matisse Gallery. Reviews: *Art News* 37(11 Feb. 1939):11; *Art Digest* 13(15 Feb. 1939):20; *Parnassus* 11(April 1939):21;

1939 Lawrence, University of Kansas. *Georges Rouault.* Review: *Art Digest* 13(1 May 1939):22.

1939 Springfield, MA, *Georges Rouault, Prints.* Review: *Springfield, Massachusetts Museum of Fine Arts Bulletin* 5(Feb.-March 1939):2.

1939 Williamburg, VA. William and Mary College. *Rouault's Graphic Work.* Review: *Art News* 37(22 April 1939):18.

1939 Paris Galerie O. Petridès. Reviews: *Beaux-arts* (3 March 1939):4; G. Lo Duco, *Emporium* 89(June 1939):402.

1939 New York, Bignou Gallery.

1940, February Kansas City, Nelson-Atkins Gallery of Art. *Exhibition of Georges Rouault Prints.* Review: *Nelson Gallery of Art News* 8(Feb. 1940):1-2.

1940	Portland, OR. Portland Art Museum. *Georges Rouault, Prints.* Review: *Portland, Oregon Art Museum Bulletin* 1(April 1940):1-2.
1940, 6-25 May	New York, Buchholz Gallery. *Georges Rouault Lithographs & Etchings.* 8 p., illus. Review: A. Frankfurter, *Art News* 38(11 May 1940):12⁺.

1940, 6-25 May New York, Buchholz Gallery. *Georges Rouault Lithographs & Etchings.* 8 p., illus. Review: A. Frankfurter, *Art News* 38(11 May 1940):12⁺.

1940 New York, Bignou Gallery. Reviews: E. McCausland, *Parnassus* 12(May 1940):40; A. Frankfurter, *Art News* 38(11 May 1940):12⁺; *Art Digest* 14(15 May 1940):20.

1940 Los Angeles, Datzell Hatfield Gallery.

1940 London, Redfern Gallery. Review: T. McGreevy, *London Studio* 20, *Studio* 120(Oct. 1940):137.

1940-41, November- 3 May Boston, Institute of Modern Art. *Georges Rouault: Retrospective Loan Exhibition.* Also shown Washington, D. C., Phillips Memorial Gallery; San Francisco, San Francisco Museum of Art; selections: New York, Marie Harriman Gallery (7 April-3 May 1941). Preface by Lionello Venturi. 96 p., illus.
a. 2nd ed.: 66 p., illus.
Reviews: J. Watson, *Magazine of Art* 33(Oct. 1940):586⁺; A. Frankfurter, *Art News* 39(9 Nov. 1940):6-9⁺; *Art Digest* 15(15 Nov. 1940):13; *Parnassus* 12(Dec. 1940):32; *Magazine of Art* 34(Feb. 1941):86-7; C. Lindstrom, *Architect & Engineer* 144(Feb. 1941):9; *California Arts & Architecture* 58(March 1941):8-9.

1941 New York, Pierre Matisse Gallery. Review: *Art Digest* 15(15 Jan. 1941):8.

1941, 7 April- 3 May New York, Marie Harriman Gallery. *Georges Rouault: A Selection from the Retrospective Loan Exhibition held at Boston, The Institute of Modern Art; Washington, The Phillips Memorial Gallery; San Francisco, The San Francisco Museum of Art.* 66 p., 32 illus. Reviews: *Art Digest* 15(15 April 1941):10; *Art News* 40(15 April 1941):27.

1942, 15 April- 9 May Paris, Galerie Louis Carré. *Rouault.* Préface de Bernard Dorival. 30 p., pl. 10 paintings.

1945 New York, Museum of Modern Art. *Georges Rouault: Paintings and Prints.* Catalogue by James Thrall Soby and Carl O. Schniewind. 132 p., illus., 3 col. 161 paintings, prints, decorations, and tapesties.
a. Other eds.: 1947, 1971.
Reviews: *Art Digest* 19(155 April 1945):7; A. Frankfurter, *Art News* 44:5(15 April 1945):16⁺; *Pictures on Exhibit* 6(May

1945):4-5; *Architectural Forum* 82(June 1945):68; *Studio* 130(Dec. 1945):188-9.

1945	Utica, NY, Munson-Williams-Proctor Institute. *Prints by Georges Rouault*. Review: *Munson-Williams-Proctor Institute Bulletin* (May 1945):4-5.
1946	Paris, Galerie St. Etienne. *Rouault*. Reviews: *Art Digest* 20(1 March 1946):16; *Pictures on Exhibit* 8(March 1946):18; *Art News* 45:1(March 1946):52.
1946, April	London, Tate Gallery. *Georges Rouault*. Catalogue by Waldemar George. 14 paintings, 25 prints.
1946, 12-30 April	Paris, Galerie René Drouin. *Pour un art religieux*. Préface de l'Abbé Maurice Morel. 117 paintinsg, 30 prints.
1947, 7 February- 1 March	Paris, Galerie Odette des Garets. *Georges Rouault: œuvres recentes*. Texte de Marcel Arland. 40 paintings. Reviews: P. Descargues, *Arts Magazine* (14 Feb. 1947):1[+]; *Emporium* 105(April 1947):180.
1947, 11 March- 5 April	New York, Pierre Matisse Gallery. *Georges Rouault, Paintings*. Reviews: *Art Digest* 21(15 March 1947):16; *Art News* 46:2(April 1947):18.
1947	Prague, Galerie du Cercle des intellectuels. *Exposition Georges Rouault*. 10 paintings, 25 prints.
1948, January	London, Redfern Gallery. *Georges Rouault; Original Aquatints for Miserere and Guerre*. 8 p., 17 pl.
1948, April-June	Zurich, Kunsthaus. *Georges Rouault*. Einleitung von Abbé Maurice Morel; Ausführliches Verzeichnis der ausgestellten Werke, von R. Wehrli. Nachwort mit Literaturverzeichnis, von W. Wartmann. 24 Abbildungen. 56 p., illus., 24 pl. 184 paintings, gouaches, watercolors, monotypes, lithographs, and etchings. Reviews: *Werk* 35(May 1948):58-9; D. Chevalier, *Arts Magazine* (28 May 1948):3; *Emporium* 107(June 1948):272-5.
1948	Venice, *Biennale*. 25 paintings.
1948, Fall- 21 December	Paris, Musée National d'Art moderne. *Miserere*. Also shown Galerie Odette des Garets (27 Nov.-21 December). Complete *Miserere* series. The exhibitions of *Miserere* since 1948 are too numerous to cite. Rouault's *Miserere* series has been shown continuously since 1948.

1948, 14 February- 5 March	New York, Kleemann Galleries. *Georges Rouault; Miserere et guerre: 59 aquatints.* 16 p., illus. Reviews: *Art Digest* 23(1 Feb. 1949):22 and (15 Feb. 1949):21.
1949	New York, Biney Gallery. Included Rouault's *Passion* series of wood engravings and colored etchings. Reviews: *Art Digest* 24(15 Oct. 1949):18; *Art News* 48:7(Nov. 1949):52.
1949, 31 October- 26 November	New York, Perls Galleries. *Georges Rouault, Paintings.* 8 p., illus. 25 paintings. Reviews: *Art News* 48:7(Nov. 1949):44+; *Pictures on Exhibit* 12(Nov. 1949):14, 32; *Art Digest* 24(1 Nov. 1949):13.
1949	Rotterdam, Museum Boymans. *Georges Rouault; Tentoonstelling: Etsen & Schilderijen.* 24 p., illus.
1949-50	Anvers, Musée d'Anvers. *Exposition de 26 peintures et gravures du Miserere.* Also shown La Louvière, Liège, Ghent, Rotterdam, Lille, Arras, Amiens, Besançon, Mulhouse, Karlsruhe, Munich, and Fribourg-en-Brisgau. Prefaces by Léon Lehmann and Kurt Martin.
1950	Bueños Aires, Museo nacional de arte decorativo. *Georges Rouault.* Review: *Museo nacional de arte decorativo* 5(April-June 1950):8.
1950	Bueños-Aires, Witcomb Galleria. *Miserere.* Preface by Jorge Roméro Brest.
1950, 2-17 June	Paris, Galeric Marigny. *Œuvres de Rouault.* 15 works.
1950	*Exhibition of Rouault Prints from Rev. Richard J. Dovaire Collection.*
1950	Kansas City, Nelson-Atkins Museum of Art. *Rouault Prints.* Review: *Nelson Gallery of Art News* 17(Dec. 1950).
1951	Brooklyn, Brooklyn Museum of Art. *Graphic Work by Rouault.* Review: *Art Digest* 26:7(1 Jan. 1952):13.
1951	Paris, Galerie Max Kaganovitch. Review: *Pictures on Exhibit* 13(July 1951):26.
1951	Stockholm, Samlaren Gallery. *Georges Rouault.* Also shown Göteborg, Museum of Göteborg. 16 paintings and prints.
1952, 21 March- 30 June	Brussels, Palais des Beaux-arts. *Georges Rouault.* Also shown Amsterdam, Stedelijk Museum (29 May-30 June). Préfaces de Georges Salles et Lionello Venturi. 78 paintings, prints.

1952	New York, Wildenstein Gallery. *Rouault, gouaches*. Included Rouault's gouaches for *Le Cirque de l'étoile filante*. Reviews: *Art News* 51(April 1952):43; *Art Digest* 26:14(15 April 1952):13.
1952, 9 July- 26 October	Paris, Musée d'Art moderne de la Ville de Paris. *Georges Rouault*. Préfaces de Georges Salles et Lionello Venturi. 39 p., 30 pl. 104 paintings, prints, ceramics, stained glass, enamels, tapestries. Reviews: *Apollo* 56(Sept. 1952):66; *Studio* 144(Dec. 1952):186.
1952	Paris, Galerie Louis Carré. *Le Miserere: cinquante-huit planches gravées par Georges Rouault*. Préface de Thierry Maulnier. 26 p., illus. Second complete presentation of *Miserere*.
1953	Cleveland, Cleveland Museum of Art. *Rouault*. Preface by Jacques Maritain. 67 paintings and prints. Also shown New York, Museum of Modern Art; Los Angeles, Los Angeles County Museum of Art (90 paintings). 32 p., illus. Reviews: *Art Digest* 27:8(15 Jan. 1953):10; *Art News* 51(Feb. 1953):52; W. Sargeant, *Life* 34(2 Feb. 1953):56-62[+]; *Art Digest* 27:3(1 April 1953):13; S. Geist, *Art Digest* 27:14(15 April 1953):10[+]; *Art News* 52(May 1953):23[+]; *Interiors* 112(May 1953):10; *Time* 62(27 July 1953):68-71; *Los Angeles County Museum of Art Bulletin* 5:3(1953):1-34; K. Lansner, *Kenyon Review* 15:3(1953):455-60.
1953	Tokyo, National Museum. *Georges Rouault*. Organisé par le Musée National de Tokio, le journal *Yomiri* sous le patronage du gouvernement français. Catalogue predité par Shigetaro Fukushima. Préface de Marcel Arland. 31 p., illus., pl. 85 paintings and prints.
1953, 11 November- 10 December	Osaka, Shiritsu Bijutsukan. *Ruōten: Nichi Futsu bunka Kyōtei hakkō Kinen*. Sponsored by Tokyo Kokuritsu Hakubutsukan, Yomiuri Shinbunsha. Catalogue by Furansu Seifu. 23 p., illus., some col.
1953	New York, Museum of Modern Art.
1953	Los Angeles, Los Angeles County Museum of Art. *Georges Rouault*. Also shown Cleveland and New York (with 90 additional paintings).
1954	New York, Carstairs Gallery. Included Rouault's series of paintings and etchings based on A. Jarry's play, *Ubu roi*, and color etchings for *Les Fleurs du mal*. Reviews: *Art Digest* 29:11(1 March 1954):18-9; *Art News* 53:1(March 1954):40.

1954, April-June	Milan, Galleria d'arte moderna, Padiglione d'arte contemporanea. *Mostra di Georges Rouault.* Preface de l'Abbé Maurice Morel. 46 p., illus., 75 pl. 114 paintings, prints, ceramics, stained glass, enamels, tapestries.
1955, 11 June- 16 July	Jerusalem, Musée national Bézalel. *Georges Rouault, œuvres graphiques choisies: "Miserere," 58 eaux-fortes, eaux-fortes en couleur et des reproductions en facsimile.* Préface de M. Narkiss. 12 p., illus.
1956, 20 July- 30 September	Albi, Musée Toulouse-Lautrec, Palais de la Berbie. *Exposition Georges Rouault peintures, gouaches, Miserere.* Préface de René Huyghe. 47 paintings, watercolors, gouaches, drawings, pastels, and engravings from *Miserere*.
1956, 12 November- 22 December	New York, Perls Galleries. *Georges Rouault (1871-).* 30 paintings. Reviews: *Art News* 55:8(Dec. 1956):8; *Arts Magazine* 31:2(Dec. 1956):50.
1957, 23 April- 15 May	New York, Schoneman Galleries. *A Loan Exhibition of Paintings by G. Rouault.* 15 p., illus. Reviews: *Art News* 56:3(May 1957):15; *Arts Magazine* 31:9(June 1957):52.
1957, 11 June- 30 July	Geneva, Galerie Gérald Cramer. *Georges Rouault; Miserere.* 4 p., illus.
1958	New York, Kirkeby Collection. Review: *Arts Magazine* 33:2(Nov. 1958):27-31.
1958	Tokyo, Mizue. *Hommage à Rouault.*
1960, February	Vienna, Albertina. *Georges Rouault, 1871-1958; Gedächtnisausstellung.* Texts by Otto Benesch, Bernard Dorival, Jean Valléry-Rado. 34 p., 1 pl. 278 drawings and prints.
1960, 3 June- 15 July	Paris, Galerie Creuzevault. *Georges Rouault.* 23 paintings and prints. Reviews: K. Morand, *Burlington Magazine* 102:809(Aug. 1960):377; A. Watt, *Studio* 160(Sept. 1960):105; P. Schneider, *Art News* 59:7(Nov. 1960):73.
1960, May	Dublin, The Building Centre. 15 paintings, *Le Miserere,* 15 paintings. Catalogue with poems by Mgr. Padraid de Brun.
1960, 13 June- 11 September	Marseille, Musée Cantini. *Rouault.* Préface de Bernard Dorival. 128 works.
1960, 18 October- 26 November	New York, Perls Galleries. *Georges Rouault (1871-1958); The Later Years.* 16 p., illus., some col. 24 paintings. Reviews: *Art News* 59:7(Nov. 1960):16-7; *Arts Magazine* 35:3(Dec. 1960):51; S. Preston, *Burlington Magazine* 102(Dec. 1960):549.

1960 Lisbon, S. N. I. *Exposicāo o Miserere de Georges Rouault.*

1960 Vienna, Albertina Museum. *Georges Rouault.* German preface
 by Otto Benesh; French prefaces by Bernard Dorival and Jean
 Valléry-Rado. 278 prints and drawings.

1960, 2 August Assisi, Pro Civitate Cristiana. *Georges Rouault.* Paintings and
 engravings.

1961, Ghent, Museum voor Schone Kunsten. *Hommage à Georges*
23 September- *Rouault.* Préface de Georges Chabot. 58 p., illus., 16 pl. 76
5 November works.

1961, Los Angeles, Los Angeles County Museum of Art. *Georges*
1 November- *Rouault Prints from the Collection of Harold P. and Jane F.*
17 December *Ullman.* Preface by Ebria Feinblatt. 56 p., illus. 200 works.

1962, January- Basel, Galerie Beyeler. *Georges Rouault.* 44 p., illus., pl.,
March some col. 47 works. Review: *Werk* 49(March 1962):68.

1962 London, Redfern Gallery. *Georges Rouault.* Prints. Review:
 M. Amaya, *Apollo* 76(April 1962):149.

1962, Dallas, Valley House Gallery. *Georges Rouault: Passion.* 66
15 November- p., 34 illus., 10 col. In English and French.
31 December

1963, 12 May- Dieppe, Musée de Dieppe. *Georges Rouault.* Préface de Jean
16 September Lapeyre. 104 p., 64 illus. 88 works. Review: G. Marchiori,
 Quadrum 15(1903):147-9.

1964, 23 June- Paris, Musée du Louvre. *Exposition Georges Rouault; œuvres*
9 November *inachevées données à l'Etat.* Préface de Bernard Dorival. 128
 p., 24 illus. 181 works. Reviews: G. Metken, *Kunstwerk*
 18(Nov. 1964):19; G. Schurr, *Connoisseur* 157(Dec. 1964):256;
 M. Pradel, *Revue du Louvre et des musées de France*
 14:3(19164):103-6.

1964, La Jolla, CA, La Jolla Museum of Art. *Works of Georges*
25 September- *Rouault; Paintings and Graphics.* 22 p., illus.
1 November

1964 Manchester, NH, Currier Gallery of Art. *The Wounded Clown.*
 Highlights Rouault's *The Wounded Clown* (1939), oil on paper
 mounted on masonite, a recent museum acquisition. Review:
 Burlington Magazine 106:740(Nov. 1964):543.

1965 New York, Perls Gallery. *Georges Rouault's The Passion.* 54
 paintings. Works executed between 1930-38, used as the basis
 for the artist's illustrations of André Suarès' *The Passion.*

Reviews: *Art News* 63:9(Jan. 1965):10; J. Barnitz, *Arts Magazine* 39:4(Jan. 1965):57.

1965, 28 January- 2 May	Québec, Musée de Québec. *Rouault.* Also shown Montréal, Musée d'Art contemporain (19 March-2 May). 60 p., 36 illus., 4 col. In French; introduction and one essay also in English. 155 works.
1965	Paris, Galerie Charpentier. *Georges Rouault: Peintures inconnues ou célèbres.* Avant-propos par Raymond Nacenta. Texte inédit de Georges Rouault. 88 p., illus. 127 works. Reviews: A. Watt, *Art in America* 53:2(April 1965):138; G. Schurr, *Connoisseur* 159:639(May 1965):44.
1965, 1 July- 3 September	Colmar, Musée d'Unterlinden. *Georges Rouault.*
1965-66, 7 October- 23 January	Tokyo, Musée National d'Art occidental. *Georges Rouault: œuvres inachevées données à l'Etat.* Also shown Osaka, Musée Municipal des Beaux-arts (12 Dec. 1965-23 Jan. 1966). 139 p., illus., 36 pl., some col.
1965, 2 November- 4 December	New York, La Boetie Gallery. *Georges Rouault.* 8 p., illus., some col. 15 works. Review: *Arts Magazine* 40:2(Dec. 1965):57-8.
1966, 12 February- 1 May	Frankfurt-am-Main, Frankfurter Kunstverein, Steinernes Haus. Adolf und Luisa Haeuser. *Georges Rouault.* Also shown Hamburg, Kunstverein (2 April-1 May). Katalogbearbeitung: Ewald Rathke und Sylvia Rathke-Köhl. 50 p., 30 illus., 50 pl. 123 works.
1966, 9 June	Bern, Kornfeld und Klipstein. *Georges Rouault: Graphik und illustrierte Bücher.* Auktion in Bern, Donnerstag. 61 p., illus. Auction instructions in English, French, and German.
1966, 20 August- 3 November	Edinburgh, Edinburgh Festival Society. *Rouault: An Exhibition of Paintings, Drawings, and Documents.* Arranged by the Arts Council of Great Britain, in association with the Edinburgh Festival Society. Also shown London, Tate Gallery (8 Oct.-3 Nov.). 62 p., illus., 158 works. Text by John Russell. Review: J. Burr, *Apollo* 84:56(Oct. 1966):332; D. Irwin, *Burlington Magazine* 108:163(Oct. 1966):536-8; A. Gordon, *Connoisseur* 163:657(Nov. 1966):187; J. Herman, *Studio* 172:883(Nov. 1966):258-9.
1967	Paris, Galerie Creuzevault. *Georges Rouault.* Préface de Jacques Guignard. 14 aquatints for *Les Fleurs du mal*, 30 original lithographs, 5 paintings.

1968, February- 16 March	London. Graphic Art Associates. *Georges Rouault.* Graphics and series. Review: J. Burr, *Apollo* 87:73(March 1968):215-6.
1968, 9 October- 9 November	London, Victor Waddington Galleries. *Rouault, 1871-1958: Paintings, Watercolours, Gouaches, and the Fourteen Aquatints for Les Fleurs du mal.* 52 p., illus. Similar exhibition as Galerie Creuzevault, Paris (1967).
1970	New York, Old Print Center. *Rouault.* Review: *Arts Magazine* 44:7(May 1970):61.
1971, 12 February- 7 March	Rochester, NY, University of Rochester Memorial Art Gallery. *Rouault.* 52 paintings and engravings.
1971, 28 May- 28 September	Paris, Musée National d'Art moderne. *Georges Rouault; exposition du centenaire.* Préface de Jean Leymarie. Texte de Michel Hoog. Paris: Ministère des Affaires Culturelles, Réunion des Musées Nationaux, 1971. 244 p., illus., some col. Paintings, prints, and uncompleted works. Reviews: P. Descargues, *Connaissance des arts* 232(June 1971):21; A. Fermigier, *Art News* 70:5(Sept. 1971):9; J. Gàllego, *Goyá* 104(Sept. 1971):126-8; G. Schurr, *Connoisseur* 178:715(Sept. 1971):66-7; *Pantheon* 29(Sept. 1971):427; *Art International* 15(Nov. 1971):65; M. Hoog, *Revue du Louvre et des musées de France* 21:2(1971):123-32.
1971, 17 July- 17 September	Saint-Paul-de-Vence, Fondation Maeght. *Hommage à Rouault.*
1971, September- 15 November	Basel, Galerie Beyeler. *Georges Rouault: visionnaire.* 58 p., 31 illus., 28 col. Reviews: *Werk* 58:9(Sept. 1971)):636; W. Jehle, *Werk* 58:11(Nov. 1971):776-7.
1971, 20 October- 27 November	Tokyo, Gallery Yoshii. *Hommage à Rouault.*
1971-72, 5 November- 5 January	Bordeaux, Musée des Beaux-arts. *Hommage à Georges Rouault.*
1972, 16 January- 27 February	South Bend, IN, University of Notre Dame, Art Gallery. *The Graphic Work of Georges Rouault.* Catalogue by Anthony J. Lauck. 24 p., 10 illus. Exhibition of selected works in lithography, etching, aquatint, and wood engraving. The focal point of the show was the complete set of 58 plates from Rouault's' *Miserere et Guerre.* Comparisons were made with other series such as *Réincarnations du Père Ubu* (1932), *Les Fleurs du Mal* (1926-27, 1936-37),

Cirque de l'étoile filante (1938), and the *Passion* (1939). Anthony J. Lauck contributes "Rouault as a Religious Artist," giving biographical details and a discussion of some of the exhibited works in the light of their religious significance.

1972, 20 January-18 March	Cologne, Baukunst Gallery. *Georges Rouault, Ölbilder und Gouachen der Jahre 1897 bis 1956, Druckgraphik.*
1972	Worcester, MA, Worcester Art Museum. *Miserere of Georges Rouault.* Review: *Connoisseur* 180:724(June 1972):134-5.
1972, 12 June-1 July	London, Eskenazi Gallery, Ltd. *Georges Rouault, 1871-1958: Paintings and the Fourteen Aquatints for Les Fleurs du mal.* Arranged by Richard Nathanson. 9 p., illus., 15 pl. 26 works, including 12 paintings. Review: M. Wykes-Joyce, *Arts Review* 24:12(17 June 1972):357.
1973	Rochechouart, Centre artistique et littéraire. Included prints and wash-drawings by Rouault.
1973, 27 November-25 December	Tokyo, Idemitsu Art Gallery. *Passion-ten Rouault.* 44 p., 116 illus., 11 pl. 8 col. 54 paintings.
1973	Athens, Hilton Gallery. *Rouault.* Organized by the French Institute and the Hilton Gallery. 90 engravings.
1974, 23 March-28 July	Munich, Haus der Kunst. *Georges Rouault, 1871-1958.* Organized in association with the Arts Council of Great Britain, London. Also shown Manchester, England, City Art Galleries (4 June-28 July 1974). 137 works. Catalogue by Bernard Dorival. English trans. by P. S. Falla. 67 p., 101 illus., 8 col. 204 works shown. Contained paintings, gouaches, watercolors, and drawings, 105 prints and 7 examples of stained glass and ceramics. The period when Rouault's paintings output lessened and he turned to engravings, working directly for the dealer Ambroise Vollard (1914-28), was represented by three print series: *Misère, Réincarnations du Père Ubu*, and *Passion.* Reviews: *Connoisseur* 185(April 1974):308; J. Morschel, *Kunstwerk* 27:3(May 1974):80; *Art & Artists* 9(June 1974):12; *Studio* 187:967(June 1974):305; A. Arber, *Museums Journal* 75:1(June 1975):5-8; N. Arber, *Arts Review* 26:13(28 June 1974):400; T. Rothon, *Studio* 188:968(July 1974):vi, 50-1; *Apollo* 100:149(July 1974):70; H. Schneider, *Pantheon* 32:3(July-Sept. 1974):312.
1974, 2 May-4 June	Paris, Galerie Yoshii. *Georges Rouault.* 18 paintings.

1974, 4 June- 28 July	Manchester, Manchester City Art Gallery. *Rouault*. Sponsored by the Arts Council of Great Britain. Catalogue by Bernard Dorival. 137 paintings and engravings.
1975, January- February	Tel-Aviv, Museum of Tel-Aviv. *Georges Rouault*. Texts by Haim Gamzu and Jacques Lassaigne. 137 paintings and prints.
1976, 15 January- 28 February	Paris, Galerie Yoshii. *Georges Rouault*. Préface de Bernard Dorival. 16 watercolors.
1976-77, 9 October- 9 January	Marcq-en-Baroeul, Fondation Anne et Albert Provost. *Georges Rouault*. Préface de Jacques Lassaigne. 46 p., illus., some col. 61 paintings and engravings. Review: G. Schurr, *Connoisseur* 194:779(Jan. 1977):69.
1977	La Rochelle, Musée des Beaux-arts. *Le Miserere de Georges Rouault*. Texte de Bernard Dorival. 36 p., 14 illus. Bernard Dorival's introductory essay to this catalogue briefly refers to the circumstances in which Rouault created his *Miserere* series of prints in the periods 1922-23 and 1926-67. He goes on to explain how the prints are divided into two separate groups, the first being the *Miserere* proper comprising 33 prints, and the second, the *War* group, comprising 24 prints. Dorival analyzes the progression in the successive prints' expression of suffering, drawing comparisons with the work of other artists including Goyá and the Expressionists. The architectural character of Rouault's representation of form and the blend of lyricism, human pity, and humor are also considered. Review: *L'Œil* 267(Oct. 1977):51.
1977-78	Baltimore, Baltimore Museum of Art. *Georges Rouault: Miserere*. Also shown at ten other locations. Essay by Jay M. Fisher. 6 p., 1 illus. 25 works shown. Illustrations for the *Miserere* were drawn from the Baltimore Museum of Art's collections.
1977	Tokyo, Yoshii Gallery. *Georges Rouault—Miserere*. Preface by Fukumatsu Miwa. 14 paintings and 58 plates from *Miserere*.
1978, 30 May- 13 July	Paris, Musée d'Art moderne de la Ville de Paris. Galerie Guiot. *Exposition Georges Rouault*. Préface de François Chapon et Jacques Lassaigne. Engravings and lithographs. Review: J.-P. Dauriac, *Pantheon* 36(Oct. 1978):377.
1978, 31 May- 10 September	Paris, Musée d'Art moderne de la Ville de Paris. *Georges Rouault: sur le thème du 'Miserere,' peintures et lavis inconnus*. Préface de François Chapon. 9 p., 43 works. Included Rouault's *Miserere* paintings and prpeviously unknown wash-drawings. Review: J.-P. Dauriac, *Pantheon* 36:4(Oct.-Dec. 1978):377.

1978, 10-23 June	London, Fine Art Society. *Georges Rouault*. Organized by Richard Nathanson. 14 works. Review: *Art & Artist* 13(Aug. 1978):48-50.
1978, 4 July- 6 September	Buffalo, Albright-Knox Art Gallerry. *Prints by Georges Rouault in the Collection*. Catalogue by Charlotta Kotik. 4 p., 2 illus., 37 works shown.
1978-79, 25 November- 28 January	Tokyo, Tamenaga Gallery. *Georges Rouault*. Also shown Osaka, Umeda Museum of Modern Art (9-28 Jan. 1979). Preface by H. Takata.
1979, 8 May- September	Tokyo, Yoshii Gallery. *Rouault*. Preface by Hideo Kobayashi, introduction by Geneviève Nouaille-Rouault. Traveling exhibition in Japan (June-Sept.). 97 p., illus. 72 paintings and wash-drawings.
1979, 17 November- 30 December	Mons, Musée des Beaux-arts. *Hommage à Georges Rouault. Art cru*. Texte de Gaëtan Picon. Paintings, gouaches, and engravings.
1979	Montréal, Musée de l'Oratoire Saint-Joseph. *Le Miserere de Georges Rouault*. 32 p., illus., includes 1 inserted sheet with English translation of texts.
1980	La Rochelle, Musée des Beaux-arts. *Le Miserere de Georges Rouault*. Review: L. Carrier, *Revue du Louvre et des musées de France* 30:5-6(1980):373-4.
1980, 21 October- 20 December	Paris, Galerie les Arts plastiques modernes. *George Rouault*. 15 paintings. Review: *L'Œil* 304(Nov. 1980):81.
1982, 6-29 November	Paris, Grand Palais, *Salon d'Automne. Hommage à Georges Rouault*. Texte de Bernard Dorival. 43 paintings and engravings. Review: B. Dorival, *L'Œil* 328(Nov. 1982):34-9.
1982-83, 9 December- 27 January	London, Redfern Gallery. *Georges Rouault*. Review: G. Burn, *Arts Review* 34:25(3 Dec. 1982):637; *Arts & Artists* 196(Jan. 1983):38.
1983	Los Angeles, Jack Rutberg Fine Arts Gallery. *Georges Rouault*. Review: R. Weisberg, *Artweek* 14:5(5 Feb. 1983):16.
1983, 11 March- 8 May	Cologne, Josef-Haubrich-Kunsthalle. *Georges Rouault*. Konzept und Leitung, Siegfried Gohr; organisation, Mia Storch. Text von Rainer Beck. 224 p., 181 illus., 22 col. Review: D. Kiocks, *Pantheon* 41(July-Sept. 1983):262-4.

1984, 28 March- 28 April	Paris, La Bouquinerie de l'Institute Paris. *Rouault, estampes diverses, épreuves rares.* 7 p. Review: *L'Œil* 346(May 1984):85.
1984, July- September	Avignon, Palais des Papes. *Exposition Rouault.* Paintings and engravings.
1984	Tokyo, Metropolitan Teien Art Museum. *Georges Rouault.* 90 paintings and engravings.
1985, 28 March- 28 April	Paris, La Bouquinerie de l'Institut. *Rouault, gravures.*
1986	London, Institut Français. *Miserere.* Review: L. Berryman, *Arts Review* 38(20 June 1986):335-6.
1986	Ontario, Art Gallery of Ontario. *Georges Rouault: Miserere.* Exhibition organized and circulated by the Art Gallery of Ontario. Catalogue by Brenda D. Rix. 16 p., illus.
1986	Tokyo, Idemitsu Museum. *Georges Rouault.* Paintings and engravings.
1988, 8-31 March	Paris, Galerie J. F. Gabbi. *Exposition Georges Rouault.* Gouaches and wash-drawings.
1988	Gradisca d'Isonzo, Galleria Regionale d'arte contemporanea Luigi Spazzapan. *Georges Rouault: incisore e litografo.* Triennale europea dell'incisione di Grado. Catalogo a cura di Paolo Bellini; schede di Silvia Beretta e Daniela Corti. Italy: Edizioni della Laguna, 1988. 127 p., illus.
1988, 26 October- 23 November	Berlin, Kunstamt Wedding, Schinkelsaal, Alte Nazareth Kirche. *Georges Rouault, 1871-1958.* Redaktion, Peter Hopf; Mitarbeit, Elisabeth Heyn, Hartmut Müller. 263 p., illus., some col. Paintings, watercolors, and engravings.
1990, 30 June- 9 September	Avallon, Centre Culturel de l'Yonne. *Georges Rouault.* Engravings, watercolors, and paintings.
1990, 15 September- 17 November	Japan, Kyoharu Shirakaba Museum. *Georges Rouault.* Also shown Osaka, Umeda Museum of Modern Art (5-17 Nov.). Preface by Professor Yanagi. 50 paintings.
1990, November	Japan, Tokuyama Bunka Kaikan. *Georges Rouault.* *Une partie de la collection Idemitsu.*
1991, 15 March- 20 April	Tokyo, Yoshii Gallery. Georges *Rouault.* Engravings and paintings on the *Miserere* theme.

1991, 10 May- 10 June	Dijon, Musée des Beaux-arts. *Autour d'un portrait de Verlaine par Rouault.*

1991, September New York, Elysiam Gallery. *Georges Rouault.* Paintings and engravings.
Review: B. Goodstein, *Art & Antiques* 8:10(Dec. 1991):96.

1992,
27 February-
4 March Paris, Centre Georges Pompidou. *Georges Rouault. Première periode 1903 à 1920.* 260 p., illus., some col.
Reviews: G. Danto, *Art News* 91:5(May 1992):139; *Connaissance des arts* 481(March 1992):18; M. James, *Burlington Magazine* 134:1071(June 1992):398-400.

1993, 11 March-
6 June London, Royal Academy of Arts. *Rouault: The Early Years, 1903-1920.* Catalogue by Fabrice Hergott and Sarah Whitfield. 80 p., illus., 32 col. pl. 94 works shown.

1993, Summer-
17 October Salzburg, Rupertinum. *Rouault: Malerei und Graphik* [Rouault: Paintings and Drawings]. Review: C. Andreae, *Christian Science Monitor* (20 Sept. 1993):16-7.

B. Group Exhibitions

1895 Paris, *Salon des Champs-Elysées.* Reviews: M. Fouquier, *Le XIXᵉ siècle* (6 and 14 May 1895); M.-F. Javel, *L'Art français* (13 May 1895); R. Serlat, *La Revue encyclopédique* (15 May 1895):187; H. Pellier, *La Petite république* (May 1895); P. Flat, *La Revue bleue* (8 June 1895); A. Michel, *Le Journal des débats* (10 June 1895); *L'Etendard* (18 June 1895).

1895 Paris, *Concours pour le prix de Rome.* Reviews: *Le Matin* (18 July 1895); Conte, *L'Echo de Paris* (21 July 1895); *L'Eclair* (21 July 1895); Bonneterre, *Le Moniteur* (22 July 1895); A. M., *Le Journal des débats* (22 July 1895); *Le Figaro* (22 July 1895); R. Benoist, *Le Moniteur universel* (23 July 1895); *Le Matin* (23 July 1895); Brassac, *Plébiscite* (4 Aug. 1895); *Fraternité* (4 Aug. 1895).

1895 Paris, *Salon des Artistes français.* 2 works: *L'Enfant Jésus parmi les docteurs* and *Etude de tête.*
Rouault participated under the name Rouault-Champdavoine.

1896, March Paris, *Salon des Champs-Elysées.* Reviews: C. Roger-Marx, *Le Public* (1 May 1896); C. Roger-Marx, *La Revue encyclopédique* (2 May 1896):299; Thiebault-Sisson, *Le Temps* (23 May 1896); P. Flat, *La Revue bleue* (6 June 1896); Debay, *Demain* (11 June 1896); P. Carbo, *Le Progrès artistique* (18 June 1896); L. Saint-Valery, *La Revue des Beaux-arts* (June 1896); Weyl, *L'Art et la vie* (June 1896); G. Geffroy, *La Vie artistique* (1897):328.

1897, 8 March-April	Paris, *Salon de la Rose-Croix*. 12 paintings. Reviews: E. L., *La Revue blanche* (15 March 1897); *Le Courrier du soir* (17 March 1897); *Le Thyrse* (April 1897).
1897, April	Paris, *Salon des Artistes français*. 2 drawings.
1897	Paris, *Salon des Champs-Elysées*. Reviews: A. Alexandre, *Le Figaro* (19 April 1897); G. Geffroy, *Le Journal* (19 April 1897); C. Roger-Marx, *Le Public* (20 April 1897).
1899	Paris, *Salon des Champs-Elysées*. Review: G. Geffroy, *La Vie artistique de 1900* (1900):427.
1900	Paris, *Exposition Universelle*. Review: G. Geffroy, *La Vie artistique de 1901* (1901):101.
1900	Paris, *Salon des Champs-Elysées*. Review: G. Geffroy, *La Vie artistique de 1903* (1903):339.
1901	Paris, *Salon des Champs-Elysées*. Review: G. Geffroy, *La Vie artistique de 1903* (1903):424.
1903	Paris, *Salon d'Automne*.
1904, 15 October-15 November	Paris, Petit Palais. *Salon d'Automne*. 44 paintings. Reviews: M. Raynal, *La Vie* (Oct. 1904); Babin, *L'Echo de Paris* (14 Oct. 1904); R. Ferry, *La Liberté* (14 Oct. 1904); L. Vauxcelles, *Gil Blas* (14 Oct. 1904); Valensol, *Petit Parisien* (14 Oct. 1904); Thiebault-Sisson, *Le Petit-temps* (14 Oct. 1904); A. Alexandre, *Le Figaro* (14 Oct. 1904); M. Fouquier, *Le Journal* (14 Oct. 1904); L. Riotor, *Le Rappel* (15 Oct. 1904); Le Masque Rouge, *L'Action* (15 Oct. 1904); *La Revue illustré* (15 Oct. 1904); Chauance, *L'Autorité* (15 Oct. 1904; F. B., *L'Intransigeant* (16 Oct. 1904); Peladan, *La Revue hebdomadaire* (22 Oct. 1904); Benedict, *L'Encyclopédie contemporaine* (25 Oct. 1904); E. Faure, *Les Arts et la vie* (Nov. 1904); G. Geoffroy, *L'Humanité* (Nov. 1904); E. Sarradin, *Le Journal des débats* (14 Nov. 1904); Dantin, *L'Epoque* (20 Nov. 1904); Delaunay, *Le Journal de Caen* (20 Dec. 1904); Boisard, *Le Monde illustré* (22 Dec. 1904); C. Mauclair, *L'Art décoratif* (Dec. 1904).
1905, 24 March-30 April	Paris, Grand Palais. *Salon des Indépendants*. 8 paintings. Reviews: L. Vauxcelles, *Gil Blas* (23 March 1905); Anner, *L'Intransigeant* (28 March 1905); C. Morice, *Mercure de France* (15 April 1905).
1905, 18 October-25 November	Paris, Grand Palais. *Salon d'Automne*. 3 paintings. Reviews: R. de Bettex, *La République française* (17 Oct. 1905); Pellier, *La Petite république* (17 Oct. 1905); E. Sarradin, *Le Journal des débats* (17 Oct. 1905); Thiebault-Sisson *Le Temps* (17 Oct. 1905); L. Vauxcelles, *Gil Blas* (17 Oct. 1905); C. Mauclair, *La*

Revue blanche (21 Oct. 1905); C. Morice, *Mercure de France* (1 Dec. 1905).

1906 Paris, Grand Palais. *Salon des Indépendants*. Reviews: L. Vauxcelles, *Gil Blas* (20 March 1906); C. Etienne, *La Liberté* (23 March 1906); R. Lestrange, *Le Tintamarre* (8 April 1906); C. Morice, *Mercure de France* (15 April 1906); C. Le Seenne, *La Revue théâtrale* (April 1906).

1906 Paris, *Salon d'Automne*. Reviews: J. Morot, *L'Intransigeant* (6 Oct. 1906); C. Mauclaire, *Art et décoration* (Nov. 1906); R. Lestrange, *Le Tintamarre* (4 Nov. 1906); *Journal de Monaco* (6 Nov. 1906).

1907 Paris, *Salon des Indépendants*. Review: *L'Amitié de France* (May-June 1907).

1907 Paris, *Salon d'Automne*. Reviews: E. Sarradin, *Le Journal des débats* (17 Oct. 1907); H. Eon, *Le Siècle* (19 Oct. 1907); F. Vallotton, *La Grande revue* (25 Oct. 1907); L. Vauxcelles, *Gil Blas* (17 Nov. 1907).

1908 Paris, *Salon des Indépendants*. Reviews: *New York Herald* (20 March 1908); L. Vauxcelles, *Gil Blas* (20 March 1908); C. Le Senne, *Le Courrier du soir* (22 March 1908).

1908 Paris, *Salon d'Automne*. Reviews: G. Kahn, *Le Radical* (30 Sept. 1908); E. Sarradin, *Journal des débats* (30 Sept. 1908); L. Vauxcelles, *Gil Blas* (30 Sept. 1908); *Le Petit parisien* (30 Sept. 1908); A. Borg, *La Grande revue* (10 Oct. 1908); C. Roger-Marx, *La Chronique des arts* (10 oct. 1908); Habert, *La Revue des Beaux-arts* (18 Oct. 1908); *Les Hommes du jour* (31 Oct. 1908); J. Ochse, *Le Thyrse* (Brussels) (Nov. 1908).

1909 Paris, *Salon des Indépendants*. Review: *Les Echoes parisiens* (15 April 1909).

1910 Paris, *Salon des Indépendants*.

1911 Paris, *Salon des Indépendants*. Reviews: A. Salmon, *Paris-journal* (20 April 1911); J. Claude, *Le Petit parisien* (23 April 1911).

1911 Paris, *Salon d'Automne*. 18 paintings and ceramics. Reviews: R. Allard, *La Cote* (4 and 17 Oct. 1911); Tabarant, *Le Siècle* (7 Oct. 1911); Peladan, *La Revue hebdomadaire* (21 Oct. 1911); A. Perate, *Le Correspondant* (25 Oct. 1911); L. Vauxcelles, *L'Art décoratif* (20 Nov. 1911).

1912 Paris, *Salon des Indépendants*.

1913	Paris, Galerie E. Druet. *Exposition Georges Rouault*. Review: *Mercure de France* (16 March 1913):441-3.
1926	Paris, *Salon des Indépendants*.
1926	Paris, Galerie des Quatre Chemins.
1926	Paris, Galerie Georges Petit. *Gustave Moreau et ses élèves*.
1930	New York, New Art Center. *Lithographs*. Review: *Art News* 29(1 Nov. 1930):12.
1930	Chicago, Art Club of Chicago.
1930	London, Saint George Gallery.
1931	New York, Demotte Galleries. Review: R. Flint, *Art News* 29(10 Jan. 1931):9.
1931	Geneva, Musée de l'Athénée. Review: P. Berthelot, *Beaux-arts* 9(Aug. 1931):24.
1931	Brussels, Galerie Schwarzenberg. Préface de Paul Fierens.
1932	New York, Reinhardt Galleries. Review: *Creative Arts* 10(June 1932):472.
1934-35, November-March	Paris, *Beaux-arts* and *Gazette des Beaux-arts*. *Les Fauves: l'atelier de Gustave Moreau*. Préface de Louis Vauxcelles. Catalogue par Raymond Cogniat. 32 p., illus.
1935-36	Northampton, MA, Smith College Museum of Art. Reviews: *Art News* 34(23 Nov. 1935):8; E. F., *Smith College Museum of Art Bulletin* 17(Juine 1936):18-9.
1936	New York, Bignou Gallery. *Modern French Tapestries by Braque, Raoul Dufy, Léger, Lurcat, Henri Matisse, Picasso, Rouault*. From the Collection of Madame Paul Cuttoli. Foreword by Edouard Herriot. 20 p., illus.
1937	Paris, Petit Palais. *Les Maîtres de l'art indépendant*. Salle Rouault. 42 works.
1937, 29 April-22 May	London, M. Knoedler & Co. *For the Young Collector: An Exhibition of Watercolours and Drawings by Picasso, Utrillo, Dufy, Rouault*. In collaboration with the Galerie Kaete Perls.
1938	Bogota, Museo de arte moderno. *Le Dessin français au XIXe siècle*.
1938	Basel, Kunsthalle. *Rouault, Vlaminck, et Dufy*.

1939 London, Zwemmer Gallery. Review: T. McGreevy, *London Studio* 17, *Studio* 117(June 1939):271.

1941 Pittsburgh, Carnegie Institute. *Prints*. Reviews: J. O'Connor, Jr., *Carnegie Magazine* 14(March 1941):300-3; R. Speaight, *Carnegie Magazine* 15(Oct. 1941):150.

1941 New York, Guy E. Mayer Galleries. Review: *Art Digest* 16:3(1 Nov. 1941):25.

1943 New York, Kleemann Galleries. *Aquatints*. Review: *Art Digest* 17:9(1 Feb. 1943):20.

1946 New York, Kleemann Galleries. *Color Aquatints*. Reviews: *Art News* 45:3(May 1946):60; *Art Digest* 20:17(June 1946):16; *Pictures on Exhibit* 8(June 1946):14.

1946 London, Tate Gallery. *Braque—Rouault*. Preface by Waldemar Georges. 14 paintings, 25 prints. Reviews: *Art News* 45(June 1946); H. Fell, *Connoisseur* 117(June 1946):123-4; C. Gordon, *Studio* 132(July 1946):21.

1946 Paris, Galerie Drouin. *Pour un art religieux*. Préface de l'Abbé Maurice Morel. 17 paintings, 30 prints.

1946 Montréal, Review: *Montreal Art Association Bulletin* 35(Nov. 1946):2.

1946-47 New York, Bignou Gallery. Review: *Art Digest* 21:7(1 Jan. 1947):12.

1946-47 Bern, *Quelques œuvres des collections de la Ville de Paris*. Also shown Fribourg-en-Brisgau, Rotterdam,

1947 Paris, Galerie René Drouin. Review: *Arts Magazine* (11 April 1947):4.

1948 Podestà, Attilio. Review: *Emporium* 108(July-Aug. 1948):45-8.

194? Los Angeles, Dalzell Hatfield Galleries. *A Superb Exhibition: Cézanne, van Gogh, Renoir, Bonnard, Vuillard, Matisse, Rouault, Sisley, Dufy, Utrillo*. 8 p., illus.

1950 Paris, Galerie Charpentier. *Autour de 1900*.

1950 Boston, Boston Public Library. *Georges Rouault, Prints*. Review: *Pictures on Exhibit* 12(April-May 1950):41, 48.

1950 Paris, Palais de Tokyo. *Salon de la peinture à l'eau*.

1950 Geneva, Galerie Motte. Review: *Werk* 37(Aug. 1950):103.

1950	Rome, Palazzo Venezia. [Religious French Art]. Also shown Florence, Centre culturel, place San Fedelo. Included *Miserere* paintings and enamels, with a preface by R. Père Régamay.
1950	Baltimore, Baltimore Museum of Art. *Prints.* Review: *Baltimore Museum of Art News* 14(Dec. 1950):5.
1950	Hamburg, Kunsthalle. *Französische Zeichnungen des XX. Jahrhunderts.*
1951	New York, Carstaires Gallery. Review: *Pictures on Exhibit* 13(April 1951):19.
1951	Paris, Musée National d'Art moderne. *Art sacré.* Also shown Eindhoven, Musée d'Eindhoven. Preface de Bernard Dorival et Jean Cassou. 22 paintings.
1951	Paris, Galerie de France. *Les Emaux de Ligugé.* 10 enamels.
1952	New York, Truman Gallery. *Prints.* Review: *Art Digest* 27:2(15. Oct. 1952):17.
1952	Amsterdam, Musée Municipal.
1954	Basel, Galerie Beyeler. Review: *Werk* 41(Feb. 1954):15.
1954	New York, Town Gallery. *Graphics.* Reviews: *Art Digest* 28:9(1 Feb. 1954):27; *Art News* 52:10(Feb. 1954):62.
1954	Maisland, Galleria d'Arte moderna. Review: *Werk* 41(Aug. 1954):193.
1954	Paris, Musée du Petit Palais. *Collection Girardin.*
1955, 6 March-8 April	Recklinghausen, Kunsthalle. *Otto Pankok, die Passion: Georges Rouault, Miserere.*
1955	Paris, Musée Galliera. *Regards sur la peinture contemporaine.*
1955	Reading, England, Reading Museum and Art Gallery. *La Semaine française.*
1955	Saint-Omer, Musée des Beaux-arts.
1956, 1-30 June	Paris, Galerie Creuzevault. *Emaux et gravures de l'abbaye Saint-Martian de Ligugé.*
1956	Tournai, Musée des Beaux-arts. *La Grande aventure de l'art au XX^e siècle.*

1956	Valenciennes, Musée des Beaux-arts. *Soixante ans d'art modernes.*
1957	Amsterdam, *Europe 1907.*
1957	Tours, Musée de Tours. *Artistes du XXe siècle.*
1957	Rome, Odyssia Galeria. Enamels.
1957-58	Delft, Stedelijk Museum. *Art sacré moderne.*
1958	New York, Hervé Gallery. Review: *Art News* 57:2(April 1958):13.
1958	Lauusanne, Galerie Vallotton. *Gravures.*
1958	Fribourg, Musée d'art et d'histoire. Lithographs and etchings. Review: M. Thiébaud, *Werk* 45(Sept. 1958):187.
1958	Paris, Galerie Le Garrec. *Lithographies.*
1958	Metz, Musée des Beaux-arts. *Evolution de la peinture en France de 1905 à 1914.* Also shown Nancy, Musée des Beaux-arts. Texte de Gérard Collot.
1958	Brussels, Pavillon de la section française. *Exposition internationale.*
1958	Paris, Bibliothèque nationale. *42e exposition de la Société des peintres-graveurs français. Hommage à Rouault.*
1959	New York, Berryman Gallery Engravings. Reviews: *Art News* 58:1(March 1959):16; *Arts Magazine* 33(April 1959):57.
1959, 3 September- 15 November	Hamburg, Kunsthalle. *Französische Zeichnungen des XX. Jahrhunderts.* Preface by Bernard Dorival.
1959, October	Paris, *Première biennale de Paris.*
1960	New York, A. A. A. Gallery. Review: *Art News* 59:2(April 1960):15.
1960	Paris. Review: *Aujourd'hui* 5(Sept. 1960):47.
1960	Brest, Bibliothéque municipale. *Gravures et lithographies.*
1961	Paris, Musée d'art moderne de la Ville de Paris. Review: A. Watt, *Studio* 161(Feb. 1961):62.

1961	New York, Carstairs Gallery. Etchings. Review: *Art News* 60:2(April 1961):11.
1961-62, 2 November- 3 March	Tokyo, *Exposition d'Art français, 1840-1940*. Paintings, prints, wash drawings.
1962, 11 March- 30 April	Rennes, Musée de Rennes. *Aspects insolites et tragiques de l'art moderne*. Préface de Jean Cassou.
1962	New York, F. A. R. Gallery. Review: *Art News* 61:2(April 1962):12-3.
1962, 26 June- 1 September	Marseille, Musée Cantini. *Gustave Moreau et ses élèves*. Préface de Jean Cassou.
1963, 8 June- 15 September	Strasbourg, Château de Rohan. *La Grande aventure de l'art au XXᵉ siècle*.
1964	New York, Perls Gallery. Review: *Art News* 63:1(March 1964):9.
1964, May-June	Florence, Palazzo Strozzi. *Mostra dell Espressionismo*.
1964, 23 June- 9 November	Paris, Musée de Louvre. *Œuvres inachevées données à l'Etat*. Préface de Bernard Dorival. 181 works.
1965, November	Saint-Dénis, Musée d'Art et d'histoire. *Les Peintres et la nature*.
1965-66	New York, Museum of Modern Art. *The School of Paris: Paintings from the Florence May Schoenborn and Samuel A. Marx Collection*. Introduction by James T. Soby, with notes by L. R. Lippard. Travelling exhibition. 56 p., 44 illus. Text analyzes characteristics of the School of Paris with annotations for each entry. Particularly well-represented artists are Matisse, Picasso, Braque, and Rouault. Information on the collectors is also given. a. 2nd ed.: 1978. 56 p., 44 illus.
1965, December	Paris, Galerie Greuze. *Les Peintures et la nature*.
1966	London, Mercury Gallery. *Coloured Aquatints*. Review: J. Burr, *Apollo* 83:49(March 1966):222.
1966, March- May	New York. *French Painting from 1900-1967*.
1967	Montréal, Exposition internationale, Pavillon français. *Peinture française 1900-1967*.

1967, 17 October- 4 November	Paris, Galerie Durand-Ruel. *Lubitch.* 16 p., illus.
1968	Atlanta, High Art Museum. *Paintings of the 18th-19th-20th Centuries.*
1969	Toronto, National Gallery of Canada. Review: *Burlington Magazine* 111:796(July 1969):451.
1969, 11 October- 5 December	Bourges, Maison de la culture. *Joie et bonheur du peintre.*
1970	New York, Weintraub Gallery. Review: *Art News* 69:2(April 1970):72.
1970	Aix-en-Provence, Pavillon Vendôme. *De la Comedia dell, Arte au cirque.* Préfaces de Pierre-Louis Duchartre et Tristan Rémy.
1970-71, 11 December- 18 January	Paris, Grand Palais. *Hommage à Christian et Yvonne Zervos.* Texte de Jean Cassou.
1971	Le Creusot, C.R.A.C.A.P. *Figuration et défiguration.*
1971	Romania. *Les Chefs d'oeuvre des musées de la Ville de Paris.* Also shown Hungary.
1972, June- September	Paris, Musée Bourdelle. *Centaures, cheavaux et cavaliers.* Textes de Michel Dufet.
1972	*Sacred Circus.* Review: *Country Life* 151 (22 June 1972):1636.
1972	London, Roland, Browse and Delbanco. *Rouault and Cournault.* Review: P. Rouve, *Arts Review* 24:13(1 July 1992):392-3.
1972	Paris, Théâtre de l'est Parisien. *Un spectacle de Daumier à Picasso.*
1973	New York, Phyllis Lucas Gallery. Review: *Arts Magazine* 47:4(Feb. 1973):89.
1973, 23 September- 11 November	Winterthur, Kunst Museum. *Kunstlerfreunde um Arthur und Hedy Hahnloser-Bühler* [Artist Friends of Arthur and Hahnloser-Bühler]. Texts by R. Koella, M. Hahnloser-Ingold, R. Hahnloser, R. Steiher. 228 p., 102 illus. Exhibition held to celebrate jointly the 100th birthday of Hedy Hahnloser Bühler and the 125 years of existence of the Kunstmuseum in Winterthur. Hedy Hahnloser-Bühler has for

many years been a keen collector of Impressionist and Fauvist paintings. The works exhibited included examples of Picasso, Rouault, Bonnard, and Hodler. The exhibition sought to capture the atmosphere of the private collection and the close relationship felt by the collector to the artists. The introduction presents a few examples of the collector's own creative work: a painting of sheaves of corn, a plan for a children's nursery, and some embroidery.

1973	Le Creusot, C.R.A.C.A.P. *L'Arbre.*
1973	Reims, Maison de la culture. *Le Cirque.*
1974, 1 February-15 April	Paris, Grand Palais. *Jean Paulhan à travers ses peintres.*

1974-75,
15 November-
2 March

Vienna, Grapghische Sammlung Albertina. *Gedächtnisausstellung Otto Benesch; Erwerbung und Bestimmung grosser Meisterwerke für die Albertina* [Otto Benesch Memorial Exhibition; Acquisitions and Bequests of Great Masterpeices for the Albertina]. Essay by Walter Koschatzky. 70 p., 35 illus. 194 works shown.
Exhibition arranged in memory of Otto Benesch containing 194 prints and drawings that he acquired for the Albertina or which he studied in order to secure scholarly attributions. Included prints by Rouault and Braque, among many other artists represented. Introduction traces the history of Benesch's work as a curator and collector for the museum.

1974

Paris, Caisse Nationale des monuments historiques et des sites. *Collection Germaine Henry—Robert Thomas.*

1974

Recklinghausen, Recklinghausen Museum. *Ruhrfestspiele.*

1974

Tokyo, Nezu Museum. *Gustave Moreau and His Students.*

1975

Turkey and Czechoslovakia. *Les Chefs-d'œuvre de la Ville de Paris.*

1975, 5 March-
13 April

Hartford, CT, Wadsworth Atheneum. *Selections from the Joseph L. Shulman Collection.* Texts by James Elliott, Joseph L. Shulman, and Mark Rosenthal. 47 p., 22 illus., 3 col. 50 works shown.
Included works by early 20th century European artists including Rouault, Matisse, Braque, and Dufy, among others.

1976-79,
15 September-
16 December

Düsseldorf, Universität Kunstmuseum. *Mensch und Tod: Totentanzammlung der Universität Düsseldorf aus fünf Jahrhunderten* [Man and Death: Dance of Death Collection of Dusseldorf University Covering Five Centuries]. Also shown

Göethe Museum Antn-und-Katharina-Kippenberg-Stiftung, Düsseldorf (19 OCt.-5 Nov. 1978); Von der Heydt-Museum, Wuppertal (21 Jan.-18 Feb. 1979); Kulturgeschichtliches Museum, Osnabrück (23 Feb.-21 Mar. 1979); Städtisches Gustav-Lübcke-Museum, Hamm (11 Nov.-16 Dec. 1979) Gestaltung der Ausstelung: Margarete Bartels und Dieter Graf. 48 p., 10 illus., 164 works shown.

Drawings and prints, late 15th-20th centuries, with death as the theme, selected from the collection of Prof. Dr. Med. Werner Block, Hannover. The collection was given to the University in 1976. Artists represented ranged from Dürer, Rembrandt, and Domenico Tiepolo to Rethel, Kollwitz, and Rouault. This exhibition, in slightly reduced form, traveled in Germany (1978-79), accompanied by a new edition of the catalogue: *Mensch und Tod: Totentanzsammlung der Universität Düsseldorf*, Ausstellung/Katalog, Margarete Bartels (111 p., 33 illus., 157 works shown).

1976 Paris, Musée d'Art moderne de la Ville de Paris. *Donation Germaine Henry-Robert Thomas.*

1976-77,
17 December-
1 March

New York, Museum of Modern Art. *European Master Paintings from Swiss Collections: Post-Impressionism to World War II.* Catalogue by John Elderfield; foreword by William Rubin. 172 p., 72 illus., 24 col. 72 works shown.

Included works by Rouault and Braque, among other artists. Review: J. Russell, *New York Times* (9 Jan. 1977):D23.

1977,
20 January-
20 April

Sarasota, FL, John and Mable Ringling Museum of Art. *The Circus in Art.* Also shown Gainesville, University of Florida, University Gallery (20 March-20 April). Preface by Richard S. Carroll. Introduction by Leslie Judd Alexander. 36 p., 42 illus., 3 col. 44 works shown.

Loan exhibition of paintings, drawings, prints, and sculpture to commemorate the opening of the new and renovated buildings of the Museum of the Circus, a part of the Ringling Museum complex. Ranging from realism to pure abstraction, the works date from 1888-1976. Artists represented included Alexander Calder, Marc Chagall, John Stewart Curry, Chaim Gross, Walt Kuhn, Gaston Lachaise, Jacques-Lipchitz, Pablo Picasso, Georges Rouault, and Henri de Toulouse-Lautrec.

1977 Northampton, MA, Smith College Museum of Art. *Modern Illustrated Books: the Selma Erving Collection.* Texts by C. Chetham and C. R. Mortimer. 64 p., 60 illus.

The Selma Erving collection, consisting of 110 books and four portfolios of prints related to books, is presented in the following order in the catalogue: *livres d'artiste*, books containing original prints, portfolios containing prints related to specific books, books illustrated with reproductions, and reference books.

Artists include Georges Braque, Raoul Dufy, Marquet, Matisse, and Rouault, among others.

1978, 1 April-
1 October

New York, Solomon R. Guggenheim Museum. *The Evelyn Sharp Collection.* Preface by Thomas M. Messer. Texts by Louise Averil Svendsen aided by Philip Verre and Hilaire Faberman. 96 p., 46 illus., 45 col. 45 works shown.
Contained works by eighteen major 20th century artists, including Rouault, Braque, Dufy, Matisse, van Dongen, and Vlaminck.

1978, 8 June-
16 September

Bern, Kunstmuseum. *Sammlung Justin Thannhauser.* Redaktion des Kataloges: Jürgen Glaesemer, Betty Studer. Vorwort von Paul Rudolf Jolles und Beiträgen von Eberhard W. Kornfeld und Hans R. Hahnloser. 113 p., 79 illus., 15 col. 64 works shown.
Works shown date from the second half of the 19th century to the first half of the 20th century, including examples by Braque, and Rouault, among others. The highlight of the collection was a group of twenty-nine works by Picasso (paintings, watercolors, drawings, and prints) dating from 1901 to 1965.
Review: C. Gaelhaar, *Pantheon* 36:4(Oct.-Dec. 1978):386-7.

1978, Spring-
31 December

Paris, Musée d'Art moderne de la Ville de Paris. *Paintings from Paris: Early 20th Century Paintings and Sculptures from the Musée d'art moderne de la Ville de Paris.* Also shown Oxford, Museum of Modern Art (2 July-13 Aug.); Norwich, Castle Museum (19 Aug.-1 Oct.); Manchester, Whitworth Art Gallery (7 Oct.-11 Nov.); Coventry, Herbert Art Gallery and Museum (18 Nov.-31 Dec.). Preface by Joanna Drew and Michael Harrison, foreword by Jacques Lassaigne, introduction by Michael Harrison. 48 p., 74 illus., 4 col. 82 works shown.
Exhibition aimed to show the way in which Fauvism, Cubism, and the School of Paris are represented in the Museum's colection. Catalogue includes an introduction on the development of early 20th century art in France and a special section devoted to Marcel Gromaire who is strongly represented in the Museum's holdings. Other artists included Braque, Derain, Dufy, Matisse, Rouault, and van Dongen, among others.
Reviews: K. Robert, *Burlington Magazine* 120:905(Aug. 1978):552; P. Macus, *Art & Artists* 13:5(Sept. 1978):18-21.

1978

Boulogne, Centre culturel. *Tapisserie-création 1928-1978.* Also shown Billancourt.

1978

Palermo, Palazzo Arcivescovile. *Art sacré contemporain.* 3 paintings and *Miserere.*

1978

Washington, D.C., National Gallery of Art. *Small French Paintings from the Bequest of Alisa Mellon Bruce.* Introduction by John Rewald. Catalogue by David E. Rust. 121 p., 67 illus., 7 col. 59 works shown.

Included one painting each by Rouault and Matisse.

1979	London, Redfern Gallery. Reviews: *Apollo* 109:1(Jan. 1979):69; *Art & Artists* 13(Feb. 1979):37.
1979, March-September	Japan. *Chefs-d'œuvre des musées de la Ville de Paris.*
1979, April-May	Tokyo, Fujikawa Galleries. *Rouault-Utrillo.* 72 paintings.
1979, 28 April-10 June	Vancouver, Vancouver Art Gallery. *The Fell Collection: An Exhibition in Honour of Ella May Fell.* Tribute to Ella Fell by Tony Emery. 24 p., 44 illus., 6 col. 38 works shown. Exhibition of paintings, mainly British and French, 19th-20th centuries, from the collection of Ella Fell, a long-standing friend and benefactor of the Vancouver Art Gallery. Most of the works in the collection were purchased through the London art dealer, Arthur Tooth and Sons Limited. Artists represented includes Boudin, Rouault, Renoir, Vuillard, Jongkind, and Paul Nash. Included full catalogue entries and reproductions of each object. Review: S. Watson, *Vanguard* 8:4(May 1979):8-11.
1979, 31 May-5 November	Paris, Musée National d'Art moderne. Centre Georges Pompidou. *Paris-Moscou.*
1979	Paris, Grand Palais. *Salon d'Automne. Les Fauves.*
1979	Seoul, National Museum of Modern Art. *Les Chef-d'œuvre des musées de la Ville de Paris.*
1979-80, 16 December-27 January	Chapel Hill, University of North Carolina, William Hoyes Ackland Memorial Art Cneter. *Ambroise Vollard, Publisher: Prints in the Ackland Art Museum.* Catalogue by Carol C. Gillham. 12 p., 6 illus. 43 works shown. Selected from the museum's print collection, exhibition presents prints by such artists as Bonnard, Chagall, Picasso, Redon, and Rouault, commissioned and published by Ambroise Vollard, the famous Parisian art dealer.
1980, 15 February-16 March	Berlin, Akademie der Künste. *Hommage à Tériade—Buchillustrationen aus Frankreich.* Katalog: Ute Schuffenhauer, Inge Zimmermann, Horst Jörg Ludwig. 84 p., 57 illus., 12 col. Exhibition honoring Emmanuel Tériade, one of the most important art publishers of the 20th century. It was his interest that helped bring literature and painting closer together. He concentrated on reproducing the style and technique of the art works in the best possible quality. Shown were illustrations by Beaudin, Bonnard, Chagall, Giacometti, Gris, Gromaire,

Laurens, Le Corbusier, Léger, Matisse, Miró, Picasso, Rouault, and Villon.

1980, 14 March-
29 May

Paris, Musée du Luxembourg. *Donation Geneviève et Jean Masurel à la Communauté urbaine de Lille.* Catalogue par Marie Anne Peneau, Jacques Jardez, Amaury Lefebure. Paris: Editions de la Réunion des Musées Nationaux, 1980. 135 p., 157 illus., 24 col. 132 works shown.
Included works by Rouault, Kees van Dongen, André Derain, and Georges Braque, among other artists.
Review: *Revue du Louvre et des musées de France* 30:2(1980):130-1.

1980, May-
September

Paris, Musée Bourdelle. *Chapeau.*

1980, 23 May-
21 June

Mulhouse, Bibliothèque municipale. *Quatrième Biennale Européenne de la gravure de Mulhouse.* Catalogue par R. Simon, D. Schneider, M. Terrapon, B. Contensou, C. Gruztmacher, E. di Marino. 100 p., 126 illus.
Catalogue to the 4th European Print Biennale, with contributions by 97 artists from 18 countries, listed mainly in alphabetical order with brief biographical notes. There are also lists of the participants in the three earlier biennales. Includes Daniel Schneider's essay, "Georges Rouault, or Obedience to an Inner Command," which surveys Rouault's career, his artistic beliefs, and the sources of his inspiration, describing in particular the *Miserere* series of prints, exhibited during the biennale, at the Musée de l'Impression sur Etoffes. There is a foreword by the president of the biennale, R. Simon, describing the growing importance of these exhibitions. Rules of the biennale and a list of the jurors are included.

1980, 21 June-
17 September

Paris, Hôtel de Ville. *Trésors des musées de la Ville de Paris.*

1980-81,
3 October-
31 January

Beauvais, Galerie Nationale de la tapisserie. *Chaîne, trame, mailles.*

1981, 1 January-
1 September

La Tapisserie contemporaine. Exposition organisée par l'association française d'action artistique. Shown at Havona, Bueños-Aires, Mendoza, Cordoba, Santa Fe, and Lima.

1981, Spring

Paris, Daniel Malingue Galerie. *L'Ecole de Paris.*
Included works by Rouault, Dufy, Vlaminck, and other artists.

1981-82, 7 May-
6 June

Milwaukee, Milwaukee Art Museum. *Center Ring; The Artist: Two Centuries of Circus Art.* Also shown Columbus, OH, Museum of Art (30 Aug.-11 Oct. 1981); Albany, New York State Museum (11 Dec. 1981-7 March 1982); Washington, D.C.,

Corcoran Gallery of Art (24 April-6 June 1982). Guest curator: Jensen Dean, assisted by Susanne Christine Voeltz. 122 p., 110 illus., 18 col. 181 works shown.

Explored the circus as an art theme. Included seventy-eight circus artifacts (posters, woodcarving, broadside, and banners), and 103 works of art on circus themes (paintings, drawings, photographs, prints, and sculptures), late 18th century to the present, by America and European artists. Artists represented include Gifford Beal, Picasso, Calder, Curry, Kuhn, Lipchitz, Rouault, and Toulouse-Lautrec.

1981, 29 May- 1 October	Moscow, Pushkin Institute and Museum. *Moscou-Paris*.

1982,
26 September-
21 November

Mechlin, Belgium, Stedelijke Musea, Cultureel Centrum Burgemeester A. Spinoy. *Social engagement in de Kunst 1850-1950* [Social Engagement in Art 1850-1950]. Introduction by M. Bafcop. Texts by Jean Goldmann, Michel Melot, Pierre Courcelles, and Christine Frérot. 144 p., illus., some col. 364 works shown.

Paintings, sculpture, drawings, and prints with social-political subjects by 141 European artists including Georges Rouault.

1982-83,
29 October-
3 July

Zurich, Kunsthaus. *Nabis und Fauves: Zeichnungen, Aqaurelle, Pastelle aus schweizer Privatbesitz* [Nabis and Fauves: Drawings, Watercolors, Pastels from Swiss Private Collections]. Also shown Bremen, Kunsthalle (27 Feb.-10 April 1983); Bielefeld, Kunsthalle (8 May-3 July 1983); Text by Ursula Perucchi, with the collaboration of Gisela Gotte, Margrit Hahnloser-Ingold, Rudolf Koella. 179 p., 244 illus., 27 col. 192 works shown.

Included works by Pierre Bonnard, Aristide Maillol, Henri Manguin, Albert Marquet, Henri Matisse, Odilon Redon, Georges Rouault, Ker-Xavier Roussel, Félix Vallotton, and Edouard Vuillard. Catalogue essay on the drawings of the nabis by Ursula Perucchi, and drawings of the Fauves by Jürgen Schultze Catalogue entries with short commentary and/or with the illustration of the paintig for which the drawings was done. Rouault's works are introduced by Margrit Hahnloser-Ingold. Review: B. Stutzer, *Pantheon* 41:1(Jan.-March 1983):77-8. 3 illus.

1983,
26 February-
24 April

Ludwigshafen, Wilhelm-Hack-Museum. *Schrecknisse des Kireges: druckgraphische Bildfolgen des Krieges aus fünf Jahrhunderten* [Horrors of War: Prints of the War from Five Centuries]. Katalog von E. Bauer. 523 p., 999 illus.

Exhibition tracing the development of cycles of prints on war since the 16th century, featuring the work of 53 artists from Andreani (16th century) to James Rosenquist (b. 1933). The catalogue is divided into sections for each artist, each with a short text discussing the background to the works and the

techniques used to achieve the desired effect. The introduction outlines the history of the anti-war print cycles, analyzing "The Disasters of War" by Goyá as a crucial work that signalled the beginning of the modern era, and discussing the contributions to the genre made by Daumier, Dix, Rouault, Picasso, Beckmann, John Heartfield (with his photomontages), Bernhard Heisig, and Alfred Hrdlicka.

1983,
26 September-
10 November

Flushing, NY, City University of New York, Queen's College, Godwin-Ternbach Museum. *20th Century Prints from the Godwin-Ternbach Museum.* Catalogue prepared by graduate students in Art History under the direction of Rose Carol Washton Long. 72 p., 55 illus. 55 works shown.
The exhibition and catalogue reflected the strength of the Museum's collection of prints from the early modernist tradition in Germany and Austria, the WPA Graphics Arts division of the Federal Art Project, and post-World War II graphics. Catalogue includes individual entries on prints by such artists as Georges Rouault, among others.

1983-84,
25 November-
5 February

Rome, Académie de France. *Honoré Daumier—Georges Rouault.* Prefazione Jean Leymarie; catalogo a cura di Robert Fohr. Milan: Electa, 1983. 228 p., 135 illus., 12 col.
First exhibition in Rome of works by these two French painters. Included twenty-five paintings and drawings and all the known sculptures by Daumier, and a group of watercolors, oils, and lithographs, 1897-1953, by Rouault. Full catalogue entries with explanatory text and reproduction of each object.

1983

New Haven, CT, Yale University, University Art Gallery. *The Katharine Ordway Collection.* Introduction by Alan Shestack, commentaires by Lesley K. Baier. 124 p., 59 illus., 21 col.
Included 19th-20th century American and European painting, sculpture, drawings, and prints, as well as Mexican and Asian art. Artists represented included Rouault, among others.

1985, 15 June-
20 October

Lausanne, Fondation de l'Hermitage. *De Cézanne à Picasso dans les collections romandes.* Catalogue par François Daulte. 200 p., 121 illus., 120 col.
Exhibition of 20th century paintings and sculptures from private and public collections in French-speaking Switzerland, by exponents of Post-Impressionism (specifically the Nabis and Pointillists), Fauvism and l'Ecole de Paris, including Cézanne, Maillol, Bonnard, Vallotton, Dufy, Derain, Marquet, Matisse, Vlaminck, Rouault, Chagall, Utrillo, Modigliani, and Picasso. The introduction summarizes the history of each of the movements represented—their major members, principal tenets, and most lasting effects on contemporary art—and profiles the collecting tastes of the French-speaking cantons.

1986, April- August	Iowa City, University of Iowa Museum of Art. *101 Masterpieces*. Catalogue by Robert Hobbs. 224 p., 161 illus., 120 col. Exhibition of works selected from the holdings of the University of Iowa Museum of Art, Iowa City, Iowa. The European and American 20th century paintings and works on paper that made up the bulk of the exhibition included works by Munch, Braque, Matisse, Rouault, de Chirico, Beckmann, Motherwell, and Morandi, and there were also sculptures by Moore, Lipchitz, Nevelson, and Noguchi. In his introduction Hobbs notes that a relatively new art museum cannot today hope to form an encyclopedic collection and must present art more as "a Great Books series" than as an all-inclusive survey. Describing a masterwork as a crystallization of the particular moment in which it was produced, he calls for greater emphasis on the study of actual works of art rather than movements, noting that recent art literature generally neglects the importance of individual creations.
1986	London, Institut Français. Review: L. Berryman, *Arts Review* 38(20 June 1986):335-6.
1986-87, 31 May- 18 January	Raleigh, North Carolina Museum of Art. *French Paintings from the Chrysler Museum*. Also shown Birmingham, AL, Museum of Art (6 Nov. 1986-18 Jan. 1987). Organized by the Chrysler Museum. Introduction by William J. Chiego. Catalogue by Jefferson C. Harrison. Norfolk, VA: Chrysler Museum, 1986. 139 p., 90 illus., 45 col. Exhibition of French paintings from the Chrysler Museum, Norfolk, Virginia. They include works by Manet, Cézanne, Pissarro, Sisley, Renoir, Degas, Gauguin, Paul Signac, Matisse, Braque, and Rouault. There is a short essay on each by Harrison, and the annotations include exhibition histories. In his introduction, Chiego comments on the importance of the Chrysler Museum's collection, and describes some of its highlights.
1986, 13 July- 21 September	Essen, Museum Folkwang. *Aktdarstellungen im 19. und 20. Jahrhundert: Aqaurelle, Zelchnungen und Druckgraphiken aus dem Bestand des Graphischen Kabinetts* [Representations of Nudes in the 19th and 20th Centuries: Watercolors, Paintings, Drawings, and Prints from the Collection of the Graphischen Kabinetts]. Katalog von Hubertus Froning. 50 p., 25 illus. Exhibition focusing of the representation of nudes in 19th and 20th century watercolor paintings, prints, and drawings. Examines the historical significance of the nude and its role in classical art, and then discusses its symbolic effect in works by Franz von Stuck, Fritz von Uhde, Max Klinger, and Edvard Munch. Froning explores Impressionist and Cubist representations, including those in paintings by Pissarro and Cézanne, and makes reference to prints by Braque, sculptures by

Rodin and Archipenko, and paintings by Matisse. He examines the use of this motif by Expressionist artists including Ernst Ludwig Kirchner, Georges Rouault, Picasso, and Marc Chagall, and then comments briefly on the nude in contemporary art, mentioning Henry Moore, Tom Wesselmann, and Mel Ramos.

1987 Rimini, *Meeting per Amicizia Fra i Popoli.*

1988 Tokyo, Galerie Yoshii. *Chozo Yoshii: Tokyo-Paris, allers et retours.* Included works by Renoir, Cézanne, Degas, and Rouault, on the occasion of the fifteenth anniversary of the Yoshii Gallery.
Review: J. Warnod, *L'Œil* 393(April 1988):56-9.

1988,
10 November-
24 December

Paris, Galerie Daniel Malingue. *Maîtres impressionnistes et modernes.* 90 p., 41 illus., 39 col.
Exhibition of twenty-four late 19th and 20th century European artists including Rouault, van Dongen, and Matisse. Detailed provenances are provided for each exhibited work.

1991, 5 June-
28 December

Boston, Museum of Fine Arts. *Pleasures of Paris: Daumier to Picasso.* Also shown New York, IBM Gallery of Science and Art (15 Oct.-28 Dec.). Catalogue by Barbara Stern Shapiro, with the assistance of Anne E. Havinga. Essays by Susanna Barrows, Philip Dennis Cate, and Barbara K. Wheaton. Boston: Museum of Fine Arts; David R. Godine, 1991. 192 p., illus., col. pl. 215 works by 70 artists. 3 watercolors by Rouault.

1990 Tokyo, Bridgestone Museum of Art. *Masterworks: Painters from the Bridgestone Museum of Art.* Catalogue by Yasuo Kamon. 102 p., illus.
Included works by Rouault, Matisse, Braque, Dufy, van Dongen, and other nineteenth and twentieth century French artists.

1992 Oberlin, Ohio. Oberlin College, Allen Memorial Art Museum. *The Living Object: The Art Collection of Ellen F. Johnson.* Included works by Rouault, among other artists.

1992-93,
11 September-
7 February

Indianapolis, Indianapolis Museum of Art. *The William S. Paley Collection.* Also shown Seattle, Seattle Art Museum. 80 works. Exhibition of a recent bequest by the late CBS founder and media mogul to New York's Museum of Modern Art. Included works by Gauguin, Cézanne, Matisse, Toulouse-Lautrec, Degas, Derain, Bonnard, and Rouault, among others.

Maurice de Vlaminck

Biographical Sketch

Now remembered chiefly for his brief association with the Fauves, Vlaminck is perhaps better categorized as a kind of late French Romantic. He rapidly abandoned the revolutionary stances of Fauvism and Cubism before the First World War and his later work is generally regarded as repetitious and of lower quality than that produced at the beginning of his career. From about 1920 to his death nearly four decades later, Vlaminck covered canvas after canvas with renderings of stormy weather, wind-tossed seas, dark, menacing skies, bare trees, slush and snow on deserted village streets—pictures in which bluish tones and blacks and whites predominate and all very far removed from his early hot-color Fauve works.

Vlaminck is often labelled the "wildest beast." With the possible exception of van Dongen, his fellow Fauves appear, by contrast, as house-broken pets. Vlaminck must be given credit for the perseverance with which he carried out his program to "burn down l'Ecole des Beaux-Arts" with his cobalts and vermilions. André Salmon once acidly observed that Vlaminck simply wanted to "show off his unculture." Yet the critic knew that Vlaminck was well read and even a highly articulated writer of novels, plays, and autobiography. When he used the strongest, hottest unmixed colors squeezed directly from the tubes—in André Derain's words, shooting the raw colors onto the canvas as if they were "dynamite cartridges"—it was to scream what he wanted to say.

Vlaminck was born in Les Halles quarter of Paris. His father was Flemish and his mother came from Lorraine. The family background was a musical one. His father, who had been a tailor, became a music teacher; his mother, who also taught music, had received second prize for piano at the Paris Conservatoire in her youth. When Vlaminck was three the family moved from Paris to live with his grandmother at the nearby town of Le Vésinet. Maurice received a rudimentary education that included some painting lessons between 1888 and 1891 from an academic artist who was a friend of the family. In 1892 he left home and went to live independently at Chatou. The great bicycling craze had just begun and Vlaminck, who was tall and powerfully built, became an adept cyclist. In 1893 he turned professional cycle racer, supplementing his income by working in a bicycle factory. Vlaminck married young, in 1894, and the following year his daughter was born. In 1896 he was forced to withdraw from an important race because of typhoid fever. This incident marked the end of his cycling career.

Four months after he had recovered he was summoned for military service. He found military atmosphere stultifying but was more fortunate than most of his comrades since, thanks to his musical skills, he was allowed to serve as a member of the regimental band. Vlaminck read widely (preferred authors included Zola, Flaubert, Alphonse Daudet,

and Guy de Maupassant) and began to write, contributing to radical magazines such as *Fin de siècle* and *L'Anarchie*. He had very little opportunity to paint, though his earliest surviving work is a decoration made in 1899 for a regimental fête.

In 1900 Vlaminck met André Derain when they were both involved in a minor railway accident during Vlaminck's last leave before the end of his military service. They rapidly became close friends and agreed to share a studio in Chatou. After his release from the army Vlaminck painted by day and worked by night as a musician in various Montmartre nightclubs and restaurants. Both artists painted extremely fast, letting their colors explode like rockets. Writing about the expeditions the two made in their youth, Derain later recalled, "We were always drunk with color, with words that describe color and the sun that gives life to color."

Vlaminck earned extra money as a semi-professional billiard-player and an oarsman, and pursued a career as a writer in collaboration with Fernand Sernada, a friend he had made in the army. His first book, a sentimental novel called *D'un lit dans l'autre* (*From One Bed to Another*), was published in 1902 with illustrations by Derain. It was followed by several other books of the same type, one of which only narrowly missed nomination for the Prix Goncourt. In 1904 he showed a painting in public for the first time, in a mixed exhibition at Galerie Berthe Weill. At about the same time he became acquainted with the critic and poet Guillaume Apollinaire and gave up playing in night clubs, although he did continue private music lessons for another year.

1905 was an important year for Vlaminck, just as it was for Derain. He showed four paintings at the spring Salon des Indépendants which attracted some attention. Later in the year he exhibited eight canvases at the controversial Salon d'Automne and found himself hailed as a member of a new and exciting radical group called the Fauves. In April, 1906 the dealer Ambroise Vollard bought the entire contents of his studio, as he had done previously with Derain, and in 1907 Vollard gave Vlaminck his first one-artist show.

None of his Fauve associates matched Vlaminck in power. His unrestrained use of pure colors, coupled with violent brushwork, compel comparisons to the German parallel group *Die Brücke*, although he had no actual contact with them. This was very much a time of transition in the painter's life. His first marriage was in the process of breaking up after the birth of a third daughter in 1905. One of his last pupils before he was able to give up teaching music for good was a fashion designer named Berthe Combe, who subsequently became his second wife and indispensable companion. He described her later as "more than a wife—a friend who understands what is in my mind before I've expressed it."

In 1908 Vlaminck abandoned the vibrant chromaticism of Fauvism and his palette began to grow darker. In 1911 he went to London at Vollard's insistence but did not enjoy his two-week visit. All his life, despite his love of motion—bicycles, motorcycles, and fast cars—he was a reluctant traveler. Two major essays on his work were published in 1913, one by Gustave Coquiot and the other by Daniel-Henry Kahnweiler. Kahnweiler was a promoter of Cubism but Vlaminck, after a brief flirtation with the new movement, abandoned it. He later denied any attraction to Cubism and developed a lifelong grudge against Picasso, whom he regarded as a trickster and an imposter.

At the outbreak of war Vlaminck was mobilized but, thanks to the influence of his brother-in-law Elie Bois, the editor of *Le Petit Parisien*, he was soon released from the army to serve in the war industries in and near Paris. He held his second individual show as soon as the war was over in 1919 and was lucky to attract the attention of a Swedish businessman, who purchased ten thousand francs worth of paintings. This windfall enabled him to buy a small country house in the Vexin, forty km from Paris. The purchase marked his virtual retirement from Montmartre and Montparnasse. In 1925 he acquired

a larger house, a farm called La Tourillière near Reuil-la-Galadière in the Eure-et-Loire. This was even further from the capital—125 km rather than forty—and his isolation from other artists increased. The surrounding countryside supplied the bulk of his subject matter for the rest of his career.

The inter-war years saw a steady growth of his reputation both at home and abroad. Several books were published about him, in 1933 he had a retrospective at the Palais des Beaux-arts in Paris, and in 1937 a substantial body of his work was included in the Exposition des Artistes Indépendants held at the Petit Palais in connection with the Paris Exposition Universelle. Vlaminck made the political gestures standard at the time. He was, for example, a member of the League of International Solidarity against Fascism, but his aesthetic views grew steadily more conservative. Modernism, he now considered, was "an art made of theories, metaphysical painting and abstraction replace sensibility, an art that lacks moral health."

When the Germans invaded France in 1940 Vlaminck took refuge at Fromentine, a small port in Normandy, but he soon returned to his farm. Like Derain he was assiduously courted by the Nazis. In 1941 he agreed to join an official party of French artists who would visit the Reich under German auspices. Other members of the group included his old friend Derain, with whom he had quarrelled, van Dongen, Othon Friesz, André Dunoyer de Segonzac, and the sculptor Charles Despiau. The tour was highly publicized by the German propaganda machine. In 1943 Vlaminck compounded this offence by publishing a critical book entitled *Portraits avant décès*, which gave free rein to his now openly hostile views of modern art. Most of the text had been written as early as 1937 but its appearance, when some of the artists Vlaminck criticized so harshly were under direct threat from the Nazis, was extremely inopportune. Immediately after the Liberation in August, 1944, he was arrested, held for forty-eight hours, and interrogated before a tribunal about his conduct. Nothing serious was proven against him but the entire affair left a question mark beside his name.

It was a decade before his reputation recovered even partially. In 1954 he was invited to show at the Venice Biennale and in 1956 he was elected a member of Belgium's l'Académie des Beaux-arts. This was also the year in which he had a major retrospective. Significantly, it was held at a private gallery, the Galerie Charpentier, and not under official auspices. Vlaminck died in 1958.

Maurice de Vlaminck

Chronology, 1876-1958

Maurice de Vlaminck wrote two autobiographical books—*Tournant dangereux: souvenirs de ma vie* (Paris: Librarie Stock-Delamain et Boutelleau, 1929) and *Portraits avant décès* (Paris: Flammarion, 1943).

1876	Born April 4 in Paris, rue Pierre Lescot, near Les Halles. His father (Edmond Julien) was Flemish, descended from Dutch seamen. His mother (Joséphine Caroline Grillet) came from Lorraine. Both parents make their living by teaching music lessons—his father the violin, his mother the piano.
1879	The family moves to Le Vésinet, in the country just outside of Paris, to the home of his maternal grandmother.
1882	Enters school. Continues violin lessons.
1891	Death of his grandmother. With proceeds from the sale of her house, Maurice purchases a bicycle which he rides around Paris and occasionally as far as Rouen and Le Havre. Physically strong and an adept cyclist, he enters bicycle races and trains at the Vélodrome Buffalo.
1892	Leaves home to live independently in Chatou.
1893	Turns professional cycle racer, supplementing his income by working in a bicycle factory. Attracted by painting, he takes drawing lessons from Monsieur Robichon, member of Artistes Français, but is more drawn to the naive paintings of Henri Rigal, whom he paints with on Ile de Chatou. Also favors the Impressionist paintings he sees at Le Barc de Bouteville in Paris.
1894	Marries Suzanne Berly, a young woman of his own age. In the next two years two daughters are born, Madeleine and Solange. Supplements his meager cycling salary with violin lessons. Competes in local races and in Rouen, Tours, Bordeaux, and Haarlem-la-Haye in Holland.

1896 August 2—Forced to withdraw from the Grand Prix de Paris because of typhoid fever, which marks the end of his cycling career. Convalesces for three months. November—summoned for military service in the 70th Regiment in Vitré, Brittany. Conscripted for three years. After six months basic training, he is allowed to serve in the regimental band. Gives private violin lessons and, thanks to a friend, has access to the officers' library. Reads widely, including Zola, Flaubert, Alphonse Daudet, Guy de Maupassant, the Goncourts, philosophy, and Marx. Describes his barrackroom friends as radicals— "Dreyfusards, anti-militarists, anti-religious." Begins to write, contributing to radical magazines such as *Fin de siècle* and *L'Anarchie*. Little opportunity to paint, though his earliest surviving work is a decoration made in 1899 for a regimental fête.

1898 Befriends Fernand Sernada, a fellow military malcontent. Together, they write the first of a two-part novel, *D'un lit dans l'autre*, illustrated with thirty drawings by André Derain when published in 1901.

1900 July—meets Derain when they are both involved in a minor railway accident in Chatou during Vlaminck's last leave before the end of his military service. They discuss art, painting, and literature and rapidly become close friends, agreeing to share a studio in Chatou. September— released from the army, he contributes articles to an anarchist paper, solicits the novelist Emile Zola for support, and earns his livelihood as a violinist in l'Orchestre Marchetti at the World's Fair and by night in various Montmartre nightclubs and restaurants. Paints during the day, to the displeasure of his father and family. Admires the Impressionists. Rents with Derain a studio for ten francs a month in an abandoned hotel-restaurant on Ile de Chatou called "La Baraque."

1901 Greatly influenced toward Expressionism and color experimentation by the van Gogh retrospective (fifty paintings) at Galerie Bernheim-Jeune. Desperately tries to purchase works by van Gogh but fails. *D'un lit dans l'autre*, with a preface by Félicien Charpentier and drawings by Derain, is published by Frères Offenstadt. Writes two more novels, *Tout pour ça* and *Ames de mannequins*.

1902 Discovers and purchases two African statues in a bistro in Chatou. A friend of his father gives him African masks and other statues, which he is later forced to sell for lack of money. Derain departs for military service in Commercy until 1904. The two correspond regularly. Paints in Chatou. Frequents Durand-Ruel's gallery and admires Cézanne.

1903 Shows paintings at Berthe Weill's store, 25, rue Victor Massé with other young artists including Matisse. Frères Offenstadt publishes *Tout pour ça*, illustrated by Derain. Continues to work in Chatou.

1904 Paints faïences produced by A. Methey. September—Derain returns from the army. Derain's decision to attend l'Académie Julien saddens Vlaminck, who wishes to continue their collaboration. Meets Guillaume

Apollinaire, critic and defender of the avant-garde. Gives up playing in night clubs but still teaches private music lessons.

1905 Encouraged by Matisse, he and Derain exhibit for the first time at the Salon des Independants. Vlaminck shows eight paintings that attract some attention, though only one sells (its sale pays for the birth of his third daughter Yolande). During the summer his style becomes more like Matisse and Derain. October-November—group exhibition with Derain, Camoin, Dufy, Manguin, Marquet, and Matisse at Galerie Berthe Weill, where he exhibits until 1908. Vlaminck shows five paintings. November—participates in the historic *cage aux Fauves* at the Salon d'Automne. Meets Picasso. In an Argenteuil café he discovers and buys African sculptures. He sells one mask to Derain who shows it to Matisse and Picasso.

1906 Shows eight canvases at the Indépendants. April—Ambroise Vollard purchases the entire contents of his studio, as he had done earlier with Derain, for 6,000 francs and agrees to continue to buy new works on a monthly basis. This arrangement enables Vlaminck to give up music and devote himself full time to painting. Settles in Rueil near Chatou. Avoids Paris and the avant-garde, preferring to work in Bougival, Marly, Vilesnes, Chatou, Le Pecq, Argenteuil, and Fécamp. Shows at the Salon d'Automne until 1908.

1907 Daniel-Henry Kahnweiler purchases several canvases. March—Vollard gives him his first one-artist show, including paintings, ceramics, faïences, plates, and vases. Shows at La Libre Esthétique in Brussels. Publishes his third novel in collaboration with Fernand Sernada, *Ames de mannequins*. The publisher, Pierre Douville, accepts the manuscript but refuses Derain's illustrations. Shows at the Indépendants. Works at Rueil.

1908 March—exhibition at Vollard's gallery. Shows at the Indépendants. Joins Derain in Martigues and, though fascinated by southern France, he prefers to work on the banks of the Seine. Abandons the violent pure-color contrasts of the Fauves for a darker palette and a Cézannesque manner that lasts until 1914.

1910 Flirts with but quickly abandons Cubism. Moves to La Jonchère, a hamlet above Bougival. Exhibits forty paintings at Vollard's; catalogue preface by Roger-Marx. Also shows at Neue Kunst in Munich with young French and German artists, at the XXX show with Friesz, and holds an individual show at Galerie Druet (catalogue preface by Gustave Geoffroy).

1911 During the years leading to World War I, Vlaminck occasionally meets Derain at a small bistro on the place du Tertre also frequented by Picasso, Max Jacob, Braque, Apollinaire, van Dongen, Fritz Vanderpyl, André Salmon, and the actor Ollin. The owner, a certain Monsieur Azon, had faith in his clientele and would extend them credit. Unfortunately, he eventually was forced to close the establishment. In *Tournant dangereux* (1929), Vlaminck claims that Cubism was born amidst the lively art

discussions held there. Travels to London at Vollard's insistence. Paints the banks of the Thames but does not enjoy his visit. November—participates with Derain in the Salon d'Automne.

1912 Exhibits at the Indépendants and at Galerie Druet.

1913 Visits the Midi with Derain. Gustave Coquiot and Kahnweiler publish essays on his work.

1914 Moves to Coteau Saint-Michel in Bougival. Mobilized at the outbreak of war, but thanks to the influence of his brother-in-law, Elie Bois, editor of *Le Peteit Parisien*, he is soon released from the army to serve in the war industries in and near Paris. Continues to paint whenever possible. May—exhibition at the Emile Richter gallery in Dresden.

1915 February—transfers to a war factory in Puteaux.

1917 Detached to the aviation center at Bourget near the end of the year. Begins to write poetry.

1918 April—renews friendship with Apollinaire, who dies on November 9. July—participates in a group exhibition of young French painters at Goupil's gallery. Prepares the decors for the play *Couleurs du temps*, but they are not used.

1919 February—individual show at Druet's that meets with favorable press. A rich Swedish businessman purchases ten thousand francs' worth of pictures. Moves from Saint-Michel to La Naze, near Valmondois (40 km from Paris), where he purchases a small country house. This purchase marks his virtual retirement from Montmartre and Montparnasse. Learns that Daumier had painted there thirty years before. Meets the writer Charles Vildrac and his brother-in-law, Georges Duhamel, with whom Vlaminck develops a long friendship. Also linked with Vanderpyl, Henry Béraud, André Salmon, Francis Carco, and Léon Werth, whom he meets at Marquet's home. Exhibits at *Peintres d'aujourd'hui*, Galerie Paul Guillaume, with Derain, de la Fresnaye, Matisse, Picasso, Utrillo, Modigliani, and de Chirico. September—exhibits at Flechtheim Gallery, Düsseldorf.

1920 Purchases a house in Auvers-sur-Oise, the small village where van Gogh lived at the end of his life and where he is buried. Berthe Combes, a fashion designer and friend for several years who will later become his second wife, lives with him. The first of their two daughters is born. Exhibits at Salon des Indépendants (four canvases) and Salon d'Automne. March—shows thirty paintings at Galerie Bernheim, highly praised by critics. Illustrates Vanderpyl's *Voyages*.

1921 Death of his father (see *Tournant dangereux*, pp. 225-6). Some of his paintings are sold at the Kahnweiler sales. Publishes *Communications*, a book of poems illustrated by himself. Shows forty paintings at Bernheim-

Jeune. Also exhibits at *Ceux d'aujourd'hui* in Brussels and at the Salon d'Automne.

1922 Shows watercolors at Galerie Vildrac. March—first New York exhibit at Brummer Galleries. Later in the year the Brooklyn Museum of Art purchases a painting. Also shows at Le Centaure in Brussels and at the Salon d'Automne.

1923 January—exhibition at Galerie Vildrac, followed by a show of watercolors and canvases at Bernheim-Jeune in February. Numerous other group exhibitions in Paris, London, and Brussels. Illustrates Georges Duhamel's *Les Trois journées de la tribu.*

1924 February—shows seventy-two paintings and watercolors at Galerie Druet. May—three paintings at Salon des Tuileries. Travels to Jura.

1925 Shows at la Grande Maison du Blanc and, in May, with Friesz and Dufresne at Vildrac's. Purchases a larger home, a farm called La Tourillière near Reuil-la-Galadière in the Eure-et-Loire about 125 km from Paris, where he lives for the rest of his life. Isolated from other artists, the surrounding countryside supplies him with the bulk of his subject matter for the rest of his career. Begins to traverse France by automobile. Fascinated by speed and freedom, newspapers satirize his love of automobiles and ensuing misadventures. Travels to Belgium, Marseille, and Cherbourg. Shows at Galerie Druet, Galerie Louis Manteau in Brussels, Salon d'Automne, Bernheim, and Manuel Frères.

1926 February—exhibits at Galerie Chéreau, Paris. April—exhibits at Salz Gallery, Cologne.

1927 Birth of his second daughter, Godelieve, by Berthe Combes at La Tourillière. February—exhibits seventy-two works at Galerie Druet. Illsutrates Duhamel's *Les Hommes abandonnés* and Gabriel Reuillard's *Grasse Normandie.* Duhamel's book on Vlaminck, with the artist's illustrations, is published by Les Ecrivains Réunis.

1928 Discovers and destroys false paintings attributed to him in a gallery in Paris. Shows at the Salon de Grenoble, Salon d'Automne, Flechtheim Gallery in Berlin, Art Gédé studios, and Les Peintres modernes in Nice. *Histoires et poèmes de mon époque,* reissued after a private printing in 1919, receives critical acclaim.

1929 Florent Fels publishes a book on his friendship with Vlaminck. February—shows at Bernheim-Jeune. Stock publishes his first book of memoirs, *Tournant dangereux,* which is welcomed by the critics.

1930 Shows thirty-two canvases at Galerie du Centaure, Brussels. June—exhibits at Galerie Marcel Bernheim. Illustrates Julien Green's *Sur le Mont Cinère.*

1931 Publishes *Poliment* with Stock, a book recounting his childhood which is well received by the critics.

1932 November—included in a group of Flemish painters at Galerie Georges Giroux.

1933 January—exhibits with Dufy, Rouault, Utrillo, and Chagall at Galerie Bernheim-Jeune. Retrospective show of seventy canvases (1904-33) at Bernheim-Jeune. Well received by the critics. May-June—retrospective exhibition of 200 works at the Palais des Beaux-arts, Brussels. Paul Claudel, the French ambassador, greets the painter warmly. Receives high praise from the press.

1934 Publishes *La Haute-Folie* and *Cartes sur table* chez Stock. Participates in *Cinquantenaire des Indépendants* and shows at Bernheim-Jeune.

1935 Exhibits at Wildenstein and Co. in London; catalogue preface by Reginald H. Wilenski. Shows at the Fauvism show sponsored by the *Gazette des Beaux-arts*, the *Société Anversoise de l'art contemporain* in Brussels, and Jean Methey's Galerie de l'Elysée.

1936 January—exhibits with Forain at Galerie de l'Elsée. February—Denoël publishes *Chemin qui mène à rièn*. March—the Luxembourg Museum purchases one of his works. April—befriends the writer Georges Simenon. May—participates in a French painting show in Ireland. June—participates in a contemporary painting exhibit in Wacken, near Strasbourg and in group exhibitions in Bucharest and Brussels. Corréa publishes *Désobéir*, a book of memoirs and aphorisms.

1937 Shows in Tunis. A substantial body of his work is included in the *Exposition des artistes indépendants*, held at the Petit Palais in conjunction with the Paris Exposition Universelle. December—*Le Ventre ouvert*, a new book of memoirs, is published by Corréa.

1938 Exhibits at Galerie de Paris, Galerie Le Niveau, Galerie de l'Elysée, Salon des Indépendants (for the first time in many years), Galerie Royale, and Salle du Syndicat d'Initiative. Works with Simenon on the decors and sets for the film *Le Marie du Port* (production Robert Aisner, réalisateur Pierre Billon). Awarded second place ($600) at the Carnegie competition in Pittsburgh.

1939 May—Vlaminck presides at a banquet of the "Vitalistes," a newly formed group of artists and writers organized by Marcel Sauvage. During dinner a portrait of Adolf Hitler is burned in effigy to protest his efforts to stamp out "degenerate art." December—retrospective at Wildenstein Gallery, New York; catalogue preface by Louis Broomfield.

1940 Takes refuge at Fromentine, a small port in Normandy, when the Germans invade France. Returns soon to his farm, La Tourillière.

1941 Assiduously courted by the Germans, he agrees to join an official party of French artists who visit the Reich under German auspices. Other members of the group include his old friend Derain, with whom he had quarreled, van Dongen, Friesz, André Dunoyer de Segonzac, and the sculptor Charles Despain. Publishes *La Mort de Maindrais*, Editions Corréa.

1943 Publishes a critical book entitled *Portraits avant décès,* which gives free rein to his now extremely critical view of modern art. Most of the text had been written as early as 1937 but its publication, when some of the artists Vlaminck criticized so harshly were under direct threat from the Nazis, was extremely inopportune.

1944 August—immediately after the liberation he is arrested, held for forty-eight hours and, interrogated before a tribunal about his conduct during the war. Nothing serious is proved against him, but the whole business leaves a question mark against his name. Publishes *Le Boeuf* with his illustrations.

1946 Visits Rouen, where he had spent six months in 1914 at the beginning of the mobilization. The town had been nearly destroyed by the war.

1947 Participates with Derain in a Fauve exhibition at Galerie Bing entitled *Chatou*.

1952 Publishes a novel, *Moyen-Age sans cathèdrale*. Interview with Maurice Sauvage.

1953 Publishes a book of reflections on daily life, art, and society after the war called *Paysages et personnages* (Flammarion).

1954 Shows at the Venice Biennale.

1955 Elected a member of l'Académie Royale de Belgique and is seated with the writer Colette.

1956 Retrospective at Galerie Charpentier, Paris. Shows his graphic work at Galerie Sagot le Garrec. Publishes *La Tête tournée*, a novel with twleve original lithographs.

1957 His novel *Fausse couleur* is published by Flammarion.

1958 His final novel, *Le Garde-fou*, is published by Flammarion. Shows twelve gouaches completed since spring at *L'Ecole de Paris*, Galerie Charpentier. Dies at age 82 on November 11, actively painting and writing to the end.

Maurice de Vlaminck

Bibliography

I. Writings by Vlaminck

1697. VLAMINCK, MAURICE DE. "Croquis de révolte." *Anarchie* (1901). Also published in *Le Libertaire* (1901).

1698. VLAMINCK, MAURICE DE and FERNAND SERNADA. *D'un lit dans l'autre*. Illustré par André Derain. Paris: Offenstadt, 1902.

a. Another ed.: Préface de Félicien Champsaur. Monte Carlo: Editions du Cap, 1956-57. 189 p., illus.

1699. VLAMINCK, MAURICE DE. *Tout pour ça.* Illustré par André Derain. Paris: Offenstadt, 1903.

1700. VLAMINCK, MAURICE DE. "Croquis de révolte." *Heures militaires* (1903).

1701. VLAMINCK, MAURICE DE and FERNAND SERNADA. *Ames de mannequins.* Pairs: Pierre Douville, 1907.

Vlaminck's third novel, published in April, 1907. Douville accepted the manuscript but refused the illustrations by André Derain. The work received many reviews, mostly positive.
Reviews: *La Dépêche de Rouen* (1 April 1907); *Le Havre* (10 April 1907); *Le Petit Havre* (11 April 1907); P. Dauville, *Selectra* (13 April 1907); M. Cabs, *Gil-Blas* (17 April 1907); Rachilde, *Le Mercure de France* (1 June 1907); J. de Courbesac, *Triboulet* (7 July 1907).

1702. VLAMINCK, MAURICE DE. "Paysage." *Apollon* 7(1911):pl. 52.

1703. VLAMINCK, MAURICE DE. "Bateaux sur la Seine." *Apollon* 3-4(1912):pl. 147.

1704. VLAMINCK, MAURICE DE. *Histoire et poèmes de mon époque.* Paris: Editions de la Belle Page, 1919.

a. 2nd ed.: 1928.
Review: *Le Messager Polonais* (Varsovie) (7 Aug. 1928).

1705. VLAMINCK, MAURICE DE. *A la santé du corps.* Illustré par André Derain. Paris: Imprimerie François Bernouard, 1919.

1706. VLAMINCK, MAURICE DE. "Courrier littéraire, poèmes de peintres." *La Rose rouge* (31 July 1919).

1707. VLAMINCK, MAURICE DE. "Une définition du classique par M. Vlaminck." *Le Quotidien* (2 June 1920).

1708. VLAMINCK, MAURICE DE. [Poèmes] *Action* 4(July 1920):5-9.

1709. VLAMINCK, MAURICE DE. *Communications; poèmes & bois gravés de Vlaminck.* Paris: Editions de la Galerie Simon, 1921. 14 p., illus., 100 copies.

Includes thirteen woodcuts by Vlaminck, comprising one on cover, one full-page opposite the first poem, ten surrounding the poems and one half-page cut above the colophon. Woodcut title vignette.

1710. VLAMINCK, MAURICE DE. "Lettre sur la peinture." *Cahiers d'aujourd'hui* 2(Jan. 1921).

1711. VLAMINCK, MAURICE DE. *Journal du peuple* (21 Oct. 1922).

Article about a screenplay Vlaminck had recently completed.

1712. VLAMINCK, MAURICE DE. *Vlaminck: lettres, poèmes & 16 reproductions des œuvres du peintre.* Paris: Librairie Stock, 1923. 48 p., illus., 16 pl. Volume in "Les Contemporains" series.

1713. VLAMINCK, MAURICE DE. "Souvenirs de Modigliani." *Art vivant* 21(1925).

1714. VLAMINCK, MAURICE DE. "Do, ré, mi, fa, sol . . ." *La Vie Lyonnaise* (12 Sept. 1925).

Article about an avant-garde theatrical production of *Le Grand Guignol.*

1715. VLAMINCK, MAURICE DE. *Maurice de Vlaminck.* Paris: Editions Albert Morance, 1928. 21 p., illus. 9 pl. "Extrait de *L'Art d'aujourd'hui.*"

a. Another ed.: 1928.

1716. VLAMINCK, MAURICE DE. "Paysage." *L'Amour de l'art* 7(Feb. 1926):76.

1717. VLAMINCK, MAURICE DE. *Histoires & poèmes de mon époque.* Avec cinq bois gravés de l'auteur. Paris: Editions de la Belle Page, 1927. 50 p., illus. 775 copies. Volume in "Collection première" series.

Vlaminck's woodcuts are numbered 77-81.
Review: *Les Nouvelles littéraires* (25 Feb. 1928).

1718. VLAMINCK, MAURICE DE. *Radios clandestines.*

1719. VLAMINCK, MAURICE DE. "Stilleven, II." *Jaarlÿksch Verslag* (1928). Antwerp: Musée Royal des Beaux-arts.

1720. VLAMINCK, MAURICE DE. "Modigliani nella vita intima." *Le Arte Plastiche* (Milan) 7(April 1929).

1721. VLAMINCK, MAURICE DE. *Tournant dangereux: souvenirs de ma vie.* Paris: Librairie Stock-Delamain et Boutelleau, 1929. 275 p. 295 copies. Volume in "Collection ateliers" series.

Includes seventeen woodcuts (numbers 82-98) and six lithographs (numbers 233 38). Regarded as the most important of Vlaminck's literary productions. *Tournant dangereux* contains valuable information on his life, the evolution of his art, and the formation of his highly individualistic conception of the world.
Reviews: *Le Crapouillot* (March 1929); *Revue de la littérature étrangère* (1929); *Le Rouge et le noir* (6 July 1929).

a. German eds.: *Gefährliche Wende: Aufzeichnungen eines Malers.* Trans. by Richard Biedrzynski. Stuttgart: Deutsche Verlags-Anstalt, 1930, 276 p.; 1959, 232 p.
b. English ed.: *Dangerous Corner.* Trans. by Michael Ross. Introduction by Denys Sutton. London: Elek Books, 1961. 171 p., illus.

c. U.S. eds.: *Dangerous Corner*. Trans. by Michael Ross. Introduction by Denys Sutton. New York: Abelard-Schuman, 1961; 1967. 171 p., illus.

1722. VLAMINCK, MAURICE DE. "Fauves et cubistes." *L'Art vivant* (1929):1-2.

1723. VLAMINCK, MAURICE DE. "A Dangerous Turning (Comments on Artists he has Known, from his Memoirs)." *Volné Směry* 27:4-6(1929):97-112, 151.

1724. VLAMINCK, MAURICE DE. *Poliment.* Paris: Stock-Delamain et Boutelleau, 1931. 195 p., 440 copies.

"Souvenirs, sans ordre, classés selon la logique intérieure qui a conduit ma vie" (p. 10). Includes reminiscences of Vlaminck's childhood.
Reviews: *L'Art vivant* (1 Aug. 1931); C. Denny, *Le Soir* (17 Aug. 1931).

1725. VLAMINCK, MAURICE DE. *La Haute-folie: suivie de Cartes sur table.* Avec un avant-propos de Lucien Descaves. Paris: Stock-Delamain et Boutelleau, 1934.

Includes portraits of peasants.
Review: Aristide, *Aux écoutes* (March 1934).

1726. VLAMINCK, MAURICE DE. "Deux époques 1900 . . . 1930." *Le Peuple* (11 April 1934).

1727. VLAMINCK, MAURICE DE. "Mes rêves." *L'Orientation médicale* (May 1934).

1728. VLAMINCK, MAURICE DE. *Le Chemin qui mène à rien.* Paris: Denoël et Steele, 1936.

Reviews: *Le Nouveau cri* (15 Feb. 1936); *Le Rouge et le noir* (10 June 1936).

1729. VLAMINCK, MAURICE DE. *Désobéir.* Paris: R. A. Corréa, 1936. 20 copies.

Memoirs and aphorisms of Vlaminck.
Review: *Corréa* (1936).

1730. VLAMINCK, MAURICE DE. *Le Ventre ouvert.* Paris: Editions R. A. Corréa, 1937. 239 p.

New book of memoirs by Vlaminck.
Review: *Le Vingtième siècle* (Brussels) (25 July 1937).

1731. VLAMINCK, MAURICE DE. "Hommage à Courbet." *Beaux-arts* (18 March 1938):1.

1732. VLAMINCK, MAURICE DE. *Pour une peinture lisible, vivante humaine.* Paris: René Debresse, 1940. 15 p. Volume in "Manifestes du vitalisme" series.

Part 1 is dated May, 1939. Part 2 consists of quotations from Vlaminck's other works, selected by Marcel Sauvage.

1733. VLAMINCK, MAURICE DE. *La Mort de Maindrais.* Paris: Editions Corréa, 1941.

Social novel by Vlaminck.

1734. VLAMINCK, MAURICE DE. "Opinions libres sur la peinture." *Les Nouvelles littéraires* (June 1942).

1735. VLAMINCK, MAURICE DE. "Sur la peinture, l'invention et le don." *Comœdia* (1942).

1736. VLAMINCK, MAURICE DE. *Portraits avant décès.* Paris: Flammarion, 1943. 278 p.

a. German ed.: *Rückblick in letzter Stunde: Menschen und Zeiten.* St. Gallen: Erker-Verlag, 1965. 213 p.

1737. VLAMINCK, MAURICE DE. *Le Boeuf.* Illustré par l'auteur. Paris: Editions Corréa, 1944.

1738. SALMON, ANDRE. *Rive gauche.* Avant-propos et illustrations de Vlaminck. Paris: Chez l'auteur à Paris, 1951. 315 copies.

Includes one original aquatint (number 147) and fifteen héliogravures (numbers 4-18) by Vlaminck.

1739. VLAMINCK, MAURICE DE. *Les Pensées et la voix de Vlaminck.* Avec cinq dessins originaux de l'auteur. Paris: Georges Burnier, 1948. 80 p., illus., 5 pl., 1 sound disc (45 rpm, 7 in.).

a. Another ed.: 1958. 80 p., illus., 5 pl., 1 sound disc (45 rpm, 7 in.).

1740. VLAMINCK, MAURICE DE. *Moyen-âge sans cathédrale.* Suivi d'un entretien avec Vlaminck de Marcel Sauvage. Monte-Carlo: Edition du Livre, 1952. 200 copies.

Includes two aquatints with drypoint (numbers 149-50) by Vlaminck.

1741. VLAMINCK, MAURICE DE. "La Radio: souricière de la gloire." *Arts* (30 April 1953).

1742. VLAMINCK, MAURICE DE. "Les Cabrioles de Picasso ont été mortelles pour l'art français." (17-23 April 1953).

1743. VLAMINCK, MAURICE DE. *Paysages et personnages.* Paris: Flammarion, 1953. 240 p.

Includes Vlaminck's correspondence, reflections on everyday life, art, and society after World War II.

1744. VLAMINCK, MAURICE DE. *Vlaminck.* Paris: Flammarion, 1954. 126 p., 200 illus., 8 col. pl.

Includes an essay, "L'Homme," by Maurice Genevoix and 200 héliogravures.

1745. VLAMINCK, MAURICE DE. "Avec Derain, nous avons crée le Fauvisme." *Jardin des arts* (June 1955):473.

1746. VLAMINCK, MAURICE DE and MARCEL SAUVAGE. *Vlaminck, sa vie et son message.* Geneva: Pierre Cailler, 1956. 116 p., illus., 26 col., 180 pl. Volume in "Peintres et sculpteurs d'hier et d'aujourd'hui" series.

a. German ed.: *Vlaminck, mein Testament. Gespräche und Bekenntnisse, Maurice Vlaminck.* Herausgegeben von Marcel Sauvage; mit Photos und Dokumenten. Zurich: Arche, 1959. 106 p., illus., 12 pl.

1747. VLAMINCK, MAURICE DE. *La Tête tournée.* Avec douze lithographies *originales de l'auteur.* Monte Carlo: André Sauret; editions du Livre, 1956. 350 copies.

Includes thirteen lithographs (numbers 254-65 and "annexe numéro" 22, p. 258) by Vlaminck.

1748. VLAMINCK, MAURICE DE. *Fausse couleur, roman.* Paris: Flammarion, 1957. 268 p.

1749. VLAMINCK, MAURICE DE. "Mon testament: 'j'ai fait ce que j'ai pu, j'ai peint ce que j'ai vu.'" *Arts* (8 Jan. 1957).

1750. VLAMINCK, MAURICE DE. "L'Art abstrait est devenu l'art officiel au siècle des robots." *Arts* (27 Feb. 1957).

1751. VLAMINCK, MAURICE DE. "La Vie et l'art." *Arts* (27 March 1957).

1752. VLAMINCK, MAURICE DE. "Bernard Buffet est un peintre sordide." *Arts* (2 April 1957).

1753. VLAMINCK, MAURICE DE. "Paysages et personnages: si Delacroix, Courbet, Corot, Cézanne étaient vivants, ils seraient toujours des 'révolutionnaires.'" (1957).

1754. VLAMINCK, MAURICE DE. "Maurice Utrillo était un poète." (1957).

1755. VLAMINCK, MAURICE DE. *Le Garde-fou, roman.* Paris: Flammarion, 1958.

1756. VLAMINCK, MAURICE DE. *Lithographs.* Preface by Léon Werth. 29 p., all pl.

1757. VLAMINCK, MAURICE DE. *Haute folie.* Lithographies originales en couleurs de l'auteur. Paris: Scripta & Picta, 1964. 260 copies.

Includes forty-eight color lithographs (numbers 278-326) by Vlaminck.

1758. LESIEUR-TOUPET, H. and MAURICE DE VLAMINCK. "Les Bois gravés de Vlaminck." *Nouvelles de l'Estampe* 31(Jan.-Feb. 1977):11-8. 12 illus.

Account of Vlaminck's woodcuts that shows how much his production in this technique was the result of the influence of Daniel-Henry Kahnweiler. A further influence was his growing knowledge of African art. Lesieur-Toupet comments on the degree to which this new appreciation was shared with Derain. Vlaminck's developing woodcut technique as it appears in his works is closely analyzed. Some letters from Vlaminck to Kahnweiler are included in an appendix.

II. Archival Materials

1759. LHOTE, ANDRE. *Letters*, 1907-29, to Gabriel Frizeau. 82 items. Holographs, signed. Located at The Getty Center for the History of Art and the Humanities, Archives of the History of Art, Santa Monica, California.

Lhote (1885-1962) was a French painter, illustrator and art critic. Consist of letters written by Lhote to his friend and patron Gabriel Frizeau. Frizeau, an art collector whose tastes and ideas did not agree exactly with Lhote's, enlisted the painter as his agent in Paris. The letters focus on the Paris art market, theoretical concerns, and Lhote's writings on art, but also include personal matters. The collection is arranged in chronological order.

In the course of his reports to Frizeau, Lhote maintains a running commentary on the art market which includes detailed assessments of the value of specific works as sound financial investments (1908, 1917, 1918) and procedures for sending paintings out on approval (1908, 1912, 1926). Lhote acts as mediator between Frizeau and other artists, often obtaining lower prices for the collector because of Lhote's friendships and the poverty of the artist in question (1914, 1916, 1917).

In early letters he explains the experience and significance of painting for him (1909) or expresses a desire that his own art reach a wider mass audience (1912, n.d.). In one letter, however, he warns that art should not become a slave to theory (1910). His descriptions of the places he visited are often revealing of his attitude to nature (1910, 1912, 1913, 1915) and balance his emphasis on an intellectual approach towards art seen most clearly in his defense of Cézanne as both intellectual and "spiritual" (1910, 1920) in a manner related to Emanual Swedenborg (1920). He discusses the relations of mysticism and Realism (1909, 1920, n.d.) and claims that his own roots can be found in the primitive/Realist tradition (1908, 1913).

In early letters Lhote extensively describes, and provides sketches of paintings by Gauguin that are for sale or which Frizeau is selling (1908, 1910, 1912, 1913, 1916). Often quoting prices, he also recommends that Frizeau buy works by the following artist: Georges Rouault (1908-10), Pierre Girieud (1908, 1910, n.d.), Emile Bernard (1908), Henri Matisse (1908), Emile-Antoine Bourdelle (1912), Marc Chagall (1914), Maurice de Vlaminck (1918), Robert Lotiron (1920, 1926, n.d.), Jacques Lipchitz

(1920), and Paul Cézanne (1917, n.d.). He specifically refers to his professional relationships with the following dealers both as artist and as buyer: Ambroise Vollard (1908, n.d.), Joseph Granié (1908-09), la Galerie Druet (1908, 1910, 1920). Léon Marseille (1913, n.d.), Paul Rosenberg (1921, 1926, n.d.), la Galerie Mantelet (1926?), Berthe Weill (1917, n.d.), and Louis Vauxcelles (n.d.). In many letters he briefly mentions several other artists whom he meets and whose work he sees while in Paris.

1760. ROUDINESCO, ALEXANDRE. *Letters Received*, 1918-49. 74 items. Holographs, signed. Located at The Getty Center for the History of Art and the Humanities, Archives of the History of Art, Santa Monica, California.

Collection consists of letters to the Paris collector Dr. Alexandre Roudinesco from various Fauve painters. Most date from the 1930s and represent an unusually intimate and informative relationship between artist and patron. Letters include 30 from Maurice de Vlaminck, 1932-49; 28 from Raoul Dufy, 1918-36; 8 from Paul Signac, 1926-34; 6 from Kees van Dongen, 1930; 2 from Georges Rouault.

1761. VLAMINCK, MAURICE DE. *Letters*, 1912-54. 8 items. Holographs, signed. Located at The Getty Center for the History of Art and the Humanities, Archives of the History of Art, Santa Monica, California.

Personal letters to mostly unidentified friends, with some mentions of work and the disruptions of war. In one letter dated 1954, Vlaminck discusses details of his career as an artist, mentioning exhibitions and museums owning his work. Other letters are addressed to Madame Gustave Coquiot, expressing condolences at the death of her husband (1926); and one letter to Ambroise Vollard, regarding the sale of paintings. Vlaminck's letters are part of the McAlpine Collection.

III. Biography and Career Development

Books

1762. BRODSKAYA, NATALIA VALENTINOVA. *Maurice de Vlaminck.* Compiled and introduced by Natalia V. Brodskaya. Trans. by Michael Molnar. Leningrad: Aurora Art Publishers, 1987. 25 p., illus., 11 pl. Volume in "Masters of World Painting" series.

1763. CLOCHARD, WILLIAM. *Vlaminck à qui je dois.* Chartres: William Clochard, 1959.

1764. CRESPELLE, JEAN-PAUL. *Vlaminck: fauve de la peinture.* Paris: Gallimard, 1958. 245 p., illus. Volume in "L'Air du temps" series.

1765. DERAIN, ANDRE. *Lettres à Vlaminck.* Paris: Flammarion, 1955. 233 p., facsimiles.

Published with the cooperation and editing assistance of Vlaminck.

1766. DUHAMEL, GEORGES. *Maurice de Vlaminck*. Illustré par l'artiste. Avec quatre cuivres originaux et vingt-quatre reproductions en phototypie. Paris: Les Ecrivans Réunis. 1927. 49 p., illus., 27 pl. 875 copies.

1767. FELS, FLORENT. *Vlaminck*. Paris: Marcel Seheur, 1928. 205 p., illus., some col. Volume in "Collection L'art et la vie" series.

Fels recounts his friendship with Vlaminck.
Review: *Jazz* (Jan. 1929).

1768. GENEVOIX, MAURICE. *Vlaminck. I. L'Homme. II. L'Œuvre, 200 héliogravures, 8 planches en couleurs*. Paris: Flammarion, 1954. 126 p., illus., 8 col. pl.

a. Another ed.: 1967.

1769. KAHNWEILER, DANIEL-HENRY. *Maurice de Vlaminck*. Leipzig: Klinkhardt und Biermann, 1920. 16 p., 32 illus., 1 col. Also published in *Der Cicerone* (1919):757-61. Volume in "Junge Kunst" series.

a. Another ed.: Berlin: Werkkunst, 1926. 32 pl., illus

1770. MANTAIGNE, ANDRE. *Maurice Vlaminck*. Paris: G. Crès, 1929. 142 p., illus., 39 pl. Volume in "Peintres et sculpteurs" series.

1771. PERLS, KLAUS GÜNTER. *Vlaminck*. Edited by André Gloeckner. New York: Hyperion Press; Harper & Brothers, 1941. 76 p., illus., some col.

1772. PERRY, JACQUES. *Maurice Vlaminck. Images de Roger Hauert*. Geneva: R. Kister, 1956. 30 p., illus. Volume in "Les Grands peintres" series.

a. English ed.: *Maurice Vlaminck. Portraits by Roger Hauert*. Trans. by F. E. Richardson. Geneva: R. Kister, 1957. 30 p., illus.

1773. POLLAG, SIGMUND. *Mes souvenirs sur Vlaminck*. Geneva: Pierre Cailler, 1968. 53 p., illus. Volume in "Collection écrits et documents de peintres" series.

1774. REY, ROBERT. *Maurice de Vlaminck, né en 1876*. Paris: Flammarion, 1955. 1 vol., illus. Volume in "Le Grand art en livres de poche" series.

a. Another ed.: 1956.
b. U.S. eds.: *Vlaminck (Born 1876)*. New York: Abrams, 1956; 1961.
c. German ed.: *Maurice de Vlaminck, geboren 1876*. Munich, Vienna, Basel: Kurt Desch, 1956.

1775. ROGER-MARX, CLAUDE. *Vlaminck, illustrateur*. Paris: Plaisir de Bibliophile, 1927.

1776. SAUVAGE, MARCEL. *Vlaminck, sa vie et son message*. Geneva: Pierre Cailler, 1956.

1777. SELZ, JEAN. *Vlaminck*. Paris: Flammarion, 1962. 94 p., illus., some col. Volume in "Les Maîtres de la peinture moderne" series.

a. Other eds.: 1965, 1967, 1975.
b. U.S. ed.: *Vlaminck*. Trans. by Graham Snell. New York: Crown Publishers, 1963. 95 p., illus., some col.
c. Other English eds.: Milan: Uffici Press, 1963; Naefels: Bonfini Press, 197_.

1778. WERNER, ALFRED. *Vlaminck, 1876-1958*. Text by Alfred Werner. New York: Abrams, 1959. 36 p., illus.

a. Portfolio ed.: *Maurice Vlaminck*. New York: Abrams, 1971. 24 p., illus., some col.

Articles

1779. ALLARD, ROGER. "Maurice de Vlaminck." *Art vivant* 1(1 April 1925):1-4.

1780. BAZIN, GERMAIN. "Maurice de Vlaminck." *L'Amour de l'art* (June 1933):133-6.

1781. BERAUD, HENRI. "Vlaminck." *L'Eclair* (5 Feb. 1919). Also published in *Bonsoir* (6 Feb. 1919).

1782. BERAUD, HENRI. "Le Peintre Maurice Vlaminck, ou le colosse anxieux." (1921).

1783. BOURET, JEAN. "Pour un portrait de Derain." *Galerie-Jardin des arts* 167(March 1977):41-5. 6 illus.

On the occasion of a Derain retrospective, held in Paris at the Grand Palais, Bouret stresses the importance of Derain's Parisian roots and discusses the path followed by Derain, from Impressionism, influenced by Seurat, to the sudden beginnings of Fauvism under the influence of Vlaminck. His connections with Picasso and discovery of Douanier Rousseau are presented for the way in which Derain's development was affected by both. After the First World War (in which he fought), Derain turned to a kind of realism, like La Fresnaye or Gromaire, but during the later part of his life his work was marked by a renewal of contact with the art of the past, from Byzantium to Signorelli, the Le Nain brothers, and Poussin.

1784. CHIARISOLO, CHARLES. "Vlaminck." *La Gazette Franco-Britannique* (23 Nov. 1934).

1785. "Un 'Coltineur' devenu champion de la palette." *L'Auto* (3 March 1921).

1786. COQUIOT, GUSTAVE. "Maurice de Vlaminck." *Le Carnet des artistes* 12(15 July 1917):12-4.

1787. D'ALAYER, MICHEL. "Maîtres actuels et peintres de demain: Maurice Vlaminck." *Arts* (2 April 1953).

1788. DOESBURG, THEO VAN. "Maurizio de Vlaminck, pittore." (July 1920).

1789. DORINGE. "Pour la 'mairie du port' de Simenon et Billon, le peintre Vlaminck va peindre son premier décor de cinéma." *Pour vous* (1938).

1790. DUHAMEL, GEORGES. "Vlaminck." *Paris-soir* (12 Aug. 1924).

1791. DUHAMEL, GEORGES. "Vlaminck." *Art d'aujourd'hui* 3(Spring 1926):5-12.

1792. DUTHUIT, GEORGES. "Maurice de Vlaminck." *Cahiers d'art* (1929).

1793. DUVAL, MAURICE. "De Vlaminck, le nouvelliste." *Je dis tout* (26 and 30 1970).

1794. ESCHOLIER, RAYMOND. "Les Arts, Vlaminck, peintre, musicien et écrivain." *La Dépêche de Toulouse* (31 Jan. 1933).

1795. ESCHOLIER, RAYMOND. "Un peintre écrivain Vlaminck." *La Dépêche de Toulouse* (18 Aug. 1936).

1796. W. E. "Derain and Vlaminck." *Studio News* 3(April 1932):2.

1797. FLEISCHMANN, HECTOR. "Maurice de Vlaminck." *Figures artistiques d'aujourd'hui* (1903).

1798. FRANK, ANDRE. "Le Banquet des Vitalistes." *L'Intransigeant* (31 May 1939). See also *La République* (10 June 1939).

Le Vitalisme, a movement of artists and writers led by Marcel Savage, held banquets on the Left Bank in Paris. Vlaminck presided over the banquet described here, during which a portrait of Adolf Hitler was burnt in protest of the Nazi's policy of condemning "degenerate art."

1799. GASQUET, JOACHIM. "Le Mouvement intellectuel: Vlaminck." *L'Eclair* (27 May 1920).

1800. GAUNT, WILLIAM. "Painter at War with Intellectual Movements." *London Studio* (Aug. 1939):58-63.

1801. GENEVOIX, MAURICE. "Mon ami Vlaminck." *Jardin des arts* (Oct. 1968).

1802. GEORGE, WALDEMAR. "Portraits de peintres, Vlaminck." *La Patrie* (20 Jan. 1928); *La Presse* (26 Jan. 1928).

1803. GYBAL, ANDRE. "Vlaminck." *Les Hommes du jour* (3 Dec. 1921).

1804. JOLINON, JOSEPH. "La Recontre de Vlaminck avec Derain." *L'Art vivant* 158 (March 1932):121.

1805. JOLINON, JOSEPH. "Visite à Vlaminck." *Les Nouvelles littéraires* (11 Feb. 1933).

1806. KAHNWEILER, DANIEL-HENRY. "Maurice de Vlaminck." *Der Cicerone* (1919):757-61.

1807. LUZZATTO, GUIDO LODOVICO. "Vlaminck." *Grandi Maestri del Colore* (Bergamo) 26(1935):1-26.

1808. "Maurice de Vlaminck." *La Vie* (11 Jan. 1913).

1809. "Maurice de Vlaminck." *L'Eventail* (15 Nov. 1918).

1810. "Maurice de Vlaminck." *L'Eclaireur du soir* (1928).

1811. "Maurizio de Vlaminck." *Bleu* (July 1920).

1812. MICHELI, MARIO DE. "Il Ritorno di Vlaminck" [Vlaminck's Return]. *Arte* (Italy) 18:187(July-Aug. 1988):48-53, 112. 8 illus., 7 col.

With reference to an exhibition of Maurice Vlaminck's work at the Centro Saint-Benin in Aosta, Italy (Summer 1988), Micheli reassesses the artist's career and art, drawing extensively on his own statements. Vlaminck's anarchic stance, his involvement with the Fauves, and the significance of this type of painting for him, are discussed. The development of his style in the 1945-55 period, which resulted in canvases expressing a "tragic grandeur," is described.

1813. MILLET, JEAN-FRANÇOIS. "Maurice de Vlaminck." *Deutsche Kunst und Dekoration* (Darmstadt) 54(1924):61-2.

1814. NICCO, G. "Maurice de Vlaminck." *Dédalo* 13(March 1933):175-91.

1815. OLIVIER, PAUL. "Quand le peintre Maurice de Vlaminck était champion cycliste." *L'Art et le sport* (1910).

1816. "Un peintre écrivain." *Le Messager Polonais* (7 Aug. 1928).

1817. "Un peintre, Maurice de Vlaminck." *L'Université de Paris* (23 Dec. 1941).

1818. "Le Peintre Vlaminck détruit des toiles qu'on lui attribue." *Le Soir* (Feb. 1928).

1819. PETRIDES, PAUL. "Pétridès: Vlaminck tel quel." *Galerie-jardin des arts* 147(May 1975):72. 2 illus.

For the first time since 1965, a retrospective of works by Vlaminck was presented in Paris by Paul Pétridès. In this brief text Pétridès recounts his friendship with the painter and Vlaminck's connection with Derain. Vlaminck's contribution to the growth of the Fauve movement is emphasized.

1820. PINTURRICHIO. "L'Ecrivain Vlaminck." *Le Carnet de la semaine* (17 June 1923).

1821. C. P. "Vlaminck et Derain." *L'Art libre* (1921).

1822. REUILLARD, GABRIEL. "Vlaminck." *La Rumeur* (2 Aug. 1928).

1823. ROELL, W. F. A. "Maurice de Vlaminck" in *Maandblad voor beeldenke Kunsten*. Amsterdam, 1925. 2 vols.

Vlaminck is discussed in volume 2, pp. 131-8.

1824. ROGER-MARX, CLAUDE. "Vlaminck, ou le fauve intégral." *Jardin des arts* (April 1956):350-4.

1825. ROMOFF, SERGE. "Les Peintres d'aujourd'hui: Maurice Vlaminck." *L'Humanité* (6 Dec. 1927).

1826. SALMON, ANDRE. "Maurice de Vlaminck." *Paris-journal* (20 Sept. 1911).

1827. SALMON, ANDRE. [untitled]. *Paris-journal* (19 March 1912).

1828. SALMON, ANDRE. "Vlaminck." *La Vie* (Paris) (Jan. 1913).

1829. SALMON, ANDRE. "Vlaminck, tu seras fauve!" *Le Sourire* (Paris) (20 March 1913).

1830. SALMON, ANDRE. Vlaminck." *Les Soirées de Paris* (Aug. 1914).

1831. SALMON, ANDRE. "Letter from Paris." *Apollo* 6(Nov. 1927):220-21.

On Fauvism and Vlaminck.

1832. SENTENAC, PAUL. "De Vlaminck et Le Fauconnier." *Studio revue*.

1833. STEINES, A. "Courses de vélocipèdes du 23 mai 1897." *Une Journée à Puteaux* (1897).

1834. VANDERPYL, FRITZ R. "Vlaminck." *L'Amour de l'art* 1(July 1920):96.

1835. VANDERPYL, FRITZ R. "Maurice de Vlaminck." *Le Point* 3(1957).

1836. VILLETARD, LUCILE. "M. Maurice de Vlaminck." *Nos loisirs* (1 July 1924).

1837. "Vlaminck." *Le Radical* (24 May 1920).

1838. "Vlaminck." *Propos d'artistes* (July 1925).

1839. "Vlaminck." *Portraits d'artistes* (1929).

1840. "Vlaminck." *Bibliographie de la France* (11 Feb. 1938).

1841. "Vlaminck." *Bibliothèque du travail* 725(1 May 1971).

1842. "Vlaminck auteur dramatique." *Le Soir* (3 Sept. 1925).

1843. "Vlaminck et Fels." *Jazz* (Jan. 1929).

1844. WERNER, ALFRED. "Vlaminck: Wildest of the 'Beasts'." *Arts Magazine* 42:5(March 1968):30-43.

Details Vlaminck's life and reviews the exhibition *Vlaminck: His Fauve Period*, New York, Perls Galleries (9 April-11 May 1968).

IV. Works (Œuvre)

A. Catalogues Raisonnés

1845. PETRIDES, PAUL. *Catalogue raisonné de l'œuvre de Vlaminck.* In preparation.

1846. WALTERSKIRCHEN, KATALIN VON. *Maurice de Vlaminck: Verzeichnis des graphischen Werkes; Holzschnitte, Radierungen, Lithographien.* Herausgeber, Sigmund Pollag. Bern: Benteli, 1974. 280 p., 640 illus.

An introduction outlining Vlaminck's life and development is followed by a *catalogue raisonné* of 326 known graphic works. The catalogue is arranged in two parts: first, works are listed according to the technique used; second, details are given about the publications in which they have appeared. Other features of this work are a chronological bibliography of original graphic work, an alphabetical list of titles of both the original graphics and reproductions, notes on the sources and documents concerned with the compilation of the catalogue, and illustrations of Vlaminck's signature at different periods of his life.
a. French ed.: *Maurice de Vlaminck: Catalogue raisonné de l'œuvre gravé; gravures sur bois, gravures sur cuivre, lithographies.* Trans. by Christine Havard. Paris: Flammarion, 1974. 280 p., illus.

B. Works in General

Books

1847. BOUDAILLE, GEORGES, ed. *Vlaminck.* Paris: Musée personnel, 1968. 15 p., illus., 16 col. pl. Volume in "Collection le musée personnel" series.

1848. CABANNE, PIERRE. *Vlaminck, paysages.* Paris: Fernand Hazan, 1966. Volume in "Petite encyclopédie de l'art" series.

1849. CARCO, FRANCIS. *M. de Vlaminck; trente et une reproductions de peintures et dessins précédée d'une étude critique par Francis Carco, de notices biographiques et documentaires et d'un portrait inédit de l'artiste dessiné par lui-même et gravé sur bois par Jules Germain.* Paris: Editions de la Nouvelle Revue Française, 1920. 63 p., illus., pl. Volume in "Les Peintres français nouveaux" series.

1850. CARRÁ, MASSIMO. *Vlaminck.* Milan: Fratelli Fabbri, 1965. 23 pl., illus., 16 pl. Volume in "I Maestri del colore" series.

1851. HERON, PATRICK. *Maurice de Vlaminck. Paintings, 1900-1945.* Introduction by Patrick Heron. London: Lindsay Drummond, 1947. 8 p., 16 col. pl.

1852. KAHNWEILER, DANIEL-HENRY. *Maurice de Vlaminck.* Leipzig: Klinkhardt und Biermann, 1920. 16 p., 32 illus., 1 col. Also published in *Der Cicerone* (1919):757-61. Volume in "Junge Kunst" series.

a. Another ed.: Berlin: Werkkunst, 1926. 32 pl., illus.

1853. LEISIEUR-TOUPET, H. and K. VON WALTERSKIRCHEN. *Maurice de Vlaminck: Verzeichnis des graphischen Werkes: Holzschnitte, Radierungen, Lithographien.* Berlin: Benteli Verlag, 1974.

1854. MAC ORLAN, PIERRE. *Vlaminck, peintures 1900-1945.* Paris: Éditions du Chêne, 1945. 6 p., 16 col. pl.

a. Other eds.: 1947, 1958. Includes one color lithograph (number 273) and four original lithographs (numbers 274-77) by Vlaminck.
b. German ed.: *Vlaminck.* Von Pierre Mac Orlan der Akademie Goncourt; die Übersetzung besorgte, Hermann Wedderkopf. Stuttgart: Galerie Valentien; Monté-Carlo: André Sauret, 1958. 42 p.
c. U.S. ed.: *Vlaminck.* Trans. by J. B. Sidgwick. New York: Universe Books, 1958. 39 p., illus., pl. 2,000 copies.

1855. PERLS, KLAUS GÜNTER. *Vlaminck.* Edited by André Gloeckner. New York: Hyperion Press; Harper & Brothers, 1941. 76 p., illus., some col.

1856. PERRY, JACQUES. *Maurice Vlaminck. Images de Roger Hauert.* Geneva: R. Kister, 1956. 30 p., illus. Volume in "Les Grands peintres" series.

a. English ed.: *Maurice Vlaminck. Portraits by Roger Hauert.* Trans. by F. E. Richardson. Geneva: R. Kister, 1957. 30 p., illus.

1857. QUENEAU, RAYMOND. *Vlaminck, ou le vertige de la matière.* Paris: Albert Skira, 1949. 12 p., col. illus., 9 pl. Volume in "Les Trésors de la peinture française" series.

1858. RAYNAL, MAURICE. *Vlaminck.* Introduced by Maurice Raynal. Geneva: A. Skira; New York: Transbook Co., 1951. 16 p., col. illus., 10 pl. Volume in "Masterpieces of French Painting" series.

1859. ROGER-MARX, CLAUDE. *Vlaminck, illustrateur.* Paris: Plaisir de Bibliophile, 1927.

1860. WERNER, ALFRED. *Vlaminck, 1876-1958.* Text by Alfred Werner. New York: Abrams, 1959. 36 p., illus.

a. Portfolio ed.: *Maurice Vlaminck.* New York: Abrams, 1971. 24 p., illus., some col.

1861. WERTH, LEON. *Vlaminck, vingt et une reproductions d'après ses tableaux.* Texte de Léon Werth. Paris: Bernheim-Jeune, 1925. 9 p., 21 pl.

Articles

1862. "Ah Vlaminck Oh Ku Singa!" *Comœdia* (30 Dec. 1921).

1863. ARISTIDE. "'La Haute folie' par Monsieur Vlaminck." *Aux écoutes* (March 1934).

1864. "Les Arts, de Vlaminck et de Fauconnier." *Paris-journal* (4 Dec. 1921).

1865. "Les Arts Vlaminck et quelques autres." *La République* (5 Feb. 1933).

1866. "Avec Vlaminck devant ses toiles." *Beaux-arts* (3 Jan. 1936):1.

1867. AZORIN. "En el studio de Vlaminck." *La Prensa* (1931).

1868. BASSANI, EZIO. "La Maschera bianca di Vlaminck e di Derain" [The White Mask of Vlaminck and Derain]. *Critica d'Arte* 20:133(Jan.-Feb. 1974):18-24. 4 illus.

Examines the importance of an original wooden African mask and its bronze copy (exhibited in Paris 1966-67) in influencing the artists of l'Ecole de Paris in 1905. Bassani describes the wooden mask that belonged to Vlaminck and then Derain, and indicates briefly its influence on Cubism. He goes on to narrate a strange coincidence of two almost identical masks described as having belonged to Derain, the one already described and another in the Toledo Museum of Art. Bassini's conclusion is that it is possible the same artist could have made them, and an error of cataloguing could be explained by the fact that the objects were not reproduced until 1958. Similar masks are then listed to illustrate this point.

1869. BILLET, JOSEPH. "Les Arts Vlaminck." *L'Avenir* (1932).

1870. BISSIERE, ROGER. "Vlaminck." *L'Opinion* (15 Feb. 1919).

1871. BISSIERE, ROGER. "Vlaminck." *Burlington Magazine* (Sept. 1919).

1872. BOUILLOT, ROGER. "Hommage à Vlaminck." *L'Œil* 383(June 1987):42-7. 7 illus., 5 col.

Review of the exhibition *Vlaminck* at the Galerie de la Présidence, Paris (Summer 1987). Bouillot commends the idea of the retrospective of thirty-five paintings by Vlaminck (1987-1958) and feels that it was of the correct size. He examines the exhibited works chronologically, starting with the Fauvist paintings and the works influenced by Cézanne. Vlaminck's attitudes to Cubism and to nature, and the features of Vlaminck's "inimitable style" are described.

1873. BOURET, JEAN. "Pour un portrait de Derain." *Galerie-Jardin des arts* 167(March 1977):41-5. 6 illus.

On the occasion of a Derain retrospective, held in Paris at the Grand Palais, Bouret stresses the importance of Derain's Parisian roots and discusses the path followed by Derain from Impressionism, influenced by Seurat, to the sudden beginnings of Fauvism under the influence of Vlaminck. His connections with Picasso and discovery of Douanier Rousseau are presented for the way in which Derain's development was affected by both. After the First World War (in which he fought), Derain turned to a kind of realism, like La Fresnaye or Gromaire, but during the later part of his life his work was marked by a renewal of contact with the art of the past, from Byzantium to Signorelli, the Le Nain brothers, and Poussin.

1874. BOURGEOIS, STEPHEN. "Maurice de Vlaminck" in *The Adolph Lewisohn Collection of Modern French Paintings and Sculptures* (New York: Weyhe, 1928), pp. 227-31.

1875. CASSOU, JEAN. "Maurice de Vlaminck." *Art et décoration* 56(Sept. 1929):65-75.

1876. "De l'Institut à Vlaminck." *Le Carnet des ateliers* (1933).

1877. DELAHAUT, JEAN-ROBERT. "Chez Vlaminck." *Terre d'Europe* (25 June 1957).

1878. DEMAY, CLAUDE. "La Ferme Vlaminck." *Méditerranéa* (March 1928).

1879. DESCAVES, LUCIEN. "Vlaminck y el Salon de los indépendientes." *La Prensa* (1929).

1880. DESCAVES, MAX. "Inutile de peindre si on n'est pas touché par la grâce." *Paris-midi* (23 Jan. 1932).

1881. DESCAVES, PIERRE. "Quand le peintre Vlaminck fait du 100 à l'heure." *T.S.F. programme* (14 Sept. 1936).

1882. HERTZ, HENRI. "Transformations du paysage dans l'art moderne: Vlaminck." *L'Amour de l'art* 4(1923):421-6.

1883. LA PALETTE [pseud.]. "Vlaminck." *Paris-journal* (29 Sept. 1911).

1884. "Le Lyrisme, Vlaminck." *La Peinture française* (June 1927).

1885. OCHSE, MADELEINE. "Vlaminck (1876-1958): exacerbation de la nature." *Jardin des arts* 217(March-April 1973):52-7. 4 illus.

1886. PRESTON, STUART. "Vlaminck." *Burlington Magazine* 129(Dec. 1987):828-9.

Article occasioned by the Vlaminck exhibition at Musée des Beaux-arts, Chartres.

1887. SCHNEIDER, OTTO ALBERT. "Maurice de Vlaminck." *Deutsche Kunst und Dekoration* (Darmstadt) 46(Sept. 1920):269-82.

1888. "Sur Vlaminck." *Paris-midi* (16 April 1920).

1889. "Tableaux de la Riviera pendant l'été." *La Revue de Paris* (15 Oct. 1935).

1890. TERIADE, EMMANUEL. "M. de Vlaminck, peintures." *Cahiers d'art* 1(Jan. 1926):10-1.

1891. VAUXCELLES, LOUIS. [Untitled]. *Gil-Blas* (18 March 1918).

1892. VERONESI, GIULIA. "L'Opera di Vlaminck del 'fauvismo' si nostri giorni." *Emporium* 124(Nov. 1956):205-8.

1893. "La Vie artistique, la formule de Monsieur Vlaminck." *La Renaissance* (22 May 1921).

1894. "Vlaminck." *La Critique* (20 April 1902).

1895. "Vlaminck." *L'Ere nouvelle* (26 May 1920).

1896. "Vlaminck dégustait les plaisirs de la table." *Cahiers d'art* 2:78(1927):supp. 7.

1897. WARNOD, ANDRE. "Faux tableaux." *Les Annales* (1 March 1925).

C. Individual Paintings

Articles

1898. "*Barques à Chatou*." *L'Œil* 359(June 1985):27.

1899. "*Les Bateaux-mouches*." *Art in America* 72(Oct. 1984):38.

1900. "*The Bridge at Chatou*." *The Artist* 103(May 1988):46 and *Du* 5(1988):15.

1901. "Charlot par Vlaminck." *Pour vous* (27 Dec. 1928).

1902. "*La Dame au chapeau rose*." *Connaissance des arts* 444(Feb. 1989):14.

1903. "*La Ferme dans les Avoines*." *Art & Antiques* 6(Jan. 1989):2.

1904. "*Fleurs*." *L'Œil* 359(June 1985):27.

1905. "*French Village, Winter*." *Apollo* 125(April 1987):23.

1906. GIRY, MARCEL. "Le Curieux achat fait à Derain et à Vlaminck au Salon des Indépendants de 1905 ou deux tableaux retrouvés." *L'Œil* 254(Sept. 1976):26-31.

Unravels the story told by Vlaminck of an ironical purchase in 1905 by a mysterious buyer of the works he found ugliest at the Salon des Indépendants that year. Giry's quest ended in the discovery of the missing paintings—unseen publicly since 1905. These are Vlaminck's *Les Bords de la Seine à Nanterre* and André Derain's *Bougival*.

Giry considers that the discovery makes a new assessment possible of the relation of these artists to Fauvism. Derain had at this time advanced much further towards this style than had Vlaminck.

1907. *"Guillaume Apollinaire sur les bords de la Seine ou l'île de la Grenouillère."* *Connaissance des arts* 416(Oct. 1986):65.

1908. *"Le Hameau."* *L'Œil* 362(Sept. 1985):16.

1909. *"Hymne à l'humanité*: une toile de Vlaminck." *Les Hommes du jour* (1929).

1910. "Landscape by Vlaminck Donated to Institute." *Bulletin of the Minneapolis Institute of Arts* (17 Feb. 1938).

1911. *"Maisons au toits rouges."* *Art & Antiques* 6(Nov. 1989):47.

1912. "Matisse: *Notre-Dame*, Vlaminck: *Notre-Dame."* *La Renaissance* (Feb. 1937).

1913. *"Les Meules."* *Apollo* 120(Oct. 1984):80.

1914. "Minneapolis Acquires 'de Vlaminck's *House*'." *Art Digest* 4(1 March 1930):8.

1915. *"Le Moulin."* *Connaissance des arts* 477(Nov. 1991):139.

1916. "Le Musée d'Art moderne de La Haye s'enrichit." *Comœdia* (10 June 1933).

Article on recent acquisitions by the museum, including works by Vlaminck and Albert Marquet.

1917. *"Nature morte aux compotier."* *Apollo* 131(April 1990):9 and *Burlington Magazine* 129(June 1987):ii.

1918. *"Nature morte aux oranges."* *Connaissance des arts* 469(March 1991):120.

1919. *"Paysage."* *L'Œil* 412(Nov. 1989):20; 413(Dec. 1989):20; 400(Nov. 1988):24.

1920. *"Paysage."* *Connaissance des arts* 457(March 1990):37.

1921. *"Paysage d'hiver."* *L'Œil* 444(Sept. 1992):26.

1922. *"Paysage de neige."* *L'Œil* 429(April 1991):17 and *L'Œil* 404(March 1989):16.

1923. *"Le Pêcheur à Argenteuil."* *Connaissance des arts* 412(June 1986):38.

1924. *"Les Pêcheurs à Nanterre."* *Burlington Magazine* 132(March 1990):v and *Connaissance des arts* 457(March 1990):169.

1925. *"Le Port."* *Connaissance des arts* 405(Nov. 1985):58.

1926. *"Le Remorquer."* *L'Œil* 382(May 1987):30.

1927. "*Rue de village enneigée, avec deux personnages.*" *Art News* 84(Nov. 1985):17.

1928. SAUVAGE, MARCELLE. "'*Snow Scene*' by Vlaminck." *Gand artistique* 9(March 1930):53-4.

1929. "*La Seine à Chatou.*" *Apollo* 125(June 1987):112.

1930. "Un tableau de Vlaminck au Musée du Luxembourg." *Le Soir* (19 July 1925).

1931. "[Untitled: *Village Street*]." *Connaissance des arts* 434(April 1988):33.

1932. "*Vase de pivoines.*" *Architectural Digest* 46(June 1989):85.

1933. "*Le Village sous la neige.*" *Connaissance des arts* 443(Jan. 1989):124.

1934. "A Watercolor by Vlaminck." *Minneapolis Institute of Arts Bulletin* 18(7 Dec. 1929):159-60.

D. Books Illustrated by Vlaminck

1935. MARVILLE, JEAN. *La Chanson de Kou-Singa.* Avec une gravure sur bois par Maurice Vlaminck. Paris: Se trouve à la Belle Edition; François Bernouard, imprimeur-libraire, 1919. 250 copies.

Vlaminck's woodcut illustration is number 25.

1936. VANDERPYL, FRITZ R. *Voyages.* Illustré de gravures sur bois par Vlaminck. Paris: Kahnweiler; Editions de la Galerie Simon, 1920. 14 p., illus. 100 copies.

Includes nineteen woodcuts by Vlaminck, numbers 27-45.

1937. WERTH, LEON. *Voyages avec ma pipe.* Avec une gravure sur bois de Maurice Vlaminck. Paris: Editions Georges Crès et Cie, 1920. 27 copies.

Vlaminck's woodcut is number 26.

1938. DUHAMEL, GEORGES. *Les Trois journées de la tribu.* Illustré de quatre lithographies et 10 gravures sur bois de Vlaminck. Paris: Editions de la Nouvelle Revue Française, 1921. 79 p., illus. 325 copies.

Vlaminck's woodcuts are numbered 46-55; his lithographs numbers 157-60.
a. Another ed.: 1923.

1939. VLAMINCK, MAURICE DE. *Communications; poèmes & bois gravés de Vlaminck.* Paris: Editions de la Galerie Simon, 1921. 14 p., illus., 100 copies.

Includes thirteen woodcuts by Vlaminck, comprising one on the cover, one full-page opposite the first poem, ten surrounding the poems and one half-page cut above the colophon. Woodcut title vignette.

1940. RADIGUET, RAYMOND. *Le Diable au corps*. Lithographies originales de Maurice de Vlaminck. Paris: Editions Marcel Seheur, 1926. 114 p., illus., 1 pl. 345 copies.

Includes one drypoint (number 114) and ten lithographs (numbers 192-201) by Vlaminck.
Review: L. Martin, *Le Crapouillot* (16 Oct. 1925). See also *Rouge et noir* (15 Oct. 1925).

1941. DUHAMEL, GEORGES. *Les Hommes abandonnés*. Illustré de lithographies de Vlaminck. Paris: Editions Marcel Seheur, 1927. 345 copies.

Includes one aquatint and drypoint (number 122) and twenty-eight lithographs (numbers 202-29) by Vlaminck.

1942. DUHAMEL, GEORGES. *Maurice de Vlaminck*. Illustré par l'artiste. Avec quatre cuivres originaux et vingt-quatre reproductions en phototypie. Paris: Les Ecrivans Réunis. 1927. 49 p., illus., 27 pl. 875 copies.

1943. REUILLARD, GABRIEL. *Grasse Normandie*. Avec 87 dessins inédits de Maurice de Vlaminck. Paris: André Delpeuch Editeur, 1927. 221 p., illus. Volume in "Invitation au voyage" series.

1944. VLAMINCK, MAURICE DE. *Histoires & poèmes de mon époque*. Avec cinq bois gravés de l'auteur. Paris: Editions de la Belle Page, 1927. 50 p., illus. 775 copies. Volume in "Collection première" series.

Vlaminck's woodcuts are numbered 77-81.
Review: *Les Nouvelles littéraires* (25 Feb. 1928).

1945. *Tableaux de Paris*. Textes inédits de Paul Valéry, Roger Allard, Francis Carco, Colette, J. Cocteau, Tristan Derème, R. Escholier, G. Duhamel, Jean Giraudoux, Max Jacob, Edmond Jaloux, Jacques de Lacretelle, Valéry Larbaud, Paul Morand, Pierre Mac Orlan, A. Salmon, Charles Vildrac, Jean-Louis Vaudoyer, André Warnod, André Suarès. Paris: Aux Editions Emile-Paul Frères, 1927. 225 copies.

Includes lithographs and engravings by A. Bonnard, E. Céria, J. H. Daragnès, H. David, A. Dunoyer de Segonzac, Falké, Foujita, Chas Laborde, Marie Laurencin, Marquet, C. Martin, Matisse, Luc-Albert Moureau, J. Oberlé, Pascin, Rouault, M. Utrillo, van Dongen, Vlaminck (lithograph, number 232), and H. de Waroquier.

1946. VLAMINCK, MAURICE DE. *Tournant dangereux: souvenirs de ma vie*. Paris: Librairie Stock-Delamain et Boutelleau, 1929. 275 p. 295 copies. Volume in "Collection ateliers" series.

Includes seventeen woodcuts (numbers 82-98) and six lithographs (numbers 233-38). Regarded as the most important of Vlaminck's literary productions. *Tournant dangereux* contains valuable information on his life, the evolution of his art, and the formation of his highly individualistic conception of the world.
Reviews: *Le Crapouillot* (March 1929); *Revue de la littérature étrangère* (1929); *Le Rouge et le noir* (6 July 1929).

1947. GREEN, JULIEN. *Sur le Mont-Cinère.* Lithographies de Vlaminck. Paris: Editions Jeanne Walter, 1930. 330 copies.

Includes thirteen lithographs (numbers 240-52) by Vlaminck.

1948. *Tableaux de Paris.* Paris: La Ville de Paris; imprimé par J. G. Daragnès, 1937. 700 copies.

Includes one aquatint by Vlaminck (number 146).

1949. *La Rue de la Glaciera.* Paris: La Ville de Paris; imprimé par J. G. Daragnès, 1937. 500 copies.

Includes one aquatint by Vlaminck.

1950. LECOIN, LOUIS. *De prison en prison.* Couverture illustrée par Vlaminck. Paris: Edité par l'auteur, 1947.

1951. VANDERPYL, FRITZ R. *Poèmes, 1899-1950.* Gravure sur bois de Maurice de Vlaminck. Paris: Le Cheval d'Ecume, 1950. 360 copies.

Vllaminck's woodcut illustration is number 76.

1952. SALMON, ANDRE. *Rive gauche.* Avant-propos et illustrations de Vlaminck. Paris: Chez l'auteur à Paris, 1951. 315 copies.

Includes one original aquatint (number 147) and fifteen héliogravures (numbers 4-18) by Vlaminck.

1953. VLAMINCK, MAURICE DE. *Moyen-âge sans cathédrale.* Suivi d'un entretien avec Vlaminck de Marcel Sauvage. Monte-Carlo: Edition du Livre, 1952. 200 copies.

Includes two aquatints with drypoint (numbers 149-50) by Vlaminck.

1954. LE BIHAN, JOBIC. *Le Margrave, ou la vocation du Ponheur.* Onré de sept bois orginaux de Vlaminck. Nantes: Sylvain Chiffoleau, 1955. 276 copies.

Vlaminck's woodcuts are numbered 99-105.

1955. HAMSUN, KNUT. *La Faim.* Paris: Imprimerie Nationale; André Sauret, Editeur, 1956. 3,400 copies.

Includes one original lithograph (number 267) by Vlaminck.

1956. VLAMINCK, MAURICE DE. *La Tête tournée.* Avec douze lithographies *originales de l'auteur.* Monte Carlo: André Saurés; Editions du Livre, 1956. 350 copies.

Includes thirteen lithographs (numbers 254-65 and "annexe numéro" 22, p. 258) by Vlaminck.

1957. MAC ORLAN, PIERRE. *Vlaminck*. Paris: Imprimerie Nationale; André Sauret, Editeur, 1958.

Includes one color lithograph (number 273) and four original lithographs (numbers 274-77) by Vlaminck.
a. U.S. ed.: Trans. by J. B. Sidgwick. New York: Universe Books, 1958. 39 p., illus., pl. 2,000 copies.

1958. VLAMINCK, MAURICE DE. *Haute folie*. Lithographies originales en couleurs de l'auteur. Paris: Scripta & Picta, 1964. 260 copies.

Includes forty-eight color lithographs (numbers 278-326) by Vlaminck.

1959. DUHAMEL, GEORGES. *L'Epave. Le Bengali. La Chambre de l'horloge. Trois nouvelles des Hommes abandonnés*. Illustrations de Vlaminck. Paris: Editions L.C.L., 1968. 104 p., pl. Volume in "Les Peintres du livre" series.

Selections from Duhamel's *Les Hommes abandonnés* (1927).

1960. *Essai sur l'histoire de la lithographie en France. Les Peintres lithographes de Manet à Matisse*. Album de lithographies originales. Paris: Galerie des Peintres-Gravures E. Frapier, n.d. 575 copies.

Includes original lithographs by Maurice Asselin, Jeanne Bardey, Pierre Bonnard, Georges Bouche, Emile-Antoine Bourdelle, Maurice Denis, Raoul Dufy, Othon Friesz, Aristide Maillol, Henri Manguin, Albert Marquet, Henri Matisse, L.-A. Moreau, Pascin, Georges Rouault, K.-X. Roussel, Toulouse-Lautrec, Maurice Utrillo, van Dongen, and Maurice de Vlaminck (number 181).

1961. TARTAS, PIERRE DE and MAURICE GENEVOIX. *Images pour un jardin sans murs*. Réalisant le voeu de Pierre de Tartas. Paris: Pierre de Tartas, n.d. 205 copies.

Includes eight woodcuts ("annexe numéros" 23-30) and nine chromolithographs ("annexe numéros" 31-33) by Vlaminck.

E. Graphic Works

Articles

1962. LESIEUR-TOUPET, H. and MAURICE DE VLAMINCK. "Les Bois gravés de Vlaminck." *Nouvelles de l'estampe* 31(Jan.-Feb. 1977):11-8. 12 illus.

Account of Vlaminck's woodcuts which shows how much his production in this technique was the result of the influence of Daniel-Henry Kahnweiler. A further influence was his growing knowledge of African art. Lesieur-Toupet comments on the degree to which this new appreciation was shared with Derain. Vlaminck's developing technique as it appears in his works is closely analyzed. Some letters from Vlaminck to Kahnweiler are included in an appendix.

1963. SÖHN, GERHARD. "Le Peintre-graveur: zum graphischen Werk von Maurice de Vlaminck" [The Painter-Engraver: On the Prints of Maurice de Vlaminck]. *Welkkunst* 58:21(1 Nov. 1988):3294-6. 7 illus.

After a biographical introduction, Söhn describes Vlaminck's contacts with artists such as Matisse, and their influence on his work as an engraver. His activities in this area are differentiated from his paintings. Söhn emphasizes the distinctive qualities of his landscapes, whether wood engravings, lithographs, aquatints or etchings, contrasts them with similar scenes in his paintings, and places them in the general context of Fauvism.

F. Works in Other Media

1964. *La Marie du Port.* Production, Robert Aisner. Réalisateur, Pierre Billon. 1938.

Vlaminck, at the request of Georges Simenon, designed the sets and worked on the scenery of this film.
Review: Doringe, *Pour vous* (May 1938).

V. Mentions

Books

1965. ATTENBOROUGH, DAVID. *The Tribal Eye.* London: British Broadcasting Corporation Publications, 1976. 144 p., 235 illus.

Work based on the BBC Television series *The Tribal Eye.* During this century the work of tribal artists has become accepted as art, but while a mask or figure has an immediate impact, the meaning it had and the intentions of its maker frequently remain obscure. Attenborough sets out to amend this through an elucidation of tribal art in the context of the societies and landscapes which produced it. In his introduction he discusses the impact of the expressive power of tribal art on such artists as Derain and Vlaminck, and the subsequent passion for "barbaric objects" which spread among French artists.

1966. BASLER, ADOLPHE and CHARLES KUNSTLER. *La Peinture indépendante en France.* Paris: G. Crès, 1929. 2 Vols., illus. volumes in "Peintres et sculpteurs" series.

Includes a section on Vlaminck.

a. English ed.: *Modern French Paintings: The Post-Impressionists from Monet to Bonnard.* London: The Medici Society, 1931. 70 p., illus., 72 pl.
b. U.S. ed.: New York: W. F. Payson, 1931. 70 p., illus., 73 pl.

1967. COQUIOT, GUSTAVE. *Les Indépendants, 1884-1920.* Paris: Ollendorff, 1920. 239 p., pl.

History of the Société des Artistes Indépendants and its annual exhibitions. Pages 157-8 contain information on Vlaminck.

1968. COQUIOT, GUSTAVE. *Cubistes, futuristes, passéistes; essai sur la jeune peinture et la jeune sculpture.* Paris: Ollendorff, 1914. 277 p., illus., pl.

Pages 175-8 discuss Vlaminck.
a. Another ed.: 1923.

1969. COQUIOT, GUSTAVE. *En Suivant la Seine.* Avec dessins inédits de Bonnard . . . van Dongen, [et al.]. Paris: A. Delpeuch, 1928. 138 p., pl.

1970. COURTHION, PIERRE. *Panorama de la peinture française contemporaine.* Paris: S. Kra, 1927. 191 p., 2 pl.

Pages 78-83 discuss Vlaminck.

1971. EDOUARD-JOSEPH, RENE. *Dictionnaire biographique des artistes contemporains, 1910-1930.* Paris, 1930-34. 3 vols.

Volume 2, pp. 401-3 include information on Vlaminck.

1972. FELS, FLORENT. *Propos d'artistes.* Paris: Renaissance du Livre, 1925. 215 p., illus., 32 pl.

Pages 189-201 discuss Vlaminck.

1973. GORDON, JAN. *Modern French Painters.* With illustrations. New York: Dodd, Mead and Co., 1923. 188 p., illus., 39 pl., 18 col.

Vlaminck is discussed on pages 121-9.
a. Other U.S. eds.: 1929, 1936, 1970.
b. English eds.: London: J. Lane, 1926. 88 p., illus., pl.

1974. GUENNE, JACQUES. *Portraits d'artistes.* Illustré de quarante-huit hors texte et de neuf reproductions de dessins eaux-fortes et lithographies inédits. Paris: M. Seheur, 1927. Volume in "L'Art et la vie" series.

Vlaminck is discussed on pages 265-90. Also includes a section on Henri Matisse.

1975. LA HORBE, ALAIN DE. *Mémoires d'outres-tubes.* Paris: Editions du Mont Pagnote, 1978. 365 p., 23 illus. 500 copies.

Autobiografical account of the artist's formation that provides an informal narration of influences on his art—Terlikowski, Vlaminck, van Dongen, and his father Florian de la Horbe—and anecdotes that recreate the atmosphere of the various periods in his life to date.

1976. RAYNAL, MAURICE. *Anthologie de la peinture en France de 1906 à nos jours.* Paris: Montaigne, 1927. 320 p., illus.

Vlaminck is discussed on pages 313-7.

1977. SAUVAGE, MARCEL. *Tavolozza nera, un colloquio sull'arte negra con Marcel Sauvage, e alcune poesie.* Trans. by Orfeo Tamburi. Milan: Edizioni del Borghese, 1963. 191 p., illus. Volume in "I libri del Borghese" series.

1978. VANDERPYL, FRITZ R. *Peintres de mon époque.* Paris: Librairie Stock, 1931. 288 p.

Pages 9-28 discuss Vlaminck. Also discusses André Derain, Kees van Dongen, Raoul Dufy, Henri Matisse, Othon Friesz, and Georges Rouault, among other contemporary artists.

1979. WARNOD, JEANINE. *Le Bateau-Lavoir, 1892-1914.* Paris: Connaissance, 1975. 163 p., illus., 8 pl. Volume in "Témoins et témoignages: histoire" series.

a. Another ed.: Paris: Editions Mayer, 1986. 191 p., illus., some col.

1980. Weisbord Collections. *The Sam Weisbord Pavilion and Collection.* Foreword by Teddy Kollek, Walter Zifkin, Jørgen Bo, Amalyah Sipkin, Stephanie Rachum, Meira Perry-Lehmann, and Martin Weyl. Jerusalem: Israel Museum, 1988, 96 p., 87 illus., 29 col. Also in Hebrew.

Presents the catalogue of the Sam Weisbord Pavilion and Collection at the Israel Museum in Jerusalem. Different sections examine the paintings, watercolors and sculptures in the collection, which include works by Auguste Renoir, Marie Laurencin, Maurice de Vlaminck, Picasso, Rodin, Aristide Maillol, and Emile-Antoine Bourdelle.

Articles

1981. "L'Art Chrétien vu par les artistes." *Le Petit messager du cœur de Marie* (Oct. 1935).

1982. "Les Artistes américains de Paris." *L'Opinion* (4 Sept. 1926).

1983. "Au temps d'Apollinaire." *Aujourd'hui* (17 Dec. 1933).

1984. BERNI, A. "Naturaleza muerta." *La Prensa* (5 Aug. 1928).

1985. BOUYER, R. "L'Art noir." *Le Bulletin de l'art ancien et moderne* (19 Oct. 1912).

1986. BROSSE, GUY DE LA. "La Céramique française de 1860 à 1925." *Paris-soir* (1928).

1987. CAPPERON, ROBERT. "La Peinture anglaise au Louvre." *Le Cahier* (April 1938).

1988. CARRE, JEAN. "Les Problèmes de l'induction." *La Vie* (15 April 1922).

1989. CAZENAVE, RAYMOND DE. "Confidences." *L'Information artistique* 30(1 May 1956).

1990. "Ceux du rail." *Le Quotidien* (14 Aug. 1932).

1991. CHANTAVOINE, JEAN. "A l'opéra. Ballets russes, la boutique fantastique." *L'Excelsior* (Jan. 1920).

1992. CHARD, MARCEL. "Sur les planches et derrière les portants." *Bonsoir* (11 July 1923).

1993. CHARENSOL, GEORGES. "De l'art préhistorique à l'art moderne." *Le Matin* (4 Dec. 1938).

1994. CHERIANE. "La Peinture à Madagascar." *L'Intransigeant* (16 Jan. 1933).

1995. "Cimaises, les cocos de génie." *L'Horizon* (1 Dec. 1928).

1996. "Courriers des ateliers, vacances d'artiste." *Paris-journal* (21 Sept. 1911).

1997. "La Crue et les peintres." *La Gazette* (4 Feb. 1910).

1998. DALEVEZE, JEAN. "La Bande à Picasso au Bateau-Lavoir. *L'Œil* 244(Nov. 1975):72-3. 5 illus.

An article following a recent book by Jeanine Warnod, *Le Bateau-Lavoir, 1892-1914* (Paris, 1975), which describes the little-known Bohemian life of those who lived in an old wooden Parisian building consisting entirely of artists' studios known as the Bateau-Lavior. The social life there and the struggle for existence are described with reference to such artists as Picasso, van Dongen, Braque, Derain, Vlaminck, Gris, Max Jacob, and others.

1999. "Dans les cinémas." *L'Epoque* (5 May 1938).

2000. DAUDET, LEON. "Clémenceau parle." *Action* (5 Feb. 1930).

2001. DAULTE, FRANÇOIS. "L'Ecole de Paris à la Galerie Daniel Malingue." *L'Œil* 310(May 1981):62-5. 7 illus.

With reference to an exhibition at the cited Paris gallery in the spring of 1981 of paintings by the Paris School, Daulte describes how the school, which originally comprised foreign artists who followed the main directions of contemporary French painting without sacrificing their deep originality, eventually came to describe generally some French painters whose work fell outside both academic and avant-garde streams, including Soutine, Pascin, Foujita, Modigliani, Chagall, Utrillo, Rousseau, Vlaminck, Matisse, Derain, Rouault, Dufy, and Marquet. Illustrations of works from the exhibition by Rouault, Dufy, Laurencin, Utrillo, and Vlaminck are annotated.

2002. DENTAIRE. "La Vie artistique, autour du Salon des Indépendants." *La Nouvelle revue* (15 Feb. 1935).

2003. DERYS, GASTON. "Décourageons les arts." *Paris-midi* (11 Feb. 1925).

2004. "Des peintres français remportent de nombreux prix à Pittsburgh." *Le Petit Parisien* (14 Oct. 1938).

2005. DESCAVES, LUCIEN. "De Thomas Couture à Vlaminck." *La Prensa* (20 Dec. 1932).

2006. DESTHIEUX, F. JEAN. "Stocks à liquider." *L'Homme libre* (29 May 1921).

2007. DUFFET, MICHEL. "Les Arts, les vents." *Eve* (26 May 1920).

2008. DUMENSIL, RENE. "La Crise de croissance." *Comœdia* (4 April 1927).

2009. "Echo de tout et de partout." *La Gazette Franco-Britannique* (1 Aug. 1925).

2010. "En bok om nutidskonsten och om världskriget." *En Modern malares memoare* (1930).

2011. ERASMUS, P. M. "The French Collection of the Johannesburg Art Gallery." *Apollo* 102:164(Oct. 1975):280-5. 16 illus.

Discussion of particular works in the collection of the Johannesburg Art Gallery and the way in which they reflect the development of French painting from the 18th century. Examines works by Vlaminck and Marquet, among other artists.

2012. ESCHOLIER, RAYMOND. "Les Arts, origines et tendances de l'art." *La Dépêche de Toulouse* (14 Jan. 1936).

2013. FANEUSE, JACQUES. "Films nouveaux, aux pays des coiffes blanches." *L'Art musical* (14 Feb. 1936).

2014. FELS, FLORENT. "Also sprach Vollard." *Der Querschitt* (May 1927).

2015. FLAMENT, ANDRE. [Untitled]. *Courte-paille* (17 April 1912).

2016. "French Farmhouses." Springfield (MA) Museum of Fine *Arts Bulletin* 8(April-May 1942):1.

2017. G., G. B. "François Bernouard et ses 'essais typographiques'." *L'Intransigeant* (4 May 1939).

2018. GAUTHIER, MAXIMILIEN. "Bio-Bibliographical Notices of Artists Represented in the Exposition of Living Art." *L'Art vivant* 6(15 May 1930):418.

2019. GEORGE, WALDEMAR. "Tendances de l'art moderne, le mouvement fauve 1905-1907." *La Patrie* (10 July 1928).

2020. GRAFLY, DOROTHY. [Untitled]. *The American Magazine of Art* 22:6(Dec. 1931).

2021. GUETIZ, PAUL. "Salon des Tuileries." *Moniteur* (Paris) (14 June 1938).

2022. HILD, ERIC. "Les Oeuvres parisiennes de Chabaud." *L'Œil* 350(Sept. 1984):64-9. 7 illus.

Assesses the Parisian paintings of Auguste Chabaud (1882-1955) and describes his lifestyle during his eight months in Paris. Some features of Chabaud's work in this period are picked out: vigor, originality, thematic and stylistic unity, and the original use of materials. Links with the work of van Dongen are denied, but some connections with that of Maurice de Vlaminck are detected. Hild places the influence on youth on Chabaud's style of painting above Expressionist qualities in his work.

2023. HOBHOUSE, JANET L. "The Fauve Years: A Case of Derailments." *Art News* 75:6 (Summer 1976):47-50. 7 illus.

The Museum of Modern Art (New York) exhibition, *The 'Wild Beasts': Fauvism and its Affinities*, presents a definition of Fauvism as, in Hobhouse's opinion, "a form of post-Impressionism (and pre-Cubism) practised chiefly by Matisse, Derain and Vlaminck between 1905 and 1907." In view of the extreme contrasts of style, personality and preoccupation of the artists involved, and of the divergent ways taken by them after this period, Hobhouse questions whether Fauvism can justifiably be termed a "movement." She compares the achievements of Derain and Matisse, noting particularly the contrast between the fundamental serenity and harmony of works such as Matisse's *Bonheur de vivre* and *Luxe, calme et volupté* (1904-05) and the restless, searching unresolved quality of Derain's *Composition (L'Age d'Or)* of 1905. In her opinion, the exceptional quality of the works in the exhibition merely adds to the confusion over terminology.

2024. HOLL, J.-C. "La Vie qui passe, l'art qui demeure." *Les Hommes du jour* (30 Dec. 1911).

2025. HUYGHE, RENE. "Le Fauvisme: les peintres pathétiques." *L'Amour de l'art* (June 1933).

2026. JIANU, IONEL. "Biland de ocazii pierdute." *Rampa* (18 Dec. 1935).

2027. JOLINSON, JOSEPH. "Tu n'aimeras plus, les papiers de Fabio." *Vendémiaire* (29 July 1936).

2028. "Une journée à bord de la péniche de l'Armée du Salut." *Le Monde illustré* (6 Sept. 1930).

2029. "Latin Quarter Glimpses." *New York Herald* (18 April 1921).

2030. "Leaves from Paris Diary." *Chicago Tribune* (22 Jan. 1928).

2031. LEHARLES. [untitled]. *Salut public* (18 Sept. 1905).

2032. LEHUARD, RAOUL. "Charles Ratton et l'aventure de l'art nègre." *Arts d'Afrique noire* 60(Winter 1986):11-33; discussion 62(Summer 1987):50-2.

Mentions Vlaminck on p. 17.

2033. MARECHAL, JEAN. "Paul Poiret ou l'amateur professionnel." *Le Petit Parisien* (11 July 1935).

2034. "Le Musée d'Art moderne de La Haye s'enrichit." *Comœdia* (10 June 1933).

Article on recent acquisitions by the museum, including works by Vlaminck and Albert Marquet.

2035. "On y cherche . . ." *D'Artagna* (20 Aug. 1930).

Article on the omission of modern painters such as Derain, Utrillo, and Vlaminck in the 1925 edition of the Larousse encyclopedia (16 vols.).

2036. PAGET, REYNIER MME. "La Psychologie enfantine dans les œuvres des grands écrivains, l'éveil de la personnalité enfantine." *L'Ecole libératrice* (6 Jan. 1934).

2037. "Painting." *Volné Směry* 22:5(1924):111-3.

2038. "Les Peintres français d'avant-garde à l'exposition Carnegie." *Paris-midi* (14 Oct. 1938).

2039. "Peinture et poésie, les peintres mis en vers." *La Liberté* (13 Feb. 1935).

2040. PERCEVAL, PIERRE. "Peinture." *Les Cahiers de la femme.*

2041. PERRIER, MARTIAL. "Au fil des jours." *L'Avenir* (1 June 1921).

2042. "Plume et pinceau. Place aux jeunes." *Le Nouveau cri* (15 Feb. 1936).

2043. PRAX, MAURICE. "Pour nos artistes." *Le Petit Parisien* (24 March 1921).

2044. PULINGS, GASTON. "Artistic Life in Belgium." *L'Art vivant* 6:125(1 March 1930):221,223.

2045. "Questionnaire: . . . réponses." *Rouge et noir* (4 May 1932).

2046. RADIGUET, RAYMOND. "Le Diable au corps." *Rouge et noir* (15 Oct. 1925).

2047. ROGER-MARX, CLAUDE. "La Vie artistique." *Le Jour* (2 Feb. 1935).

2048. ROUCHER, PIERRE. "Confidences, les vacances des autres." *L'Eclaireur de Nice* (24 Sept. 1935).

2049. SALMON, ANDRE. "La Semaine artistique." *L'Europe nouvelle* (1918).

2050. SALMON, ANDRE. "Le Cas de Monsieur Jacques-Emile Blanche." *L'Europe nouvelle* (8 Aug. 1920).

2051. SALMON, ANDRE. [untitled]. *L'Europe nouvelle* (26 Dec. 1920).

2052. SALMON, ANDRE. "L'Age d'or de Montparnasse." *Bravo* (Dec. 1930).

2053. SANARY, PIERRE. "Lettres de Tananarive." *XX⁶ siècle* (1932).

2054. SARRADIN, EDOUARD. [untitled]. *Le Journal des débats* (19 March 1912).

2055. SIEMSEN, HANS. "Paintings." *Deutsche Kunst* 54(May 1924):61-8.

2056. SOIZE, PIERRE. "Recrute des dynamiteurs." *Paris-journal* (28 Dec. 1923).

2057. "Sujet: secret de créateur, un ami de la nature, la bonne excuse." *Voilà* (30 Nov. 1935).

2058. "Tous nos peintres ont leur violin d'Ingres." *L'Ami du peuple* (10 Nov. 1929).

2059. VAUXCELLES, LOUIS. "Les Décors de Derain." *L'Excelsior* (Jan. 1920).

2060. "La Vie artistique à Paris sous l'occupation" in *Paris-Paris: Créations en France 1937-1957* (Paris: Centre Georges Pompidou, 1981), pp. 96-105. 8 illus. Texts by Susan Wilson, Camille Mauclair, and Maurice de Vlaminck. Compiled by A. Lionel-Marie, M.-C. Llopès, and M. Thomas.

Reviews the influence of the Third Reich and particularly Hermann Goering on the art of occupied Paris, comparing conformist and resistance art magazines and describing exhibitions which adhered to Nazi guidelines by returning to traditional, naturalistic styles. Appended contemporary documents comprise a commentary on the art scene under the occupation by Camille Mauclair, an attack by Vlaminck on Picasso's "malicious" art, and two of Goering's ordinances of art.

2061. "La Vie artistique art nègre." *L'Humanité* (19 May 1913).

2062. VITERAC, HENRI. "La Vie artistique." *La Revue moderne des arts et de la vie* (July 1933).

2063. VOGT, BLANCHE. "Ingénument la tradition bousculée." *L'Intransigeant* (25 Sept. 1927).

2064. VOISIN, JOSEPH. "Au dessus des blés." *Le Peuple* (12 Aug. 1933).

2065. WAN, G. K. "De snoek." *Dienst voor Kunsten Mededeelingen* 3(March 1933):26-7.

2066. WATSON, SUSAN. "Réalité poétique: The Fell Collection." *Vanguard* 8:4(May 1979):8-11. 4 illus.

Paintings in the collection of the late Ella May Fell, shown at the Vancouver Art Gallery, Vancouver, British Columbia, perhaps indicate more about their collector than the artists. The main body of works is from France and England and concentrate on landscapes and interiors. Fell has an eye for the "*intime*" and the predominant

mood of these paintings is that when an ordinary object of place is suddenly "tranformed." Among the English works are a set of visionary landscapes by Paul Nash. Among the French, Vlaminck and Derain are represented by subdued and individual works rather than by ones that contributed to the mainstream of innovation. The emphasis is upon what is continuous in the tradition of painting. In regards to the collection, Watson comments that the intimate moments of private reverie are capable of surviving the maelstrom of the present.

VI. Exhibitions

A. Individual Exhibitions

1908, March Paris, Galerie Vollard. *Exposition Vlaminck.* Seascapes, landscapes, still lifes, ceramics.
Review: L. Vauxcelles, *Gil-Blas* (27 March 1908).

1910, March-
April Paris, Galerie Vollard. *Maurice de Vlaminck.* Préface de Claude Roger-Marx. 40 works.
Reviews: Guillaume, *L'Intransigeant* (16 March 1910); R. Bouyer, *Bulletin de l'art* (2 April 1910); *La Gazette de la Capitale* (2 April 1910).

1910 Paris, Galerie E. Druet. *Exposition Maurice de Vlaminck.* Catalogue avec préface de Gustave Geoffroy.

1919, February Paris, Galerie E. Druet. *Exposition Maurice de Vlaminck.* 72 paintings and watercolors.
Reviews: *L'Eclair* (5 Feb. 1919); G. Kahn, *L'Heure* (5 Feb. 1919); H. Béraud, *Bonsoir* (6 Feb. 1919); L. Vauxcelles, *Excelsior* (6 Feb. 1919); T. Sisson, *Le Temps* (6 Feb. 1919); *La Liberté* (7 Feb. 1919); *Le Journal* (8 Feb. 1919); Pinturicchio, *Le Carnet de la semaine* (9 Feb. 1919); A. Alexandre, *Le Figaro* (10 Feb. 1919); *Le Journal des débats* (10 Feb. 1919); R. Bissière, *L'Opinion* (15 Feb. 1919); P. Forthung, *L'Avenir* (21 Feb. 1919); L. Werth, *La Vie* (March 1919); Una, *La Paix sociale* (2 March 1919); L. Vauxcelles, *L'Evénement* (2 March 1919).

1920,
10-22 March Paris, Galerie Bernheim. *Exposition Maurice de Vlaminck.* 30 paintings.
Reviews: H. Béraud, *Bonsoir* (20 March 1920); L. Werth, *Action* (March 1920); J. Gasquet, *L'Eclair* (27 May 1920).

1922, March New York, Brummer Galleries. *Maurice de Vlaminck.*
Reviews: *New York Herald* (12 March 1922); *American Art News* (18 March 1922).

1923, January Paris, Galerie Vildrac. *Exposition Maurice de Vlaminck.*
Reviews: D. Mirabeau, *Le Journal de Liège* (1 Feb. 1923); *La République* (6 Feb. 1923); *La Liberté* (11 Feb. 1923).

1923, February-
March Paris, Galerie Bernheim-Jeune. *Exposition Maurice de Vlaminck.* Included watercolors and paintings.
Reviews: *L'Œuvre* (20 Feb. 1923); F. Vanderpyl, *Le Petit Parisien* (20 Feb. 1923); P. Dermée, *L'Information* (28 Feb. 1923); L. Martin, *L'Europe nouvelle* (March 1923).

1924, February Paris, Galerie E. Druet. *Exposition Maurice de Vlaminck.* 72 paintings and watercolors.

Reviews: *L'Avenir* (21 Feb. 1924); *Le Temps* (1 March 1924); *L'Evénement* (2 March 1924).

1925, January Paris, Grand Maison du Blanc. *Exposition Maurice de Vlaminck.*
Reviews: D. de Touchagues, *L'Art vivant* (1 Jan. 1925); *Comœdia* (9 Jan. 1925); R. Jean, *Comœdia* (12 Jan. 1925); G. Perreux, *Paris-midi* (20 Jan. 1925).

1926,
4 February-
14 March Chicago, Art Institute. *Art Club Exhibition: Maurice de Vlaminck.*
Review: *L'Art vivant* (1 March 1926).

1927, February Paris, Galerie Druet. *Exposition Maurice de Vlaminck.* 72 prints (landscapes, seascapes, still lifes, flowers, ceramic faïences).
Reviews: Thiébault-Sisson, *Parisian* (20 Feb. 1927); *Art et curiosité* (1927).

1929, February Paris, Galerie Bernheim-Jeune. *Exposition Vlaminck.*
Reviews: *L'Ere nouvelle* (8 Feb. 1929); A. Salmon, *La Revue de France* (15 Feb. 1929).

1930,
18 January-
5 February Brussels, Galerie du Centaure. *Exposition Maurice de Vlaminck.* 32 works.
Reviews: *Le Cri du jour* (11 Jan. 1930); C. M., *L'Ami du peuple* (16 Jan. 1930); *Face à main* (18 Jan. 1930); *Le Peuple* (22 Jan. 1930); C. B., *La Nation Belge* (22 Jan. 1930); *La Métropole* (Anvers) (26 Jan. 1930); R. D., *Le Soir* (Brussels) (28 Jan. 1930); *Le Cri du jour* (1 Feb. 1930).

1933,
23 January-
3 February Paris, Galerie Bernheim Jeune. *Rétrospective Maurice de Vlaminck.* 70 paintings (1904-33).
Reviews: L. Vauxcelles, *Excelsior* (23 Jan. 1933); C. P., *L'Europe nouvelle* (23 Jan. 1933); *L'Intransigeant* (24 Jan. 1933); *A Paris* (27 Jan. 1933); G. Gros, *Beaux-arts* (27 Jan. 1933); *Art et industrie* (1 Feb. 1933); J. Guenne, *L'Art vivant* (Feb. 1933):64-6; F. Neugass, *Weltkunst* 7(5 Feb. 1933):3; P. F., *Le Journal des débats* (14 Feb. 1933); *L'œil de Paris* (18 Feb. 1933); J. Cassou, *Marianne* (22 Feb. 1933); C. Mauclair, *Le Figaro* (27 Feb. 1933); L. Blondel, *L'Action nouvelle* (9 March 1933); E. Dabit, *L'Europe* (15 March 1933); A. Salmon, *Gringoire* (24 March 1933); *Tecza* (28 March 1933); *La Vie* (1 April 1933);

1933, 27 May-
June Brussels, Palais des Beaux-arts. *Rétrospective Vlaminck.* 200 works (paintings, gouaches, drawings, lithographs).
Reviews: *Le Peuple* (18 May 1933); L. P., *Le Peuple* (26 May 1933); *La Nation Belge* (26-7 May 1933); M. Devigne, *L'Horizon* (27 May 1933); L. P., *Le Peuple* (28 May 1933); *Le Journal* (28 May 1933); R. Dupierreux, *Le Petit Parisien* (28

May 1933); *Het Laatste Nieuwe* (28 May 1933); *La Nouvelle revue* (1 June 1933); *Les Beaux-arts* (2 June 1933); E. Scouflaire, *La Wallonie* (4 June 1933); *Vooruit-Gand* (4 June 1933); H. College, *La Métropole* (4-5 June 1933); H. L., *Le Soir illustré* (8 June 1933); *Rotterdam* (9 June 1933); G. Vanzype, *Les Beaux-arts* (9 June 1933); *L'Indépendance Belge* (26 June 1933); *Le Thyrse* (1 July-1 Aug. 1933); L. J., *La Flandre libérale* (1933).

1935, February- 30 April	London, Wildenstein & Co. Gallery. *Maurice de Vlaminck.* Preface by Reginald H. Wilenski. Reviews: *Bulletin du Palais des Beaux-arts* (Brussels)(1 Feb. 1935); R. Wilenski, *Beaux-arts* (1 Feb. 1935); *La Vie française* (25 Feb. 1935); G. Duhamel, *Le Cahier* (April 1935); *Le Mois* (April 1935).
1935-36, November- January	Paris, Galerie de l'Elysée (Jean Methey). *Exposition Vlaminck.* Paintings and watercolors. Reviews: *Beaux-arts* (22 Nov. 1935); F. Vanderpyl, *Le Petit Parisien* (23,25 Nov. 1935); *Le Charivarie* (7 Dec. 1935); *Nieuwe rotterdamsche courant* (11 Dec. 1935); R. Bouyer, *Bulletin de l'art* (Dec. 1935); *Le Mois* (Jan. 1936).
1938, February- March	Paris, Galerie de l'Elysée. *Vlaminck.* Reviews: F. Vanderpyl, *Marianne* (16 Feb. 1938); M. Fabiani, *Juvenal* (26 Feb. 1938).
1939, June	London, Wildenstein Gallery. *Vlaminck.* Review: *Beaux-arts* (16 June 1939).
1939, December	New York, Wildenstein Gallery. *Retrospective Vlaminck.* Preface by Louis Bromfield.
1947, Spring- 29 June	London, Crane Kalman Gallery. *A Selection of Paintings by M. de Vlaminck.*
1956	Paris, Galerie Charpentier. *L'Œuvre de Vlaminck du fauvisme à nos jours.* Texte de Claude Roger-Marx. 36 p., illus. Review: *Pictures on Exhibit* 19(May 1956):26.
1956	Paris, Galerie Sagot le Garrec. *Vlaminck—œuvres gravées.*
1961, May-June	Stuttgart, Galerie Valentien. *Maurice de Vlaminck, Ausstellung: Gemälde, Aquarelle, Holzschnitte, Radierungen, Lithographien.* 20 p.
1961	Bern, Kunstmuseum. *Vlaminck.* Préface de H. Wagner.

1968, 9 April- 11 May	New York, Perls Galleries. *Vlaminck (1876-1958); His Fauve Period (1903-1907)*. A Loan Exhibit for the Benefit of the New York Studio School. Text by John Rewald. 36 p., 28 illus. 17 col. Review: A. Werner, *Arts Magazine* 42:5(March 1968):30-3.
1974, October- November	Tokyo, Palace Art Corporation. *Maurice de Vlaminck, 1876-1958. Morisu do Vuramanku.* 29 p., illus., 18 pl.
1975	Chicago, R. S. Johnson International Gallery. *Vlaminck, Master of Graphic Art: A Retrospective Exhibition of Graphic Works, 1905-1926.* 46 p., illus.
1977	New York, Perls Galleries. *Vlaminck (1876-1958); His Fauve Period (1903-1907).* 35 p., illus.
1982, 15 May- 20 June	Yamaguchi, Musée Préfectural d'art de Yamaguchi. *Exposition Maurice de Vlaminck*. Organisée par le Yomiuri Shimbun. Edited by Shinichi Seghi. Trans. by Junihiko Matsuo and Tae Matsuo. 128 p., illus. In Japanese and French.
1987, May-June	Paris, Galerie de la Présidence. *Maurice Vlaminck*. 84 p., illus., 35 paintings. Review: R. Bouillot, *L'œil* 383(June 1987):42-7.
1987, 26 June- 28 October	Chartres, Musée des Beaux-arts. *Vlaminck: le peintre et la critique*. Also shown Turin, Palazzo Graneri; Rome, Ferare, Palazzo dei Diamanti. Chartres: Le Musée; Milan: Fabbri, 1987. 391 p., illus. Review: S. Preston, *Burlington Magazine* 129(Dec. 1987):828-9. a. Italien ed.: *Vlaminck, il pittore e la critica*. Milan: Fabbri, 1988. 391 p., illus.
1987, September- October	Düsseldorf, Graphik-Salon Gerhart Söhn. *Maurice de Vlaminck: Auswahl aus dem graphischen Werk.* 36 p., illus.
1988, 28 May- 28 August	Aosta, Centro Saint-Benin. *Vlaminck, il pittore e la critica*. Conception et textes par Maithe Valles-Bled. 391 p., illus., some col. In Italian and French. Review: M. de Micheli, *Arte* 18:187(July-Aug. 1988): 48-53, 112.
1989	New York, Taménaga Gallery. *Maurice de Vlaminck (1876-1958)*. Review: R. La Presti, *Art & Antiques* 7(April 1990):132.

B. Group Exhibitions

1903	Paris, Galerie Berthe Weill. Exhibited several paintings with other young artists, including Matisse.
1905, 24 March- 30 April	Paris, Grand Palais. *Salon des Indépendants*. 8 paintings (no. 4148-55).
1905, 18 October- 25 November	Paris, Grand Palais. *Salon d'Automne*. 5 paintings. Reviews: *La Correspondance Hada* (22 Oct. 1905); E. Charles, *Chronique Parisienne* (25 Oct. 1905); M. Nicolle, *Journal de Rouen* (20 Nov. 1905);
1905, 21 October- 20 November	Paris, Galerie Berthe Weill. 5 paintings (no. 43-7).
1906, 20 March- 30 April	Paris, Grand Palais. *Salon des Indépendants*. 8 paintings. Reviews: L. Vauxcelles, *Gil-Blas* (20 March 1906); *La Liberté* (23 March 1906); *Le Petit caporal* (8 April 1906); R. Boulet de Monnel, *La Revue illustrée* (9 April 1906).
1906, 26 May- 30 June	Le Havre, Hôtel de Ville. *Cercle d'Art moderne*.
1906, 6 October- 15 November	Paris, Grand Palais. *Salon d'Automne*. 7 paintings. Reviews: E. Charles, *La Liberté* (5 Oct. 1906); J. Holl, *Les Incohérents* (Oct. 1906).
1907, 3 March- 3 April	Brussels, *La Libre esthétique*. Catalogue par Octave Maus. 5 paintings. Reviews: S. Pierren, *L'Indépendant Belge* (March 1907); *XXe siècle* (24 March 1907); *Bulletin de l'art moderne* (30 March 1907).
1907, March	Paris, Galerie Vollard. *Exposition Vollard*. Paintings and ceramics. Reviews: G. Kahn, *L'Aurore* (10 March 1907); A. S., *Paris-journal* (16 March 1907); J. Schnerb, *Chronique des arts* (26 March 1907).
1907, 20 March- 30 April	Paris, Grand Palais. *Salon des Indépendants*. 6 paintings. Reviews: G. Bal, *New York Herald* (21 March 1907); *Herald Tribune* (1 April 1907); La Palette, *La Liberté* (1 April 1907);
1907, June	Le Havre, Hôtel de Ville. *Cercle de l'Art moderne*. Catalogue texte par Ferdinand Fleuret. 2 paintings.
1907, 1-22 October	Paris, Grand Palais. *Salon d'Automne*. 6 paintings.

1908, 20 March- 2 May	Paris, Grand Palais. *Salon des Indépendants*. 6 paintings.
1908, June	Le Havre, Hôtel de Ville. *Cercle de l'Art moderne*. Catalogue texte de Guillaume Apollonaire.
1908, September	Dresden, Richter Art Salon.
1908, 1 October- 8 November	Paris, Grand Palais. *Salon d'Automne*. 6 paintings.
1910	Munich, *Neue Kunst*. Catalogue with preface by André Salmon.
1910	*XXX*. First exhibition of the XXX group, which included works by Vlaminck and Othon Friesz.
1911, November	Paris, Grand Palais. *Salon d'Automne*.
1912	Paris, Grand Palais. *Salon des Indépendants*.
1912	Paris, Galerie E. Druet.
1914, May	Dresden, Galerie Emile Richter.
1918, July	Paris, Galerie Goupil. *La Jeune peinture française*. Review: Criton, *La Vérité* (16 July 1918).
1919, Spring	Paris, Galerie Paul Guillaume. *Peintres d'aujourd'hui*. Included works by Vlaminck, Derain, de la Fresnaye, Matisse, Picasso, Utrillo, Modigliani, and de Chirico, among other artists. Review: *Les Arts* (15 May 1919).
1919, September	Düsseldorf, Gallery Flechtheim. Review: *La Presse libre* (8 Sept. 1919).
1919, October- November	Paris, Grand Palais. *Salon d'Automne*. Reviews: L. Arressy, *Le Journal du peuple* (18 Oct. 1919); *Colour Magazine* (Oct. 1919); W. George, *Le Crapouillot* (1 Nov. 1919).
1920, January- April	Paris, Grand Palais. *Salon des Indépendants*. 4 paintings. Reviews: M. Pays, *L'Ordre publique* (23 Jan. 1920); F. Poncetton, *La France* (29 Jan. 1920); V. Bash, *Les Amitiés nouvelles* (1 Feb. 1920); Pinturrichio, *Le Carnet de la semaine* (25 April 1920).
1920, October- November	Paris, Grand Palais. *Salon d'Automne*. 7 paintings. Reviews: L. Marin, *Le Crapouillot* (16 Oct. 1920); L. Vauxcelles, *Excelsior* (16 Oct. 1920); *Le Journal du peuple* (19 Oct. 1920); L. Dilé, *Annales politiques et littéraires* (24 Oct.

1920); L. Pannelles, *Excelsior* (25 Oct. 1920); *Les Cahiers bleus* (1 Nov. 1920).

1921	Paris, Galerie Kahnweiler. Included works by Vlaminck, André Derain, and Raoul Dufy, among other artists. Review: F. Jean-Desthias, *L'Homme libre* (29 May 1921).
1921, November	Brussels, Musée des Beaux-arts, Salle Aeolian. *Ceux d'aujourd'hui*. Reviews: Félicien, *Demain* (21 Nov. 1921); *Le Petit Parisien* (27 Nov. 1921).
1922, February-March	Paris, Galerie Vildrac. *Aquarelles de Vlaminck*. Included watercolors by Vlaminck. Reviews: *Le Peuple* (27 Feb. 1922); J. Fouquet, *Le Crapouillot* (1 March 1922); F. Vanderpyl, *Le Petit Parisien* (22 March 1922).
1922, Spring	Brussels, Galerie Le Centaure.
1922, October	Paris, Grand Palais. *Salon d'Automne*. Reviews: *Le Journal du Peuple* (26 Sept. 1922); *L'Amour de l'art* (1 Oct. 1922); F. Carco, *La Revue française* (1 Oct. 1922); C. Marx, *L'Humanité* (14 Oct. 1922); *L'International* (21 Oct. 1922); G. Janneau, *La Renaissance* (23 Oct. 1922); L. Marin, *Le Crapouillot* (1 Nov. 1922); P. Lenglois, *La Prose* (3 Nov. 1922); Kunel, *Le Journal de Liège* (1922).
1923, Spring	London, New Art Salon. *French Painters of the Modern Movement*. 2 paintings by Vlaminck. Other artists represented included André Derain, Othon Friesz, and Georges Braque, among others.
1923, 25 April-15 May	Paris, Chambre Syndicale de la curiosité des Beaux-arts. *Œuvres des XVIIIᵉ, XIXᵉ, et XXᵉ siècles*. Reviews: G. M., *L'Echo de Paris* (26 April 1923); A. Gide, *Le Quotidien* (2 May 1923); Pinturrichio, *Le Carnet de la semaine* (6 May 1923).
1923, Spring	Paris, Palais de Bois (porte Maillot). *Salon des Tuileries*. Included landscapes and still-life paintings by Vlaminck. Reviews: R. Jean, *Comœdia* (15 May 1923); *Bonsoir* (6 June 1923); F. Vanderpyl, *Le Petit Parisien* (7 June 1923); *La Cloche* (9 June 1923); A. Salmon, *La Revue de France* (15 June 1923); L. Vauxcelles, *L'Eclair* (26 June 1923); *La Tribune de Genève* (10 July 1923); *Les 7 jours* (12 Aug. 1923).
1923, May	Brussels, Galerie Le Centaure. Included landscapes, seascapes, still lifes, and watercolors by Vlaminck, who also served on the jury "Prix des peintres."

Reviews: C. B., *La Nation Belge* (21 May 1923); G. Michel, *Chronique des Beaux-jours* (22 May 1923); F. Fels, *Les Nouvelles littéraires* (26 May 1923); A. Eggermont, *Le Thyrse* (1 June 1923); A. Fasbender, *Gazette de Liège* (2 June 1923).

1923, October Paris. *La Jeune peinture française.*
Reviews: *Le Mercure de France* (1 Oct. 1923); H. Poulaille, *Mon ciné* (4 Oct. 1923); *Le Correspondant* (25 Oct. 1923).

1923, November Brussels, Galerie Giroux. *Exposition.* Included 12 paintings and several watercolors.
Reviews: *Les 7 arts* (8 Nov. 1923); J. T., *Le Midi* (Brussels)(19 Nov. 1923).

1924, May-June Paris, *Salon des Tuileries.* 3 paintings.
Reviews: L. de Tahours, *Le Rappel* (5 May 1924); L. Vauxcelles, *L'Eclair* (26 June 1924); R. Jean, *Comœdia* (28 June 1924).

1925, May-June Paris, Galerie Vildrac. *Vlaminck, Friesz, Dufresne.*
Reviews: A. Montaigne, *Le Journal du peuple* (9 May 1925); F. Fels, *L'Art vivant* (15 May 1925); *L'Art et les artistes* (May 1925); *Le Carnet des ateliers* (May 1925); F. Vanderpyl, *Le Courrier de la presse* (20 June 1925).

1925, July Paris. *La Jeune peinture française.* Group exhibition of 25 contemporary French artists.
Reviews: A. Montaigne, *Le Journal du peuple* (11 July 1925); *Le Soir* (19 July 1925); *Gazette Franco-Britannique* (1 Aug. 1925).

1925, Summer Paris, Galerie Druet. Exposition of 25 contemporary French painters, including 6 works by Vlaminck.

1925 Paris, Grand Palais. *Salon d'Automne.*
Reviews: Pinturrichio, *Le Carnet de la semaine* (8 Nov. 1925); *Paris-midi* (11 Nov. 1925); A. Flament, *Le Monde illustré* (15 Nov. 1925); H. Comstock, *Art News* 24(14 Nov. 1925):3; M. Kunel, *Le Journal de Liège* (4 Dec. 1925).

1925, December Paris, Galerie Bernheim-Jeune.
Reviews: R. Jean, *Comœdia* (6 Dec. 1925); A. Montaigne, *Le Journal du peuple* (12 Dec. 1925); *L'Homme libre* (16 Dec. 1925); J. Forain, *Le Nouveau siècle* (17 Dec. 1925).

1925, December Paris, Galerie Manuel Frères. Included paintings by Vlaminck, among other artists.
Review: *L'Homme libre* (16 Dec. 1925).

1926, February Paris, Galerie Chéreau.

1926, April	Cologne, Galerie Salz.
1927, 15-30 April	Paris, Galerie Bing. *Les Fauves de 1904 à 1908*.
1928, January	Grenoble. *Salon de Grenoble*. 6 paintings and watercolors. Review: *Le Petit Dauphinois* (19 Jan. 1928).
1928, May	Paris. *Salon des Tuileries*. Reviews: R. Jean, *Comœdia* (6 May 1928); *Les Arts à Lyon* (15 May 1928); *Le Carnet de la semaine* (21 May 1928).
1928, November	Paris, Grand Palais. *Salon d'Automne*. Reviews: A. Warnod, *Comœdia* (4 Nov. 1928); F. Vanderpyl, *Le Petit Parisien* (Nov. 1928);
1928, November	Berlin, Galerie Flechtheim.
1928, December	Nice, Les Peintres Modernes. Included works by Vlaminck. Review: *L'Eclaireur du soir* (Nice) (27 Dec. 1928).
1928, December	Paris, Ateliers d'art Gédé. *Céramiques de Methey*. Included collaborative projects by Vlaminck, Georges Rouault, and other painters. Review: G. de la Brosse, *Paris-soir* (5 Dec. 1928).
1930, June-July	Paris, Galerie Marcel Bernheim. Reviews: Y. Mareschal, *La Semaine de Paris* (27 June 1930); G. Reuillard, *Paris-soir* (9 July 1930).
1931-32, 22 December- 17 January	Chicago, Art Institute. *Exhibition of the Arthur Jerome Eddy Collection of Modern Paintings and Sculpture*. Catalogue issued in *Chicago Art Institute Bulletin* 35:9(Dec. 1931). Included works by Vlaminck (pp. 24-6) and André Derain (pp.10-2).
1932, November	Paris, Galerie Georges Giroux. *Flandre*. Review: *La Meuse* (23 Nov. 1932).
1933, May	Saint-Etienne. *Salon de Printemps*.
1933, June	Strasbourg, Galerie Artyargus. *Gravures modernes*. Included drawings, aquatints, woodcuts, and lithographs by Vlaminck, among other artists. Review: M. Lenossos, *Les Dernières nouvelles de Strasbourg* (26 June 1933).
1933, November	Paris, Grand Palais. *Salon d'Automne*. Review: *Beaux-arts* (3 Nov. 1933).
1934, April	Paris, Grand Palais. *Cinquantenaire des Indépendants*. 1 painting.

Reviews: C. Zervos, *Editions des cahiers d'art* (April 1934); *CPDE Bulletin du personnel* (April 1934).

1934 Paris, Galerie Bernheim Jeune.

1934-35, Paris, *Beaux-arts* and *Gazette des Beaux-arts. Le Fauvisme.* 1
November-March painting (*Le Potager*) by Vlaminck.
 Review: J. Baschet, *L'Illustration* (9 March 1935).

1935, May Brussels, Palais des Beaux-arts. *Société Anversoise de l'art
 contemporain. Exposition jubilaire.*
 In the French room were works by Vlaminck, Derain, Matisse,
 Rouault, and Dufy.
 Review: *La Métropole* (Anvers) (5 May 1935).

1936, January Paris, Galerie de l'Elysée. *Exposition Vlaminck et Forain.*
 Reviews: G. Waldemar, *La Revue mondiale* (10 Jan. 1936); A.
 Salmon, *Le Petit Parisien* (21 Jan. 1936); *Comœdia* (27 Jan.
 1936); *Le Mois* (Jan. 1936); G. B., *L'Amour de l'art* (Jan.
 1936); *Beaux-arts* (7 Feb. 1936); *Le Journal* (7 Feb. 1936); *Le
 Temps* (8 Feb. 1936); A. Salmon, *Le Cri du jour* (Feb. 1936).

1936, May St. Thomas Rathfarnham, National Gallery of Ireland. *French
 Paintings.*
 Review: *Irish Times* (30 May 1936).

1936, June Strasbourg, Palais de la foire européenne. *Exposition de
 peinture contemporaine.* Included works by Vlaminck,
 Matisse, Derain and other artists.
 Reviews: *Les Dernières nouvelles de Strasbourg* (2,4 June
 1936); *La Renaissance* (June 1936).

1936, June Bucharest, Berriero Gallery. Group exhibition of works by
 Vlaminck, Matisse, and Rouault, among other artists.
 Review: *Kurjer Codzienny* (15 July 1936).

1936, November Brussels, Galerie Manteau. Group exhibition with Vlaminck,
 Derain, Dufy, and Utrillo.
 Review: Argo, *L'Indépendance Belge* (20 Nov. 1936).

1936, December Paris. *Exposition Campagnes.* Group exhibition of 30 painters,
 including works by Vlaminck, Friesz, Marquet, and Dufy,
 among other artists.
 Review: *La Semaine de Paris* (10 Dec. 1936).

1937, February- Tunis, Automobile-Club de Tunis. *Exposition.* Also shown
March Bône, Algeria. 1 landscape, 1 wash-drawing, 1 watercolor.
 Review: M. Greinet, *La Presse de Tunisie* (26 Feb. 1937).

1937, Spring Paris, Petit Palais. *Exposition des maîtres de l'art indépendant.*

Included works by Vlaminck, Marquet, Derain, Matisse, and Rouault, among other artists.
Reviews: *Le Nouveau cri* (13 March 1937); *La Dépêche de l'est* (13 March 1937).

1938,
10-27 January

Paris, Galerie de Paris. Exposition organisée par la Maison des intellectuels. Included works by Vlaminck, Friesz, Utrillo, Kisling, van Dongen, Camoin, and Luce, among other artists.
Reviews: L. Vauxcelles, *Vendémaire* (5 Jan. 1938); *Paris-midi* (7 Jan. 1938); *L'Epoque* (9 Jan. 1938); *Les Heures de Paris* (11 Jan. 1938).

1938, February

Paris, Galerie Le Niveau. Group exhibition of 68 artists, including works by Vlaminck, Derain, Matisse, Friesz, and Dufy, among others.
Reviews: *Marianne* (16 Feb. 1938); S. H., *Vendémaire* (16 Feb. 1938).

1938, March

Paris, Pavillon des salons, Esplanade des Invalides. *Salon des Indépendants.* Vlaminck was represented in salle 18 by landscapes and a still life.
Reviews: R. Jean, *Le Temps* (3 March 1938); *Excelsior* (3 March 1938); F. Vanderpyl, *Le Petit Parisien* (4 March 1938); R. Charvange, *La Liberté* (4 March 1938); G. Gros, *Paris-midi* (4 March 1938); *La Renaissance* (March 1938).

1938

Pittsburgh, Carnegie Institute. *International Exposition.* Vlaminck's painting *Hiver* won second place ($600). In 1937, first place ($1,000) was awarded to Georges Braque.
Reviews: *Le Petit Parisien* (14 Oct. 1938); *Paris-midi* (14 Oct. 1938); *Pittsburgh Post Gazette* (14 Oct. 1938).

1938

Paris. *Exposition Vlaminck.*
Reviews: *Beaux-arts* (11 Nov. 1938):7; L. Mazauric, *Beaux-arts* (18 Nov. 1938); F. Vanderpyl, *Le Petit Parisien* (1938).

1938-39,
10 December-
January

Paris, Galerie Royale. *XXI^e exposition de la maison des intellectuels.* Included works by Vlaminck, Friesz, Marquet, and van Dongen, among other artists.
Reviews: *La Dépêche d'Eure-et-Loir* (11 Dec. 1938); *La Vie* (15 Dec. 1938).

1938-39,
15 December-
January

Paris, Réunion, Salle du Syndicat d'initiative. Group exhibition of works by Vlaminck and Marquet, among other artists.
Review: *France-URSS* (1938).

1939, June-July

Geneva, Galerie Moos. *Exposition des peintres français.* 6 paintings.
Review: J. M., *La Tribune* (17 June 1939).

1939, August– September	Montevideo, National Gallery of Fine Arts. *French Art.* Review: *La Mañana* (22 Aug. 1939).
1939, December	New York, Sciences and Arts Gallery, World's Fair. Vlaminck won $100 for a Valmondois landscape, awarded by International Business Machines, Inc. Review: *Beaux-arts* (15 Dec. 1939).
1939-40, 30 December– January	Paris, Faubourg Saint-Honoré. *Exposition des artistes mobilisés.* Organisée par le sculpteur Despiau. Included works by Vlaminck and Friesz, among other artists. Reviews: *Aux écoutes* (30 Dec. 1939); F. Vanderpyl, *Beaux-arts* (1939).
1940, March	New York, Wildenstein Galleries. Introduction by Louis Bromfield. Review: *Pictures on Exhibit* 3(Feb. 1940):6-7.
1945	New York, Niveau Gallery. Review: *Pictures on Exhibit* 6(May 1945):20.
1947	Paris, Galerie Bing. *Chatou.* Included many Fauve works by Vlaminck and Derain.
1950, 29 April– 29 May	Bern, Kunsthalle. *Les Fauves.* Foreword and essay by Arnold Rüdlinger. 26 p., 14 pl. 19 works.
1950, 8 June– 15 October	Venice, XXV⁰ Biennale. *Internazionale d'Arte: Mostra dei Fauves.* 8 works. Reviews: M. Georges-Michel, *Biennale di Venezia* 2(1950):9-1; G. Veronesi, *Emporium* 122(1950):51-60.
1951	Review: G. Veronesi, *Emporium* 114(Sept. 1951):141.
1958, Spring	Paris, Galerie Charpentier. *L'Ecole de Paris.* Included 12 gouaches by Vlaminck, painted during the spring of 1958.
1968, 10 October	New York, Parke-Bernet Galleries. *School of Paris Paintings . . . From the Collection of Doctor Roudinesco.* Sold by his order, public auction October 10. Sale no. 2742. Included works by Vlaminck, among other artists.
1972	Chartres, Office de Tourisme et chambre de commerce de Chartres. *Vlaminck et sept peintres Beaucerons.*
1976, 26 March– 31 October	New York, Museum of Modern Art. *The 'Wild Beasts': Fauvism and its Affinities.* Also shown San Francisco, San Francisco Museum of Modern Art (29 June - 15 Aug.); Forth Worth, Kimbell Art Museum (11 Sept. - 31 Oct.). Catalogue by John Elderfield. 167 p., illus., some col. 21 works.

1978, 16 February- 16 April	Paris, Orangerie des Tuileries. *Donation Pierre Lévy.*
1978, 16 November- 21 December	London, Lefevre Gallery. *Les Fauves.* Introduction by Denys Sutton. 30 p., 11 illus. In his brief introduction to this catalogue to an exhibition of eleven paintings by Braque, Derain, Matisse and Vlaminck, Sutton discusses the current state of information about the Fauves and suggests some of the avenues that remain to be explored.
1981, Spring	Paris, Galerie Daniel Malingue. *L'Ecole de Paris.* Review: F. Daulte, *L'Œil* 310(May 1981):62-5.
1983, 4 June- 2 October	Martigny, Fondation Pierre Gianadda. *Manguin parmi les Fauves.* Textes de Lucile Manguin, Pierre Gassier, et Maria Hanhloser. 175 p., 107 illus. Catalogue to an exhibition of paintings and drawings by Henri Manguin (1874-1949) and ten Fauves: Braque, Charles Camoin, Dufy, Emile-Othon Friesz, Albert Marquet, Matisse, Jean Puy, Louis Valtat, Kees van Dongen, and Maurice de Vlaminck. In his essay Gassier gives an account of Fauvism from its origins in a meeting of Manguin, Matisse and Marquet in the studio of Gustave Moreau, to its "official" birth at the Salon d'Automne in 1905, tracing the interest of its members in Cézanne and the decline of the movement as Cézanne's work became more widely known. Hahnloser describes the importance for Manguin of his visits to Switzerland, especially Lausanne. Manguin's daughter gives her recollections of his personality. The exhibits are divided into Fauvist works and works by Manguin from the post-Fauvist period (1908-49).
1987, 16 April- 28 June	Los Angeles, Los Angeles County Museum of Art. *Degas to Picasso: Modern Masters from the Smooke Collection.* Catalogue by Carol S. Eliel. 144 p., 106 illus., 72 col. Catalogue to an exhibition of paintings and sculptures from the collection of late 19th and early 20th century European art assembled by Nathan and Marion Smooke. Although particularly strong in works by Degas, Matisse and Picasso, the exhibition also included important pieces by Vlaminck, Derain, Kandinsky, Kirchner, Gabo, Braque, and Gris. In her introduction Eliel discusses the avant-garde movements represented in the collection and describes its origins and expansion.
1989, 23 March- 7 May.	Auckland, Auckland City Art Gallery. *The Reader's Digest Collection: Manet to Picasso.* Catalogue by John Rewald. 96 p., 42 col. illus. Catalogue to an exhibition of French Impressionist and Post-Impressionist paintings, drawings, and sculptures from the

collection started by Lila Acheson Wallace. Rewald briefly discusses the scope of the collection and provides a short commentary on each of the exhibited artists, including Bonnard, Degas, Dufy, Modigliani, Monet, Morisot, Utrillo, van Gogh, Vuillard, and Vlaminck.

1991, 9 June- Los Angeles, Los Angeles County Museum of Art. *Monet to*
11 August *Matisse: French Art in Southern California Collections.* Catalogue and texts by Philip Conisbee, Judi Freeman, and Richard Rand. 144 p. Included 1 landscape by Vlaminck.

André Derain

Biographical Sketch

Derain was born in 1880 at Chatou, which was then a kind of artists' colony on the banks of the Seine at the gates of Paris. His father was a successful baker and a town councilman and André received a middle-class education. He disliked school. Much later he wrote, "the teachers, ushers and pupils were a far more bitter memory for me than the darkest hours of my military career." He left, in his own words, "with few regrets and the reputation of being a bad, lazy and noisy scholar," but also with a prize for drawing.

Derain took his first painting lessons in 1895 from an old friend of his father's and of Cézanne's but who nevertheless thoroughly disliked Cézanne's work. In 1898 he went to l'Académie Camillo in Paris, where he met Matisse and other Fauves-to-be. In June, 1900 he met Maurice Vlaminck and formed a close friendship with him. The two young artists rented an unused restaurant on Ile de Chatou for a studio. Meanwhile, Derain pursued his studies, copying in the Louvre and visiting exhibitions of contemporary art. In 1901 he was extremely impressed by the van Gogh retrospective at the Bernheim-Jeune Gallery. It was there that he introduced his two friends, Vlaminck and Matisse, to each other.

In the fall of 1901 Derain was called up for military service. He could do very little serious work but carried on a lively correspondence with Vlaminck until his release in September, 1904. He returned to Chatou and it was about this time that he met the avant-garde critic and champion Guillaume Apollinaire. The following year, 1905, was an important one for Derain. The dealer Ambroise Vollard, to whom he had been introduced by Matisse, bought the entire contents of his studio, as he did for Vlaminck. Derain exhibited at the Salon des Indépendants and sold four paintings, and then at the Salon d'Automne where he, Matisse, Vlaminck and others were hung together as a group in a room that was promptly dubbed the "*cage aux fauves*" by Louis Vauxcelles, critic for *Gil Blas*. Fauvism was officially born.

Following his success at the Salon d'Automne, Vollard commissioned him to do some views of London and he visited England for the first time, returning again in 1906. Like the other Fauves, Derain experimented with the optical contrasts of strong, luminous colors, treated as independent decorative elements, and shaved little concern for the contours and substance of the original objects. During the Fauve period he painted many portraits, figure compositions, landscapes, and street scenes, as well as his celebrated London views. The summer of 1906 was spent painting at L'Estaque on the Riviera, where he met Picasso. In the next year he signed a contract with Daniel-Henry Kahnweiler, Picasso's dealer. He married on the strength of this and with his wife Alice

went to live in Montmartre, where his friendship with Picasso continued. Fernande Olivier, Picasso's mistress at that time, left a vivid description of him:

> Slim, elegant, with a lively color and enamelled black hair. With an English chic, somewhat striking. Fancy waistcoats, ties in crude colors, red and green. Always a pipe in his mouth, phlegmatic, mocking, cold, an arguer.

Alice Derain at this period was so calm and beautiful that she was nicknamed "La Vièrge"—the Holy Virgin. Her husband's ties with Picasso and his circle were strengthened when he supplied the illustrations for Apollinaire's first book, *L'Enchanteur pourissant*, in 1909 and illustrated a collection of poems by Max Jacob in 1912. Derain was attracted to Cubism and for a while he subdued his color in favor of structure, much in the manner of Cézanne. With the outbreak of war in 1914 Derain was mobilized and remained in the army throughout the conflict. fighting on the Somme, at Verdun and in the Vosges. There was little opportunity to paint but his career did not entirely come to a halt. The dealer Paul Guillaume gave him his first single-artist show in 1916, with a catalogue preface by Apollinaire, and he provided another set of illustrations for André Breton's first book, *Mont de Piété*. He was forced to remain in the army until 1919, serving with the French occupation forces in Mainz, but when he was finally released the Parisian art world received him with open arms.

In 1919 he designed the ballet *La Boutique fantastique* for Diaghilev, the first of many ballet commissions, which scored a major success, and in 1920 he signed another contract with Kahnweiler, replaced by a contract with Paul Guillaume in 1923. Four books were published about his work between 1920 and 1924 and he began to move in fashionable circles—the aristocratic patron Count Etienne de Beaumont, who set himself up as Diaghilev's rival, offered him further theatrical commissions in 1924 and 1926. Derain's reputation rose to new heights when he was awarded the Carnegie Prize in 1928 and began to exhibit extensively abroad—in London in 1928; in Berlin, Frankfurt and Düsseldorf in 1929; in New York and Cincinnati in 1930; and again in London and New York in 1931.

By now Derain's art had evolved considerably since his Fauve days. First, he had passed through a period when he showed the influence of African art (of which he was a pioneer collector) and also of Picasso's and Braque's Cubism. After the war, like many artists he felt the renewed appeal of classicism. Derain deadened his colors increasingly and became more and more concerned with technique and elaborate preparations of the canvas. He went to Italy in 1921 for the Raphael centenary celebrations held that year and was deeply impressed by High Renaissance painting. He also drew on more directly classical sources such as Fayum portraits and Roman mosaics. The increasing conservativism of his work was not challenged until 1931, when a book called *Pour ou contre André Derain*, containing essays by various authors, was published. A particularly damaging verdict came from the veteran painter and critic Jacques-Emile Blanche, who wrote: "Youth has departed; what remains is a highly cerebral and rather mechanical art."

Derain's work now divided informed opinion. During the 1930s he gradually lost touch with many old friends. He bought a large house at Chambourcy near Saint Germain-en-Laye and maintained an apartment in Paris. The apartment served several purposes: he found it difficult to find good models at Chambourcy, where he lived with his wife, his wife's sister, and the latter's daughter; it also provided a convenient place to meet his mistresses. Despite the animosity which some of the avant-garde now displayed towards him, he continued to receive plenty of official recognition. He was given a retrospective at the Kunsthalle in Bern in 1935 and was included in the important Exposition des Artistes

Indépendants held at the Petit Palais in connection with the Paris Exposition Universelle in 1937.

The Second World War marked the beginning of the long decline of Derain's career and reputation. In 1940 he fled from his house in Chambourcy and returned to find it had been requisitioned by the Germans. 1941 saw the birth of an illegitimate son, the child of a favorite model. During the occupation he lived mostly in Paris, dividing his time between several households—his own studio, the house he had provided for his wife, and the apartment of his mistress. He was also courted by the Germans, since he belonged to a group of artists who were not condemned as by Nazi theoreticians as "degenerate" (as was the case with the Cubists and Surrealists), but who, on the contrary, represented the prestige of French culture with which the Nazis wished to identify themselves. Ribbentrop wanted him to come to Germany and paint his family. Derain rejected this offer but accepted an invitation to make an official visit to Germany in 1941. Vlaminck agreed to accompany the party and the tour was preceded by a series of official receptions designed, in part, to reconcile the two artists who had quarrelled some time previously. The German propaganda machine made much of Derain's presence in the Reich and after the Liberation he was branded a collaborator and generally ostracized.

Derain continued his public activity as an artist to some extent. He did book illustrations, including a splendid series for Rabelais' *Pantagruel* published in 1944. He executed more theatre commissions, notably the ballet *Mam'zelle Angot* for the Royal Opera House, Covent Garden, in 1947; Mozart's *Seraglio* for the Aix-en-Provence Festival in 1951; and Rossini's *Barber of Seville* for the same festival in 1953. But gradually he became more and more reclusive. He and his wife and her relations had returned to Chambourcy after the war, together with his illegitimate son whom he had now formally adopted. His wife gave the necessary consent for this but their relationship was otherwise very strained, especially when a second illegitimate child was born (whom he dared not acknowledge).

In 1953 Derain fell ill and his sight was seriously affected. His wife made an attempt to seize control of his affairs and to keep certain old friends (and the mothers of his two children) away from him. He recovered gradually and as soon as he was well again he and Alice separated. In 1954 he was struck by a truck in Chambourcy. He was taken to the hospital and at first it was thought that he was not seriously injured. But the shock was too much for a man now in his seventies. Derain lingered but failed to recover, living only long enough to effect an official reconciliation with his wife.

André Derain

Chronology, 1880-1955

Information for this chronology was gathered from Jane Lee, *Derain* (Oxford: Phaidon; New York: Universe, 1990); Pierre Cabanne, *André Derain* (Paris: Somogy, 1990); Gaston Diehl, *Derain* (Paris: Flammarion, 1991); and Denys Sutton, *André Derain* (London: Phaidon, 1959), among other monographs and exhibition catalogues.

1880	Birth of André Derain on June 17 at Chatou, a suburb of Paris on the Seine. His family are well-to-do businessmen and he is destined for l'Ecole Polytechnique.
1895	Leaves the Collège Chaptal to prepare for l'Ecole des Beaux-Arts. Frequent visitor to the Louvre where he particularly admires the primitive artists.
1898	Enters l'Académie Camillo, rue de Rennes, Paris, where Eugène Carrière instructs.
1899	Meets Matisse and Puy at l'Académie Camillo.
1900	Meets Maurice de Vlaminck following a commuter train accident betweeen Chatou and Paris. Vlaminck also lives in Chatou. They agree to paint together the next day and soon rent a studio, "La Baraque," in a dilapidated restaurant on an island in the Seine at Chatou.
1901	Copies Biago d'Antonio's *Road to Calvary* in the Louvre. Introduces Vlaminck to Matisse at the van Gogh exhibition at Galerie Bernheim-Jeune. Spends the summer in Belle-Isle, Brittany, where Matisse and Puy had worked. Begins military service in the fall.
1901-04	Compulsory military service at Commercy. Reads the *Revue blanche* and corresponds with Vlaminck. Paints only two landscapes and one large canvas, *Dancing at Suresnes*.

1905 In February the dealer Ambroise Vollard, following Matisse's advice, purchases nearly the entire contents of Derain's studio. Shows for the first time at the Salon des Indépendants. Rents a studio on rue Tourlaque, Montmartre. Paints with Matisse in Collioure during the summer. Exhibits in the *"cage aux fauves"* room at the Salon d'Automne; also at Berthe Weill's. Visits Marseille and L'Estaque. Painting trip to London financed by Vollard.

1906 Second trip to London, where he discovers Turner and African art. Late spring and summer are spent painting at L'Estaque and Cassis. Shows at the Indépendants and Automne, also at Weill's. Associates with Picasso in Montmartre.

1907 Shows at the Indépendants (*Les Baigneuses*) and Automne (woodcuts). Works in Cassis where he asks Vlaminck in vain to join him. Stays with Picasso in Avignon while he paints *Demoiselles d'Avignon*. Picasso introduces Derain to Alice Princet (née Géry) who becomes Derain's wife in October. They move to 22, rue Tourlaque. He is increasingly interested in African art and Roman sculpture. Makes woodcuts and tries his hand at sculpture. Contracts with Daniel-Henry Kahnweiler.

1908 Lives at rue Tourlaque where Vlaminck visits him frequently. In the nearby rue Ravignon restaurant, they gather with Picasso, van Dongen, Braque and other "Bateau-Lavoir" artists. Works in Martigues with Vlaminck. Spends May-November in the south of France, joined by Braque, Dufy, and Friesz. Paints Bather motifs. Is troubled and attracted by Cubism. Definitive separation from Fauvism.

1909 Paints in Le Havre in January-February. Summer on the Brittany coast and around Marseille. Illustrates Apollinaire's *L'Enchanteur pourrissant*. Death of Derain's father.

1910 Travels to Boulogne and England with his mother. Spends winter painting in and around Marseille and Cagnes; summer and fall in and around Cadaques and Beauvais. Moves to 13, rue Bonaparte, Paris.

1911 Summer in Crécy-en-Brie and environs and in Boulogne.

1912 Summer in Cahors and Vers (Lot). Illustrates Max Jacob's *Les Œuvres burlesques et mystiques de Frère Matorel mort au couvent de Barcelone*.

1913 Summer in Serbonne, Lyon, Martigues, and Sausset. Vlaminck paints with him.

1914 Paints with Picasso and Braque in Avignon and Montfavet, near Avignon.

1914-18 During World War I, Derain serves in Champagne, Somme, Verdun, and L'Aisne and participates in the march to Mainz.

1916 Illustrates André Breton's *Mont-de-Piété*, published in 1919. Private show at Galerie Paul Guillaume in October.

1917	Exhibition at New York's Modern Gallery.
1918	Designs sets for Paul Claudel's *L'Annonce faite à Marie* for the Duvoc theatre company.
1919	Spends the summer in London. Designs sets and costumes for Ballets-Russes's *La Boutique fantastique* (Sergei Diaghilev). Paints decorations for Halversen's rooms. Illustrates Vlaminck's *A la santé du corps* and René Dalize's *Pauvre Macchabé mal enterré*.
1920	Paints in and around Cahors. Illustrates André Salmon's *Calumet* and Georges Gabory's *La Cassette de plomb*.
1921	Trip to Rome and the Campagna. Spends the summer painting in Sanary and La Ciotat, joined by Kisling and Mondzain.
1922	Summer in Sanary, Les Lecques, and St. Cyr-sur-mer, as he does every summer through the 1920s. Illustrates Georges Gabory's *Le Nez de Cléopâtre*. Private shows in Stockholm, Berlin, New York, and Munich.
1924	Designs decor for the ballet *Gigues* (Soirées de Paris). Buys a house in Chailly-en-Bière in the Fontainebleau forest.
1926	Designs decor for the ballet *Jack in the Box* (Etienne de Beaumont). Illustrates Georges Coquiot's *En suivant la Seine*.
1927	Set of lithographs, *Metamorphoses*, published by Les Quatre Chemins. Private exhibition at Flechtheim Gallery in Düsseldorf.
1928	Wins the Carnegie Prize. Moves to 5, rue du Douanier near Parc de Montsouris, next door to Braque. Private show at London's Lefevre Gallery in March. Illustrates Vincent Muselli's *Les Travaux et les jeux*.
1929	Buys Château Parouzeau.
1930	Paints in Saint Maximim, Var, and Bandol. Private show in Chicago at the end of the year.
1932	Designs decor for the ballet *La Concurrence* (Ballets-Russes de Monte-Carlo). Paints in St.-Rémy. Private show at Durand-Ruel Galleries, New York, with a preface by Waldemar George.
1933	Conceives and designs two ballets, *Les Fastes* and *Les Songes* (Les Ballets 33). Paints in St.-Rémy. Exhibition at Arthur Tooth and Sons, London, at the end of the year.
1934	Paints in Gravelilines, Dunkirk, and St.-Rémy. Illustrates Antonin Artaud's *Héliogabale*, Petronius's *Le Satyricon* (published 1951), and La Fontaine's *Contes et nouvelles* (published 1950). Designs the cover of the surrealist journal *Minotaur*. Paul Guillaume, Derain's dealer, dies.

1935 Buys "La Rosarie," a house in Chambourcy. Sells his houses in Paris and Chailly-en-Bière and the Château Parouzeau. Shares Léopold-Lévy's studio in rue d'Assas near the Jardin de Luxembourg. Designs the cover of the classicist journal *Voyage en Grèce*. Private shows in Stockholm, Paris, Basel, Bern, and London.

1936 Paints on the northern coast of France. Designs sets for the ballet *Epreuve d'amour* (Ballets-Russes de Monte-Carlo). Large show at New York's Joseph Brummer Gallery, New York, November-January 1937.

1937 Trip to London.

1938 Illustrates Oscar Wilder's *Salomé* and Ovid's *Les Héroïdes*.

1940 Leaves Paris in the war exodus. Private show of paintings after 1938 at Pierre Matisse's Gallery, New York, April-May.

1941 Paints at Oussons-sur-Loire. In Paris, he lives in the rue de Varenne. Travels to Germany.

1943 Paints at Donnemarie-en-Montois. Illustrates Rabelais' *Pantagruel*.

1944 Shows early in the year at Pierre Matisse's New York gallery.

1947 Illustrates Héron de Villefosse's *Eloge des Pierreries*.

1948 Designs decor for the ballet *Le Diable l'emporte* (Ballets Roland Petit). Illustrates *Le Génie du vin* for Etablissements Nicholas (published 1972). Designs the decor for the ballet *Mam'zelle Angot* (Sadlers Wells). November in London.

1949 Private exhibition, *Hommage à Derain*, at Galerie de Berri, Paris, in March.

1950 Illustrates Antoine de Saint-Exupery's *Citadelle* in the *Œuvres complétes* of that author. Illustrations for *Amie et Amille* (published 1957) may also have been completed this year.

1951 Designs decor for the ballet *Il Seraglio* (Festival d'Aix-en-Provence).

1953 *Anacréon* published for which Derain's numerous lithographic illustrations may have been done sometime earlier. Designs decor for the ballet *The Barber of Seville* (Festival d'Aix-en-Provence).

1954 Dies September 8 at Garches (Seine-et-Oise).

1954-55 Retrospective at the Musée National d'Art moderne. Preface by Jean Cassou, catalogue by Gabrielle Vienne.

André Derain

Bibliography

I. Primary Bibliography

A. Statements, Interviews, and Writings

2067. DERAIN, ANDRE. "Hommage à Jacques-Emile Blanche, peintre splendide et critique admirable." *Signaux de Belgique et de la France* (Paris and Brussels) (Sept. 1921):243[+]. Reprinted in Pierre Lévy, *Des artistes et un collectionneur* (Paris, 1976), pp. 142-7.

2068. CREVEL, RENE. "Ou va la peinture?" *Commune* 21, 22, 24 (May, June, Aug. 1935).

Includes quotations from André Derain in the May, 1935 issue, pp. 940-3.

2069. DERAIN, ANDRE. *André Derain*. Prague: Melantrich, 1938. 17 p., 25 pl.

2070. DERAIN, ANDRE. "Quand les fauves, quelques souvenirs." *Comœdia* (20 June 1942):1,6.

2071. *Peintres d'aujourd'hui: les maîtres*. Collection Comœdia-Charpentier. Paris, 1943.

Includes quotations from André Derain.

2072. DERAIN, ANDRE. *Derain, dessins*. Paris: F. Mourlot, 1947. 1 vol. of illus.

2073. DERAIN, ANDRE. "André Derain." Interview published in *Le Prisme des arts* (Nov. 1956):2-6.

Includes comments on art collected by Denise Lévy, wife of Pierre Lévy.

2074. DERAIN, ANDRE. *Le Génie du vin*. Présenté par Thierry Maulnier de l'Académie Française. Paris: Nicolas, 1972.

2075. DERAIN, ANDRE and ROSANNA WARREN. "A Metaphysic of Painting: The Notes of André Derain." Excerpts from *The Notes of André Derain*. Translated and selected by Rosanna Warren. *Georgia Review* 32:1(Spring 1978:94-149. 8 illus.

Comments on the art historical significance of André Derain's private notes, which have been collected from barely legible handwritten notebooks found in his studio after his death in 1954, excerpts being presented in this issue of *Georgia Review* (pp. 121-49). Warren outlines the problematic and enigmatic nature of Derain's art and describes why the artist's position was considered highly polemical in his relation to other contemporary art developments, pointing out the elucidatory importance of the notes in providing an affirmation of the mature aesthetic underpinning Derain's painting in the years following his departure from Cubism around 1910. Insights provided by the notes into Derain's thought, particularly his belief in the importance of things perceived in relationship to other things, his metaphysical interest in the "plurality-unity" problem, and his interpretation of the Christian myth, are analyzed, and the philosophical framework in which the notes place the various phases of Derain's pictorial œuvre are discussed in detail.

2076. DERAIN, ANDRE. "Les Notes d'André Derain." Gabrielle Salomon, editor. *Cahiers du Musée National d'Art moderne* 5 (1980):343-62. 4 illus.

Publishes Derain's notes on painting. Comments on his attitudes toward art and aesthetics, seen as focusing on the relationship of the particular to the universal. With the exception of his letters to Vlaminck, few of Derain's writings or pieces of correspondence remain. He consistently refused to formulate a methodical explanation of his painting, but his philosophy of life nevertheless seems to be intimately linked to his activities as a painter. Two batches of Derain's writings have recently gained closer attention for the light they shed on these activities: notes for a treatise entitled "De l'art de peindre," written in school exercise books and discovered in his studio, and the more obscure and difficult manuscript entitled "De la Kabbale chez les Hébreux." Only those parts of each document which clearly bear relation to Derain's pictorial aesthetic are cited in Salomon's examination of Derain's activity as a painter.

2077. DERAIN, ANDRE. *André Derain.* Redakation, Detlev Gretenkort. Cologne: Michael Werner, 1989. 34 p., illus., some col.

B. Correspondence

2078. DERAIN, ANDRE. *Lettres à Vlaminck.* Maurice Vlaminck, editor. Paris: Flammarion, 1955.

Correspondence between the two painters which covers the years 1900-17. The letters are from three distinct periods: Derain's compulsory military service (1901-04), his painting trips to the south of France (1905-08), and his service in the First World War (1914-17).

2079. Paris, Galerie Louise Leiris. *Daniel-Henry Kahnweiler Collection.*

Includes the largely unpublished correspondence between Derain and Kahnweiler from the period 1907-24, with a single letter dated 1927. There is also some slight correspondence with Madame Derain after the artist's death in 1954. A few of these letters were published in the exhibition catalogue, *Donation Louise et Michel Leiris, Collection Kahnweiler-Leiris*, Paris, Musée National d'Art moderne, 1984, pp. 37-8.

C. Archival Materials

2080. DERAIN, ANDRE. *Manuscript Essay*, ca. 1900. 1 item. Located at The Getty Center for the History of Art and the Humanities, Archives of the History of Art, Santa Monica, California.

Includes an appreciation of the city of Marseille and the Provençal spirit.

2081. Bibliothèque Littéraire Jacques Doucet, Paris. *André Derain, Manuscripts.*
Collection of papers recovered from Derain's house at Chambourcy soon after the artist's death in 1954. The notes are assembled into four main categories: "De Picturae Rerum de l'art de peindre," "Suite de notes sur la peinture," "Extraite de l'imagique," and "Respect aux angles." A few of the manuscript notes deal with practical matters, lists of paintings, guests to be invited to private viewings, but the majority of them are poetic or theoretical writings. A number of them are notes from

Derain's reading, compilations of the results of his research into a variety of subjects, experiments with signs, letters, and language, and experiments in musical notation and composition. His unpublished treatise on painting, "De Picturae Rerum" was written between 1919 and 1921. Nearly all of these documents are undated, but using only the dated documents among them, they can be seen to span at least the period 1903-33, and there is a great deal of internal evidence for dating some of the notes in the late 1930s and after the Second World War. Substantial selections from the notes have been published in the citations which follow. See particularly Rosanna Warren, "A Metaphysic of Painting: The Notes of André Derain," *Georgia Review* 32:1(Spring 1978):94-149, in which a large part of Derain's treatise on painting is published in English translation. See also Gabrielle Salomon, "Les Notes d'André Derain," *Cahiers du Musée National d'Art moderne* 5(1980):343-62, in which most of the text of the three manuscripts of the treatise on painting is published.

2082. GAUT, PIERRE. *Papers*, 1918-69. 1.5 boxes. Manuscripts (holographs, typescripts); photographs; printed matters. Located at The Getty Center for the History of Art and the Humanities, Archives of the History of Art, Santa Monica, California.

Gaut was a French paint manufacturer and art collector. The collection contains letters and orders from artists, many of them personal friends, including 18 letters from Georges and Marcelle Braque and two orders from Picasso; material relating to Gaut's collections of Braque and Picasso and some architectural files regarding his house in Robinson, including correspondence with Le Corbusier and drawings by A. and G. Perret.

Organization: I. Correspondence, 1918-75 (Folders 1-40, 105 items); II. Subject files (Folders 41-50); III. "Notes sur la Peinture à la Detrampe," 1920 (Folder 51); IV. Gaut collection (Folders 52-53); V. Property files (Folders 54-63); VI. Personal photographs (Folders 64-66); VII. Clippings (Folders 67-68).

Series I: Correspondence arranged alphabetically by correspondent includes letters or orders from the artists Jacques Boullaire (1935-75), Georges and Marcelle Braque (1926-53), Maurice Brianchon (1941-42), André Derain (1942), Jacques Lipchitz (1921), Jean Lurçat (1939), Pablo Picasso and Dora Maar (n.d.) and Camile Roche (1938-39); also, letters from the writer Blaise Cendrars (1939-48), from the composer Petro Petridis (1949-69); and from dealers, critics, and editors Daniel-Henry Kahnweiler, Pierre Loeb, Albert Skira, Pierre Daix, Douglas Cooper, and André Weil in regard to Gaut's collection of Braque and Picasso paintings.

Series VI: Personal photographs, including photos of Braque, Derain, Lipchitz, and Picasso.

2083. JALOUX, EDMOND. *Derain et le paysage français* (article), ca. 1930. 1 item, 4 p. manuscript. Located at The Getty Center for the History of Art and the Humanities, Archives of the History of Art, Santa Monica, California.

Jaloux (1878-1949) was a French writer and art critic. This article was possibly a salon review or an article written for publication.

2084. Paris, Galerie Louise Leiris. *Daniel-Henry Kahnweiler Collection.*

Includes the largely unpublished correspondence between Derain and Kahnweiler from the period 1907-24, with a single letter dated 1927. There is also some slight correspondence with Madame Derain after the artist's death in 1954. A few of these letters were published in the exhibition catalogue, *Donation Louise et Michel Leiris, Collection Kahnweiler-Leiris*, Paris, Musée National d'Art moderne, 1984, pp. 37-8.

2085. LEVEL, ANDRE. *Letters Received*, 1899-1936. ca. 100 items. Holographs, signed; photographs. Located at The Getty Center for the History of Art and the Humanities, Archives of the History of Art, Santa Monica, California.

Level (1863-1946) was a French dealer and art critic. The collection consists of ca. 60 letters received frorm several correspondents including Maurice Denis (1914), André Derain (1914-15), Dunover de Segonzac (1912-14), Othon Friesz (1905), René Piot (1899, 1914), and Felix Vallotton (1914). The letters generally concern the sale of paintings but also contain information on personal matters and travel. One group of 13 letters from Augustin Grass-Mick is extensively illustrated and includes vignettes characterizing his experience of the war. Collection also contains two photographs and 42 black-and-white reproductions of paintings, many of which arc by Picasso. Letters received are arranged alphabetically by correspondent.

2086. MASSINE, LEONIDE. *Papers*, 1932-68 (1940-55 bulk). 337 folders, 8 boxes. In English, Russian, Italian, and French. Located at the Dance Collection, New York Public Library, New York.

Massine (1896-1979) was a Russian-born choreographer.

Series include Personal correspondence, 1934-52; Professional Correspondence, 1938-58; "Ballet Russe (Suites)" Bookings, November 1944-May 45; Legal Material; Professional Material; Financial Material; and Memorabilia. Most significant in the personal correspondence are letters from Leonide to his third wife, Tatiana. Correspondents in the Professional Correspondence file include Marc Chagall, Salvador Dalí, Manuel de Falla, André Derain, Sir Maynard Keynes, Henri Matisse, Lucia Chase, Sergei Denham, Mstislav Doboujinsky, Nicholas Nabokov, Michael Powell, Leopold Stokowski, Pavel Tchelichev, Ninette de Valois, Aleksandra Danilova, Irina Baronova, Nina Verchinina, and Rosella Hightower. In Russian, Italian, English, and French. Register and card catalogue available.

2087. SCHLEMMER, OSKAR. *Journal*, 1928-43. ca. 100 p. Typescript. Located at The Getty Center for the History of Art and the Humanities, Archives of the History of Art, Santa Monica, California.

Schlemmer (1888-1943) was a German painter and designer, teacher at the Bauhaus School, and a stage designer.

Transcripts of entries from Schlemmer's journals for the year 1935-43, except for a single month (September, 1941); with scattered records from published sections and full entries where only extracts have been published. The journal is in diary form, with notes on daily activities, including his reading, but serves also as a vehicle for extended reflections on art and artists, art theory and techniques, and Schlemmer's own works. There is detailed discussion of color and form in abstraction, portrait and landscape painting, and the effect of the Nazis on art and artists. Artists mentioned

prominently in his discussions and notes include: Emil Nolde, Julius Bissier, Paul Klee, Christian Rohlfs, Georg Muche, Willi Baumeister, Auguste Renoir, Giorgio de Chirico, Georges Rouault, Georges Seurat, Henri Rousseau, André Derain, Paul Cezanne, Hans von Marees, Eugène Delacroix, Caspar David Friedrich, and Otto Meyer-Amden ("OM" or "Otto Meyer").

Indexes: A list of entries, with a key-word description of subjects covered in each and a collation of this text with that of Tut Schlemmer, ed. *Oskar Schlemmer, Briefe und Tagebuecher* (Stuttgart, 1977) is available.

II. Secondary Bibliography

A. Biography and Career

Books

2088. CABANNE, PIERRE. *André Derain*. Paris: Somogy, 1990. 143 p., illus., some col.

2089. DIEHL, GASTON. *Derain*. Paris: Flammarion, 1964. 46 p., illus., some col. Volume in "Les Maîtres de la peinture" series.

a. Another ed.: 1991.
b. English ed.: *Derain*. Trans. by A. P. H. Hamilton. Milan: Uffici Press, 1966. 94 p., illus., some col.
c. U.S. eds.: New York: Crown, 1974; 1977. 94 p., illus., some col.

2090. FAURE, ELIE. *André Derain*. Paris: G. Crès, 1923. 102 p., illus., 59 pl. Volume in "Cahiers d'aujourd'hui" series.

a.Another ed.: 1926.

2091. HILAIRE, GEORGES. *Derain*. Geneva: Pierre Cailler, 1959. 200 p., 24 col. illus., 210 pl. Volume in "Les Grandes monographies" series.

Excellent source of illustrations.

2092. KALITINA, NINA N., E. GEORGIYEVSKAYA, and ANNA BARSKAYA. *André Derain*. Leningrad: Aurora Art Publishers, 1976. Introduction by N. Kalitina, commentary by A. Barskaya and E. Georgiyevskaya. Trans. by Yuri Nemetsky. 147 pl., col. illus.

a.French ed.: Trans. by C. Maximova. Lenigrad: Aurora Art Publishers, 1976. 147 p., col. illus.

2093. LEVY, DENISE. *André Derain*. Paris, 1970.

2094. PAPAZOFF, GEORGES. *Derain, mon copain*. Paris: Valmont, S. N. E. V., 1960. 261 p. pl.

2095. *Pour ou contre André Derain: enquête, opinions, documents.* Paris: Editions des Chroniques du Jour, 1931. 38 p., illus., 20 pl. Published as *Chroniques du Jour* 8 (Jan. 1931).

2096. SANDOZ, MARC. *Eloge de Derain.* Paris: Bruker, 1958. 25 p.

2097. SUTTON, DENYS. *André Derain.* London: Phaidon Press, 1959. 158 p., illus., some col.

a. U.S. ed.: New York: Phaidon; dist. by Doubleday, 1959. 158 p., 100 illus., 24 col., 2 pl.
Reviews: *Connoisseur* 145(May 1960): 196, reply by D. Sutton, *Connoisseur* 146(Sept. 1960):59; *Werk* 47(July 1960):supp. 143-4; N. Lynton, *Burlington Magazine* 103(Oct. 1961):440; H. Hofstätter, *Kunstwerk* 17(Aug. 1963):83.

2098. VAUGHAN, MALCOLM. *Derain.* New York: Hyperion Press; Harper & Brothers, 1941. 78 p., illus., some col. Volume in "Modern Masters" series.

Includes an extensive account of Derain's Fauve period.
Reviews: F. Caspers, *Art Digest* 15(15 May 1941):24; F. Berryman, *Magazine of Art* 34(June 1941):332.

Articles

2099. "André Derain." *Chroniques du Jour* 8(Jan. 1931):1-17. 20 illus.

Includes "Pour ou contre," pp. 3-8; "Ce qu'a dit la critique," pp. 9-14; "Documents," pp. 15-7.

2100. BELL, CLIVE. "Derain." *Formes* 2(Feb. 1930):5-6, 26.

2101. BELL, LELAND. "The Case for Derain as an Immortal." *Art News* 59:3(May 1960):24-7, 62-3.

2102. BLIGNE, YVES. "Derain 1880-1954." *Peintre* 6(15 Feb. 1981):3-5. 3 illus.

Reviews the exhibition *Hommage à André Derain* at the Musée d'Art moderne de la Ville de Paris (17 Dec. 1980-8 March 1981). Briefly traces Derain's career and assesses his current status as a painter.

2103. BOURET, JEAN. "Pour un portrait de Derain." *Galerie-Jardin des arts* 167(March 1977):41-5. 6 illus.

On the occasion of the 1976-77 Derain retrospective held in Rome and Paris, Bouret stresses the importance of Derain's Parisian roots and discusses the path followed by Derain from Impressionism, influenced by Seurat, to the sudden beginnings of Fauvism under the influence of Vlaminck. His connections with Picasso and discovery of Douanier Rousseau are presented for the way in which Derain's development was affected by both. After the First World War (in which he fought), he turned to a kind of realism like La Fresnaye or Gromaire, but during the later part

of his life his work was marked by a renewal of contact with the art of the past, from Byzantium to Signorelli, the Le Nain brothers, and Poussin.

2104. BRIELLE, ROGER. "André Derain, peintre classique." *Art et artist* 28(April 1934):220-6. 8 illus.

2105. CARRÀ, CARLO. "André Derain" in Carrà's *Le Neoclassicisme dans l'art contemporain* (Rome: Valoti Platici, 1923), pp. 92-6.

2106. CARRÀ, CARLO. "Parere intorno ad Henri Matisse e André Derain" in *Pittura metafisica* (Milan: Il Balcone, 1945), pp. 139-49.

Originally published in 1919.

2107. CUMMING, CAROLYN. "A. Derain and Fauve Record" in *Christie's Review of the Season, 1978*. Edited by J. Herbert. (London: Studio Vista, 1978). 520 p., 762 illus.

Discusses Derain's role as a Fauve painter.

2108."Derain à Marsiglia." *Domus international* 418(Sept. 1964):67.

2109. FRIGERIO, SIMONE. "Lettre de Paris, 1: Derain réhabilité" [Letter from Paris, 1: Derain Rehabilitated]. *Colóquio Artes* 2:32(April 1977):68-9. 4 illus.

Contends that the period of Derain's fall from favor coincided with the rise of abstraction, but the 1977 Rome and Paris retrospective exhibition marked his reacceptance in France as a leading Fauvist. Briefly describes Derain's career.

2110. GIACOMETTI, ALBERTO. "Derain" in *Derrière le miroir* (Paris: Galerie Maeght, 1957).

Includes an appreciation of Derain.

2111. GOLDIN, AMY. "Forever Wild: A Pride of Fauves." *Art in America* 64:3(May-June 1976):90-5. 5 illus.

Article occasioned by the large exhibition, *Fauvism and its Affinities* held at the Museum of Modern Art, New York, Spring 1976. Historical perspective attributes increasing importance to Matisse and the Fauves, now that color and space have taken priority over natural forms. Derain is given considerable emphasis in the exhibition and is seen as the motive force behind Matisse's interaction with the Fauves. Fauvism took its themes from Gauguin but its handling from van Gogh, at least in the use of strong colors. The substitution of color for line and composition as a means to pictorial structure and unity is the essence of Fauvist paint-handling techniques. Goldin disputes the assertion that the instinctive, emotional Fauvist style gave way to the measured form and sobriety of Cubism—this is only applicable to the Fauves' use of color and the Cubists' lack of it. The movements were in fact united in their daring use of technique, the integration of form and ground, and in the search, common to artists everywhere, for a method that would confirm art's tie to a deeper reality while loosening its bondage to nature and to inappropriate conventions.

2112. GOLDING, JOHN. "Fauvism and the School of Chatou: Post-Impressionism in Crisis." *British Academy Proceedings* 66(1980):85-102. 16 illus. *Aspects of Art* lecture, read 7 February 1980.

Discusses the Fauvism of Vlaminck and Derain following their 1900 meeting and subsequent association, the influence of van Gogh and Cézanne, and Vlaminck's paintings, 1900-08, in the context of contemporary aesthetic problems and cross-currents.

2113. HOWE, RUSSELL WARREN. "André Derain." *Apollo* 61(Feb. 1955):47-9.

2114. JOLINON, JOSEPH. "La Rencontre de Vlaminck avec Derain." *L'Art vivant* 158(March 1932):121.

2115. LEVY, PIERRE and S. THIERRY (Interviewer). "La Donation Pierre Lévy." *L'Œil* 272(March 1978):26-33. 16 illus.

Interview with Pierre Lévy in which he surveys and discusses important items, notably late 19th and early 20th century paintings by French masters, in the part of his collection that he donated to the French state. Lévy retraces the beginnings and growth of his collection, mentioning his reasons for choosing the work of particular artists, his friendship with Derain, and his introduction to primitive art. The Lévy Collection is housed at the Musée d'Art moderne, Troyes.

2116. MANNES, M. "André Derain, Thoughtful Painter." *International Studio* 94 (Nov. 1929):24-9.

2117. "Obituary." *Art News* 53(Oct. 1954):7.

2118. PERL, JED. "A Fauve's Domain (the Studio of André Derain)." *Art & Antiques* 6:457(Jan. 1988):88-95 '.

2119. "*Portrait.*" *Arts Week* 1(18 March 1932):26; *Time* 55(26 June 1950):57.

2120. "*Portrait by Balthus.*" *Art Digest* 12(15 Jan. 1938):20; *Museum of Modern Art* 24:3(1956-7):14; *Studio* 153(June 1957):184; *Canadian Art* 16(Nov. 1959):237.

2121. "*Portrait by J. Davidson.*" *Carnegie Museum* 12(May 1938):53; *London Studio* 16 (*Studio* 16) (July 1938):32.

2122. "*Portrait by Matisse.*" *Illustrated London News* 225(4 Dec. 1954):1007; *Connoisseur* 135(March 1955):53; *Fortune* 52(Dec. 1955):127; *Artist* 55(June 1958):52; *Apollo* 80(Dec. 1964):511.

2123. "*Portrait by Vlaminck.*" *Art News Annual* 22(1952):119.

2124. "*Portrait Head by J. Davidson.*" *Studio* 143(May 1952):156.

2125. "Psychological Study of Derain by Balthus." *Art News* 46(Sept. 1947):29.

2126. ROGER-MARX, CLAUDE. "2 grands disparus: André Derain, Henri Matisse." *Plaisir de France* 197(Feb. 1955):2-7. 8 illus., 2 col.

2127. RUSSELL, JOHN. "The Birth of a Wild Beast." *Horizon* 18: 3(Summer 1976):4-17. 23 illus.

In this largely biographical account of Matisse, Russell discusses the influence of Collioure, a small coastal town in southern France on Matisse's painting through the changed conception of nature it offered; his relationship with Derain, whose *View of Collioure* (1905) is illustrated; critical reception of their work; their color theories; Matisse's drawings and portraits of his family at Collioure, and Matisse's sculptures *Reclining Nude, I* and *La Serpentine*.

2128. SAURE, WOLFGANG. "Wiederbegegnung mit einem modernen Klassiker" [Reunion with a Modern Classicist]. *Weltkunst* 51:4(15 Feb. 1981):300-1. 6 illus.

Reviews the first major exhibition of painting and sculptures by Derain in France since before his long prohibition because of his collaboration with the Nazis, held at the Musée d'Art moderne de la Ville de Paris (Feb.-March 1981). Saure describes how Derain sought to combine ideals with banal reality, suggesting that his bitterness at critical misunderstanding might have influenced his acceptance of Nazi art. His development is examined in detail and it is concluded that he was an "adventure" in art, guided by temperament rather than intention. Tragic undertones disappeared in the 1930s when Derain turned to Oceanic and Etruscan forms, but he was a perennial outsider.

2129. SAURE, WOLFGANG. "Hohe Tradition und das Klassische: das Werk von André Derain" [High Tradition and the Classical: The Work of André Derain]. *Kunst* 7(July 1987):580-6. 9 col. illus.

Traces Derain's development from his early contact with Matisse in Paris, his visit to London in 1906 to his mature style of painting, in which he represents living forms rather than reproducing them, and his stage designs. The influence of Turner, Gauguin, Cézanne, and van Gogh is described, as well as the main events of Derain's life and the central contrast between the fascinations that the avant-garde and ancient art exerted on him.

2130. SHIMADA, N. "André Derain: hanjidai no shougen" [André Derain: Testimony Against the Time]. *Mizue* (Japan) 914(May 1981):56-75. 23 illus.

On the occasion of the exhibition *Master of Fauvism: Derain*, which travelled throughout Japan (April-July 1981), Shimada surveys Derain's career and the development of his style. Derain is considered important as a precursor of the Fauves and as one of the founders of Cubism. His works during the 1920s and 1930s were representational, and after the Second World War he chose to revive the spirit of French Classicism, seeking order and clarity in his paintings in opposition to current trends.

2131. VLAMINCK, MAURICE DE. "Avec Derain, nous avons crée le Fauvisme." *Jardin des arts* (June 1953):473.

2132. WEBER, NICHOLAS FOX. "Historic Houses: André Derain (Preserving the Artist's Residence in Chambourcy, France)." *Architectural Digest* 49(Aug. 1993):48+.

2133. WERNER, ALFRED. "The Fauve Who Was No Beast." *Antioch Review* 16(June 1956):198-206.

2134. WERNER, ALFRED. "Tragedy of André Derain." *Arts Magazine* 32:4(Jan. 1958):22-5.

2135. ZERVOS, CHRISTIAN. "Histoire de l'art contemporain, André Derain." *Cahiers d'art* (1938):173-84.

B. Influence on Other Artists

Articles

2136. DAIX, PIERRE. "Comment Picasso rompit-il avec son dessin classique?" [How did Picasso Break with his Classical Style?]. *Revue des sciences morales & politiques* 142:1(1987):75-84.

Between 1905 and 1907 Picasso abandoned his classical style of design in favor of one characterized by "barbarous" visual distortions. States that major influences in that stylistic transformation were his contacts with Leo and Gertrude Stein and with the artists Matisse and Derain.

2137. DAIX, PIERRE. "Les Trois périodes de travail de Picasso sur *Les Trois femmes,* automne 1907-automne 1908, les rapports avec Braque et les débuts du cubisme" [Picasso's Three Periods of Work on the *Three Women*, Autumn 1907-Autumn 1908, his Relations with Braque and the Beginnings of Cubism]. *Gazette des Beaux-arts* 111:1428-9(Jan.-Feb. 1988):141-54. "Hommage à Jean Adhémar." 14 illus.

Establishes 1907 as the date of the first version of Picasso's *Three Women* (lost; final version in the Hermitage, Leningrad), presenting evidence concerning the development of the picture in relation to primitivism and Cézanne, and casting light on the beginnings of Cubism Daix also examines the relationship between Picasso and Braque in 1907-08 and the role of Derain.

2138. DAIX, PIERRE. "Dread, Desire, and the *Demoiselles.*" *Art News* 87:6(Summer 1988):133-7. 6 illus., 5 col.

Analysis of Picasso's *Demoiselles d'Avignon* (Museum of Modern Art, New York), its genesis and development. Cites Picasso's rage against his mistress Fernande Olivier and the scandal provoked by Matisse and Derain at the 1907 Salon des Indépendants, Paris, as sources for the radical change in Picasso's conception of the painting.

2139. HAUPENTHAL, UWE. "Peter Herkenrath." *Weltkunst* 60:9(1 May 1990):1387-9. 4 illus., 3 col.

An appreciation of the work of Cologne painter Peter Herkenrath on the occasion of his 90th birthday. Herkenrath's work is examined in terms of its relationship to modernist french painting. Influences on his work are discussed—André Derain is cited as being of particular importance—and his gradual discovey of a truer voice of his own is detailed.

2140. MOCANU, AURELIA. "Arta românească in patrimoniul artei universale" [Romanian Art as Part of the Inheritance of World Art]. *Arta* (Romania) 33:7(1986):15-6. 8 illus., 5 col.

Argues that the aim of painter Stefan Dimitrescu (1886-1933) was to create a Romanian spiritual space. His lyrical temperament gave his work a forceful artistic idiom, and influences on his style ranged from Derain to Neue Sachlichkeit. Mocanu places Dimitrescu in the context of contemporary artists, especially his links with Nicolae Tonitza and the Group of Four, cites their assessment of his work and surveys the range of his activity, mentioning his correspondence and his many portraits of authors.

2141. PETRIDES, PAUL. "Pétridès: Vlaminck tel quel" [Pétridès: Vlaminck just as he is]. *Galerie-Jardin des arts* 147(May 1975):73. 2 illus.

For the first time since 1965, a retrospective of works by Vlaminck was presented in Paris by dealer Paul Pétridès. In this brief text, Pétridès recounts his friendship with the painter and Vlaminck's connection with Derain. Vlaminck's contribution to the growth of the Fauve movement is emphasized.

2142. PIAUBERT, JEAN and ANDRE PARINAUD (Interviewer). "Jean Piaubert." *Galerie-Jardin des arts* 169(May 1977):30-4. 6 illus. In French.

On the occasion of a retrospective exhibition at Artcurial, Paris, Piaubert discusses his career in this interview. Through the dressmaker Poiret he met Derain, who influenced him, but he also learned from Raoul Dufy, whom he sees as the opposite pole. Piaubert explains the importance of sand as material in his paintings and the problem of spirituality; sand stands both for art in its infancy and for the permanency for which he is always searching.

2143. WEBER, MARIA SUSANNA. "Gli affreschi ferraresi di Achille Funi" [The Ferrarese Frescoes of Achille Funi]. *Museu Ferraresi: Bollettino Annuale* 13-4(1983-84):145-59. 20 illus. In Italian; summary in English.

Briefly surveys Funi's artistic development and his adoption of a monumental classical style in reaction to both 19th century naturalism and avant-garde superficiality, before considering his frescoes in the town hall, Ferrara (1934-37), on the theme of the myth of Ferrara. The presence in the frescoes of elements from Roman and Renaissance traditions is seen as an influence of the 1933 exhibition of Ferrarese Renaissance art. Weber also sees in the vigorous painting and composition the influence of de Chirico and Derain. Funi's reaction against Impressionism is placed in the context of reactions to that exhibition and of other cultural initiatives of the time aiming to spread the image of a glorious contemporary period, in direct succcession to the Renaissance, with a consequent mythification of the past.

C. Mentions

Books

2144. APOLLINAIRE, GUILLAUME. *Chroniques d'arts*. L.-C. Breunig, ed. Paris, 1960.

Reprints articles written by Apollinaire about Derain.

2145. ASSOULINE, PIERRE. *L'Homme de l'art: D. H. Kahnweiler (1884-1979)* [The Man of Art: D. H. Kahnweiler (1884-1979)]. Paris: Balland, 1988. 54 p., 31 illus., 16 pl.

Biography of Daniel-Henry Kahnweiler, known as one of the greatest art dealers of his time and renowned in particular for his patronage of the Cubists. Traces Kahnweiler's early life in Germany, his first encounters with the arts, his training as a banker, his move to Paris in the early 1900s, and the opening of the Galerie Kahnweiler in Paris in 1907. Describes how Kahnweiler became known as an ardent supporter of Cubism and discusses his long association with Vlaminck, Derain, Picasso, Braque, Gris, Léger, Masson, and Klee, among others.

2146. ATTENBOROUGH, DAVID. *The Tribal Eye*. London: British Broadcasting Corporation Publications 1976. 144 p., 235 illus., 24 pl.

During this century the work of tribal artists has become accepted as art, but while a mask or figure has an immediate impact, the meaning it had and the intentions of its maker frequently remain obscure. Based on the BBC Television series, Attenborough sets out to amend this reaction through an elucidation of tribal art in the context of the societies and landscapes which produced it. In his introduction he discusses the impact of the expressive power of tribal art on such artists as Derain and Vlaminck, and the subsequent passion for "barbaric objects" which spread among French artists. He also considers the theories about the stylized form of tribal art and refers to its popularity among collectors.

2147. BELL, CLIVE. *Since Cézanne*. London: Chatto and Windus, 1922. 229 p., 7 pl.

Includes Bell's essay, "The Authority of M. Derain" (chapter 19), among others. Reprinted from various periodicals.

2148. BELL, CLIVE. *Civilization and Old Friends*. London, 1956.

a. U.S. ed.: Chicago: University of Chicago Press, 1973. 189, 199 p., illus.

2149. BRETON, ANDRE. *Les Pas perdus*. Paris: Gallimard, 1919. 180 p.

Includes comments on Derain from an essay, "Idées d'un peintre."
a. Other eds.: 1924, 1949, 1969, 1979.

2150. COLLINS, J., et al. *Techniques of Modern Masters*. London: Macdonald, 1983. 192 p., 309 illus.

Survey of the techniques of painting developed during the 20th century, divided into four chronological sections, each with an introduction covering general trends: 1900-20, 1921-40, 1941-60, 1961-onwards. Sections consist of detailed analyses of one painting by Derain, Braque, and Matisse, among others. Technological innovations in materials as well as stylistic developments are identified so that they can be related to artistic practice. A glossary of terms is appended.

2151. COQUIOT, GUSTAVE. *En Suivant la Seine*. Paris: A. Delpeuch, 1926. 138 p., pl.

2152. DUCHARTRES, P.-L. *Commedia dell'Arte*. Paris, 1924.

2153. EINSTEIN, CARL. *Die Kunst des 20. Jahrhunderts*. Berlin: Propyläen-Verlag, 1926.

Derain is discussed on pp. 33-46, 207-26, and 557-8.

2154. *L'Esprit nouveau: revue internationale illustrée de l'activité contemporaine, arts, lettres, sciences*. Numbers 1-28, 1920-25.

Includes information on Braque, Derain, and Fauvism.
a. Reprint: New York: Da Capo Press, 1968-69. 8 vols., illus., some col.

2155. *French Contemporary Masters*. New York: French European P ›lications, 1932. 2 vols., illus.

Volume 1: Cézanne, Derain, Renoir; volume 2: Van Gogh, Degas, Monet.

2156. GEE, MALCOLM. *Dealers, Critics, and Collectors of Modern Painting: Aspects of the Parisian Art Market 1910-1930*. Thesis, History of Art, University of London, 1977; New York: Garland Publishing, 1981. 2 vols., 300, 266 p.

Analyzes the "support system" for modern painting. Includes chapters on salons, the Hôtel Drouot, dealers, the press, and collectors, followed by a chronological survey of modern art on the market, in four sections: the avant-garde 1910-25 and 1925-30, l'Ecole de Paris, and l'Ecole Française 1918-30. Sections on D.-H. Kahnweiler, P. Guillaume, Bernheim-Jeune, W. Uhde, A. Basler; L. Vauxcelles, A. Salmon, W. George, M. Raynal, A. Lefèvre, D. Tzanck, P. Poiret, and J. Doucet. A second volume contains appendices, including an annotated catalogue of modern paintings sold at auction, 1918-30; an analysis of buyers at auction; a detailed study of Uhde and Kahnweiler auctions 1921-23; and a list of modern art exhibitons in Paris, 1910-30. Principal artists considered include Braque, Derain, Dufy, and Matisse, among others.

2157. GEIST, SIDNEY. *Brancusi/The Kiss*. New York: Harper & Row, 1978. 111 p., 66 illus. Volume in "Icon Editions" series.

Explores the theme of the kiss historically, with special attention to its manifestation at the end of the 19th century. Examines the direct influence on Brancusi's first *Kiss* (1907-08, Muzeul de arta, Craiova) of works by Gauguin, Derain, and Matisse, and the indirect—as it were, negative—influence of Rodin's *The Kiss*, and the probable

intellectual influence of Charles Morice. All of Brancusi's later versions and adaptations of *The Kiss* are studied, as well as a number of drawings.

2158. GIMPEL, RENE. *Journal d'un collectionneur.* Paris, 1963.

a. English eds.: *Diary of an Art Dealer.* Trans. by John Rosenberg. Introduction by Sir Herbert Read. Hamilton,1966; 1986. 465 p., illus., 8 pl.

2159. GORDON, JAN. *Modern French Painters.* With Forty Illustrations. New York: Dodd, Mead, 1923. 188 p., illus., 39 pl., 18 col.

Chapter 13 (pp. 121-31) concerns Derain and Maurice de Vlaminck.

2160. HERMAN, JOSEF. *Related Twilights: Notes from an Artist's Diary.* London: Robson Books, 1975, 224 p., 36 illus.

Josef Herman's autobiography is presented in three main sections, illustrated throughout by his own drawings and other works. Herman's reminiscences and anecdotes show how places and people influencd his development and enriched his art. Part 1 describes his childhood and adolescence in Warsaw's Jewish quarter, and later years spent working in Scotland, London, and Wales. Part 2 describes places which fed his artistic imagination—Burgundy, Andalusia, Amsterdam, New York, Israel, and Mexico. In Part 3, Herman discusses artists whose qualities were most meaningful to his own artistic self-revelation, among them Derain.

2161. HOOG, MICHEL. *Musée de l'Orangerie: catalogue de la collection Jean Walter et Paul Guillaume* [Musée de l'Orangerie: Catalogue of the Collection of Jean Walter and Paul Guillaume]. Paris: Réunion des Musées Nationaux, 1984. 324 p., 203 illus., 145 col.

The collections of the Musée de l'Orangerie in Paris are drawn largely from the collection of late 19th and early 20th century paintings assembled by the art dealer Paul Guillaume, by his wife, and by her second husband, the industrialist Jean Walter. This catalogue raisonné presents all the works in the collection, which includes paintings by Cézanne, Renoir, Rousseau, Matisse, Derain, Picasso, Modigliani, and Soutine. In the introduction Hoog sketches the history of the collection and assesses Guillaume's role in the artistic life of his time.

2162. JACOB, MAX. *Le Cornet à dés.* Préface de Michel Leiris. Paris: Impr. Levé, 1916. 191 p. Volume in "Collection Poésie" series.

Includes poems that mention Derain.
a. Other eds.: 1945, 1967.

2163. KELDER, DIANE. *The Great Book of Post-Impressionism.* New York: Abbeville, 1986. 383 p., 413 illus., 236 col.

Section on Fauvism has particular reference to Matisse, Derain, Dufy, and Vlaminck.

2164. *Kunsthalle Bremen: Masterpieces in the Collection*. Edited by Bernhard Decker. Bremen: Kunsthalle Bremen, 1989. 129 p. 57 illus., 27 col. Also in German and French.

Annotated selection of paintings and sculptures from the collection of the Kunsthalle in Bremen, dating from the 16th to the 20th century. Modern artists represented include André Derain, among others.

2165. LESAGE, JEAN-CLAUDE. *Peintres des côtes du Pas-de-Calais de Turner à Dubuffet* [Painters of the Coasts of the Pas-de-Calais from Turner to Dubuffet]. Preface de Bruno Foucart. Etaples-sur Mer, France: Amis du Musée de la Marine, 1987. 151 p., 79 illus., 35 col.

Discusses the popularity of the landscape of the French region of the Pas-de-Calais for painters of the 19th and 20th century. In his preface, Foucart analyzes in general terms the artistic potential of this area. Lesage then looks at the wave of English painters who "discovered" the region, the transition from romanticism to realism, Impressionism, artists' foyers at the turn of the century, and 20th century painters. He mentions works by André Derain and Albert Marquet among others.

2166. LEVY, PIERRE GEORGES. *Des artistes et un collectionneur.* Paris: Flammarion, 1976. 381 p.

Reprints statements by Derain on pp. 142-7.

2167. LEWIS, WYNDHAM. *Wyndham Lewis on Art: Collected Writings 1913-1956.* Edited and introduced by Walter Michel and C. J. Fox. London: Thames and Hudson, 1971. 480 p.

Includes writings on Derain, Matisse, and Rouault.

2168. LEYMARIE, JEAN. *L'Aquarelle*. Geneva: Skira, 1984. 139 p., col. illus. Volume in "Les Métiers de l'artiste" series.

Traces the development of watercolor painting in the west since Dürer in the 15th century. Includes a section on Derain's watercolors.
a. English ed.: *Watercolors: From Dürer to Balthus.* Trans. by James Emmons. London: Weidenfeld & Nicolson, 1985. 139 p., 141 illus., 123 col.

2169. LOVE, RICHARD H. *John Barber: The Artist, the Man.* Chicago: Haase-Mumm Publishing; dist. by the Amart Book and Cataloging Distributing Co., 1981. 189 p., 125 illus.

Biographical and critical study of the Romanian-born American artist John Barber (1893-1965), who became a social realist under the influence of John Sloan and the Ash Can School. Love discusses Barber's art within his socio-political environment, paying particular attention to the formative years Barber spent in Paris in the late 1920s with Jules Pascin, André Derain, and André Lhote. He also examines Barber's artistic evolution and discusses his mature style of painting, which reflects a combination of American and European ideas in his works.

2170. MCQUILLAN, MELISSA ANN. *Painters and the Ballet, 1917-1926: An Aspect of the Relationship Between Art and Theatre.* PhD diss., New York University, 1979. 826 p., 305 illus.

Between 1917 and 1926, three theatrical enterprises—the Ballets Russes, the Ballets Suédois, and the Soirées de Paris—directed the majority of their commissions for décor and costume designs towards painters who had been active in the pre-War Parisian avant-garde. Prior to this decade most artists had shown little interest in theatrical forms other than the circus or cabaret, and after the mid-1920s few continued to have a significant involvement with theatre or theatre design. This dissertation investigates the broad art historical questions of the episode's location in, and significance to, the history of early 20th century art and focuses on a detailed reconstruction of twenty-six works by thirteen artists, including Picasso, Derain, Matisse, Léger, Gris, Braque, Miró, and Ernst. McQuillan proposes that, rather than being an aberration or an interruption of more serious pursuits, the collaboration between these painters and the three companies occupied a central position in the artistic concerns of the period.

2171. MENDES, VALERIE D. and FRANCES M. HINCHCLIFFE. *Zika and Lida Ascher: Fabric-Art-Fashion.* Catalogue by Valerie D. Mendes and Frances M. Hinchcliffe. London: Victoria and Albert Museum, 1987. 264 p., 237 illus., 118 col.

Published in association with an exhibition of the same title, this book explores the contribution of Zika and Lida Ascher to the art of textile design. Born in Czechoslovakia, the Aschers emigrated to London in 1939 where they established a small textiles business. In the late 1940s Zika Ascher began to commission contemporary artists to design screen-printed headscarves, a project he called Art for Fabric. Alexander Calder, André Derain, Henry Moore, Barbara Hepworth, Ben Nicholson, and Graham Sutherland were among those who participated in the project. From the 1950s onwards the Aschers began to supply leading fashion designers with Lida Ascher's fabric designs, which won attention because of her unconventional use of patterns and colors. The authors trace the firm's progress to the present day. Although Lida Ascher died in 1983, Zika Ascher continues his investigations into the links between fabric, art, and fashion.

2172. NEAR, PINKNEY L. *French Paintings in the Collection of Mr. and Mrs. Paul Mellon in the Virginia Museum of Fine Arts.* Introduction by John Rewald. Richmond, Virginia: Virginia Museum of Fine Arts; dist. by University of Washington Press, Seattle and London, 1985. 146 p., 69 col. illus.

Catalogue to the paintings by 19th and 20th century French artists collected by Paul and Rachel Mellon, now in the collection of the Virginia Museum of Fine Arts, Richmond, Virginia. The Mellon Collection includes works by Braque, Cézanne, Degas, Derain, Kees van Dongen, Gauguin, van Gogh, Roger de la Fresnaye, Matisse, Picasso, among others.

2173. OBERLE, JEAN. *La Vie d'artiste (souvenirs).* Illus. de l'auteur. Paris: Denoël, 1956. 275 p., illus.

2174. PERL, JED. *Paris Without End: On French Art Since World War I.* San Francisco: North Point Press, 1988. 146 p., 50 illus.

Series of ten interlinked essays in which Perl explores the developments and major personalities of French art since the First World War, focusing on Matisse, Derain, Dufy, Léger, Picasso, Braque, Giacometti, Hélion, and Balthus. In the final essay Perl compares and contrasts Paris and New York as the cultural capitals, respectively, of the early and late 20th century.

2175. RIVIERE, JACQUES. *Etudes*. Paris: Editions de la Nouvelle Revue Française; Marcel Rivière et Cie, 1911. 264 p.

2176. SACHS, SAMUEL. *Favorite Paintings from the Minneapolis Institute of Arts*. New York: Abbeville Press, 1981. 102 p., 60 illus.

Presents a selection of works from the collection of the Minneapolis Institute of Arts, ranging in data from the 14th century to the 1950s, arranged chronoloically and each accompanied by a commentary. The selection is introduced by a discussion of the hisotry of the collection and its range in terms both of age and of geographical scope. Painters working in the 20th century whose pictures are illustrated and discussed include Derain and Matisse, among others.

2177. SALMON, ANDRE. *La Jeune peinture française*. Paris: Société des Trente, 1912. 124 p.

2178. SALMON, ANDRE. *Souvenirs sans fin*. Paris: Gallinard, 1956. 3 vols.

Contents: Volume 1: Première époque (1903-1908); volume 2: Deuxième époque (1908-1920); volume 3: Troisième époque (1920-1940).

2179. Santa Fe, Gerald Peters Gallery. *Modernist Themes in New Mexico: Works by Early Modernist Painters* [exh. cat.] Santa Fe, New Mexico: Gerald Peters Gallery, 1989. Introduction by Barbara G. Bell. 56 p., 60 illus., 48 col.

Catalogue to an exhibition of paintings (4-16 Aug. 1989) by the artists of Santa Fe and Taos, New Mexico, who responded to the spread of modernism across the U.S. in the period following the New York Armory Show of 1913 by adapting its tenets to their own particular needs. Comparing the New Mexican environment to Cézanne's Provence, Bell notes Cézanne's influence on the New Mexican modernists, as well as that of André Derain, Louis Valtat, and Wassily Kandinsky.

2180. SHONE, RICHARD NOEL. *Bloomsbury Portraits: Vanessa Bell, Duncan Grant, and Their Circle*. Oxford: Phaidon; New York: Dutton, 1976. 272 p., 170 illus., 8 col.

Narrative of the working life of Vanessa Bell (1879-1961) and Duncan Grant (b. 1885) up to ca. 1940 with particular emphasis on the years from 1910 to 1920. After an account of the early and student years of the two painters, Shone concentrates on their involvement in the modern movement in England, their relations with Roger Fry and with foreign artists such as Picasso, Derain, and Matisse. Detailed central section concerns the Omega Workshops (1913-19) and the artistic and intellectual ferment in figurative art in 1914 and 1915. The last section of the book deals mainly with the painters' work as decorators and applied designers, and their work in private houses.

2181. TASSET, JEAN-MARIE. *Kisling centenaire 1891-1953* [exh. cat.] Paris: Galerie Daniel Malingue, 1991. 165 p., 84 illus., 66 col.

Catalogue to an exhibition of paintings by Moïse Kisling dating from 1911 to 1953. Kisling studied in Paris where he was influenced initially by Chagall and where he met Picasso, Gris, Derain, Soutine, and Modigliani. Tasset states that the width of his artistic circle influenced the richness of his early works which combine luxuriant color with the formal rigor of Cubism.

2182. VANDERPYL, FRITZ R. *Peintres de mon époque.* Paris: Librarie Stock, 1931. 228 p.

2183. VARSHAVSKAYA, M. YA., et al. *Iskusstvo Frantsii XV-XXvekov* [French Art from the 15th-20th Centuries to the present]. Leningrad: Aurora, 1975. 232 p., illus. In Russian.

Collection of articles dealing with various aspects of French artistic culture from teh 15th century to the present. Subjects include three French *livres d'heures* in the Hermitage collection, the work of Georges Rouault, and the paintings of André Derain in Soviet collections.

2184. ZERVOS, CHRISTIAN. *Histoire de l'art contemporain.* Préface par Henri Laugier. Paris: Cahiers d'art, 1938. 447 p.

Derain is discussed on pp. 173-84. Also deals with Fauvism (pp. 113-38), Henri Matisse (pp. 147-72), and refers to other Fauve painters.

Articles

2185. ANSCOMBE, ISABELLE. "A Matisse to go Round your Neck." *Times* (16 Sept 1978):10. 2 illus.

Matisse, Moore, Piper, Derain, Picabia, Sutherland, and Hepworth were among those artists who lent their designs to scarf squares, which began to be marketed in 1948.

2186. BASLER, ADOLPHE. "Das formproblem der malerei seit Cézanne." *Kunst und Kunstlers* 29(Oct. 1930):32-4.

2187. BAZIN, GERMAINE. "Le Réveil des traditions sensibles." *L'Amour de l'art* 7(July 1933):175-84.

2188. BENJAMIN, ROGER. "Recovering Authors: The Modern Copy, Copy Exhibitions and Matisse." *Art History* 12:2(June 1989):176-201. 26 illus.

Although in recent years painting copies of works of art has for the first time become a principal practice of significant artists, the modern copy features little in post-modern discourse concerning the theorization of the copy. Benjamin seeks to redress this neglect by assessing the copy within the discursive and material context of French art between 1890 and 1916, discussing the practice of the academic copy by Matisse in 1896, the rise of the interpretative copy in van Gogh, Matisse, and Derain, the

holding of the exhibition *D'Après les maîtres* of 1910, and the painting of Cubist copies by Gris and Matisse in 1915-16.

2189. BURGESS, GUY. "Wild Men of Paris." *Architectural Record* (May 1910):404-15.

Mentions Derain's *London Bridge*. See the important discussion of this article by Edward F. Fry, "Cubism, 1907-1908: An Early Eyewitness Account," *Art Bulletin* 48(March 1966):70-3.
a. Reprint: *Architectural Record* 140(July 1966):237-40.

2190. "Bust by A. Joncquières." *Beaux-arts magazine* (16 Dec. 1938):3.

2191. CARSTAIRS, C. "Impressions of our French Contemporaries." *International Studio* 93(Aug. 1929):71.

2192. CHARENSOL, GEORGES. "Paul Guillaume, curieux homme et homme curieux." *Plaisir de France* (Dec. 1955):15.

2193. COLE, HENRI. "Point of Views." *Art & Antiques* 8(Summer 1991):70-3[+].

Concerns the small Riviera town of Cassis, Cape Canaille, a mecca for artists.

2194. COUSINOUL, OLIVIER. "Un achat des musées de Marseille: *L'Académie d'homme* (1900-01) d'Henri Matisse." *Revue du Louvre et des musées de France* 41:1(March 1991):119-25. 9 illus., 3 col.

Discusses an acquisition by the Musée Cantini in Marseille, which Cousinoul argues belongs to a relatively neglected period essential to the understanding of 20th century art. He describes Matisse's career between 1890 and 1900 including his meeting with André Derain and his relationship with the work of Cézanne and van Gogh as well as the circumstances leading up to the painting of the picture itself. Cousinoul concludes by detailing the fate of the picture after its creation and prior to its current purchase.

2195. DAIX, PIERRE. "La Révolution du Cubism." *Connaissance des arts* 375(May 1983):93-4.

Concerns the exhibition, *The Essential Cubism*, at the Tate Gallery, London (27 April-9 July 1983).

2196. DALEVEZE, JACQUES. "La Bande à Picasso au Bateau-Lavoir" [Picasso and his Gang at the Bateau-Lavoir]. *L'Œil* 244(Nov. 1975):72-3. 5 illus.

Article following a recent book by Jeanine Warnod, *Le Bateau-Lavoir, 1892-1914* (Paris; 1975), which describes the little-known Bohemian life of those who lived in an old wooden Parisian building consisting entirely of artists' studios and known as the Bateau-Lavoir. The social life there and the struggle for existence is described with reference to such artists as Picasso, van Dongen, Braque, Derain, Vlaminck, Gris, Max Jacob, and others.

2197. DAULTE, FRANÇOIS. "L'Ecole de Paris à la Galerie Daniel Malingue" [The Paris School at the Daniel Malingue Gallery]. *L'Œil* 310(May 1981):62-5. 7 illus.

With reference to an exhibition at the cited Paris gallery in the spring of 1981 of paintings by the Paris School, Daulte describes how the school, which originally comprised foreign artists who followed the main directions of contemporary French painting without sacrificing their deep originality, eventually came to describe generally some French painters whose work fell outside both academic and avant-garde streams, including Vlaminck, Matisse, Derain, Rouault, Dufy, and Marquet. Illustrations of works from the exhibition by Rouault, Dufy, Laurencin, Utrillo, and Vlaminck are annotated.

2198. DEROUET, CAMILLE. "Les Réalismes en France: rupture ou rature" [Realism in France: Rupture or Erasure] in *Les Réalismes 1919-1939* (Paris: Centre National d'Art et de culture Georges Pompidou, 1980), pp. 196-207. 9 illus.

Describes the call to order in the arts in France coinciding with the political insecurity of the inter-war years, and discusses the return to a study of their artistic heritage by artists including Picasso, Derain, and Balthus.

2199. DES CARS, C. "Des ivoires venus d'ailleurs, annonciateurs de l'art moderne" [Ivories from Elsewhere, Precursors of Modern Art]. *L'Œil* 291(Oct. 1979):34-41. 12 illus.

Surveys the ways in which primitive or ethnic art works influenced the direction taken by 20th century art, commenting that iconographical elements found by the Cubists in African art provided them with a repertoire of style which is highly variable. Artists whose work is discussed with reference to such originals are Picasso, Brancusi, Archipenko, Derain, Pompon, and Giacometti.

2200. DUTHUIT, GEORGES. "Le Fauvisme." *Cahiers d'art* 5:3(1930):129-35.

2201. ELDERFIELD, JOHN. "The Garden and the City: Allegorical Painting and Early Modernism." *Houston Museum of Fine Arts Bulletin* 7:1(Summer 1979):3-21. 25 illus.

Investigates the new meaning given to allegory by French modernist painters. Illustrates the argument with examples by Derain, Matisse, Signac, Seurat, Ingres, and other 19th and 20th century painters.

2202. FORGES, MARIE-THERESE LEMOYNE DE and G. ALLEMAND. "Orangerie des Tuileries: la collection Jean Walter—Paul-Guillaume." *Revue du Louvre et des musées de France* 16:1(1966):58.

2203. FRY, EDWARD F. "Cubism 1907-1908: An Early Eyewitness Account." *Art Bulletin* 48(March 1966):70-3.

2204. GARVEY, ELEANOR M. "Cubist and Fauve Illustrated Books." *Gazette des Beaux-arts* ser. 6, 63(Jan. 1964):38-41.

2205. GEORGE, WALDEMAR. "1933 Ballets and the Spirit of Contemporary Art." *Formes* 33(1933):377-9. 2 col. pl.

2206. HAUSER, R. "La Grande époque de Montparnasse" [The Great Era of Montparnasse] *Clés pour les arts* 29(Jan. 1973):11-3. 15 illus.

This exhibition at the Palais des Beaux-Arts in Charleroi occasions a brief look at the painters working in the Montparnasse district in the early 20th century. The "subjectivism" of the painters of this era and place took very many different forms, and Montparnassse was the starting-point for several great names. Artists for whom brief biographies are provided include Chagall, Moïse Kisling, Jules Pascin, Soutine, Kees van Dongen, and André Derain.

2207. "Henri Rousseau and Modernism" in *Henri Rousseau* (Paris: Grand Palais, 1984), pp. 35-89. 104 illus.

Considers Rousseau in the context of his contemporaries, comparing him to Gauguin and Seurat. The authors find his paintings very different in feeling from Gauguin's though having much in common with his manner, and noting a similar candor in the process of painting of both Rousseau and Seurat. They consider Rousseau in relation to the Post-Impressionists and Fauvists, stating that he used the styles of both schools, and describe the influence of Rousseau on Picasso from 1908, comparing it with that of Cézanne. In their opinion, it was through Picasso that Rousseau's influence penetrated to later artists such as Derain, Dufy, Diego Rivera, and Weber; for Braque and Léger, however, the influence of Rousseau was direct. The extent of Rousseau's influence on Delaunay, Kandinsky, Marc, Beckmann, de Chirico, Ernst, Miró, Tanguy, Magritte, Dalí and the Romanian Victor Brauner is also assessed, and the authors state that his influence on the Surrealists was largely through the medium of de Chirico. They conclude that his influence on subsequent art was as profound and fully comparable with that of other Post-Impressionists.

2208. HONEYMAN, THOMAS J. "Les Fauves—Some Personal Reminiscences." *Scottish Art Review* 12:1(1969):17.

2209. HÜNEKE, ANNE. "Plastiken von Malern" [The Sculptures of Painters]. *Bildende Kunst* 6(1979):289-94. 12 illus.

Points out that many important developments in modern sculpture came about due too the efforts of artists who were known primarily for their work as painters. In this connection, Hüneke looks at sculptures by Daumier, Degas, Renoir, Gauguin, Matisse, Picasso, Braque, Boccioni, Derain, Ernst, Modigliani, Schmidt-Rottluff, Nolde, Schwitters, and Schlemmer. She concludes with a closer look at the work of two German "realist" painter-sculptors: Käthe Kollwitz and Otto Pankol.

2210. JÜRGEN-FISCHER, KLAUS. "Der gebrochene Stil" [The Broken Style]. *Kunstwerk* 40:1(Feb. 1987):5-39. 36 illus., 8 col.

Declares that the style of the 20th century is not "broken" like a broken promise, but is nevertheless characterized by more transformations and changes of direction than any before. This reflects the broken nature of modern existence. Jürgen-Fischer surveys the changes in style throughout the lives of artists such as Munch, Picasso,

and Chagall, and suggests that the "healing" process of old age removes the tensions that helped to created the great works of their earlier years. A number of other artists, including Derain, de Chirico, Malevich, Jean Hélion, Kurt Schwitters, and Mark Tobey, are included in the survey to demonstrate how there is no longer a simple linear progression in art from one stlye to another. The conclusion is that individual works should be considered in a wider context which can no longer be adequately defined as "style." Derain's *Portrait de Matisse* and *Les Deux sœurs* are discussed on pp. 6+.

2211. LADERMAN, GABRIEL. "Expressionism; Concentric and Eccentric." *Artforum* 7(Feb. 1969):53.

2212. LADERMAN, GABRIEL. "On the Uses of the Past and of the Too-Recent Past." *Artforum* 8(Feb. 1970):57.

2213. LEHUARAD, RAOUL. "Charles Ratton et l'aventure de l'art nègre." *Arts d'Afrique noire* 60(Winter 1986)11-33; discussion, 62(Summer 1987):50-2.

Mentions Maurice de Vlaminck on p. 17; André Derain on p. 18.

2214. MASARYKOVÁ, ANNA. "*III výstava Skupiny výtvarných umělců*" [The Third Exhibition of the Group of Avant-Garde Artists] in the Communal House, Prague, May-June 1913]. *Umění* 30:4(1982):379-81. 1 illus. In Czech.

Appreciation of the historical importance of the exhibition of Czech and foreign artists (Picasso, Braque, Derain) as well as of popular art. Analyzes the poster designed by Josef Kysela and the theoretical positions of the participants revealed in the introduction to the catalogue by the painter Vincenc Beneš.

2215. MASSON, ANDRE and DEBORAH ROSENTHAL (Interviewer). *Arts Magazine* 55:3(Nov. 1980):88-94. 6 illus.

Rosenthal interviewed the 84-year-old artist in his Paris home in 1980. Among the many facets of his life and work explored and recorded during this interview was his relation to the School of Paris. The transcript also includes Masson's comments on a number of artists and movements from the 19th and 20th centuries—among them Kandinsky, Derain, Picasso, the Cubists, and the Surrealists. The importance of Far Eastern art and Zen on Masson's work in the late 1920s is also noted.

2216. MORET-MARTINGAY, VERONIQUE. "Hans Hartung, peintre cubiste?" *Histoire de l'art* 7(Oct. 1989):53-66. 12 illus.

Rejecting the descriptions "abstract lyricism" and "lyric expressionism" for the work of Hans Hartung, Moret-Martingay attempts to approach Hartung's work from a Cubist angle, however unlikely the influence on him of Lhote and Léger, his trip to the South of France, the interest that he had in fine art, his studies of Cézanne and Derain, and the culmination of all this groundwork at an exhibition at the Galerie Heinrich Kuhl, Dresden, during the winter of 1931. Concludes that the Cubists must take their place among Hartung's many influences.

2217. MULLINS, EDWIN. "Sculpture and Mechanics." *Apollo* 76(Nov. 1962):712.

2218. NAUMANN, FRANCIS M. and MARIUS DE ZAYAS. "How, When and Why Modern Art Came to New York." *Arts Magazine* 54:8(April 1980):96-126. 129 illus.

With the help of his better-known friend and associate Alfred Stieglitz, the Mexican author, caricaturist and gallery owner Marius de Zayas (1880-1961) was instrumental in the presentation, promotion, and acceptance of modern art in New York during the second decade of this century. This account, composed by de Zayas sometime in the late 1940s, makes extensive use of the many newspaper reviews which accompanied or followed exhibitions held at either his gallery or Stieglitz's "291." Of special note are de Zayas's discussions of Rodin, Matisse, the critics, Cézanne, Rousseau, Manolo, Picasso, Cubism, Braque, the Armory Show, Brancusi, Picabia, African Negro Art, the magazine *291* (which he founded and edited), Stieglitz, Marin, and exhibitions held at the Modern and de Zayas Galleries of van Gogh, modern sculpture, André Derain, Maurice de Vlaminck, and various group exhibitions. The article is accompanied by an introduction, conclusion and notes by Francis Naumann, with an appendix by Eva Epp Raun listing the exhibitions held at the Modern and de Zayas Galleries.

2219. "Œuvres dans le Musée d'Art moderne occidental à Moscou." *Cahiers d'art* 25(1950)2:339-40.

2220. "Propos sur l'art." *Prisme des arts* (Nov. 1956):2-6.

2221. RINUY, PAUL-LOUIS. "1907: Naissance de la sculpture modern? Le Renouveau de la taille directe en France" [1907: Birth of Modern Sculpture? The Renewal of Direct Sculpture in France]. *Histoire de l'art* 3(1988):67-76. 5 illus.

Discussion of works by Joseph Bernard, Brancusi, Derain, Matisse, and Picasso which were sculpted directly into wood or stone. Priority is given to the material as opposed to the subject, the basis of abstract sculpture where invention and realization are united. Rinuy discusses the argument that these artists were influenced by Gauguin and by primitive art, concluding that it is historically fragile and needs to be supplemented by an awareness of each artist's individual situation and of the development of sculpture between 1880 and 1907. He proposes that direct sculpture developed as an acceptable technique because of criticism of the non-participation of the creator in the realization of his work and of modelling and the respect of material. Rinuy concludes that the works created in 1907 are fundamental in the development of contemporary sculpture.

2222. RODITI, EDOUARD. "Paris: A Market Report." *Arts Magazine* 36(Sept. 1962):32.

2223. ROSSI, ALDO. "Arte sulle punte" [Art on Tiptoes]. *Arte* 14:138(Feb. 1984):57-63. 11 illus.

Traces the history of dance as portrayed in art from the first terra cotta vases of ancient Greece to the present day, with reference to Degas, Matisse, Picasso, and others. The 17th century is shown to be the high spot for the marriage of art and dance, while in the early years of this century, Picasso, Utrillo, Bakst, and Derain were some of the contributors to successful productions of the Ballets Russes.

2224. SCHLUMBERGER, EVELINE. "Un bond en avant: les Ballets Russes." *Connaissance des arts* 208(June 1969):98.

2225. STEFANI, ALESSANDRO DE. "Matisse e il cubismo: per una nuova datazione del *Grand nu* di Braque." *Paragone* 39(March 1988):35-61.

2226. STEWART, IAN. "Diaghilev's Magic Lantern: The Work of Some Designers for the Ballets Russes." *Country Life* 152(16 March 1972):627.

2227. STRAUSS, MONICA J. "Late Nineteenth and Early Twentieth-Century Pictures Lent to the Tate Gallery by Mr. John Hay Whitney." *Burlington Magazine* 103(Jan. 1961):31.

2228. SUTTON, DENYS. "The World of Sachaverell Sitwell, 7: 'Tonight the Ballet'." *Apollo* 112:224(Oct. 1980):238-47. 25 illus.

Sitwell had a deep appreciation of theatre, the ballet, and the relationship of the two to the visual arts. Like many others of his generation, he was deeply impressed by the Russian ballet, knew and worked with Sergei Diaghilev, and came across a number of the artists who worked with the impresario, meeting them or at least becoming familiar with their set and costume designs, among them being Picasso, Matisse, Braque, and Derain.

2229. TAYLOR, J. R. "First Impressions" [Influence of London on Some of the Key Figures of Early Modern Art]. *Art & Artists* 188(May 1982):25-6.

2230. THIERRY, SOLANGE. "La Donation Pierre Lévy." *L'Œil* 272(March 1978):30-2.

2231. TUCKER, WILLIAM. "Matisse's Sculpture: The Grasped and the Seen." *Art in America* 63:4(July-Aug. 1975):62-66. 10 illus.

Formal analysis of some of Matisse's sculpture. Compares Matisse's work with figure compositions by Cézanne and groups by Rodin, Derain, and Brancusi.

2232. WALTZOLDT, STEPHAN. "Les Peintres des années vingt: du réalisme au surréalisme" [The Painters of the 1920s: From Realism to Surrealism]. *L'Œil* 266(Sept. 1977):28-33. 9 illus.

Short article occasioned by the 15th Council of Europe Art Exhibition, *Tendencies of the 1920s,* held in Berlin (14 Aug.-16 Oct. 1977). Waltzoldt briefly outlines the interrelationships between those movements inherent in the theme of the exhibition, with reference to specific works by Dalí, Miró, Picasso, Grosz, de Chirico, Magritte, Derain, and Léger.

2233. WATSON, SUSAN. "Réalité poétique: The Fell Collection." *Vanguard* 8:4(May 1979):8-11. 4 illus.

Paintings in the collection of the late Ella May Fell, shown at the Vancouver Art Gallery, Vancouver, perhaps indicate more about their collector than the artists. The main body of works is from France and England and concentrate on landscapes and

interiors. Fell had an eye for the "*intime*" and the predominant mood of these paintings is that when an ordinary object or place is suddenly "transformed." Among the English works are a set of visionary landscaped by Paul Nash. Among the French, Vlaminck and Derain are represented by subdued and individual works rather than by ones that contributed to the mainstream of innovation. The emphasis is upon what is continuous in the tradition of painting, and the collection states that the intimate moments of private reverie are capable of surviving the maelstrom of the present.

2234. WESTHEIM, PAUL. "Über das Kunstlerische Situation in Frankreich." *Das Kunstblatt* (Sept. 1922).

2235. "The 'Wild Beasts': Fauvism and its Affinities." *Mizue* (Japan) 855(June 1976):5-20. 17 illus. No text.

Portfolio of illustrations of paintings by Matisse, Derain, Braque, Vlaminck, Dufy, and van Dongen drawn from the exhibition with the above title held at the Museum of Modern Art, New York, 26 March-1 June 1976.

2236. WOIMANT, FRANÇOISE, MARIE-CECILE MIESSNER, and ANNE MOEGLIN-DELCROIX. "Les Enrichissements 1990 de la Bibliothèque nationale: estampes modernes." *Nouvelles de l'estampe* 116(May-June 1991):13. 47 illus.

Details acquisitions made in 1990 by the Bibliothèque nationale in Paris. These include fifty-one pieces by twenty-five artists dating from the latter half of the 19th century onwards; donations and deposits; foreign prints which include a large proportion of American prints; artist's albums; and artists' books. This last section is divided into travel, conceptual works, books originating in specific movements such as the Fluxus group and books about books. Artists whose work is considered include Louis Valtat and André Derain, among others.

2237. YOUNG, M. S. "Cubist Epoch." *Apollo* 93(Jan. 1971):22.

III. Works (Œuvre)

A. Catalogues Raisonnés

2238. CAILLER, PIERRE. *Catalogue raisonné de l'œuvre sculpté de André Derain; première partie: l'œuvre édité.* Préfaces de Georges Hilaire et Marie-Noëlle Pradel. Aigle: Imprimerie de la Plaine du Rhône, 1965.

2239. *Catalogue raisonné of André Derain.* Paris: Galerie Schmit, 1991.

2240. KELLERMANN, MICHEL. *Catalogue raisonné de l'œuvre de Derain* (in preparation).

B. Works

Books

2241. BASLER, ADOLPHE. *André Derain, 24 phototypies.* Notice d'Adolphe Basler. Paris: Librarie de France, 1929. 7 p., illus., 24 pl. Volume in "Les Albums d'art Druet" series.

2242. BASLER, ADOLPHE. *Derain.* Paris: G. Crès, 1931. 13 p., illus., 32 pl. Volume in "Collection les artistes nouveaux" series.

2243. BERTRAND, GERARD. *Illustration de la poésie à l'époque du Cubisme, 1900-1914: Derain, Dufy, Picasso.* Paris: Editions Klinsieck, 1971. 238 p., illus. Volume in "Collection le signe de l'art" series.

2244. BRODSKAYA, NATALIA. *André Derain.* Compiled and introduced by Natalia Brodskaya. Trans. from the Russian by Monica Wilkinson. Designed by Viacheslav Bakhtin. New York: Abrams, 1981. 29 p., col. illus., 16 pl. Volume in "Masters of World Painting" series.

2245. CARRÀ, CARLO. *André Derain; avec 32 reproductions en phototypie.* Rome: Editions de 'Valori Plastici', 1921. 22 p., 32 illus. Volume in "Collection les artistes nouveaux."

a. English ed.: 1924.

2246. CARRÀ, MASSIMO. *André Derain.* Testo di Massimo Carrà. Milan: Fratelli Fabbri, 1966. 7 p., illus., 15 col. pl. Volume in "I Maestrei del colore" series.

2247. GILBERT, E. *L'Œuvre gravé d'André Derain.* Thesis, Université de Paris IV, 1985.

2248. HILAIRE, GEORGES. *Derain.* Geneva: Pierre Cailler, 1959. 200 p., 210 pl., mostly col. Volume in "Les Grandes monographies" series.

Excellent source of illustrations.

2249. KAHNWEILER, DANIEL-HENRY. *André Derain.* Von Daniel Henry [pseud.]. Leipzig: Klinkhardt und Biermann, 1920. 16 p., illus., 33 pl. Volume in "Junge Kunst" series.

2250. LEE, JANE H. *The Work of Derain Between 1907 and 1914.* M.A. thesis, Courtauld Institute of Art, University of London, 1979.

2251. LEE, JANE H. *Derain.* Oxford: Phaidon; New York: Universe Books, 1990. 144 p., illus., some col.

Published for the exhibition *André Derain*, held at the Museum of Modern Art, Oxford (16 Dec. 1990-18 March 1991); the Scottish National Gallery of Modern Art, Edinburgh (27 March-27 May 1991); and the Musee d'Art moderne de la Ville de Troyes (22 June-16 Sept. 1991).

2252. LEYMARIE, JEAN. *André Derain, ou le retour à l'ontologie.* Geneva: A. Skira, 1948. 10 p., col. iluus., 10 pl. Volume in "Les Trésors de la peinture française" series.

a. Other eds.: Paris, 1949, 1950, 1956.

2253. PARKE-TAYLOR, MICHAEL. *André Derain's 'Fauve' Era Sketchbook c. 1903-1906.* M.A. thesis, Courtauld Institute of Art, University of London, 1979.

2254. SALMON, ANDRE. *André Derain; 26 reproductions de peintures précédées d'une étude critique par André Salmon, de notices biographiques et documentaires et d'un portrait inédit de l'artiste dessiné et gravé sur bois par Georges Aubert.* Paris: Nouvelle Revue Française, 1924. 63 p., illus., pl. 25 copies. Volume in "Les Peintres français nouveaux" series.

2255. SALMON, ANDRE. *André Derain.* Paris: Editions des Chroniques du Jour, 1929. 53 p., illus., 30 pl. 400 copies. Volume in "Collection XXᵉ siècle" series.

2256. SAWYER, DAVID. *Prints by André Derain.* 1988. 88 p., illus.

2257. SEGONZAC, ANDRE DUNOYER DE. *André Derain, 1880-1954.* Paris: Editions d'Art du Lion; New York: Arts, Inc., 1961. 12 pl.

2258. SVRCEK, J. B. *André Derain.* Prague: Melantrich A. S., 1938. 4 p., 25 pl., 1 col. Volume in "Prameny, sbírka dobrého umění" series.

Articles

2259. "André Derain in New York Survey." *Arts Magazine* 39(Nov. 1964):42-3.

2260. BALL, SUSAN L. "The Early Figural Paintings of André Derain, 1905-1910. A Re-Evaluation." *Zeitschrift für Kunstgeschichte* 43:1(1980):79-96. 11 illus.

Derain's major figural painting of 1905-10 have often been misdated and given erroneous histories. Stating that an ordered and logical chronology of the painter's early figural works soon becomes clear when they are subjected to thorough scrutiny, Ball investigates several pictures (*Composition* of 1905, *La Dance baigneuse* I, II, and III, and *Toilette*) and the details of Derain's life up to and during this period. She also examines the lives and careers of his friends and colleagues and the artistic milieu to which they were all exposed.

2261. BASSANI, EZIO. "La Maschera bianca di Vlaminck e di Derain [The White Mask of Vlaminck and Derain]." *Critica d'arte* 20:133 (Jan.-Feb. 1974):18-24. 4 illus.

Examines the importance of an original wooden African mask and its bronze copy (exhibited in Paris in 1966-67) in influencing the artists of l'Ecole de Paris in 1905. Bassani describes the wooden mask, which belonged to Vlaminck and then Derain, and indicates briefly its influence on Cubism. He narrates a strange coincidence of two almost identical masks described as having belonged to Derain, the one already described and the other in the Toledo Museum of Art in Ohio. Bassani's conclusion

is that it is possible that the same African artist could have made both masks, and that an error of cataloguing could be explained by the fact that the objects were not reproduced until 1958. Similar masks are then listed to illustrate this point.

2262. CHAMPIGNEULLE, BERNARD. "Derain, avait-il perdu son génie?" *France illustration* 423(June 1955):67.

2263. CHARMET, RAYMOND. "Utrillo-Derain-Chabaud: trois expressionnistes français" [Utrillo-Derain-Chabaud: Three French Expressionists]. *Jardin des arts* 217(March-April 1973):58-61. 5 illus.

2264. CHRISTIN, ANNE-MARIE. "Portrait de Salomé dansant" [Portrait of the Dancing Salome]. *Revue d'esthétique* 1-2(1978):90-106.

Studies the presentation in texts and visual images of this masculine fantasy, which reached its height at the end of the last century. The duality of the Wildeian incarnation of Salome as both flirtatious and an embodiment of destruction gave rise to multiple pictorial variations from Beardsley's stylized images of complicity in evil to Derain's ghostly and feminine representations.

2265. DAGEN, PHILIPPE. "L''Exemple égyptien': Matisse, Derain et Picasso entre fauvisme et cubisme, 1905-1908." *Bulletin de la Société de l'histoire de l'art français* (1984):289-302. 21 illus.

Suggests that, while African tribal art may have led Matisse, Derain, and Picasso to Cubism, they were introduced to that art by a detailed knowledge of Egyptian art. Placing this assertion in the context of the "Egyptomania" of the turn of the century, Dagen notes that these artists constantly frequented the collections of antiquities in the Louvre and argues for the influence of those collections on the development of their art, particularly in the period 1906-07.

2266. DAIX, PIERRE. "Picasso's Time of Decisive Encounters." *Art News* 86:4(April 1987):136-41. 6 illus., 3 col.

In the early years of the 20th century Picasso was influenced by Matisse and Derain, not because of their Fauvism, but because of the violent quality of expression they were able to give their figures. Daix describes how Picasso tried to duplicate this quality by borrowing from primitivism and Cézanne, turning his back on classicism because he shared the view held by many of his generation that academicism spelled the death of painting.

2267. DAVIDSON, MARTHA. "Careful Vision of André Derain." *Art News* 35(14 Nov. 1936):17-8.

2268. "Derain." *Beaux-arts* (1991). Hors séries, no. 53.

2269. "Derain Lifts Himself Out of Tradition." *Art Digest* 5(1 March 1931):10.

2270. "Derain of Paris Consolidates His Knowledge, Bows to Titian." *Art Digest* 13(15 Nov. 1938):8.

2271. "Derain Wins Praise of Conservative Critic." *Art Digest* 7(15 March 1933):11.

2272. FLINT, RALPH. "Contrasts in Art of Vlaminck and Derain Revealed." *Art News* 30(27 Feb. 1932):5⁺.

2273. GEORGE, WALDEMAR. "Derain's Message." *Formes* 19(Nov. 1931):145-6. 6 pl.

2274. GEORGE, WALDEMAR. "Derain; or, The Return to Melody." *Formes* 31(1933):343-4.

2275. GEORGE, WALDEMAR. "André Derain." *L'Amour de l'art* 14:7(July 1933):157-63.

Also published in René Huyghe, *La Peinture française: les contemporains*. (Paris: Bibliothèque Français des Arts; Editions Pierre Tisné, 1939), pp. 157-63.

2276. GEORGE, WALDEMAR. "André Derain ou l'apprenti sorcier." *Renaissance* 22(March 1939):37-41, 48. English summary.

2277. HAYOT, MONELLE. "André Derain: une côté qui devrait monter." *L'Œil* (March 1973):38-41.

2278. HEILMAIER, HANS. "Bilder aus der Provence von André Derain." *Kunst* 65(July 1932):307-11.

2279. HERON, PHILIP. "Derain Reconsidered." *Arts Magazine* 32(Jan. 1958):26-9.

2280. JALOUX, EDMOND. "Derain and French Landscape." *Formes* 12(Feb. 1931):20-1. 4 pl.

2281. KRAMER, HILTON A. "Thinking About Derain." *Arts Magazine* 37(Sept. 1963):42-7; reply by R. J. Wolf 38(Nov. 1963):6.

2282. LEVY, DENISE. "Propos d'André Derain." *Prisme des arts* (Nov. 1956):2-6.

2283. MAUNOURY, R. "Derain." *Le Nouveau fémina* 8.

2284. NEMECZEK, ALFRED. "Genie und doch ein Verräter?" [A Genius and Yet a Traitor?]. *ART: das Kunstmagazin* 5(May 1991):28-47. 36 illus., 34 col.

Reviews the life and works of eclectic French painter André Derain (1880-1954), whose stylistic diversity has met with a lot of criticism over the years, referring to several exhibitions, including *Derain's Late Works* at the Scottish National Gallery of Modern Art, Edinburgh (March-May 1991), which documented the fact that behind the artist's seemingly erractic style, the underlying principle is utter and total subjectivity in perception. Nemeczek suggests that this has proved to be an obstacle in his becoming a stylistic influence for other artists.

2285. NEUGASS, FRITZ. "André Derain." *Kunst* 59(March 1929):177-84.

2286. PARKE-TAYLOR, MICHAEL. "André Derain: les copies de l'album fauve." *Cahiers du Musée National d'Art moderne* 5(1980):363-77. 35 illus.

Studies copies after works in the Louvre, contained in a sketchbook from Derain's Fauve period (1903-06), now in the Musée National d'Art moderne, Centre Beaubourg, Paris. Despite the fact that André Derain was the most ardent visitor to the Louvre of all the Fauve painters, there are few painting or studies which attest to this fact and fewer records of his visits there. In view of this one of Derain's albums/sketchbooks, which dates from the Fauve years (1903-06) and contains twenty-three pages of sketches of paintings and sculptures in the Louvre, is important. By identifying the paintings and sculptures which Derain sketched, it is possible to see how he interpreted the art of the past and how deeply he was fascinated by it. Among these works are paintings by Biagio d'Antonio, Rubens, and Delacroix, and many sculptures of heads and statuettes from ancient Egypt.

2287. PERL, JED. "André Derain." *Arts Magazine* 53:5(Jan. 1979):4. 1 illus.

Review of a recent show of twenty André Derain paintings from his late period at the David Findlay Gallery, New York. Derain's reaction to Cubism and abstract art was violent. Perl states that to lose the force of this reaction would be to miss the full greatness of his vision. Derain's later career was an attempt to reach back to the vocabulary of French naturalism that reached its perfection in Chardin, and to embrace the entire history of art.

2288. PERL, JED. "A Fauve's Domain (the Studio of André Derain)." *Art & Antiques* 6:457(March 1990):88-95.

2289. PHILLIPS, DUNCAN. "Derain and the New Dignity in Painting." *Art and Understanding* 1(Nov. 1929):78-91.

2290. REY, ROBERT. "Derain." *Art et décoration* (Feb. 1925):33-44.

2291. RUMPEL, H. "André Derain." *Werk* 42(July 1955):230-6.

2292. RUSSELL, JOHN. "Pondering the Path of Derain." *New York Times* (20 July 1980):D23.

2293. SALMON, ANDRE. "André Derain." *L'Amour de l'art* 6(1920):196-9.

2294. SALMON, ANDRE. "André Derain, peintre français." *L'Art vivant* 39(Aug. 1925):570-3.

2295. SALMON, ANDRE. "Derain." *Chroniques du jour* 1(March 1929).

2296. SAURE, WOLFGANG. "Das Musée d'Art moderne in Troyes" [The Museum of Modern Art in Troyes]. *Kunst* 4(April 1986):267-74. 8 col. illus.

Discusses the holdings of the Musée d'Art moderne, Troyes, which houses the collection of Pierre Lévy, an important private collector whose holdings of modern art are rendered all the more interesting by his refusal to blindly follow tastes dictated by intellectuals. The museum thus possesses works by significant artists who have

almost been forgotten, including Charles Despiau, Marcel Gimond, and Joseph Csaky. The strength of the collection is its holdings of works by Derain and Braque.

2297. "Sculptors' Jewelry." *Art in America* 50:2(Summer 1962):76.

2298. "Sketches Reveal the Search of Derain." *Art Digest* 8(1 April 1934):17.

2299. "The Troyes Museum of Modern Art." *Beaux-arts magazine* (1991):1-81.

Special issue devoted to the Troyes Museum and Pierre and Denise Lévy collection, which is particularly strong in works by Derain and Braque. Includes eight essays. For information on Derain, see Thalie Goetz and Manuel Jover's essay, "From Fauvism to the Post-War Period," pp. 40-65.

2300. SUTTON, DENYS. "André Derain: Art as Fate." *Encounter* (Oct. 1955):68-72.

2301. TSELOS, D. "Derain and Medievalism." *Parnassus* 10(March 1938):7-10.

2302. VIGNOHT, GUY. "Derain." *Peintre* 540(1 March 1977):3-6. 4 illus.
Reviews the exhibition of Derain's paintings at the Grand Palais, Paris (15 Feb.-11 April 1977). Vignoht discusses Derain's Fauve work, his qualities as a realist, and his nudes, and praises the exhibition for grouping his work in a different way from usual.

C. Individual Works

Articles

2303. "Acquisitions of Modern Art by Museums." *Burlington Magazine* 116(March 1974):171.

Highlights Derain's *Collioure*.

2304. AMBLER, J. "*At the Suresnes Ball*." *St. Louis Museum of Art Bulletin* 30(Aug. 1945):25-8.

2305. "*Arlequin et Pierrot*." *Apollo* 121(June 1985):365.

2306. "*At the Suresnes Ball* for St. Louis Art Museum." *Art Digest* 19(July 1945):22.

2307. "*At the Suresnes Ball* (Showing Self Portrait at Age of 23) Acquired by St. Louis." *Art News* 44(15 March 1945):8.

2308. "*Blue Horse*." *Art & Artists* 227(Aug. 1985):35.

2309. "*Buste de femme*." *L'Œil* 441(May 1992):19.

See also *Burlington Magazine* 134(June 1992); inside back cover and *Connaissance des arts* 483(May 1992):29.

2310. CAMPBELL, R. "*Paysage du Midi* by A. Derain." *Southern Australian Art Bulletin* 16(Jan. 1955):6-7.

2311. "Chicago Obtains Derain's Classic *Stag Hunt.*" *Art Digest* 14(15 Oct. 1939):8.

2312. "Cincinnati Gets a Still-Life by Derain: *Les Trois paniers.*" *Art News* 40(July 1941):25.

2313. DAGEN, PHILIPPE. "*L'Age d'or*: Derain, Matisse et le bain turc." *Bulletin du Musée Ingres* 53-4(Dec. 1984):43-54. 5 illus.

Discusses the iconography and dating of Derain's *Composition (l'Age d'or)* (Museum of Contemporary Art, Teheran) and Matisse's *La Joie de vivre* (Barnes Foundation, Merion, PA). Analyzes their relationship to Ingres's *Turkish Bath* (Louvre, Paris), and argues that, while Matisse's painting is a tribute to Ingres, Derain's is a critique of both Matisse and Ingres.

2314. "Derain's *Les Trois paniers* for Cincinnati." *Art Digest* 15(July 1941)12.

2315. "Derain's *Portrait of Marie Harriman* Shown." *Art Digest* 10(15 Feb. 1936)12.

2316. "*Diane au chien noir.*" *Connaissance des arts* 392(Oct. 1984):13 and *L'Œil* 351(Oct. 1984):7.

2317. DORIVAL, BERNARD. "Quatre bronzes nouvellement entrés au Musée National d'Art moderne." *Revue du Louvre et des musées de France.* 11:2(1961):91-3.

2318. DORIVAL, BERNARD. "Nouvelles acquisitions, Musée National d'Art moderne." *Revue du Louvre et des musées de France* 14:3(1964):145-9.

Discusses Derain's *l'Age d'or.*

2319. DORIVAL, BERNARD. "Un chef-d'œuvre fauve de Derain au Musée National d'Art moderne." *Revue du Louvre et des musées de France* 4-5(1967):283-8.

2320. DORIVAL, BERNARD. "Un album de Derain au Musée National d'Art moderne." *Revue du Louvre et des musées de France* 19:4-5(1969):257-68. 23 illus., 1 col.

2321. DORR, G. H. III. "Putnam Dana McMillan Collection." *Minneapolis Institute of Arts Bulletin* 50(Dec. 1961):10-1, 18-9.

Mentions Derain's *St. Paul's from the Thames* and *Bagpiper.*

2322. DURET-ROBERT, F. "New York—Bordeaux." *Connaissance des arts* 353(July 1981):72-7. In French. 5 illus.

A close look at five masterpieces of French art, among the 229 works selected from the thousands in the fifteen departments of New York's Metropolitan Museum of Art for a special exhibition in Bordeaux, in 1981. The works are a 16th century "mille fleurs" Flemish tapestry, an 18th century bronze and gold bourguinotte, *Le Retour du*

Bétail (1773) by Hubert Roberts, *Rochers dans le forêt* (ca. 1897) by Cézanne, and *Le Parlement, la nuit* (1905-06) by Derain.

2323. "Enriching U.S. Museums: Minneapolis, Minn." *Art News* 60(Jan. 1962):29.

Mentions Derain's *Bagpiper.*

2324. "*Femme au collier à 2 rangs.*" *Art in America* 73(June 1985):45.

2325. *"The Fountain."* *Museum Studies* 12:2(1986)):231.

2326. GAUNT, WILLIAM. "Masterpieces from the Great Age of French Landscape." *Connoisseur* 148(Dec. 1961):318.

Mentions Derain's *Westminister.*

2327. GELDZAHLER, HANS. "World War I and the First Crisis in Vanguard Art." *Art News* 61(Dec. 1962):51.

Mentions a still-life by Derain and *Set Table.*

2328. "*La Gibecière.*" *Pantheon* 42(Oct.-Dec. 1984):400.

2329. GIRY, MARCEL. "Une composition de Derain: *La Danse*" in *A travers l'art français (Hommage à René Jullian).* (Paris: La Société de l'Histoire de l'Art Français; De Nobele, 1976), pp. 443-7. Also published in *Archives de l'art français* 25(1976):443-7. 3 illus.

Examines a painting by André Derain, stemming from his Fauve period and dated around 1906. Giry finds the painting's title *La Danse* unsatisfactory, since it is clearly telling a story rather than portraying a dance. He suggests a more likely theme, combining medieval philosophy with oriental mythology, and emphasizes Derain's familiarity with Asian, and specifically Hindu, art. Giry concludes that the painting represents an attempt to expand the domain of Fauvism by introducing imaginary elements into the subject matter.

2330. GIRY, MARCEL. "Le Curieux achat fait à Derain et à Vlaminck au Salon des Indépendants de 1905 ou deux tableaux retrouvés" [The Curious Purchase of Works by Derain and Vlaminck at the Salon des Indépendants in 1905 or Two Rediscovered Paintings]. *L'Œil* 254(Sept. 1976):26-31. 6 illus.

Giry believes he has succeeded in unravelling a story told by Maurice de Vlaminck of an ironical purchase in 1905 by a mysterious buyer of the works he found ugliest at the Salon des Indépendants that year. His quest ended in the discovery of the missing paintings—unseen publically since 1905. These are Vlaminck's *Les Bords de la Seine à Nanterre* and Derain's *Bougival.* Giry considers that the discovery makes a new assessment possible of the relation of these artists to Fauvism. Derain had at this time advanced much further towards this style than had Vlaminck.

2331. "*Grapes.*" *Museum Studies* 12:2(1986):232.

2332. HOBHOUSE, JANET L. "The Fauve Years: A Case of Derailments." *Art News* 75:6(Summer 1976):47-50. 7 illus.

The Museum of Modern Art, New York's, exhibition, *The 'Wild Beasts': Fauvism and its Affinities*, presents a definition of Fauvism as, in the author's opinion, "a form of post-Impressionism (and pre-Cubism) practised chiefly by Matisse, Derain and Vlaminck between 1905 and 1907." In view of the extreme contrasts of styles, personalities and preoccupations of the artists involved, and of the divergent ways taken by them after this period, Hobhouse questions whether Fauvism can justifiable be termed a "movement." She compares the achievements of Derain and Matisse, noting particularly the contrast between the fundamental serenity and harmony of works such as Matisse's *Bonheur de vivre* and *Luxe, calme et volupté* (1904-05) and the restless searching unresolved quality of Derain's *Composition (L'Age d'or)* of 1905. In her opinion, the exceptional quality of the works in the exhibition merely adds to the confusion over terminology.

2333. HOOG, MICHEL. "*'Les Deux péniches'* de Derain, Musée National d'Art moderne." *Revue du Louvre et des musées de France* 22:3(1972):212-6.

Discusses Derain's two paintings, *The Two Barges* and *The Barge: London*.

2334. HOOG, MICHEL. "Les *Demoiselles d'Avignon* et la peinture à Paris en 1907-1908." *Gazette des Beaux-arts* ser. 6,82(Oct. 1973):211-4.

Discussion of Derain's *Interprétation des massacres de Scio* on p. 211.

2335. HORNE, JEANNETTE. "Two New Monumental Derains and his Other Recent Paintings and Drawings." *Art News* 12(Nov. 1938):12, 19.

2336. "Houston: Purchase of a Derain Still Life." *Art News* 37(3 June 1939):17.

2337. "*Kahnweiler.*" *Apollo* 121(April 1985):272.

2338. "*Landscape.*" *Museum Studies* 12:2(1986):233.

2339. LEE, JANE H. "Painting as Divination: A Still Life by André Derain." *Stanford Museum Bulletin* 14-5(1984-85):2-8. 4 illus.

Assesses a group of still-life paintings produced by André Derain in the 1930s and 1940s, a period which Lee identifies as the climax of a long philosophical and technical development in the artist's career. She describes a philosophic dualism in which the artist's true task is that of "divination"—the act of portraying both the matter and spirit of objects. She traces this "divination" through Derain's still lifes, with particular reference to the painting *Still Life with Fruit* (1938), acquired by the Stanford University Museum of Art, California, and emphasizes the importance of the use of light in Derain's work as a means of drawing.

2340. LEE, JANE H. "Derain's *The Painter and His Family.*" *Burlington Magazine* 130:1021(April 1988):287-90. 2 illus., 1 col.

Analyzes this self-portrait of 1939 by André Derain, recently acquired by the Tate Gallery, London. Lee considers the style and size of the painting, the work as a statement about painting itself, the circular structure of the painting, the contrast between this work and Derain's "manifesto" self-portrait from before the First World War, and his belief that painting was like a myth, an act of material and spiritual change. She concludes that the domestic circle is a symbol of the sanctum of the painter, necessary to his art.

2341. LOWE, J. "Two New Monumental Derains, and His Other Recent Paintings and Drawings." *Art News* 27(12 Nov. 1938):12[+].

2342. "*Madame Paul Guillaume.*" *Apollo* 121(June 1985):365 and *Burlington Magazine* 126(Sept. 1984):595.

2343. MARCHAN FIZ, SIMON. "Arquitectura y ciudad en la pintura de las vanguardias." *Goyá* 180(May-June 1984):329-41.

Derain's *Big Ben* is discussed on pp. 329-39.

2344. MCINTYRE, R. "Contrast in Lithographs: Derain's *Femme nu* and Raverat's *Reclining Girl.*" *Architectural Review* 69(April 1931):135.

2345. "Notable Works of Art Now on the Market." *Burlington Magazine* 100(June 1958):supp. 4 (*Still Life*); 100(Dec. 1958):supp. 8 (*La Danse*); 101(June 1959):supp. 1 (*Standing Nude-Drawing*); 105(Dec. 1963):supp. 5 (*Le Sentier à Ollioules*).

2346. PAUL, FREDERIC. "Derain: *Paysage I*" [Derain: *Landscape I*]. *Noise* 5(Sept. 1986):32-4. 1 illus.

Brief analytical description of Derain's drawing, *Paysage I*. Paul comments on the early morning light of the drawing, in which everything is waking up, and sees a significance in the fact that landscape is outdoors, making it necessary for the viewer to go outside mentally. He also comments on the trees and rocks that are separate and yet form an ensemble.

2347. PAUL, FREDERIC. "Derain: *Paysage II*" [Derain: *Landscape II*]. *Noise* 5(Sept. 1986):42-3.

This analysis of a landscape drawing by Derain is mainly concerned with attitudes to landscape as expressed by other artists such as Albert Marquet, to whom Paul compares Derain.

2348. "*Paysage au bord d'une rivière.*" *L'Œil* 444(Sept. 1992):71.

2349. PEILLEX, GUY. "Quelques chefs-d'œuvre des collections suisses." *Werk* 51(Sept. 1964):344.

Mentions Derain's *Bâteaux dans le port*.

2350. "*Le Peintre et sa famille.*" *L'Œil* 370(May 1986):13.

2351. *"Pierrot."* *Antiques* 135(Jan. 1989):174.

2352. *"Le Pont de Chatou."* *Apollo* 133(June 1991):front cover. See also *Connaissance des arts* 457(March 1940):166.

2353. *"Portrait of an Englishwoman*: Painting Presented to the Carnegie Institute." *Carnegie Museum* 14(June 1940):72-3.

2354. PRADEL, MARIE-NOËLLE. "Nouvelles acquisitons. Musée National d'Art moderne." *Revue du Louvre et des musées de France* 12:5(1962):241.

Mentions Derain's *Femme aux bras écartés* (terra cotta).

2355. *"Rue à Collioure."* *Burlington Magazine* 133(July 1991):xvii.

2356. SAFIN-CRAHAY, FRANÇOIS. "Neuf chefs-d'œuvre du Musée de Liège" [Nine Masterpieces in the Liège Museum]. *Beaux-arts magazine* 7(Nov. 1983):58-63. 10 illus.

Traces the growth and history of the Musée de Liège, giving details of its collections and illustrating with notes nine works, including *Head of a Young Woman* by André Derain.

2357. SIPLE, W. H. *"Les Trois paniers* by A. Derain; Gift in Memory of Elsic Holmes Warrington." *Cincinnati Museum of Art Bulletin* 12(April 1941):29-31.

2358. SUTTON, DENYS. *"Self-Portrait with a Cap* by André Derain." *Apollo* 116:245(July 1982):44-5. 3 illus., 1 col.

Discusses the painting of ca. 1906 (private collection) and the earlier *Self-portrait*, 1904 (private collection). States that Derain's self-portraits are vital for the understanding of this unusual and often paradoxical artist. Derain tried to come to grips with the man behind the mask, and from about 1899 he painted himself in various moods, in general striking a dour, worried note. *Self-Portrait with a Cap* is striking for the pointillist style with which the artist has turned his features into a still life and for the insight it provides into his questing nature.

2359. SWEET, F. A. *"Stag Hunt* by A. Derain." *Chicago Art Institute Bulletin* 33 (Sept. 1939):73-5; *Art Quarterly* 2:4 (1939):402d.

2360. TRAPP, FRANK ANDERSON. "Art Nouveau Aspects of Early Matisse." *Art Journal* 26:1(Fall 1966):3+.

Mentions Derain's *L'Age d'or* and *La Danse*.

2361. *"The Turning Road."* *Art News* 84(Sept. 1985):156.

2362. *"Window on the Park."* *Art & Antiques* 57(Jan. 1988).

2363. *"Woman with Fan."* *Burlington Magazine* 127(Jan. 1985):66.

D. Graphic Works

Articles

2364. BLAIZOT, A. "Les Gravures d'André Derain pour le Satyricon." *Art & décoration* 22(1951):38-9.

2365. CHAPON, FRANÇOIS. "Sur quelques livres d'Albert Skira" [On Some Books Produced by Albert Skira]. *Bulletin du bibliophile* 4(1973):366-76.

Tribute to the work of Skira, who produced some of the most beautiful books for the bibliophile in the last half century. The text relates to the following inspired choices of illustrator: Picasso and Ovid's *Metamorphoses*; Matisse and Mallarmé's *Poems*; Dalí and *Les Chants de Maldoror* of Lautréamont; Beaudin and Vergil's *Eclogues*; and Derain and Rabelais. The trials that Skira and Matisse underwent during the World War II in preparing for the latter's edition of Ronsard's *Amours* are described in particular detail.

2366. CHAPON, FRANCIS and EVELINE SCHLUMBERGER (Interviewer). "Le Livre illustré français au 20ᵉ siècle" [The French Illustrated Book in the 20th Century]. *Connaissance des Arts* 341(July 1980):71-80. 15 illus.

In this interview, Chapon, Librarian of the Bibliothèque littéraire Jacques Doucet, discusses aspects of the development of the illustrated book in France over the period 1870-1970, with reference to the annotated illustrations of books illustrated by Braque, Picasso, Redon, Sonia Delaunay, Miró, Matisse, Masson, André Derain, Bonnard, Toulouse-Lautrec, Manet, Giacometti, and others.

2367. LEE, JANE H. "L'Enchanteur pourrissant" [The Decaying Enchanter]. *Revue de l'art* 82(1988):51-60. 15 illus.

History of the first artist's book, *L'Enchanteur pourissant* (Paris: Kahnweiler, 1909) written by Guillaume Apollinaire and illustrated with woodcuts by Derain, in the context of Kahnweiler's activity and aims and of contemporary art, notably the Symbolist revival. Lee stresses the importance of this book as an example of the catalyzing influence of the publisher Daniel-Henry Kahnweiler and of the close links between painting and poetry that characterize the early days of Cubism. She notes the influence of Kandinsky on some of Derain's engravings and sees the slow sales of the limited edition as a commercial success rather than a failure. She considers various aspects of the book and the subsequent history of such collaborations.

2368. LEE, JANE H. "The Prints of André Derain." *Print Quarterly* 7:1(1990):36-55. 15 illus.

Discusses André Derain's woodcuts, lithographs, etchings, and engravings with reference to the 1955 retrospective exhibition held at the Bibliothèque nationale, Paris. The difficulties of dating much of Derain's work are highlighted, and the influences, themes, motifs, and links with his paintings are scrutinized. Lee states that a better knowledge of Derain's prints would lead to a wider reassessment of French art between the two world wars.

2369. MCINTYRE, R. "Contrast in Lithographs: Derain's *Femme nu* and Raverat's *Reclining Girl.*" *Architectural Review* 69(April 1931):135.

2370. SCHWARZ, ARTURO, "*Minotaure*: The Pride of European Culture." *FMR* (Italy) 7:31(March-April 1988):16-34. 13 col. illus.

Traces the history of the journal *Minotaure*, published by Albert Skira between 1933 and 1939, as a forum for Surrealism and all types of modernism. Schwarz describes the covers, designed by distinguished artists of the time: Picasso, André Derain, Marcel Duchamp, Miró, Dalí, Matisse, and others; as well as the important contributions to several issues by Man Ray. The editorials that opened each issue (except nos. 8 and 10) are reproduced as an appendix.

2371. STRACHAN, W. J. "Derain, Illustrator." *Studio* 161(March 1961):114-7.

E. Illustrated Books, 1909-56

2372. APOLLINAIRE, GUILLAUME. *L'Enchanteur pourrissant*. Illustré de gravures sur bois par André Derain. Paris: H. Kahnweiler, 1909. 76 p. illus., pl. 104 copies.

a. Other eds.: Paris: Editions de la Nouvelle Revue Française, 1921. 89 p., illus. Paris: Editions L.C.L., 1971. 85 p., illus.; edition établie, présenté et annotée par Jean Burgos. Paris: Lettres Modernes, 1972.

2373. JACOB, MAX. *Les Œuvres burlesques et mystiques de Frère Matoral, mort au couvent*. Illustré de gravures sur bois par André Derain. Paris: Daniel-Henry Kahnweiler, 1912. 153 p., illus.

2374. BRETON, ANDRE. *Mont de piété (1913-1919)*. Avec deux dessins inédits d'André Derain. Paris: Au Sans Pareil, 1919. 39 p., illus. 115 copies. Volume in "Collection de littérature" series.

2375. VLAMINCK, MAURICE DE. *A la santé du corps*. Illustré par André Derain. Paris: Imprimerie François Bernouard, 1919.

2376. REVERDY, PIERRE. *Etoiles peintes*. Avec une eau-forte originale d'André Derain. Paris: Editions du Sagittaire, 1921. 42 p., illus., 1 pl.

2377. MUSELLI, VINCENT. *Les Travaux et les jeux*. Accompagnés de lithographies d'André Derain. Paris: J. E. Pouterman, 1928. 53 p., pl. 40 lithographs.

2378. WILDE, OSCAR. *Salomé: drame en un acte*. Illustrations par André Derain. Paris: Imprimé pour les membres de The Limited Editions Club, 1930. 74 p., illus., 9 col. pl. 1,500 copies.

2379. ARTAUD, ANTONIN. *Héliogabale: ou, l'Anarchiste couronné*. Avec six vignettes d'André Derain. Paris: Editions Denoël et Steele, 1934, 191 p., illus.

2380. OVID. *Héröides*. Traduction de Marcel Prévost, eaux-fortes originales par André Derain. Paris: Société des Cent-Une, 1938. 315 p., illus., 134 copies.

Latin text and French translation on opposite pages. Issued in loose quires in a paper cover, in a slipcase.

2381. RABELAIS, FRANÇOIS. *Les Horribles et espovantables faictz et prouesses du très renommé Pantagruel, roy des Dipsodes, fils du grand géant Gargantua.* Composé nouvellement par maître Alcofrybas Nasier [pseud.]. Orné de bois en couleurs dessinés et gravés par André Derain. Paris: Albert Skira. 1943. 187 p., col. illus. 275 copies. Text edited by Abel Lefranc.

Probably not published until 1945, although the typography was completed on April 15, 1943. Illustrations include: 129 wood engravings in color, comprising 17 full-page cuts (including frontspiece), 22 large cuts in the text, and 90 smaller cuts (including title-vignette); woodcut initials, tailpieces and cover-title. All illustrations were designed and engraved by André Derain and the blocks colored under his direction.

2382. HERON DE VILLEFOSSE, RENE. *A Tribute to Precious Stones.* With an original lithograph by André Derain. Trans. by Barbara Watkins. Paris: Cartier, 1947. 45 p., illus.

2383. GIDE, ANDRE. *Récits, roman, soties.* Edition illustré de 60 aquarelles et gouaches par André Derain [et al.] et d'un portrait de l'auteur par A. Dunoyer de Segonzac. Paris: Gallimard, 1948. 2 vols., illus., some col.

2384. PETRONIUS ARBITER, T. *Le Satyricon.* Cuivres gravés par André Derain. Paris: Marthe Pequet et Pierre Baudier, 1951. 200 p., illus.

a. Another ed.: Traduction de Héguin de Guerle. Illustrations d'André Derain. Paris: Editions L.C.L., 1967. 89 p., pl.

2385. ANACREON. *Odes anacréontiques.* Traduction de Leconte de Lisle. Lithographies originales d'André Derain. Lyon: Cercle Lyonnais du Livre, 1953. 88 p., illus.

2386. WILDE, OSCAR. *Salomé.* Avec des illustrations au pochoir d'après des gouaches de Derain. Monte Carlo: Editions du Cap, 1956. 68 p., col. illus. Volume in "Les Fermiers généraux" series.

IV. Exhibitions

A. Individual Exhibitions, 1916-1993

1916, October	Paris, Galerie Paul Guillaume. *André Derain*. Préface de Guillaume Apollinaire. Catalogue includes poems by Apollinaire, Divoire, Reverdy, Cendrars, and Jacob.
1917, November	New York, Modern Gallery. *André Derain*.
1922, September	Stockholm, Svensk-Franska Konstgalleriet. *André Derain*.
1922, October	Berlin, Flechtheim Gallery. *André Derain*.
1922	New York, Brummer Gallery. *André Derain*. Preface by Joseph Brummer.
1922-23, December-January	Munich, Moderne Galerie, Tannhauser. *André Derain; Ausstellung von Gemälden, Aquarellen, Zeichnungen und Graphik aus den Jahren 1912 bis 1922.* 28 p., illus., 7 pl.
1927	Düsseldorf, Flechtheim Gallery. *André Derain*.
1928, March	London, Lefevre Gallery. *André Derain*. Preface by Etienne Bignou.
1929, November	Düsseldorf and Berlin, Flechtheim Gallery. *André Derain*. Review: H. Purrmann, *Kunst und Kunstlers* 27(June 1929):358-62.
1930	New York, Reinhardt Galleries. *André Derain*. Reviews: *Art News* 28(1 Feb. 1930):10; *Parnassus* 2(Feb. 1930):4-5.
1930, April	New York, M. Knoedler & Co. *Works by Derain*. Preface by Etienne Bignou. 18 p., illus. Reprints Bignou's preface for the Derain exhibition at the Lefevre Gallery, London (1928). Reviews: F. Watson, *Arts Magazine* 16(April 1930):576-7; *International Studio* 95(April 1930):74; *Parnassus* 2(April 1930):5; *Art News* 28(5 April 1930):3+.
1930, 24 November-13 December	Chicago, M. Knoedler & Co. *Derain*. Text by Etienne Bignou. 16 p., illus. Review: *Art News* 29(29 Nov. 1930):13.
1930-31, 21 December-18 February	Cincinnati Art Museum. *An Exhibition of Paintings by André Derain*. 34 p., 21 pl. 50 paintings. Reviews: *Art Digest* 5(1 Jan. 1931):8; *Art News* 29(3 Jan. 1931):3, 29(31 Jan. 1931):4; G. McCann, *Cincinnati Museum of Art Bulletin* 2(Jan. 1931):1-6.

1931, March	New York, Marie Harriman Gallery. *Nine New Landscapes by A. Derain.* Reviews: R. Flint, *Art News* 29(7 March 1931):3; *Art Digest* 5(15 March 1931):15; H. Schnakenberg, *Arts Magazine* 17(April 1931):499-500; C. Burrows, *Apollo* 13(April 1931):238.
1933, March-April	New York, Durand-Ruel Galleries. *André Derain.* Preface by Waldemar George. Reviews: R. Flint, *Art News* 31(25 Feb. 1933):3; *Art Digest* 7(15 March 1933):14; *Creative Art* 12(April 1933):316.
1933, May	Paris, Galerie aux Quatres Chemins. *André Derain.*
1933, November-December	London, Arthur Tooth & Sons Gallery. *An Exhibition of Recent Paintings by André Derain.* Review: *Apollo* 18(Dec. 1933):384.
1934, March-April	New York, Marie Harriman Gallery. *Watercolours and Drawings by Derain.* Review: *Art News* 32(31 March 1934):6.
1935, February	Stockholm, Svensk-Franska Konstgalleriet. *André Derain.*
1935, May	Paris, Galerie Renou et Colle. *André Derain.* Review: *Beaux-arts magazine* (17 May 1935):3.
1935, June	Basel, Kunsthalle. *Exposition André Derain.*
1935, July-August	Bern, Kunsthalle. *André Derain.*
1935	London, Thos. Agnew & Sons. *New Pictures by Derain.*
1936, January	New York, Marie Harriman Gallery. *Lithographs and Etchings by André Derain.* Review: A. Frankfurter, *Art News* 34(22 Feb. 1936):5+.
1936	New York, Valentine Galleries. *André Derain.* Review: M. Morsell, *Art News* 34(11 Jan. 1936):6-7.
1936	New York, Bignou Galleries. *André Derain.* Reviews: A. Sayre, *Art News* 34(9 May 1936):9; *Art Digest* 10(15 May 1936):13.
1936-37, November-January	New York, Joseph Brummer Gallery. *André Derain.* Preface includes texts by Guillaume Apollinaire, Clive Bell, Jean Cassou, and T. W. Earp. Reviews: *Art Digest* 11(15 Nov. 1936):8; M. Breuning, *Parnassus* 8(Dec. 1936):30.
1937	London, Reid and Lefevre Gallery. *André Derain.*

1938, November-
December

New York, Marie Harriman Gallery. *Two New Derains*.

1939, February-
March

New York, Lilienfeld Galleries. *André Derain*.
Reviews: *Art News* 37(25 Feb. 1939):13; *Art Digest* 13(1 March 1939):20.

1939, April-May

New York, French Art Galleries. *Derain Drawings*.

1940, April-May

New York, Pierre Matisse Gallery. *Derain Paintings from 1938 and After*.
Reviews: *Art Digest* 14(15 April 1940):15; D. Brian, *Art News* 38(20 April 1940):10[+]; E. McCausland, *Parnassus* 12(May 1940):40.

1940

London, Redfern Gallery. *André Derain*.
Review: T. McGreevy, *London Studio* 20(*Studio* 120) (Oct. 1940):137.

1942

New York, Lilienfeld Galleries. *André Derain*.
Review: *Art News* 40(15 Jan. 1942):28.

1944, January

New York, Pierre Matisse Gallery. *André Derain*.
Reviews: *Art Digest* 18(15 Jan. 1944):13; R. Goldwater, *Art News* 42(15 Jan. 1944):19[+].

1947, January

Chicago, The Arts Club of Chicago. *André Derain*.

1949, March

Paris, Galerie de Berri. *Hommage à Derain*.

1954-55,
11 December-
30 January

Paris, Musée National d'Art moderne. *André Derain*. Préface de Jean Cassou, catalogue par Gabrielle Vienne. 31 p., 20 pl.
Reviews: *Apollo* 61(Jan. 1955):22; *Art News* 53(Feb. 1955):16; D. Cooper, *Burlington Magazine* 97(Feb. 1955):51-2; A. Watt, *Studio* 149(March 1955):88-9.

1955, 9-11 March

Paris, Hôtel Drouot. *Collection André Derain*.

1955, May-
September

Paris, Galerie Charpentier. *Cinquante tableaux importants d'Andre Derain*. Textes de Raymond Nacenta et Georges Hilaire. 32 pl., illus.
Review: *Art News* 54(Sept. 1955):46.

1955, July

Paris, Galerie Jeanne Castel. *André Derain*. Préface de Georges Hilaire.

1955, September-
October

Lausanne, Galerie Paul Vallotton. *Exposition André Derain*. Preface by V. Photiades.

1955, 6 October- Geneva, Galerie Motte. *André Derain, 1880-1954.*
10 November Review: *Werk* 42(Dec. 1955):supp. 251.

1955 Paris, Bibliothèque nationale. *André Derain.* Préface de
 Julien Cain, catalogue par Jean Adhémar. 16 p. Includes
 Jean Vallery-Radot's essay, "Derain, peintre-graveur."
 Exhibition of woodcuts, lithographs, etchings, and
 engravings.
 Review: J. Lee, *Print Quarterly* 7:1(1990):36-55.

1955 Sao Paolo, Museu d'Arte moderne. *Second Biennale. Derain
 Retrospective.*

1957, March Paris, Galerie Maeght. *Dessins de Derain.* Préface includes
 a text by Alberto Giacometti.
 Review: *Connoisseur* 139(June 1957):260-1.

1957, April-May London, Wildenstein Gallery. *André Derain, 1880-1954. A
 Loan Exhibition in Aid of the National Art Collections Fund.*
 Catalogue by Denys Sutton.
 Reviews: *Burlington Magazine* 99(May 1957):170;
 Illustrated London News 230(18 May 1957):825; L.
 Alloway, *Art News* 56(June 1957):62; *Studio* 154(July
 1957):29.

1957 Paris, Galerie Chalette. *Exposition André Derain.*
 Reviews: *Art News* 56(June 1957)72; *Arts Magazine* 31(June
 1957):51.

1958 Asnières, Salon d'Asnières. *Hommage à Derain.* Textes de
 André Salmon et Florent Fels.

1958 Paris, Galerie Maeght. *Derain.*

1959 Paris, Galerie Maeght.
 Review: *Apollo* 69(Feb. 1959):47.

1959 Zurich, Galerie Suzanne Bollag.
 Review: *Werk* 46(March 1959):supp. 63.

1959, July-October Geneva, Musée de l'Athénée. *André Derain.* Text de
 Guillaume Apollinaire.
 Review: *Werk* 46(Sept. 1959):supp. 191.

1959, 21 October- New York, Charles E. Slatkin Gallery. *Sculptures by André
14 November Derain.* Trans. by Waldemar George. 16 p., illus.
 Reviews: *Art News* 58(Oct. 1959):13; *Burlington Magazine*
 101(Dec. 1959):469; *Arts Magazine* 34(Oct. 1959):55.

1961 Zurich, Kunsthalle.
 Review: *Werk* 48(Jan. 1961):supp. 23.

1961-62, November- January	Houston, Houston Museum of Fine Art. *Derain Before 1915.*
1962, March	Frankfurt am Main, Galerie F. A. C. Prestel. *André Derain, 37 Bronzen.* Katalog von Peter Voiglaender Tetzner. 16 p.
1962, 20 June- 15 October	Paris, Charles Zalber. *Charles Zalber and Galerie Bellechasse présente les 37 sculptures d'André Derain.* Also shown Paris, Galerie Bellechasse. 18 p., illus.
1962	New York, Hammer Gallery. Review: *Art News* 61 (Summer 1962):46.
1962	London, Reid Gallery. Review: M. Amaya, *Apollo* 76(Oct. 1962):630.
1962	London, Brook Street Gallery. 51 bronzes Review: G. Whittet, *Studio* 164(Dec. 1962):252.
1963, June- September	New York, Museum of Modern Art. *André Derain in the Museum Collection.*
1964, 8 June- 1 September	Marseille, Musée Cantini. *André Derain.* Préface de Frank Elgar. ca. 200 p., illus., pl.
1964, 20 October- 21 November	New York, Hirsch Adler Galleries. *André Derain, 1880-1954. Retrospective Exhibition.* Preface by Jean Bouret. 39 p., illus. Under the sponsorship of M. Morot Sir, Attaché Culturel of the French Embassy. Reviews: S. Faunce, *Art News* 63(Nov. 1964):38-91[+]; M. Mastai, *Connoisseur* 157(Nov. 1964):204[+].
1967, August- 5 November	Edinburgh, Royal Scottish Academy. *André Derain: An Exhibition of Paintings, Drawings, Sculpture, and Theatre Designs.* Also shown London, Royal Academy (30 Sept.-5 Nov. 1967). Preface by Jean Leymarie, texts by Guillaume Apollinaire, André Breton, P. Diamond, Alberto Giacometti. 96 p., 104 illus. Reviews: J. Russell, *Art News* 66(Oct. 1967):60; J. Burr, *Apollo* 86(Oct. 1967); K. Roberts, *Burlington Magazine* 109(Nov. 1967):659; R. Melville, *Architectural Review* 142(Dec. 1967):465.
1969	London, Piccadilly Gallery. Review: J. Burr, *Apollo* 89(March 1969):234.
1971, 16 February- 13 March	London, Piccadilly Gallery. *André Derain: Drawings and Watercolours.* 8 p. Reviews: M. Wykes-Joyce, *Arts Review* 23:3(13 Feb. 1971):77; I. Dunlop, *Apollo* 93(Feb. 1971):132.

1971, June-July	Paris, Galerie Knoedler. *André Derain*. 34 p., 11 illus.

1973-74,
22 November-
2 February

Cologne, Baukunst. *André Derain: Handzeichnungen, Gouachen, Ölbilder, Terrakotten, Plastiken Ausstellung.* [André Derain: Drawings, Gouaches, Oils, Clayware, Sculpture]. 50 p., illus., 5 col.

1974, June-
September

Albi, Musée Toulouse-Lautrec. *Derain, connu et inconnu.* Préface de Claude Roger-Marx, texte de Gaston Diehl. Catalogue par Jean Devoisins. 49 p., 16 illus., 14 pl., 8 col. 82 works shown.

Introduction to this exhibition of Derain's paintings, watercolors, and drawings argues that Derain stands alone, apart fron his contemporaries. Diehl's own relations with Derain brought out the artist's statement that "art is a staircase of perpetual revelations, but it's also always the memory of generations." Diehl examines this statement in relation to Derain's paintings and the development of his particular artistic universe. He believes that Derain's continual defiance, his desire to overstep limits, and the power of renewal in his work all combine in a sad dualism that explains his unique role in contemporary art.

1975, 27 June-
6 September

Lausanne, Galerie Paul Vallotton. *Hommage à Derain: huiles, aquarelles, dessins.*

1976, 12 May-
20 June

Paris, Galerie Schmit. *Derain, 1880-1954.* Préface de Jean Bouret. 76 p., 4 illus., 76 pl., 38 col.
Reviews: *Apollo* 103(May 1976):445; *Burlington Magazine* 118(May 1976):339; *L'Œil* 250(May 1976)L:48; *Connaissance des arts* 292(June 1976):21; *Goyá* 133(July 1976):59.

1976-77,
13 November-
11 April

Rome, Académie de France à Rome, Villa Medici. *André Derain.* Also shown Paris, Grand Palais (15 February-11 April). Introduction de Jean Leymarie. Textes de G. Apollinaire, André Breton, Alberto Giacometti. Catalogue par Isabelle Monod-Fontaine. Paris: Editions des Musées Nationaux, 1977. 165 p., 86 illus., 16 col. 75 works shown. In French.

Major retrospective which presented a representative selection of Derain's works from all phases of his career: 57 oil paintings, 1904-50; 12 drawings, 1910-43; two sculptures; and four albums of designs for theater productions. Full catalogue entries and reproductions of each object. Catalogue text includes previously published commentaries on the artist by Apollinaire, Breton, and Giacometti. In an introductory essay, Jean Leymarie analyzes Derain's painting and temperament through records by friends and contemporaries, and through analysis of a portrait by Balthus in 1936. Derain's relationship with

Fauvism and his fascination with classical Rome are discussed. The preface to the Derain exhibiton in Paris in 1916 by Guillaume Apollinaire, in which the poet assesses Derain's development and draws attention to the co-existent qualities of audacity and discipline, is included, with comments on Derain from "Idées d'un peintre" in *Les Pas perdus* (1924) by André Breton, and an appreciation of Derain by Giacometti from *Derrière le miroir* (1957). The catalogue is divided into paintings, drawings and sculptures.
Reviews: *L'Œil* 258-9(Jan.-Feb. 1977):52; Henze, *Kunstwerk* 30:1(Feb. 1977):49; J. Bouret, *Galerie-Jardin des arts* 167(March 1977):42; *Connoisseur* 194(March 1977):222; *Connoisseur* 194(April 1977):298; G. Vignoht, *Peintre* 540(1 March 1977):3-6; P. Schneider, *New York Times*(30 March 1977):42; S. Frigerio, *Colóquio Artes* 32(April 1977):68-9; *Burlington Magazine* 119(April 1977):304[1]; B. Scott, *Apollo* 105(May 1977):390; *Revue du Louvre et des musées de France* 27:1(1977):53; B. Scott, *Apollo* 105:184(June 1977):390; *Goyá* 139(July 1977):24; P. Dauriac, *Pantheon* 35:3(July-Sept. 1977):265.

1978-79	New York, David Findlay Gallery. *André Derain.* 20 paintings from his late period. Review: J. Perl, *Arts Magazine* 53:5 (Jan. 1979):4.
1980, Spring- 4 June	Toronto, Waddington Galleries. *André Derain.* Also shown London, Theo Waddington Gallery (31 May-4 June). 16 p., illus. Reviews: M. Parke-Taylor, *Artscanada* 234-5(April-May 1980):36-7; *Burlington Magazine* 121(June 1979):3997; F. Spalding, *Arts Review* 32:13(4 July 1980):278.
1980-81, 17 December- 8 March	Paris, Musée d'Art moderne de la Ville de Paris. *Hommage à André Derain, 1880-1954.* 40 p., 43 illus. Exhibition derived from a Grand Palais retrospective in 1977. Presented Derain's work in the museum's collection, including oils and watercolors, clay figurines, masks, painted pottery and woodcuts, and being designed to illustrate Derain's bold experimentation with a wide range of techniques. It is stated that the paintings chosen, spanning the years 1904-51, are each representatvie of a phase in his development. Reviews: *Connoisseur* 206:827(Jan. 1981):14; *Burlington Magazine* 123(Feb. 1981):120; W. Sauré, *Weltkunst* 51:4(15 Feb. 1981):300-1; Y. Bligné, *Peintre* 619(15 Feb. 1981):3-5; *Apollo* 113(March 19981):194.
1981, April-July	Tokyo. *Master of Fauvism: Derain.* Also shown Osaka, Kyoto, Takashimaya Art Gallery; Nagoya, Nagoya City Museum. Preface by Denys Sutton. 186 p., illus., some col. Review: N. Shimada, *Mizue* 914(May 1981):56-75.

1981, 2 July- 27 September	Munich, Villa Stuck. *Maler machen Bücher: illustrierte Werke von Manet bis Picasso—Lithographien, Holzschnitte, Radierungen* [Artists Make Books: Illustrated Works from Manet to Picasso—Lithographs, Woodcuts, Engravings]. Katalog von A. Ziersch und Erhart Kästner. 80 p., 27 illus. Exhbition devoted to the book illustrations of about thirty European artists, including Derain, Georges Braque, and Henri Matisse.
1981, 30 October- 28 November	New York, Theo Waddington Galleries. *André Derain, 1880-1954; Paintings and Drawings.* 20 p., illus., some col.
1982-83, 29 October-June	Regina, Saskatschuwan, University of Regina, Norman Mackenzie Art Gallery. *André Derain in North American Collections.* Also shown Berkeley, University of California, Art Museum (12 Jan.-13 March 1983) and [selections] London, Stoppenbach & Delestre (May-June 1983). Catalogue by Michael Parke-Taylor. 138 p., 80 illus., 19 col., 8 photographs of the artist. Reviews: A. Marechal-Workman, *Artwerk* 14:6(12 Feb. 1983):8-9; *Apollo* 117:253(March 1983):253-4; H. Mullaly, *Apollo* 117:255(May 1983):409; C. Collier, *Arts Review* 35:10(27 May 1983):280; M. Wykes-Joyce, *Art & Artists* 201(June 1983):28.
1984	Melun, Musée de Melun. *André Derain.* Catalogue par Annie-Claire Lussiez.
1984-85	London, Stoppenbach and Delestre Gallery. Review: *Art & Artists* 220(Jan. 1985):29-30.
1987	Nantes, Galerie des Beaux-arts. *André Derain.*
1987, 4-28 November	New York, Grace Borgenicht Gallery. *André Derain (1880-1954), Paintings, Drawings.* 8 p., illus. Review: R. Bass, *Art News* 87(Feb. 1988):138+.
1990-91, 16 December- 16 September	Oxford, England, Museum of Modern Art. *André Derain.* Also shown Edinburgh, Scottish National Gallery of Modern Art (27 March-27 May 1991); Troyes, Musée d'Art moderne (22 June-16 Sept. 1991). Catalogue by Jane H. Lee. Oxford: Phaidon; New York: Universe Books, 1990. 144 p., illus., some col. Reviews: R. Shone, *Burlington Magazine* 133:1055(Feb. 1991):134-6; A. Whitworth, *Arts Review* 43(8 Feb. 1991):74-5; A. Nemeczek, *ART: das Kunstmagazin* 5(May 1991):28-47; *L'Œil* 432-3(July-Aug. 1991):87.
1991, 19 June- 20 July	London, Stoppenbach & Delestre Gallery. *André Derain: Drawings & Watercolours, 1900-1906.* 48 p., 18 illus., 3 col. Essay in English and French.

Catalogue to an exhibition of drawings and watercolors by André Derain. In the catalogue, Derain recalls his student days and his obsession with the early Renaissance paintings in the Louvre, his meeting with Linoret, and the Fauve movement.

1991-92,
3 October-
20 January

Paris, Musée de l'Orangerie. *Un Certain Derain.* Introduction de Michel Hoog. Paris: Réunion des Musées Nationaux, 1991. 200 p., 116 illus., 16 col. 64 works (paintings, drawings, prints).

Derain's art underwent numerous renewals, an indication of his restlessness and unceasing research. This attitude is clearly seen in an unspectacular body of work, often little known, presented in this book; studies, sketches and limited-edition engraving, his copy of Ghirlandaio's *Carrying of the Cross*, which produced a very personal work that caused a scandal in 1901, and some illustrated books. Also included are more finished works shown only after his death, such as the *Arlequin et Pierrot*, the portrait of Mme. Paul Guillaume, and the *Table de cuisine*. Besides the texts on the works exhibited, the catalogue also includes important unpublished interviews of the artist with Edmonde Charles-Roux, autobiographical texts, and critical statements by the first commentators on his work (in particular with Apollinaire), as well as a biography and bibliography.

Reviews: M. Hoog, *Revue du Louvre et des musées de France* 41(Oct. 1991):112; *Connaissance des arts* 478(Dec. 1991):12

B. Group Exhibitions, 1905-1993

1905, 24 March-
30 April

Paris, Grand Palais. *Salon des Indépendants.* 8 paintings.

1905, 18 October-
25 November

Paris, Grand Palais. *Salon d'Automne.* 9 paintings, including views of Collioure.

1905, 21 October-
20 November

Paris, Galerie Berthe Weill. 5 paintings.

1906, 20 March-
30 April

Paris, Grand Palais. *Salon des Indépendants.* 3 paintings.

1906, 26 May-
30 June

Le Havre, Hôtel de Ville. *Cercle de l'Art moderne.*

1906, 6 October-
15 November

Paris, Grand Palais. *Salon d'Automne.* 8 paintings, including 1 painting of London and 5 of L'Estaque.

1907, 3 March- 3 April	Brussels. *La Libre esthétique*. Catalogue par Octave Maus. 4 paintings of London, shown in 1908 at the Toison d'or, Moscow.
1907, 20 March- 30 April	Paris, Grand Palais. *Salon des Indépendants*. 5 paintings (*Baigneuses 1*, 3 of L'Estaque, 1 portrait).
1907, 30 March	Paris, Galerie Berthe Weill.
1907, June	Le Havre, Hôtel de Ville. *Cercle de l'Art moderne*. Catalogue texte par Ferdinand Fleuret. 2 paintings.
1907, 1-22 October	Paris, Grand Palais. *Salon d'Automne*. 5 paintings.
1908, 20 March- 2 May	Paris, Grand Palais. *Salon des Indépendants*. 8 paintings.
1908, 18 April- 24 May	Moscow, Salon de la Toison d'or. 6 paintings, including 4 views of London.
1908, June	Le Havre, Hôtel de Ville. *Cercle de l'Art moderne*.
1908, 1 October- 8 November	Paris, Grand Palais. *Salon d'Automne*. 6 paintings.
1908-09, 21 December- 15 January	Paris, Galerie Notre-Dame-des-Champs. 3 paintings.
1913, May-June	Prague, Communal House. *III. výstava Skypiny výtvarných umělců* [Third Exhibition of the 'Group of Avant-Garde Artists' in the Communal House]. Included paintings by Czech and foreign artists (Braque, Picasso, and Derain, among others).
1907	Washington, D.C., Phillips Memorial Gallery. *Leaders of French Art Today: Exhibition of Characteristic Works by Matisse, Picasso, Braque, Segonzac, Bonnard, Vuillard, Derain, André, and Maillol.* 16 p., 9 illus.
1931	Paris, Galerie Paul Guillaume. *Paysages*. 11 works by Derain. Reviews: P. Berthelot, *Beaux-arts* 9(April 1931):22; P. Fierens, *Art News* 29(25 April 1931):20; *Cahiers d'art* 6:3(1931):167; *Formes* 14(April 1931):69-70; *Art et décoration* 59(May 1931):supp, 1; A. Salmon, *Apollo* 13(May 1931):309-11; W. George, *Creative Arts* 8(July 1931):458-9; C. Woodward, *International Studio* 99(July 1931):57.

1931-32, 22 December- 17 January	Chicago, Art Institute. *Exhibition of the Arthur Jerome Eddy Collection of Modern Paintings and Sculpture.* Catalogue issued in *Chicago Art Institute Bulletin* 35:9 (Dec. 1931). Included works by Derain (pp. 10-2) and Vlaminck (pp. 24-6).
1937	Paris, Petit Palais. Review: G. Gros, *Beaux-arts magazine* 2(July 1937):2.
1947, 20 October- 1 November	New York, American British Art Center. *Ascher Squares: Designed by Matisse, Moore, Derain and Others.* 6 p., col. illus. Exhibition of textile designs.
1950, 8 June- 15 October	Venice, XXV^e Biennale. *Internazionale d'Arte: Mostra dei Fauves.* 6 works.
1955	Paris, Grand Palais, *Salon d'Automne.* Préface de André Dunoyer de Segonzac.
1962	New York, Marlborough Galleries. Review: M. Fried, *Arts Magazine* 36(Jan. 1962):52.
1963	New York, Hutton Gallery. Reviews: *Art News* 61(Jan. 1963):11; V. Raynor, *Arts Magazine* 37(Feb. 1963):46.
1963	Lausanne. Review: G. Peillex, *Werk* 50(May 1963):supp. 109.
1963	Paris, Galerie des Arts plastiques moderne. Review: A Watt, *Studio* 166(Oct. 1963):167.
1971	Los Angeles, Los Angeles County Museum of Art. *The Cubist Epoch.* Catalogue by Douglas Cooper. London: Phaidon, 1971. 320 p., 347 illus. Included works by Braque and Derain. Reviews: M. Young, *Apollo* (Jan. 1971):18-27; R. Krauss, Artforum 9:6(Feb. 1971):32-8; H. Kramer, *Art in America* 59:2(March-April 1971):51-7; M. Kozloff, *Art News* 70:2(April 1971):34-7, 78-82; C. Rosenberg, *Artforum* 9:8(April 1971):30-6; *Arts Magazine* 45:7(May 1971):53; B. Robertson, *Times* (18 May 1971):12; R. McMullen, *American Scholar* 40:3(Summer 1971):432-46.
1971	Munich, Bayerische Staatsgemäldesammlungen. Review: E. Steingraber, *Münch Jahrbuch Bilt Kunst*, ser. 3, 22(1971):269.
1973, 3 January- 11 March	London, Hayward Gallery. *The Impressionists in London.* Introduction by Alan Bowness. Catalogue by Anthea

Callen. Organized by The Arts Council of Great Britain.
5 paintings by Derain. 80 p., 66 illus.
Introduction to this catalogue discusses the central theme of
the exhibition, the work of the Impressionists and their
followers in London. Callen provides a chronological table
as well as biographical and catalogue notes on Monet,
Pissarro, Sisley, Renoir, Derain, and Kokoschka.

1974 Boston, Harkus Krakow Rosen Sonnabend Gallery.
 Review: *Art News* 73(Summer 1974):70.

1974 Houston, Museum of Fine Arts, Jesse H. Jones Galleries.
 *The Collection of John A. and Audrey Jones Beck;
 Impressionist and Post-Impressionist Paintings.* Catalogue
 by Thomas P. Lee. 101 p., illus., 47 col.
 Catalogue issued on the occasion of the first public
 exhibition of the Beck Collection, put on indefinite loan at
 the Houston Museum. Among the forty-seven works
 catalogued are paintings by van Gogh, Matisse, Seurat,
 Degas, Toulouse-Lautrec, Braque, Cassatt, and Derain.

1975, 11 April- Toronto, Art Gallery of Ontario. *The Fauves.* Catalogue by
11 May Richard J. Wattenmaker. 45 p., 29 illus., 12 col. 29 works
 shown. Representative paintings from private and public
 collections in Europe and North America by ten of the
 artists who, between 1904 and 1908, created a style called
 Fauvism—Henri Matisse, Albert Marquet, Raoul Dufy,
 André Derain, Maurice de Vlaminck, Georges Braque, Kees
 van Dongen, Othon Friesz, Louis Valtat, and Henri
 Manguin.

1975-76, Paris, Musée Jacquemart-André. *Le Bateau-Lavoir.*
30 October- Catalogue par Jeanine Warnod. 163 p., 8 illus. ca. 200
31 January works shown.
 Exhibition devoted to the Bateau-Lavoir, a building on top
 of Montmartre where Cubism was born and which became
 between 1900 and 1914 the abode or meeting place of artists
 and writers such as Picasso, Braque, Derain, Mondigliani,
 van Dongen, Gris, Max Jacob, and Apollinaire. Includes
 paintings, prints, drawings and watercolors by these artists
 and others plus African masks and sculpture. Documentary
 material such as manuscripts, letters, catalogues and
 photographs also included.
 Review: P. Schneider, *New York Times* (1 Dec. 1975):40.

1976, 2 March- Santa Barbara, Santa Barbara Museum of Art. *European
18 April Drawings in the Collection of the Santa Barbara Museum of
 Art.* Edited by Alfred Moir.
 The Museum's first comprehensive catalogue of its drawings
 collection, published in conjunction with this exhibition,
 included works by Derain, Matisse, and others.

1976, 26 March- 31 October	New York, Museum of Modern Art. *The 'Wild Beasts';* *Fauvism and its Affinities.* Also shown San Francisco, Museum of Modern Art (29 June-15 Aug.); Fort Worth, Kimball Art Museum (11 Sept.-31 Oct.). Catalogue by John Elderfield. 167 p., 206 illus., 24 col. 210 works shown. Published to coincide with the exhibition of the same title, the book provides a definition of Fauvism—as a movement, a group, and a style—describing its origins and development, the philosophies and intellectual backgrounds of the Fauvist painters, and the works of art they produced. Elderfield sees Matisse as the movement's common denominator: "The history of Fauvism is largely the history of this essentially private artist's single sustained period of cooperation with the Parisian avant-garde, albeit for a very short period." Discussed in detail are the Fauve works of Matisse, Derain, and Vlaminck, the principal artists of the movement, as well as works by Dufy, Braque, Friesz, Marquet, Rouault, Manguin, and van Dongen.
1977, 6 July- 9 October	London, Somerset House. *London and the Thames.* Selected and catalogued by Harley Preston. 109 p., 137 illus., 23 col. 114 works shown. Catalogue text explains the criteria for the selection of works representing a partial cross-section of the sequences of development in European art, 1650-1970. Artists include Canaletto, his contemporaries and followers, Constable, Turner, Whistler, Monet, Derain, and Kokoschka. Full catalogue entries and reproductions of each object. Reviews: J. Daniels, *Times* (13 Aug. 1977):7; C. Neve, *Country Life* 162:4176(14 July 1977):72-93; K. Roberts, *Burlington Magazine* 119:894(Sept. 1977):660-3; R. Rushton, *Royal Society of Arts Journal* 125:5254(Sept. 1977):655; D. Thomas, *Connoisseur* 196:787(Sept. 1977):72.
1977, 14 August- 16 October	Berlin, 15th Council of Europe Art Exhibition. *Tendencies* *of the 1920s.* Review: S. Waetzoldt, *L'Œil* 266(Sept. 1977):28-33.
1977-79, Fall- 18 March	London, Arts Council of Great Britain. *19th and 20th* *Century Drawings and Prints from the Courtauld Collection.* Also shown Sheffield, Graves Art Gallery (29 Oct.-11 Dec. 1977); Wolverhampton, Municipal Art Gallery and Museum (17 Dec. 1977-28 Jan. 1978); Bolton, Central Museum and Art Gallery (4 Feb.-18 March 1978); Newcastle-upon-Tyne, Laing Art Gallery and Museum (28 Oct.-10 Dec. 1978); Kingston-upon-Hull, Ferens Art Gallery (16 Dec. 1978-28 Jan. 1979); Portsmouth, City Museum and Art Gallery (3 Feb.-18 March 1979). Essay on Samuel Courtauld by Michael Harrison. 32 p., 46 illus. 77 works shown.

The works of twenty-five artists were presented, including John Armstrong, Boudin, Daumier, Eric Gill, Constantin Guys, Georg Kolbe, Jean Hippolyte Marchand, Munch, Seurat, Sickert, Maillol, Cézanne, Degas, Derain, Epstein, Forain, Gaugain, Manet, Matisse, and Picasso.

1977, 14 August-
16 October

Berlin, Orangerie, Schloss Charlottenburg. *Neue Wirklichkeit: Surrealismus und Neue Sachlichkeit* [The New Reality: Surrealism and Neue Sachlichkeit]. Sponsored by the Council of Europe. Catalogued by W. Schmied and M. Eberle. 272 p., illus.

One of four simultaneous exhibitions in Berlin that aimed to present a comprehensive survey of European art from 1910 to 1930. The catalogue to the exhibition of painting in the 1920s contains an introduction describing the wide variety of realistic tendencies represented, from Picasso's neo-classical position in 1920, metaphysical painting, Neu Sachlichkeit, Surrealism and Dada to Verism. Catalogue entries are listed alphabetically by artist, the annotations including detailed commentaries on representative paintings by André Derain, Henri Matisse, and others.

1977-78, August-
January

Paris, Centre National d'Art et de culture Georges Pompidou, Musée National d'Art moderne and Moscow, Pushkin State Museum of Fine Arts. *Odinadcat' kartin iz sobranija Nacional'nogo centra sovremennogo iskusstva i kul'tury imeni Zorza Pompidu (Francija) v Moskve i Leningrade: Katalog vystavki* [Eleven Paintings from the Collection of the Centre National d'art et de culture George Pompidou in Moscow and Leningrad: Exhibition Catalogue]. Also shown Hermitage. Avtor-sostavitel': M. A. Bessonova. 24 p., 11 illus., 11 works shown. In Russian.

Included are paintings by Matisse, Picasso, and Derain, who are well represented in U.S.S.R. museums, as well as canvases by Modigliani and Dufy, who are less well known to Soviet viewers.

1977-78,
10 December-
29 January

Edinburgh, Scottish National Gallery of Modern Art. *Towards Abstract Art*. 31 p., 42 works shown.

Seven groups of works arranged to represent different types of abstraction. Aims to demonstrate how certain visual themes or categories develop towards abstraction. Artists include Braque and Derain, among others. Works are drawn from the gallery's collection and from long-term loans.

1978,
16 February-
16 April

Paris, Musée de l'Orangerie. *Donation Pierre Lévy*. Introduction par Michel Hoog. Les Notices du catalogue ont été rédigées par Antoinette Fay-Halle, Patrice Godin, Michel

Hoog, Clette Noll, Gabrielle Salomon. 279 p., 422 illus., 12 col. 395 works shown.

Exhibition presents a representative selection of works from the Lévy gift of more than 2,000 items given to the city of Troyes. Paintings, sculptures and drawings by 19th and 20th century French artists predominate (276 objects); works range from Millet and Courbet to Balthus, with particular emphasis on works by the Fauves, most especially André Derain (107 objects). Roger de La Fresnaye is represented by twenty works from all phases of his career as well as sixteen illustrations for Claudel's *Tête d'or*. Maurice Marinot is also represented in depth with forty-three examples of glass and several paintings and drawings. Other artists represented by three or more works include Degas, R. Delaunay, Dufresne, Dufy, Dunoyer, de Segonzac, Maillol, Matisse, Picasso, Seurat, Soutine, and Jacques Villon. Also shown are sixty-three African sculptures, many formerly from the collections of Félix Fénéon and Paul Guillaume. Full catalogue entires with explanatory text and reproductions of each object.

Reviews: X. Muratova, *Burlington Magazine* 120:901(April 1978):260. R. Micha, *Art International* 22:4(April-May 1978):48. J.-P. Dauriac, *Pantheon* 36:3(July-Sept. 1978):281.

1978, 2 July-
31 December

Oxford, Museum of Modern Art. *Paintings from Paris: Early 20th Century Paintings and Sculptures from the Musée d'Art moderne de la Ville de Paris.* Also shown Norwich, Castle Museum (19 Aug.-1 Oct. 1978); Manchester, Whitworth Art Gallery (7 Oct.-11 Nov. 1978); Coventry, Herbert Art Gallery and Museum (18 Nov.-31 Dec. 1978). Organized by the Arts Council of Great Britain. Catalogue by Michael Jacques Lassaigne. 48 p., 76 illus. 82 works shown.

Harrison outlines the major movements during the period of Paris's dominance as an artistic center before the Second World War, describing the origins and subsequent development of Fauvism, Cubism, and the School of Paris. Artists whose works are discussed and exhibited include Matisse, Rouault, Dufy, Derain, Delaunay, Friesz, Braque, Picasso, Gris, Utrillo, Modigliani, Soutine, Pascin, Chagall, and Léger. Harrison's introduction is followed by a brief essay by Lassaigne on Gromaire (1892-1971) whose œuvre is well represented in the Musée d'Art moderne and in this exhibition. The list of exhibits provides brief biographical sketches of the artists as well as details of materials, measurements, and provenance.

Reviews: K. Roberts, *Burlington Magazine* 120:905 (Aug. 1978):552; P. Marcus, *Art & Artists* 13:5 (Sept. 1978):18-21.

1978, 16 November- 21 December	London, Lefevre Gallery. *Les Fauves*. Catalogue by Denys Sutton. 30 p., 11 illus. In a brief introduction to this catalogue to an exhibition of eleven paintings by Braque, Derain, Matisse and Vlaminck, Sutton discusses the current state of information about the Fauves and suggests some of the avenues that remain to be explored.
1979-80, 21 April- 20 April	Atlanta, High Museum of Art. *Corot to Braque: French Paintings from the Museum of Fine Arts, Boston*. Also shown Tokyo, Seibu Museum of Art (28 July-18 Sept. 1979); Nagoya, City Museum (29 Sept.-31 Oct.); Kyoto, Kukuritsu Kindrai Bijutsukan (10 Nov.-15 Jan. 1980); Denver, Art Museum (13 Feb.-20 April 1980). Introduction and catalogue by Anne L. Poulet. Essays by Alexandra R. Murphy. 148 p., 81 illus., 69 col. 69 works shown. Selected from the ca. 600 French paintings in the High Museum's collection, the sixty-nine works shown range in date from 1831 to 1927 and present examples by thirty-four artists, including Derain, Braque, and Matisse.
1980, 14 March- 25 May	Paris, Musée du Luxembourg. *Donation Geneviève et Jean Masurel à la Communauté urbaine de Lille* [The Geneviève and Jean Masurel Gift to the Communauté urbaine de Lille]. Catalogue par Marie Anne Peneau, Jacques Jardez et Amaury Lefebure. Paris: Editions de la Réunion des Musées Nationaux, 1980. 135 p., 157 illus, 24 col, 132 works shown. Exhibition of some of the over 200 works, many of them Cubist (paintings, drawings, gouaches, prints, and sculptures) by G. Braque, A. Derain, G. Rouault, K. van Dongen and other artists who lived in France in the first half of the 20th century. The collection was formed by Roger Dutilleul and his nephew Jean Masurel. Discusses the formation of the collection, Dutilleul's development as a connoisseur, and his patronage of the Kahnweiler gallery. Notes Dutilleul's preference for emotional rather than cerebral works. Review: *Revue du Louvre et des musées de France* 30:2(1980):130-1.
1980, 25 July- 31 August	Portland, OR, Art Museum. *The Phillips Taste in Portland*. Introduction by William J. Chiego. 32 p., 26 illus. 37 works shown. Exhibition of paintings and sculpture by American and French artists, 19th-20th centuries, selected from the permanent collection of the Portland Art Museum to complement *The Phillips Collection in the Making: 1920-1930*, an exhibition circulated by the Smithsonian institution Traveling Exhibition Service (1979-80). Artists represented included Monet, Derain, Delacroix, Renoir, Avery, Eakins, and Hassam.

1981, Spring	Paris, Galerie Daniel Malingue. *L'Ecole de Paris.* Review: F. Daulte, *L'Œil* 310 (May 1981):62-5.
1981, 2 July- 27 September	Munich, Villa Stuck. *Maler machen Bücher: illustrierte Werke von Manet bis Picasso—Lithographien, Holzschnitte, Radierungen* [Artists Make Books: Illustrated Works from Manet to Picasso—Lithographs, Woodcuts and Engravings]. Katalog von A. Ziersch und E. Kästner. Munich: Christoph Dürr Verlag, 1981. 80 p., 27 illus. Included book illusstrations of André Derain, Georges Braque, and Henri Matisse, among others.
1981-82, October- January	Marcq-en-Barœul, France, Fondation Anne et Albert Prouvost. Review: *L'Œil* 317(Dec. 1981):79.
1983, 23 April- 18 July	Oklahoma City, Oklahoma Museum of Art. *Impressionism/Post-Impressionism; XIX & XX Century Paintings from the Robert Lehman Collection of the Metropolitan Museum of Art.* Catalogue by George Szabo. Introduction by Joan Carpenter. 89 p., illus., 35 col. 35 works shown. Covering a century of major artistic changes, the exhibition began with Barbizon paintings by Jules Dupré and Henri Harpignies and features Impressionist canvases by Monet, Renoir, and Degas and Post-Impressionist paintings by Cézanne, Signac, Derain, Gauguin, van Gogh, Matisse, and Bonnard. Some thirty artists are represented. Full catalogue entries with explanatory texts and color reproductions of each painting.
1983, 4 June- 2 October	Martigny, Fondation Pierre Gianadda. *Manguin parmi les Fauves.* Catalogue par Lucile Manguin, Pierre Gassier, Maria Hahnloser. 175 p., 107 illus. Features twenty-four Fauve canvases (1903-1908) by Manguin shown with paintings of the same periood by eleven other artists associated with Fauvism: Braque, Camoin, Derain, Dufy, Friesz, Marquet, Matisse, Puy, Valtat, van Dongen, and Vlaminck. Also presents twenty-five Manguin paintings, watercolors, and drawings executed after his Fauvist period (1908-49). A group of thirteen French posters of the period also shown. Catalogue contains an introductory essay by Gassier, an appreciation by the artist's daughter, Lucile Manguin, and an essay on Manguin in Switzerland by Maria Hahnloser.
1983, May-10 July	London, Tate Gallery. *Cubism.* Review: F. Daix, *Connaissance des arts* 375(May 1983):92-7.

1984, 5 July-
30 September

Geneva, Musée d'Art et d'histoire. *Sculptures du XXᵉ siècle: de Rodin à Tinguely* [20th Century Sculpture: From Rodin to Tinguely]. Catalogue par Claude Lapaire. 128 p., 217 illus.

Exhibition of sculptures by more than 150 artists, many of them Swiss, with a short survey of the collection of the author. The following artists were particularly well represented: Albert Angst, Paul Baud, André Derain, Alice Jacobi-Bordier, Auguste Rodin, Auguste de Niederhäusern Rodo, Jean Tinguely, and James Vibert.

1985, 15 June-
20 October

Lausanne, Fondation de l'Hermitage. *De Cézanne à Picasso dans les collections romandes*. Catalogue par François Daulte. 200 p., 121 illus., 120 col. Exhibition of 20th century paintings and sculptures from private and public collections in French-speaking Switzerland, by exponents of Post-Impressionism (specifically the Nabis and Pointillists); Fausism and l'Ecole de Paris, including Cézanne, Maillol, Bonnard, Vallotton, Dufy, Derain, Marquet, Matisse, Vlaminck, Rouault, Chagall, Utrillo, Modigliani, and Picasso. The introduction summarizes the history of each of the movements represented—their major members, principal tenets, and most lasting effects on contemporary art—and profiles the collecting tastes of the French-speaking cantons.

1985-86,
23 November-
12 January

Washington, D.C., Phillips Collection. *French Drawings from the Phillips Collection*. Sponsored by the National Endowment for the Arts. Catalogue by Sasha M. Newman. 8 p., 5 illus.

Exhibition of drawings by French or French-based artists, from the Phillips Collection, including works by Bonnard, Braque, Henri-Edmond Cross, Degas, Derain, Charles Despiau, Dufy, Dunoyer de Segonzac, Fantin-Latour, Gaudier-Brzeska, van Gogh, Marcel Gromaire, Roger de La Fresnaye, Aristide Maillol, Matisse, Modigliani, Jules Pascin, Picasso, Renoir, Seurat, Nicolas de Staël, and Toulouse-Lautrec. In the introduction Newman briefly describes the collection and analyzes some of the outstanding works it contains.

1985

Duisburg, Wilhelm-Lehmbruck Museum. *Meisterwerke internationaler Plastik des 20. Jahrhunderts* [Master Works of International Sculpture of the 20th Century]. Catalogue by Chritstoph Brockhaus. 88 p., 68 illus., 29 col.

Catalogue in loose-leaf sheet form to an exhibition of 20th century sculpture by thirty-two artists, from the holdings of the Wilhelm-Lehmbruck Museum, with a brief introduction to the origins and expansion of the collection. Included works by Derain.

1987, 16 April- 28 June	Los Angeles, Los Angeles County Museum of Art. *Degas to Picasso: Modern Masters from the Smooke Collection.* Catalogue by Carol S. Eliel. 144 p., 106 illus., 72 col. Exhibition of paintings and sculptures from the collection of late 19th and early 20th century European art assembled by Nathan and Marion Smooke. Although particularly strong in works by Degas, Matisse, and Picasso, the selection also included important pieces by Vlaminck, Derain, Kandinsky, Kirchner, Gabo, Braque, and Gris. In the introduction Eliel discusses the avant-garde movements represented in the collection and describes its origins and expansion.
1987, 9 August- 15 November	Lugano, Villa Favorita. *Impressionisten und Post-Impressionisten aus sowjetischen Museen II* [Impressionists and Post-Impressisonists from Soviet Museums II]. Catalogue by Albert Kostenevich, Marina Bessonova, and E. Georgievskaya. Milan: Electa, 1987. 143 p., 80 illus., 40 col. Also in English. Annotated catalogue to an exhibition of forty paintings by Moet, Renoir, Sisley, Cézanne, Signac, Gauguin, André Derain, Matisse and Picasso, from the Pushkin Museum, Moscow, and Hermitage Museum, Leningrad. The exhibition was arranged in exchange for forty Old Master paintings from the Thyssen-Bornemisza collection. There are two essays. Kostenevich traces the history of the French collections in Russia since the 18th century, focusing on the collections of Shchukin and the Morozov brothers at the turn of the century that formed the basis of the collections of the Pushin and Hermitage Museums after the 1917 Revolution. Bessonova discusses some aspects of Impressionism in the exhibited works: their atmosphere, the predominance of landscape, the move to Post-Impressionism, the Fauvism of Matisse, and the Cubism of Picasso. Details of provenance and exhibition histories are given in German only.
1987, 18 November- 19 December	Paris, Galerie Daniel Malingue. *Maîtres impressionnistes et Modernes.* 72 p., 31 illus., 30 col. Exhibition of thirty paintings and one sculpture by predominantly French artists, including Pissarro, Braque, Monet, Derain, Jean Dubuffet, Gauguin, Jean Hélion, Marie Laurencin, Matisse, Ben Nicholson, Yves Tanguy, and Auguste Herbin. Details of provenance are given for each of the paintings, accompanied by quotations by the artists or critics.
1987	London, Barbican Art Gallery. *The Image of London: Views by Travellers and Emigrés, 1550-1920* .
1988, 17 March- 23 April	Lausanne, Galerie Paul Vallotton. *Maîtres suisses et français des XIXe et XXe siècles* [Swiss and French Masters fo the 19th and 20th Century]. 28 p., 31 illus., 12 col. Catalogue

to an exhibition of watercolors, pastels, drawings and sculptures by French and Swiss artists of the cited period, including Derain and Albert Marquet. No text.

1989-90, 15 July- 28 January

Portsmouth, England. City Museum and Art Gallery. *Sculptures of the 20th Century from the Wilhelm Lehmbruck Museum, Duisburg.* Sheffield, England: Graves Art Gallery (14 Sept.-28 Oct. 1989); Cardiff, National Museum of Wales (9 Dec. 1989-28 Jan. 1990). Texts by Christoph Brockhaus, Gottlieb Leinz, Barbara Lepper, Thorsteen Rodiek, and Renate Heidt. 80 p., 71 illus., 21 col. Catalogue to an exhibition of 20th century sculptures and related prints and drawings from the Wilhelm Lehmbruck Museum of Duisburg, Germany, arranged in the following sections: German Expressionism, Cubism, Constructivism, Iron and Steel, Surrealism, Object Art, and the Human Figure. Included works by André Derain and others.

1990, June- September

London, Tate Gallery. *On Classic Ground: Picasso, Léger, de Chirico, and the New Classicism 1910-1930.* Included works by Derain. Review: D. Sutton, *Gazette des Beaux-arts* ser. 6, 119(Jan. 1992):48-56.

1990-91, 4 October- 1 September

Los Angeles, Los Angeles County Museum of Art. *The Fauve Landscape: Matisse, Derain, Braque, and Their Circle, 1904-1908.* Also shown New York, Metropolitan Museum of Art (19 Feb.-5 May 1991); London, Royal Academy of Art (10 June-1 Sept. 1991). Catalogue by Judi Freeman with contributions by Roger Benjamin, James P. Herbert, John Klein, and Alvin Martin. 350 p., col. illus., col. pl. 345 works shown. Reviews: J. Pissarro, *Burlington Magazine* 133(Feb. 1991):144-6; H. Potterton, *Apollo* 133(June 1991):424-5; B. Denvir, *The Artist* 106(Aug. 1991):22-4; J. Phillips, *American Artist* 55(Oct. 1991):48-53[+].

1991, 5 June- 28 December

Boston, Museum of Fine Arts. *Pleasures of Paris: Daumier to Picasso.* Also shown in New York, IBM Gallery of Science and Art (15 Oct.-28 Dec.). Catalogue by Barbara Stern Shapiro, with the assistance of Anne E. Havinga. Essays by Susanna Barrows, Philip Dennis Cate, and Barbara K. Wheaton. Boston: Museum of Fine Arts and David R. Godine, Publisher, 1991. 192 p., illus., col. pl. 1 watercolor by Derain.

1991, 9 June- 11 August

Los Angeles, Los Angeles County Museum of Art. *Monet to Matisse: French Art in Southern California Collections.* Catalogue with texts by Philip Conisbee, Judi Freeman, and Richard Rand. 144 p., illus. Included 1 watercolor by Derain.

1992-93,
11 September-
7 February

Indianapolis, Indianapolis Museum of Art. *The William S. Paley Collection*. Also shown Seattle, Seattle Art Museum (15 Dec.-7 Feb. 1993).

Recent bequest by the late CBS founder and media mogul to New York's Museum of Modern Art. Includes eighty works by Gauguin, Degas, Cézanne, Matisse, Toulouse-Lautrec, Derain, Bonnard, and Rouault.

Kees van Dongen

Biographical Sketch

Cornelius ("Kees") Theodorus Marie van Dongen was born in 1877 at Delfshaven, a suburb of Rotterdam. His father ran a malthouse and Kees quit school at age twelve to work with him. As an adolescent he painted and drew realistic works and was influenced by the French Impressionists. In 1892 he began taking evening classes at the Royal Academy of Fine Arts of Rotterdam, where he studied regularly for the next four years. From 1893-96, Kees worked in a makeshift studio in the attic storeroom of his father's tavern, producing dark landscapes, scenes of people, views of the port, and portraits of family members. He studied classic and contemporary Dutch painters.

In July, 1897 van Dongen settled in Paris and sold sketches to several satirical journals. Though drawing and painting continually, van Dongen earned his living until 1908 by all kinds of odd jobs—lettering for a printer, working as a mover, wrestling in fairs, painting houses, selling newspapers on the streets, and as a stage extra. He married August (Guus) Preitinger in 1901 and became established in the Montmartre artistic milieu. He began to show at the Salon des Indépendants in 1904 and held his first single-artist exhibition at Vollard's gallery in November of that year.

A natural colorist, van Dongen responded enthusiastically to Fauvism. He juxtaposed tones in wide parallel bands with little concern for depth, achieving richness with direct, simple, and concentrated means. Critically acclaimed by Louis Vauxcelles and others, the paintings of the next six or seven years were dominated by the recurring image of a woman with immense eyes and flaming hair, her skin streaked with vibrant yellows, greens, blues, and vermilions. The contours are brutally outlined and the colors, strongly contrasted without modulation, tend to overflow the elliptical and somewhat slack line. The texture is rich and painterly. Sacrificing intellectuality, an intense sensuality emanates from every painting.

In the years before World War I, van Dongen exhibited frequently in Paris and abroad. In 1907, Max Pechstein visited him from Dresden and invited him to show with the Die Brücke group. Two private shows were organized by Daniel-Henry Kahnweiler in 1908, one in Paris and the other in Düsseldorf. Later that year the Galerie Bernheim-Jeune held a very successful individual exhibition. Fame increased and in 1912 he rented a large studio at 33, rue Denfert-Rochereau. He participated in group shows in London, St. Petersburg, and elsewhere that year and held a one-artist exhibition in Brussels. The following year he traveled to Egypt. One of his paintings, *Nude among the Pigeons*, was withdrawn from the Salon d'Automne in violation of decency laws by police order. On the eve of World War I, van Dongen had become an accepted member of the artistic and intellectual circles of Paris and counted many celebrities as friends. Guus and their

daughter Dolly left for Rotterdam in June, 1914 and were forced to remain there because of the war until 1918.

After the war, van Dongen was a fashionable portraitist of Parisian society. He made few concessions to his sitters, neither flattering them nor concealing their physical or moral flaws. He created what became known as the "van Dongen" type—half princess of the international set and half drawing-room prostitute—thin, pallid, with red lips, spindly arms, adorned with sparkling jewels and veiled in silk or tulle or stripped cynically nude. He also produced less provocative portraits touching in their simplicity, although his portraits of Anatole France, the Countess de Noailles, and the politician Charles Rappoport are merciless in their frankness. His few landscapes are painted for pleasure without artifice or display of virtuosity, employing direct and telling forms reduced to essentials.

In 1929 van Dongen received French citizenship. Over the next two decades he showed widely in Europe and in the United States. The Galerie Charpentier held giant retrospectives in 1942 and 1949. In his later work the sensuality, pessimism, dexterity, and verve largely disappeared. He spent his last years, from 1959-68, in Monaco.

Kees van Dongen

Chronology, 1877-1968

Information for this chronology was gathered from Gaston Diehl, *Van Dongen* (New York: Crown Publisher, 1969); Jean Melas Kyriazi, *Van Dongen et le Fauvisme* (Lausanne, Paris: La Bibliothèque des Arts, 1971) and *Van Dongen: après le Fauvisme* (Lausanne: Harmonies et Couleurs, 1976); Anne Devroye-Stilz, "Biographie" in *Van Dongen, le peintre: 1877-1968* (Paris: Musée d'Art moderne de la Ville de Paris, 1990), pp. 223-32; among other sources.

1877-91	Cornelis ("Kees") Theodorus Marie van Dongen is born on January 26 at 96 Voorhaven, Delfshaven, a suburb of Rotterdam. Kees is the second of four children in a middle-class family. His father owns and runs a malthouse. Kees is educated in the standard fashion at the local gymnasium. He quits school at the age of twelve to work with his father. Drawing interests him and he sketches his sister Maggi, his father, and a few landscapes.
1892	At age fifteen he begins taking evening classes at the Royal Academy of Fine Arts of Rotterdam. He studies, more or less regularly, for four years under the direction of J. Striening and J. G. Heyberg.
1893-96	Works in a makeshift studio in the attic storeroom of his family's tavern, where he draws and paints dark landscapes, scenes of people, views of the port of Rotterdam, and portraits of family members. He produces a large-format, blue self-portrait drawing entitled *Chimère*, which he keeps for the rest of his life. In 1952, he makes a smaller version for his studio in Monaco. He studies classic (Rembrandt and Frans Hals) and contemporary Dutch painters (especially George Hendrik Breitner).
1895	Experiments with color. Occasional commissioned. illustrations for the newspaper *Rotterdamsche Nieuwsblad*, including drawings and watercolors of street scenes in Rotterdam.
1896	Leaves the family home and rents a room in a rundown neighborhood of Rotterdam.

1897 Arrives in Paris in July for a visit of several months. He stays with his compatriot, Siebe Ten Cate, at 65, rue de Malte. Although fascinated by Paris, he feels handicapped as an alien. Until 1908, he earns his living with all kinds of small jobs—he does lettering for a printer, works as a mover, a wrestler in fairs, a newspaper vendor in the streets of Paris, a stage extra, a student when he has time, and makes drawings for minor publications.

1898 Participates in an exhibition at Barc de Boutteville (two watercolors). Félix Fénéon, art critic, praises his work. Destitute, he returns to Holland where he continues to paint numerous landscapes, scenes of ports, canals, and farms. He furnishes the *Rotterdamsch Nieuwsblad* with reportorial drawings and illustrates the coronation of Queen Wilhelmina on September 6.

1899 At the Academy, he meets August (Guus) Preitinger, who goes to Paris and finds a job there in October. Kees joins her in Paris in December.

1900 The couple lives on the rue Ordener, then 10 impasse Girardon in Montmartre, where van Dongen keeps a studio for several years. He returns regularly to Holland during vacations. Through Fénéon, he develops a friendship with Maximilien Luce. Kees takes various odd jobs (including a guide at the World's Fair), but draws the bulk of his income from his collaboration with the illustrated journals *L'Assiette au beurre, Froufrou, Le Rabelais, Le Rire, L'Indiscret,* and *Gil Blas,* all of which publish his satiric drawings and sketches. Also, Fénéon introduces him to the journal *La Revue blanche.*

1901 Kees and Guus marry on July 11. Illustrates a special issue (October) of *L'Assiette au beurre* on the lives of prostitutes.

1902-03 Collaborates with various journals and paints continually. Makes initial contacts with Galerie Druet.

1904 Begins to be noticed in the artistic community of Paris. Six paintings (three views of Montmartre and three landscapes) are shown at the Indépendants in February-March, with the help of Luce, and two at the Salon d'Automne in October-November. First individual show (105 works) held in November at Vollard's. Catalogue preface by Félix Fénéon.

1905 Expands his range of subjects to include acrobats, clowns, and equestrians and is well established in the Montmartre artistic milieu. Visits the Médrano circus with Picasso and participates in group shows in January and February at Berthe Weill. Six paintings and two watercolors are shown in March-April at the Indépendants. Birth on April 18 of his daughter Augusta, called Dolly. The family spends part of the summer in Fleury-en-Bière (near Barbizon), where he completes a landscape series. Exhibits two paintings, *Torse* and *La Chemise,* in the scandalous *"cage aux fauves"* room at the October-November Salon d'Automne. At the same time, he holds a one-artist show (nineteen paintings from Fleury

and some watercolors and drawings) at the Galerie Druet. In December, the family moves to the Bateau-Lavoir at 13, rue Ravignon, where the hospitality of his wife gives rise to amiable relations with Picasso, Fernande Olivier, Max Jacob, Paco Durio, and other Montmartre artists.

1906	Participates in the Indépendants with six paintings, one pastel, and one drawing; and in the Salon d'Automne with three paintings. Receives favorable reviews from Louis Vauxcelles. Exhibits sixty-two paintings and eleven drawings at the Kunstring, Rotterdam in May-June. His financial condition improves.
1907	Spends February-August in Holland and shows in Amsterdam. Guus stays longer because of an illness. Daniel-Henry Kahnweiler, who has opened a gallery on the rue Vignon, takes van Dongen under oral contract. Back in Paris in September he lives with a journalist named Cohen in the rue Lamarck, Montmarte. Max Pechstein visits him from Dresden and invites him to show with the German Expressionist Die Brücke group.
1908	Two private shows are organized by Kahnweiler, one at the rue Vignon gallery in March and the other at the Gallery Flechtheim in Düsseldorf in May. Shows six paintings at the Indépendants and four at the Salon d'Automne. Also exhibits in Berlin and with Die Brücke in Dresden. In November he enters into contract with the Galerie Bernheim-Jeune and holds a very successful show (86 works) there in November-December.
1909	Occupies a vast studio at 6, rue Saulnier, where he remains until 1913. Shows at Moscow, Odessa, and at two large Parisian salons. On June 2, he assists at the premiere of Serge Diaghilev's *Cleopatra* ballet at Châtelet. Profoundly moved by the experience, he paints a colorful, dynamic ballet tableaux. Near the end of the year he signs a seven-year contract with Galerie Bernheim-Jeune, negotiated in part by Félix Fénéon.
1910	Takes part in a group show at Berthe Weill's and, in Munich, at the Tannhauser Gallery. Sends two paintings to the Indépendants and two to the Salon d'Automne. Also exhibits in Budapest, Berlin, Prague, St. Petersberg, Riga, Kiev, Düsseldorf, Cologne, and Dresden. Takes short trips to Holland and Italy. Spends the winter in Morocco after having crossed Spain.
1911	Participates in the Indépendants with five paintings, three of which are decorative compositions (*Jaune et bleu, Rouge et jaune, Rouge et bleu*). His painting is deliberately oriented towards a new decorative style. June show at Bernheim-Jeune with an ensemble of works painted in Holland, Paris, Spain, and Morocco. Catalogue introduction by Elie Faure. Sends three paintings to the Salon d'Automne. A new group of twenty-nine paintings and small pictures is exhibited at Bernheim-Jeune in December, for which van Dongen writes the foreword himself ("Avant-propos capricieux").

1912 Rents a large studio at 33, rue Denfert-Rochereau while keeping his apartment on rue Saulnier until May. Participants in group shows in St. Petersburg, London, and elsewhere and sends two paintings to the Salon d'Automne. In October-November, he holds a one-artist show (sixty works) at Galerie Giroux in Brussels. Organizes receptions, costume parties, and lectures at l'Académie Vitti in Montparnasse.

1913 Private show (thirty-seven works) in January-February at Bernheim-Jeune, which includes his first bathers series. Sends two decorative canvases to the Indépendants and three paintings to the Salon d'Automne, one of which is withdrawn by order of the police in violation of decency laws (*Nude among the Pigeons*). Takes his first trip to Egypt in March-April and spends the summer at Deauville with the Desjardins. Van Dongen had become an accepted member of the artistic and intellectual circles of Paris and counts friends among the celebrities of high society.

1914 Guus and Dolly leave for Rotterdam in late June, where they are forced to remain during all of World War I. The family is separated until 1918. Private show in July at the Cassirer Gallery in Berlin.

1916 Due to wartime conditions, Bernheim-Jeune rescinds its contract with van Dongen. Kees meets the fashion director Jasmy Jacob, the Marquise Casati, and other members of the *haut monde*.

1917 Private show (fifty works) in March at the Galerie d'Antin. Begins a liaison with Jasmy Jacob that lasts until 1927. The couple takes up luxurious residence at 29 Villa Saïd.

1918 Exhibition (twenty-five works) at Galerie Paul Guillaume in March, introduced by Guillaume Apollinaire. Contracts with Editions de la Sirène to illustrate *One Thousand and One Nights*. Guus and Dolly return from Holland; Kees continues his relationship with Jacob.

1919 Private shows in Berlin and Düsseldorf. Sends three paintings to the Salon d'Automne. Favorite portraitist of Parisian celebrities.

1920 Participates in the Indépendants (one portrait and a screen) and in the Automne (five portraits). Editions de la Sirène commissions illustrations for an edition of Kipling's stories.

1921 Presents one canvas at the Indépendants. At La Nationale he shows a unflattering portrait of Anatole France that creates a scandal in the press. Private show in March at Bernheim-Jeune. Visits Venice with Michel Georges-Michel, returning with a series of canvases of which sixteen are sold by Bernheim-Jeune in December. Of the five canvases proposed for the Salon d'Automne one, the portrait of the actress Maria Ricotti, is refused. Purchases, in Jasmy's name, a country house at Louvard du Bois de Chigny. The divorce from Guus, who shows her own work at the Galerie Artes, becomes final.

1922	Sends a portrait of a businessman to the Indépendants and his own portrait as Neptune to the Salon d'Automne. With Jasmy's help, he organizes elaborate gatherings and *soirées* and mixes with the Parisian upper class, whose portraits he paints.
1923	Sends portraits to the Salon d'Automne, to La Nationale, and to the Tuileries. In April he shows, in his own studio, a series of canvases painted on the Riviera, and in November, a series of Parisian scenes.
1924	In November, he brings an ensemble of portraits together in his studio.
1925	Private show in March-April at Bernheim-Jeune. Reception show in May in his studio. In November, he shows in his studio illustrations for a deluxe edition of Victor Margueritte's novel *La Garçonne* (published in 1926) and an ensemble dedicated to Versailles, with a preface by Maurice Rostand.
1926	Made a Knight of the Legion of Honor and, the following year, of the Order of the Crown of Belgium.
1927	Show in April at the Stedelijk Museum of Amsterdam, his first museum exhibition. Publishes an autobiographical book about Rembrandt, *La Vie de Rembrandt*. Separates from Jasmy Jacob, although he continues to live at rue Juliette-Lamber. Dolly is now often responsible for organizing his receptions.
1928	Second trip to Egypt in the spring. Works made during the voyage are shown in his studio in November.
1929	Receives French nationality. In May, he begins his elegant Tuesday receptions again. Two works enter the Musée de Luxembourg.
1930	Death of his father. Portrait commissions slow down and he works on a series of illustrations for a book on Deauville commissioned by Paul Poiret, published in 1931.
1931	Shows in May, in his studio, *Trentes ans de peinture* [30 Years of Painting] (64 works). At La Nationale, he shows the portrait of the Comtesse de Noailles, and at the Automne, those of Barthou and Painlevé. In December, an exhibition of thirty works in Amsterdam at Frans Buffa.
1932	Jasmy sells the house on rue Juliette-Lamber and Kees moves to Garches. Liaison with Alicia Alonova and, later, with Arina Gedeonov.
1933	Shows at Georges Bernheim in February (forty canvases).
1934	Rents a studio at 75, rue de Courcelles.
1935	Visits the United States and spends the summer at Deauville.

1936 Léopold III, King of Belgium, commissions a portrait.

1937 Shows at the Palais des Beaux-arts in Brussels, and in New York at the Gimpel Galleries and the Carnegie Institute. Retrospectives in Paris at the Musée Galliéra, in Eindhoven at the Stedelijk van Abbe Museum, and in Amsterdam at the Stedelijk Museum.

1938 Exhibition at the Galerie Borghèse, introduced by Louis Vauxcelles. Meets Marie-Claire, whom he marries in 1953.

1939 Watercolor exhibition at the Rodrigues-Henriques Gallery. Ambroise Vollard dies.

1940 Marie-Claire gives birth to their son, Jean Marie. Daniel-Henry Kahnweiler's gallery closes.

1942 Retrospective at the Galerie Charpentier. Includes 248 works executed over fifty years. Introduction by Sacha Guitry. Visits Germany with other French artists, including Vlaminck and Derain, at the instigation of Arno Breker. Receives criticism for the trip; some boycott his Charpentier show.

1943 Retrospective at the Musée des Beaux-arts in Bordeaux, introduced by Sacha Guitry and Elie Faure.

1944 Death of van Dongen's friend and ardent supporter, Félix Fénéon.

1945 Paints at Deauville and rebuilds a celebrity portrait clientele.

1946 Illustrates Montherlant's *Les Lépreuses*. Guus dies.

1947 Illustrates Proust's *A la recherche du temps perdu*.

1948 Illustrates Voltaire's *La Princesse de Babylone*.

1949 Retrospective at the Galerie Charpentier (251 works), introduced by André Siegfried. Nearly the same works are shown at Rotterdam's Boymans Museum in May, introduced by André Maurois, then at the Kunstzaal in Amsterdam in August. Marie-Claire and Jean Marie move to Monaco, to a villa called "Le Bateau-Lavoir" on the avenue Hector Otto. Van Dongen stays with them during the winter months, but prefers to spend the summer working in Paris or in Deauville. Illustrates Raymond Dorgelès' *Au bon temps de la Butte*.

1950 Jasmy Jacob dies.

1951 Illustrates Anatole France's *La Revolte des anges*.

1952 Shows in February at the Galerie Pétridès.

| 1953 | Exhibition at the Galerie de Berri in October dealing with the Fauve period. Show at New York's Wildenstein Gallery. Marries Marie-Claire and spends more time in Monaco. |

1953 Exhibition at the Galerie de Berri in October dealing with the Fauve period. Show at New York's Wildenstein Gallery. Marries Marie-Claire and spends more time in Monaco.

1954 Shows at the O'Hara Gallery in London.

1959 Retrospective at the Musée des Ponchettes in Nice, introduced by Jean Cocteau and Louis Chaumeil. This show is transferred, with some modifications, to the Musée Rath in Geneva. Moving out of his studio on the rue de Courcelles, van Dongen resides permanently in Monaco except for occasional visits to Deauville through 1963.

1960 Retrospective at the Musée d'Albi, introduced by Paul Guth.

1963 Exhibits in Paris at Galerie Jacques Chalom.

1964 Retrospective, introduced by René Deroudille, at the Musée des Beaux-arts in Lyon (86 works). Another retrospective at Charleroi's Palais des Beaux-arts.

1965 Shows in New York at the Leonard Hutton Gallery.

1967 Retrospective, introduced by Bernard Dorival, in October at the Musée National d'Art moderne in Paris, which is transported in December to the Boymans-van Beuningen Museum in Rotterdam.

1968 Van Dongen is hospitalized several times and dies at age 91 at his home in Monaco on May 28.

Kees van Dongen

Bibliography

I. Statements and Interviews by van Dongen

2387. DONGEN, KEES VAN. "Neurasthénie parce que nous sommes trop raisonnables." *L'Intransigeant* (4 April 1924).

2388. DONGEN, KEES VAN and M. VALOTAIRE (Interviewer). "An Interview with Kees van Dongen." *Drawing and Design* (London) 1:3(Sept. 1926):83-6.

2389. DONGEN, KEES VAN. *Van Dongen raconte ici la vie de Rembrandt et parle à ce propos de la Hollande, des femmes et de l'art.* Paris: Flammarion, 1927. 160 p.

Review: R. Jean, *Comœdia* (10 Nov. 1927):2.
a. Reprint: *The Complete Etchings of Rembrandt.* Edited by Bruce and Seena Harris. Introduction by Frank Getlein. With an appreciation by Kees van Dongen. New York: Bounty Books, 1970. 251 p., illus.

2390. DONGEN, KEES VAN. "Vacances de peintre, aux Dames de France." *L'Intransigeant* (15 Oct. 1928).

2391. DONGEN, KEES VAN. "La Beauté d'aujourd'hui." *Conférencia* (20 Dec. 1928).

2392. DONGEN, KEES VAN. "La Troisième rue." *L'Intransigeant* (11 March 1929).

2393. DONGEN, KEES VAN. "Quand van Dongen fait son cours de maquillage." *L'Intransigeant* (20 June 1932):2.

2394. DONGEN, KEES VAN. "La Côte d'Azur et les estivants." *Le Journal* (11 Aug. 1934).

2395. DONGEN, KEES VAN. "Nouveaux riches." *Le Journal* (4 Aug. 1936).

2396. DONGEN, KEES VAN. "Peindre, conseils pratiques." *Revue mieux vivre* 3(March 1937).

2397. DONGEN, KEES VAN and PAULE CORDAY (Interviewer). "Kees van Dongen." *La Presse* (10 Dec. 1946).

2398. DONGEN, KEES VAN and JEAN PALAISEUL (Interviewer). "Kees van Dongen." *Noir et blanc* (13 April 1949).

2399. DONGEN, KEES VAN and JEAN BOURET (Interviewer). "Kees van Dongen." *Les Arts* (12 Jan. 1952).

2400. "Kiki's Memoirs." *Time* 59(17 March 1952):64+.

2401. BAROTTE, RENE. "Van Dongen: 'Ce n'est pas vrai je n'ai pas encore 75 ans.'" *France-soir* (29 March 1952).

2402. DONGEN, KEES VAN and RENE BERNARD (Interviewer). "Van Dongen: dernier des Fauves et l'un des premiers exposants à l'automne: 'les salons sont inutiles.'" *Arts* (Oct.-Nov. 1959).

2403. MULLEN, R. M. "Van Dongen Remembers." *Réalités* 15(June 1960):64.

2404. DONGEN, KEES VAN and PIERRE CABANNE (Interviewer). "Interview de van Dongen." *Les Arts* (14-20 Sept. 1960).

2405. DONGEN, KEES VAN and MADELEINE CHAPSAL (Interviewer). "Entretien." *L'Express* (27 June 1963).

2406. PERRUCHOT, HENRI. "Van Dongen me disait." *Jardin des arts* (July-Aug. 1967):16-25.

2407. BOGGS, JEAN SUTHERLAND. "Van Dongen's *Souvenir de la saison d'opéra russe*, 1909." *National Gallery of Canada Bulletin* 6(1968):14-9.

2408. DONGEN, KEES VAN. "La Vita di Rembrandt." *Civiltà delle Macchine* 18:2(March-April 1970):37-50.

"The text, written by van Dongen in 1927, has been translated into Italian by Orfeo Tamburi, and has been printed here for the first time together with drawings expressly done by Tamburi."

II. Archival Materials

2409. DONGEN, KEES VAN. *Letters*, 1912-52. 15 items. Holographs, signed. Located at The Center for the History of Art and the Humanities, Archives of the History of Art, Santa Monica, California.

Collection includes one letter to an unnamed correspondent, stating that he is unsure which is the ugliest monument in Paris and proposing candidates for this distinction (1919); one letter to Georges Armand Masson concerning the purchase of a painting (1952); one detailed autobiographical letter to an unspecified friend, recounting his difficult childhood and his earliest artistic endeavors (n.d.); one card to art critic Félix Fénéon (1907); one letter to the editor of *Les Nouvelles litteraires*, proposing to write an article on Anatole France (1924); one letter (illustrated) to a critic commenting on a recent article in *France-Hollande* (1920); one letter to Paul Signac, reporting on the anticipated defense of the Salon des Indépendants by the government official Paul Boncourt (1912); and several personal letters conveying greetings and arranging social gatherings.

2410. COQUIOT, GUSTAVE. *Letters*. 2 items. Holographs. Located at The Getty Center for the History of Art and the Humanities, Archives of the History of Art, Santa Monica, California.

Coquiot (1865-1926) was a French art critic and playwright. These two letters concern the preface for a catalogue on which he is working, and the sale of works by Henri Epstein, Marie Laurencin, Othon Friesz, and Kees van Dongen.

2411. DEZARROIS, ANDRE. *Letters Received*, 1913-59. ca. 100 items. Holographs. Located at The Getty Center for the History of Art and the Humanities, Archives of the History of Art, Santa Monica, California.

Dezarrois (1890-1939) was editor of the *Revue de l'art ancien et moderne*, administrator of the Fondation americaine pour la pensée et l'art français (Fondation Blumenthal), and director of the Musée du jeu de paume, Paris.

Includes four letters received from Kees van Dongen and two from Othon Friesz, among others.

2412. LUCE, MAXIMILIEN. *Letters, Sketches, and Exhibition Catalogues*, 1899-1930. ca. 20 items. Holographs, signed; sketches; printed materials. Located at The Center for the History of Art and the Humanities, Archives of the History of Art, Santa Monica, California.

Luce (1858-1941) was a French painter and lithographer. Collection includes 14 letters (some illustrated), three small sheets of sketches, and four catalogues from

private gallery exhibitions. The letters generally concern personal matters with some mention of work in progress. One letter to Charlot contains brief references to paintings seen during travels, while one letter to Aynaud mentions plans to visit Holland with Kees van Dongen and Ludovic-Rodo (n.d.) Other correspondents are Miguet, Oulevey, Charles Remond, and Camille Pissarro. The sketches include a seascape, a landscape, and figure drawings. The four catalogues range in date from 1899 to 1930, with one containing illustrations and an essay by Gustave Geoffroy (1907).

2413. ROUDINESCO, ALEXANDRE. *Letters Received*, 1918-49. 74 items. Holographs, signed. Located at The Getty Center for the History of Art and the Humanities, Archives of the History of Art, Santa Monica, California.

Dr. Roudinesco (1883-) was a Parisian art collector. Collection consist of letters to Roudinesco from various Fauve painters. Most date from the 1930s and represent an unusually intimate and informative relationship between artist and patron. Letters include 30 from Maurice de Vlaminck (1932-49); 28 from Raoul Dufy (1918-36); 8 from Paul Signac (1926-34); 6 from Kees van Dongen (1930); and 2 from Georges Rouault.

2414. TURPIN, GEORGES. *Papers*, 1917-52. 218 items. Holographs, typescripts. Located at The Getty Center for the History of Art and the Humanities, Archives of the History of Art, Santa Monica, California.

Turpin (b. 1885) was a French art critic and dealer. The collection consists of about 190 letters received and six essays ranging from critical studies to eulogies of contemporary artists. The letters involve Turpin's work as art critic for the journals *La Ville de Paris* and *La Revue moderne*, as well as business related matters for the Galerie Sélection of Tunis. Dating mostly from the 1930s and 1940s, the letters are from over 50 correspondents, mostly artists, and concern reviews, exhibitions, sale of paintings and publications, often containing musings on artistic theory or practice. Several of the letters are in response to an "enquête" on "la strategie artistique." Correspondents include Kees van Dongen, among others.

III. Biography and Career Development

Books

2415. ADRICHEM, JAN VAN, DONALD KUSPIT, and MICHEL HOOG. *Kees van Dongen*. Rotterdam: Museum Boymans-van Beuningen, 1991. 168 p., 85 illus., 53 col.

2416. BRODSKAYA, NATALIA. *Van Dongen*. Introduction and Selections by Natalia Brodskaya. Trans. by Yuri Pamfilov. Leningrad: Aurora, 1987. 22p., illus., 10 pl., some col. Volume in "Masters of World Painting" series.

2417. CHAUMEIL, LOUIS. *Van Dongen, l'homme et l'artiste; la vie et l'œuvre*. Geneva, Paris: Cailler, 1967. 327 p., 175 illus., 132 col. pl.
Volume in "Peintres et sculpteurs d'hier et d'aujourd'hui" series.

Heavily illustrated and informative work on van Dongen.

2418. DES COURIERES, EDOUARD. *Van Dongen*. Paris: Henri Floury, 1925. 43 p., illus., 108 pl., some col.

2419. DIEHL, GASTON. *Van Dongen*. Paris: Flammarion, 1968. 94 p., illus., some col. Volume in "Les Maîtres de la peinture moderne" series.

a. Another ed.: 1976.
b. German ed.: *Van Dongen*. Trans. by Sabine Ibach. Munich: Südwest, 1968. 94 p., illus. Volume in "Meister der modernen Malerei" series.
c. English ed.: *Van Dongen*. Trans. by Stephanie Winston. Milan: Uffici Press, 1968. 94 p., illus.
d. Italian ed.: *Van Dongen*. Milan: Uffici Press, 1968. 94 p., illus.
e. U.S. ed.: *Van Dongen*. New York: Crown, 1969. 94 p., illus.

2420. FIERENS, PAUL. *Van Dongen, l'homme et l'œuvre*. Paris: Les Ecrivans Réunis, 1927. 17 p., 29 illus. Text originally published in *Art et décoration* 44:289(Jan. 1926):23-32.

a. Another ed.: 1929.

Articles

2421. ALLARD, ROGER. "Van Dongen." *L'Art d'aujourd'hui* 17(1928).

Special issue devoted to van Dongen.

2422. APOLLINAIRE, GUILLAUME. "Van Dongen." *L'Intransigeant* (6 Feb. 1913).

2423. BAROTTE, RENE. "Van Dongen dans tout son éclat." *L'Aurore* (8 Nov. 1972).

2424. BAZIN, GERMAIN. "Van Dongen." *L'Amour de l'art* 14:5(May 1933), pp.125-8.

Includes a bibliographical note and bibliography by Bazin and Charles Sterling. Reprinted in René Huyghe, *Histoire de l'art contemporain: la peinture* (Paris: Félix Alcan, 1935):125-8.

2425. BAZIN, GERMAIN. "Van Dongen." *L'Amour de l'art* (May 1953):4, 125-7.

2426. BESSON, GEORGE. "Van Dongen." *Les Lettres françaises* (12 Nov. 1953).

2427. BESSON, GEORGE. "Quand van Dongen revient à ses origines." *Les Lettres françaises* (12 Nov. 1953).

2428. BOURET, JEAN. "Van Dongen." *Arts* (12 Jan. 1952).

2429. CABANNE, PIERRE. "Arrivé de Hollande en sabots, il y a cinquante ans, van Dongen est le plus Parisien des peintres." *Arts de France* (24 Feb. 1955):46-9.

2430. CABANNE, PIERRE. "Un Fauve, un Fauve nommé van Dongen." *Lecture pour tous* 115(July 1963):34-41.

2431. CARDINAL, HUBERT. "Van Dongen, le Hollandais violent." *Le Figaro littéraire* (16 Oct. 1962):42-3.

2432. CHABRUN, JEAN-FRANÇOIS. "Van Dongen retrouve son passé." *Match* (10 Oct. 1959):66-77.

2433. CHARENSOL, GEORGES. "Chez van Dongen." *Paris Journal* (11 Jan. 1924).

2434. CHARENSOL, GEORGES. "Van Dongen n'a jamais cessé d'être un Fauve." *Plaisir de France* (Oct. 1967):36-41.

2435. CHAUMEIL, LOUIS. "Van Dongen et le Fauvisme." *Art de France* 1(1961):386-9.

2436. CHRISTLIEB, WOLFGANG. "Kees van Dongen, der elegante Fauve." *Die Kunst und das schöne Heim* 2(Aug. 1966):456-8.

2437. COLOMBIER, PIERRE DU. "Van Dongen." *Beaux-arts* (10 Nov. 1942):8-9.

2438. CORDAY, PAULE. "Van Dongen." *La Presse* (10 Dec. 1946).

2439. CRESPELLE, JEAN-PAUL. "Van Dongen, se penche sur sa folle jeunesse." *France-soir* (17 Oct. 1953).

2440. DAIREAUX, MARX. "Van Dongen." *Comœdia* (14 April 1923).

2441. DALEVEZE, JACQUES. "Un Fauve mal apprivoisé." *Le Figaro littéraire* (12 Aug. 1969):8.

2442. DES COURIERES, EDOUARD. "Van Dongen." *L'Art vivant* 6(1925):5-7.

2443. DESCARGUES, PIERRE. "Racontez docteur Roudinesco." *Arts Magazine* 204(Feb. 1969):68+.

2444. DESCARGUES, PIERRE. "Racontez docteur Roudinesco (votre collection? j'ai vendu)." *Connaissance des arts* (Feb. 1969):68-73.

2445. DESTEZ, ROBERT. "Un soir chez van Dongen." *Le Figaro* (9 May 1929):2.

2446. DIEHL, GASTON. "Kees van Dongen." *Les Nouvelles littéraires* (13 June 1968):8.

2447. DUTOUR, JEAN. "Le Nonagénaire resplendissant." *Nice-Matin* (2 March 1968).

2448. ENGELMAN, JAN. "Van Dongen." *Kronick van Kunst en Kultur* (Jan. 1938).

2449. ERTEL, K. F. "Kees van Dongen anlässlich seines 90. Geburtstages." *Kunst* 65(1966-67):567-70.

2450. FELS, FLORENT. "Van Dongen." *Arts-documents* 25(Oct. 1952):10-1.

2451. FIERENS, PAUL. "Van Dongen, l'homme et l'œuvre." *Art et décorations* 44:289(Jan. 1926):23-32.

2452. FLAMENT, ALBERT. "Van Dongen, le surprenant." *La Revue de Paris* (15 July 1923):452-5.

2453. FLAMENT, ALBERT. "Visite chez van Dongen." *La Revue de Paris* (July 1923).

2454. FOURNIER, C. "Van Dongen: jeune homme à barbe blanche a fait le portrait d'une époque." *France illustration* 5(8 Jan. 1949):43-5.

2455. GAUTHIER, MAXIMILIEN [MAX GOTH]. "Van Dongen et la police." *Les Hommes du jour* (22 Nov. 1913).

2456. GAUTHIER, MAXIMILIEN [MAX GOTH]. "Notice bibliographique." *L'Art vivant* (1 May 1930):392-418.

2457. GAUTHIER, MAXIMILIEN [MAX GOTH]. "Justice pour van Dongen." *Les Arts* (1 Dec. 1966).

2458. GEORGES-MICHEL, MICHEL. "Réouverture chez van Dongen." *L'Œuvre* (15 May 1925).

2459. GEORGES-MICHEL, MICHEL. "Kiki, peintre mondain." *Le Quotidien* (7 Feb. 1926):2.

2460. GEORGES-MICHEL, MICHEL. "Van Dongen. Venu à Paris pour trois jours, peint chez nous depuis 70 ans." *L'Aurore* (5 April 1967):7-10.

2461. GROOS, G. J. "Van Dongen et le temps présent." *Paris-midi* (30 Oct. 1936):2.

2462. GSELL, PAUL. "Van Dongen." *La Renaissance de l'art français* (1925):62-79.

2463. HOOG, MICHEL. "Van Dongen" in *Encyclopédie de la Pléiade-Histoire de l'art* (Paris: Gullimard, 1969), vol. 4, pp. 560-4.

2464. IMBOURG, PIERRE. "Van Dongen." *Le Journal de l'amateur d'art* (28 March 1955):10-1.

2465. JEAN, RENE. "Rembrandt et van Dongen." *Comœdia* (10 Nov. 1927):2.

2466. JEANNEAU, CHARLES G. "Le Peintre Kees van Dongen." *Gil Blas* (11 June 1911).

2467. JEANNEAU, GUILLAUME. "Van Dongen." *Renaissance* (1920):376-82.

2468. LE TARGAT, FRANÇOIS. "Kees van Dongen: le regard Fauve" [Kees van Dongen: The Wild Look]. *Beaux-arts magazine* 26(July-Aug. 1985):46-55, 114. 14 illus.

With reference to an exhibition at Saint-Tropez of paintings by the Dutch artist Kees van Dongen (1877-1968), Le Targat traces van Dongen's career from his arrival in Montmartre at the age of 20. His relationships with Luisa Casati and Marie-Claire, and the work produced in the course of these relationships, are described in detail. Van Dongen is seen as a Frenchman and as a figure of critical controversy. In a separate text, the author describes the atmosphere of Cannes and Deauville in van Dongen's time and the artist's affection for these places.

2469. LEBESQUE, MORVAN. "Van Dongen." *L'Express* (31 May 1962):30.

2470. MAZARS, PIERRE. "Van Dongen, le Fauve devenu vieux." *Le Figaro littéraire* (14 June 1968).

2471. MEGRET, FREDERIC. "Van Dongen, le 'Fauve' perdu dans les boudoirs." *Le Figaro littéraire* (19 Aug. 1964).

2472. MEYDEN, HANS VAN DER. "Kees van Dongen: From Wild Beast to Servant of Mammon." *Apollo* 131(March 1990):192-4.

Article occasioned by the van Dongen exhibition at the Museum Boymans van Beuningen, Rotterdam.

2473. "Le Modèle le plus insaisissable du monde: Jean-Marie van Dongen, deux ans." *Toute la vie* (5 Oct. 1942).

2474. Obituaries: Raymond Cogniat, "Mort de van Dongen." *Le Figaro* (29 May 1968); Jacques Michel, "Van Dongen est mort, le dernier des Fauves." *Le Monde* (30 May 1968):15; Jean Chabanon, "28 mai." *Le Peintre* (1 June 1968):11; Gaston Diehl, "Le Rire jaune de van Dongen." *L'Œil* (13 June 1968):8; Gaston Diehl, "Kees van Dongen." *Les Nouvelles littéraires* (13 June 1968):8; Pierre Mazars, "Van Dongen, le Fauve devenu vieux." *Le Figaro littéraire* (14 June 1968).

2475. OCHSE, M. "Van Dongen (1877-1968): le maître des fêtes contemporaines" [Van Dongen (1877-1968): The Master of Contemporary Festivals]. *Jardin des arts* 216(Jan.-Feb. 1973):54-9. 6 illus.

2476. O'HARA, FRANK. "Kees van Dongen." *Art News* (Jan. 1954):64.

2477. PALAISEUL, JEAN. "Van Dongen." *Noir et blanc* (13 April 1949).

2478. PERRUCHOT, HENRI. "Kees van Dongen." *Les Nouvelles littéraires* (7 Aug. 1958).

2479. POULAIN, GASTON. "Kees van Dongen." *Les Lettres françaises* (April 1960).

2480. RAYNAL, MAURICE. "Van Dongen chez les Fauves." *Le Peintre* 42(1952):9-10.

2481. REUILLARD, GABRIEL. "Kees van Dongen." *Paris-Normandie* (29 April 1952).

2482. SCHILPEROORT, TOM. "Van Dongen." *Op de Hoogte* 2(1905):735-9.

2483. SIEGFRIED, ANDRE. "Kees van Dongen." *Réalités* (July 1959).

2484. SPEENHOFF, JACOBUS HENDRICUS. "Van Dongen" in *Groot Nederland* (1939), vol. 1, pp. 333-4.

2485. STALTER, KARL-ANDRE. "Van Dongen" in *Petit Larousse de la peinture* (Paris: Larousse, 1979), p. 1895.

2486. TORDAY, SANDOR. "Van Dongen." *Phoenix* (Sept. 1949).

2487. TREVES, ANDRE. "Il y a cinq ans mourait au dernier jour de mai: Kees van Dongen." *Le Peintre* 473(15 Nov. 1973):10-4. 3 illus.

Sets out the various stages of van Dongen's life, relating them briefly to developments in his painting, and stresses that van Dongen remained true to his own conception of painting throughout his career.

2488. "Van Dongen." *Bulletin de la vie artistique* (1921):111.

2489. "Van Dongen et le Fauvisme." *Les Arts* (1961).

2490. "Van Dongen et Mary Glory." *Le Figaro* (19 Dec. 1936):1.

2491. WARNOD, ANDRE. "Chez van Dongen." *Conférencia* (20 Dec. 1929):49-57.

2492. WELLING, DOLF. "De Wilde Jaren van Kees van Dongen." *Kunst Beeld* (Dec. 1939):16-20.

2493. WENTINCK, CHARLES. "Kees van Dongen." *Septentrion* 1(May 1977):117-85.

2494. WERNER, ALFRED. "Kees van Dongen." *Arts Magazine* 40(Dec. 1965):19-21.

IV. Works (Œuvre)

Books

2495. BRODSKAYA, NATALIA. *Van Dongen dans les musées d'U.R.S.S.* Leningrad, 1987.

2496. DEVROYE, ANNE. *L'Œuvre de Kees van Dongen jusqu'en 1920*. M.A. thesis, Paris, L'Ecole du Louvre, 1984.

2497. DOELMAN, CORNELIUS. *Van Dongen schilder*. Rotterdam; Antwerp: Donker, 1947.

2498. LOUP, FRANÇOIS. *L'Influence de Paris sur Kees van Dongen*. Thesis, Université de Paris-Sorbonne, 1971.

2499. MELAS-KYRIAZI, JEAN. *Van Dongen et le fauvisme*. Lausanne, Paris: La Bibliothèque des Arts, 1971. 150 p., illus. Préface de Dolly A. van Dongen.

2500. MELAS-KYRIAZI, JEAN. *Van Dongen après le fauvisme*. Lausanne: Harmonies et Couleurs; Paris: Vilo, 1976. 147 p., illus., some col.

Analysis of van Dongen's work after 1914. The first portion of the painter's career was discussed by the author in *Van Dongen et le fauvisme* (Lausanne: La Bibliothèque des Arts, 1971). Includes a bibliography and exhibitions list.

2501. NEVEJEAN, GENEVIEVE. *Le Portrait féminin dans l'œuvre de Kees van Dongen*. M.A. thesis, Paris, Université de la Sorbonne, 1983.

2502. WENTINCK, CHARLES. *Van Dongen*. Amsterdam: J. M. Meulenhoff, 1963. 39 p., illus., 4 col., 20 pl. In Dutch. Volume in "Bildende Kunst und Baukunst in den Niederlanden" series.

a. French ed.: *Van Dongen*. Amsterdam: Les Beaux-arts aux Pays-Bas, 1963.
b. English ed.: *Van Dongen*. Trans. by James Brockway. Amsterdam: J. M. Meulenhoff, 1964. 34 p., illus., 4 col., pl.
c. German ed.: *Van Dongen*. Amsterdam: J. M. Meulenhoff, 1964. 39 p., illus., 4 col., 20 pl.

Articles

2503. ALVARD, JULIEN. "Paris: Van Dongen's Vamps." *Art News* 66:8(Dec. 1967):19, 60.

2504. APOLLINAIRE, GUILLAUME. "Kees van Dongen." *L'Intransigeant* (13 Dec. 1911).

2505. APOLLINAIRE, GUILLAUME. "Van Dongen." *Les Arts à Paris* 1(15 March 1918):6-9.

Reprint of Apollinaire's preface to the catalogue of an exhibition held at Galerie Paul Guillaume.

2506. BERTHELOT, PIERRE. "L'Atelier de van Dongen." *Beaux-arts* 8(July 1929):24-5.

2507. BUCHWALD. "Van Dongen." *New York Herald Tribune* (14 Aug. 1954).

2508. C., J. R. "Le Monde de van Dongen." *Le Figaro* (7 Jan. 1970):25.

2509. "Carnegie Purchases a van Dongen Portrait: *E. Berry Wall.*" *Art News* 37(28 Jan. 1939):17.

2510. DAVIS, F. "Talking about Sale-Rooms." *Country Life* 148(2 July 1970):16; 150(19 Aug. 1971):443.

Discusses the sales of van Dongen's *La Femme aux colonnes* and *Near the Pyramids*.

2511. DEFLIN, EMILE. "La Pudeur du Commissaire." *L'Intransigeant* (15 Nov. 1913):1.

Concerns the withdrawal, by police order, of van Dongen's painting *Nude among the Pigeons* from the 1913 Salon d'Automne.

2512. DELCOURT. "La Liberté dans l'art." *Paris-Midi* (15 Nov. 1913):1.

Concerns the withdrawal, by police order, of van Dongen's painting *Nude among the Pigeons* from the 1913 Salon d'Automne.

2513. DIEHL, GASTON. "Le Rire jaune de van Dongen." *L'Œil* (13 June 1968):8.

2514. DUNCAN CAROL. "Virility and Domination in Early Twentieth-Century Vanguard Painting" in *Feminism and Art History: Questioning the Litany*. (New York: Harper & Row, 1982). 18 illus. Presviously published in *Artforum* 12(Dec. 1973):30-39.

In the decade before World War I, Matisse, Vlaminck, Picasso, van Dongen, Kirchner, Heckel and many other vanguard artists painted scores of pictures in which women are portrayed as powerless, dehumanized and sexually subjugated beings. This essay discusses the male sexual fears and fantasies embodied in these works and locates them in an historical context. At a time when many progressive voices were recognizing women as the human equals of men, the claims of these works appear culturally regressive and historically reactionary. The intensified and desperate reassertions of male cultural supremacy that permeate so much of early 20th century culture are both responses to and attempts to deny the new possibilities history was unfolding. In this light, the notion of the avant-garde artists as a socially liberated or radical individual must be critically examined. Duncan contends that in their paintings, vanguard artists were as willing as their wealthy patrons to exploit those below them on the social scale for the sake of their own interests.

2515. GSELL, PAUL. "Le Peintre des névroses élégantes—van Dongen." *La Renaissance de l'art français* (1929):63-74.

2516. GUERMANTES. "Le Bateau-Lavoir de van Dongen." *Le Figaro* (4 May 1959):1.

2517. GUILLEMOT, MAURICE. "Exposition K. van Dongen." *L'Art et les artistes* (1905):91.

Reviews the van Dongen exhibition at Galerie Druet, Paris.

2518. HEIJBROEK, J. F. "Een onbekend portret van Fritz Mannheimer door Kees van Dongen" [Unknown Portrait of Fritz Mannheimer by Kees van Dongen]. *Bulletin van het Rijksmuseum* 35:4(1987):329-33, 349-50. 3 illus. In Dutch, summary in English.

Noting the scarcity of portraits of the collector Dr. Fritz Mannheimer (1890-1939), Heijbroek describes a photographic reproduction of a portrait by Kees van Dongen, painted around 1930 and exhibited in 1937, but since lost. He relates the circumstances of the portrait commission.

2519. HENAIOT, EMILE. "Van Dongen, le peintre à la mode." *Paris-midi* (9 March 1921).

2520. HILD, ERIC. "Kees van Dongen" in *Catalogue du musée de l'Annonciade, Saint-Tropez* (Nice: Le Musée, 1989), pp. 263-5.

2521. HOOG, MICHEL. "Repères pour van Dongen." *La Revue de l'art* 12(1471):93-7.

2522. LAZAREFF, PIERRE. "Van Dongen a repris ses réceptions et d'autres peintres connus l'imitent." *Paris-midi* (11 May 1929):2.

2523. LEIGHTEN, PATRICIA. "The White Peril and l'art nègre: Picasso, Primitivism, and Anticolonialism." *Art Bulletin* 72(Dec. 1990):609-30.

Discusses van Dongen's *Le Peril blanc*, pp. 610[+].

2524. LEVEQUE, JEAN-JACQUES. "Van Dongen: un peintre Janus." *Galerie* 120(Oct. 1972):34. 2 illus.

Brief article occasioned by the exhibition of van Dongen's work at the Salon d'Automne, Paris, in which Levêque argues that van Dongen's work should be seen in two distinct phases: the early, experimental phase, which showed his true ability, and the later, very popular phase when he aimed to please.

2525. LEVIN, KIM. "Wild Beast of High Life." *Art News* 64:8(Dec. 1965):28-9.

2526. MONTBORON. "Une fête champêtre chez van Dongen." *Comœdia* (16 July 1921).

2527. PARINAUD, ANDRE. "Riscoperta di van Dongen." *Arti* 17:10(1967):13-7.

2528. "Patrons Art Fund Purchase: *Portrait of E. Berry Wall* by Cornelius T. M. Van Dongen." *Carnegie Museum* 12(Jan. 1939):147-8.

2529. "*Portrait of E. Berry Wall* by van Dongen Bought for the Carnegie." *Art Digest* 13(15 Feb. 1939):21.

2530. SANSOM, WILLIAM. "Van Dongen's Land." *Réalities* (June 1971):70-1. 1 illus.

2531. SCHAEFER, PATRICK. "Van Dongen, le Fauve." *L'Œil* 418(May 1990):52-7. 8 illus., 5 col.

Reappraisal of the painting of Kees van Dongen (1877-1968) on the occasion of an exhibition of his work at the Musée d'Art moderne de la Ville de Paris, Paris (23 March-17 June 1990). Van Dongen left his native Rotterdam for Paris in 1897 and soon established contacts with the French avant-garde, becoming involved in early Fauvism and adhering to its style up until the First World War. His early recognition led to exhibitions throughout Europe as early as 1910 and to considerable popularity of his works on the art market. However, after the War he moved away from the intellectual concerns of his companions and devoted himself exclusively to portraits of the privileged in fashionable Parisian society.

2532. SHIKES, RALPH E. and STEVEN HALLER. "The Art of Satire: Painters and Caricaturists and Cartoonists.' *Print Review* 19(1984):8-125.

Discusses Kees van Dongen's *Le Peril blanc* and *Cocotte* on pp. 58-9.

2533. SUTTON, DENYS. "A Diamond as Big as the Ritz: Kees van Dongen." *Apollo* 93(Jan. 1971):36-43. 15 illus.

Reprinted in the van Dongen exhibition catalogue, Tucson, University of Arizona Museum of Art (1971).

2534. VAUXCELLES, LOUIS. "Van Dongen." *Gil Blas* (4 March 1908).

2535. VAUXCELLES, LOUIS. "Van Dongen." *Gil Blas* (4 Dec. 1908).

2536. VAUXCELLES, LOUIS. "Van Dongen." *Gil Blas* (30 Jan. 1913).

2537. VAUXCELLES, LOUIS. "Van Dongen." *Beaux-arts* (21 Oct. 1938):4.

2538. VERVOOT, ANDRE. "Un peu de pudeur." *Paris-Journal* (15 Nov. 1913).

Concerns the withdrawal, by police order, of van Dongen's painting *Nude among the Pigeons* from the 1913 Salon d'Automne.

2539. "Vus par van Dongen." *Fémina* (May 1946):67-70.

2540. WALEFFE, MAURICE DE. "Vernissage chez van Dongen." *Paris-midi* (20 Nov. 1924).

2541. WARNOD, ANDRE. "Un vernissage chez van Dongen." *Comœdia* (17 Nov. 1928).

2542. WENTINCK, CHARLES. "Van Dongen, avant-propos." *Marseille* 78(1969):41-4.

Reprints the text of the catalogue of the van Dongen exhibition in Marseille at the Musée Cantini in 1969.

V. Illustrated Books

2543. MARDRUS, DR. *Hassan Baddredine-el-Bassraoui. Les Contes des mille et une nuits.* Paris: Les Editions de la Sirène, 1918. 200 p., illus., some col.

2544. KIPLING, RUDYARD. *Les Plus beaux contes.* Paris: La Sirène, 1920.

2545. DONGEN, KEES VAN. *Venise 1921.* Seize reproductions d'après les tableaux de van Dongen. Texte de Gérard Bauer. Paris: Bernheim-Jeune, 1921. 7 p., 16 pl.

2546. LECLERE, PAUL. *Venise, seuil des eaux.* Paris: A la Cité des Livres, 1925.

2547. MARGUERITE, VICTOR. *La Garçonne, roman.* Paris: Flammarion, 1926. 311 p.

2548. COQUIOT, GUSTAVE. *En suivant la scène.* Paris: Delpeuch, 1926.

Includes one illustration by van Dongen.

2549. COCTEAU, JEAN, MARC RAMO, and WALDEMAR GEORGE. *Maria Lani.* Paris: Editions des Quatre Chemins, 1929. 20 p., 51 pl.

Includes one illustration by van Dongen.

2550. MURAT, PRINCESSE LUCIEN, et al. *Réflections sur l'hiver.* Paris: Grande Maison de Blanc, 1930.

Includes one illustration by van Dongen.

2551. POIRET, PAUL. *Deauville.* Paris: Trémors, 1931.

2552. MONTHERLANT, HENRY DE. *Les Lépreuses.* Paris: Nouvelle Revue Française, 1946.

2553. PROUST, MARCEL. *A la recherche du temps perdu.* Paris: Gallimard, 1947.

Review: F. Davis, *Country Life* 160(30 Sept. 1976):878.

2554. VOLTAIRE. *La Princesse de Babylone.* Paris: Scripta et Picta, 1948.

2555. DORGELES, ROLAND. *Au bon temps de la Butte.* Paris: Nouvelle Librairie de France, 1950.

2556. FRANCE, ANATOLE. *La Révolte des anges.* Paris: Scripta et Picta, 1951.

2557. *Sous le signe de quelques jolies filles des provinces de France.* Paris: Nicolas, 1953.

2558. MARDRUS, DR. *Le Livre des mille et une nuits.* Paris: Nouvelle Revue Française, 1955.

2559. GUTH, PAUL and ANDRE SIEGFRIED. *Eloge de Van Dongen.* Avant-propos d'André Siegfried. Lithographies originales en couleurs. Paris: Manuel Bruker, 1957. 53 p., col. illus.

2560. BAUDELAIRE, CHARLES. *Les Fleurs du mal.* Paris: Gallimard, 1963.

VI. Mentions

Books

2561. CACHIN, FRANÇOISE. *Paul Signac.* Paris: Bibliothèque des Arts, 1971. 141 p., illus., some col.

a. U.S. ed.: Trans. by Michael Bullock. Greenwich, CT: New York Graphic Society, 1971. 141 p., illus.
b. Italian ed.: Milan: Silvano Editoriale d'Arte, 1971. 141 p., illus.

2562. CHABERT, PHILIPPE. *Donation Pierre et Denise Lévy, Musée d'Art moderne, Troyes.* Troyes: Le Musée, 1982.

2563. CHARENSOL, GEORGES. *Les Grands maîtres de la peinture moderne.* Lausanne: Editions Rencontre, 1967. 207 p., illus., some col. Volume in "Histoire générale de la peinture" series.

a. U.S. ed.: *The Great Masters of Modern Painting.* Trans. by Pamela Marwood. New York: Funk & Wagnalls, 1970. 207 p., illus., some col.
b. English ed.: London: Heron, 1970. 207 p., illus., some col.

2564. CHASSE, CHARLES. *Les Fauves et leur temps.* Lausanne; Paris: La Bibliothèque des Arts, 1963. 188 p., col. pl.

Van Dongen is discussed on pp. 133-8.

2565. CLAY, JEAN. *De l'impressionnisme à l'art moderne.* Paris: Hachette; Succès du Livre, 1975. 318p., illus., some col.

a. U.S. ed.: *Modern Art, 1890-1918.* New York: Vendome Press; dist. by Viking Press, 1978. 320 p., illus., some col.

2566. COQUIOT, GUSTAVE. *Les Indépendants 1884-1920.* Paris: Ollendorf, 1920. 239 p., pl.

Mentions van Dongen on pp. 116-8.

2567. COQUIOT, GUSTAVE. *En suivant la Seine*. Paris: A. Delpeuch, 1926. 138 p., pl.

Includes one illustration by van Dongen.

2568. CRESPELLE, JEAN-PAUL. *La Folle époque, des ballets russes au surréalisme*. Paris: Hachette, 1968. 288 p., illus.

2569. CRESPELLE, JEAN-PAUL. *Les Fauves*. Neuchâtel: Ides et Calendes, 1962. 365 p., illus., some col.

Discusses van Dongen on pp. 216-23.
a. U.S. ed.: *The Fauves*. Trans. by Anita Brookner. Greenwich, CT: New York Graphic Society, 1962. 351 p., illus.
b. English ed.: London: Oldbourne Press, 1962. 351 p., illus.
c. German ed.: *Fauves und Expressionisten*. Munich: Bruckmann, 1963. 365 p., illus.

2570. DAGEN, PHILIPPE. *La Peinture en 1905*. *"L'Enquête sur les tendances actuelles des arts plastiques" de Charles Morice*. Paris: Lettres modernes, 1986. 147 p. Volume in "Archives des arts modernes" series.

2571. DELHAYE, JEAN. *Art Deco Posters and Graphics*. London: Academy Editions, 1977. 96 p., illus., some col.

Mentions van Dongen's and Dufy's posters.
a. Another ed.: 1984.
b. U.S. ed.: New York: Rizzoli, 1977. 96 p., illus., some col.
c. French ed.: *Affiches et gravures, art déco*. Trans. by Dominique Carson. Paris: Flammarion, 1977. 96 p., illus., some col.
d. French excerpt: "Histoire de l'affiche: Art Déco." *Galerie des arts* 177(Feb. 1978):49-51. 4 illus.

2572. DESLANDRES, YVONNE. *Poiret: Paul Poiret, 1879-1944*. Yvonne Deslandres assistée de Dorothée Lalanne; préface, Didier Grumbach; photographies Jacques Boulay, Jean-Michel Tardy; iconographie et légendes, Anne Bony and Florence Muller; mise en œuvre, Jérome Jullien-Cornic. Paris: Editions du Regard, 1986. 331 p., illus., some col.

a. English ed.: Trans. by Paula Clifford. London: Thames & Hudson, 1987. 330 p., illus.
b. U.S. ed.: New York: Rizzoli, 1987. 330 p., illus.

2573. DORIVAL, BERNARD. *Les Etapes de la peinture française contemporaine*. Paris: Gallimard, 1943-44. 4 vols.

Van Dongen is discussed in vol. 2, p. 88.

2574. DORIVAL, BERNARD. *Les Peintres du XXᵉ siècle; Nabis, Fauves, Cubistes*. Paris: P. Tisné, 1957. 2 vols., col. illus.

a. U.S. ed.: *Twentieth Century Painters*. New York: Universe Books, 1958. 2 vols., col. illus.

b. German ed.: *Die Französischen Maler des XX. Jahrhunderts*. Trans. by Condia Bickel. Munich: F. Bruckmann, 1959-60. 2 vols., col. illus.

2575. DORIVAL, BERNARD. *L'Ecole de Paris au Musée National d'Art moderne*. Paris: Editions Aiméry Somogy, 1961. 324 p., illus., col. pl. Volume in "Trésors des grands musées" series.

2576. DUTHUIT, GEORGES. *Les Fauves: Braque, Derain, van Dongen, Dufy, Friesz, Manguin, Marguet, Matisse, Puy, Vlaminck*. Geneva: Editions des Trois Collines, 1949. 254 p., illus., some col.

Van Dongen's Fauve period is discussed on pp. 79-83.

2577. FEGDAL, CHARLES. *Ateliers d'artistes*. Paris: Stock, 1925. 322 p., illus.

Chapter 4 (pp. 39-45) concerns van Dongen; chapter 3, Albert Marquet.

2578. FELS, FLORENT. *L'Art vivant de 1900 à nos jours*. Avec 550 illus. réunies et présentées par Pierre Callier. Geneva: P. Cailler, 1950.

2579. FOUCART-WALTER, ELISABETH and PIERRE ROSENBERG. *Le Chat et la palette; le chat dans la peinture occidentale du XV' au XX' siècle*. Paris: A. Biró, 1987. 223 p., illus., some col.

a. U.S. ed.: *The Painted Cat; The Cat in Western Painting from the Fifteenth to the Twentieth Century*. New York: Rizzoli, 1988. 223 p., illus., some col.

2580. GENAILLE, ROBERT. *La Peinture contemporaine*. Paris: F. Nathan, 1955. 355 p., illus. Volume in "L'Activité contemporaine" series.

Van Dongen is discussed on pp. 39-41.

2581. GIRY, MARCEL. *Le Fauvisme, ses origines, son évolution*. Ph.D. thesis, Université de la Sorbonne, Paris, 1979; Neuchâtel: Ides et Calendes, 1981. 271 p., illus., some col.

a. U.S. ed.: *Fauvism; Origins and Development*. New York: Alpine Fine Arts Collection, 1982. 275 p., illus., some col.

2582. GORDON, DONALD E. *Modern Art Exhibitions, 1900-1916. Selected Catalogue Documentation*. Munich: Prestel, 1974. 2 vols.

2583. GRONKOWSKI, CAMILLE. *Catalogue sommaire des collections municipales*. Avec la collaboration de Georges Pascal et François Gilles de la Tourette. Paris: Imprimerie Crêté, 1927. 344 p., pl.

Catalogue of the Musée du Petit Palais in Paris.

2584. GUEORGUIEVSKAÌA, E. and I. KOUZNETSOVA. *La Peinture française au Musée Pouchkine*. Leningrad: Aurore; Paris: Cercle d'art, 1980. 433 p., illus., 281 col.

2585. GUTH, PAUL. *Quarante contre un*. Paris: Corréa, 1947-52. 3 vols.

Discusses van Dongen in vol. 3, pp. 129-38.
a. Another ed.: Paris: Filipacchi, 1991. 308 p.

2586. HAMMACHER, ABRAHAM MARIE. *Strominen en Persoonlijkheden; Schets van een halve eeuw Schilderkunst in Nederland, 1900-1950*. Amsterdam: J. M. Meulenhoff, 1955. 177 p., 6 pl., 4 col.

2587. Hermitage Museum, Leningrad. *Catalogue de l'Ermitage, peinture occidentale, I*. Leningrad: Aurore, 1976.

2588. HUEBNER, FRIEDRICH MARKUS. *Die neue Malerei in Holland*. Leipzig: Klinkhardt & Biermann, 1921. 119 p., illus., 76 pl. Volume in "Die junge Kunst in Europa" series.

2589. HUYGHE, RENE. *La Peinture française; les contemporains*. Paris: Pierre Tisné, 1949. 160 p., 164 pl., some col. Volume in "Peinture française" series.

2590. JEDLICKA, GOTTHARD. *Der Fauvismus*. Zurich, 1961.

2591. KELDER, DIANE. *Masters of the Modern Tradition*. New York: LeFrak Organization, 1988. 95 p., 55 illus., 49 col.

Selection of paintings from the collection of Samuel J. and Ethel LeFrak, which consists of works by the Impressionists, Post-Impressionists and later painters. The collection includes works by Braque, Dufy, Matisse, Picasso, Rouault, Kees van Dongen and Maurice de Vlaminck, among others.

2592. KOSTENEVICH, ALBERT GRIGOREVICH. *Western European Painting in the Hermitage, 19th-20th Centuries*. Trans. by N. Johnstone and H. Perham. Leningrad: Aurora Art Publishers, 1976. 306 p., col. illus.

a. French ed.: *L'Ermitage: peinture XIXe and XXe siècles*. Paris: Flammarion; Leningrad: Editions d'Art Aurora, 1987. 379 p., illus., some col.

2593. LA HORBE, ALAIN DE. *Mémoires d'outre-tubes* [Memories of 'outre-tubes']. Paris: Editions du Mont Pagnote; diffusion F. Lanore, 1978. 365 p., 23 illus.

Autobiographical account of de La Horbe's artistic formation, which provides an informal narration of influences on his art—Terlikowski, Vlaminck, van Dongen, and his father Florian de la Horbe—and anecdotes that recreate the atmosphere of the various periods in his life to date. After a section devoted to a characterization of his "masters," de la Horbe discusses his experiences, researches and experimentations in his investigation of painting, referring to metaphysical ventures, his life in Saint-Germain-des-Prés at different times, his travels—notably to Germany, his approach

to portraiture and his work in this genre, other subjects seen as "escapist," art dealers and art critics.

2594. LEJARD, ANDRE. *Le Nu dans la peinture française*. Paris: Editions du Chêne, 1947. 93 p., illus., pl., some col.

2595. LEMOINE, SERGE. *Le Musée de Grenoble*. Paris: Musées et Monuments de France, 1989. 135 p., col. illus. Volume in "Musées et monuments de France" series.

a. English ed.: *The Grenoble Museum of Art*. Paris: Musées et Monuments de France, 1988. 135 p., col. illus.

2596. LEYMARIE, JEAN. *Le Fauvisme*. Geneva: Skira, 1959. 163 p., col. illus. Volume in "Le Goût de notre temps" series.

a. U.S. ed.: *Fauves and Fauvism*. New York: Skira/Rizzoli, 1987. 120 p., illus., some col.

2597. LOOSJES-TERPSTRA, ALEIDA BETSY. *Moderne Kunst in Nederland, 1900-1914*. Utrecht: Haentjens, Dekker & Gumbert, 1959. 2 vols. in 1, illus.

a. Another ed.: Utrecht: Veen Reflex, 1987. 352 p., illus., 132 pl., some col.

2598. MARUSSI, GARIBALDO. *Fauves*. Venice, 1950.

2599. MAUROIS, ANDRE. *Estampes*. Paris, 1950.

2600. MELAS-KYRIAZI, JEAN. *Le Nu féminin dans l'Ecole de Paris*. Lausanne: Harmonies et Couleurs; Edita; dist. en Suisse également par la Galerie Paul Vallotton; Paris: en France par Denoël, 1975. 175 p., illus., some col.

2601. MULLER, JOSEPH-EMILE. *Le Fauvisme*. Paris: F. Hazen, 1956. 95 p., col. illus. Volume in "Bibliothèque Aldine des arts" series.

Discusses van Dongen on pp. 52-6.
a. Another ed.: 1967. 256 p., illus., some col.

2602. Musée National d'Art moderne, Paris. *100 œuvres nouvelles, 1974-1976*. Paris: Le Musée, 1977. 139 p., illus., some col.

2603. Musée National d'Art moderne, Paris. *La Collection du Musée National d'Art moderne, Centre Georges Pompidou*. Catalogue établi par la Conservation du Musée sous la direction d'Agnès de La Beaumelle et Nadine Pouillon. Introduction de Dominique Bozo. Paris: Le Musée, 1986. 619 p., illus., some col.

Van Dongen's works are described on pp. 588-9.

2604. Musée Picasso, Paris. *Musée Picasso: catalogue sommaire des collections*. Introduction par Dominique Bozo; catalogue par Marie-Laure, Besnard-Bernadac, Michèle Richet, Hélène Seckel; biographie par Laurence Marceillac. Paris: Ministère

de la Culture; Editions de la Réunion des Musées Nationaux, 1985-87. 2 vols., illus., some col.

2605. Museum Boymans-van Beuningen, Rotterdam. *Kunst van de 20e eeuw: Catalogus*. Rotterdam: The Museum, 1972. 309 p., illus., some col.

Catalogue of the Museum's 20th century collections, which include works by van Dongen.

2606. OLIVIER, FERNANDE. *Picasso et ses amis*. Préface de Paul Léautaud. Paris: Librairie Stock, 1933.

a. Other eds.: 1945, 1973.
b. German ed.: *Neun Jahre mit Picasso: Erinnerungen aus den Jahren 1905 bis 1913*. Zurich: Diogenes Verlag, 1957. 161 p., illus.
c. English ed.: *Picasso and His Friends*. Trans. by Jane Miller. London: Heinemann, 1964. 186 p., illus., 5 pl.
d. Spanish ed.: *Picasso y sus amigos*. Madrid: Taurus, 1964. 158 p., illus.
e. U.S. ed.: *Picasso and His Friends*. Trans. by Jane Miller. New York: Appleton-Century, 1965. 186 p., illus.

2607. RAYNAL, MAURICE. *Anthologie de la peinture en France de 1906 à nos jours*. Paris: Montaigne, 1927. 319 p., illus.

Discusses van Dongen on pp. 109-12.
a. U.S. eds.: *Modern French Painters*. Trans. by Ralph Roeder. New York: Brentano's, 1928. 275 p., pl.; New York: Arno Press, 1969. 275 p., pl.

2608. RAYNAL, MAURICE. *Histoire de la peinture moderne. Matisse, Munch, Rouault: Fauvisme et expressionnisme*. Introduction de Georg Schmidt. Traductions de S. Stelling-Michaud. Geneva: Skira, 1950. 154 p., illus., some col.

2609. RAYNAL, MAURICE. *Histoire de la peinture moderne*. Geneva: Skira, 1949-51. 3 vols.

Volume 2 mentions van Dongen on p. 20.

2610. REDON, ARI, ed. *Lettres de Gauguin, Gide, Huysmans, Jammes, Mallarmé, Verhaeren . . . à Odilon Redon*. Présentées par Ari Redon. Avec douze dessins et un auto-portrait inédits par Odilon Redon. Textes et notes par Roseline Bacou. Paris: J. Corti, 1960. 314 p., 12 pl.

2611. SALMON, ANDRE. *L'Art vivant*. Paris: G. Crès, 1920. 302 p., illus., 12 pl. Volume in "Artistes d'hier et d'aujourd'hui" series.

Mentions van Dongen on pp. 103-4.

2612. VANDERPYL, FRITZ R. *Peintres de mon époque*. Paris: Librairie Stock, 1931. 228 p.

2613. VAUXCELLES, LOUIS. *Le Fauvisme*. Geneva: P. Cailler, 1958. 115 p., 11 col. illus. Volume in "Peintres et sculpteurs d'hier et d'aujourd'hui" series.

Discusses van Dongen on pp. 109-10.

2614. VENEMA, ADRIAAN. *Nederlandse schilders in Parijs 1900-1940* [Dutch Painters in Paris 1900-1940]. Baarn: Het Wereldvenster, 1980. 293 p., 228 illus., 25 col. In Dutch.

History of the Dutch painters who were attracted to Paris and worked there between 1900 and 1940. Works of the Post-Impressionists, Piet Mondrian, Kees van Dongen, the Hague School, notably Isaac Israëls, the Cercle en Carré group and De Stijl are discussed and the book closes with a brief biographical dictionary of minor artists who worked in Paris during this period. Illustrations include facsimile pages of Edouard Houbolt's *Wandering Through Montmartre with Paintbox and Sketchbook* (1926).

2615. VLAMINCK, MAURICE DE. *Portraits avant décès*. Paris: Flammarion, 1943. 278 p., illus.

a. German ed.: *Rückblick in letzter Stunde: Menschen und Zeiten*. St. Gallen: Erker-Verllag, 1965. 213 p.

2616. WARNOD, ANDRE. *Les Berceaux de la jeune peinture: Montmartre, Montparnasse*. Avec 121 dessins et 16 hors-texte. Paris: Albin Michel, 1925. 288 p., 137 illus., 16 pl.

2617. WARNOD, JEANINE. *Le Bateau-Lavoir, 1892-1914*. Paris: Presses de la Connaissance; diffusion Weber, 1975. 163 p., illus., pl., some col. Volume in "Témoins et témoignages: histoire" series.

a. Another ed.: Paris: Editions Mayer, 1986. 191 p., illus., some col.

2618. WEILL, BERTHE. *Pan! dans l'œil!; ou trente ans dans les coulisses de la peinture contemporaine, 1900-1930*. Avec une préface de Paul Reboux. Orné des aquarelles et dessins de Raoul Dufy, Pascin et Picasso. Paris: Librairie Lipschutz, 1933. 325 p., illus., 4 pl., some col.

2619. WEISS, EVELYN. *Katalog der Gemälde des 200. Jahrhunderts, die älteren Generationen bis 1915 im Wallraf-Richartz-Museum*. Cologne: Wallraf-Richartz-Museum, 1974. 207 p., illus., 143 pl.

2620. WENTINCK, CHARLES. *De Nederlandse schilderkunst sinds van Gogh*. Utrecht: Het Spectrum, 1960. 167 p., 80 pl.

Articles

2621. "L'Affiche." *La Renaissance* (Sept. 1920):376-82.

2622. "Art News of Paris." *Art News* 35(28 Nov. 1936):22.

2623. AZARKOVIC, V. "Tvorcestvo V. V. Hlebnikovoj" [The Art of V. V. Hlebnikova]. *Iskusstvo* 9(1979):43-7. 6 illus., 2 col. In Russian.

Written in connection with the Moscow retrospective of the paintings and drawings of Vera Vladimirovna Hlebnikova (1891-1941). Surveys the early education of Hlebnikova at the Kazan Gymnasium and at K. F. Juon's studio in Moscow, and then turns to Hlebnikova's experiences at van Dongen's studio in Paris from 1912 onwards. Reference is made to Hlebnikova's orientalism, to her interest in folklore, and to her connections with P. V. Mituric and V. V. Hlebnikova.

2624. BERTY, JEAN. "Tout Paris, hors Paris." *Paris-midi* (11 Aug. 1932):2.

2625. BRINCOURT, ANDRE. "Les Heures chaudes de Montparnasse." *Le Figaro* (12 Dec. 1962):20.

2626. CHASSE, CHARLES. *L'Histoire du Fauvisme revue et corrigée* (Oct. 1962):54-9.

2627. CHASTEL, ANDRE. "Paris." *Art News* (Jan. 1954):16.

2628. CLARISSE. "L'Art et la mode." *L'Art vivant* (1 July 1925):31-4.

2629. CLARISSE. "L'Art et la mode, tenue de soirée de rigueur." *L'Art vivant* (15 Dec. 1927):1019-20, 1023.

2630. CRESPELLE, JEAN-PAUL. "Les Peintres témoins de leur temps." *France-soir* (11 March 1955):8.

2631. DALEVEZE, JEAN. "La Bande à Picasso au Bateau-Lavoir" [Picasso and his Gang at the Bateau-Lavoir]. *L'Œil* 224(Nov. 1975):72-3. 5 illus.

Article following upon a recent book by Jeanine Warnod *Le Bateau-Lavoir, 1892-1914*, (Paris, 1975), which describes the little-known Bohemian life of those who lived in an old wooden Parisian building consisting entirely of artist's studios and known as the Bateau-Lavoir. The social life there and the struggle for existence is described with reference to such artists as Picasso, van Dongen, Braque, Derain, Vlaminck, Gris, Max Jacob, and others.

2632. DIEHL, GASTON. "Le Fauvisme." *Beaux-arts* (20 June 1942):5-7.

2633. DORIVAL, BERNARD. "Un an d'activité au Musée National d'Art moderne." *Bulletin des musées de France* (Aug.-Sept. 1948):180-271.

2634. DORIVAL, BERNARD. "Musée National d'Art moderne." *Bulletin des musées de France* 6(1949):155.

2635. FENEON, FELIX. "Le 14 juillet des peintres." *Bulletin de la vie artistique* (15 July 1921).

2636. FENEON, FELIX. "Les Cadres." *Bulletin de la vie artistique* (1 Feb. 1922).

2637. GALAHEAD, PHILIPPE. "Poiret le magnifique." *Réalités* (April 1974):50-67.

2638. GIRAUDY, DANIELE, ed. "Correspondance Henri Matisse—Charles Camoin." *Revue de l'art* 12(1971):7-34. 4 illus.

Includes reprints of 25 documents, some with comments on van Dongen.

2639. GIRY, MARCEL. "Le Salon d'Automne de 1905." *L'Information de l'histoire de l'art* (Jan.-Feb. 1968):16-25.

2640. GIRY, MARCEL. "Le Salon des Indépendants de 1905." *L'Information de l'histoire de l'art* (May-June 1970):110 4.

2641. GORDON, DONALD E. "Kirchner in Dresden." *Art Bulletin* 48(Sept.-Dec. 1966):345-7.

2642. GROS, LOUYS. "Il y a fait entrer B. B. dans le dictionnaire." *Point de vue, images du monde* (16 Feb. 1962):12-3.

2643. HAUSER, R. "La Grande époque de Montparnasse" [The Great Era of Montparnasse]. *Clés pour les arts* 29(Jan. 1973):11-13. 15 illus.

The exhibition at the Palais des Beaux-arts in Charleroi occasions a brief look at the painters working in the Montparnasse district in the early 20th century. The "subjectivism" of the painters of this era and place took very many different forms, and Montparnasse was the starting-point for several great names. Those for whom brief biographies are provided include Chagall, Moïse Kisling, Jules Pascin, Soutine, Kees van Dongen, and André Derain.

2644. HOOG, MICHEL. "La Direction des Beaux-arts et les Fauves en 1905." *Art de France* (1963):363-6.

2645. HUYGHE, RENE. "Le Fauvisme: le réveil des traditions." *L'Amour de l'art* (7 July 1933):153-6.

2646. JEANNEAU, GUILLAUME. "Diagnostics." *Bulletin de la vie artistique* (15 March 1924):311.

2647. JOUHANDEAU, MARCEL. "Le Visage et les peintres." *Arts loisirs* (22 March 1967):32-5.

2648. KAHNWEILER, DANIEL-HENRY. "Du temps que les Cubistes étaient jeunes." *L'Œil* (15 Jan. 1955):27.

2649. LAUWICK, HERVE. "Que dit-on à Paris?" *Noir et blanc* (22 Sept. 1960):7.

2650. MARX, ROGER. "Exposition de peintures et dessins de R. Carré, Delannoy, E. Torrent, C. van Dongen." *Chronique des arts et de la curiosité* (28 Jan. 1905):26.

Review of an exhibition at Galerie Berthe Weill, Paris (16 Jan.-15 Feb. 1905).

2651. MERCEREAU, ALEXANDRE. "Les Artistes." *Les Hommes du jour* (Oct.-Nov. 1920).

2652. MORICE, CHARLES. "Enquête sur les tendances actuelles des arts plastiques." *Mercure de France* (1 Aug. 1905):538-55.

2653. N., J. "A propos d'une émission consacrée à quelques Hollandais de Paris (émission de Marianne Oswald et Remo Forlani)." *Le Figaro* (25 May 1962):22.

2654. NEEL, HUGHES. "L'Emigration de la collection Roudinesco." *L'Express* (24 Occt. 1968):118.

2655. "Panaches." *Fémina* (Oct. 1947):53-6.

2656. "Le Portrait des dames d'aujourd'hui." *La Revue de Paris* (15 July 1923):458-9.

2657. RODITI, EDOUARD. "Paris: A Market Report." *Arts Magazine* 36(Sept. 1962):32.

2658. SALMON, ANDRE. "Les Fauves et le fauvisme." *L'Art vivant* (1 May 1933):321-4.

2659. SARAB'JANOV, DMITRIJ. "David Sterenberg." *Tvorcestvo* 259(July 1978):16-9. 10 illus., 3 col. In Russian.

Short account of the life and work of Sterenberg, relating this to the one-man show also of 1978. Mentions Sterenberg's residence in Paris and his debt to van Dongen and the Cubists. Gives particular attention to Sterenberg's experimental planar paintings of around 1920 and to his graphic pieces of the 1920s; e.g., his book illustrations for Mariengof and Mayakovsky.

2660. SCHNEIDER, PIERRE. "Four Fauves." *Art News* 61(Sept. 1962):49.

2661. SCHULTZE, JÜRGEN. "Umgang mit Vorbildern: Jawlensky und die französische Kunst bis 1913" [Dealing with Precedents: Jawlensky and French Art to 1913] in *Alexej Jawlensky, 1864-1941*, edited by Armin Zweite (Milan: Electra, 1989), pp. 72-86. 27 illus.

In this study of Jawlensky's work between 1903 and 1914, Schultze documents the influence of the Fauves on the artist's landscapes of Kees van Dongen and Marianne Werefkin on his female portraits, and of Edouard Vuillard and Matisse on his interiors and still-lifes.

2662. SFOBERG, YVES. "Peintre de la vie silencieuse." *L'Amour de l'art* (1946):106-7.

2663. TERNOVIETZ, V. "Le Musée d'Art moderne de Moscou." *L'Amour de l'art* (Dec. 1925):455-88.

2664. TERNOVIETZ, V. "La Vie artistique à Paris." *Presse et révolution* 1(1928):65-89. In Russian.

2665. THIRION, JAQUES. "Musées de Nice: l'enrichissement des collections modernes de 1958 à 1964." *Revue du Louvre et des musées de France* 17:1(1967):67-8.

Discusses the acquisition of van Dongen's *Portrait de l'ambassadeur Casseus.*

2666. "The Wild Beasts." *Life* (8 Feb. 1960).

2667. WOODMAN, R. "Curnoe's New Drawings: Homage to van Dongen." *Artscan* 33(April-May 1976):68-9.

VII. Exhibitions

A. Individual Exhibitions

1904, 15-25 November	Paris, Galerie Vollard. *Exposition Kees van Dongen.* Préface de Félix Fénéon. 105 paintings, 20 drawings and watercolors. First individual exhibition. Fénéon's preface reprinted in *Au-delà de l'impressionnisme* (Paris: Hermann, 1961):150-1. Reviews: *Le Figaro* (24Nov. 1904); *L'Action* (1Dec. 1904).
1905, 23 October- 11 November	Paris, Galerie E. Druet. *Kees van Dongen.* 19 paintings, some watercolors and drawings. Reviews: M. Guillemot, *L'Art et les artistes* (1905):91; L. Vauxcelles, *Gil Blas* (26Oct. 1905).
1906, 21 May- 17 June	Rotterdam, Kunstkring. *Kees van Dongen.* 62 paintings and 11 drawings.
1907, July- August	Amsterdam, Kunsthandel C. M. Van Gogh. *Moderne Meesters en Kees van Dongen.* 47 works.
1908, 2-28 March	Paris, Galerie Kahnweiler. *Kees van Dongen.* Préface de Saint-Georges de Bouhélier. 30 paintings. Reviews: P. Hepp, *Chronique des arts* (March 1908); L. Vauxcelles, *Gil Blas* (4March 1908).
1908, May	Düsseldorf, Galerie Flechtheim. *Kees van Dongen.*
1908, 25 November- 12 December	Paris, Galerie Bernheim-Jeune. *Exhibition van Dongen.* Préface de Marius-Ary Leblond. 86 works (paintings dated 1892-1908); 64 paintings, 10 watercolors, 1 pastel, 3 sculptures, 9 faïences de Methey. Reviews: J.-L. Vaudoyer, *Chronique des arts* (Dec. 1908); L. Vauxcelles, *Gil Blas*(4 Dec. 1908).
1911, 6-24 June	Paris, Galerie Bernheim-Jeune. *Van Dongen.* Préface d'Elie Faure. 35 paintings, 1 ceramic.
1911, 4-16 December	Paris, Galerie Bernheim-Jeune. *Œuvres nouvelles de van Dongen.* "Avant-propos capricieux" de Kees van Dongen. 6 p., pl. 29 paintings, some small works. Reviews: G. Apollinaire, *L'Intransigeant* (13 Dec. 1911); R. Jean, *Chronique des arts* (16 Dec. 1911):292.
1912, 20 October- 5 November	Brussels, Galerie Georges Giroux. *Kees van Dongen.* 60 works.
1913, 17 January- 8 Februrary	Paris, Galerie Bernheim-Jeune. *Van Dongen.* 37 works, including his first bathers. Reviews: R. Gignoux, *Cahier d'aujourd'hui* (1913):143-5; M. Von Brücken Fock, *De*

Groene Amsterdamer (5Jan. 1914); L. Vauxcelles, *Gil Blas* (30Jan. 1913):4; R. Jean, *Chronique des arts* (1Feb. 1913):55.

1914, July	Berlin, Galerie Paul Cassirer. *Van Dongen.*
1917, 9-31 March	Paris, Galerie d'Antin. *Kees van Dongen.* Préface de Boccace. 50 works.
1918, 17-30 March	Paris, Galerie Paul Guillaume. *Œuvres de van Dongen.* Préface de Guillaume Apollinaire. Reprinted in *Les Arts à Paris* 1(15March 1918):6-9. 25 paintings.
1918	Paris, Galerie Devambez. *Van Dongen.*
1919, June-July	Berlin, Galerie Paul Cassirer. *Kees van Dongen.* 27 works.
1919, 5-18 October	Düsseldorf, Galerie Flechtheim. *Kees van Dongen, Frauen.* Preface by Daniel-Henry Kahnweiler.
1921, 1-9 March	Paris, Galerie Bernheim-Jeune. *Kees van Dongen.* Review: E. Henriot, *Paris-Midi* (9 March 1921):3.
1921, 15-31 December	Paris, Galerie Bernheim-Jeune. *Kees van Dongen, Venise.* 16 paintings from Venice. Catalogue de Gérard Bauër. Review: F. Fénéon, *Bulletin de la vie artistique* (15Dec. 1921).
1921	Liège, Salon de la Triennale. *Van Dongen.*
1923, April	Paris, Atelier de l'artiste, 5 rue Juliette-Lamber. Riviera paintings. Review: M. Daireaux, *Comoedia* (14April 1923).
1923, November	Paris, Atelier de l'artiste, 5 rue Juliette-Lamber. Parisian scenes.
1923, December	Brussels, Le Centaure. *Kees van Dongen.* Review: A. de Ridder, *Sélection* 2(Dec. 1923):222-3.
1924, November	Paris, Atelier de l'artiste, 5 rue Juliette-Lamber. Portraits. Review: M. de Waleffe, *Paris-Midi* (20 Nov. 1924):1.
1925, March-April	Paris, Galerie Bernheim-Jeune. *Kees van Dongen.*
1925, May	Paris, Atelier de l'artiste, 5 rue Juliette-Lamber. Reviews: L. Werth, *L'Art vivant* (1May 1925):22;

G. Charensol, *L'Art vivant* (15May 1925):13-7; M. Georges-Michel, *L'Œuvre* (15May 1925).

1925, September	Paris, Atelier de l'artiste, 5 rue Juliette-Lamber.
1925, November	Paris, Atelier de l'artiste, 5 rue Juliette-Lamber. Préface (2 sonnets) de Maurice Rostand. Illustrations for *La Garçonne* and an ensemble dedicated to Versailles.
1927, 9 April-6 June	Amsterdam, Stedelijk Museum. *Kees van Dongen Tentoonstelling.* Also shown Rotterdam, Kunstkring (14May-6June). Georganiseerd door Weekblad Het Leven. 16 p. 35 works.
1928, November	Paris, Atelier de l'artiste, 5 rue Juliette-Lamber. Works made during a spring voyage to Egypt. Reviews: A. Warnod, *Comoedia* (17Nov. 1928):3; A. Warnod, *Conférencia* (20Dec. 1928).
1931, May	Paris, Atelier de l'artiste, 5 rue Juliette-Lamber *Trente ans de peinture.* 64 works. Reviews: P. Berthelot, *Beaux-arts* 9(May 1931):24; C. Martial, *L'Œuvre* (2May 1931):1-2; R. Chavance, *Liberté* (8May 1931):2; *Art et décoration* 59(June 1931):supp. 4; J. Guenne, *L'Art vivant* (June 1931):260-73; Montboron, *Comoedia* (16July 1931).
1931, December	Amsterdam, Galerie Frans Buffa. *Kees van Dongen.* 30 works.
1932	Baltimore, Baltimore Museum of Art. *Kees van Dongen.* Also shown St. Louis, City Art Museum.
1933, February	Paris, Galerie Georges Bernheim. *Kees van Dongen.* 40 paintings. Review: *Art et décoration* 62(March 1933):supp. 4.
1935, 4-28 March	Amsterdam, Galerie Frans Buffa. *Kees van Dongen.*
1935, 20 April-12 May	Rotterdam, Kunstkring. *Kees van Dongen.* 28 works.
1937, 31 March-5 May	New York, René Gimpel Galleries. *Kees van Dongen.* Reviews: *Art News* 35(1May 1937):supp. 14; *Art Digest* 11(1May 1937):11.
1937, 17 April-2 May	Brussels, Palais des Beaux-arts. *Kees van Dongen.* Review: *Beaux-arts* (9April 1937):8.
1937	Paris, Musée Galliéra. *Kees van Dongen.*

1937	Eindhoven, Stedelijk van Abbe museum. *Van Dongen, 1877-1937.*
1937-38, December-January	Amsterdam, Stedelijk Museum. *Kees van Dongen.*
1938	Paris, Galerie Borghèse. *Kees van Dongen.* Avant-propos de Louis Vauxcelles.
1938, 17 October-16 November	London, Rosenberg and Helft Galleries. *Exposition of Works by van Dongen.* 12 p., illus.
1939, 24 June-31 July	Rotterdam, Koch Grebr. *Kees van Dongen.* Review: H. Speenhoff, *Groot Nederland* (1939):333-4.
1942	Paris, Galerie Charpentier. *Exposition Kees van Dongen.* Catalogue de Sacha Guitry. Review: P. du Colombier, *Beaux-arts* (10Nov. 1942):8-9.
1943-44, 11 December-3 January	Bordeaux, Musée des Beaux-arts. *Kees van Dongen.* Indroduction de Sacha Guitry et Elie Faure. 26 p., illus.
1945	Paris, Galerie Charpentier. *Kees van Dongen.*
1948	Paris, Galerie Paul Pétridès. *Van Dongen.*
1949	Paris, Galerie Charpentier. *Kees van Dongen, œuvres de 1890 à 1948.* Préface d'André Siegfried. 38 p., illus., 251 works. Reviews: *Combat*(31March 1949):2; C. Roger-Marx, *Le Figaro littéraire* (9April 1949); *France illustration* 5(9April 1949):352; J. Palaiseul, *Noir et blanc* (13April 1949); P. Guth, *La Revue de Paris* (June 1949):132-40; *Studio* 138 (Aug. 1949):60; S. Torday, *Phoenix* (Sept. 1949).
1949, 28 May-10 July	Rotterdam, Museum Boymans-van Beuningen. *Tentoonstelling Kees van Dongen, werken van 1894 tot 1949.* Preface by André Maurois and J.C. Ebbunge Wubben. 40 p., illus., 20 pl. 100 works. Reviews: M. Hennus, *Maandblad voor Beeldende Kunsten* 25:1(Jan. 1949):178-82; *Le Figaro* (15June 1949):1.
1952, 28 February-15 March	Paris, Galerie Paul Pétridès. *Kees van Dongen.* Reviews: P. du Colombier, *Journal de l'amateur d'art* 86(29Feb. 1952):15; J. Chabanon, *Le Peintre* (1March 1952):11; *France-soir* (2March 1952):3; *France illustration* 335(15March 1952):264.
1952, 19 May-8 June	London, O'Hana Gallery. *Kees van Dongen: From Fauvism to Today.* 38 works.

1952	Geneva, Galerie Motte. *Van Dongen.* Review: *Werk* 39(Dec. 1952):supp. 177.
1953, 15 October- 15 November	Paris, Galerie de Berri. *Kees van Dongen.* Fauve paintings. Reviews: J. Bouret, *Franc-tireur* (16Oct. 1953):2; J.-P. Crespelle, *France-soir* (17Oct. 1953); A. Martinie, *Le Parisien libéré* (20Oct. 1953):6; A. Warnod, *Le Figaro* (20Oct. 1953):10; A. Chastel, *Le Monde* (23Oct. 1953); C. Roger-Marx, *Le Figaro littéraire* (24Oct. 1953):11; F. Elgar, *Carrefour* (28Oct. 1953):8; G. Ver, *Emporium* (Nov. 1953):224, 229; G. Besson, *Les Lettres françaises* (12Nov. 1953); *Apollo* 58(Dec. 1953):186; *Art News* 52(Jan.1954):161.
1953-54	New York, Wildenstein Gallery. *Van Dongen.* Reviews: *Art Digest* 28(15Dec. 1953):20; *Art News* (Jan. 1954):64.
1954, 19 May- 10 June	London, O'Hara Gallery. *Kees van Dongen.* Review: *Apollo* 59(June 1954):154.
1956	New York, Wildenstein Galleries. *Van Dongen.*
1957	Clermont-Ferrand. *Van Dongen.* Review: P. Guth, *La Montagne* (Clermond-Ferrand) (12Sept. 1957).
1959	Nice, Galerie des Ponchettes. *Exposition van Dongen.* Avant-propos de Jacques Thirion, textes de Jean Cocteau et Louis Chaumeil. 43 p., 12 pl. 112 works. Texts include "Van Dongen" by Louis Chaumeil (pp. 9-15) and "Oursin de lumière" by Jean Cocteau (p.3).
1959, 30 October- 29 November	Geneva, Musée Rath. *Exposition van Dongen.* Geneva: Arts Graphiques, 1959. 56 p., illus., 16 pl. 126 works. Similar to Nice, Musée des Ponchettes exhibition. Review: *Werk* 46(Dec. 1959):supp. 260.
1959	Paris, Galerie Paul Pétridès. *Van Dongen.*
1960, 1-30 April	Albi, Musée Toulouse-Lautrec. *Exposition van Dongen. Peintures, aquarelles, dessins.* Préface de Paul Fierens et Bernard Dorival (pp. 6-13). Texte de Paul Guth (pp. 17-26). Review: G. Poulain, *Les Lettres françaises* (7 Aug. 1960).
1962	Asnières, *Hommage à van Dongen.* Texte ("Souvenirs") d'André Salmon. 15 works.
1963	Paris, Galerie Jacques Chalom. *Kees van Dongen.* Review: A. Brookner, *Burlington Magazine* 104(Aug. 1963):363.

1963, June- November	Paris, Galerie Bellechasse. *Charles Zalber présente van Dongen: dessins.* Texte de Claude Roger-Marx. 28 p., illus. 48 works. Reviews: J. Warnod, *Figaro* (20June 1963); E. Roditi, *Arts Magazine* 38(Oct. 1963):36.
1964	Charleroi, Musée des Beaux-arts. *Van Dongen.* 85 works.
1964	Lyon, Musée des Beaux-arts. *Exposition van Dongen.* Texte de René Déroudille. 86 works. Includes Déroudille's essay, "Kees van Dongen chroniqueur des années folles." Review: A. Werner, *Arts Magazine* 40(Dec. 1964):19-21.
1965, 16 November- 18 December	New York, Leonard Hutton Galleries. *A Comprehensive Exhibition of Paintings, 1900 to 1925, by van Dongen.* 24 p., illus. 35 paintings. Reviews: K. Levin, *Art News* 64:8(Dec. 1965):28-9; S. Preston, *Apollo* 83(Jan. 1966):73.
1966	Edinburgh, Institut français. *Van Dongen.*
1967-68, 13 October- 28 January	Paris, Musée National d'Art moderne. *Van Dongen.* Also shown Rotterdam, Museum Boymans-van Beuningen (8Dec. 1967-28Jan. 1968). Préface de Bernard Dorival. 136 p., illus., 164 works. Reviews: A. Beucler, *Les Nouvelles littéraires* (12Oct. 1967):7-8; G. Diehl, *L'Œil* (12Oct. 1967); *L'Aurore* (14Oct. 1967); C. Roger-Marx, *Le Figaro littéraire* (16Oct. 1967):41; R. Petit, *Le Figaro* (17 Oct. 1967); G. Besson, *Les Lettres françaises* (18Oct. 1967):27; M. Conil-Lacoste, *Le Monde* (18Oct. 1967):12; J. Tenand, *Tribune des nations* (20Oct 1967); A. Fermigier, *Nouvel observateur* (25Oct. 1967); J. Chabrun, *Le Nouveau Candide* (Oct. 1967); G. Charensol, *Plaisir de France* (Oct. 1967):36-41; A. Parinaud, *Galerie des arts* (Oct. 1967):4-5; H. Faure-Geors, *L'Aurore* (1 Nov. 1967); J. Alvard, *Art News* 66:8(Dec. 1967):19, 60; J.-D. Rey, *Jardin des arts* 157 (Dec. 1967); H. de France, *Rhythmes et couleurs* (Jan.-March 1968).
1969, June- September	Marseille, Musée Cantini. *Hommage à van Dongen.* Avant-propos de Charles Wentinck. Catalogue par Danièle Giraudy, avec le concours de Frédérique Cuchet. Marseille: Presses Municipales, 1969. ca, 200 p. illus., some col. 84 works. Wentinck's preface reprinted in *Marseille* 78(1969):41-4. Review: H. Cingria, *Les Lettres françaises* (16 July 1969).
1971, 14 February- 14 March	Tucson, University of Arizona, Museum of Art. *Cornelius Theodorus Marie van Dongen, 1877-1968. Hommages de William E. Steadman et Denys Sutton.*

Also shown Kansas City, Nelson-Atkins Museum. 198 p., illus., some col. Included paintings, watercolors, drawings, and lithographs. 110 works. First American retrospective. Reprints Sutton's article, "A Diamond as Big as the Ritz," from *Apollo* 93(Jan. 1971):36-43.

1971,
9-18 September

Lausanne, Galerie Paul Vallotton. *Hommage à van Dongen.*

1972, 31 October-
27 November

Paris, Grand Palais, Salon d'Automne. *Van Dongen.* Texte de Jean Mélas-Kyriaz. 42 works. Reviews: J.-J. Lévêque, *Galerie* 120(Oct. 1972):34; *Gazette des Beaux-arts* ser. 6, 80(Nov. 1972):supp. 12.

1976, 3 May-
2 June

Montrouge, Salon de Montrouge. *Art contemporain; van Dongen.* 58 p., illus. 76 works. 21st Salon de Montrouge.

1976, 15 July-
15 October

Geneva, Musée de l'Athenée. *Van Dongen: 1877-1968.* Review: M. M. de Calloti, *Goya* 134(Sept. 1976):122-3.

1978, 25 March-
11 June

Saint-Marcellin, Fondation Rey-Pieferd. *Hommage à Kees van Dongen.*

1979, 4 April-
5 May

Cannes, Galerie Robin. *Exposition rétrospective de van Dongen, 1877-1968.* Reviews: J. Mouraille, *Nice-Martin* (30April 1979); *Connaissance des arts* 326(April 1979):49.

1981, Summer

Nice, Musée des Beaux-arts (Jules Chéret). *Kees van Dongen (1877-1968), aquarelles et dessins.* Textes par Anne Devroye, Claude Fournet, Jean Forneris. 59 p., 30 illus., 8 col. 35 works shown. Forneris's text is entitled "Kees van Dongen et le rappel à l'ordre." Reviews: P. Cabanne, *Le Matin*(4Sept. 1981); *L'Œil* 314(Sept. 1981):75.

1985, 6 July-
November

Saint-Tropez, Musée de l'Annonciade. *Kees van Dongen, 1877-1968.* Also shown Toulouse, Réfectoire des Jacobins (Oct.-Nov. 1985). Textes par Eric Hild, Alain Mousseigne, Anne Devroye, Marcel Giry. 103 p., 39 illus. 39 works shown. Exhibition of van Dongen's paintings, mostly portraits and female figures. Texts explore the artist's place within Fauvism. Full catalogue entries with illustrations of all exhibited works. Reviews: F. Le Targat, *Beaux-arts magazine* 26(July-Aug. 1985):46-55; *Connaissance des arts* 401-2(July-Aug. 1985):6; *L'Œil* 360-1(July-Aug. 1985):91.

1989-90, 17 December- 11 January	Rotterdam, Museum Boymans-van Beuningen. *Kees van Dongen*. Redactie catalogues: Talitha Schoon, Jan van Adrichem, Hanneke de Man. 168 p., illus. In Dutch and English. 53 works. Jan van Adrichem's text is entitled "Kees van Dongen's Early Years in Rotterdam and Paris" (pp. 6-33). Review: H. van der Meyden, *Apollo* 131(March 1990):192-4.
1990, 22 March- 17 June	Paris, Musée d'Art moderne de la Ville de Paris. *Van Dongen: le peintre*, 1877-1968. Préface par Suzanne Pagé. 260 p., 169 illus., 145 col. First major retrospective since 1967. Provided a survey of van Dongen's œuvre from 1888-1959. Essays include: "L'Homme à l'écharpe" by Françoise Marquet; "Eloges de van Dongen, mêlées de réticences" by Gilbert Lascault; "L'Œil indien" by Phillippe Dagen; "Van Dongen: Les Premières chimères" by Xavier Girard; "Kees van Dongen: couleur pure et sexualité impure" by Donald Kuspit; "Catalogue Repères pour van Dongen" by Michel Hoog; "Van Dongen et l'Allemagne 1908-1966" by Marion Leuba; "D'un certain voyage" by Lionel Richard; "Biographie" by Anne Devroye-Stilz. Reviews: *Connaissance des arts* 459(May 1990):6; P. Schaefer, *L'Œil* 418(May 1990):52-7; G. Burn, *Arts Review* 42(18May 1990):270; S. Preston, *Burlington Magazine* 132(June 1990):429; F. Marquet, *Cimaise* 37(June-Aug. 1990):131-2.
1990, May	New York, Galerie Taménaga, *Exposition Kees van Dongen*.

B. Group Exhibitions

1898, March	Paris, Galerie le Barc de Boutteville. 2 paintings. Review: Bulée, *De Amsterdammer Weekblad voor Nederland* (27March 1898).
1901, 22 April- 30 June	Paris, Salon de la Société nationale des Beaux-arts. 1 paintings.
1903, 16 April- 30 June	Paris, Salon de la Société nationale des Beaux-arts. 1 painting.
1904, 21 February- 24 March	Paris, Grand Palais. *Salon des Indépendants*. 6 paintings.
1904, 15 October- 15 November	Paris, Petit Palais, *Salon d'Automne*. 2 paintings.

1905, 16 January- 15 February	Paris, Galerie Berthe Weill. Included paintings and drawings by R. Carré, Delannoy, E. Torrent, and van Dongen (8 paintings). Text signed "Place aux 'Jeunes'." Review: R. Marx, *Chronique des arts et de la curiosité* (28Jan. 1905):26.
1905, 25 February- 25 March	Paris, Galerie Berthe Weill. 10 paintings.
1905, 24 March- 30 April	Paris, Grand Palais. *Salon des Indépendants.* 6 paintings, two watercolors. Reviews: L. Riotor, *Le Rappel* (25March 1905):1; Masque rouge, *L'Action* (27March 1905):1; Pip, *La Nouvelle revue* (April 1905); P.-L. Hervier, *La Revue illustrée* (1April 1905); Le-Strange, *Le Tintamare* (2April 1905); C. Saunier, *La Plume* (15April 1905):328-34.
1906, 20 March- 30 April	Paris, Grand Palais. *Salon des Indépendants.* 6 paintings, 1 pastel, 1 drawing.
1906, 6 October- 15 November	Paris, Grand Palais, *Salon d'Automne.* 3 paintings. Reviews: L. Vauxcelles, *Gil Blas* supp.(5Oct. 1906):5; P. Jamot, *Chronique des arts et de la curiosité* (24Nov. 1906):37.
1907-08, 16 December- 4 January	Paris, Galerie Bernheim-Jeune. *Portraits d'hommes.* 2 paintings.
1908, 20 March- 2 May	Paris, Grand Palais, *Salon des Indépendants.* 6 paintings. Review: G. Apollinaire, *La Revue des lettres et des arts* (1May 1908).
1908, 18 April- 24 May	Moscow, Salon de la Toison d'Or. 4 paintings.
1908, Spring	Berlin, *Secession.* 2 paintings.
1908, June	Le Havre, Hôtel de Ville. *Cercle de l'Art moderne.* Catalogue texte de Guillaume Apollonaire.
1908, September	Dresden, Richter Art Salon. Exhibition with Die Brücke artists.
1908, 1 October- 8 November	Paris, Grand Palais. *Salon d'Automne.* 4 paintings. Review: L. Vauxcelles, *Gil Blas* (30Sept. 1908).

1908-09, 21 December- 16 January	Paris, Galerie E. Druet.
1909, 24 January- 28 February	Moscow, Salon de la Toison d'Or. 5 works.
1909, 25 March- 2 May	Paris, Grand Palais, *Salon des Indépendants.* 2 paintings.
1909, 1 October- 8 November	Paris, Grand Palais, *Salon des Indépendants.* 8 paintings. Review: P. Goujon, *Gazette des Beaux-arts* (1909):374.
1909-10, 17 December- 27 March	Odessa. Also shown Kiev, Salon Izdebsky (25Feb.- 27March 1910). 4 paintings.
1910, January	Munich, Moderne Galerie Tannhäuser.
1910, 18 March- 1 May	Paris, *Salon des Indépendants.* 2 paintings. Review: G. Apollinaire, *L'Intransigeant* (18March 1910).
1910, April- May	Budapest, Müvészhaz. *Nemzetközi Impresszionista Kiallitas.* 2 paintings.
1910, 28 April- 28 May	Paris, Berthe Weill Galerie.
1910, Spring	Berlin, *Secession.* 1 painting.
1910, 2 May- 20 July	St. Petersburg. Also shown Riga, Salon Izdebsky (25 June-20 July 1910). 4 paintings.
1910, 17-28 May	Paris, Galerie Bernheim-Jeune. *Nus.* 3 paintings.
1910, 16 July- 9 October	Düsseldorf, *Sonderbund westdeutscher Kunstfreunde und Künstler.* 1 painting.
1910, 1-14 September	Munich, Moderne Galerie Tannhäuser. *Neue Künstlervereinigung.* 2 works.
1910, 1 October- 8 November	Paris, Grand Palais, *Salon d'Automne.* 2 paintings. Review: G. Apollinaire, *L'Intransigeant* (1Oct. 1910).
1910, 19-30 December	Paris, Galerie Bernheim-Jeune. *La Faune.* 1 painting.
1910	Cologne, Wallraf-Richartz Museum. 3 paintings.
1910	Dresden.

1911, January-February	Berlin, Paul Cassirer Gallery. 1 painting
1911, 21 April-30 June	Paris, *Salon des Indépendants*. 5 paintings.
1911, Spring	Berlin, *Secession*. 2 paintings.
1911, May	Frankfurt, Galerie Ludwig Schanes. 3 paintings.
1911, 20 May-2 July	Düsseldorf, *Sonderbund westdeutscher Kunstfreunde und Künstler*.
1911, 1 October-8 November	Paris, Grand Palais. *Salon d'Automne*. 3 paintings.
1911, 6 October-5 November	Amsterdam, *Moderne Kunstkring*. 3 paintings.
1912, January	Moscow, Le Valet de carreau. 2 paintings.
1912, February	Budapest. 1 work.
1912, February	Cologne, Rheinischer Kunstsalon. 2 paintings
1912, February	St. Petersburg.
1912, 9 March-14 April	Brussels, *La Libre esthétique*. 7 paintings.
1912, 1-15 May	Paris, *Salon de mai*. 2 paintings.
1912, May	Cologne, Rheinischer Kunstsalon. 4 paintings.
1912, 25 May-30 September	Cologne, *Sonderbund westdeutscher Kunstfreunde und Künstler*. 1 painting.
1912, Spring-2 July	Hagen, Museum Folkwang. *Moderne Kunst: Plastik, Malerei, Graphik*. 1 painting.
1912, 1 October-8 November	Paris, Grand Palais, *Salon d'Automne*. 2 paintings. Review: G. Apollinaire, *L'Intransigeant* (30Sept. 1912).
1912, 5 October-31 December	London, Grafton Galleries. *Second Post-Impressionist Exhibition*. The Allied Artists Association. 4 paintings.
1912, 6 October-7 November	Amsterdam, Moderne Kunstkring. 1 work.
1912, October	Munich, Hans Goltz. *Neue Kunst, erste Gesamtausstellung*. 4 paintings.

1913, January-February	Vienna, Galerie Miethke. *Die Neue Kunst.* 1 painting.
1913, March-June	Rome, *Secessione, I. Internazionale.* 3 works.
1913, 19 March-18 May	Paris, *Salon des Indépendants.* 2 paintings.
1913, May	Cologne, Rheinischer Kunstsalon. 2 works.
1913, Spring	Berlin, *Secession.* 1 painting.
1913, August-September	Munich, Hans Goltz. *Gesamtausstellung.* 1 painting.
1913, Fall	Budapest, Ernst-Muzeum. *Szazad nagy Francia Mesterei.* 2 paintings.
1913, October-November	Berlin, Neue Galerie. *Erste Ausstellung.* 3 paintings.
1913, 7 November-8 December	Amsterdam, Moderne Kunstkring. 1 painting.
1913-14, 15 November-5 January	Paris, Grand Palais, *Salon d'Automne.* 3 paintings, one of which was withdrawn by order of the police (*Nude among the Pigeons*). Reviews: E. Deflin, *L'Intransigeant* (15Nov. 1913):1; Delacourt, *Paris-midi* (15Nov. 1913):1; A. Vervoot, *Paris-journal* (15Nov. 1913); *Le Matin* (15Nov. 1913):1; G. Apollinaire, *L'Intransigeant* (19Nov. 1913).
1913, December	Frankfurt, Goldschmidt. 2 paintings.
1914, 1 March-30 April	Paris, *Salon des Indépendants.* 3 paintings. Reviews: G. Apollinaire, *L'Intransigeant* (2March 1914); F. Fénéon, *Bulletin de la vie artistique* (28March 1914).
1914, May	Rotterdam, Kunstkring. 4 paintings.
1914, May-June	Amsterdam, "De Onafhankelijken." *Beeldende Kunstenaas.* 8 works.
1914, May-June	Prague, Mànes. *XXXXVI. Vystava.* 3 works.
1914	Lyon. Reviews: R. Cantinelli, *Gazette des Beaux-arts* (July-Aug. 1914):141-2; H. Beraud, *L'Art et les artistes* 19(1914):297.

1914, Summer	Munich, Hans Goltz. *Neue Kunst, Sommerschau.* 1 work.
1914	Paris, Grand Palais. *Salon d'Automne.*
1918	Geneva, Galerie Moos. *Exposition d'art français.*
1919, November	Paris, Grand Palais. *Salon d'Automne.* 3 works.
1920	Barcelona, Galerie Dalman. *Art français d'avant-garde.*
1920, March	Paris, *Salon des Indépendants.* 1 portrait and a screen.
1920, November	Paris, Grand Palais. *Salon d'Automne.* 5 portraits.
1921, March	Paris, *Salon des Indépendants.* 1 painting.
1921	Paris, La Société nationale des Beaux-arts. 1 painting, a portrait of Anatole France, which caused a scandal in the press. Reviews: E. Bricon, *Le Gaulois* (12April 1921):3; *L'Eclair* (19April 1921); H. Vidal, *Le Figaro* (20April 1921); H. Asselin, *Gazette de Hollande* (22April 1921); G. Jeanneau, *Bulletin de la vie artistique* (1921):229.
1921, November	Paris, *Salon d'Automne.* 4 paintings. Another portrait, of Maria Ricotti, was refused. Reviews: J. d'Horton, *Comœdia* (28Oct. 1921); R. Jean, *Comœdia* (31Oct. 1921); *L'Intransigeant* (1Nov. 1921); Le Wattman, *L'Intransigeant* (2Nov. 1921); Le Senne, *La France* (14Nov. 1921):1-2; L. Gillet, *Gazette des Beaux-arts* (Nov. 1921):301-16; *Bulletin de la vie artistique* (1921):509.
1922	Paris, La Société nationale des Beaux-arts. 2 paintings.
1922, 5 February-1 March	Hannover, Kestner-Gesellschaft, e.V. *Meister-werke, deutscher Kunst aus Hannoverischem Privatbesitz.*
1922, March	Paris, *Salon des Indépendants.* 1 painting.
1922, November	Paris, *Salon d'Automne.* 1 painting, self-portrait as Neptune.
1923	Paris, La Société nationale des Beaux-arts. 1 painting.
1923	Paris, *Salon d'Automne.* 2 paintings.
1924	Paris, *Salon des Tuileries.* 1 painting.
1924	Paris, La Sociéte nationale des Beaux-arts.

1924, November	Paris, *Salon d'Automne*. 5 paintings. Review: A. Alexandre, *La Renaissance de l'art français* (1924):635-47.
1925	Paris, *Salon des Tuileries*. 1 painting.
1925	Paris, La Société nationale des Beaux-arts.
1925, October	Paris, *Salon d'Automne*. 1 painting. Review: F. Fels, "Images." *L'Art vivant* (15Oct. 1925):25.
1926	Paris, La Société nationale des Beaux-arts. Reviews: G. Charensol, *L'Art vivant* (1May 1926):513; J. Guenne, *L'Art vivant* (15May 1926):361-7.
1926	Paris, *Salon d'Automne*. 1 painting. Review: J. Guenne, *L'Art vivant* (5Nov. 1926):811-8.
1927	Paris, *Salon des Indépendants*. Review: J. Guenne, *L'Art vivant* (15Jan. 1927):97.
1927	Paris, La Société nationale des Beaux-arts. 1 painting.
1927, October	Paris, *Salon d'Automne*. 1 painting. Review: *L'Art vivant* (15Oct. 1927):865-73.
1928	Paris, La Société nationale des Beaux-arts. 1 painting.
1928	Paris, *Salon d'Automne*. 2 paintings. Review: C. Vautel, *Comœdia* (16Nov. 1928):1.
1929	Paris, La Société nationale des Beaux-arts. Review: *Beaux-arts* 5(1929):16-7.
1929	London, St. George's Gallery. Review: R. McIntyre, *Architectural Review* 66(July 1929):32.
1929	Paris, *Salon d'Automne*. 1 painting. Reviews: J. Guenne, *L'Art vivant* (1Nov. 1929):829-35; P. Berthelot, *Beaux-arts* (Nov. 1929):18.
1930	Paris, La Société nationale des Beaux-arts. 1 painting.
1930, May	Paris, Théâtre de Pigalle. *Exposition de l'art vivant*. Review: *L'Art vivant* (1May 1930):385-91.
1930	Venice, *Biennale*. Review: Y. Maraini, *Apollo* 12(Aug. 1930):135-6.
1930	Paris, *Salon d'Automne*. 1 painting.

1931	Paris, La Société nationale des Beaux-arts.
1931	Paris, *Salon des Tuileries.* 1 painting.
1931	Paris, La Société nationale des Beaux-arts. 1 portrait (of the Comtesse de Noailles).
1931	Paris, *Salon d'Automne.* 2 paintings, portraits of Barthou and Painlevé.
1932	Paris, La Société nationale des Beaux-arts. 1 painting.
1932	Paris, *Salon d'Automne.* 1 painting.
1933	Paris, La Société nationale des Beaux-arts. 1 painting.
1933	Paris, *Salon d'Automne.* 1 painting. Reviews: R. Escholier, *Le journal* (31Oct. 1933):3-4; G. Pascal, *Beaux-arts* (3Nov. 1933):1-4.
1934	Paris, La Société des artistes français. Review: P. Diole, J. Laprade, *Beaux-arts* (27April 1934):1-2.
1934	Paris, *Salon d'Automne.* 1 painting.
1934, November-December	Paris, Gazette des Beaux-arts. *Les Fauves; l'atelier de Gustave Moreau.* 17 works.
1935	Paris, Petit Palais. *Les Chefs-d'œuvre du Musée de Grenoble.* Review: P. Diole, *Le Journal* (29April 1935):6
1935	Paris, La Sociéte nationale des Beaux-arts.
1935	Paris, *Salon d'Automne.* 1 painting. Review: P. Diole, *Beaux-arts* (1 Nov. 1935).
1936	Paris, La Société nationale des Beaux-arts.
1936	Paris, *Salon d'Automne.* 1 painting. Review: R. Moutard-Uldry, *Beaux-arts* (16Oct. 1936):2.
1936	Paris, Petit Palais. *Donation Emanuele Sarmiento.* 1 painting.
1937, April	Paris, La Société nationale des Beaux-arts. 1 painting. Reviews: *Beaux-arts* (30April 1937); P. Courthion, *Beaux-arts* (5May 1937):1-2.
1937	New York, Carnegie Institute.

1937, June- October	Paris, Petit Palais. *Les Maîtres de l'art indépendant: 1895-1937*. 14 works. Review: G. Besson, *Les Maîtres de l'art indépendant au Petit-Palais* (2 July 1937):1-2, 7.
1937	Paris, *Salon d'Automne*. 1 painting. Review: *Beaux-arts* (29Oct. 1937).
1938	Paris, La Société nationale des Beaux-arts.
1938	Paris, *Salon d'Automne*. 1 painting.
1939	Paris, La Société nationale des Beaux-arts. Review: R. Jean, *Le Temps* (16May 1939).
1939, 12-17 June	Paris, Galerie Rodriques-Henriques. *P. Bonnard et K. van Dongen*. Watercolors.
1940, April- May	Rotterdam, Museum Boymans-van Beuningen. *Peintures, sculptures et dessins d'artistes de Rotterdam*. 6 works.
1940	Paris, *Salon d'Automne*. 2 paintings.
1941	Paris, *Salon d'Automne*. 4 paintings.
1942	Paris, *Salon d'Automne*. 2 paintings.
1943	Paris, *Salon d'Automne*. 1 painting.
1944, April	Paris, *Salon des Indépendants*. Review: D. Imbourg, *Beaux arts* (30April 1944):9-10.
1946	Rome, Galerie du Zodiaque. *Mostra di pittori francesi*.
1946	Zurich, Kunsthaus. *Musée et bibliothèque de Grenoble*.
1947	Paris, Musée National d'Art moderne. *Le Fauvisme*. Review: B. Dorival, *Bulletin des musées de France* (April 1947):22.
1949, 31 August- 24 September	Amsterdam, Kunstzaal de Moderne Boekhandel.
1950	Bern, Kunsthalle. *Les Fauves und die Zeitgenossen*. 9 works.
1951, June- September	Paris, Musée National d'Art moderne. *Le Fauvisme*. 9 works.
1951	Paris, Galerie Charpentier. *Natures mortes françaises du XVII^e siècle à nos jours*. 2 paintings.

1951, 20 September- 24 October	Rotterdam, Museum Boymans-van Beuningen. *Chefs-d'œuvre du Musée de Liège*. Préface d'André Maurois.
1951	Knokke-le-Zoute, Casino. *75 œuvres de la moitié du siècle*.
1952, 28 April- 25 May	Rennes, Musée de Rennes. *Le Fauvisme*. 4 paintings.
1953	Amsterdam, Stedelijk Museum. *Les 40 ans des Indépendants*.
1953-54, December-January	Paris, Musée d'Art moderne de la Ville de Paris. *De Corot à nos jours*.
1954	Eindhoven, Stedelijk van Abbe Museum. *Collection Graindorge et du Musée de Liège*.
1954	Venice, *Biennale*.
1954	Paris, Galerie Charpentier. *Le Pain et le vin*.
1955	Paris. *De Bonnard à Picasso*. Review: J.-P. Crespelle, *France-soir* (11March 1955):8.
1955	New York, Museum of Modern Art. *Recent Acquisitions*.
1956	Valenciennes. *Cinquante chefs-d'œuvre du Musée national d'art moderne*. Also shown Dijon; Strasbourg; Besançon; Rennes; Paris, Musée National d'Art moderne. 1 painting.
1956	Leningrad, Hermitage. *L'Art français au XXe siècle*.
1957, 23 March	Paris, Musée National d'Art moderne. *Depuis Bonnard*. 2 paintings.
1957	London, The Art Council. *An Exhibition of Paintings from the Museum of Modern Art of Paris*. 3 paintings.
1957, 8 July- 30 September	Amsterdam, Stedelijk Museum. *Europa 1907*. 3 paintings.
1958, 6-20 March	Paris, Musée National d'Art moderne. *L'Art hollandais depuis van Gogh*. 4 paintings. Review: A. Chastel, *Le Monde* (7March 1958).
1958	Paris, Palais Galliéra. Review: J. Fallard, *Jardin des arts* (May 1958):144, 439.

1958, August- September	Nancy, Musée des Beaux-arts. *Evolution de la peinture en France de 1905 à 1914*. 3 paintings.
1959, 5 July- 15 November	Schaffhausen, Museum zu Allerheiligen. *Triumph der Farbe; Die europäischen Fauves*. Also shown Berlin, Nationalgalerie (20Sept.-15Nov.). 5 paintings.
1959	Basel, Galerie Beyeler. *Les Fauves*.
1960, April- May	Paris. *L'Art hollandais depuis 1900*.
1960, May	New York, Museum of Modern Art. *Les Portraits du Musée d'Art moderne*.
1960	Paris, Musée National d'Art moderne. *Chefs-d'œuvre de la peinture française dans les musées de Leningrad et de Moscou*.
1960-61, 4 November- 23 January	Paris, Musée National d'Art moderne. *Les Sources du XX^e siècle; les arts en Europe de 1884 à 1914*. 4 paintings.
1961, June- July	Paris, Galerie André Weill. *La Danse de l'impressionnisme à nos jours*.
1961-62	Melbourne, National Gallery of Victoria. *Trends in Dutch Painting*.
1962	Paris, Musée National d'Art moderne. *Chefs-d'œuvre des collections françaises*.
1962	Paris, Galerie Charpentier. *Les Fauves*. 14 works.
1963	Amsterdam, Stedelijk Museum. *150 Jaar Nederlandse Kunst, 1813-1963*.
1963-64	Washington, D.C., National Gallery of Art. *Paintings of The Museum of Modern Art, New York*.
1964, 7 February- 5 April	Turin, Galleria d'Arte moderna. *80 peintres de Renoir à Kisling*.
1964, May- June	Florence, Palazzo Strozzi. *L'Expressionismo pittura, scultura, architettura; XXVII Maggio musicale*.
1964	Laren, Singer Museum. *Peinture de la Belle Epoque*.
1984	Liège, Musée des Beaux-arts. *Musée d'art vivant; Jumelage Liège, Cologne, Lille, Rotterdam, Turin*.

1964	Bordeaux, Galerie des Beaux-arts. *La Femme et l'artiste, de Bellini à Picasso.*
1964, August	London, Marlborough Fine Arts Gallery. *Aspects of Twentieth Century Art.*
1964	Lausanne, *Chefs-d'œuvre des collections suisses de Manet à Picasso.*
1964-65, December-January	Tel-Aviv, Museum of Tel-Aviv. *50 peintres, de Renoir à Kisling.*
1965	Houston, Museum of Fine Arts. *The Heroic Years; Paris 1908-1914.*
1965, May-June	Paris, Galerie Paul Pétridès. *Cinquante toiles de maîtres.*
1965	Geneva, Musée Rath. *Peintres de Montmartre et de Montparnasse.*
1965	Paris, Galerie Charpentier. *Les Fauves.*
1965, 7 September- 26 November	Tokyo, *Les Fauves.* Also shown Osaka (5-22Oct.); Fukuoka (26Oct.-16Nov.). 6 paintings.
1965	Paris, Galerie de Paris. *La Cage aux fauves, Salon d'automne 1905.*
1966, 15 January- 15 May	Paris, Musée National d'Art moderne. *Le Fauvisme français et les débuts de l'expressionnisme allemand.* Also shown Munich, Haus der Kunst (26March-15May).
1966, 3 March- 16 May	Paris, Musée des Arts décoratifs. *Les Années 25.* 2 paintings.
1966	Paris, Musée Galliéra. *60 maîtres de Montmarte à Montparnasse, de Renoir à Chagall.* 4 paintings.
1966, July- September	Montauban, Musée Ingres. *L'Art contemporain dans les collections du Quercy.* 5 paintings.
1966	Hamburg, Kunstverein. *Matisse und seine Freunde, les Fauves.*
1966	Prague, Národni Gallery. *Les Tableaux inconnus de l'école de Paris.*
1968	New York, Leonard Hutton Galleries. *Fauves et expressionnistes.*

1968	Geneva, Petit Palais. *L'Aube du XX^e siècle.*

1968

Geneva, Petit Palais. *L'Aube du XXᵉ siècle.*

1968, 10 October

New York, Parke-Bernet Galleries. *School of Paris Paintings . . . From the Collection of Doctor Roudinesco.* Sold by his order. Public auction October 10, sale no. 2742. 121 p., illus. Included works by van Dongen, among others artists.

1969, January-February

Charleroi, Palais des Beaux-arts, *Utrillo et les peintres de Montmartre.*

1969, 14 September-16 November

Mechelen, Cultureel centrum burgmeester Antoon Spinoy. *Fauvisme in de Europese Kunst.* 6 works.

1969

Cairo. *La Peinture en France de Signac au surréalisme.* Also shown Athens, Hotel Hilton.

1970

Montréal, Musée des Beaux-arts. *Portraits et figures de France.*

1970

London. Review: J. Daniels, *Apollo* 91(June 1970):472.

1971

London, Editions Graphiques Gallery.
Review: G. Whittet, *Art and Artists* 6(April 1971):36.

1971

Ottawa, National Gallery of Canada. *Peinture française, 1840-1924.* Also shown Halifax, Dalhousie Art Gallery, St John's Memorial University of Newfoundland; Charlottetown, Musée de la Confédération; Frederickon, Beanerbrook Art Gallery; Québec, Musée du Québec.

1971

Malines. *La Figure humaine dans l'art du XXᵉ siècle.*

1972, 3 October-26 November

Moscow, Pushkin State Museum of Fine Arts. *Portret v evropejskoj zivopisi XV-nacala XX veka.* [European Portrait Painting of the 15-Early 20th Centuries]. Introductory article by I. E. Danilova. Catalogue edited by I. A. Kuznecova. 222 p., 99 illus. In Russian and English. Included portrait paintings of the Renaissance (e.g., Pintoricchio, Lorenzo Costa), Leonardo's *Lady with Ermine* (Czartoryski collection, Muzeum Narodowe, Kraków), and two works by Rembrandt. Well represented were French and Russian schools of the 18th and 19th centuries, including works by Renoir, Cézanne, van Dongen, Koncalovskij, and Vrubel'.

1972-73

Charleroi, Palais des Beaux-arts. *Montparnasse.*
Review: R. Hauser, *Clés pour les arts* 29(Jan. 1973):11-3.

1973	Paris, Grand Palais. Review: M. Gauthier, *Gazette des Beaux-arts* ser. 6, 81(Jan. 1973):supp. 13-4.
1973, 23 March- 10 April	Paris, *Salon des Indépendants: L'Art 1912-1919.* 1 painting.
1973	Pau, Musée des Beaux-arts. *L'Autoportrait dans la peinture.*
1974, January	Paris, Musée Jacquemart-André. *Poiret, le magnifique.*
1974, 15 August- 27 October	Tokyo, Seibu Gallery. *The Fauves.* Also shown Kanazawa, Departmental Museum of Ishikawa (28Sept.-27Oct.).
1975, 29 May- 21 June	Lausanne, Galerie Paul Vallotton. *Le Nu dans l'école de Paris.*
1975	Toronto, Art Gallery of Ontario. *The Fauves.*
1975-76, 30 October- 31 January	Paris, Musée Jacquemart-André. *Le Bateau-Lavoir, berceau de l'art moderne.* Catalogue par Jeanine Warnod. 163 p., 8 illus. ca. 200 works shown. Exhibition devoted to the Bateau-Lavoir, a building on top of Montmartre where Cubism was born and which became between 1900 and 1914 the abode or meeting place of artists and writers such as Picasso, Braque, Derain, Modigliani, van Dongen, Gris, Max Jacob, and Apollinaire. Included paintings, prints, drawings and watercolors by these artists and others plus African masks and sculpture. Documentary material such as manuscripts, letters, catalogues and photographs were also included. Review: P. Schneider, *New York Times* (1Dec. 1975):40.
1976, 6 July- 17 August	Deauville, Salle des fêtes. *Le Fauvisme en Normandie.* 2 paintings.
1976	Paris, Musée National d'Art moderne. *Œuvres nouvelles 1974-1976.*
1976	New York, Museum of Modern Art. *The Wild Beasts: Fauvism and its Affinities.* Also shown San Francisco, Museum of Art; Fort Worth, Kimbell Art Museum.
1976, October- December	Tokyo, Mitsukoshi. *Promenade dans les musées et fondations de la Côte d'Azur.* Also shown Osaka.
1976-77, 18 December- 21 February	The Hague, Haags Gemeente Museum. *Licht door Klei-Nederlandse luministen.*

1977	Nice, Musée des Beaux-arts (Jules Chéret). Review: *L'Œil* 264-5(July-Aug. 1977):48.
1978, 3 February-24 April	Paris, Grand Palais. *L'Art moderne dans les collections des musées de province.* 2 paintings.
1978, 16 February-16 April	Paris, Orangerie des Tuileries. *Donation Pierre Lévy.* 2 paintings.
1978, 2-13 March	Tokyo, Galerie de Isetan, Shinjuku. *Exposition de van Dongen.* Tokyo: Shimbun, 1978. ca. 125 p., illus., pl.
1978, 1 April-1 October	New York, Solomon R. Guggenheim Museum. *The Evelyn Sharp Collection.* Preface by Thomas M. Messer. Texts by Louise Averill Svendsen aided by Philip Verre and Hilarie Faberman. 96 p., 46 illus., 45 col. 45 works shown. Catalogue to an exhibition of paintings, sculpture, and a few works in other media by eighteen 20th century artists. The works selected complement and augment the Guggenheim's own collection. Included eight Picassos, five Modiglianis and Calders and four Archipenko bronzes as well as works by Bombois, Braque, Chagall, van Dongen, Dufy, Léger, Maillol, Matisse, Miró, Pascin, Rouault, Soutine, Utrillo, and Vlaminck.
1978, 12 June-6 November	Paris, Centre Georges Pompidou. *Paris-Berlin.* 3 paintings.
1978	Paris, Musée du Louvre. *Donation Picasso, la collection personnelle de Picasso.*
1978, 2 July-31 December	Oxford, Museum of Modern Art. *Paintings from Paris; Early 20th Century Paintings and Sculptures from the Musée d'Art moderne de la Ville de Paris.* Also shown Norwich, Castle Museum (19 Aug.-1 Oct.); Manchester, Whitworth Art Gallery (7 Oct.-11 Nove.); Coventry, Herbert Art Gallery and Museum (18 Nov.-31 Dec.) Preface by Joanna Drew and Michael Harrison, foreword by Jacques Lassaigne, introduction by Michael Harrison. 48 p., 74 illus., 4 col. 82 works shown. Exhibition aimed to show the ways in which Fauvism, Cubism and the School of Paris are represented in the museum's collection. Catalogue includes an introduction on the development of early 20th century art in France and a special section devoted to Marcel Gromaire, who is strongly represented in the Museum's holdings. Other artists shown included Braque, Delaunay, Derain, Dufy, La Freshaye, Léger, Lhote, Lipchitz, Matisse,

Metzinger, Pascin, Picasso, Rouault, Utrillo, Valadon, and van Dongen.

1978	Tokyo, Gallery Mitsukochi. *La Ruche, l'école de Paris à Montparnasse, 1910-1930.*
1979, March-September	Japan, *Chefs-d'œuvre des musée de la Ville de Paris.*
1979, July-October	Montpellier, Musée Fabre. *Le Portrait.*
1979	Paris, Musée Jacquemart-André. *La Ruche et Montparnasse.*
1980, 14 March-25 May	Paris, Musée du Luxembourg. *Donation Geneviève et Jean Masurel à la Communauté urbaine de Lille* [The Geneviève and Jean Masurel Gift to the Communauté Urbaine de Lille]. Catalogue par Marie Anne Peneau, Jacques Jardex, Amaury Lefebure. Paris: Editions de la Réunion des Musée Nationaux, 1980. 135 p., 157 illus., 24 col. 132 works shown. Exhibition of some of the over 200 works, many of them Cubist (paintings, drawings, gouaches, prints, sculpture) by Rouault, van Dongen, and other artists who lived in France in the first half of the 20th century. The collection was formed by Roger Dutilleul and his nephew Jean Masurel. Discusses the formation of the collection, Dutilleul's development as a connoisseur, and his patronage of the Kahnweiler Gallery. Notes his preference for emotional rather than cerebral works. Review: *La Revue du Louvre et des musées de France* 30:2(1980):130-1.
1980, 28 May-30 September	Paris, Musée Bourdelle. *Chapeau!*
1980, 19 August-24 November	Tokyo, Museum of Modern Art. *Le Musée National d'art moderne, Centre Georges Pompidou; l'art du XX^e siècle.* Also shown Kyoto, museum of Modern Art (17 Oct.-24 Nov.). 1 painting.
1981, 13 May-18 July	Paris, Galerie Schmit. *Regards sur une collection.*
1982	London. *Sounds of Colour.* Also shown Southampton, Sheffield, Nottingham, Manchester.
1982-83, 30 September-3 January	Dublin, National Gallery of Ireland. *Exhibition of Acquisitions, 1981-82.* Catalogue by Homan Potterton and Michael Wynne. 72 p., 45 illus., 66 works.

Acquisitions of paintings and sculpture, including van Dongen's *Stella in a Flowered Hat* (ca. 1907).

1983, 8-27 March	Paris, *Salon des Indépendants: Montmarte, les ateliers du génie.* 16 works.
1983, 4 June- 4 September	Martigny, Fondation Pierre Gianadda. *Manguin parmi les fauves.* 4 paintings.
1983	Paris, *Salon d'Automne.*
1984, June- August	Basel, Galerie Beyeler. *Nudes, nus, Nackte.*
1984	Dublin, National Gallery of Ireland. *Fifty French Paintings.* Catalogue by Honor Quinlan. 54 p., 54 illus., 50 col. Selection of fifty of the 150 French paintings in the collection of the National Gallery of Ireland, Dublin. Included works by Morisot, Sisley, Pissarro, Degas, Detaille, Bonnard, Signac, van Dongen, Gris, Picasso, and Soutine.
1984-85, 22 November- 28 January	Paris, Musée National d'Art moderne, Centre Georges Pompidou. *Donation Louise et Michel Leiris: collection Kahnweiler-Leiris.* Catalogue par Isabelle Monod-Fontaine, Agnès Angliviel de La Baumelle, Claude Laugier; assistées de Sylvie Warnier et Nadine Pouillon. 238 p., 298 illus. 38 col.
1985, 10 May- 20 July	Paris, Galerie Schmit. *De Corot à Picasso.*
1986	Paris, Musée Bourdelle. *Blatas et l'école de Paris.*
1987, 26 May- 28 September	Paris, Musée de l'Orangerie. *Autour de Derain, fauve.*
1987, 12 June- 30 August	Paris, Musée d'Art moderne de la Ville de Paris. *Paris 1937, l'art indépendant.* 2 paintings.
1987	Turin, Mole Antonelliana. *Lo Specchio e il doppio.*
1988, 23 June- 3 September	Lausanne, Galerie Paul Valloton. *1913-1988, exposition anniversaire.*
1988-89, 20 September- 26 April	Kurashiki, Museum of Fine Art. *Le Musée des Beaux-arts du Havre.* Also shown Osaka, Museum Nabio (21Oct.-20Nov.); Toyohashi, Seibu Art Gallery (28Dec.-11Jan. 1989); Saga, Departmental Museum of Fine Arts (27Jan.-26Feb.); Kumamoto, Departmental Museum of

Fine Arts(1March-2April); Tokyo, Tokyu Art Gallery (7-26April). 1 painting.

1989, May-July

Paris, Galerie Schmit. *Maîtres français XIX*-XX* siècles.*

1989, July-October

Verona, Galerie d'Art moderne. *Van Gogh a Schiele.*

1989, 12 August-24 September

Osaka, City Museum. *Yuzo Saheki et les peintres de l'école de Paris.* 4 works.

1990

Paris, Petit Palais. Review: B. Adams, *Art in America* 78(Nov. 1990):85-7.

1990

Tokyo, Bridgestone Museum of Art. *Masterworks: Paintings from the Bridgestone Museum of Art.* Catalogue by Yasuo Kamon. 102 p., illus.
Included works by van Dongen, Dufy, Matisse, Braque, and other nineteenth and twentieth-century French artists.

1991, 5 June-28 December

Boston, Museum of Fine Arts. *Pleasures of Paris: Daumier to Picasso.* Also shown New York, IBM Gallery of Science and Art (15Oct.-28Dec.). Catalogue by Barbara Stern Shapiro, with the assistance of Anne E. Havinga. Essays by Susanna Barrow, Philip Dennis Cate, and Barbara K. Wheaton. Boston: Museum of Fine Arts and David R. Godine, Publisher, 1991. 192 p., illus., col. pl. 215 works by 70 artists. 1 painting by van Dongen.

Albert Marquet

Biographical Sketch

Born in 1875 in Bordeaux, at age fifteen Marquet went to Paris to study at l'Ecole des Arts Décoratifs. In 1892 he met Henri Matisse for the first time. Marquet entered l'Ecole des Beaux-Arts in 1897 where he studied under Gustave Moreau. Matisse, Rouault, and Camoin were among his fellow students. Marquet copied in the Louvre and showed a preference for Corot, Chardin, and Claude Lorraine. By 1899 he began to paint in a pre-Fauve style and would later claim that he and Matisse were working in a Fauvist manner before the turn of the century. Marquet's lifelong friendship with Matisse developed at this time. They shared the early struggles of their careers and together endured the tedium of interior decorating in order to earn a living. In 1900 Marquet worked with Matisse on decorations for the Paris Exposition Universelle at the Grand Palais.

Marquet exhibited at the Salon des Indépendants in 1901 and yearly thereafter for a decade. In 1904 he was a founding member of the Salon d'Automne and showed in the famous "*cage aux Fauves*" the following year. Although he was one of the boldest Fauves, he was more concerned with the solidity of forms and the harmonious unity of tones. By the first decade of the twentieth century Marquet had developed a manner of painting and a repertory of subjects that he kept without considerable change throughout his career. His most characteristic canvases are panoramic views of the quais, embankments, and bridges along the Seine and the ports of Honfleur, Algiers, Naples, Hamburg, and Stockholm with their docks, cranes, tugboats, and ships at anchor. Marquet presents them with lucid simplicity as if from a hotel room on a top floor. He sought harmony through firm contours and accurate gradation of tone based on a careful study of atmosphere and light-and-shade relationship.

Marquet resembled Matisse in his use of powerful expressive colors as a means of heightening the visual impact of his paintings. Despite his expressiveness, Marquet's palette was composed almost entirely of cool colors. Following luminous Fauve portraits, fairgrounds, and nudes were works executed in rich atmospheric tones, mostly in different shades of grey. His characteristically muted coloring was accomplished by a classical composition based on contrasting areas of movement and passivity. Marquet subsequently revealed a growing preference for hazy settings, which found expression in numerous rain and snowscapes. Marquet was fond of the neutral tones caused by a morning haze or an overcast sky. He returned again and again to the same subjects, repeated the same methods, and produced countless variations of the same picture—the Pont-Neuf in rain, on a sunny day, in mist, under snow, at different seasons, and at all hours of the day and night.

Marquet traveled extensively in France and abroad. In 1905 he was in Trouville and St.-Tropez, in 1906 in Le Havre (with Raoul Dufy), and in 1907 in London and St.-Jean-de-Luz (with Camoin and Friesz). In 1908 he took over Matisse's studio on the rue St-Michel. From 1915 to 1919 he lived partly in La Varenne and partly in Marseille; in 1921-22 he was in Algiers; in 1923 in Sidi-Bou-Said, in 1924 Sète and Bordeaux; in 1925 Bougie and Norway. He visited Egypt in 1928. In 1931 he took a flat and studio on the rue Dauphine, where it joins the quai des Grands Augustins. From 1932 to 1938 he visited Spain, Rumania, Russia, North Africa, Switzerland, and Holland. During the German occupation he lived in Algiers. In May, 1946 he returned to Paris, and later the same year made his last journey—to Les Grisons in Switzerland.

With Vlaminck and Derain, Marquet abandoned the hot colors of Fauvism around 1907, but unlike them he did not follow the experiments of Cubism. No longer associated with the avant-garde, after 1908 his name was largely forgotten. From that date until his death in 1947 he only exhibited twice in Paris. Marquet lived unobtrusively in solitude, refusing the Légion d'Honneur and every other honor. From 1925 Marquet painted largely in watercolor. He was also a superb draughtsman—his rapid sketches and brush drawings are astonishing pieces of observation that possess the suggestive power of the Japanese artists. Matisse said of him, "He is our Hokusai."

Albert Marquet

Chronology, 1875-1947

Two essential works on Marquet remain George Besson's *Marquet* (Paris: G. Crès, 1929) and Francis Jourdain's *Marquet* (Paris: Editions Cercle d'Art, 1959). Based on personal associations with Marquet, both contain important documents and illustrations. Other personal recollections include Marcelle Marquet's *Marquet* (Paris: R. Loffant, 1951), Jourdan's *Marquet* (Paris: Braun, 1948), and André Rouveyre's essay "Marquet: dessins," in *Le Point* (1943).

1875	Born March 26 in Bordeaux to a family of modest means. His father works for the railroad.
1890-95	Studies at l'Ecole des Arts décoratifs in Paris. His mother opens a sewing shop in Paris to support him.
1892	Meets Henri Matisse for the first time. Matisse becomes a lifelong friend.
1893-94	Continues at l'Ecole des Arts décoratifs and begins to frequent, as a "free student," the studio of Gustave Moreau.
1895-97	Enrolls at Moreau's studio where he works with Matisse, Charles, Manguin, Georges Rouault, and Charles Camoin.
1898	On Moreau's advice he copies in the Louvre, showing a preference for Claude Lorrain, Poussin, Chardin, Velásquez, and Veronese. Moreau dies. Frequents Eugène Carrière's academy with Matisse.
1899	Works mostly in Paris after leaving l'Ecole des Beaux-arts, painting still lifes, nudes, and landscapes—some in a proto-Fauve style.
1900	Trip to the Vosges mountains. Works with Matisse in the Luxembourg gardens and in Arcueil. Collaborates with Matisse on a series of decorations for the Exposition Universelle at the Grand Palais.
1901	Paints in La Percaillerie near Cherbourg in Normandy with Manguin and

in and around Paris with Matisse. Shows for the first time ten paintings at the Salon des Indépendants, with whom he exhibits regularly until 1908.

1902 Moves to quai de la Tournelle. Paints views of Notre-Dame. Shows at Berthe Weill's gallery, with whom he also exhibits in 1904 and 1905.

1903 Lives at avenue de Versailles. Summer at La Percaillerie with Manguin. Participates in the foundation of the Salon d'Automne, where he exhibits regularly until 1908.

1904 Paints often at Manguin's studio, rue Boursauult. Member of hanging committee at the Indépendants. The state purchases his *Les Arbres à Billancourt* (Musée de Bordeaux) at the Salon d'Automne. Shows at Galerie Druet.

1905 Lives at quai des Grands-Augustins. Paints characteristic panoramic views of the quais along the Seine. Contract with Druet. The state buys *Notre-Dame au soleil* (Musée de Pau) at the Indépendants. Paints during the summer with Camoin at Cassis, Agay, Menton, and at Saint-Tropez, near Manguin. Visits Paul Signac at Saint-Tropez. Participates in the historic *cage des Fauves* at the Salon d'Automne, but none of his Riviera canvases are shown.

1906 Works in Paris. Summer trip to Normandy with Raoul Dufy, painting in Le Havre, Trouville, and Ste. Adresse. With Dufy he completes a *Fourteenth of July* series. Exhibits at Galerie Druet.

1907 February—first individual shows (39 works) at Druet's. Paints in Paris, Le Havre, and St.-Jean-de-Luz. Short trip to London with Camoin and Othon Friesz.

1908 Moves into Matisse's studio, quai St. Michel. Matisse keeps the apartment below. Paints in Paris, Poissy, Fécamp, and Collioure. Spring—travels to Italy with Manguin. They visit Naples, Livorno, and Florence. Shows at the Toison d'or in Moscow. Works at l'Academie Ranson with Manguin, Francis Jourdain, and members of the Nabis group. Becomes a member of the Salon d'Automne committee. Begins to darken his palette, abandoning Fauvism and turning to naturalistic landscape.

1909 Visits Hamburg and Naples. For the rest of his life he travels extensively in France and abroad, painting wherever he goes.

1910 Visits Villennes (Yvelines). Exhibits at Druet's.

1911 Paints in Honfleur and Conflans (Yvelines).

1912 Collioure and Rouen.

1913 Visits Morocco with Matisse and Camoin. Individual exhibition at Galerie Druet.

1914	Rotterdam and Collioure.
1915-19	Lives partly in La Varenne (Val-de-Marne) and Marseille.
1920-22	Lives partly in Algiers. Visits La Rochelle and Les Sables-d'Olonne.
1923	Visits Sidi-Bou-Said in Tunisia.
1924	Sète and Bordeaux. Exhibits in Brussels at Galerie Giroux.
1925	Bougie (Algeria) and Norway. Exhibits at Bernheim-Jeune. Paints largely in watercolors.
1926	La Goulette (Tunisia) and Hendaye.
1927	Saint-Jean-de-Luz, Rouen, Vieux Port (Eure), Algiers, La Mailleraye (Seine-Maritime).
1928	Egypt and Audierne (Finistère). May—exhibits at Druet's.
1929	February—exhibits forty drawings and watercolors at Galerie Rodrigues-Henriques, Paris.
1930	Algiers and Boulogne-sur-mer.
1931	Algiers, Triel (Yvelines), and Spain. New studio and apartment on the rue Dauphine, where it joins the quai des Grands-Augustins.
1932	Algiers and Spain (Santander and Vigo).
1933	Algiers, Rumania, Les Sables-d'Olonne.
1934	Algiers, Russia, Le Havre. Exhibits at Druet's gallery.
1935	Algiers, Le Pyla (Gironde), Rabat (Morocco). Exhibits at Tooth's Galleries, London.
1936	Venice and Switzerland (Davos, Geneva, Crans-sur-Sierre). Shows forty four watercolors from Venice at Druet's.
1937	Exhibits at Musée de l'Athénée, Geneva. Visits Switzerland (Montreux, Lausanne, Ouchy) and Méricourt (Yvelines).
1938	Amsterdam, Stockholm, Méricourt, Cap-Brun (Var), Porquerolles (Var).
1939	Porquerolles, La Frette (Val-d'Oise).
1940	La Frette, Céret (Pyrénees-Orientales), Vernett-les-Bains (Pyrénées-Orientales), Collioure, Algiers.
1940-45	Algiers. Returns to Paris on May 5, 1945.

1946 La Frette, Davos, and Les Grisons (Switzerland).

1947 Dies on June 14 in Paris.

Albert Marquet

Bibliography

I. Archival Materials

2668. MARQUET, ALBERT. *Letters*, 1906-07, to Georges-Jean Aubry (1882-1950). 3 items. Holographs. Located at The Getty Center for the History of Art and the Humanities, Archives of the History of Art, Santa Monica, California.

The letters concern travel plans and work in progress.

2669. Albert Marquet Archives, Fondation Wildenstein, Paris.

2670. Archives Nationales, Paris. "Marquet dossier d'achats d'état, 1901, 1930." Série F21 4243.

2671. MATISSE, HENRI and PIERRE COURTHION (Interviewer). *Interview with Pierre Courthion and Related Papers*, 1940-41. ca. 125 items. Manuscripts (holographs, signed; typescripts); some printed matter. Located at The Getty Center for the History of Art and the Humanities, Archives of the History of Art, Santa Monica, California.

Collection consists of correspondence betweeen Matisse and the French writer and art critic Pierre Courthion (1902-) concerning the editing and publication of a series of interviews conducted by Courthion in 1941; a typescript of the nine interviews; and other related notes and other materials.

Organization: I. Interview correspondence, 1940-41 (folder 1); II. Interview (folder 13); III. Notes and papers (folders 2-12).

Series I: Interview correspondence, 1940-41. Thirty-one letters between Henri Matisse, Pierre Courthion and Lucien Chachaut concerning the transcription, editing and publication of the interview. One letter is illustrated.

Series II: Interview, 1941. 142 p. typescript of nine interviews with Matisse by Pierre Courthion. The interviews constitute an oral autobiography with information of Matisse's education, travels and major works, and with substantial discussion of Eugene Carrière, Paul Cézanne, Marcel Jambon, Albert Marquet, Gustave Moreau, Auguste Renoir, Auguste Rodin, Georges Rouault, and the Ballets russes. The final interview includes a lengthy conversation about Matisse's perception of the role of the artist as well as his theories of color and light. Index available.

Series III: Notes and papers, Pierre Courthion's papers concerning the Matisse interview, including a hand-edited copy of the text. Courthion's notes of the conversations, his contract with the publisher Skira and printed ephemera on Matisse. Also included are portions of the interview rejected for publication by Matisse which concern Matisse's relationships with Marcel Sembat and American collectors

II. Books

2672. BELL, CLIVE. *Since Cézanne*. London: Chatto and Windus, 1922. 229 p., 7 pl.

Reprints Bell's essay, "Marquet."

2673. BESSON, GEORGE. *Marquet*. Paris: G. Crès, 1920. 36 p., 40 illus., 39 pl. Volume in "Cahiers d'aujourd'hui" series

a. 2nd ed.: 1929. 101 p., 102 illus., 101 pl., 1 col.
b. Another ed.: 1941.

2674. BESSON, GEORGE. *Marquet: la cordialité pour le réel*. Geneva: A. Skira, 1948. 10 p. 8 col. illus., 9 pl. Volume in "Les Trésors de la peinture française, XXᵉ siècle" series.

2675. BESSON, GEORGE. *Marquet*. Paris: Braun; New York: E. S. Herrmann, 1947. 12 p., 60 illus., 48 pl. Text in French, English, and German. Volume in "Les Maîtres" series.

a. Another ed.: 1948.

2676. George and Adèle Besson Collection, Besançon. *Dessins et estampes de la collection George et Adèle Besson* [Drawings and Stamps from the Collection of George and Adèle Besson]. Avant-propos par George Besson. Besançon: Musée des Beaux-arts d'archéologie, 1985. 219 illus.

Catalogue raisonné to the collection of 20th century prints and drawings assembled by George and Adèle Besson and donated to the Musée des Beaux-arts et d'archéologie in Besançon, in 1970. George Besson briefly discusses his interest in 20th century art, and recalls the origins and growth of his collection, it including works by more than forty European artists and several examples by Albert Marquet and Louis Valtat.

2677. CASTAIS, NICOLE and MICHEL PARET. *Albert Marquet.* Paris: Fondation Wildenstein, 1988.

2678. CHASSE, CHARLES. *Albert Marquet—Zeichnungen aus Hamburg von 1909.* Hamburg: Hans Christians Verlag, 1964.

2679. COWART, WILLIAM JOHN III. *'Ecoliers' to 'Fauves': Matisse, Marquet, and Manguin Drawings, 1890-1906.* Ph.D. diss., Johns Hopkins University, 1972. 360 p.

These three artists received almost all their formal education in a national school system predominantly influenced by pedagogic directives. Notwithstanding later creative innovations, all were demonstrably molded by various aspects of he teaching structure. Cowart inspects the pervasive rationale of drawing instruction at l'Ecole Nationale des Arts décorativs and l'Ecole des Beaux-arts, Paris. Instructional literature of the period is also scrutinized and the early graphic œuvre of all three specifically related to it. The stylistic chronologies of Matisse, Marquet, and Manguin are more completely established for this period with emphasis on isolating distinct traditional elements in their work and on their participation in the Salons. After a brief examination of the role of Roger Marx, Cowart concludes his study with a determination of those elements which will establish a "graphic fauvism."

2680. DORIVAL, BERNARD. *L'Ecole de Paris au Musée National d'Art moderne.* Paris: Editions Aimery Somogy, 1961. Volume in "Trésors des grands musées" series.

a. Dutch ed.: *De Parijse School: Musée National d'Art moderne.* The Hague: W. Gaade, 1961. 323 p., 3 pl.
b. U.S. ed.: *The School of Paris in the Musée d'Art moderne.* Trans. by Cornelia Brookfield and Ellen Hart. New York: H. N. Abrams, 1962. 316 p., illus.
c. Spanish ed.: *La Escuela de Paris en el Museo de Arte Moderno.* Trans. by Gumersindo Díaz. Madrid, Barcelona: Ediciones Daimon-Manuel Tamayo, 1966. 320 p.

2681. FEGDAL, CHARLES. *Ateliers d'artistes.* Paris: Stock, 1925. 322 p., illus.

Chapter 3 concerns Marquet; chapter 4, van Dongen.

2682. FLEMMING, HANS THEODOR. *Jean Paul Kayser.* Hamburg: Verlag Hans Christians, 1980. 91 p., 68 illus. In German. Volume in "Hamburger Künstler-Monographien zur Kunst des 20 Jahrhunderts" series.

Assesses the life, career, and artistic importance of the Hamburg landscape artist Jean Paul Kayser (1869-1942), a member of the Hamburger Künstlerklub founded in 1892. Kayser believed that art was more than skill alone and attached great importance to the relationship between art and nature in his paintings. He was a skilled landscape

artist but also a good portrait painter and his best medium of expression was oil painting. However, Kayser was also interested in watercolor painting, etching, and lithography. Kayser's artistic development led in stages from Realism to Impressionism and from Jugendstil to a modified form of Expressionism, and finally he achieved a synthesis of all these styles. Flemming also includes a detailed analysis of his paintings, examines the importance of Kayser's meeting with the French artist Albert Marquet in 1909, and shows how after 1900 Kayser's work was often accompanied by letters and notes from his diary which revealed important details about his life and his ideas on art.

2683. GERMAN, M. *Albert Marquet*. Moscow, 1972. In Russian.

2684. HUYGHE, RENE and JEAN RUDEL. *L'Art et le monde moderne*. René Huyghe et Jean Rudel avec la collaboration de Thérèse Burollet, et al. Paris: Larousse, 1970. 2 vols.

2685. JOURDAIN, FRANCIS. *Marquet*. Paris: Braun, 1948. 11 p., 16 pl. Volume in "Collection 'plastique'" series.

2686. JOURDAIN, FRANCIS. *Marquet*. Paris: Editions Cercle d'Art, 1959. 206 p., 158 illus., some col.

a. German ed.: *Albert Marquet*. Dresden: Verlag der Kunst, 1959. 234 p.

2687. LESAGE, JEAN-CLAUDE. *Peintres des côtes du Pas-de-Calais de Turner à Dubuffet* [Painters of the Coasts of the Pas-de-Calais from Turner to Dubuffet]. Préface par Bruno Foucart. Etaples-sur-Mer, France: Amis du Musée de la Marine, 1987. 151 p., 79 ilus., 35 col.

Discusses the popularity of the landscape of the French region of the Pas-de-Calais for painters of the 19th and 20th centuries. In his preface, Foucart analyses in general terms the artistic potential of this area. Lesage then looks at the wave of English painters who "discovered" the region, the transition from romanticism to realism, Impressionism, artists' foyers at the turn of the century, and 20th century painters. He mentions works by André Derain and Albert Marquet, among other artists.

2688. MARQUET, ALBERT. *Zeichnungen aus Hamburg von 1909*. Mit einer Einführung von Hans Platte. Hamburg: Christians, 1964. 40 p., illus.

2689. MARQUET, MARCELLE. *Marquet*; avec 29 dessins originaux. Paris: R. Laffont, 1951. 189 p., 29 illus.

a. 2nd ed.: Paris: Hazan, 1955.

2690. MARQUET, MARCELLE and FRANÇOIS DAULTE. *Marquet: Vie et portrait de Marquet par Marcelle Marquet. L'Œuvre de Marquet par François Daulte*. Avec des notices analytiques et une bibliographie par François Daulte. Paris, 1954.

Review: *Werk* 41(Dec. 1954): supp. 296.

2691. MARQUET, MARCELLE. *Albert Marquet.* Paris: Fernand Hazan, 1955. 23 p., 28 pl., some col. Volume in "Bibliothèque Aldine des arts."

2692. MARQUET, MARCELLE. *Marquet—Voyages.* Lausanne: International Art Book; Paris: La Bibliothèque des Arts, 1968. 30 col. illus. Volume in "Rythmes et couleurs" series.

a. English ed.: *Marquet—Journeys.* Trans. by Diane Imber. Lausanne: International Art Book, 1969. 62 p., col. illus.

2693. MATHIEU, PIERRE-LOUIS. *Gustave Moreau: sa vie, son œuvre: catalogue raisonné de l'œuvre achevé.*

Aims to trace the year by year development of Moreau's art. Also evaluates the influence exerted by Moreau both in literature and art, particularly as a teacher at l'Ecole des Beaux-arts in Paris, where Rouault, Matisse, and Marquet were his students. André Breton regarded Moreau as a true initiator of Surrealism, and it has only recently been realized that Moreau was one of the first painters to venture into the field of abstract art. The catalogue raisonné includes ca. 500 works.
a. U.S. ed.: *Gustave Moreau: Complete Edition of the Finished Paintings, Watercolors, and Drawings.* Trans. by James Emmons. Boston: New York Graphic Art Society, 1976. 400 p., 486 illus., 40 col.
b. English ed.: Oxford: Phaidon, 1977.
Reviews: A. Brookner, *Times Literary Supplement* (18 Mar. 1977):300; F. Calvocoressi, *Connoisseur* 196:787 (Sept. 1977):68; A. V. Frankenstein. *Art News* 76:9 (Nov. 1977):64; D. Kaplan, *Burlington Magazine* 897:99 (Dec. 1977):869-70, 873.

2694. MERMILLON, MARIUS. *Marquet.* Paris: G. Crès, 1929. 45 p., 32 pl. Volume in "Les Artistes nouveaux" series.

Concerns Marquet's graphic works
Review: *Apollo* 11(April 1930):282.

2695. MURA, ANNA MARIA. *Albert Marquet.* Milan: Fratelli Fabbri, 1965. 23 p., illus., 16 pl., some col. Volume in "I Maestri del colore" series.

2696. *La Photographie.* Colmar, 1936. 42 p.

Reprinted from *Le Point* (Souillac) 1:6(1936).

2697. RAYNAL, MAURICE. *History of Modern Painting, Matisse, Munch, Rouault, Fauvism, Expressionism; van Gogh, Gauguin, Matisse, Marquet, Vlaminck, Derain, Dufy, Friesz, Braque, Modersohn, Kirchner, Schmidt-Rottluff, Kandinsky, Jawlensky, Munch, Hodler, Ensor, Rouault, Nolde, Weber, Kokoschka, Chagall, Soutine.* Geneva: A. Skira, 1950. 151 p., illus.

2698. SANDOZ, MARC. *Signac et Marquet à La Rochelle, Les Sables d'Olonne, La Chaume, Croix-de-vies. Influence du sites sur leur œuvre. Œuvres inédites (1911-1933).* Paris: Editart, 1957. 31 p., illus.

2699. SANDOZ, MARC. *Présence de Marquet.* Paris: Manuel Bruker, 1962. 8 illus.

Includes eight original engravings by Marquet.

2700. SZITTYA, EMILE. *Marquet parcourt le monde.* Paris, 1950.

2701. TERRASSE, CHARLES. *Albert Marquet.* Pairs: L'Art d'Aujourd'hui, Crès, 1928. 20 illus.

a. Abridged ed.: Paris: Albert Morancé.

2702. TRAZ, GEORGES DE. *Albert Marquet.* Trente reproductions de peinture et dessins précédées d'une étude critique par François Fosca [pseud.]; de notices biographiques et documentaires et d'un portrait inédit de l'artiste dessiné par lui-même et gravé sur bois par J. Germain. Paris: La Nouvelle Revue Française, Gallimard, 1922. 63 p., 26 illus. Volume in "Les Peintres français nouveaux" series.

2703. WERTH, LEON. *Eloge d'Albert Marquet.* Paris: Manuel Bruker, 1948. 11 illus.

Includes eleven original engravings by Marquet.

2704. Westbrook College, Joan Whitney Payson Gallery of Art, Portland, Maine. *The Joan Whitney Payson Gallery of Art.* Portland: The College, 1977. 64 p., 28 illus.

Catalogue of the twenty-eight paintings in the permanent collection of the Joan Whitney Payson Gallery of Art. The predominately Impressionist/Post-Impressionist collection includes: oil paintings by Courbet, Gauguin, Homer, Albert Marquet (2), Monet, Renoir, Reynolds (2), Rousseau, Sisley, Soutine, and van Gogh; watercolors by Chagall, Picasso, Prendergast (2), Sargent (2), and Wyeth; pastels by Degas, Glackens, and Whistler; drawings by Daumier, Ingres, and Picasso (2); and tempera by Wyeth.

III. Articles

2705. ALAZARD, JEAN. "Il Pittore Albert Marquet." *Dedalo* 6(1925):320-342. 18 illus.

2706. "Albert Marquet." *Emporium* 106(Sept. 1947):78.

2707. "Albert Marquet." *Art & Artists* 219(Dec. 1984):34.

2708. "Albert Marquet (1875-1947): l'harmonie par la clarté" [Albert Marquet (1875-1947): Harmony Through Light]. *Jardin des arts* 214(Sept. 1972):61-3. 4 illus.

2709. "Art of Marquet." *Apollo* 68(July 1958):2.

2710. BAZIN, GERMAIN. "Marquet, le régisseur des brumes." *L'Amour de l'art* 23(1947):207-13.

2711. BESSON, GEORGE. "Albert Marquet." *Arts de France* 3(1946):42-5. 7 illus.

2712. BOUILLOT, ROGER. "Albert Marquet." *L'Œil* 359(June 1985):73.

2713. CARTIER, JEAN-ALBERT. "Gustave Moreau, professeur à l'Ecole des Beaux-arts." *Gazette des Beaux-arts* ser. 6, 61(May1963):347-58. English summary.

2714. CASSOU, JEAN. "Miracle of Marquet." *Art News* 46(Nov. 1947):50.

2715. COSTA, BERNARD DE. "L'Apothéose d'Albert Marquet." *Réalités* 226(Nov. 1964):44-9.

2716. DAULTE, FRANÇOIS. "Marquet et Dufy devant les mêmes sujets." *Connaissances des arts* 69(Nov. 1957):86-93. 20 illus., some col.

2717. DAULTE, FRANÇOIS. "Les Voyages de Marquet." *L'Œil* 390-1(Jan.-Feb. 1988):42-9.

2718. DAULTE, FRANÇOIS. "Albert Marquet, peintre de Paris." *Connaissance des arts* 433(March 1988):72-81.

2719. DORIVAL, BERNARD. "Nouvelles œuvres de Matisse et Marquet au Musée National d'Art moderne." *Revue des arts* 7(May 1957):114-20.

Highlights Marquet's *Nu dans l'atelier* and *Nu d'atelier*.

2720. DORIVAL, BERNARD. "Nouvelles acquisitions du Musée National d'Art moderne." *Revue des arts* 9:4-5(1959).

Discusses Marquet's *Le Pont Saint-Michel*.

2721. DORIVAL, BERNARD. "Nouvelles acquisitions du Musée National d'Art moderne." *Revue des arts* 10:6(1960):282-3.

Mentions two drawings by Marquet: *Le Vieux cheval attelé* and *La Dormeuse*.

2722. DORIVAL, BERNARD. "Musée National d'Art moderne: la donation Lung." *Revue du Louvre et des musées de France.* 11:3(1961):151-3.

Mentions Marquet's *Le Port de Bougie*.

2723. ERASMUS, P. M. "The French Collection of the Johannesburg Art Gallery." *Apollo* 102:164(Oct. 1975):280-5. 16 illus.

Discussion of particular works in the collection of the Johannesburg Art Gallery and the way in which they reflect the development of French painting from the 18th century. Erasmus examines works by Vlaminck and Marquet, among other artists.

2724. ERNOULD-GANDOUET, MARIELLE. "Marquet au jour, banlieue de Paris." *Antiques* 136(Oct. 1989):690. See also *L'Œil* 412(Nov. 1989):78-9.

2725. GAUTHIER, MAXIMILIEN. "Albert Marquet et ses voyages." *Beaux-arts* (1 May 1940):91.

2726. HABERT, J. "Œuvres du XXᵉ siècle." *Revue du Louvre et des musées de France* 34:1(1984):32.

Mentions Marquet's *La Frette vue d'Herblay*.

2727. HILD, ERIC and ELISABETH HARDOUIN-FUGIER. "Bouquets de fleurs de Fantin-Latour à Marquet" [Bouquets of flowers from Fantin-Latour to Marquet] *L'Œil* (July-Aug. 1982):7-70. 11 illus., 6 col.

The exhibition, *Fleurs de Fantin-Latour à Marquet*, held at the Musée de l'Annonciade, Saint-Tropez, Summer 1982, revealed the restricted place of flower painting in avant-garde pictorial art. Among the Impressionists, Manet and Monet often painted bouquets, as did some Pointillistes (Signac). The Fauves, except for Manguin (1908), were not much tempted by the subject. Symbolists such as Moreau associated flowers with women, and Redon transformed bouquets into a hymn of life. Well known as these works are, they are far less numerous than the forgotten paintings so often shown in the salons of the mid-19th century in Paris and the provinces. This innumerable production, frequently marked by amateurism, nevertheless included some outstanding works, particularly by the School of Lyon, exemplified by Chabal-Dussurgey.

2728. "Hommage à Albert Marqet." *Arts magazine* (20 June 1947):1[+].

2729. JACOMETTI, NESTO. "Artistes de France: Marquet." *Pro-arte* (Sept. 1943):217-20.

2730. JACOMETTI, NESTO. "Rencontre avec Marquet." *Art-documents* 33(1953):10.

2731. JAIMOT, PAUL. "Exposition de tableaux d'Albert Marquet." *Chronique des arts et de la curiosité* (23 Feb. 1907):51-2.

Reviews Marquet's paintings shown at the Galerie E. Druet, Paris.

2732. LADERMAN, GABRIEL. "Expressionism, Concentric and Eccentric." *Artforum* 7(Feb. 1969):53.

2733. LANE, JAMES W. "The Paintings of Albert Marquet." *Gazette des Beaux-arts* ser. 6, 31(May-June 1947):183-90.

2734. LECLERE, TRISTAN. "Albert Marquet." *Art et décoration* 37(May 1920):129-38. 10 illus.

2735. LEVEQUE, JEAN-JACQUES. "Corot, Marquet et la dégradation du paysage" [Corot, Marquet and the Debasement of Landscape]. *Galerie-Jardin des arts* 148(June 1975):43-6. 17 illus.

With relation to two recent exhibitions of paintings by Corot at l'Orangerie, Paris, and by Marquet at the Galerie des Beaux-arts de Bordeaux, Levêque discusses the

changing attitude towards landscape since the time of the Impressionists under the influence of increasing urbanism and pollution of the landscape. In contrast to the Impressionists and to the painters of the early 20th century who exalted modernism, contemporary artists use the discarded elements of civilization to arouse awareness of ecological problems and to exalt the survival of unpolluted nature.

2736. LEVEQUE, JEAN-JACQUES. "Marquet fut un admirable voyeur" [Marquet Made an Admirable Observer]. *Galerie-Jardin des arts* 151(Oct. 1975):41-3. 6 illus.

The nude is quite rare in Marquet's works which were composed principally of town and port scenes. Yet the exhibition of his work at l'Orangerie, Paris, allowed discovery of another side to Marquet. Through painting women he showed a new aspect of his character—a kind of perversity and terror of woman, linking his visions to a Western tradition which society is only now exorcizing.

2737. LEYMARIE, JEAN. "Il Fauvismo, la Fasa preparatoria." *L'Arte moderna* (1967).

2738. "Marquet: dessins." *Le Point* (Souilac)27(1943). 48 p., 36 illus.

Special issue of *Le Point* dedicated to Marquet. Includes an essay by André Rouveyre and an historical resumé ("19, quai Saint Michel") by George Besson. Marquet's relationship with Galerie Druet is discussed on pp. 42-5.

2739. "Marquet, Gentle Fauve." *Art News* 63(Summer 1964):44.

2740. "Marquet: Works Now on the Market." *Burlington Magazine* 103(Dec. 1961):supp. 7.

2741. MARQUET, ALBERT. "*Alger, les palmiers.*" *Apollo* 130(Nov. 1989):24.

2742. MARQUET, ALBERT. "*Assouan.*" *Apollo* 128(Oct. 1988):6.

2743. MARQUET, ALBERT. "*Le Carnaval à Fécamp.*" *Connaissance des arts* 452(Oct. 1989):171.

2744. MARQUET, ALBERT. "*L'Ete.*" *L'Œil* 418(May 1990):13.

2745. MARQUET, ALBERT. "*La Gare Montparnasse sous la neige.*" *Art News* 84(April 1985):5.

2746. MARQUET, ALBERT. "*La Rochelle, départ des voiliers.*" *L'Œil* 360-1(July-Aug. 1985):43.

2747. MARQUET, ALBERT. "*The Lagoon, Venice.*" *Apollo* 120(Sept. 1984):208.

2748. MARQUET, ALBERT. "*Le Point du jour, banlieue de Paris.*" *Antiques* 136(Oct. 1989):690.

2749. MARQUET, ALBERT. "*Le Pont de Chennevières.*" *Art News* 89(April 1990):31.

2750. MARQUET, ALBERT. "*Le Pont-neuf.*" *Connaissance des arts* 436(June 1988):24.

2751. MARQUET, ALBERT. "*Porquerolles.*" *Connaissance des arts* 399(May 1985):33.

2752. MARQUET, ALBERT. "*Le Port d'Alger.*" *L'Œil* 395(June 1988):18.

2753. MARQUET, ALBERT. "*Quai des Grands-Augustins, effet de pluie.*" *L'Œil* 393(April 1988):inside back cover.

2754. MARQUET, ALBERT. "*Quai du Louvre en été.*" *Connaissance des arts* 394(Dec. 1984):116.

2755. MARQUET, ALBERT. "*La Seine à Triel.*" *Connaissance des arts* 401-2(July-Aug. 1985):8.

2756. MARQUET, ALBERT. ["*Streetscape with Flags*"]. *Apollo* 127(June 1988):140 and *L'Œil* 392(March 1988):back cover.

2757. MARQUET, ALBERT. "*Vedette in Hamburg.*" *Yale University Arts* 394(Dec. 1984):116.

2758. MARQUET, ALBERT. "*Venise.*" *Connaissance des arts* 393(Nov. 1984):20.

2759. MARQUET, ALBERT. "*Venise, l'entrée du Grand Canal.*" *L'Œil* 382(May 1987):71.

2760. MARQUET, ALBERT. "*Venise, l'entrée du Grands, effet de pluie.*" *Connaissance des arts* 424(June 1987):53.

2761. MARQUET, ALBERT. "*View of a City Harbor.*" *Connoisseur* 214(Nov. 1984):10.

2762. MARQUET, ALBERT. "*Les Voiles rouges, Audierne.*" *Art & Antiques* (March 1986):32 and *Connaissance des arts* 399(May 1985):28.

2763. MARQUET, ALBERT. "*Voiliers près d'un port.*" *Connaissance des arts* 415(Sept. 1986):12 and *L'Œil* 375(Oct. 1986):7.

2764. MARQUET, MARCELLE. "Bubu vu par Marquet." *L'Œil* (1958).

2765. MARQUET, MARCELLE. "Les Céramiques d'Albert Marquet" in *Cahier de la céramique et des arts du feu* (Sèvres, 1960), pp. 144+.

2766. MARTIN-MERY, GILBERTE. "Inauguration des Salles Marquet, Musée des Beaux-arts, Bordeaux" *Museum* (Unesco) 14:2(1961):125-6. English text.

2767. MEGRET, FREDERIC. "Marquet." *Vie des arts* (Winter 1963-64):42-9.

2768. MERMILLON, MARIUS. "Marquet." *Apollo* 11(April 1930):382.

2769. MERMILLON, MARIUS. "Marquet." *Arts de France* 15(1947):16.

2770. MERMILLON, MARIUS. "Albert Marquet est mort." *Arts de France* 15-6(1947):113-4. 4 illus.

2771. MICHA, RENE. "Albert Marquet: l'univers des solides" [Albert Marquet: The Universe of Solids]. *Art international* 20:2-3 (Feb.-March 1976):p. 34-6. 4 illus.

Discusses of Marquet's works in the light of the exhibition of his paintings and drawings held at the Musée des Beaux-arts, Bordeaux, and l'Orangerie, Paris. Micha analyzes works in relation to particular themes and problems concerned with aspects of color and drawing, subject matter, and the ink drawings.

2772. MONTFORT, EUGENE. "Les Dessins de Marquet." *Les Marges* 16:60(15 March 1919).

2773. NATHANSON, THADEE. "Deux élèves de Gustave Moreau: Marquet et M. Matisse" in *Peints à leur tour* (Paris: Albin Michel, 1948), pp.197-205.

2774. NEMIROVSKAJA, M. "Obrazy, rozdennye vremenem" [Images Born by Time] *Tvorcestvo* 264(Dec. 1978):21-3. 8 illus. In Russian.

Examines the work of a group of artists of the early 1930s, little known and appreciated, who avoided the dictates of Socialist Realism. The group included Antonina Sofronova (to whom the article is devoted), Daniil Dara, Nikolaj Kuz'min, and others. Nemirovskaja notes parallels between Sofronova and Albert Marquet and also Aleksandr Drevin.

2775. "Notable Works of Art Now on the Market." *Burlington Magazine* 103(Dec. 1961):supp. 7.

Mentions Marquet's *L'Aloès, Alger* and *Conflans Ste. Honorine.*

2776. "Notable Works of Art Now on the Market." *Burlington Magazine* 106(June 1964):supp. 4.

Discusses Marquet's *La Seine et le Panthéon.*

2777. "Œuvres dans le Musée d'Art moderne occidental à Moscou." *Cahiers d'art* 25:2(1950):342.

2778. "Omaggio a Marquet." *Emporium* 103(April 1946):201.

2779. PANCERA, MARIO B. "Indimenticabile Parigi di Marquet" [Marquet's Unforgettable Paris]. *Arte* 15:158(Dec. 1985):52-9, 118. 9 illus.

Account of the life and career of Albert Marquet (1875-1947). Pancera states that, throughout his life, which was mostly spent in Paris, Marquet rebelled against conventional painting, and his pictures of Paris shown an unrivalled luminosity and sense of color. Includes a section on the prices that paintings by Marquet command at auction.

2780. PAUL, FREDERIC. "Derain: *Paysage II*" [Derain: *Landscape II*] *Noise* 5(Sept. 1986):42-3.

Analysis of a landscape drawing by André Derain which is mainly concerned with attitudes to landscape as expressed by other artists such as Marquet, with whom Paul compares Derain.

2781. PHILIPPE, CHARLES-LOUIS. "Sur dix croquis d'Albert Marquet." *La Grande revue* (Oct. 1908).

2782. "Il Pittore Albert Marquet." *Dedalo* 6(1925-6):320-42.

2783. "Portrait by Matisse." *Art News Annual* 22(1952):118.

2784. REUILLARD, GABRIEL. "Albert Marquet." *Paris-Normande* (10 Dec. 1951).

2785. ROGER-MARX, CLAUDE. "Marquet." *Gazette des Beaux-arts* ser. 6, 21:905(March 1939):175-93. 14 illus.

2786. SANDOZ, MARC. "Il y a dix ans . . . Albert Marquet." *Le Jardin des arts* 32(June 1957).

2787. SANDOZ, MARC. "Le Peintre Albert Marquet en Aunis, Saintonge et Poitou." *Cahiers de l'ouest* 9(Jan. 1956).

2788. SANDOZ, MARC. "Signac et Marquet à La Rochelle, Les Sables-d'Olonne, La Chaume, Croix-de-Vie." *Dibutade* (Poitrers) 4:91(1957):1-32. 18 illus.

2789. SCHLUMBERGER, EVELINE. "Regards amis" [Friendly Looks]. *Connaissance des arts* 381(Nov. 1983):62-9. 16 illus.

Gérald Schurr has built up one of the best collections of portraits in the world. In his description of the collection, the author cites Schurr's statements on his attitude towards portraits and his reasons for his collection. Some of the self-portraits, which can be regarded as the cream of the collection, are illustrated and accompanied by the brief biographies of the artists and descriptions of their work. These include works by Albert Marquet, among other artists.

2790. SCHMALENBACK, FRITZ. "Notizen zu Marquet" in *Kunsthistorische Studien* (Basel: Fritz Schmalenback, 1941), pp. 105-11.

2791. SCHURR, GERALD. "A. Marquet, peintre de la mésure." *Galerie des arts* 46(May 1967):30-3.

2792. SCHURR, GERALD. "Marquet." *Arti* 6(1967):34-7.

2793. SEMBAT, MARCEL. "Albert Marquet." *L'Art et les artistes* 104(Nov. 1913):64-9. 7 illus.

2794. STEELE, R. "French Impressionism." *Art and Australia* 22:1(Spring 1984):87-93. 8 illus.

Surveys the Art Gallery of New South Wales's collection of French Impressionist paintings. The collection is small, and the paintings in it should be viewed as examples of one artist's work at a particular time, and not as representative of the movement itself. Steele considers eight paintings, used to explain the development of the movement including Albert Marquet's *The Pont Neuf in the Snow*.

2795. STERLING, CHARLES and GERMAIN BAZIN. "Pierre-Albert Marquet" in René Huyghe, *L'Historie de l'art contemporain: la peinture* (Paris: Félix Alcan, 1935), p. 123.

2796. SZITTYA, EMILE. "Marquet parcourt le monde" in *Portraits contemporains* (Paris, 1950). 5 illus.

Includes one original lithograph by Marquet.

2797. LE TARGAT, FRANÇOIS. "Les Paysages d'Albert Marquet" [The Landscapes of Albert Marquet]. *Beaux-arts magazine* 24(May 1985)·94-5. 5 illus.

Account of the oil and watercolor landscape paintings of Albert Marquet, who concentrated on an evocation of atmosphere and light. Marquet was shortsighted, and this, according to Le Targat, explains why his works abandon detail and opt for a generalized view which captures the essence of their subjects. He resembles Matisse, and his love of color in many ways puts him in the same category as the Fauves. Marquet, who came from Bordeaux, travelled extensively and first exhibited in Paris. Much of his best work is characterized by a contemplative strain akin to that of Corot.

IV. Catalogue Raisonné

2798. MARTINET, JEAN-CLAUDE. *Catalogue raisonné de l'œuvre de Marquet.* Paris: Fondation Wildenstein. In preparation.

V. Illustrated Books

2799. MONTFORT, EUGENE. *Mon Brigadier Triboulère*. Illustré de 20 dessins clichés au trait par Albert Marquet. Paris: Société Littéraire de France, 1918. 127 p., illus.

Montfort (1877-1930) was a critic, essayist, novelist, and founder of the journal *Les Marges*. Raoul Dufy illustrated another of his books, *La Belle enfant ou l'amour à quarante ans*, edited by Ambroise Vollard and published in 1930.

2800. *L'Académie des dames*. 20 lithographies originales d'Albert Marquet. Paris, New York: Editions des Quatre-Chemins Editart. 365 copies.

2801. MARTY, MARCELLE [pseud. for Marcelle Marquet]. *Moussa, le petit noir*. Illustré de 20 dessins et 5 aqaurelles en couleurs d'Albert Marquet. Paris: Editions Crès, 1925. 365 copies.

2802. COQUIOT, GUSTAVE. *En suivant la Seine.* Avec dessins inédits de Bonnard, Boris, Bottini, Chagall, Delcourt, André Derain, Raoul Dufy, Henri Epstein, Othon Friesz, Pierre Laprade, Marie Laurencin, Luce, Manguin, Luc-Albert Moreau, Marquet, Picasso, Utrillo, van Dongen, Suzanne Valedon, Vlaminck. Paris: A. Delpeuch, 1926. 138 p., pl.

2803. *Bords de Seine.* Suite de six pointes sèches originales d'Albert Marquet. Paris, New York: Editions des Quatre Chemins Editart, 1927. 80 copies (10 on Japan Imperial, 70 on vellum).

2804. *Séjour à Venise: Quatre lettres familières du Président de Brosses.* Illustré de 31 gravures à l'eau fort d'Albert Marquet. Paris: Editions Textes et Prétextes, 1947. 290 copies.

2805. MARTY, MARCELLE [pseud. for Marcelle Marquet]. *Images d'une petite ville arabe.* 26 gravures originales sur cuivre d'Albert Marquet. Paris: Editions Manuel Bruker, 1947. 200 copies.

2806. MARQUET, ALBERT. *Dix estampes originale.* Présentées par George Besson. Six lithographies en couleurs, trois lithographies en noir et blanc, 2 pointes sèches, 1 eau-forte d'Albert Marquet. Paris: Editions Rombaldi, 1947, 100 copies. Volume in "Maîtres de l'estampe française contemporaine" series.

2807. MARQUET, ALBERT. *Les Grisons.* Suite de sept lithographies originales d'Albert Marquet. Paris, 1947. 50 copies.

2808. BOSCO, HENRI. *Sites et mirages.* Illustré de 24 aqaurelles d'Albert Marquet reproduits au pochoir et de 23 dessins d'Albert Marquet. Paris, Casablanca: Editions de la Cigogne, 1950. 185 p., illus. 225 copies.

a. Another ed.: Paris: Gallimard, 1951.

2809. CASSOU, JEAN. *Rhapsodie parisienne.* Illustré de 12 lithographies en noir et blanc et de quatre lithographies en couleurs d'Albert Marquet. Paris: Editions de la Galerie Charpentier, 1950. 123 p., illus. 130 copies.

2810. MARQUET, ALBERT. *Venise, carnet de voyage.* Préface par Marcelle Marquet. Paris: Editions Quatre-Chemins Editart, 1953. 2 vols., illus., some col. 250 copies.

Portfolio of forty-six drawings and five watercolors, reproduced in facsimile.

2811. MARQUET, MARCELLE and ALBERT MARQUET. *Le Danube, voyage de printemps.* Préface par Marcelle Marquet. 16 aquarelles et 4 dessins d'Albert Marquet reproduits au pochoir par Daniel Jacomet. Lausanne: Editions Mermod, 1954. 29 p., illus., 16 col. pl. 470 copies. Volume in "Carnets de Françoise" series.

2812. PHILIPPE, CHARLES-LOUIS. *Bubu de Montparnasse.* Illustrations d'Albert Marquet. Paris: Editions C. Coulet et A. Faure, 1958.

2813. MARQUET, ALBERT. *Marquet dessine les animaux.* Présentation par Marcelle Marquet. Illustré de 36 dessins d'Albert Marquet. Paris: Editions du Pont-Neuf; La Bibliothèque des Arts, 1963. 21 p., illus., 17 pl. 500 copies.

2814. MARQUET, MARCELLE. *Pluie de printemps.* Illustré de 16 dessins d'Albert Marquet. Paris, Lausanne: La Bibliothèque des Arts, 1969. 309 p., illus. 500 copies.

VI. Exhibitions

A. Individual Exhibitions

1907, 11-23 February	Paris, Galerie E. Druet. *Exposition Albert Marquet.* 39 works. Review: P. Jamot, *Chronique des arts et de la curiosité* (23 Feb. 1907):51-2.
1910, May-June	Paris, Galerie E. Druet. *Exposition de peintures d'Albert Marquet.*
1913, 31 March- 12 April	Paris, Galerie E. Druet. *Exposition de peintres d'Albert Marquet.*
1920, May	Paris, Galerie E. Druet. *Exposition de peintures d'Albert Marquet.*
1924	Brussels, Galerie Giroux, *Albert Marquet.*
1925, November	Paris, Galerie Bernheim-Jeune. *Albert Marquet.*
1928, May	Paris, Galerie E. Druet. *Albert Marquet.*
1929, February	Paris, Galerie Rodrigues-Henriques. *40 dessins et aquarelles d'Albert Marquet.*
1933	Paris. *Albert Marquet.* Review: G. Besson, *Beaux-arts* (3 Nov. 1933):3.
1934, 4-15 June	Paris, Galerie E. Druet. *Albert Marquet, ses œuvres récentes.* Review: C. Devau, *Beaux-arts* (8 June 1934):8.
1935	London, Tooth's Galleries. *Albert Marquet.* Reviews: *Apollo* 22(Aug. 1935):109; *Beaux-arts* (20 Sept. 1935):6.
1936, 14-24 December	Paris, Galerie E. Druet. *Venise par Marquet.* 44 paintings and watercolors. Review: J. de Laprade, *Beaux-arts* (18 Dec. 1936):8.
1937-38	Paris, Galerie Bernheim-Jeune. Review: J. Bonjean, *Beaux-arts* (31 Dec. 1937):8.
1937	Geneva, Musée de l'Athénée. *Albert Marquet.*
1938	Paris, Galerie de l'Elysée. Review: G. Besson, *Beaux-arts* (2 Dec. 1938):1[+].
1938	Amsterdam, Galerie Santee, Landweer. *Marquet.*

1939	*Albert Marquet à Algers.* Review: *Beaux-arts* (14 April 1939):4.
1946-47	Paris, Galerie des Quatre-Chemins. Review: *Art Magazine* (13 Dec. 1946):4.
1948, June-August	Zurich, Kunsthaus, Gedächtnis-Ausstellung. *Albert Marquet, 1875-1947.* Verzeichnis mit Einfürungen von George Besson, W. Wartmann, Claude Roger-Marx. 45 p., 3 illus., 9 pl. 280 works. 181 paintings, 47 watercolors, 51 drawings. Review: *Arts Magazine* (6 Aug. 1948):3.
1948, October-December	Paris, Musée National d'Art moderne. *Albert Marquet, 1875-1947.* Textes de Jean Cassou, George Besson, Claude Roger-Marx. 97 paintings.
1949, Spring	Alger, Musée National des Beaux-arts d'Alger. *Exposition d'œuvres d'Albert Marquet.* Texte de Jean Alazard. 76 paintings, 20 watercolors, 20 drawings.
1949, 30 May-30 June	Bordeaux, Musée des Beaux-arts. *Rétrospective des œuvres de Marquet.* 51 paintings, 20 watercolors, 20 drawings.
1950, 9 September-3 December	Copenhagen, Statens Museum for Kunst. *Albert Marquet, 1875-1947: malerier, akvareller tegninger, grafik.* Also shown Oslo, Maison des arts (4 Nov.-3 Dec. 1950). Text by Joorn Rubow, W. halvorsen. 42 p., illus., 8 pl. 54 paintings, 74 watercolors and drawings.
1950	Paris, Galerie Motte. Review: *Werk* 37(June 1950):supp. 80.
1951, April-May	Jerusalem, Musée Bezlel. *Marquet.* Also shown Tel Aviv, Musée des Beaux arts (May). 50 paintings, 22 watercolors, 34 drawings.
1952, January	Paris. *Albert Marquet: dessins.* Review: *Time* 59(21 Jan. 1952):58.
1952, 15 October-15 November	London, Wildenstein Gallery. *Paintings by Albert Marquet.* Preface by George Besson. 45 paintings.
1953, 21 January-21 February	New York, Wildenstein Gallery. *A Loan Exhibition of Marquet, Sponsored by Count Jean Vyau de Lagarde.* Private preview for the benefit of "Le Pélerinage artistique et littéraire en France," a special scholarship fund set up by l'Alliance française of New York, for

American students. Texts by George Besson and Marcelle Marquet. 32 p., illus. 73 paintings.
Reviews: *Apollo* 50(Nov. 1952):137; *Connoisseur* 130(Jan. 1953):207; *Architectural Review* 112(Dec. 1952):413; *Studio* 145(Jan. 1953):26-7; *Art Digest* 27(1 Feb. 1953):14; *Art News* 51(Feb. 1953):58.

1953, 13 June-
13 September

Vevey, Switzerland, Musée Jenisch. *Exposition Albert Marquet.* Préface de Marcelle Marquet, catalogue par François Daulte. 48 p., illus., 16 pl. 74 paintings, 15 watercoliors, 16 drawings, 8 illustrated books.
Review: *Werk* 40(Sept. 1953):supp. 40.

1953, 16 June-
11 July

Paris, Galerie des Quatre-Chemins Editart. *Les Voyages d'Albert Marquet.* 33 watercolors and drawings.

1953, 22 October-
14 December

Paris, Maison de la Pensée française. *Albert Marquet.* Préface de George Besson. 92 paintings and watercolors, 26 drawings.
Reviews: *France illustration* 406(Jan. 1954):86; L. Landini, *Paragone* 51(March 1954):48.

1954

Lausanne, La Vielle Fontaine. *Marquet: aquarelles, dessins.*
Review: *Werk* 41(Sept. 1954):supp. 212.

1954

Toulouse, Musée des Augustins. *Albert Marquet.* 48 paintings, 19 watercolors, 27 drawings, 8 illustrated books.

1955, 9 July-
30 September

Besançon, Musée des Beaux-arts. *Exposition Albert Marquet: peintures, aqaurelles, dessins.* Texte de Bernard Dorival. 22 p., illus., 4 pl.

1955-56,
18 December-
5 April

Rotterdam, Boymans Museum. *Marquet.* Also shown Arnheim, Gemeentemuseum (12 Feb.-5 April 1956). Text by Marcelle Marquet, J. C. Ebbinge Wubben. 40 p., illus. 52 paintings, 17 watercolors, 31 drawings.

1956

Paris, Galerie Katia Granoff. *Les Marquets sans eau.*

1957, Spring

Sète, Musée de Sète. *Marquet.* 5 paintings, 20 drawings of Sète, 9 illustrated books.

1957, 6 July-
25 September

Albi, Musée Toulouse-Lautrec. *Albert Marquet, 1875-1947: peintures, aqaurelles, dessins.* Textes de George Besson, Edouard Julien. 124 p., illus. 74 paintings, 16 watercolors, 36 drawings.

1958, 26 May-Fall

Baltimore, Baltimore Museum of Art. *Albert Marquet, 1875-1947.* Also show Cincinnati Art Museum; Utica,

New York, Munson-Williams-Proctor Institute; San Francisco Museum of Art; Seattle Art Museum. Text by Grace Morley. San Francisco: San Francisco Museum of Art, 1958. 31 p., illus.

1958, 2 November-1 December	Paris, Grand Palais, Salon d'Automne. *Hommage à Marquet.*
1958	Moscow, Gosudartvennyi Muzei Izobrazitelnykh Iskusstv imeni tv imeni A. S. *Vystavka Proizvedeni í Albera Marke 1875-1947: Lartiny, Akvareli, Risunki, Graviury, Knizhniye illiustratsii iz sobranía Marcel Marke vo frantsii i Muzeev SSSR: Katalog.* 32 p., illus.
1959, March-April	Leningrad, Gosudarstvennyi Ermitazh. *Vystavka Albera Marke.* Text by I Urii Aleksandrovich Rusakov. 15 p., illus.
1959, June-July	Nancy, Musée des Beaux-arts. *Exposition Albert Marquet.*
1959, August-September	Metz, Musée de la Ville. *Exposition Albert Marquet.* Also shown Nancy, Musée des Beaux-arts. Texte de George Besson. 78 p., illus.
1960, May-June	Paris, Maison de la Pensée française. *Marquet à Bordeaux.* Texte par Gilberte Martin-Mery. 35 paintings, 50 drawings. 30 p., illus. Reviews: P. Schneider, *Art News* 59:3(May 1960):44; K. Morand, *Burlington Magazine* 102(May 1960):224; A. Watt, *Studio* 159:806(June 1960):221.
1960, 9-30 June	Paris, Galerie Huguette Berès. *Marquet.*
1960, June	Belgrad, Narodni Muzej. *Albert Marquet, 1875-1947.* 46 p., illus.
1960, 18 September-30 October	Tokyo, Bridgestone Museum of Art. *Albert Marquet.* Texte de Marcelle Marquet.
1960	Zagreb, Moderna Galerija. *Albert Marquet.* 18 p.
1961, 13 April-4 May	Lyon, Galerie Saint-Georges. *Albert Marquet.* Texte de George Besson.
1962	Paris, Galerie du Cirque. *Marquet: dessins et aquarelles.* Review: A. Brookner, *Burlington Magazine* 104(Jan. 1962):44.

1962, 9 May-2 June	Paris, Galerie Jean-Claude et Jacques Bellier. *Aspects insolites de Marquet.*
1962, Summer	Lyon, Musée des Beaux-arts. *Marquet: exposition.* Organizée sous l'égide du Syndicat d'initiative de Lyon. Rédigé par Madeleine Rocher-Jauneau. Texte de René Jullian. 64 p., 23 illus., 6 pl. 92 paintings and watercolors, 26 drawings. Includes Jullian's essay, "Marquet peintre de l'eau."
1962	Amsterdam, Rijksakademie. *Albert Marquet.*
1964, May	New York, Knoedler Gallery. *Marquet.* Text by François Daulte. 42 p., illus., some col. 60 paintings. Reviews: *Art News* 63(Summer 1964):12; V. Raynor, *Arts Magazine* 38(Sept. 1964):67.
1964	Montréal, Musée des Beaux-arts. *Albert Marquet, peintre française.* Also shown Québec, Musée des Beaux-arts and Ottawa, National Gallery of Canada. 92 p., illus.
1964-65, 14 November-10 January	Hamburg, Kunstverein. *Albert Marquet: Gemälde, Pastelle, Aquarelle, Zeichnungen.* Ausstellung befürwartet von ICom. Forward by Marcelle Marquet; introduction by Hans Platte. 93 pl. 82 paintings, 12 pastels, 5 watercolors, 52 drawings. Review: H. Flemming, *Kunstwerk* 18(Jan. 1965):25.
1966, 23 July-31 August	Honfleur, Le Grenier à Sel. *Exposition A. Marquet, de Paris à la mer.*
1966	Montrouge, Salle des Fêtes. *Marquet exposition.*
1967, 17 May-17 June	Paris, Galerie Schmit. *Exposition Marquet, 1875-1947.* Texte de George Besson. 126 p., 7 illus. 101 paintings, 24 watercolors, 15 drawings. Review: G. Schurr, *Connoisseur* 165(June 1967):129.
1967, Summer	Nice, Palais de la Méditerranée. *Albert Marquet.*
1968, 5 July-5 October	Saintes, Musée des Beaux-arts. *Marquet.* 34 p., 5 illus.
1968	Bordeaux, Musée des Beaux-arts. *Albert Marquet: dessins.* Texte de Gilberte Martin-Méry.
1970, February-March	Tokyo, Fujikawa Galleries. *Marquet.*

1971, 28 October-
4 December

New York, Wildenstein & Co. *Albert Marquet*. A Loan Exhibition for the Benefit of the Hospitality Committee of the United Nations. Preface by Raymond Cogniat. 52 p., illus. 73 paintings.
Reviews: G. Brown, *Arts Magazine* 46(Nov. 1971):49; *Art News* 70(Nov. 1971):76; *Art International* 16(Jan. 1972):41.

1972, 12 January-
18 February

London, Wildenstein Gallery. *Albert Marquet*. Loan Exhibition in Aid of the National Art-Collections Fund. Preface by Raymond Cogniat. 56 p., 46 illus. 46 paintings.
Reviews: *Country Life* 151(20 Jan. 1972):141; M. Wykes-Joyce, *Arts Review* 24:2(29 Jan. 1972):37; *Apollo* 95(Jan. 1972):65, (Feb. 1972):138; *Burlington Magazine* 114(Feb. 1972):106⁺.

1972, 27 April-
13 July

Paris, Galerie Bernheim-Jeune. *Marquet.* Texte de Charles Kunstler. 44 paintings, 6 pastels and watercolors.
Review: J.-P. Dauriac, *Panthéon* 30(July 1972):335.

1972, June-July

Buenos Aires, Galerie Wildenstein. *Albert Marquet*.

1973-74,
20 September

Tokyo, Seibu Museum of Art. *Albert Marquet*. Also shown Kyoto, National Museum of Modern Art; Fukuoka, Musée des Beaux-arts. Texts by Marcelle Marquet and François Daulte.
Review: *L'Œil* 217-8(Aug.-Sept. 1973):64.

1973, October

Prague, Narodni Galerie. *Albert Marquet, 1875-1947, obrazy a Kresby ze sbirky Muzea Krasnych umeni v Bordeaux*. 52 p., illus. Profily a prehledy, 18.

1974, 21 June-
31 August

Geneva, Galerie des Granges. *Albert Marquet: rétrospective*. Préface de François Daulte. 49 p., illus. 39 paintings, 7 watercolors and drawings.

1975-76, 9 May-
5 January

Bordeaux, Galerie des Beaux-arts. *Albert Marquet, 1875-1947*. Also shown Musée de l'Orangerie, Paris (24 Oct. 1975-5 Jan. 1976). Catalogue rédigé par Gilberte Martin-Mery et Michel Hoog; préface par Jacques Chaban-Delmas; introduction par Jean Cassou; textes par Marcel Sembat, Hélène Adhémar et Marcelle Marquet. 184 p., 216 illus., 15 col., 192 works shown. First French retrospective exhibition of the artist prepared on the centenary of his birth. Included were 92 paintings, dating 1895-1947, watercolors, drawings, pastels, illustrated books, and albums of his prints. Also shown were 27 paintings, sculpture and drawings from the artist's private collection bequeathed to the

French national museums, including works by Matisse, Guys, Redon, Renoir, and Gargallo. Jean Cassou gives a brief characterization of Marquet's paintings through descriptions of the impact of Moreau's art and teaching on his development, of his early Fauve period, and of his mature work. Marcel Sembat discusses technical aspects of Marquet's painting—its geometry, vivd colors, and luminosity—and the artist's predilection for ports as a subject matter for his work. A complete catalogue of the works on show divides them into paintings, watercolors, drawings, and pastels, book illustrations, ceramics. Also included is a catalogue of the works in Albert Marquet's art collection, and a chronology of the artist's travels abroad.

Reviews: *L'Œil* 239(June 1975):78; G. Schurr, *Connoisseur* 189:762(Aug. 1975):315; *Revue du Louvre* 25:4(1975):293; J. Levêque, *Galerie jardin des arts* 151(Oct. 1975):43-6; E. Hoffmann, *Burlington Magazine* (Jan. 1976):54-7; *Goyá* 130(Jan. 1976):247-8; J. P. Dauriac, *Panthéon* 34:1(Jan.-March 1976):66; R. Micha, *Art international/Art Spectrum* 20:2-3(Feb.-Mar. 1976):34-6; E. Mai, *Kunstwerk* 29:2(March 1976):81-2.

1975,
6-30 November

Paris, Galerie Art Yomiuri. *Marquet au Pont-neuf.*

1976, 18 September-
12 December

Munich, Städtische Galerie im Lenbachhaus. *Albert Marquet, 1875-1947.* Organized by the Musée des Beaux-arts, Bordeaux. Texts by Hans Platte, Jean Cassou, Marcel Sembat, Marcelle Marquet. 144 p., 193 illus., 17 col. In German. 154 works shown, 122 by Marquet, 9 by Matisse.

The text of this catalogue is divided into four sections: an introduction to the artist's work by Platte, an essay on his connections with the work of Gustave Moreau by cassou, a critical essay linking his work with Fauvism by Sembat, and an "in memoriam" by Marcelle Marquet which describes memories of her life with the artist and his flirtation with Art Deco. There are descriptions and explanations appended to most of the illustrations.

Review: J. Morscel, *Kunstwerk* 30(Feb. 1977):87-8;

1977, 6 August-
27 November

London, Arts Council of Great Britain. *Albert Marquet: Paintings and Drawings from the Musée des Beaux-Arts, Bordeaux.* Also shown Art Gallery and Museum, Glasgow (6 May-5 June 1977); Ferens Art Gallery, Kingston-upon-Hull (11 June-2 July 1977); Scottish Arts Council Gallery, Edinburg (9-31 July 1977); Graves Art Gallery, Sheffield (6-28 Aug. 1977); National Museum of Wales, Cardiff (3-25 Sept. 1977); Walker Art Gallery, Liverpool (Oct. 1977); Castle Museum,

Nottingham (5-27 Nov. 1977). Foreword by Joanna Drew 2 p., 7 illus., 1 col. 57 works shown.

Marquet is known primarily for his friendship with Matisse and his participation in the Salon d'Automne of 1905 when the epithet "les Fauves" was applied to the group around Matisse. After the inception of Cubism, Marquet's work was neglected by the public as he continued to follow his own style with remarkable consistency, ignoring the succession of artistic fashions. This representative selection from the Marquet collection at Bordeaux was intended to introduce a little-known artist to the British public. Catalogue entries are based on those provided for the artist's centenary exhibition at the Galerie des Beaux-arts, Bordeaux, and l'Orangerie, Paris (1975-76).
Reviews: F. Spalding, *Arts Review* 29:14(8 July 1977):465; F. Spalding, *Connoisseur* 195:786(Aug. 1977):310; H. Mullaly, *Apollo* 106:186(Aug. 1977):155.

1981, 10 January-
22 February

Charleroi, Palais des Beaux-arts. *Albert Marquet: rétrospective.* Sponsored by the Association Française d'Action Artistique. Textes de Robert Rousseau, Jacques Chaban-Delmas, Jacques Lassaigne. 44 p., 20 illus. 65 paintings, 7 watercolors, 46 drawings.
Retrospective exhibition of paintings and drawings by the Bordeaux artist Albert Marquet (1875-1947), containing short texts by Robert Rousseau, Jacques Chaban-Delmas, and Jacques Lassaigne, which provide insights into his life and artistic career.
Reviews: *L'Œil* 306-7(Jan.-Feb. 1981):93.

1981, 11 March-
30 April

Paris, Artcurial. *Albert Marquet.*
Review: *L'Œil* 308(March 1981):78.

1982, 19 June-
17 July

Tokyo, Galerie Wildenstein. *Exposition Albert Marquet.* 25 paintings, 24 watercolors, pastels, drawings.

1983, January-
February

Bordeaux, Galerie des Beaux-arts. *Hommage à Marcelle et Albert Marquet; collection permanente et donation.* Préface par Gilberte Martin-Méry. 144 p., 136 illus., 8 col. 129 works.
Paintings, drawings, and prints by Albert Marquet from the permanent collection, and works given by Marcelle and Albert Marquet to the museum, including eight paintings by Matisse, four by Redon, and one by Seurat.

1985, 10 April-
31 July

New York, Wildenstein Gallery. *Albert Marquet, 1875-1947.* A tribute to the late Jean-Claude Martinet, author of a forthcoming catalogue raisonné of the artist's

works. Also shown London, Wildenstein Gallery (19 June-31 July). 104 p., 121 illus., 27 col. 148 paintings, pastels, watercolors, drawings.

Illustrations are preceded by a selection of comments on Marquet by his contemporaries: Marcel Sembat, George Besson, André Rouveyre and Georges Duthuit, with brief biographies of these men.

Reviews: R. Shone, *Burlington Magazine* 127(Aug. 1985):557; J. Gardner, *Art News* 84(Oct. 1985):131-2.

1985, 24 April- 30 June	Paris, Galerie de la Présidence. *Albert Marquet: peintures, aquarelles, pastels, dessins.* Textes de Robert Marteau, Jean Guichard-Meili. 94 p., illus., 38 pl., some col. 34 paintings, 3 pastels, 5 watercolors, 7 drawings. Reviews: *Connaissance des arts* 399(May 1985):30; R. Bouillot, *L'Œil* 359(June 1985):73; S. Preston, *Burlington Magazine* 127(July 1985):479.
1985, 19 June- 31 July	New York, Wildenstein Gallery. *Albert Marquet, 1875-1947: A Tribute to the Late Jean-Claude Martinet, Author of the Forthcoming Catalogue Raisonné of the Artist's Works.* 104 p., illus., some col.
1988, 12 February- 22 May	Lausanne, Fondation de l'Hérmitage. *Albert Marquet, 1875-1947; donation famille Bugnion.* François Dault, ed. 224 p., 319 illus., 128 col. Paintings, drawings, watercolors, pastels, illustrated books. Reviews: F. Daulte, *L'Œil* 390-1(Jan.-Feb. 1988):42-9; F. Daulte, *Connaissance des arts* 433(March 1988):72-81.
1989-90, November- January	Sainte-Croix, Musée de l'Abbaye Sainte-Croix. *Marquet aux Sables d'Olonne, 1921-33.* 32 p., illus. Cahiers de l'Abbaye Sainte-Croix, no. 64. Reviews: M. Ernould-Gandouet, *Antiques* 136(Oct. 1989):690; *L'Œil* 412(Nov. 1989).

B. Group Exhibitions

1904, 21 February- 24 March	Paris, Grand Palais. *Salon des Indépendants.* 5 paintings.
1904, 2-30 April	Paris, Galerie Berthe Weill. 6 paintings.
1904, 15 October- 15 November	Paris, Petit Palais. *Salon d'Automne.* 10 paintings.
1905, 24 March- 30 April	Paris, Grand Palais. *Salon des Indépendants.* 8 paintings.

1905, 6-29 April	Paris, Galerie Berthe Weill. 5 paintings.
1905, 18 October-25 November	Paris, Grand Palais. *Salon d'Automne*. 5 paintings.
1905, 21 October-20 November	Paris, Galerie Berthe Weill. 6 paintings.
1906, 22 February-25 March	Brussels. *La Libre Esthétique*. Catalogue par Octave Maus. 6 paintings.
1906, 20 March-30 April	Paris, Grand Palais. *Salon des Indépendants*. 8 paintings.
1906, 26 May-30 June	Le Havre, Hôtel de Ville. *Cercle de l'Art moderne*.
1906, 6 October-15 November	Paris, Grand Palais. *Salon d'Automne*. 8 paintings.
1907, 30 March	Paris, Galerie Berthe Weill.
1907, March-April	Vienna, Galerie Miethke. Catalogue text by Rudolf A. Meyer. 7 paintings.
1907, June	Le Havre, Hôtel de Ville. *Cercle de l'Art moderne*. Catalogue texte par Ferdinand Fleuret. 2 paintings.
1907, 1-22 October	Paris, Grand Palais. *Salon d'Automne*. 2 paintings.
1907, 24 October-10 November	Paris, Galerie Eugène Blot. Catalogue texte par Louis Vauxcelles. 10 paintings.
1908, 20 March-30 April	Paris, Grand Palais. *Salon des Indépendants*. 3 paintings.
1908, 18 April-24 May	Moscow, Salon de la Toison d'Or. 3 paintings.
1908, June	Le Havre, Hôtel de Ville. *Cercle de l'Art moderne*. Catalogue texte de Guillaume Apollonaire.
1908, 3-20 July	Paris, Galerie Druet. 3 paintings.
1908, September	Dresden, Richter Art Salon.
1908, 1 October-8 November	Paris, Grand Palais. *Salon d'Automne*. 6 paintings.
1908, 11-31 December	Paris, Galerie Berthe Weill.

1908-09, 21 December- 16 January	Paris, Galerie E. Druet.
1937, June-October	Paris, Musée de Petit-Palais. *Les Maîtres de l'art indépendant*. 37 paintings.
1938	Stockholm. Review: *Beaux-arts* (5 June 1938):5.
1940	Paris, Galerie Beaux-arts. Review: M. Zahar, *London Studio* 20(*Studio* 20)(July 1940):25-6.
1950, 29 April- 29 May	Bern, Kunsthalle. *Les Fauves*. Foreword and essay by Arnold Rüdlinger. 26 p., 14 pl. 9 works.
1950, 8 June- 15 October	Venice, XXV Biennale. *Internazionale d'Arte: Mostra dei Fauves*. 6 works. Reviews: M. Georges-Michel, *Biennale di Venezia* 2(1950):9-10; G. Veronesi, *Emporium* 112(1950):51-60.
1955	Poitiers, Musée de Poitiers. *Marquet et Signac*. Texte par Marc Sandoz.
1957	Poitiers, Musée de Poitiers. *Signac et Marquet: influence du site sur leur œuvre; œuvres inédites: 1911-1933*. Texte par Marc Sandoz.
1959	Paris, Musée du Petit-Palais. *De Géricault à Matisse*.
1959, 17 June- 10 August	London, Crane Kalman Gallery. *A Selection of Paintings by Albert Marquet (1875-1947) and Jean Puy (b. 1876)*.
1961, 5 July- 8 September	Chartres, Chambre de commerce. *Marquet et ses amis*. 15 p., illus.
1962	Paris, Galerie Charpentier. *Les Fauves*. Review: A. Brookner, *Burlington Magazine* 104(May 1962):221.
1964	Lausanne, Palais de Beaulieu. *Chefs-d'œuvre des collections suisses de Manet à Picasso*.
1964	Paris, Musée du Louvre. *Collection George et Adèle Besson*.

1966

Paris, Musée National d'Art moderne. *Le Fauvisme français et les débuts de l'expressionisme allemand.* Also shown Munich, Haus der Kunst.

1973-74,
7 November-
24 March

College Park, Maryland, University of Maryland, Art Gallery. *Twentieth Century Masterpieces from the Musée de Grenoble.* Also shown J. B. Speed Art Museum, Louisville (7 Jan.-3 Feb. 1974); University of Texas, Art Museum, Austin (17 Feb.-24 Mar. 1974). Essay and catalogue by Stephen Whitney. Trans. by Eda M. Levitine. 112 p., 46 ilus., 6 col. 45 works shown. Exhibition of paintings by Baumeister, Bonnard, di Chirico, R. Delaunay, Le Corbusier, Léger, Magritte, Marquet, Matisse, Picasso, Servranckx, Signac, Vasarely, and Vuillard. Whitney's introductory essay traces the history of the Grenoble museum's collection of modern art, which was developed during the directorship (1919-50) of Pierre Andry-Farcy, and greatly augmented in 1923 by the Agutte-Sembat bequest, eight paintings from which were included in this exhibition.

1974

London, Lefevre Gallery.
Review: *Architectural Review* 155(Feb. 1974):98.

1975, 23 October-
23 November

Paris, Grand Palais. Salon d'Automne. *Hommage à Michel-Ange: Sculpteurs italiens contemporains; François Desnoyer; Marquet intime; Présence de J. Villon chez un collectionneur; Aménagement et architecture, l'habitat individuel en région parisienne; Le Carreau des Halles.* 146 p., 67 illus.
Along with the works exhibited in the 1975 Salon d'Automne were sections devoted to Michelangelo (six casts of sculptures), contemporary Italian sculpture, Desnoyer, Marquet, Villon, modern Parisian architecture, and plans for the Les Halles site.

1981, Spring

Paris, Galerie Daniel Malingue. *L'Ecole de Paris.*
Review: F. Daulte, *L'Œil* 310(May 1981):62-5.

1981-82,
10 November-
14 March

New York, Metropolitan Museum of Art. *Twentieth Century French Drawings from the Robert Lehman Collection.* Catalogue by George Szabo. 71 p., 64 illus. 63 works shown.
Drawings and watercolors by modern French artists, including Signac (nineteen works), Jacques Villon (eight works), Matisse, Bonnard, Marquet, Vlaminck, and Valadon.

1982, Summer

Saint Tropez, Musée de l'Annonciade. *Fleurs de Fantin-Latour à Marquet.*

Review: E. Hild and E. Hardouin-Fugier, *L'Œil* (July-Aug. 1982):67-70.

1983, 4 June-
2 October

Martigny, Fondation Pierre Gianadda. *Manguin parmi les Fauves*. Catalogue par Lucile Manguin, Pierre Gassier, Maria Hahnloser. 175 p., 107 illus.
Exhibition of paintings and drawings by Henri Manguin (1874-1949) and ten members of Les Fauves: Braque, Charles Camoin, Dufy, Emile-Othon Friesz, Albert Marquet, Matisse, Jean Puy, Louis Valtat, Kees van Dongen, and Maurice de Vlaminck. In his essay Gassier gives an account of Fauvism from its origins in a meeting of Manguin, Matisse, and Marquet in the studio of Gustave Moreau, to its "official" birth at the Salon d'Automne in 1905, tracing the interest of its members in Cézanne and the decline of the movement as Cézanne's work became more widely known. Hahnloser describes the importance for Manguin of his visits to Switzerland, especially Lausanne. Manguin's daughter gives her recollections of his personality. The exhibits are divided into Fauve works and works by Manguin from the post-Fauvist period (1908-49).

1984

London, J. P. L. Fine Art Gallery. *Signac-Marquet*.
Review: *Art & Artists* 219(Dec. 1984):34.

1985, 15 June-
20 October

Lausanne, Fondation de l'Hermitage. *De Cézanne à Picasso dans les collections romandes*. Catalogue par François Daulte. 200 p., 121 illus., 120 col.
Annotated catalogue to an exhibition of 20th century paintings and sculptures from private and public collections in French-speaking Switzerland, by exponents of Post-Impressionism (specifically the Nabis and Pointillists); Fauvism and l'Ecole de Paris, including Cézanne, Maillol, Bonnard, Vallotton, Dufy, Derian, Marquet, Matisse, Vlaminck, Rouault, Chagall, Utrillo, Modigliani, and Picasso. The introduction summarizes the history of each of the movements represented—their major members, principal tenets, and most lasting effects on contemporary art—and profiles the collecting tastes of the French-speaking cantons.

1985

Besançon, Musée des Beaux-arts. *Dessins et estampes de la Collections George et Adèle Besson*. 84 p., illus.
Included works by Marquet and Louis Valtat, among other artists.

1987

Rotterdam, Museum Boymans-van Beuningen. *Concours hippique: The Horse in Art*. Foreword by W. H. Crouwel, catalogue by J. R. ter Molen. 64 p., 77 illus., 11 col. Also in Dutch.

Exhibition of art in a variety of media representing the horse, including works by Odilon Redon, Degas, Toulouse-Lautrec, Albert Marquet, Raoul Dufy, among others.

1988, 17 March-
23 April

Lausanne, Galerie Paul Valloton. *Maîtres suisses et français des XIX^e et XX^e siècles* [Swiss and French Masters of the 19th and 20th Century]. 28 p., 31 illus., 12 col. No text.

Exhibition of watercolors, pastels, drawings, and sculptures by French and Swiss artists of the cited period, including André and Albert Marquet.

Emile-Othon Friesz

Biographical Sketch

Like Georges Braque and Raoul Dufy, Friesz was born in Le Havre and studied under Dufy's teachers, Charles Lhuillier at the local art school and Léon Bonnat at l'Ecole des Beaux-Arts in Paris, where he stayed from 1899 to 1904. Friesz was a frequent visitor to the Louvre and to the Impressionist exhibitions at the Galerie Durand-Ruel. In 1901 he met Pissarro and Armand Guillaumin and painted with Guillaumin in Falaise and the Creuze valley, adopting an Impressionist style. Influenced by Matisse's high-color techniques, Friesz was an early convert to Fauvism and showed in the historic 1905 Salon d'Automne. His Fauve works were composed of fluid separated strokes in which color took the place of form and line. His colors were neither as violent nor as saturated as some of the other Fauves and his line was heavier and more exuberant.

From 1905 to 1907 he worked in La Ciotat, Falaise (with Dufy), Anvers (with Braque), Honfluer, Antwerp, and several locations in the Midi (primarily with Braque). In 1906 Druet contracted for his entire production through 1912. Abandoning Fauvism by 1908 for a brief flirtation with Cubism and finally for more conventional colors and composition, Friesz was Matisse's neighbor at the Couvent des Oiseaux in Paris until 1910. He spent the pre-war years traveling (Italy, Germany, Portugal, and Belgium), working in the Midi, and teaching at l'Academie moderne, rue Nôtre-Dame-des-Champs, where he lived until his death in 1949. He completed a series of paintings on the Circus Médrano in 1909 and another series on the city of Toulon in 1914. Friesz served in World War I making topographical drawings and painting camouflage on airplanes. His military documents, sketches, and aviation painting are preserved in the Musée de l'Aéronautique in Paris.

Demobilized in 1919, he traveled to Jura in 1919 and to Italy in 1920. In 1921 he resumed teaching at l'Académie moderne. He contracted with Katia Granoff in 1924 and was awarded the Carnegie Prize in Pittsburgh the following year. In 1926 he received the Chevalier of the Legion of Honor, followed in 1933 by the rank of Commander. He taught at the Scandinavian School in Paris in 1929 and at l'Académie de la Grande-Chaumière in Paris during World War II. In 1936 he signed a contract with Galerie Kaganovitch, and three years later with Paul Pétridès. Friesz's later works were thickly painted with a palette limited to ochers, earth colors, and whites. He completed a series on the city of Honfluer in 1936 and another on La Rochelle in 1947. Friesz died in 1949 at his home in Paris.

Emile-Othon Friesz

Chronology, 1879-1949

Information for this chronology was gathered from Maximilien Gauthier's *Othon Friesz* (Geneva: Editions Pierre Cailler, 1957), among other sources and exhibition catalogues.

1879 Birth of Achille-Emile-Othon Friesz at Le Havre (Seine-Inférieure) on February 6 to a family of shipowners and sea voyage captains.

1892 Evening classes at l'Ecole Municipale des Beaux-arts. Meets Raoul Dufy and Georges Braque, also native Havrais artists.

1895 First Normandy landscapes, including *Maisons à falaise*. As early as sixteen years of age he demonstrates a masterly technique and sound artistic vision.

1896-99 Student of Charles Lhullier at l'Ecole des Beaux-arts du Havre with Dufy. Paints landscapes and portraits of his parents.

1899 Receives a Le Havre municipal scholarship for art study in Paris. Enters Léon Bonnat's studio at l'Ecole Nationale des Beaux-Arts, where he stays until 1904. Dufy later joins him there. Lives at quai Saint-Michel, then rue Campagne-Première. Frequent visitor to the Louvre and to the Impressionist exhibitions at the Galerie Durand-Ruel.

1900 Exhibits at the Salon des Artistes Français until 1903.

1901 Meets Pissarro and Jean-Baptiste-Armand Guillaumin. Adopts an Impressionists style. Works with Guillaumin in Falaise and the Creuze valley. Lives in Montmartre at 12, rue Cortot (house of Susan Valadon, Utrillo, and other painters).

1902 Works in Paris and Creuse.

1903 Exhibits at the Salon des Indépendants until 1908. Pissarro notices his work while he paints views of Pont-Neuf.

1904 Private exhibitions at Galerie des Collectionneurs (Soulié's) and Galerie Prath et Magnier. Participates in the Salon d'Automne until 1908. Influenced by Matisse's high-color technique, he abandons Impressionism. Lives at quai des Orfèvres, then at place Dauphine, near Pont-Neuf, with Charles Camoin as a neighbor.

1905 Shows at Berthe Weill's gallery. No paintings from this period survive; Friesz may have destroyed them. Works in Antwerp, Honfleur, and La Ciotat. In December he exhibits at Galerie Prath et Magnier along with Matisse, Marquet, Derain, Vlaminck, and van Dongen.

1906 Exhibits Normandy landscapes at the Independents, works in Falaise with Dufy and, during the summer, at Anvers with Braque, whom he influences. Shows *Vues d'Anvers* at Le Havre and later at the Salon d'Automne. Contracts with Antoine Druet for his entire production until 1912.

1907 Exhibits five Normandy landscapes at the Indépendants. Rejoins Braque in La Ciotat for the summer. Paints his first Midi landscapes, five of which he shows at the Salon d'Automne. Works with Braque in L'Estaque in September. Druet gives him a one-artist show.

1908 Neighbor of Matisse in Couvent des Oiseaux (boulevard des Invalides), where he resides until 1910, establishing a studio at 55 boulevard Montparnasse which he will sell in 1914. Works in Rouen, Les Andelys, La Ciotat, and L'Estaque. Abandons Fauvism for more conventional colors and composition. First purchases by the Russian collector Sergei Shchukin, whom he introduces to Matisse. Death of his mother.

1909 Completes a series of paintings on the Circus Médrano. Travels to Munich with Dufy.

1911-12 Travels to Portugal.

1912 Travels to Belgium.

1913 Contracts with Galerie Marseille. Teaches at l'Académie moderne, rue Nôtre-Dame-des-Champs, where he will live until his death in 1949.

1914 Completes a series of paintings on the city of Toulon. Mobilizes on August 4 with the 24th Territorial Regiment. Establishes residence at 73, rue Nôtre-Dame-des-Champs, where he will live until his death in 1949.

1915 Because of illness, he transfers to an auxiliary military unit where he makes topographical drawings.

1917 Assigned to the aeronautics technical service, where he paints camouflage on airplanes. His military documents, sketches, and aviation paintings are preserved in the Musée de l'Aéronautique.

1919-20 Demobilized in March, 1919. Travels to Jura in 1919, Italy in 1920.

1921	Resumes classes at l'Académie moderne.
1923	Presides over one of the two sections of the newly organized Salon des Tuileries.
1924	Contracts with Katia Granoff.
1925	Awarded the Carnegie Prize in Pittsburgh for his *Portrait du Décorateur Paul Paquereau*. Death of his father in December.
1926	Chevalier de la Légion d'honneur.
1929	Teaches at l'Académie scandinave with Charles Despiau, Charles Dufresne, and Henri de Waroquier. Students include Francis Gruber, Tal-Coat, and Francis Tailleux.
1931	Paints at Dieppe.
1933	Officier de la Légion d'honneur.
1934	Commandeur de l'Ordre de Vasa (Sweden).
1936	Contracts with Galerie Kaganovitch. Completes his Honfleur series.
1937	Commandeur de la Légion d'honneur.
1939	Contracts with Mme Zak and Paul Pétridès in December.
1941-44	Stays in Paris during the Occupation. Teaches at l'Académie de la Grande-Chaumière. Pupils include members of l'Echelle group—Busse, Calmettes, Cortot, Dalembert, and Patrix.
1947	Paints a series on La Rochelle.
1948	Paints still lifes.
1949	Dies January 10 at his home in Paris. Internment at Montparnasse cemetery.

Emile-Othon Friesz

Bibliography

I. Archival Materials

2815. FRIESZ, ACHILLE-EMILE-OTHON. *Letters, Notes and Essays*, ca. 1905-38. ca. 100 items. Manuscripts. Located at The Getty Center for the History of Art and the Humanities, Archives of the History of Art, Santa Monica, California.

Includes 56 letters from Friesz to his wife Andrée, written while on painting trips as well as in Paris. They provide detailed information about financial affairs, travel plans and work in progress. Several letters discuss Friesz's exhibitions in the United States (1938), while others express the artist's anxiety over the political situation in Germany (1934). Ca. 30 letters, many illustrated, are addressed to, among others, Léon Pedron, André Salmon, the critic Fritz Vanderpyl, Georges Iackowski, and Louis Vauxcelles. One detailed letter to "Noel" describes a series of paintings on the theme of aviation. Also included are an essay about tradition in art in the form of a letter to Jakob Rosenberg; a 2 p. response to an enquête in which he names the major movements in French art and gives their social origins and impacts; a signed statement on theater decoration; two manuscript essays and several pages of notes on painting; a draft of a speech delivered to the Carnegie Foundation entitled "Sur le Fauvisme"; and a photograph of an installation.

Organization: I. Letters to Andrée Friesz (folders 1-4); II. General letters (in alphabetical order by correspondent) (folders 506); III. Notes and essays (folder 7).

2816. BÜNEMANN, HERMANN. *Letters Received*, 1928-68. 43 items. Holographs, signed; typescripts. Located at The Getty Center for the History of Art and the Humanities, Archives of the History of Art, Santa Monica, California.

2817. Bünemann (b. 1895) was a German art historian and critic. Collection consists of letters received by Bünemann from artists, art historians and dealers concerning their work, arranged in alphabetical order. Most notable are three letters from André Dunover de Ségonzac (1937), one letter from Othon Friesz (1937), expressing thanks for Bünemann's appreciation of their work and interest in purchasing paintings (1937); seven letters from Elisabeth Erdmann-Macke, August Macke's wife, 1939-68, who writes about the death of her second husband in a concentration camp, discusses the identity of various paintings by Macke and Franz Marc, and reports on exhibitions and her autobiography.

2818. COQUIOT, GUSTAVE. *Letters*. 2 items. Holographs. Located at The Getty Center for the History of Art and the Humanities, Archives of the History of Art, Santa Monica, California.

Coquiot (1865-1926) was a French art critic and playwright. The letters concern the preface to a catalogue on which he is working, and the sale of works by Henri Epstein, Marie Laurencin, Othon Friesz, and Kees van Dongen.

2819. DEZARROIS, ANDRE. *Letters Received*, 1913-59. ca. 100 items. Manuscripts. Located at The Getty Center for the History of Art and the Humanities, Archives of the History of Art, Santa Monica, California.

Dezarrois (b. 1890) was editor of the *Revue de l'art ancien et moderne*; administrator of the Fondation americaine pour le pensée et l'art français (Fondation Blumenthal) and director of the Musée du jeu de paume, Paris.

Organization: I. Letters received (general) 1913-59; II. Letters received from Wassily Kandinsky, 1937-39; III. Letters concerning the Exposition Lady Janet Clerk, 1936-37.

Series I: General letters received from François Desnoyer (13 items); Kees van Dongen (4 items); Jean Dunand (8 items); Othon Friesz (2 items); Edouard Goerg (2 items); Paul Landowski (37 items); Henri Lebasque (2 items); Alphonse Mucha (1 item); Victor Prouve (2 items); Edouard Vuillard (2 items) and Ossip Zadkine. Letters primarily concern the Exposition universelle in Brussels (1936) for which Dezarrois was an administrator, and the business of the Fondation americaine, including mention of grants and member selectiton. Arranged alphabetically.

2820. LEVEL, ANDRE. *Letters Received*, 1899-1936. ca. 100 items. Holographs, signed; photographs. Located at The Getty Center for the History of Art and the Humanities, Archives of the History of Art, Santa Monica, California.

Level (1863-1946) was a French dealer and art critic. Collection consists of a ca. 60 letters received from several correspondents including Maurice Denis (1914), André Derain (1914-15), Dunover de Segonzac (1912-14), Othon Friesz (1905), Rene Piot (1899, 1914), and Félix Vallotton (1914). The letters generally concern the sale of paintings but also contain information on personal matters and travel. One group of 13 letters from Augustin Grass-Mick is extensively illustrated and includes vignettes characterizing his experience of the war. Collection also contains two photographs and 42 black-and-white reproductions of paintings, many of which are by Picasso. Letters received are arranged alphabetically by correspondent.

II. Books

2821. BELL, CLIVE. *Since Cézanne*. London: Chatto and Windus, 1922. 229 p., 7 pl.

Essays reprinted from various periodicals. Chapter 16 includes Bell's article, "Othon Friesz," from *Burlington Magazine* (June, 1921).

2822. BRIELLE, ROGER. *Othon Friesz*. Paris: G. Crès, 1930. 48 p., illus., 35 pl. Volume in "Les Artistes nouveaux" series.

2823. BUSSE, JACQUES. *Othon Friesz*. Geneva: Documents Cailler, 1958. 19 p. Volume in "Les Cahiers d'art-documents" series.

2824. COQUIOT, GUSTAVE. *Cubistes, futuristes, passéistes; essai sur la jeune peinture et la jeune sculpture*. Paris: Librarie Ollendorff, 1914. 277 p., 48 illus., pl.

Friesz is discussed on pp. 60-2.

2825. COQUIOT, GUSTAVE. *Les Indépendants, 1884-1920*. Paris: Editions Ollendorff, 1920. 239 p., pl.

Pages 88-9 discuss Friesz.

2826. COQUIOT, GUSTAVE. *En suivànt la Seine*. Paris: A. Delpeuch, 1926. 138 p., pl.

2827. DESNOS, YOUKI. *Les Confidences de Youki*. Dessins originaux de Foujita et de Robert Desnos. Paris: Arthème Fayard, 1957. 236 p., illus.

2828. EDOUARD-JOSEPH, RENE. *Dictionnaire biographique des artistes contemporains*. Paris: Art & Edition, 1930-34. 3 vols., illus.

Note on Friesz in vol. 2, pp. 83-6.

2829. ESCHOLIER, RAYMOND. *La Peinture française, XXe siècle*. Paris: H. Floury, 1937. 144 p., illus., col. pl. Volume in "Bibliothèque artistique" series.

Friesz is discussed on pp. 62-6.

2830. FELS, FLORENT. *L'Art vivant de 1900 à nos jours*. Avec 500 illustrations réunies et présentées par Pierre Cailler. Geneva: Editions P. Cailler, 1950. Volume in "Peintres et sculpteurs d'hier et d'aujourd'hui" series.

2831. FOCILLON, HENRI. *La Peinture aux XIXe et XXe siècles: du réalisme à nos jours*. Ouvrage illustré de 210 gravures. Paris: Librairie Renouard, 1928. 524 p., illus. Volume in "Manuels d'histoire de l'art" series.

Friesz is discussed on pp. 311-2.

2832. FONTAINAS, ANDRE and LOUIS VAUXCELLES. *Histoire générale de l'art français de la Révolution à nos jours.* Paris: Librairie de France, 1922. 3 vols., illus., 124 pl., 20 col.

Friesz is mentioned in vol. 3, p. 261.

2833. FRIESZ, ACHILLE-EMILE-OTHON. *Friesz: œuvres (1901-1927); cinquante reproductions en phototypie.* Textes: "Petits mélanges sur un grand peintre" par Fernand Fleuret; "Emile Othon Friesz en regard de son époque" par Charles Vildrac; "Lyrisme de Friesz par un critique" par André Salmon. Paris: Chroniques du Jour, 1928. 31 p., illus., 50 pl. Volume in "Maîtres nouveaux" series.

2834. FRIESZ, ACHILLE-EMILE-OTHON. *Othon Friesz, 24 phototypies.* Notice de Maurice Le Sieutre. Paris: Librairie de France, F. Sant' Andrea, 1931. 8 p., illus., 24 pl. Volume in "Les Albums d'art Druet" series.

Includes texts by Fernand Fleuret, Charles Vildrac, and André Salmon.

2835. FRIESZ, ACHILLE-EMILE-OTHON. *Douze lithographies d'Othon Friesz présentées par Maximilien Gauthier.* Paris: Rombaldi, 1949.

2836. FRIESZ, ACHILLE-EMILE-OTHON. *E. Othon Friesz: dix estampes originales présentées par Maximilien Gauthier.* Paris: Rombaldi, 1949. 6 p., illus.

2837. GAUTHIER, MAXIMILIEN. *Othon Friesz.* Paris: Editions Les Gémeaux, 1949. 23 p., illus., 21 pl.

2838. GAUTHIER, MAXIMILIEN. *Othon Friesz.* Avec une biographie, une bibliographie et une documentation complète sur le peintre et son œuvre. Geneva: P. Cailler, 1957. 160 p., 10 col. illus., 120 pl. Volume in "Collection Peintres et sculpteurs d'hier et d'aujourd'hui" series.

2839. GEORGES-MICHEL, MICHEL. *Les Montparnos, roman.* Illustré par les Montparnos. Paris: Fasquelle, 1929. 301 p., illus.

Illustrations by Modigliani, Picasso, Foujita and other Montparnassian artists.
a. Another ed.: Paris: del Duca, 1957. 357 p., illus.
b. U.S. ed.: *Left Bank.* Trans. by Keene Wallis. Introduction by William A. Drake. New York: H. Liveright, 1931. 262 p., illus.

2840. GIRY, MARCEL. *La Jeunesse de Othon Friesz: 1879-1914.* Ph.D. thesis, La Faculté des lettres de Lyon, 1951.

2841. GORDON, JAN. *Modern French Painters.* London: J. Lane, The Bodley Head Ltd., 1923. 188 p., illus., col. pl.

2842. HUYGHE, RENE. *La Peinture française: les contemporains.* Notices biographiques par Germain Bazin. Paris: P. Tisné, 1939. 91 p., 160 pl., some col. Volume in "Bibliothèque française des arts" series.

2843. KIM, YOUNGNA. *The Early Works of Georges Braque, Raoul Dufy and Othon Friesz: The Le Havre Group of Fauvist Painters.* Ph.D. diss., Ohio State University, 1980. 434 p., 265 illus.

Detailed stylistic examination of the early work of these three artists who grew up together in Le Havre and studied together in Paris, and of their Fauvist works from 1906 to 1907. Contends that Braque was the more innovative member of the group. Braque's movements towards Cubism are compared to Picasso. Concludes that the two artists mutually created the style and that Fauvism and the influence of Cézanne on Braque in 1907 and 1908 played a fundamental role in its formation.

2844. LHOTE, ANDRE. *Traité du paysage.* Paris: Librairie Floury, 1939. 195 p., illus., some col. Volume in "Ecrits d'artistes" series.

Mentions Friesz on p. 179.
a. Other eds.: 1946, 1948.
b. English ed.: *Treatise on Landscape Painting.* Trans. by W. J. Strachan. London: A. Zwemmer, 1950. 50 p., illus., 66 pl.

2845. MAUCLAIR, CAMILLE. *Les Arts du XVIII*ᵉ *siècle à nos jours.* Paris: Flammarion, 1926.

Friesz is mentioned on p. 186.

2846. PUY, MICHEL. *Le Dernier état de la peinture; les successeurs des impressionnistes.* Paris: Union Française d'Edition, 1910. 69 p.

Friesz's work is discussed on pp. 42-3.

2847. RAMEIX, CHRISTOPHE. *L'Ecole de Crozant: les peintres de la Creuse et de Gargilesse, 1850-1959.* Paris: Editions Lucien Souny, 1991. 196 p., 127 illus., 70 col.

Methodical presentation of over 400 artists who worked in France's Creuse Valley between 1850 and 1950. Sums up the history of the School of Crozant from the Romantic movement to Post Impressionism. Numerous minor artists were inspired by the work of Claude Monet, Armand Guillaumin, Emile-Othon Friesz, and Francis Picabia.

2848. RAYNAL, MAURICE. *Anthologie de la peinture en France de 1906 à nos jours.* Paris: Montaigne, 1927. 319 p., illus.

Discusses Friesz on pp. 151-5.
a. U.S. eds.: *Modern French Painters.* Trans. by Ralph Roeder. New York: Brentano's, 1929. 275 p., pl.; New York: Arno Press, 1969.

2849. RAYNAL, MAURICE. *Histoire de la peinture moderne.* Geneva: Editions Skira, 1949-51. 3 vols, col., illus., col. pl.

Friesz is mentioned in vol. 2: *Matisse, Munch, Rouault; Fauvisme, die Brücke, l'expressionnisme.*

2850. ROGER-MARX, CLAUDE. *Avant la destruction d'un monde: de Delacroix à Picasso*. Paris: Editions Plon, 1947. 308 p., illus. Volume in "Les Maîtres de l'histoire" series.

2851. SALMON, ANDRE. *L'Art vivant*. Paris: Editions G. Crès, 1920. 302 p., illus., 12 pl. Volume in "Artistes d'hier et d'aujourd'hui" series.

Friesz is discussed on pp. 55-63.

2852. SALMON, ANDRE. *Emile-Othon Friesz*. Vingt-six reproductions de peintures et dessins précédées d'une étude critique par André Salmon, de notices biographiques et documentaires et d'un portrait inédit de l'artiste dessiné par lui-même et gravé sur bois par Georges Aubert. Paris: Editions de la Nouvelle Revue Française, 1920. 63 p., illus., pl. (pp. 17-63). Volume in "Les Peintres français nouveaux" series.

2853. SALMON, ANDRÉ. *Propos d'atelier*. Avec un portrait de l'auteur. Paris: Editions G. Crès, 1922. 275 p. Volume in "Mémoires d'écrivains et d'artistes" series.

a. Another ed.: Paris: Nouvelles Editions Excelsior, 1938. 275 p.

2854. VANDERPYL, FRITZ R. *Peintres de mon époque*. Paris: Librairie Stock, 1931. 228 p.

Friesz is discussed on pp. 131-40.

2855. VENTURI, LIONELLO. *La Peinture contemporaine*. Milan: Ulrico Hoepli, 1948.

Mentions Friesz on p. 17.
a. Another ed.: 1950.
b. Italian ed.: *Pittura contemporanea*. Milan: U. Hoepli, 1948. 70 p., 251 pl., 12 col.

2856. WARNOD, ANDRE. *Les Berceaux de la jeune peinture: Montmarte, Montparnasse*. Avec 121 dessins et 16 hors texte. Paris: Albin Michel, 1925. 288 p., 137 illus., 16 pl.

2857. WARNOD, ANDRE. *Ceux de la butte*. Paris: Editions R. Julliard, 1947. 290 p., illus. Volume in "La petite histoire des grands artistes" series.

Discusses Friesz on pp. 196-203.

III. Articles

2858. "Ateliers d'artistes." *Beaux arts* (2 June 1933):2.

2859. BATAILLE, PHILIPPE. "Le Havre: Othon Friesz, Fauve de la première heure." *Journal de l'Amateur d'Art*. 648(June-Aug. 1979):21-2.

2860. BAZIN, GERMAIN, FRITZ NEUGASS, and RENE HUYGHE. "Histoire de l'art contemporain." *L'Amour de l'art* (1933).

2861. BELL, CLIVE. "Othon Friesz." *Burlington Magazine* 38(June 1921): 278-82. Reprinted in *Since Cézanne* (London: Chatto and Windus, 1922).

2862. BONNIERS. "Hos Maleren Othon Friesz." *Tage Trotte* (Stockholm) (2 Oct. 1927).

2863. BRIELLE, ROGER. "Othon Friesz." *Cahiers du sud* (Marseille) (April 1932).

2864. BRIELLE, ROGER. "Othon Friesz." *Mobilier et décoration* (Aug. 1932).

2865. BUSSE, JACQUES. "Othon Friesz (1879-1949): notices diverses établies." *Art-documents* 82(1958):20.

2866. *Cahiers d'aujourd'hui* 2 (1921).

Mentions Friesz and includes four drawings by Braque.

2867. CANN, LOUISE GEBHARD. "Othon Friesz." *The Arts* (New York) 10(July 1926):278-84.

2868. CANN, LOUISE GEBHARD. "Othon Friesz." *The Arts* (New York) 10(Nov. 1926).

2869. CHAMPIGNEULLE, BERNARD. "L'Œuvre d'Othon Friesz." *France illustration* 6(30 Dec. 1950):743.

2870. COLOMBIER, PIERRE DU. "Othon Friesz." *Journal de l'amateur d'art* 59(Nov. 1950): 1,5.

2871. COLOMBIER, PIERRE DU. "Othon Friesz." *La Revue française* (Nov. 1952).

2872. DORIVAL, BERNARD. "La Peinture française" in *Arts, styles et techniques* (Paris: Larousse, 1946).

Mentions Friesz on p. 216.

2873. DORIVAL, BERNARD. "Friesz (Emile-Othon)." *Larousse mensuel, Paris* (April 1949):245-6.

2874. DORIVAL, BERNARD. "Trois tableaux d'Othon Friesz au Musée d'Art moderne." *Musées de France* 10(Dec. 1950):235-8.

Reproduces Friesz's *Portrait de Fernand Fleuret* and *Portrait de Mme Othon Friesz.*

2875. DUTHUIT, GEORGES. "Le Fauvisme." *Cahiers d'art* 5(1931).

2876. FELS, FLORENT. "Othon Friesz." *Propos d'artistes* (1925): 63-71.

2877. FELS, FLORENT. "Othon Friesz." *A.B.C.* (Paris) (June 1928).

2878. FIERENS, PAUL. "Othon Friesz." *Art et décoration* (Jan. 1927).

2879. GENEUX, PAUL. "L'Œuvre fougueuse d'Othon Friesz." *Les Beaux-arts* 425 (21 Aug. 1953):6.

2880. GIRY, MARCEL. "Le Paysage à figures chez Othon Friesz (1907-1912)." *Gazette des Beaux-arts* ser.6, 69 (Jan. 1967):45-57. 11 illus.

2881. GIRY, MARCEL. "A propos d'un tableau d'Othon Friesz au Musée National d'Art moderne." *Revue du Louvre et des musées de France* 20:3 (1970):168-70.

2882. GUILLEMARD, JULIEN. "Un jugement." *La Mouette* (Le Havre) (April 1925).

Concerns a lawsuit between Friesz and a critic from Le Havre.

2883. IMBOURG, PIERRE. "Rentrée d'Amérique, Othon Friesz nous parle du prix Carnegie." *Beaux arts* (25 Nov. 11938):1⁺.

2884. JOUVET, LOUIS. "Quelques mots sur Othon Friesz." *Comédie des Champs-Elysées* (1920-27).

Occasional notes on Friesz in Parisian theatre programs.

2885. LE SIEUTRE, MAURICE. "Othon Friesz." *Librairie de France* (1931).

2886. "Der maler Othon Friesz." *Deutsch Kunst und Dekoration* 67 (Nov. 1930):92-102.

2887. MARTIN, ALVIN and JUDI FREEMAN. "The Distant Cousins in Normandy" in *The Fauve Landscape* [exh. cat.] Los Angeles County Museum of Art (New York: Abbeville Press, 1990). pp. 215-39. 33 illus., 20 col.

Concerns Friesz, Braque, and Fauvism.

2888. MARTINE, HENRI. "Othon Friesz" in *Histoire générale de l'art*, Georges Huisman, ed. (Paris: Editions Guillet, 1938):248.

2889. MORICE, CHARLES. "Othon Friesz." *Mercure de France* (16 April 1908).

2890. MORICE, CHARLES. "Othon Friesz." *Mercure de France* (1 May 1909).

2891. MORICE, CHARLES. "Othon Friesz." *Nouvelles littéraires* (2 April 1933).

2892. NEUGASS, FRITZ. "Emile Othon Friesz." *Die Kunst* 57:12(Sept. 1928):379-81, 384.

2893. NEUGASS, FRITZ. "Othon Friesz." *L'Amour de l'art* 14:7(July 1933):165-8.

2894. Obituaries: *Art Digest* 23(1 Feb 1949):31; *Art News* 47(Feb. 1949):7.

2895. O'CONNOR, J., JR. "Jury of Award." *Carnegie Magazine* 12(Sept. 1938):102-4.

2896. "L'Œuvre de Friesz." *Beaux-arts magazine* (29Nov. 1935):8.

2897. "Une œuvre nouvelle d'Othon Friesz; *La Paix*, maquette de tapisserie pour le palais de la Société des nations." *Beaux-arts magazine* (5April 1935):1.

2898. "Othon Friesz." *Beaux-arts magazine* 7(July 1929):19.

2899. "Othon Friesz." *Magazine of Art* (Nov. 1938).

2900. "Othon Friesz fera partie du jury international qui décernera le prix de la fondation Carnegie." *Beaux-arts magazine* (29July 1938):1.

2901. "Portrait." *Beaux-arts magazine* (21July 1933):1; *Art Digest* 13(1 Oct. 1938):12; *Magazine of Art* 31(Nov. 1938):675.

2902. SALMON ANDRE. "Othon Friesz à Saint-Malo." *L'Art et les artistes* 29(Jan. 1935):130-3. 4 illus.

2903. TERIADE, EMMANUEL. "Œuvres récentes de Friesz." *Cahiers d'art* 9(1926).

2904. TERIADE, EMMANUEL. "Emile-Othon Friesz." *Art d'aujourd'hui* 12(Winter 1926):41-3.

2905. TURPIN, GEORGES. "Emile-Othon Friesz." *L'Acropole* (Jan. 1951).

2906. VALLON, FERNAND. "Othon Friesz." *Art et médecine* (1926).

2907. VAUDOYER, JEAN-LOUIS. "E.-Othon Friesz." *L'Art et les artistes* (March 1926).

2908. VAUXCELLES, LOUIS. "Salon des Fauves." *L'Illustration* (1905).

2909. VAUXCELLES, LOUIS. "Othon Friesz." *Gil Blas* (15Nov. 1912).

2910. VAUXCELLES, LOUIS. "Othon Friesz." *Gil Blas* (Fall 1913).

2911. VILDRAC, CHARLES. "Emile-Othon Friesz en regard de son époque." *L'Amour de l'art* (Jan. 1928).

2912. WALDEMAR, GEORGE. "Othon Friesz." *L'Amour de l'art* (Oct. 1920):200-4.

2913. ZAK, EUGEN. "Emile-Othon Friesz." *Deutsche Kunst und Dekoration* (Feb. 1925).

IV. Illustrated Books

2914. TELLIER, JULES. *Le Pacte de l'écolier.* Paris: Bernouard, 1920.

2915. PEDRON, JEAN. *Echelles de soie.* Paris: Bernouard, 1924.

2916. MAURIAC, FRANÇOIS. *Le Désert de l'amour.* Paris: B. Grasset, 1925. 260 p. Volume in "Les Cahiers vert" series. 600 copies.

a. Other eds.: 1939, 1970.
b. U.S. eds.: Edited with introduction, notes and vocabulary by Wallace Fowlie. Waltham, MA: Blaisdell Pub. Co., 1968. 154 p. Introduction in English.

2917. BARRES, MAURICE. *Le Jardin sur l'Oronte.* Paris: G. Crès, 1926.

Frontispiece and ornamental decorations by Friesz.

2918. COQUIOT, GUSTAVE. *En suivant la Seine.* Avec dessins inédits de Bonnard . . . Othon Friesz . . . [et al.]. Paris: A. Delpeuch, 1926. 138 p., pl.

Includes one drawing by Friesz.

2919. MAUROIS, ANDRE. *Rouen.* Avec dix lithographies de Othon Friesz. Paris: Société d'éditions 'Le Livre', 1929. 86 p., 10 illus.

Includes ten lithographs by Friesz.

2920. EXQUEMELIN, ALEXANDRE OLIVER. *Les Aventuriers et les boucaniers d'Amérique.* Edition enrichie de documents, de gravures anciennes et de cartes géographiques, et publiée par Bertrand Guégan. Paris: Aux Editions du Carrefour, 1930. 370 p., illus. volume in "Collection voyages et découvertes" series.

2921. *Le Cantique des cantiques.* 1931.

Includes twelve watercolors by Friesz.

2922. RONSARD, PIERRE DE. *Poèmes.* Illustré par Othon Friesz. Paris: Se vend chez les Frères Gonin, 1934. 90 p., pl., some col.

2923. *Paris 1937.* Paris: J.-G. Daragnes, 1937. 384 p., illus.

Includes one engraving by Friesz.

2924. SAINT-PIERRE, BERNARDIN DE. *Paul et Virginie.* Paris: P. Cailler, 136 p. Volume in "Les Trésors de la littérature française" series.

Includes colored woodcuts by Friesz.
a. U.S. ed.: Illus. d'Othon Friesz gravées sur bois en couleurs par Gérard Angiolini. New York: Editions de la Maison Française, 1947. 146 p., col. illus. Volume in "Le Florilège des chefs-d'œuvre français" series.

2925. POUSSARD, PIERRE. *Le Livre de Job.* Paris: Star, 1949.

Includes eighteen lithographs by Friesz.

2926. PETRONIUS ARBITER, T. *Le Satiricon.* Traduit par Laurent Tailhade. Lithographies originales de Emile-Othon Friesz. 249 p. pl. Paris: Aux Dépens d'un amateur [sur les presses de Fequet et Baudier], 1949.

Includes two-tone lithographs by Friesz.

2927. CHENEVIERE, JACQUES. *Le Bouquet de la mariée, roman.* Paris: R. Julliard, 1955. 189 p.

Includes one illustration by Friesz.

V. Individual Exhibitions

1904, 20 April- 15 May	Paris, Galerie des Collectionneurs (Soulié's). *Exposition Emile-Othon Friesz.* 46 paintings.
1905, July	Paris, Galerie Prath et Magnier.
1906, 5-11 September	Le Havre, *Vue d'Anvers.*
1907, 4-16 November	Paris, Galerie Druet. *Othon Friesz.* Préface de Fernand Fleuret.
1908-09, 21 December- 16 January	Paris, Galerie Druet.
1910, April	Paris, Galerie E. Druet. *Exposition de peintures d'Othon Friesz.*
1912, November	Paris, Galerie Druet.
1913, March	Berlin, Galerie Cassirer.
1919, May	Paris, Editions G. Crès.
1921, May	London, The Independent Gallery.
1921, July	Le Havre, Halle de la cloche.
1922, March	Paris, Galerie Bernheim-Jeune. *Othon Friesz: aquarelles.*
1925, February	Brussels, Galerie du Centaure.
1926, May	Paris, Galerie Granoff.
1927, 2 May- 10 June	Paris, Galerie Granoff. *Othon Friesz: cent tableaux choisis de 1900 à 1927.*
1927, December	Brussels, Galerie Georges Giroux.
1928, May	Paris, Galerie Granoff.
1929-30, December-February	New York, Brummer Gallery. Reviews: *Art News* 28(21 Dec. 1929):11; *Art Digest* 4(1 Jan. 1930):17; L. Goodrich, *Arts Magazine* 16(Jan 1930):337.
1930, February	Chicago, The Art Club.

1930, May	Paris, Galerie Bernier. *Friesz: aquarelles et peintures récentes.* Avant-propos d'André Naurois. Review: P. Berthelot, *Beaux-arts* 8(June 1930):23.
1931, June	Paris, Galerie Cardo.
1932, April	Paris, Galerie Georges Bernheim. Reviews: P. Berthelot, *Beaux-arts magazine* 10(May 1932):19-20; *Formes* 25(May 1932):280.
1933	Paris. Review: *Art et décorations* 62(March 1933):supp. 4-5.
1934, November	Paris, Galerie Katia Granoff. Review: *Beaux-arts* (9 Nov. 1934):6.
1935, November	Paris, Galerie Zak.
1936, March	London, Zwemmer Gallery.
1937, June	Paris, Galerie Max Kaganovitch. *Friesz: l'œuvre, 1925-37.* Review: *Beaux-arts magazine* (4June 1937):1.
1938, April	Zurich, Galerie und Sammler Gotthard Jedlicka. *Othon Friesz.* Catalogue by Fritz Vanderpyl.
1938, October	New York, Durand-Ruel Galleries. Reviews: *Art News* 37(29Oct. 1938):13; *Art Digest* 13(1 Nov. 1938):12; F. Watson, *Magazine of Art* 31(Dec. 1938):714.
1938	New York, Knoedler Galleries. Review: *Magazine of Art* 31(Nov. 1938):660+.
1941, March	Paris, Galerie O. Pétridès.
1943, March	Paris, Galerie O. Pétridès.
1948, January	Paris, Galerie Pétridès. Review: *Arts Magazine* (6Feb. 1948):4.
1948, August	Lucerne, Galerie d'Art nationale.
1948, October	Geneva, Galerie Moos.
1948, November	Paris, Galerie Pétridès.
1949	Paris, Salon d'Automne. *Friesz rétrospective.* Review: *Werk* 36(Dec. 1949):supp. 171.
1950, April	Le Havre, Galerie Jacques Hamon.

1950, June	Marseille, Musée de Galerie Jouvène.
1950, 12 October	Geneva, Galerie Motte. *Othon Friesz, l'un des créateurs du Fauvisme.* Textes de Waldemar George et Charles de Richter. Includes George's essay, "Friesz et la tradition vivante de la peinture française."
1950, November-December	Paris, Galerie Paul Pétridès. *Fleurs, fruits, compositions, marines et portraits.*
1950, December	Paris, Galerie Charpentier. *Rétrospective Othon Friesz.* Textes de Charles Vildrac, Bersier, Maximilien Gauthier.
1950	Paris, Musée d'Art moderne. Reviews: B. Dorival, *Musées de France* 10(Dec. 1950):235-8; B. Champigneulle, *France illustration* 6(30 Dec. 1950):743.
1951, February	Musée d'Alger.
1951, July	Honfleur, Mairie d'Honfleur.
1953, 4 July-27 September	Geneva, Musée d'Art et d'histoire. *Othon Friesz, 1879-1949.* Catalogue par André Salmon. Review: *Werk* 40(Sept. 1953):supp. 42.
1953, October-December	Lyon, Musée des Beaux-arts. *E. Othon Friesz, 1879-1949.* Textes de Marcel Giry et René Jullian. 30 p. Essays includes the essays "Friesz et le Fauvism" by Giry and "Friesz et la tradition" by Jullian.
1956, March	Paris, Galerie Montmorency.
1956	Dieppe, Musée de Dieppe. *Othon Friesz.* Catalogue textes d'Albert Sarraut et André Maurois.
1959, October-November	Paris, Musée Galliéra. *Othon Friesz.* Préface de René Heron de Villefosse. 45 p., illus., 22 pl. Reviews: *Burlington Magazine* 101(Dec. 1959):472; *Art News* 58(Jan. 1960):52.
1966, 6 July-24 September	Dieppe, Musée de Dieppe. *Exposition E. Othon Friesz, peintures, aquarelles, dessins.*
1971, July-August	Honfleur, Grenier à sel. *Othon Friesz.* Textes de René Barotte, J. Bouyssou, M. Saelens.
1973	Paris, Galerie Drouant. *Friesz.*

1979, 10 March- 30 June	La Roche-sur-Yonne. Musée municipal. *Exposition rétrospective: Othon Friesz (1879-1949)*. Also shown Le Havre, Musée des Beaux-arts André Malraux (7 July-26 Aug. 1979); La Rochelle, Musée des Beaux-arts de La Rochelle (11 May-30 June 1979). Catalogue par Francis Ribemont. 39 p., 14 illus. Exhibition of Friesz's paintings to celebrate the centenary of his birth, in which the author briefly describes Friesz as one of the greatest masters of French painting in the first half of the 20th century, and comments on his participation in the Fauve movement and his marked preference for the circus, the sea and seaports, and man in nature as subjects. A list of principal individual exhibitions is appended.

VI. Group Exhibitions

1900	Paris, Salon des Artistes français.
1901	Paris, Salon des Artistes français.
1902	Paris, Salon des Artistes français.
1903	Paris, Salon des Artistes français.
1904, 21 February- 24 March	Paris, Grand Palais. *Salon des Indépendants*. 5 paintings.
1904, June	Paris, Société des Peintres du Paris moderne.
1904, 15 October- 15 November	Paris, Petit Palais. *Salon d'Automne*. 4 paintings.
1905, 24 March- 30 April	Paris, Grand Palais. *Salon des Indépendants*. 8 paintings.
1905, 12 May- 10 June	Paris, Galerie Berthe Weill. *Peintures et pastels par Bouche, Dufrenoy, Fornerod, Friesz, Minartz*. 12 paintings and pastels.
1905, 18 October- 25 November	Paris, Grand Palais. *Salon d'Automne*. 4 paintings.
1905, December	Paris, Galerie, Berthe Weill.
1906, 20 March- 30 April	Paris, Grand Palais. *Salon des Indépendants*. 8 paintings.

1906, 26 May- 30 June	Le Havre, Hôtel de Ville. *Cercle de l'Art moderne.*
1906, 6 October- 15 November	Paris, Grand Palais. *Salon d'Automne.* 4 paintings.
1907, 3 March- 3 April	Brussels. *La Libre Esthétique.* Catalogue par Octave Maus. 5 paintings.
1907, 30 March	Paris, Galerie Berthe Weill.
1907, June	Le Havre, Hôtel de Ville. *Cercle de l'Art moderne.* Catalogue texte par Ferdnand Fleuret. 2 paintings.
1907, 1-22 October	Paris, Grand Palais. *Salon d'Automne.* 5 paintings.
1908, 20 March- 2 May	Paris, Grand Palais. *Salon des Indépendants.* 6 paintings.
1908, 18 April- 24 May	Moscow, *Salon de la Toison d'Or.* 3 paintings.
1908, June	Le Havre, Hôtel de Ville. *Cercle de l'Art moderne.* Catalogue texte de Guillaume Apollinaire
1908, 3-20 July	Paris, Galerie Druet. 3 paintings.
1908, September	Dresden, Richter Art Salon.
1908, 1 October- 8 November	Paris, Grand Palais. *Salon d'Automne.* 6 paintings.
1910	*XXX.* First exhibition of the XXX group, which included works by Friesz and Vlaminck.
1920, December	Geneva, Exposition Internationale d'art moderne.
1927, April	Paris, Galerie Bing. *Les Fauves.*
1934	Venice, *Biennale.*
1934, February	Paris, Petit-Palais. *Artistes de ce temps.*
1934, November	Paris, Galerie des Beaux-arts. *Les Fauves.* Catalogue par Louis Vauxcelles. Review: R. Cogniat, *Gazette des Beaux-arts* (Nov. 1934).
1935, February	Brussels, Palais des Beaux-arts. *Artistes de Paris.*

1942, September	Geneva, *Jeunes peintres français et leurs maîtres*. Also shown Zurich, Bern, Luzern, Basel.
1950, May	Bern, Musée de Berne. *Les Fauves*.
1951, Fall	New York, Sydney Janis Gallery. *Les Fauves*.
1952, May	Berlin, Institut français de Berlin. *Peinture et tradition*. Includes an essay, "Othon Friesz," by Charles Kunstler.
1952-53, 8 October-1 January	New York, Museum of Modern Art. *Les Fauves*. Also shown Minneapolis, Minneapolis Institute of Arts (21 Jan.-22 Feb. 1953); San Francisco, San Francisco Museum of Art (13 March-12 April 1953); Art Gallery of Toronto (1-31 May 1953). Catalogue with text by Andrew Carnduff-Ritchie. 47 p., illus. Dist. by Simon and Schuster. Reviews: *Cahiers d'art* 27:2(1952):82-5; J. Fitzsimmons, *Art Digest* 27:2(15 Oct. 1952):10-1, 30; *Minneapolis Institute of Arts Bulletin* 42(3, 17, 24 Jan. 1953):2-7, 133-4, 17-8.
1968, 10 October	New York, Parke-Bernet Galleries. *School of Paris Paintings From the Collection of Doctor Roudinesco*. Sold by his order. Public auction October 10. Sale no. 2742. 121 p., illus. Included works by Friesz, among others.
1985-86, 6 September-1 February	Glasgow, Glasgow Art Gallery and Museum. *Colour, Rhythm & Dance: Paintings & Drawings by J. D. Fergusson and His Circle in Paris*. Also shown Dundee, Dundee Museum and Art Gallery (26 Oct.-23 Nov. 1985) and Edinburgh, City Art Centre (18 Dec. 1985-1 Feb. 1986). Organized by Scottish Arts Council. Catalogue by Elizabeth Cumming. Edinburgh: Scottish Arts Council, 1985, 72 p., 66 illus., 12 col. Exhibition of paintings, drawings, sculptures and periodicals produced by John Duncan Fergusson (1874-1961) and his circle from 1910-1914, when he lived and worked in Paris. Other artists represented include William Zorach, costume designer Margaret Morris, Anne Estelle Rice, Jo Davidson, and Emile-Othon Friesz. There are three essays. Cumming surveys the works from stylistic and historical perspectives, noting Fergusson's adoption of Fauvist color principles and his "rhythmist" approach to composition. Sheila McGregor examines the artist's involvement in the establishment of the London arts periodical *Rhythm*. John Drummond discusses the revival of dance in early 20th century Paris and its

influence on Fergusson and other contemporary painters. A chronology of Parisian exhibitions and musical and artistic events for 1905-18 is included.

Charles Camoin

Biographical Sketch

Camoin was born in 1879 in Marseille. His father, Joseph, owned a painting and decorating business. In 1885 the family moved to Paris, where Joseph soon died. His mother, Marie, was left to provide for their four children. Charles was sent to stay with an aunt's family in Venice the following year, returning to Marseille in 1887 to live with his grandmother. He soon enrolled at the Lycée d'Aix, the first of thirteen schools he attended. In 1892-94 he lived with his mother in Paris. From 1895-96, Charles attended l'Ecole des Beaux-Arts and l'Ecole de Commerce in Marseille. He was accepted into Gustave Moreau's studio at l'Ecole des Beaux-Arts in Paris in 1897, where he met Henri Matisse, Jean Puy, and his close, lifelong friend Albert Marquet.

A consummate traveler, Camoin met Cézanne and Monet and painted with Marquet in the Midi. In 1903 he exhibited at the first Salon des Indépendants and at Berthe Weill's gallery. The following year he began showing at the Salon d'Automne. During the summer of 1905 he painted at Agay, Cassis, and Saint-Tropez with Marquet and became friendly with Paul Signac, who purchased one of his paintings. Camoin entered his summer landscapes in the historic Salon d'Automne of 1905 with the other Fauve painters in Matisse's circle. He painted in Marseille the following year and traveled to Corsica with Emile Charmy, his companion until 1913. In 1907, Camoin accompanied Marquet and Friesz on a trip to London and later painted in Seville and Granada. He abandoned Fauvism by 1908, continued to travel extensively, and contracted with the Schames Gallery in Frankfurt and Druet's gallery in Paris.

In 1913, distraught over his separation from Emilie Charmy, he destroyed almost eighty canvases. Some of these, recovered and restored, were the object of a well-publicized legal trial in 1927 against Francis Carco which concluded in Camoin's favor. The ruling helped clarify an artists's right over his or her work. Camoin was mobilized in 1914 and sent to the trenches. In 1916 he was attached to a blackout and camouflage unit with Charles Vildrac and Dunoyer de Segonzac. Camoin corresponded regularly with Matisse and other former Fauve friends during the war. He spent the post-war years mostly in the south of France. In 1920 he married Charlotte Prost and bought a house in Saint-Tropez the following year. In 1925 the couple moved to Paris, establishing a studio on l'avenue Junot. Like Matisse, he divided the rest of his time between Paris and the Midi, where his circle included the Marquets, the writer Colette, Jean Puy, Matisse, and Pierre Bonnard.

In 1943 his studio in Saint-Tropez was ransacked by soldiers. A major retrospective was held in 1945 at Charpentier's gallery, for which Colette wrote the catalogue preface. Many honors came Camoin's way in later life. He was awarded the

Legion of Honor in 1955; in 1959 he received the Commander of Arts and Letters. A major retrospective was held at Galerie Bernheim in 1959 and he was honored as the sole survivor represented at the Musée Cantini's 1962 *Gustave Moreau et ses élèves* exhibition. The year before his death in 1965, the inaugural exhibition at Galerie Michel André in Paris was devoted to the artist. He died at age eighty-six in his studio in Montmartre.

Charles Camoin

Chronology, 1879-1965

Information for this chronology was gathered from Danièle Giraudy, *Camoin: sa vie, son œuvre* (Marseille: La Savoisienne, 1972), and various exhibition catalogues.

1879 September 23	Birth of Charles Camoin to Marie Legros and Joseph Camoin, their fourth child and second son. The family resides at 1, rue du Théâtre-Français, Marseille. Joseph owns a painting and decorating business.
1885	The Camoin family moves to Paris, where Joseph soon dies. Marie is left to provide for their four children: Gustave, Elise, Jeanne, and Charles.
1886	Charles stays with his aunt's family (Mme de Costanzo, a sister of his mother) in Venice.
1887	Returns from Venice to live with his grandmother Bonnefoy in Marseille. Enrolls at the Lycée d'Aix, the first of thirteen schools he attends.
1888-91	Attends boarding schools in Nice and Cannes.
1892-94	Lives in Paris with his mother, where he attends the Lycée Montaigne.
1895	Attends l'Ecole des Beaux-arts in Marseille from 6 to 8 a m. in the mornings, followed by classes at l'Ecole de Commerce.
1896	Awarded first prize in figure drawing at l'Ecole des Beaux-arts, Marseille, on July 19.
1897-98	Student at Gustave Moreau's atelier, l'Ecole des Beaux-arts, Paris. Although Moreau soon dies, Camoin makes friends, paints and travels with Henri Matisse, Jean Puy, and especially Albert Marquet.
1899	Paints at Marnes-la-Coquette. One canvas, wrongly entitled *La Cabaretière d'Arles*, is attributed to Paul Gauguin.
1899-1902	Military service, first in Arles with the 55th Infantry Regiment, where he paints van Gogh's motifs (*Le Pont de Langlois*) and under his influence

(*Autoportrait*). Meets van Gogh's doctor. Billeted in Aix-en-Provence, Camoin pays frequent visits to Cézanne during three months. Camoin subsequently keeps up the friendship through correspondence. Camoin greatly admired and was influenced in his work by Cézanne. Released from the military and returns to Paris at the end of 1902.

1903 Visits Claude Monet at Giverny. Exhibits at the first Salon des Indépendants in the spring and at Berthe Weill's gallery. Spends the winter in Martigues and settles at rue des Pyramides, Paris.

1904 Spends time painting in Marseille and Cassis with Marquet. Travels to Rome, Naples, and Capri. His *La vue de Naples* is acquired by the state. Participates in the Salon d'Automne where he exhibits yearly until 1908. Shows also with Moreau's students at Weill's.

1905 Lives at place Dauphine, Paris, near Othon Friesz. Exhibits at the Salon des Indépendants, where all of his canvases are sold. Paul Signac buys *La rue Bouterie*, painted in 1904. during the summer he paints in Agay, Cassis, and Saint-Tropez with Marquet. Visits Signac in Saint-Tropez. Paints Marquet's portrait and *La Fille de joie*. Enters his summer landscapes in the historic Salon d'Automne with other Fauve painters in Matisse's circle.

1906 Exhibits at the Salon des Indépendants and Salon d'Automne. Paints in Marseille and travels to Corsica with Emilie Charmy, his companion until 1913.

1907 Exhibits at the Salon des Indépendants and Salon d'Automne. Accompanies Marquet and Friesz on a trip to London in May. In June he travels to Spain and paints in Seville and Granada.

1908 Individual show at Galerie Kahnweiler (29 paintings and drawings) in April. Contracts with Schames Gallery in Frankfurt-am-Main. Travels to Corsica in the summer. Passes a difficult winter in his new Parisian studio, rue Cortot.

1909 Spends time in Toulon and Porquerolles with the Latil family, whose portraits he paints.

1910 Occupies the former studio of Utrillo in Montmartre. Visits Ajaccio and later Frankfurt for a group exhibition at Schames Gallery. Typical of this "dark" period, his views of Paris and a self-portrait are somber.

1912 Stays with Marquet at Collioure. Renews his contract with Druet. In December, leaves for Tangiers, where he joins Matisse, Marquet, and the Canadian painter Morrice.

1913	Spends seventeen days in military barracks at Marseille. Becomes reacquainted with the painters Mathieu Verdilhan and Louis Audibert. In Paris, he separates from Emilie Charmy. Distraught, he destroys almost eighty canvases. Some of these, recovered and restored, later become the object of a well-publicized legal trial.
1914	Stays at Vernon, where he is mobilized on August 2. Enlists in the 115th territorial and is sent to the trenches.
1916	Attached to a blackout and camouflage unit with Charles Vildrac and Dunoyer de Segonzac. Corresponds regularly with Matisse, who remains in Paris.
1918	Joins Matisse in Nice. Decisive meeting with Renoir at Cagnes.
1919	Discharged from military service on February 19, Camoin resumes painting and participating in exhibitions. Spends twenty-eight days at Toulon, during which time he paints *La Jeune fille au bouquet*.
1920	Marries Charlotte Prost in Marseille on March 13. Spends the summer around Aix and the winter in Antibes and Cannes.
1921	Purchases the Val-Flor house in Saint-Tropez, where he has been painting for most of the year. Following an exhibition of fifty canvases at Galerie Bernheim in Paris, he signs a one-year contract with this dealer.
1922	Camoin paints in Paris and Saint-Tropez. Contracts with Bernheim and Vildrac.
1925	Shows at *Trente ans d'art indépendant*, Strasbourg, and at Saint-Etienne. Moves to Paris and establishes a studio on l'avenue Junot.
1927	Lengthy trial regarding canvases destroyed in 1913 against Francis Carco concludes in Camoin's favor. This ruling helps to clarify an artist's rights over his work. Travels in Brittany with Jean Puy and the Marquets in July.
1928	Camoin's *Le Port de Saint-Tropez* is acquired by the Musée National d'Art moderne. Makes a visit to Marseille to be near his mother.
1929	Travels to Geneva for a short stay.
1930	Travels to Spain with the Marquets in the spring. His mother dies. Spends the summer in Paris then in Bologna with the Marquets.
1931	Shows in Rouen with Marquet in March. Spends the spring in Saint-Tropez, summer in Brittany. With the Eiffels, celebrates the fiftieth anniversary of Berthe Signac in Saint-Tropez.
1933	His daughter, Anne-Marie, is born on October 12.

1934 Stays at Vevey in June, then at Aix-les-Bains. Spends the summer in Marseille. Experiences financial difficulties.

1935 The Musée du Luxembourg purchases a portrait of his daughter.

1936 Shows with Jean Launois in Nantes in March. Spends the summer in Marseille. Renews friendship with the French writer Colette in Saint-Tropez, who lives at *La Treille muscate*.

1939 Leaves Paris for the Midi, where the Camoins stay for four years during the war. His painting *La Fille de joie* is attacked with a knife at the Salon des Indépendants. Camoin never participates again in this exhibition.

1942 Exhibits with Jean Puy in Lyon. Begins his *Journal*.

1943 Soldiers ransack his studio in Saint-Tropez. Visits Pierre Bonnard in Cannes. Returns to Paris and shows at Galerie Carré in November.

1944 Destroys an important series of paintings. Holds a successful exhibition at Galerie Charpentier in August.

1945 Spends the summer in Saint-Tropez and visits Matisse in Cimiez. Exhibits sixty-one paintings at Charpentier's in August, for which Colette writes the catalogue preface.

1946 In February, Camoin paints in his new apartment overlooking the port at Saint-Tropez. Rombaldi edits Camoin's *Album de dix estampes originales*, with a preface by Jean Alazard.

1947 The Musée d'Alger purchases one of his *Portrait de femme*. Marquet dies on June 14. Shows thirty-four paintings at Charpentier's at the end of the year.

1949 Visits the Eiffel family in Ploumanach, Brittany. Manguin and Friesz die.

1950 Paints *Portrait de Paul Getty*. The state acquires *La Baie des Canoubiers*.

1954 Matisse dies.

1955 Travels to Italy in April. Awarded Grand Prix of the 3rd Menton Biennale. Made an officer of the Legion of Honor.

1956 Exhibits at Gas and Druet. His daughter Annie marries Pierre Grammont. Travels to Munich in November.

1957 Visits Jean Puy in Roanne, with whom he has kept a regular correspondence. Spends time in Cannes and Nice before returning to Saint-Tropez.

1958 First major retrospective (seventy paintings) held in June at Galerie Bernheim.

1959 Exhibits at Galerie Charpentier in Paris and Galerie Abels in Cologne, where Camoin visits. Receives Commander of Arts and Letters.

1960 Travels to Bagnols-sur-Cèze and Avignon. Shows thirty small paintings at Galerie Schneider; other works are exhibited in Chicago.

1961 Spends May and June in New York City, where a retrospective exhibition is held at Hammer Galleries.

1962 Spends April and May in Aix, June in Marseille. Participates in *Les Fauves* exhibition at Charpentier's and is the sole survivor represented at the Musée Cantini's *Gustave Moreau et ses élèves* exhibition.

1963 Spends the summer in Aix. Participates in *Les Peintres du vieux port* exhibition in Marseille.

1964 Completes Bather-theme paintings in Midi. Inaugural exhibition at Galerie Michel André, Paris.

1965 Leaves Saint-Tropez in January for Paris, following several blood transfusions. On May 20, at age eighty-six, Camoin dies in his studio in Montmartre. Buried May 25 in Marseille's Saint-Pierre cemetery.

Charles Camoin

Bibliography

I. Archival Materials

2928. CAMOIN, CHARLES. *Letters*, 1929-53. 6 items. Located at The Getty Center for the History of Art and the Humanities, Archives of the History of Art Santa Monica, California.

Letters to the dealer M. Gas about Camoin's paintings, current exhibitions, and Fauvism.

2929. ZAMARON. *Letters Received*, 1925-36. 7 items. Holographs. Located at The Getty Center for the History of Art and the Humanities, Archives of the History of Art Santa Monica, California.

Zamaron was associated with the Paris Préfecture de Police, where he maintained a private collection of paintings. The letters concern minor police matters in general. One is a letter of introduction to the painter André Lanskoy; others have to do with the sale of paintings. Correspondents include Charles Camoin, Henri Hayden, and Louis Vauxcelles.

II. Books

2930. ALAUZEN, ANDRE DI GENOVA. *La Peinture en Provence du XIV^e siècle à nos jours*. Préface de Henri Perruchot. Marseille: La Savoisienne, 1962. 242 p., illus., 100 col., 100 pl.

Discusses Camoin on pp. 187-8, including a color reproduction of *La Jeune Marseillaise*.

Includes ten original lithographs by Camoin.

2931. *Archives du procès Camoin-Carco.* Paris, 1927.

2932. BRASSAÏ [GYULA HALÄZ]. *Conversations avec Picasso.* Paris: Nouvelle Revue Française, Gallimard, 1964. 384 p., illus., 48 pl. Volumes in "Collection Idées" series.

Mentions Camoin on pp. 101-6.
a. Other eds.: 1969, 1986.
b. U.S. ed.: *Picasso and Co.* Preface by Henry Miller, introduction by Roland Penrose, with photographs by the author. Translated from the French by Francis Price. Garden City, NY: Doubleday, 1966. 289 p., illus.
c. German ed.: *Gespräche mit Picasso.* Reinbeck bei Hamburg: Rowohlt, 1966.
d. Spanish ed.: *Conversaciones con Picasso.* Madrid: Aguilar, 1966. 357 p., illus., pl.
e. English ed.: *Picasso & Co.* Preface by Henry Miller, introduction by Roland Penrose, with photographs by the author. Translated from the French by Francis Price. London: Thames & Hudson, 1967. 289 p., 40 pl.

2933. CARTIER, JEAN-ALBERT. *Charles Camoin, 1879.* Documentation réunie par J.-A. Cartier. Geneva: Documents Cailler, 1958. 14 p., illus. Volume in "Les Cahiers d'art-documents" series.

First monograph dedicated exclusively to Charles Camoin.

2934. CEZANNE, PAUL. *Correspondance recueillie, annotée et préfacée par John Rewald.* Paris: Grasset, 1937. 319 p., pl.

Cites all letters written by Cézanne to Camoin.

2935. CHARMET, RAYMOND. *Dictionnaire de l'art contemporain.* Paris: Larousse, 1965. 319 p., illus. Volume in "Les Dictionnaires de l'homme du XXᵉ siècle" series

Includes an entry on Camoin.

2936. CHASSE, CHARLES. *Les Fauves et leur temps.* Lausanne: Bibliothèque des Arts, 1963. 188 p., col. pl.

Mentions Camoin.

2937. COQUIOT, GUSTAVE. *Les Indépendants, 1884-1920.* Paris: Librairie Ollendorff, 1920. 239 p., pl.

Mentions Camoin.

2938. CORNEAU, EUGENE. *Charles Camoin, dix estampes originales.* Présentés par Jean Alazard. Paris: Editions Rombaldi, 1946. 13p., 12pl. Volume in "Les Maitres de l'estampe française contemporaine" series.

2939. CRESPELLE, JEAN-PAUL. *Les Fauves.* Neuchâtel: Ides et Calendes, 1962. 365 p., illus., some col.

Discusses Camoin on pp. 227-30, including reproductions of four paintings (no. 77-88).
a. U.S. ed.: *The Fauves.* Trans. by Anita Brookner. Greenwich, CT: New York Graphic Society, 1962. 351 p., illus.
b. English ed.: *The Fauves.* Trans. by Anita Brookner. London: Oldbourne Press, 1962. 351 p., illus.
c. German ed.: *Fauves und Expressionisten.* Munich: Bruckmann, 1963. 365 p., illus.

2940. CRESPELLE, JEAN-PAUL. *Montmartre vivant.* Paris: Hachette, 1964. 286 p., 18 illus.

Includes a section on Camoin, pp. 991-113; and twenty-two documents.

2941. DORIVAL, BERNARD. *Les Etapes de la peinture française contemporaine.* Paris: Gallimard, 1943-48. 4 vols.

Charles Camoin is mentioned in volume 2, pp. 73, 130+.

2942. ESCHOLIER, RAYMOND. *Matisse, ce vivant.* Paris: André Fayard, 1956. 286 p., illus.

Mentions Camoin on pp. 10, 21, 30, 59, 98, 104-5, 108, 112-3, 128, 157, 170, 222-4, 227-37, 271.
a. German ed.: *Henri Matisse, sein Leben und Shaffen.* Zurich: Diogenes, 1958. 310 p., illus., 87 pl.
b. English ed.: *Matisse, From the Life.* Trans. by Geraldine and H. M. Colvilé; with an introduction and notes on the illustrations by R. H. Wilenski. London: Faber and Faber, 1960. 226 p., illus., 56 pl.

2943. ESCHOLIER, RAYMOND. *La Peinture française au XXᵉ siècle.* Paris: Floury, 1937. 152 p., illus., col. pl. Volume in "Bibliothèque artistique" series.

Mentions Camoin.
a. Another ed.: 1956.

2944. FAURE, ELIE. *Histoire de l'art: l'art moderne.* Paris: Le Livre de Poche, 1961. 2 vols. Volume 2, p. 274 discusses Camoin.

2945. GIRAUDY, DANIELE. *Camoin: sa vie, son œuvre.* Marseille: La Savoisienne, 1972. 261 p., illus., some col.

2946. GRAUTOFF, OTTO. *Die Französische Malerei seit 1914.* Berlin: Mauritius-Verlag, 1921. 49 p., illus., pl.

Mentions Camoin.

2947. HUYGHE, RENE and GERMAIN BAZIN. *Les Contemporains.* Notices biographiques par Germain Bazin. Paris: P. Tisné, 1939. 91 p., 160 pl. Volume in "Bibliothèque frànçaise des arts" series.

Camoin mentioned on p. 133 of the 1949 ed. Includes a reproduction of his painting, *Nu à la chemise mauve.*
a. Another ed.: 1949. 160 p., 164 pl., some col.

2948. LARGUIER, LEO. *Le Dimanche avec Paul Cézanne (souvenirs).* Paris: L'Edition, 1925. 166 p., pl.

Mentions Camoin.

2949. LEYMARIE, JEAN. *Le Fauvisme: étude biographique et critique.* Geneva: Skira, 1959. 163 p., col. illus. Volume in "Le Gôut de notre temps" series.

Discusses Camoin on pp. 36, 38; includes a color reproduction of his painting, *Portrait de Marquet.*
a. U.S. ed.: *Fauves and Fauvism.* New York: Skira/Rizzoli, 1987. 120 p., illus.

2950. MARQUET, MARCELLE. *Marquet; avec 29 dessins originaux.* Paris: Robert Laffont, 1951. 189 p., illus.

Mentions Camoin.

2951. MARQUET, MARCELLE and FRANÇOIS DAULTE. *Marquet.* *Vie et portrait de Marquet par Marcelle Marquet. L'Œuvre de Marquet par François Daulte.* Avec des notices anàlytiques et une bibliographie par François Daulte. Lausanne: Editions Spes, 1953. 65 p., 46 pl., 6 col.
Volume in "Bibliothèque des arts" series.

Mentions Camoin.

2952. MELAS-KYRIAZI, JEAN. *Van Dongen et le Fauvisme.* Lausanne: Bibliothèque des Arts, 1971. 150 p., illus.

Mentions Camoin on p. 36; color reproduction of his painting, *Portrait de Marquet,* p. 37.

2953. MULLER, JOSEPH-EMILE. *Le Fauvisme.* Paris: F. Hazan, 1956. 95 p., col., illus. Volume in "Bibliothèque Aldine des arts" series.

Camoin is discussed on p. 43; includes a reproduction of his painting, *Portrait de Marquet,* p. 40.
a. Another ed.: Paris: F. Hazan, 1967. 256 p., illus.

2954. PLEYNET, MARCELLIN. *L'Enseignement de la peinture.* Paris: Editions du Seuil, 1971.

Camoin is discussed on pp. 96-7.

2955. THIEME, ULRICH and FELIX BECKER. *Künstler Lexikon.* Leipzig: E. A. Seemann, 1911.

Mentions Camoin on p. 444.

2956. VAUXCELLES, LOUIS. *Le Fauvisme.* Geneva: P. Cailler, 1958. 115 p., 11 col. illus. Volume in "Peintres et sculpteurs d'hier et d'aujourd'- hui" series.

Mentions Camoin on pp. 101-3.

2957. VAUXCELLES, LOUIS. *Histoire illustrée de la peinture: de l'art rupestre à l'art abstrait.* Paris: F. Hazan, 1961. 320 p. col. illus.

Discusses Camoin on pp. 270-9.

2958. VILDRAC, CHARLES. *Eloge de Charles Camoin.* Paris: Manuel Brucker, 1956.

2959. VOLLMER, HANS. *Künstler Lexikon.* Leipzig: E. A. Seemann, 1953.

Camoin is mentioned on p. 378.

2960. WEILL, BERTHE. *Pan! dans l'œil.* Avec une préface de Paul Reboux; orné des aquarelles et dessins de Raoul Dufy, Pascin et Picasso. Paris: Librairie Lipschutz, 1933. 325 p., illus., 4 pl., some col.

Sketchy reminiscences of a pioneer Parisan art dealer.

III. Articles

2961. BARBER, BETTE E. "Still-Sprightly Camion [*sic*] in NY." *Jackson Daily News* (20 June 1961).

2962. BAROTTE, RENE. "Camoin doit tout à la lumière de provence." *Le Provençal-Dimanche* (6 July 1958).

2963. BASSAN, LUC. "Charles Camoin." *Signatures 39* (June 1967): 14-6. 2 illus.

2964. BESSON, GEORGE. "Charles Camoin." *Le Point* (July 1937) and *Beaux-arts* (July 1937). 1 illus.

2965. BESSON, GEORGE. "Lettre à une provinciale." *Les lettres françaises* (15 Dec. 1960).

2966. BILLETDOUX, FRANÇOIS. "Charles Camoin." *ARTS* (18 Feb. 1953).

2967. CAMOIN, CHARLES. "Ce Gauguin, *La Belle cabaretière d'Arles,* est de Camoin" *Arts* (30 Jan. 1948):1[+]; discussion, Peter Bellow, *Arts* (6 Feb. 1948):1[+].

2968. "Camoin." *Gazette des Beaux-arts* (1909):378.

2969. "Camoin." *Art et décoration* (1919).

2970. "Camoin; Fifty-Four Years Fauve." *Art News* 60(Summer 1961): 45+.

2971. "Carco Case Once More in Court." *Art News* 29(25 April 1931):17.

2972. "Charles Camoin." *Chronique des arts* (1904):119.

2973. "Charles Camoin." *Chronique des arts* (1908):147.

2974. "Charles Camoin." *Gazette des Beaux-arts 2* (1909):377-8.

2975. "Charles Camoin." *Kunst und Künstler aus Bonner Privatbesitz* (15 Jan. 1911).

2976. "Charles Camoin." *Jours de France* 19(1955).

2977. "Charles Camoin." *Vogue* (11Jan. 1957).

2978. "Charles Camoin." *Connaissance des arts* 128(Oct. 1962):54.

2979. "Charles Camoin." *Alpha-Encyclopédie* (Paris, 1968):10.

2980. "Charles Camoin." *Connaissance des arts* (April 1969):125.

2981. "Charles Camoin." *Les Muses* (11Nov. 1970). 1 illus.

Biographical notice.

2982. "Charles Camoin." *L'Homme libre de Montmartre* 14(March 1967).

2983. CHARMET, RAYMOND. "Camoin: on n'a rien compris à la leçon de Cézanne." *Arts.*

2984. COURTHION, PIERRE. "Rencontre de Charles Camoin." *Art-documents* (July 1953):10-1. 3 illus.

2985. GEORGES-MICHEL, MICHEL. "Un de la grande époque, Camoin." *Aux écoutes.*

2986. GIRAUDY, DANIELE, ed. "Correspondance Henri Matisse—Charles Camoin." *Revue de l'art* 12(1971):7-34. 4 illus.

Includes reprints of twenty-five documents.

2987. GRANDJEAN, MICHELE. "Charles Camoin à l'œil nu." *Vision sur les arts* (1959):23-7. 3 illus.

2988. GRANDJEAN, MICHELE. "Charles Camoin: . . . je suis un coloriste." *Le Soir* (6-7Oct. 1959).

2989. HAMMOND, SALLY. "Charles Camoin." *New York Post* (28May 1961).

2990. HERAUT, HENRI. "Charles Camoin." *Sud-magazine* 105(1Aug. 1933):18-20. 3 illus.

2991. HOOG, MICHEL. "La Direction des beaux-arts et les Fauves." *Arts de France* (1963):363-4.

2992. JOURDAIN, FRANCIS. "Un artiste, est-il propriétaire de son œuvre?" *L'Amour de l'art* 112(Dec. 1925):489.

2993. LASSAIGNE, JACQUES. "Camoin." *Arts* (9 Jan. 1958).

2994. LECLERE, TRISTAN. "Camoin, original et séduisant." *Les Derniers états des lettres des arts* (1916):66.

2995. "Maison Buvelot; Camoin, antiquaire et éditeur." English translation by Arsène Alexandre. *Renaissance* 12(Aug. 1929):388-93.

2996. MAUCLAIR, CAMILLE. "La Poubelle aux œufs d'or." *Dépêche de Toulouse* (Feb. 1925).

2997. "*Nature morte aux fleurs*." *Connaissance des arts* 482(April 1992):144.

2998. REY, ROBERT. "Charles Camoin." *Bulletin de l'art français et japonais* (Aug. 1927).

First serious, documented study of Camoin.

2999. ROUVIER, CAMILLE. "Charles Camoin au Musée Longchamps." *Le Provençal* (25Oct. 1966).

3000. TOURETTE, JEAN. "Cinq minutes avec le peintre fauve Charles Camoin." *La Marseillaise* (6 July 1962).

3001. TOURSKY. "Charles Camoin." *Le Soir* (26 Oct. 1966).

3002. WARNOD, ANDRE. "Visite d'atelier: Charles Camoin." *Arts* (17Aug. 1945).

3003. WILMES, M. "Camoin, le peintre de la fraîcheur." (13 April 1944).

IV. Individual Exhibitions

1907, March	Paris, Galerie Druet. *Charles Camoin.*
1908, 6-18 April	Paris, Galerie Kahnweiler. *Charles Camoin.* 29 paintings and drawings. 2 p.
1914, February-March	Paris, Galerie Druet. *Charles Camoin.* 60 paintings. 6 p., 3 illus.
1921, April	Paris, Galerie Bernheim-Jeune. *Charles Camoin.* 50 paintings.
1923, January	Paris, Galerie Bernheim-Jeune. *Charles Camoin.* 46 paintings. 6 p., 5 illus.
1924, January	Paris, Galerie Druet. *Exposition Charles Camoin.* Pastels.
1925, January-May	Strasbourg, Galerie Aktuarius. *Charles Camoin.*
1925, February-May	Paris, Galerie Marcel Bernheim. *Charles Camoin.* 21 paintings.
1925, May	Saint-Etienne. *Charles Camoin.*
1929, March	Paris, Galerie Druet. *Camoin.* Review: *Beaux-arts* 7(May 1929):19.
1933, February	Paris, Galerie Bernheim-Jeune. *Charles Camoin.* Review: *Art et décorations* 62(April 1933):supp. 6
1937, March	Nantes, Galerie Mignon-Manquart. *Charles Camoin.* 21 paintings.
1943, November	Paris, Galerie Louis Carré. *Charles Camoin.* 45 paintings.
1944, August	Paris, Galerie Charpentier. *Charles Camoin.*
1945, August	Paris, Galerie Charpentier. *Charles Camoin.* Préface de Colette. 61 Paintings.
1947-48, December-January	Paris, Galerie Charpentier. *Charles Camoin.* Préface de Charles Camoin. 34 paintings. Reviews: *Arts* (26Dec. 1947):4; J. Lassaigne, *Arts* (9Jan. 1948):4; *Arts* (30Jan 1948):1[+]; *Arts* (6Feb. 1948):1[+].

1952, November	Paris, Galerie Charpentier. *Charles Camoin.*
1956, June	Paris, Galerie André Maurice. *Exposition Charles Camoin.* 27 paintings.
1956, June	Paris, Galerie Druet. *Charles Camoin, petits formats.*
1958, June	Paris, Galerie Marcel Bernheim. *Rétrospective Charles Camoin.* 70 paintings. Camoin's first retrospective exhibition.
1959, June	Paris, Galerie Charpentier. *Charles Camoin.*
1959, October-November	Cologne, Galerie Abels. *Charles Camoin, Gemälde.* 30 paintings.
1960-61	Paris, Galerie Robert Schneider. *Charles Camoin.* 30 petits formats, peints dans le Midi.
1961, May-June	New York, Hammer Galleries. *Charles Camoin.* 40 paintings. Second major retrospective. Review: B. Barber, *Jackson Daily News* (20June 1961).
1962	Paris, Salon d'Automne. *Hommage à Camoin.* 21 paintings.
1964, March	Paris, Galerie Michel André. *Charles Camoin, exhibition inaugurale.*
1966, October-November	Marseille, Musée Cantini, Palais Longchamp. *Camoin, rétrospective.* Préface de Marielle Latour. 44 p., 19 illus. Reviews: C. Rouvier, *Le Provençal* (25Oct. 1966); Toursky, *Le Soir* (26Oct. 1966); *Centre Arto* (Jan. 1967):13.
1967	New York, Beilin Gallery. *Charles Camoin.* Review: *Art News* 66(Summer 1967):13.
1968, May-June	Cologne, Galerie Abels. *Charles Camoin, 1879-1965: Gemälde.* 43 paintings.
1970	New York, Wally F. Gallery. Review: *Art News* 69 (Sept. 1970):12.
1971, March-April	Nice, Palais de la Méditerrannée. *Charles Camoin, soixante-dix ans de peinture.* Préface de Dunoyer de Segonzac, introduction de Danièle Giraudy. 16 p., 13 illus. 77 paintings, 66 drawings.
1978, 3-29 April	Stuttgart, Kunsthaus Buhler. *Französische Postimpressionisten.* 44 p., 17 illus.

This exhibition catalogue is introduced by a brief survey of movements in French art reacting against the Impressionist style during the 1870's and 1880's, including the Neo-Impressionists, the Pont Aven group, the Nabis, the Symbolists and the Fauves, all of which, it is stated, made contributions to Post-Impressionism. Illustrations from the exhibiton are accompainied by commentaries ont the artists' careers and significance within the Post-Impressionist movement. Artists exhibited include Moret, Loiseau, Lebourg, Valtat, and Camoin.

1991 | St.-Tropez, Musée de l'Annonciade. *Camoin et St.-Tropez.* 43 p., illus., 16 col.

V. Group Exhibitions

1904, 21 February-24 March | Paris, Grand Palais. *Salon des Indépendants.* 6 paintings.

1904, 2-30 April | Paris, Galerie Berthe Weill. Préface de Roger Marx. 4 p. 6 paintings.

1904, 15 October-15 November | Paris, Petit Palais. *Salon d'Automne.* 7 paintings.

1905, 24 March-30 April | Paris, Grand Palais, *Salon des Indépendants.*

1905, 6-29 April | Paris, Galerie Berthe Weill. 1 painting.

1905, 18 October-25 November | Paris, Grand Palais. *Salon d'automne.* 5 paintings.

1905, 21 October-20 November | Paris, Galerie Berthe Weill. 6 paintings.

1906, 22 February-25 March | Brussels. *La Libre Esthétique.* 4 paintings. Catalogue par Octave Maus.

1906, 20 March-30 April | Paris, Grand Palais. *Salon des Indépendants.* 8 paintings, many painted in Corsica.

1906, late May | Marseille, *Exhibition Coloniale.* Included Camoin's paintings of negresses.

1906, 6 October-15 November | Paris, Grand Palais. *Salon d'Automne.* 5 paintings.

1907, 20 March-30 April | Paris, Grand Palais. *Salon des Indépendants.* 6 paintings.

1907, 30 March	Paris, Galerie Berthe Weill.
1907, 1-22 October	Paris, Grand Palais. *Salon d'Automne.* 7 paintings.
1908, 20 March-2 May	Paris, Grand Palais. *Salon des Indépendants.* 6 paintings.
1908, 1 October-8 November	Paris, Grand Palais. *Salon d'Automne.* 5 paintings.
1910	Frankfurt-am-Main, Gallery Schames. Included somber views of Paris (*Le Moulin-Rouge*) and a self-portrait, typical of Camoin's "dark" period.
1913, February	New York, *The Armory Show.*
1925	Paris, Salon des Indépendants. *Trente ans d'art indépendant.*
1929	Paris, *Salon d'Automne.* Shows *Portrait de L.-P. Fargue,* among other works.
1929	Paris, Galerie Druet.
1931, March	Rouen, Musée des Beaux-arts. *Camoin et Marquet.*
1936, March	Nantes. *Camoin et Launois.*
1942, February-March	Lyon, Galerie des Jacobins. *Charles Camoin et Jean Puy.*
1960	Chicago, Johnson Galleries. *Contemporary French Masters.*
1962	Marseille, Musée Cantini. *Gustave Moreau et ses élèves.* Préface de Jean Cassou, catalogue de Marielle Latour. Camoin was the sole survivor of Moreau's students.
1962, March	Paris, Galerie Charpentier. *Les Fauves.*
1963	Marseille. *Les Peintres du Vieux-port.*
1964, August-September	Besançon, Musée des Beaux-arts. *Valtat et ses amis: Albert André, Charles Camoin, Henri Manguin, Jean Puy.* Préface de George Besson.
1965	Toyko. *Les Fauves.*
1978, 3-29 April	Stüttgart, Kunsthaus Buhler. *Franzosische Postimpressionisten.* 44 p., 17 illus.

Exhibition catalogue includes a brief survey of movements in French art reacting against the Impressionist style during the 1870's and 1880's, including the Neo-Impressionists, the Pont Aven group, the Nabis, the Symbolists and the Fauves, all of whom made contributions to Post-Impressionism. Illustrations from the exhibitions are accompanied by commentaries on the artists' careers and significance within the Post-Impressionist movement. Artists exhibited include Moret, Loiseau, Lebourg, Louis Valtat, and Charles Camoin.

Henri Manguin

Biographical Sketch

Manguin was born in Paris in 1874 to upper-class parents. His father died at the age of 50, when Henri was six years old. Henri dutifully passed through the Lycée Colbert, filling notebooks with sketches and figures in profile and dreaming of becoming an artist. Eventually convincing his mother that he was right, he left school at fifteen to devote his life to painting. Although rejected as insufficiently qualified when he first applied for admission in November, 1894, Manguin entered l'Ecole des Beaux-Arts as a pupil in Gustave Moreau's studio. There he met Henri Matisse, Albert Marquet, Georges Rouault, Charles Camoin, Louis Valtat, and the Belgian painter Henri Evenepoel.

Marquet was a very close friend with whom Manguin kept a lifelong correspondence. The two students sketched the streets, cafés, bars, and music halls of Paris in the evenings. Manguin lived in a studio apartment at rue Bachelet, on the north side of Montmartre in the 18th arrondissement. He copied at the Louvre and was greatly impressed by the Cézanne retrospective at Vollard's gallery in 1895.

In the summer of 1896 Manguin went with his friend De Mathan to the tip of Cotentin near Cherbourg, where he met Jeanne Carette, his future wife. During the trip he visited Pont-Aven and stayed at the Pension Gloanec, Paul Gauguin's old headquarters. In 1899 certain of his Louvre copies, Titian's *Portrait of a Man*, Poussin's *Echo and Narcissus*, and Velázquez's *Infanta Maria Teresa* were purchased by the state. In June of that year he married Jeanne Carette and moved to 61, rue Boursault in Batignolles. The two were happily married and had three children.

Manguin's life was extraordinarily private, with little dramatic incident and no major changes of vocation or destiny, just as his art has an essential continuity and homogeneity. Aside from painting there were two sides to Manguin's life—an enthralled and responsible lifelong marital relationship, and a physical restlessness that took him from place to place, sometimes abroad but especially in France. He maintained a home base in Paris, but as his life went on he spent more and more of each year near Saint-Tropez at the Villa Demière. Except for Marquet, whom he loved and admired, his relations with fellow painters were mutually respectable, even cordial, but not close.

Manguin first showed at the Société Nationale in 1900 and then at Berthe Weill's small gallery on the Left Bank. He was also represented at the Salon des Indépendants in 1902 and belonged to its committee for ten years. He exhibited at the Salon d'Automne from its inception in 1903 and became a *sociétaire*. In 1905, Manguin showed with the Fauves at their famous group exhibition at the Salon d'Automne and for some times was a member of the movement. Manguin found in the violence of color the means to express his vitality. His paintings are joyful, vibrating with the warmly colored harmonies of the

Mediterranean sun under which most are done.

Manguin's name was early well known to connoisseurs. As soon as 1900 Olivier Sainsère bought one of his pictures and in 1905 Ambroise Vollard acquired 150 canvases in one deal. Leo Stein was also an admirer and collector. In 1908, while working at the Atelier Ransom, Manguin renewed his friendship with Marquet and the two artists, with Manguin's wife, traveled to Naples. The following year Jeanne and Henri moved to a small town house at rue Saint-James, Neuilly. In 1910, when Manguin was at Honfleur, Félix Vallotton introduced him to two Swiss art collectors, Arthur and Hedy Hahnloser. It was a fortunate encounter, for they took to each other immediately and were soon on intimate terms. The Hahnlosers bought many pictures from Manguin and their home, the Villa La Flora at Winterhür, became a private gallery for the artist. Charles Montag, the painter and dealer, sold Manguin's other work to other Swiss collectors such as Oscar Reinhardt, Buhler, and Sulzer. For most of his career he enjoyed a steady and loyal swiss clientele. Manguin's letters to the Hahnlosers from 1910 to 1942 contain details about his trips and career but, above all, they shed light on his role in helping to form one of the most individual collections of the period, one rich in nineteenth and early twentieth-century painting.

Manguin's own work was on view in various galleries in the first decade of the twentieth century. Octave Maus invited him to send three works, including *La Sieste*, to the Société des XX (La Libre esthétique) show in Brussels in 1906, and he appeared in group exhibitions at Galerie Druet at 20, rue Royale in the heart of Paris, where he had a one-artist exhibition in 1907. He was represented in the great exhibition of 450 French paintings organized by the French Institute and the art review *Apollon* in St. Petersburg, Russia. His work won praise from such critics Guillaume Apollinaire who, in 1910, remarked that Manguin was an esteemed painter of voluptuous nudes.

Manguin usually left Paris during the summer months to work in the country. He spent the summer of 1911 in Sanary, where André Derain painted in the 1920s, and from 1912-14 he was at Cassis. Letters to Madame Hahnloser show that during this period he sometimes underwent bouts of depression regarding his work, although it continued to celebrate the visual pleasures of life. Unlike many contemporary artists, the war years did not distract Manguin from painting. He and his wife went to Lausanne in 1915 and in 1917 and 1918 they spent the summer at Colombier, near Neuchâtel, where he painted views of the lake.

When the war was over the Manguins returned to France and he resumed his customary practice of retreating for the summers to the Midi. In 1920 he returned to Saint-Tropez, where he bought a villa called "L'Oustalet." His circle there included Georges Grammont, founder of the Musée de l'Annociade, Jules Supervielle the author, Louis Jouvet the actor, and Charles Vildrac the poet and playwright. He also knew the critic Roger Fry. In August, 1920 his villa and studio in Neuilly were burglarized.

The pattern of his life remained almost the same to the end. He made various trips throughout France in his Buick, always hunting for a new motif. In 1923 he stayed in Marquet's studio in Marseille and in the 1930s he went to Normandy and Brittany. The Manguins remained at Neuilly until 1938 when they moved to an apartment in the rue Washington, off the Champs-Elysées. When World War II broke out they left for the Midi, staying with their son Claude at the Ile de la Barthelasse, opposite Avignon, where Manguin continued to paint. They returned to the capital after the war was over and later to Saint-Tropez, where Manguin died after a short illness in 1949.

Manguin's paintings are straightforward and clear in their intention. He found his subject matter and technique when young and abandoned neither in subsequent years. He loved strong harmonies and luxuriated in the qualities of paint. His canvases celebrate nature and gentle living and invite contemplation of a golden age.

Henri Manguin

Chronology, 1874-1949

Information for this chronology was gathered from *Manguin in America: Henri Manguin, 1874-1949* [exh. cat.] (Tucson: The University of Arizona Museum of Art, 1974); Pierre Cabanne, *Henri Manguin* ((Neuchâtel: Ides et Calendes, 1964); Charles Terrasse, *Eloge d'Henri Manguin* (Paris: Manuel Bruckner, 1954), among other sources.

1874	Henri Charles Manguin born March 23 in Paris at 21, rue de Dunkerque of upper-class parents. His father was from Chartres; his mother, Emelie Catherine Lemanissier, from Paris.
1880	Manguin's father dies at age 50. Manguin remains with his mother and sister Adrienne, four years old. His father leaves the boy a small inheritance.
1890	At age 15, with no objections from his mother, Manguin abandons his studies at the Lycée Colbert to devote himself exclusively to painting.
1893-1904	Makes numerous copies at the Louvre of masterpieces by Delacroix, Poussin, Titian, Velázquez, Chardin, and Rembrandt. Some were later purchased by the state. Sketches with Albert Marquet on the streets of Paris.
1894	In November, Manguin enters the studio of Gustave Moreau at l'Ecole des Beaux-arts. He becomes friends with Marquet, Matisse, Puy, Rouault, Evenepoel, Desvallières, De Mathan, Camoin, Valtat, and other artists. Rejected as insufficiently qualified when he first applied for admission, Manguin sketches (along with Marquet, Matisse, Rouault and others) in the school's glass-roofed courtyard, which contained copies of Europe's great art masterpieces. He lives in bachelor's quarters on rue Bachelet, on the north side of Montmartre.
1895	On Moreau's recommendation, Manguin and fellow students visit Cézanne's retrospective (150 works) at Ambroise Vollard's gallery on rue Lafitte.

1896 Under the influence of De Mathan, Manguin spends part of the summer at La Percaillerie, Contentin, near Cherbourg, where he meets Jeanne Carette, his future wife. During the trip he visits Pont-Aven and stays at the Pension Gloanec, Paul Gauguin's old headquarters.

1894 Marries Jeanne Carette on June 27, whose portrait he often paints over the next thirty years. The couple enjoys a happy marriage and have three children. Manguin sets up his studio at 61, rue Boursault, in the Batignolles *quartier* of Paris where he later works in common with Marquet, Matisse, and Puy.

1900 Manguin exhibits for the first time at Berthe Weill's gallery, then at the Société Nationale. Olivier Sainsère purchases one of his paintings.

1902 Lives at Le Raincy and spends the summer at Paris-Plâge. Meets Camille Pissarro and visits him at Moret. Shows at the Salon des Indépendants and becomes a member of its committee for the next ten years. Completes Maurice Ravel's portrait.

1903 Spends the summer at La Percaillere with Marquet. Corresponds regularly with Matisse. Shows at the first Salon d'Automne. Remains faithful to this salon until his death in 1949. In 1950, the Automne honors him with a posthumous exhibition.

1904 After spending the summer at La Percaillerie, Manguin discovers Saint-Tropez and becomes friends with Paul Signac. Captivated by the Mediterranean light, he rents the villa Demière, a small house in the pines above the village, to which he returns annually until 1910. During the winter Matisse, Marquet, and Puy paint at the rue Boursault studio in Paris.

1905 Spends the winter in Paris, where he meets Gertrude and Leo Stein who purchase one of his nude paintings. Goes to Saint-Tropez in June. In frequent contact with Matisse and Marquet. An associate of the Salon d'Automne, Manguin exhibits five paintings in the room where he and his friends were called "*les Fauves*" for the first time. Shows for the first time in New York at the Carnegie Institute, in Paris at the Salon des Tuileries, and at the Venice Biennale. Art dealers Vollard, Druet, and Bernheim-Jeune also show interest. Becomes a member of the Berlin Secession.

1906 Private exhibition at Galerie Druet. In March, Vollard purchases 150 canvases. Spends time in Cavalière, where he meets Théo van Ryssselberghe and Henri-Edmond Cross. Participates in exhibitions in Germany and in Brussels with Les XX.

1907 After the winter in Paris, he returns to Saint-Tropez. Group exhibitions in Bordeaux. First private exhibition at Druet (39 works) in November introduced by Fernand Fleuret.

1908	Travels to Italy with his family and Marquet in the spring. They visit Naples, Florence, and Livorno. Manguin completes drawings and watercolors. Meets André Dunoyer de Ségonzac. Pierre Bonnard lives at the villa Demière during the summer. At the end of the year Manguin works at the Ranson Academy with Marquet and Francis Jourdain.
1909	At the beginning of the year he moves to 7, rue Saint-James in Neuilly. In July he visits Félix Vallotton in Honfleur. Chairs the Salon d'Automne's hanging committee. Participates in a group exhibition in Russia.
1910	While on a trip to Honfleur in June-July, Manguin meets the Swiss collectors Arthur and Hedy Hahnloser through Vallotton. He visits them in Winterthur, Switzerland in the fall and meets the Sulzers and Reinhardts. Manguin corresponds with the Hahnlosers until 1942, advising them on paintings for their collection. Charles Montag, a Swiss painter and dealer, sells Manguin's works to other collectors. Private exhibition at Galerie Druet.
1911	In April, the Hahnlosers visit him in Neuilly. Stays the summer at Sanary, where Derain painted in the 1920s. Participates in an exhibition in Berlin. Declines an invitation to teach art in Berlin.
1912	Spends the winter in Paris, spring in Winterthur where he advises the Hahnlosers on acquisitions, and summer in Cassis with Othon Friesz. Group exhibitions in Moscow and St. Petersburg. Russian collectors Shchukin and Morosov buy several paintings including two shown at the 1906 Salon d'Automne.
1913	Similar itinerary to the previous year, with the addition of a visit to Villefranche in the fall. Receives a letter from Matisse in Tangiers early in the year. Private exhibition at Druet and group shows at São Paulo, Rome, New York (Armory Show), Chicago, Boston, Brussels, Ghent, and Lausanne.
1914	Returns to Cassis for the summer where news of the war reaches him. Relieved of military obligation, Manguin and his family move to Lausanne at the end of the year, near the Vallotton brothers.
1915-18	Lives in Lausanne and visits the Hahnlosers in Winterthur and the Vallottons in Broc. Paints during the summers of 1917 and 1918 at Colombier, near Neuchâtel. Makes numerous excursions into the Swiss Alps with friends and family. Paints nude portraits of his wife Jeanne. Shows at Galerie Moos, Geneva, in 1918.
1919	Returns to Neuilly. During the summer he lives in "La Valentine" (La Serviane), near Marseille and in Saint-Tropez. Manguin renews ties with the Salon d'Automne and shows works there.
1920	Settles in "l'Oustalet" at Saint-Tropez, a villa he purchases several years later. His circle there includes Georges Grammont, founder of the Musée

de l'Annonciade, Jules Supervielle the author, and Louis Jouvet the actor. Manguin is keen on the theatre and every Christmas takes his family to the Théâtre du Vieux Colombier. Another friend from Saint-Tropez is the poet Charles Vildrac, author of the play *Le Paquebot tenacité* and owner of a small gallery on the Left Bank. Vildrac is a close friend of Roger Fry who also stayed at Saint-Tropez in the 1920s and knew Manguin. In the years that follow he divides his time between Paris and Provence, which does not prevent taking long working trips throughout France. In August, his villa and studio in Neuilly are burglarized; his son Claude's unexpected return prevents major theft.

1920-48 Travels extensively in France in his Buick, searching for new motifs.

1921 Spends the winter at Neuilly and makes a short visit to Honfleur in the spring. In mid-June, he travels to Saint-Tropez via Moissac and Avignon. Returns in the fall to Neuilly via Avignon, Clermont-Ferrand, and Montluçon. Private show at Galerie Druet.

1922 After the winter in Neuilly, Manguin travels to Saint-Tropez via the Alps and the Galibier Pass. Stays in Saint-Tropez until January, 1923. Charles Picart-Ledoux visits him during the summer.

1923 Private show at Druet in April-May. Leaves Neuilly in June, works in Albi, and arrives in Saint-Tropez in July. Stays in Marquet's studio in Marseille in December-January, 1924, while Marquet is in Paris.

1924 Returns to Neuilly from Marseille via Lyon at the end of January. Leaves around July 10 for Honfleur, La Rochelle, Noirmoutier, and Bordeaux, where he joins Marquet and Jean Puy accompanied by their model named "La Grenouillette." They travel together to the Pyrénées, staying at Cette (Sète). Manguin produces many watercolors at each place and arrives in Saint-Tropez in late August. Helps plan the Musée Troupelen, which later becomes the Musée de l'Annonciade.

1925 Stays at Neuilly during the winter and spring. Short trip to Anvers. In July he travels to Uzerches and Cahors, where he paints. Spends time in Avignon and arrives in Saint-Tropez at the end of August. Visits Marseille in December and January, 1926. Shows at Saint-Etienne and Brussels.

1926 Leaves Marquet's studio in Marseille at the end of January for Neuilly. On August 5, his son Claude marries Odette Redon, who poses for Henri Manguin for several years. Travels to Saint-Tropez via Nevers, Valence, and Arles. Finishes the year working at Toulon.

1927 Leaves Toulon at the end of March for Neuilly. Works in Avignon and vicinity in July, then in Saint-Tropez. Short trip to Gien and Castellanne in August. Shows at the Fauve retrospective at Galerie Bing in Paris.

1928	Returns to Paris in mid-March. Brief trip to Belgium in June. Leaves for Saint-Tropez in late July. Short stay in Cannes. Hunts with his son during the fall and paints several still-lifes with game.
1929	Spends winter and spring in Neuilly, summer in Saint-Tropez. Begins to make drawings and watercolors with Odette, his daughter-in-law, as model. Also experiments with engravings.
1930	In Neuilly and Saint-Tropez.
1931	Leaves Neuilly at the end of April for two months in Brittany. Stays in Le Croisic, Port-Louis, La Trinité-sur-mer, and Concarneau, where he works energetically, producing many watercolors. Returns to Saint-Tropez for the summer.
1932	Neuilly, Concarneau, and summer in Saint-Tropez.
1933	Neuilly, Lorient, Concarneau, April in Avignon, and summer in Saint-Tropez.
1934	Neuilly and Saint-Tropez. Plans to visit Marquet in Algeria fall through. Involved in a car accident returning from a hunting trip in Sologne.
1935	Neuilly and Saint-Tropez. Shows at both the Indépendants and Automne salons in the Petit Palais.
1936	Neuilly and Saint-Tropez. Works with Grammont, Dunoyer de Segonzac, Turin, Person and others on the creation of the Musée de Saint-Tropez. Private show in Saint-Quentin.
1937	Neuilly and Saint-Tropez. Participates in group exhibitions in Tunis, Cairo, Berlin, Canada, and France. In the fall Manguin moves to 23, rue Washington in Paris.
1938	Paris, Saint-Tropez, and a brief stay in Saint-Paul-de-Vence near Nice in November. His son Claude purchases, at the closure of the Galerie Druet, Manguin's unsold canvases. Henri destroys eight works before turning them over to Claude. Shows in Pittsburgh and London.
1939	Paris and Saint-Tropez. Shows in Adelaide, New York, Stockholm, London, Liège, and Paris.
1940	Paris, Villefranche-sur-mer, and Saint-Tropez. At the end of the year Manguin flees the German occupation by moving to Avignon, near his son Claude. Shows at the Venice Biennale.
1941	Avignon and Saint-Tropez. Shows in Tunisia.
1942	Returns to Paris. Lives with his daughter Lucile at "La Reinerie" and paints in the Chevreuse Valley. Takes a cure at Royat. Rents a studio in Avignon (rue Banasterie) before returning to Paris.

1943 Paris, Avignon, and the Chevreuse Valley into 1944. Private show at Galerie Pétridès.

1944 Works in Tain, Tournon, and Avignon. Claude and Odette store around seventy paintings before he leaves for Saint-Tropez.

1945 Takes a cure at Royat and works in Avignon.

1946-47 Exhibitions in Paris, Tunisia, and Brussels.

1948 Villefranche-sur-mer, Paris, Royat, and Saint-Tropez.

1949 Shortly after Henri and Jeanne's fiftieth wedding anniversary celebration in Paris, they travel to Saint-Tropez and arrive at "l'Oustalet" on August 9. Manguin dies in Saint-Tropez on September 25 after a brief illness, leaving on his easel an unfinished still-life.

Henri Manguin

Bibliography

I. Archival Material

3004. MANGUIN, HENRI. *"Manguin dossier d'achats d'état, 1904, 1916, 1929."* Série F21 4241. Located at the Archives Nationales, Paris.

II. Books

3005. ALLAN, ROBERT. *Hommage à Henri Manguin.* Avignon.

3006. BARSKAYA, ANNA. *La Peinture française, seconde moitié du XIX^e siècle, début du XX^e siècle, Musée de l'Ermitage.* Introduction d'Antonina Izerghina; réalisation et commentaires de Anna Barskaya; présentation de Vladimir Smolkov; traduit du russe par Mireille de Karton et Zénobius Spetchinsky. Leningrad: Editions d'Art Aurore; Paris: Editions Cercle d'Art, 1975. 416 p., col. illus. In Russian and French.

a. 2nd ed.: 1982. 416 p., col. illus.

3007. CABANNE, PIERRE. *Henri Manguin. Hommages d'André Dunoyer de Segonzac et Charles Terrasse. Souvenirs de Madame Albert Marquet et Hans H. Hahnloser.* Neuchâtel: Editions Ides et Calendes, 1964. 168 p., illus., 34 col. pl. Volume in "Collection des grandes monographies" series.

3008. CASSOU, JEAN, BERNARD DORIVAL, and GENEVIEVE HOMOLLE. *Musée National d'Art moderne, catalogue-guide.* Paris: Editions des Musées Nationaux, 1947. 106 p., illus., 16 pl. Volume in "Art et style" series

a. Other eds.: 1948, 1950, 1954.

3009. *Catalogue de la collection Chtchoukine.* Moscow, 1913.

3010. *Catalogue du Musée d'Art occidental moderne à Moscou.* Moscow: Editions d'Etat Art, 1928. 37 p., illus., 32 col. pl.

3011. COQUIOT, GUSTAVE. *En Suivant la Seine.* Avec dessins inédits de Bonnard . . . Manguin . . . [et al.] Paris: A. Delpeuch, 1926. 138p., pl.

3012. COWART, WILLIAM JOHN III. *'Ecoliers' to 'Fauves': Matisse, Marquet, and Manguin Drawings, 1890-1906.* Ph.D. diss., Johns Hopkins University, 1972. 355 p., illus.

These three artists received almost all of their formal education in a national school system predominantly influenced by pedagogic directives. Notwithstanding later creative innovations, all were demonstrably molded by various aspects of the teaching structure. Cowart inspects the pervasive rationale of drawing instruction at the l'Ecole Nationale des arts décoratifs and the l'Ecole des Beaux-arts, Paris. Instructional literature of the period is also scrutinized and the early graphic œuvre of all three specifically related to it. The stylistic chronologies of Matisse, Marquet, and Manguin are more completely established for this period with emphasis on isolating distinct traditional elements in their work and on their participation in the salons. After a brief examination of the role of Roger Marx, Cowart concludes with a discussion of those elements that will establish a "graphic Fauvism."

3013. DAVAL, JEAN-LUC. *Journal de l'art moderne (1884-1914).* Textes, notices explicatives, déroulement synoptique à travers le témoignage des contemporains. Geneva: Skira, 1973. 310 p. illus., some col.

3014. HUYGHE, RENE and JEAN RUDEL. *L'Art et le monde moderne.* René Huyghe et Jean Rudel avec la collaboration de Thérèse Burollet, et al. Paris: Larousse, 1970. 2 vos., illus., some col.

Manguin is mentioned in vol. 1.

3015. JEAN-PETIT-MATILE, MAURICE. *Le Léman vu par les peintres* [The Lake of Geneva as Seen by Painters]. Lausanne: Edita, 1983. 127 p., 58 illus., some col.

Paintings and watercolors of the Lake of Geneva, late 18th century to the present, by thirty-nine artists, including Swiss artists and others, including Manguin.

3016. KALITINA, NINA NIKOLAEVNA. *Peinture du paysage français.* Leningrad, 1972. 260 p., 166 illus., 62 col. In Russian.

3017. KUENY, GABRIELLE. *Le Musée de Grenoble, peintures.* Mulhouse: Braun & Cie., 1966.

3018. KUENY, GABRIELLE and GERMAIN VIATTE. *Grenoble, Musée de peinture et de sculpture: dessins modernes.* Paris: Editions des Musées Nationaux, 1963. illus. Volume in "Inventaire des collections publiques françaises" series.

3019. LEVINSON-LESSING, V. F. *Catalogue Ermitage.* Leningrad, 1958.

3020. MOUSSEIGNE, ALAIN. *Catalogue du Musée de l'Annonciade, Saint-Tropez.* Saint-Tropez: Imprimerie de Cogolin, 1977.

3021. NACENTA, RAYMOND. *L'Ecole de Paris; son histoire, son époque.* Neuchâtel: Ides et Calendes, 1960. 366 p., illus., some col.

3022. REAU, LOUIS. *Catalogue de l'art français dans les musées russes.* Paris: A. Colin, 1929. 154 p., pl. Volume in "Publication de la Société de l'histoire de l'art français" series.

3023. SERE, OCTAVE [pseud. for Jean Poueigh]. *Musiciens français d'aujourd'hui.* Notices biographiques, suivies d'un essai de bibliographie et accompangées d'un autographe musical. Paris: Mercure de France, 1911.

3024. TERRASSE, CHARLES. *La Peinture française au XXe siècle.* Paris: Hypérion, 1939. 136 p., illus., some col., 12 pl.

3025. TERRASSE, CHARLES. *Eloge de Henri Manguin.* Paris: Editions Manuel Brucker, 1954 36 p., illus.

3026. VINCENT, MADELEINE. *Catalogue du musée de Lyon—la peinture des XIX^e et XX^e siècles.* Lyon: Les Editions de Lyon, 1956. 417 p., 104 pl., some col.

III. Catalogue Raisonné

3027. MANGUIN, LUCILE, CLAUDE MANGUIN, et al. *Henri Manguin: catalogue raisonné de l'œuvre peint.* [Henri Manguin: Complete Catalogue of Paintings]. Sous la direction de Lucile et Claude Manguin...[et al.] Avant-propos par Jacques Lassaigne. Textes par Pierre Cabanne, Alain Mousseigne, Marie-Caroline Sainsaulieu, Jean-Pierre Manguin. Neuchâtel: Ides et Calendes, 1980. 432 p.; 1,318 illus., 16 col.

Contents: "L'Homme," par Pierre Cabanne; "L'Œuvre," par Alain Mousseigne; "Catalogue raisonné," par Marie-Caroline Sainsaulieu; "Notes biographiques," par Jean-Pierre Manguin.

IV. Articles

3028. AGORNIAK, MAREK. "*Le Chateau de Swierklaniec*, œuvre oubliée d'Hector Lefuel: à propos d'un dessin du Musée d'Orsay." *Revue du Louvre et des musées de France* 29:1(1989):46-52.

3029. "*Autoportrait.*" *Apollo* 131(Feb. 1990):2.

3030. BENJAMIN, ROGER. "Une copie par Matisse du Balthazar Castiglione de Raphaël." *Revue du Louvre et des musées de France* 35:4(1985):275-7.

3031. CARTIER, JEAN-ALBERT. "Gustave Moreau, professeur à l'Ecole des Beaux-arts." *Gazette des Beaux-arts* ser. 6, 61(May 1963):355.

3032. COGNIAT, RAYMOND. "Autour de Matisse et de Bonnard" in René Huyghe, *Histoire de l'art contemporain: la peinture* (Paris: Alcan, 1935), pp. 117-21.

3033. COGNIAT, RAYMOND. "Henri Manguin: la peinture à l'état pur." *Galerie des arts* (1April 1969).

3034. DAULTE, FRANÇOIS. "Manguin parmi les fauves." *L'Œil* 335-6 (June-July 1983):68-9.

3035. DIEHL, GASTON. "Manguin: le fauve du bonheur" [Manguin: The Fauve of Happiness]. *L'Œil* 399 (Oct. 1988):32-9. 9 illus., 6 col.

Brief survey of the life and work of Henri Manguin. Discusses the influences of Gustave Moreau and Cézanne on Manguin's paintings and his use of color, arguing that he should be categorized among the Fauves owing to a number of shared points of view between him and this movement, such as the need to return to an intensity of color in order to recover and express an enthusiasm for life.

3036. DORIVAL, BERNARD. "Nouvelles œuvres de Matisse et Marquet au Musée national d'art moderne." *Revue des arts, musées de France* 3(1957).

3037. EPSTEIN, M. "Henri-Charles Manguin." *Genève magazine et revue de l'aéroport* 3 (Aug. 1972).

3038. GEORGE, WALDEMAR. "Henri Manguin." *L'Amour de l'art* 6:1 (May 1920):31.

3039. GEORGE, WALDEMAR. "Un maître de la couleur: Henri Manguin." *L'Amour de l'art* 4:4(April 1923):529-32.

3040. GIELLY, L. "La Ville des mécènes: Winterthur." *L'Art et les artistes* (Jan. 1924).

3041. GLEINY, C. "Manguin, triomphe de la couleur" [Manguin, Triumph of Color]. *Galerie-Jardin des arts* 156(March 1976):39-41. 3 illus.

Contends that Manguin tried to draw painting away from Impressionism and towards a completely new future. Manguin's attempt depended on a vivid use of color, outrageous at the time, and in this respect he may be called a Fauve. Yet he was an individual within that group, expressing tenderness and wonder throughout his painting; his nudes, for example, are sensual without being erotic. Manguin used light for the vehement exaltation of colors, in contrast to its use by the Impressionists for the breaking up of forms. Although many Fauves abandoned the movement and began to look elsewhere after 1908, Manguin continued along the same path for several years.

3042. GOLDMAN, JEAN. "Ein Leben in Glück und Sonne: Henri Manguin." *Die Kunst und das schöne Heim* 82:9(Sept. 1970):544-7. 4 illus.

3043. *"Les Gravures."* *Apollo* 131(March 1990):2.

3044. "Henri Manguin." *L'Arte Moderna* 3:26(1967).

3045. HILD, ERIC and ELISABETH HARDOUIN-FUGIER. "Bouquets de fleurs de Fantin-Latour à Marquet" [Bouquets of Flowers from Fantin-Latour to Marquet]. *L'Œil* (July-Aug. 1982):67-70. 11 illus., 6 col.

The exhibition, *Fleurs—de Fantin-Latour à Marquet,* held at the Musée de l'Annonciade, Saint-Tropez, Summer 1982, revealed the restricted place of flower painting in avant-garde pictorial art. Among the Impressionists, Manet and Monet often painted bouquets, as did some pointillists such as Signac. The Fauves, except for Manguin (1908), were not much tempted by the subject. Symbolists such as Gaustave Moreau associated flowers with women, and Odilon Redon transformed bouquets into a hymn to life. Well known as these works are, they are far less numerous than the forgotten paintings so often shown in the salons of the mid-19th century in Paris and the provinces. This innumerable production, frequently marked by amateurism, nevertheless included some outstanding works, particularly by the School of Lyon exemplified by Chabal-Dussurgery.

3046. *"Jeanne au bord du bassin, villa Demière."* *Antigues* 138(Oct. 1990):610.

3047. *"Maison rouge."* *Connaissance des arts* 451(Sept. 1989):54.

3048. "Manguin, témoin du bonheur." *Galerie des arts* 68(1 April 1969).

3049. MANGUIN, JEANNE CARETTE. "Souvenirs de Madame Marquet." *Galerie des arts* (1 April 1969).

3050. *"Nature morte au tapis oriental."* *Art Antiques* (March 1988):16.

3051. "Nouvelles acquisitions des musées de Province." *Revue du Louvre et des musées de France* 5-6 (1976).

3052. *"Nu sur un canapé."* *Connoisseur* (June 1986):142.

3053. PASQUET, A.-L "Manguin, ou le bonheur d'être fauve." *Connaissance des arts* 231(May 1971):70-1. 3 col. illus.

3054. PEIGNOT, J.-P. "Les Premiers Picassos de Gertrude Stein." *Connaissance des arts* (Nov. 1969).

3055. "Place of Manguin." *Art News* 58(April 1959):55.

3056. "Portrait by H. Manguin." *Art Digest* 27(15 Oct. 1952):10; *Art News Annual* 22(1952):119.

3057. "Les Principales acquisitions des musées de Province." *Revue du Louvre et des musées de France* 2 (1979).

3058. "Redécouvrir Henri Manguin." *Connaissance des arts* 440(Oct. 1988):22.

3059. RODITI, EDOUARD. "Paris: A Market Report." *Arts Magazine* 36 (Sept. 1962):32.

3060. SCHNEIDER, PIERRE. "Four Fauves." *Art News* 61(Sept. 1962):49.

3061. STEINGRABER, ERICH. "Bayerische Staatsgemäldesammlungen, München; Neuerwerbungen." *Münchner Jahrbuch der Bildenden Kunst* ser. 3, 22(1971):270.

3062. STERLING, CHARLES and GERMAIN BAZIN. "Un maître de la couleur: Henri Manguin." *L'Amour de l'art* 14:3(May 1933):123.

Reprinted in René Huyghe, *Histoire de l'art contemporain: la peinture.* (Paris: Félix Alcan, 1935), p. 123.

3063. *"La Table."* *Art News* 84(Jan. 1985):6.

3064. TERNOVIETZ, V. "Le Musée d'Art moderne de Moscou (anciennes collections Stchoukine et Morosoff)." *L'Amour de l'art* 12(Dec. 1925).

3065. TERRASSE, CHARLES. "Henri Manguin." *L'Art d'aujourd'hui* 6:23 (Autumn 1929):21-5, 41-53. 13 pl.

3066. TERRASSE, CHARLES. "Manguin le Fauve." *Galerie des arts* (1 April 1969).

3067. TERRASSE, CHARLES, et al. "Manguin il Fauve." *Arti* (Milan) (May 1969).

3068. TOUGUENHOLD, J. "Collection de la peinture française de Chtchoukine." *Apollon* 1-2(Jan.-Feb. 1914). In Russian.

3069. *"Villefranche-sur-mer."* L'Œil 350(Sept. 1984):8.

V. Individual Exhibitions

1907, 4-16 November	Paris, Galerie Druet. *Henri Manguin.* Préface de Fernand Fleuret. 39 works, all painted in Normandy, Belgium, or near Marseille.
1910	Paris, Galerie E. Druet. *Manguin.*
1913	Paris, Galerie E. Druet. *Manguin.*
1921	Paris, Galerie E. Druet. *Exposition Henri Manguin.*
1923, 30 April-11 May	Paris, Galerie E. Druet. *Henri Manguin.*
1925	Brussels, Galerie Giroux. *Henri Manguin.*
1936	Saint-Quentin, Musée de Saint-Quentin. *Exposition Henri Manguin.*
1938	Paris, Galerie de l'Elysée. *Manguin.* Review: *Beaux-arts* (29 April 1938):5.
1943	Paris, Galerie Pétridés. *Exposition Manguin.*
1954	Paris, Galerie Hector Brame. *Manguin, peintre du Fauvisme.*
1957, 10 April-25 May	Albi, Musée Toulouse-Lautrec. *Exposition Henri Manguin (1874-1949): peintures, aquarelles, dessins.* Préface d'Edouard Julien. 118p., illus.
1958, 24 July-20 September	Geneva, Galerie Motte. *Quarante tableaux de Manguin.* Préface de Charles Terrasse.
1958	Paris, Galerie Montmorency. *Quarante tableaux de Manguin.*
1958	Paris, Salon de couture Manguin. *Henri Manguin, toiles Fauves 1903-1907.*
1959	Avignon, Musée Calvet. *Manguin.*
1960	Paris, Galerie de Paris. *Exposition Henri Manguin.*
1960	Paris, Galerie de Paris. *Manguin: peintures de Saint-Tropez.*
1961	Aix-en-Provence, Galerie Lucien Blanc, Cour Mirabeau. *Henri Manguin.*

1962, 3 May- 2 June	Paris, Galerie de Paris. *Manguin, tableaux Fauves*. Texte de Jean-Paul Crespelle. 24 p., illus.
1964	Paris, Galerie de Paris. *Œuvres de Manguin*.
1964, 4 June- 6 September	Neuchâtel, Musée des Beaux-arts. *Henri Manguin Exposition*. Préface de Daniel Vouga.
1964	Paris, Galerie de Paris. *Manguin dans les collections suisses*.
1965, 10 April- 30 June	Cagnes-sur-mer, Château-musée de Cagnes. *Henri Manguin*.
1965	Paris, Galerie de Paris. *Manguin, les plaisirs de la table*.
1966, 25 October- 13 November	London, Arthur Tooth & Sons Gallery. *Henri Manguin, 1874-1949*. Text by Edwin Mullins. 20 p., illus. Reviews: J. Russell, *Art News* 65(Dec. 1966):20; E. Lucie-Smith, *Studio* 172(Dec. 1966):318.
1967	Montrouge, Centre administratif. *Hommage à Henri Manguin*.
1968, 13 July- 31 August	Honfleur, Salles d'exposition du Grenier à sel. *Exposition Manguin, 1874-1949*. Texte de F. Ledoux. 16 p., illus.
1969, February- April	Nice, Palais de la Méditerranée. *Henri Manguin; plus de cent cinquante œuvres*. Texte de Pierre Cabanne. 48 p., illus.
1969	Geneva, Galerie du Théâtre. *Manguin*.
1969	La Rochelle, Musée des Beaux-arts. *Manguin*.
1969-70, 24 October- 7 December	Düsseldorf, Städtische Kunsthalle. *Henri Manguin: erste deutsche Retrospektive*. Texts by Karl Ruhrberg and Jean Goldman. 44 p., illus. Review: G. Pfeiffer, *Kunstwerk* 23(Feb. 1970):79-80.
1970, 3 April- 3 May	Berlin, Neuer Berliner Kunstverein. *Henri Manguin-erste deutsche Retrospektive*. Texts by Jörn Merkert and Jean Goldman.
1970	Tokyo, Galerie Yoshii. *Henri Manguin*.
1972	Cologne, Galerie Abels. *Henri Manguin*.
1974	Cavaillon, Chapelle du Grand Couvent. *Manguin*. Review: *Connaissance des arts* 270(Aug. 1971)):11.

1974-75, 21 December- 19 October	Tucson, University of Arizona, Museum of Art. *Manguin in America: Henri Manguin, 1874-1949.* Also shown New York Cultural Center; Los Angeles, University of California, Frederick S. Wight Art Gallery; Athens, University of Georgia, Museum of Art (22 Feb.-29 March 1975); San Antonio, Marion Koogler McNay Art Institute, San Antonio; Wichita, Wichita State University, Edwin A. Ulrich Musseum of Art; Bloomington, Indiana University, Art Museum (7 Sept.-19 Oct. 1975). Introduction by William E. Steadman. Text by Denys Sutton. 214 p. 82 illus., 28 col., 82 works shown. First retrospective exhibition in America of fifty paintings and thirty-two watercolors and drawing by Henri Manguin, who together with Matisse, Derain, Vlaminck, Rouault, Marquet, and Camoin participated in the color experimentations in Fauve painting around 1905. Review: *Apollo* 101(Feb. 1975):141.
1976, 20 June- 30 September	Saint-Tropez, Chapelle de la Miséricorde. *Henri Manguin, 1874-1949.* Texte de Jean-Pierre Manguin; catalogue d'Alain Mousseigne. 96 p., illus., some col.
1980	Lausanne, Galerie Paul Vallotton. *Hommage à Henri Manguin (1879-1943): exposition.* Review: *L'Œil* 300-1(July-Aug. 1980):71.
1980	Saint-Tropez, Musée de l'Annonciade. *Trois nus Fauves peints dans l'atelier de Manguin.* 3 paintings. Review: A. Mousseigne, *Revue du Louvre et des musées de France* 30:5(1980):367-70.
1980, 5 June- 31 August	Tokyo, Isetan Museum of Art. *Exposition Henri Manguin.* Also shown Yamaguchi and Fukushima. Organisée par Yomiuri Shimbun Sha. Edition, Art Yomiuri. Catalogue par François Daulte. 156 p., illus., some col. In Japanese and French.
1985	L'Isle-sur-Sorgue, Hôtel Donadai de Campredon. *Henri Manguin.* Review: *L'Œil* 362(Sept. 1985):73.
1988	Tokyo, Galerie Yoshii. *Exposition Henri Manguin.*
1988-89, 19 October- 8 January	Paris, Musée Marmottan. *Henri Manguin, 1874-1949.* 157 p., illus., some col. 100 works (84 paintings, 12 drawings, 4 prints). Review: *Connaissance des arts* 440(Oct. 1988):22.
1989, 17 March- 15 May	Fribourg, Musée d'Art et d'histoire. *Henri Manguin, 1874-1949.* Textes de Yvonne Lehnherr, Margrit Hahnloser-Ingold, Charles Terrasse, Gaston Diehl, Lucile Manguin.

Catalogue par Marianne Delafond. 171 p., 220 illus., 80
col. pl. Review: *L'Œil* 407(June 1989):84.

1990, 7 March-
12 April

London, J.P.L. Fine Arts. *Henri Manguin, 1874-1949:
Paintings, Pastels, Watercolours and Drawings*. 72 p.,
illus., some col.
Annotated catalogue contains no text.

VI. Group Exhibitions

1900

Paris, Berthe Weill Galerie.

1900

Paris, Société nationale.

1902

Paris, Grandes Serres de l'Exposition universelle. *Salon
des Artistes Indépendants*.

1903

Paris, Petit Palais. *Salon d'Automne*.

1904, 21 February-
24 March

Paris, Grand Palais. *Salon des Indépendants*. 6 paintings.

1904, 2-30 April

Paris, Galerie Berthe Weill. 8 paintings.

1905, 24 March-
30 April

Paris, Grandes Serres de la ville de Paris. *Salon des
Indépendants*. 8 paintings.

1905, 6-29 April

Paris, Galerie Berthe Weill. 7 paintings.

1905, 18 October-
25 November

Paris, Grand Palais. *Salon d'Automne*. 5 paintings.
Review: *L'Illustration* (4 Nov. 1905).

1905, 21 October-
20 November

Paris, Galerie Berthe Weill. 7 paintings.

1905

New York, Carnegie Institute.

1905

Paris. *Salon des Tuileries*.

1905

Venice. *Biennale*.

1906, 22 February-
25 March

Brussels. *La Libre esthétique*. Catalogue par Octave
Maus. 3 paintings.

1906, 20 March-
30 April

Paris, Grandes Serres de la ville de Paris. *Salon des
Indépendants*. 8 paintings.

1906, 26 May-
30 June

Le Havre, Hôtel de Ville. *Cercle de l'Art moderne*.

1906, 6 October- 15 November	Paris, Grand Palais. *Salon d'Automne*. 6 paintings.
1906-07	Munich, *Ausstellung französischer Künstler*. Also shown Frankfurt, Dresden, Karlsruhe, Stüttgart.
1907, 30 March	Paris, Galerie Berthe Weill.
1907	Paris, Grandes Serres de la Ville de Paris, Cour-la-Reine. *Salon des Indépendants*.
1907, June	Le Havre, Hôtel de Ville. *Cercle de l'Art moderne*. Catalogue texte par Ferdinand Fleuret. 2 paintings.
1907, 1-22 October	Paris, Grand Palais. *Salon d'Automne*. 4 paintings. Review: A. Perate, *Gazette des Beaux-arts* (Nov. 1907).
1907, 24 October- 10 November	Paris, Galerie Eugène Blot. Catalogue texte par Louis Vauxcelles. 8 paintings.
1908, 20 March- 2 May	Paris, Grand Palais. *Salon des Indépendants*. 6 paintings.
1908, 18 April- 24 May	Moscow, Salon de la Toison d'Or. 2 paintings.
1908, 3-20 July	Paris, Galerie Druet. 3 paintings.
1908, 1 October- 8 November	Paris, Grand Palais. *Salon d'Automne*. 1 painting.
1908, 11-31 December	Paris, Galerie Berthe Weill.
1908-09, 21 December- 16 January	Paris, Galerie Druet.
1909	Paris, Grand Palais. *Salon d'Automne*. Review: P. Goujon, *Gazette des Beaux-arts* (Nov. 1909).
1909	Russia, *Salon de l'exposition internationale*. Shown in Odessa, Kiev, Riga, and St. Petersburg.
1910	Paris, Grand Palais. *Société des Indépendants*. Review: H. Bidou, *Gazette des Beaux-arts* (May 1910).
1910	Paris, Grand Palais. *Salon d'Automne*.
1910	Bordeaux.

1911	Paris, Quai d'Orsay. *Société des Indépendants*.
1911, May	Berlin.
1911	Paris, Grand Palais. *Salon d'Automne*.
1912	Paris, Quai d'Orsay. *Société des Indépendants*.
1912	Moscow, St. Petersburg.
1913	São Paulo. *Exposition d'art français*.
1913-14	Paris, Grand Palais. *Salon d'Automne*.
1914	Lausanne.
1914	Copenhagen.
1918	Geneva, Galerie Moos. *Exposition d'art français*.
1919	Paris, Grand Palais. *Salon d'Automne*.
1922	Paris, Grand Palais. *Salon d'Automne*. Review: *Le Semaine de Genève* (Jan. 1923).
1923	Paris, Grand Palais. *Salon des Indépendants*.
1925	Saint-Etienne, Place Carnot. *Exposition de peinture moderne*.
1925	Brussels, Galerie Giroux.
1926	Paris, Grand Palais. *Société des Indépendants. Trente ans d'art indépendant, rétrospective de 1884 à 1914*.
1926	Paris, Grand Palais. *Salon d'Automne*.
1926	Brussels, Galerie Giroux. *Peintres français*.
1927	Paris, Galerie Bing. *Les Fauves*.
1928	Paris, Grand Palais. *Salon d'Automne*.
1928	Brussels, Galerie Giroux.
1929	Paris, Grand Palais. *Salon d'Automne*.
1930	Paris, Grand Palais. *Salon d'Automne*.
1931	Paris, Galerie Druet.

1932	Paris, Grand Palais. *Salon d'Automne.*
1933	Paris, Grand Palais. *Salon d'Automne.*
1934	Paris, Grand Palais. *Société des Indépendants. 1884-1934, exposition du cinquantenaire.*
1934	Paris, Grand Palais. *Salon d'Automne.*
1935	Paris. Petit Palais. *Société des Indépendants.*
1935	Paris, Grand Palais. *Salon d'Automne.*
1936	Paris, Grand Palais. *Société des Indépendants.*
1936	Paris, Esplanade des Invalides, Pavillon des salons. *Salon d'Automne.*
1937	Paris, Pavillon des salons. *Société des Indépendants.*
1937	Paris, Pavillon des salons. *Salon d'Automne.*
1937	Tunis.
1937	Cairo.
1937	Berlin.
1938	Paris, Palais de Chaillot. *Salon d'Automne.*
1938	London.
1938	Pittsburgh.
1939	Liège. *Exposition de l'eau.*
1939	Adelaide.
1939	Geneva, Galerie Moos.
1939	London.
1939	Stockholm.
1939	New York.
1940	Venice, *XXIIᵉ Biennale internationale des Beaux-arts.*
1940	Paris, Palais de Chaillot. Groupement du Salon d'automne, de la Société des artistes indépendants et du Salon des Tuileries, Salon de 1940.

1941	Tunis, Galerie Brami.
1942	Paris, Musée d'Art moderne de la Ville de Paris. *Société des Indépendants.*
1942	Paris, Galerie de France. *Les Fauves, 1903-1908.*
1942	Paris, Palais des Beaux-arts de la Ville de Paris. *Salon d'Automne.*
1942	Tunis.
1943	Paris, Musée d'Art moderne. *Société des Indépendants.*
1943	Paris, Galerie Charpentier. *Jardins de France.*
1943	Paris, Palais des Beaux-arts de la Ville de Paris. *Salon d'Automne.*
1943	Cannes.
1944	Paris, Galerie Charpentier. *La Vie familiale, scènes et portraits.*
1944	Paris, Musée d'Art moderne de la Ville de Paris. *Société des Indépendants.*
1944	Paris, Palais des Beaux-arts de la Ville de Paris. *Salon d'Automne.*
1944	Paris, Galerie Charpentier. *Marines.*
1945	Paris, Musée d'Art moderne. *Société des Indépendants.*
1945	Paris, Galerie Charpentier. *Paysages d'eau douce.*
1945	Paris, Galerie Charpentier. *Paysages de France.*
1945-46	Limoges, *Peintures du Musée National d'Art moderne.* Also shown Saint-Etienne, Perpignan, Toulouse, Bordeaux, Amiens, and Lille.
1946	Paris, Musée d'Art moderne. *Société des Indépendants.*
1946	Paris, Galerie "Couleur du Temps." *Céria, Marquet, Manguin, H. de Waroquier, Wlerick.*
1946	Paris, Galerie Charpentier. *Cent chefs-d'œuvre des peintres de l'Ecole de Paris.*
1946	Paris, Galerie Charpentier. *La Vie silencieuse.*

1946	Vienna, Staatliches Kunstgewerbe-Museum. *Paris à Vienne, 250 artistes exposent.*
1946	Brussels, Galerie Giroux. *35ᵉ anniversaire de la Galerie Giroux.*
1946	Paris, Musée des Beaux-arts de la Ville de Paris. *Salon d'Automne.*
1947	Paris, Galerie La Licorne. *Gustave Moreau et quelques-uns de ses élèves.*
1947	Paris, Galerie Charpentier. *Beautés de la Provence.*
1947	Paris. *Quelques œuvres des collections de la Ville de Paris.* Also shown Zurich.
1947	Paris, Musée des Beaux-arts de la Ville de Paris. *Salon d'Automne.*
1947	Tunis.
1950	Paris, Grand Palais. *Société des Indépendants.*
1950, 29 April-29 May	Bern, Kunsthalle. *Les Fauves.* Introduction d'Arnold Rüdlinger.
1950	Paris, Galerie Charpentier. *Autour de 1900.*
1950	Paris, Grand Palais. *Salon d'Automne.*
1950	New York, Sidney Janis Gallery. *Les Fauves.*
1951, June-September	Paris, Musée d'Art moderne. *Le Fauvisme.* Préface de Jean Cassou.
1952	Rennes, Musée des Beaux-arts. *Le Fauvisme.*
1952	Saint-Brieuc. *La Mer vue par les peintres depuis Jongkind à nos jours.* Also shown at Rennes.
1952	Paris, Ecole Polytechnique. *Fêtes du Point Gamma.*
1952-53, 8 October-1 January	New York, Museum of Modern Art. *Les Fauves.*
1954	Paris, Petit Palais. *Collection Girardin.*
1957	Paris, Musée National d'Art moderne. *Depuis Bonnard.*
1958	Paris, Grand Palais. *Salon d'Automne.*

1959, 5 July- 15 November	Berlin, Nationalgalerie der ehemals Stäatlichen Museen, Orangerie des Schlosses Charlottenburg. *Triumph der Farbe:die Europäischen Fauves*. Also shown Schaffhouse, Museum zu Allerheiligen. Introduction by Leopold Reidemeister. Reviews: *Werk* 46(Sept. 1959):supp. 192-3; *Kunstwerk* 13(Oct. 1959):38,41.
1960	Paris, Musée Galliéra. *Femmes d'hier et d'aujourd'hui*.
1960	Nice, Palais de la Méditerranée. *Peintres à Nice et sur la Côte d'Azur*.
1960	Geneva, Musée de l'Athénée. *De l'Impressionnisme à l'Ecole de Paris*.
1961	Paris, Galerie de Paris. *Les Amis de Saint-Tropez*.
1961	Dieppe, Musée de Dieppe. *Les Bains de mer*.
1961	Nancy, Musée des Beaux-arts. *Collection Henri Galilée*.
1961	Chartres, Chambre de commerce. *Marquet et ses amis*.
1961-62	Paris, Galerie de Paris. *Importants tableaux moderne*.
1962	Paris, Bibliothèque nationale. *Centenaire Claude Debussy*.
1962	London, Crane Kalman Gallery. *La Mer*.
1962	Paris, Galerie Charpentier. *Les Fauves*.
1962, 26 June- 1 September	Marseille, Musée Cantini. *Gustave Moreau et ses élèves*. Préface de Jean Cassou.
1962, 7 July- 23 September	Vévey, Musée Jenisch. *De Cézanne à Picasso maîtres de l'aquarelle au XXe siècle*. Introduction par François Daulte.
1962	Geneva, Musée de l'Athénée. *60 ans de peinture française*.
1963	Brussels, Musée d'Art moderne. *Art français de David à Matisse*.
1963	Rotterdam, Museum Boymans van Beuningen. *Le Paysage français de Cézanne à nos jours*.
1964	Nice, Palais de la Méditerranée. *Le Midi des peintres*.
1964	Turin, Galleria Civica d'Arte moderna. *80 pittori da Renoir a Kisling*.

1964	Annecy, Musée-château d'Annecy. *Maîtres connus et méconnus de Montmartre à Montparnasse.*
1964, Summer	Lausanne, Palais de Beaulieu. *Chefs-d'œuvre des collections suisses, de Manet à Picasso.* Catalogue par François Daulte.
1964, August-September	Besançon, Musée des Beaux-arts. *Valtat et ses amis: Albert André, Charles Camoin, Henri Manguin, Jean Puy.* Préface de George Besson.
1965	Geneva, Musée Rath. *Peintres de Montmartre à Montparnasse.*
1965	Vévey, Musée Jenisch. *De Vallottan à Desnos.*
1965	Recklinghausen, Städtische Kunsthalle. *Signale. Manifeste. Proteste.*
1965	Saint-Denis, Musée d'Art et d'histoire. *Les Peintres et la nature en France depuis l'Impressionnisme.*
1965	Paris, Galerie Charpentier. *Les Jardins et les fleurs de Breughel à Bonnard.*
1965	Tokyo, *Les Fauves.*
1965	Lisbon, Foundation Gulbenkian. *Um Seculo de pintura francesca 1850-1950.*
1965, 12 October-12 November	Paris, Galerie de Paris. *La Cage aux Fauves: Salon d'Automne, 1905.* Préface de Jean Cassou, texte de Pierre Cabanne. 16 p., illus.
1965-66	Bordeaux, Musée des Beaux-arts. *Chefs d'œuvre de la peinture française dans les musées de Léningrad et de Moscou.* Also shown at Paris.
1966, 15 January-10 July	Paris, Musée National d'Art moderne. *Le Fauvisme français et les débuts de l'Expressionnisme allemand.* Also shown at Munich.
1966, 25 May-10 July	Hamburg, Kunstverein. *Matisse und seine Freunde—les Fauves.* Catalogue with introduction by Hans Platte. 105 p., 82 illus., 24 pl. Review: S. Whitfield, *Burlington Magazine* 108 (Aug. 1966):439.
1966	Recklinghausen, Städtische Kuntshalle. *Variationen.*
1966	Paris, Musée Galliéra. *60 maîtres de Renoir à Chagall.*

1966	Brussels, Musée d'Art moderne. *Art français de David à Matisse dans les collections des musées royaux.*
1967	Oklahoma City, Oklahoma Art Center. *Les Fauves.*
1967	Paris, Galerie de Paris. *Les Lumières de l'été.*
1967	Recklinghausen, Städtische Kunsthalle. *Zauber des Lichtes.*
1967	Paris, Orangerie des Tuileries. *Chefs-d'œuvre des collections suisses de Manet à Picasso.*
1967-68, November-January	Charleroi, Palais des Beaux-arts. *Autour du Fauvisme; Valtat et ses amis.* Textes de R. Rousseau et G. Peillex.
1968	New York, Leonard Hutton Galleries. *Fauves and Expressionists.*
1969	Baden-Baden, Stäatliche Kunsthalle. *Maler und Modell.*
1969, 8 August-19 October	Munich, Stäatliche Graphische Sammlung. *Europäische Meisterwerke aus Schweizer Sammlungen.* Introduction by Hans R. Hahnloser.
1969	Bourges, Maison de la culture. *Joies et bonheur du peintre.*
1969	Aix-en-Provence, Pavillon Vendôme. *Paysage du Midi de Cézanne à Derain.*
1971	Paris, Fondation Mercédès-Benz. *Le Mouvement et la vie.*
1971	Brussels, Musée d'Art moderne. *La Vie des choses: natures mortes et fleurs du XIX^e et XX^e siècles.*
1972	Tokyo, Galerie Nichido.
1972	Otterlo, State Museum Kröller Muller. *De van Gogh à Picasso.*
1972-73, 23 December-25 February	Nice, Galerie des Ponchettes. *Les Peintres loserde Saint-Tropez.*
1973	Turin, Galleria d'Arte Pirra. *Il Movimiento Fauve.*
1973	Bevaix-Neuchâtel. Galerie Pro-Arte. *Maîtres de la réalité poétique et de la tradition française.*

1973, 23 September- 11 November	Winterthur, Kunstmuseum. *Künstlerfreunde um Arthur und Hedy Hahnloser-Bühler—Französische und Schweizer Kunst.* Texts by Rudolf Koella and Hans R. Hahnloser.
1973, April- May	Pau, Musée des Beaux-arts. *L'Autoportrait du XVII^e siècle à nos jours.*
1973-74	Marseille. *Le Peintre et sa palette.* Also shown at Bordeaux, Toulouse, and Lyon.
1974, 15 August- 8 December	Tokyo, Ishikawa Museum, Kanazawa. *Les Fauves.* Also shown Osaka, Seibu Takatsuki Galleries (15 Nov.-8 Dec.). Organisée par le Yomiuri Simbun Osaka Honsha. Catalogue par François Daulte. 150 p. In Japanese and French. Review: *L'Œil* 230 (Sept. 1974): 67.
1974	Paris, Caisse Nationale des monuments et des sites. *La Collection Germaine Henry et Robert Thomas.*
1974	Okayama. *Gustave Moreau et ses élèves.* Also shown at Hiroshima and Tokyo.
1976	Paris, Galerie de Paris. *Centenaire Henri Matisse.* Reviews: *L'Œil* 248(March 1976):44; *Apollo* 103(May 1976):445.
1976, 26 March- 31 October	New York, Museum of Modern Art. *The 'Wild Beasts,' Fauvism and its Affinities.* Also shown San Francisco and Fort Worth.
1977	Lausanne, Galerie Paul Vallotton. *Maîtres de la peinture.*
1978	Luberon, Galerie Cance-Manguin. Review: *L'Œil* 270-1(Jan.-Feb. 1978): 89.
1978	Paris, Grand Palais. *Artistes Indépendants.*
1978	Paris, Galerie de Paris. *Grands maîtres des XIX^e et XX^e siècles.*
1978	Paris, Forum des Halles. *Paris, patrie des peintres.*
1978, Summer	Saint-Tropez, Musée de l'Annonciade. *D'un espace à l'autre, la fenêtre.* Préface d'Alain Mousseigne.
1979	Paris, Galerie Schmit. *Maîtres français XIX^e et XX^e siècles.*
1979, November	Paris, Grand Palais. *Salon d'Automne. La Grande aventure du Salon d'Automne; 75 ans d'ardeur: Les Fauves.* Texte de Gaston Diehl.

1983, 4 June-
2 October

Martigny, Switzerland, Fondation Pierre Gianadda. *Manguin parmi les Fauves.* Introduction et catalogue par Pierre Gassier. Textes de Maria Hahnloser et Lucile Manguin. 175 p., col., illus., 105 works shown.

Features twenty-four Fauvist canvases (1903-1908) by Manguin shown with paintings of the same period by eleven other artists associated with Fauvism: Braque Camoin (3), Derain (4), Dufy (5), Friesz (5), Marquet (4), Matisse (5), Puy (3), Valtat (2), van Dongen (4), and Vlaminck (4). Also presents twenty-five Manguin paintings, six watercolors and seven drawings executed after his Fauvist period (1908-1949). A group of thirteen French posters of the period were also shown. In his essay, Gassier gives an account of Fauvism from its origins in a meeting of Manguin, Matisse, and Marquet in the studio of Gustave Moreau, to its "official" birth at the Salon d'Automne in 1905; tracing the interest of its members in Cézanne and the decline of the movement as Cézanne's work became more widely known. Hahnloser describes the importance for Manguin of his visits to Switzerland, especially Lausanne. Manguin's daughter Lucile gives her recollections of his personality. The exhibits were divided into Fauvists works and works by Manguin from the post-Fauvist period (1908-49).

Review: F. Daulte, *L'Œil* 335-6 (June-July 1983): 68-9.

1988-89
19 October-
8 January

Paris, Musée Marmottan. *Henri Manguin: 1874-1949.* 157 p., illus.

Jean Puy

Biographical Sketch

Puy, born in 1876 at Roanne on the Loire in central France, studied architecture in Lyon and painting with Jean-Paul Laurens at l'Académie Julian (1897-98). He then transferred to l'Académie Carrière (1899-1900) with Eugène Carrière, where Henri Matisse and other artists in Matisse's circle were his friends and fellow students. Puy began to exhibit impressionist works at the Salon des Indépendants in 1901. He was attracted to the pure color simplifications of Matisse and exhibited with the Fauves at the controversial 1905 Salon d'Automne.

Puy was a more moderate Fauve with a highly individualized concept of painting. Although he left a body of work of great vitality—landscapes, nudes, interiors, flowers and so on in a natural and spontaneous style—Puy was in no sense an innovator. His withdrawn and meditative temperament made him prefer the isolation of his native region or the Breton coast to the excitement of Parisian art circles. He retained a Fauve style for the landscapes, still lifes, portraits, ample nudes, and Breton seascapes of his later career, stressing a more formal composition and a preoccupation with design and volume in some works and surface pattern and decorative design in others. In 1923 he illustrated Ambroise Vollard's *Le Père Ubu à la guerre*. He also executed several mural decorations and ceramic designs.

Jean Puy

Chronology, 1876-1960

1876	Born November 8 in Roanne to a prosperous family of property managers, tile manufacturers, and civil servants with origins in Lyon. His parents had moved to Saint-Alban-les-Eaux, twelve kilometers from Roanne, two years earlier, where they manage a large health, industrial, and agricultural enterprise until 1889.
1895-97	Receives his diploma in Literature and Philosophy from the lycée in Roanne. Following his father's advice, in October he enrolls in architectural drawing courses at l'Ecole des Beaux-arts in Lyon. Makes rapid progress in painting under direction of the painter Tony Tollet.
1898	Arrives in Paris to study at l'Académie Julian. Attends classes by Benjamin Constant and Jean-Paul Laurens. Visits the Louvre and is especially impressed by the Impressionist paintings from the Caillebotte Bequest at the Musée du Luxembourg.
1899	Enrolls in Eugène Carrière's new Académie Camillo in the rue de Rennes. Fellow students include former pupils of Gustave Moreau—Rouault, Marquet, Manguin, Lehmann, Evenepoel, Derain, and Matisse. Lives at 69, rue de Lepic, Montmartre, and works in a studio on l'Ile Saint-Louis. Influenced by Cézanne.
1900	Close ties with Matisse and Derain at Carrière's academy. Studies Cézanne's works at Vollard's gallery.
1901	Exhibits at the Salon des Indépendants, where he will show regularly until 1910. Summer in Belle-Ile, Brittany. Shows for the first time at Berthe Weill's gallery.
1903	Exhibits at the second Salon d'Automne, where he will show regularly until 1938.
1904	Participates in the Salon d'Automne with other Fauve painters. Paints often with Matisse, Marquet, and Camoin in Manguin's studio, rue Boursault. Shows at Berthe Weill's gallery.
1905	Exhibits in the historic "*cage aux fauves*" at the Salon d'Automne. Critics describe him as one of the more moderate Fauve painters.

Decorates ceramics for Vollard, who, on Matisse's advice, becomes his dealer until 1926 and purchases his last five years of production.

1907 Summer in Talloires (Alps).

1915 Despite a frail constitution and nearsightedness, he enlists at age 38 in the 300th Territorial Reserve. Corresponds regularly about art with his younger brother Michel, an art critic and civil servant in the ministry of agriculture.

1916-18 Transfers in August to a camoflage section, where Camoin, Villon, and Dunoyer de Segonzac already work. Spends the next two years in Bar-le-Duc, Compiègne, Le Mans, and Rennes.

1919 Demobilized in January, he returns to painting. For the next twenty years he works in Paris in the winter, in Brittany and the Riviera in the spring, and in Roanne and la Savoie during summers.

1920-30 Group exhibitions at the Petit Palais with Marquet, Manguin, Camoin, Asselin, and other artists. Visits Toulon, Cavalière, Saint-Tropez, Grenoble, Sappey, and the Hautes-Alpes.

1920 Illustrates Vollard's *Le Père Ubu à la guerre*, a tragi-comedy burlesque of Vollard's memories of the war. He later illustrates Vollard's *Le Pot de fleurs de la mère Ubu* (1924) and *Le Déjeuner de l'Evêque* (1924).

1928 Contracts with Galerie Bernheim-Jeune, Paris until 1932. Establishes his studio in rue Daguerre, Paris.

1930 Shows forty-three works at Bernheim-Jeune in July.

1937 Participates with Camoin, Marquet, and Friesz in *Les Maîtres de l'art indépendant (1895-1937)* exhibition at the Petit Palais, Paris.

1939 Seeks refuge from the impending war with his sister and brother-in-law, Philippe Vindrier, in Roanne where he lives for the remainder of his life.

1940-45 Visits Doctor Gay at Saint-Jeoire and Sallanches, near Mont-Blanc.

1942 Joint exhibition with Camoin at Galerie des Jacobins, Lyon.

1949 Exhibition at Galerie Lorenceau, Paris. Another exhibition follows in 1954.

1953 Writes from Roanne to George Besson that illness prevents him from completing more than four or five paintings each year.

1957 Leaves Roanne to attend the opening of an exhibition at the Galerie Vendôme in Paris.

1960 Dies March 6 in his sister's home in Roanne.

Jean Puy

Bibliography

I. Books

3070. BETTEX-CAILLER, NANE. *Jean Puy.* Geneva: Documents-Cailler, 1959.

3071. GAY, PAUL. *Jean Puy.* Paris, Mulhouse: Braun, 1945. 24 p., illus. Volume in "Collection 'Initier'" series.

3072. *Paris 1937.* Paris: J.-G. Daragnès, 1937. 384 p., illus.

Mentions Jean Puy.

3073. PUY, MICHEL. *Jean Puy: vingt-six reproductions de peintures et dessins; précédées d'une étude critique par Michel Puy; de notices biographiques et documentaires; et d'un portrait inédit de l'artist dessiné par lui-même et gravé sur bois par Jules Germain.* Paris: Nouvelle Revue Française, 1920. 63 p., illus., pl. Volume in "Les Peintres français nouveaux" series. Text by Michel Puy, pp. 3-12; plates, pp. 15-63.

3074. PUY, MICHEL. *Jean Puy par son frère Michel Puy.* Paris: Nouvelle Revue Française, 1925.

3075. STAUB, F. X. *Jean Puy peintre 1876-1960.* Ph.D. thesis, Université de Paris, June 1967.

3076. VOLLARD, AMBROISE. *Le Père Ubu à la guerre.* Dessins de Jean Puy. Paris: Editions G. Crès, 1920. 110 p., illus.

Other eds.: Paris: Ambroise Vollard, 1923. 134 p., 109 prints (including four aquatints and one original lithograph). 60 copies; Paris: G. Crès, 1923. 116 p., illus. 500 copies.

3077. VOLLARD, AMBROISE. *Le Pot de fleurs de la mère Ubu.* Paris, 1924.

3078. VOLLARD, AMBROISE. *Le Déjeuner de l'Evêque.* Paris, 1924.

II. Articles

3079. ALEXANDRE, ARSENE. "Jean Puy." 1930.

3080. BESSON, GEORGE. "Jean Puy." *Les Lettres françaises* (10 Oct. 1958).

3081. BETTEX-CAILLER, NANE. "Jean Puy." *Cahiers d'art-documents* (Geneva) 104(1959).

3082. BOURET, JEAN. "Jean Puy." 1944.

3083. CAZENAVE, RAYMONDE W. DE. "Jean Puy." *L'Information artistique* (Oct. 1957):48-51.

3084. DORIVAL, BERNARD. "Jean Puy." *Art de France* 1(1961):385.

3085. GAY, PAUL and FRANCIS JOURDAIN. "Jean Puy." *Connaître* (1955).

3086. GAY, PAUL. "Portrait d'artiste." *Arts Magazine* (14 Feb. 1947):4.

3087. HOWE, RUSSELL WARREN. "Chalk and Cheese: Puy and Léger." *Apollo* 50(Aug. 1949):31-3.

3088. KLINGSOR, TRISTAN. "Jean Puy." *Arts et décoration* (1926).

3089. LAUGHTON, BRUCE. "J.-F. Millet in the Allier and the Auvergne." *Burlington Magazine* 130(May 1988):345-51.

3090. MANHEIM, RON. "Expressionismus—zur Entstehung eines kunsthistorischen Stil-und Periodenbegriffes." *Zeitschrift für Kunstgeschichte* 49:1(1988):73-91.

Puy's *Venus* is discussed on p. 83.

3091. "Matisse." *Le Point* (Colmar). 48 p., illus., pl.

Mentions Jean Puy.

3092. "La Plaine du Roànne." *Revue du Louvre et des musées de France* 41(Oct. 1991):95-6.

3093. "*Portrait* by H. Manguin." *Art Digest* 27(15 Oct. 1952): 10; *Art News Annual* 22(1952):119.

Concerns a portrait of Jean Puy by Manguin.

3094. PUY, JEAN. "Souvenirs." *Le Point* (Colmar) 4:21(July 1939):112-33.

3095. "Société des amis du peintre Jean Puy." *Connaissance des arts* 294 (Aug. 1976):11.

3096. STAUB, F. X. "Jean Puy peintre 1876-1960." *L'Information d'histoire de l'art* 1(1968):31-6.

3097. STERLING, CHARLES and GERMAIN BAZIN. "Jean Puy." *L'Amour de l'art* 14:5(May 1933) pp. 123-4. Also published in René Huyghe, *Histoire de l'art contemporain: la peinture* (Paris: Félix Alcan, 1935), pp. 123-4.

3098. WAGNER, ALFRED. "Jean Puy, 1876-1960, zum hundertsen Geburtstag" [Jean Puy, 1876-1960, Centenary]. *Kunst und das schöne Heim* 88:11(Nov. 1976):663-6. 5 illus. Summary in English.

Discusses Puy's work on the occasion of the centenary exhibition in his honor at the Joseph Déchelette Museum, Roanne, the artist's birthplace. His early paintings display a style which is close to Impressionism, but by the turn of the century his technique changed. Color became increasingly luminous and used in a Fauvist manner.

III. Individual Exhibitions

1907, 24 October- 10 November	Paris, Galerie Eugène Blot. Catalogue texte par Louis Vauxcelles. 14 paintings.
1911, 9-28 January	Paris, Galerie Blot. *Exposition de peinture de Jean Puy.* Préface de Théodore Duret. 32 works.
1923, February	Paris, Galerie Druet. *Peintures et dessins de Jean Puy.*
1926, December	Paris, Galerie Druet. *Peintures et dessins de Jean Puy.*
1930, July	Paris, Galerie Bernheim-Jeune. *Exposition Jean Puy.* Préface d'Arsène Alexandre. 43 works. Reviews: A. Alexandre, *Renaissance* 13(June 1930):155-60; P. Berthelot, *Beaux-arts magazine* 8(July 1930):21.
1934	Paris, *Jean Puy.* Review: R. Cogniat, *Beaux-arts* (23 Feb. 1934):3.
1938, November	Paris, Galerie Bernheim-Jeune. *Jean Puy.*
1944	Paris, Galerie Allard. *Jean Puy.*
1945	Paris, Galerie La Boétie. *Jean Puy.*
1946	Paris, Galerie Champion-Cordier. *Exposition Jean Puy: 40 peintures de 1900 à 1845.* Review: *Arts Magazine* (6Dec. 1946):4.
1947	St.-Jean-en-Foucigny, l'Art au village. *Jean Puy.*
1949	Mulhouse, Musée de Mulhouse. *Jean Puy.*
1949	Paris, Galerie Allard. *Exposition Jean Puy.* 66 works.
1949	Paris, Galerie Lorenceau. *Jean Puy.*
1950	Roanne, Hôtel de Ville. *Exposition Jean Puy.* Organized by Monsieur Priollet. 62 works.
1954	Paris, Galerie Lorenceau. *Jean Puy.*
1955	Lausanne, Caveau des Quatre Arts. *Exposition Jean Puy.*
1956	Annécy, Palais de l'Isle. *Exposition Jean Puy.*
1957	Paris, Galerie Vendôme. *Jean Puy.*
1959	Paris, Grand Palais. *Salon d'Automne. Rétrospective Jean Puy.* Introduction de George Besson.

1961	Paris, Galerie Mady Bonnard. *Exposition Jean Puy.* Préface de George Besson. 41 works.
1962	Lyon, Salon du Sud-Est. *Rétrospective Jean Puy.*
1963	Lyon, Musée des Beaux-arts. *Rétrospective Jean Puy.* Préface de George Besson. 136 works.
1965	Paris, Galerie Durand-Ruel. *Jean Puy.*
1970	Paris, Galerie La Cave. *Jean Puy, exposition.*
1976	Roanne, Musée Joseph Déchelette. *Rétrospective pour le centenaire de la naissance de J. Puy.* Préface de Michel Degenne. 45 works. Exhibition on the occasion of the centenary of Puy's birth in his hometown. Reviews: *L'Œil* 25(May 1976):46; A. Wagner, *Kunst und das Schöne Heim* 88:11(Nov. 1976):663-6.
1977	Paris, Galerie La Cave. *Jean Puy, peintures et pastels.* Review: *L'Œil* 262(May 1977):53.
1977	Geneva, Musée du Petit Palais. *J. Puy.* Collection dirigée par Ezio Gribaudo. Préface de Georges Rochas. 98 p., col. illus., 74 col. pl. 74 works. Review: *L'Œil* 263(June 1977):48.
1988-89, 5 November- 31 January	Roanne, Musée Joseph Déchelette. *Rétrospective Jean Puy (Roanne 1876—Roanne 1960).* Commissaire de l'exposition, Eric Moinet avec la participation de Jacqueline Munck. 158 p., illus., some col. Review: *Connaissance des arts* 443(Jan. 1989):21.

IV. Group Exhibitions

1901	Paris, Grand Palais. *Salon des Indépendants.*
1902	Paris, Galerie Berthe Weill.
1902	Paris, Grand Palais. *Salon des Indépendants.*
1903	Paris, Grand Palais. *Salon des Indépendants.*
1903	Paris, Galerie Berthe Weill.
1904, 21 February- 24 March	Paris, Grand Palais. *Salon des Indépendants.* 6 paintings.
1904, 2-30 April	Paris, Galerie Berthe Weill. 8 paintings.

1904, 15 October- 15 November	Paris, Petit Palais. *Salon d'Automne*. 5 paintings.
1905, 24 March- 30 April	Paris, Grand Palais. *Salon des Indépendants*. 8 paintings.
1905, 18 October- 25 November	Paris, Grand Palais. *Salon d'Automne*. 4 paintings.
1906, 22 February- 25 March	Brussels. *La Libre Esthétique*. Catalogue par Octave Maus. 6 paintings.
1906, 26 May- 30 June	Le Havre, Hôtel de Ville. *Cercle de l'Art moderne*.
1906, 6 October- 15 November	Paris, Grand Palais. *Salon d'Automne* 10 paintings.
1907, 20 March- 30 April	Paris, Grand Palais. *Salon des Indépendants*. 6 paintings.
1907, 30 March	Paris, Galerie Berthe Weill.
1907, March-April	Vienna, Galerie Miethke. Catalogue by Rudolf A. Meyer. 7 paintings.
1907	Paris, Galerie Bernheim-Jeune.
1907	Paris, Galerie Druet.
1908, 18 April- 24 May	Moscow, Salon de la Toison d'Or. 3 paintings.
1908, 1 October- 8 November	Paris, Grand Palais. *Salon d'Automne*. 5 paintings.
1908, 11-31 December	Paris, Galerie Berthe Weill.
1908-09, 21 December- 16 January	Paris, Galerie Druet.
1937	Paris, Petit Palais. *Les Maîtres de l'art indépendants* (1895-1937). Included works by Camoin, Marquet, Friesz, Puy, and others.
1942	Lyon, Galerie des Jacobins. *Charles Camoin—Jean Puy*.
1950	Mulhouse. *Albert Marquet et Jean Puy*. Catalogue par Pierre Braun.

1959, 17 June- 10 August	London, Crane Kalman Gallery. *A Selection of Paintings by Albert Marquet (1875-1947) and Jean Puy (b. 1876).*
1964, August- September	Besançon, Musée des Beaux-arts. *Valtat et ses amis: Albert André, Charles Camoin, Henri Manguin, Jean Puy.* Préface de George Besson.
1989-90, November- January	Les Sables d'Olonne, Musée de l'Abbaye Sainte Croix. *Albert Marquet aux Sables d'Olonne, 1921-1933.* 32 p., illus. Includes information on Jean Puy.

Louis Valtat

Biographical Sketch

A prolific and technically gifted artist, Valtat was one of the first French painters to
construct canvases with pure color rather than line. Born in 1869 at Dieppe, a port city
in Normandy, Valtat went to Paris in 1888 to study at l'Académie Julian where he met
Pierre Bonnard, Edouard Vuillard, and Albert André. He made frequent trips to the south
of France and much of his work was influenced by that region. It was there that he met
Renoir, Signac, and Henri-Edmond Cross. After a pointillist period, Valtat in 1895 began
to turn toward paintings with broad strokes and violent colors that foreshadowed Fauvism.
At the famous Salon d'Automne of 1905 he came under the same critical disapproval as
Matisse and the other so-called Fauve painters. In 1913 Valtat left the Midi and settled
in Paris. Little concerned with worldly success, he continued to paint quietly until his
eyesight failed. He died in Paris in 1952.

Louis Valtat

Chronology, 1869-1952

1869 Born at Dieppe to a family of shipowners.

1880 Receives a classical education at Versailles' Lycée Hoche.

1888 Encouraged by his family, he studies at l'Académie Julian in Paris, under
the direction of Jules Dupré. There he becomes acquainted with the
Nabis group—Sérusier, Maurice Denis, Bonnard, Roussel, Vuillard,
Ibels, etc. Contrary to what is often said, he does not frequent the studio
of Gustave Morean.

1889 Shows for the first time at the Salon des Indépendants, where he
regularly participates until 1914.

1890 Rents his own studio in Paris. Already paints neoimpressionist canvases
in violent color contrasts.

1894 Travels to England.

1894-95 Spends time at Banyuls and Collioure in Provence. Meets the sculptor
Aristide Maillol. Travels to Catalonia with Daniel de Monfreid. Sees
Monfreid's Gauguin collection. Designs theatre decors with Albert
André and Lugné Poe, including *Chariot de terre cuite*.

1897 Spends time painting at Arcachon, on the coast south of Bordeaux. His
Les Porteuses d'eau à Arcachon prefigures the violent colors of the
Fauves. Drawings and woodcuts are published in the magazine
L'Omnibus de Corinthe.

1897-98 Visits Agay. Renews friendship with Maillol.

1899 Builds a house in Anthéor, in the L'Estérel region of the Riviera. Stays
there regularly for part of each year.

1900 Marries Suzanne Noël. Visits Renoir at Cagnes-sur-mer and works with
him at Magagnosc. Contracts with Ambroise Vollard, the Parisian

dealer. Shows in Brussels at La Libre Esthétique with Luce, Signac, and Roussel.

1902 Travels to Venice.

1903 Exhibits for the first time at the Salon d'Automne. Later described as a "natural Fauve," his pure-color paintings prefigure Fauvism and help lay its foundation. Visits Saint-Tropez and sees Paul Signac.

1904 Second visit to Saint-Tropez, where he is influenced by Signac. Participates in the Impressionist painters section of La Libre Esthétique in Brussels. Renews his contract with Vollard.

1905 Shows at the historic Salon d'Automne, but outside the Fauve room with Marinot, Kandinsky, and Jawlensky. His *Marine* is reproduced in *L'Illustration*. Critics laud his "power." Disassociates himself with the Fauves by not showing at group exhibitions at Berthe Weill's and Prath and Magnier's galleries.

1906 Shows eight paintings at the Independants in the same room as Signac. Critic Louis Vauxcelles highly praises his work. Shows ten paintings at the Salon d'Automne. Invited to participate in the Secession in Berlin. Travels to Algeria.

1907-08 Does not show at the Independants.

1908 Birth of his son Jean at Versailles. Exhibits at the Salon d'Automne.

1914 Retires to the valley of the Chevreuse but maintains a prolific output until losing his sight in 1948.

1952 Dies in Paris.

Louis Valtat

Bibliography

I. Books

3099. Besson Collection, Besançon, Musée des Beaux-arts et d'archéologie. *Dessins et estampes de la collection George et Adèle Besson* [Drawing and Stamps from the Collection of George and Adèle Besson]. Foreword by George Besson. Besançon, France: Musée des Beaux-Arts et d'Archéologie, 84 p.,219 illus.

Catalogue raisonné to the collection of 20th century prints and drawings assembled by George and Adèle Besson and donated to the Musée des Beaux-arts et d'archéologie in Besançon in 1970. George Besson briefly discusses his interest in 20th century art, and recalls the origins and growth of his collection. It includes works by more than forty European artists, including several examples by Louis Valtat, among others.

3100. COGNIAT, RAYMOND. *Louis Valtat.* Neuchâtel: Ides et Calendes, 1963. 189 p., illus., 38 col. Introduction in French and English. Volume in "Collection des grandes monographies."

3101. *Modernist Themes in New Mexico: Works by Early Modernist Painters.* Santa Fe, New Mexico: Gerald Peters Gallery (4-16Aug. 1989). Introduction by Barbara G. Bell. 56 p., 60 illus., 48 col.

Catalogue to an exhibition of paintings by the artists of Santa Fe and Taos, New Mexico, who responded to the spread of modernism across the U.S. in the period following the New York Armory Show of 1913 by adapting its tenets to their own particular needs. Comparing the New Mexican environment to Cézanne's Provence, the author notes his influence on the New Mexican modernists, as well as that of André Derain, Louis Valtat, and Wasily Kandinsky.

II. Articles

3102. ANDRE, ALBERT. "Louis Valtat." *Les Lettres françaises* (13March 1953).

3103. GUELFI, J.-D. "Les Dons de Vollard à la ville d'Aix." *Arts livres de Provence* 81(1972):24-9. 2 illus.

Relates the history of Vollard's rejected offer of a canvas by Cézanne to the Musée d'Aix in France, his donation of a bronze bust of the painter by Louis Valtat, to be housed in the Bibliothèque Méjanes, and his commission of a memorial fountain, adorned by a bronze medallion of Cézanne by Richard Guino, a pupil of Maillol.

3104. "Parigi: una nuova mostra di Valtat." *Emporium 125(Jan. 1957):35-7.*

3105. PARINAUD, ANDRE. "Valtat le chaînon" [Valtat the Link]. *Galerie* 120(Oct. 1972):36. 2 illus.

Brief article, occasioned by the exhibition of Valtat's work at the Galerie Findlay, Paris, which describes his career and interprets his oeuvre as a link between that of Bonnard and that of Matisse.

3106. VALTAT, LOUIS. "*Paysage d'Anthéor. La Mer à Anthéor.*" *Apollon* 3-4(1912):144-5.

3107. VALTAT, LOUIS. "*Au bal.*" *Apollo* 121 (March 1985):72.

3108. VALTAT, LOUIS. "*Les Baigneurs.*" *Connoiseur* 215(Oct. 1985):72.

3109. VALTAT, LOUIS. "*Bouquet de roses au vase bleu.*" *Connaissance des arts* 478(Dec. 1991):155.

3110. VALTAT, LOUIS. "*Les Deux amies au fauteuil bleu.*" *Apollo* 131(May 1990):7; 135(June 1992):55.

3111. VALTAT, LOUIS. "*Femme aux raisins.*" *Art News* 88(Feb. 1989):19.

3112. VALTAT LOUIS. "*Madame Suzanne Valtat et son fils Jean.*" *Art & Antiques* 7(Oct. 1990):74.

3113. VALTAT, LOUIS. "*La Mère Cousant et l'enfant au fauteuil.*" *Connoisseur* 216(Nov. 1986):106.

3114. VALTAT, LOUIS. "*Les Porteuses d'eau à Arachon.*" *Apollo* 134(Aug. 1991):117.

3115. VALTAT, LOUIS. [Untitled: *Rowboats on a Lake*]. *Art News* 83(Sept. 1984):113.

3116. "Valtat." *Emporium* 118(Sept. 1953):129-31.

3117. WOIMANT, FRANÇOISE, MARIE-CECILE MIESSNER, and ANNE MOEGLIN-DELCROIX. "Les Enrichissements 1990 de la Bibliothèque nationale: estàmpes modernes." *Nouvelles de l'estampe* 116(May-June 1991):13. 47 illus.

3118. WARNOD, ANDRE. "Louis Valtat." *Le Figaro* (24July 1949).

III. Catalogues Raisonnés

3119. VALTAT, JEAN. *Louis Valtat: Catalogue de l'oeuvre peint, 1869-1952.* Edité sous la direction de Jean Valtat. Vol. 1-Neuchâtel: Editions Ides et Calendes, 1977-.

3120. VALTAT, LOUIS-ANDRE. Forthcoming catalogue raisonné by Louis-André Valtat.

IV. Individual Exhibitions

1952, 3-22 March	New York, Fine Arts Associates. *Louis Valtat.* 15 p., 1 pl. Reviews: *Pictures on Exhibit* 14(April 1952):18.
1956	Paris, Musée Galliéra. *Louis Valtat.* Preface de René Domergue.
1959, 26 June-21 September	Dieppe, Musée de Dieppe. *Louis Valtat.* Préface de George Besson. 15 p., pl.
1960, 6-20 February	New York, Fine Arts Associates. *Louis Valtat (1869-1952), Early Paintings.*
1962, 6 April-1 May	Geneva, Musée de l'Athénée. *Louis Valtat, 1869-1952.*
1962, November-10 December	New York, Acquavella Galleries. *Paintings by Louis Valtat.* 15 p., illus.
1967	Chicago, Wally Findlay Galleries. *Louis Valtat: Important Post-Impressionist and Fauve.* 8 p., illus., some col.
1969, 20 June-21 September	Geneva, Petit Palais. *Louis Valtat, retrospective centinaire (1869-1969).* 53 p., 45 pl. Supplement also published (3p., 10 pl.).
1972	Paris, Wally Findlay Galleries International. *Louis Valtat.* Review: A. Parinaud, *Galerie* 120(Oct. 1972:36.
1974, October	Torino, Galleria d'Arte Pirra. *Louis Valtat.*
1989, 8 July 2 October	Saint-Tropez, Musée de l'Annonciade. *Louis Valtat: Paysages de l'Estérel.* 28 p., illus., some col.

V. Group Exhibitions

1904, 21 February-24 March	Paris, Grand Palais, *Salon des Indépendants.* 3 paintings.
1904, 25 February-29 March	Brussels. *La Libre esthétique.* Catalogue par Octave Maus. 3 paintings.
1904, 15 October-15 November	Paris, Petit Palais, *Salon d'Automne.* 3 paintings.
1905, 24 March-30 April	Paris, Grand Palais. *Salon des Indépendants.* 3 paintings.

1905, 18 October- 25 November	Paris, Grand Palais. *Salon d'Automne.* 5 paintings.
1906, 20 March- 30 April	Paris, Grand Palais. *Salon des Indépendants.* 8 paintings.
1906, 6 October- 15 November	Paris, Grand Palais. *Salon d'Automne.* 10 paintings.
1907, 20 March- 30 April	Paris, Grand Palais. *Salon des Indépendants.* 6 paintings.
1907, March- April	Vienna, Galerie Miethke. Catalogue text by Rudolf A. Meyet. 8 paintings.
1907, 1-22 October	Paris, Grand Palais. *Salon d'Automne.* 6 paintings.
1908, 1 March- 5 April	Brussels. *La Libre esthétique.* Catalogue par Octave Maus. 3 paintings.
1908, 18 April- 24 May	Moscow, Salon de la Toison d'Or. 2 paintings.
1908, 1 October- 8 November	Paris, Grand Palais. *Salon d'Automne.* 6 paintings.
1964	Besançon, Musée des Beaux-arts. *Valtat et ses amis: Albert André, Charles Camoin, Henrii Manguin, Jean Puy.*
1967-68, 25 November- 1 January	Charleroi, Palais des Beaux-arts. *Autour du fauvisme: Valtat et ses amis.* Sous le patronage de l'Institut de la vie; Modern Art Foundation Oscar Ghez. 69 p., illus., some col. 44 pl.
1978, 3-29 April	Stüttgart, Kunsthaus Buhler. *Französische Postimpressionisten.* 44 p., 17 illus. This exhibition catalogue is introduced by a brief survey of movements in French art reacting against the Impressionist style during the 1870's and 1880's, including the Neo-Impressionists, the Pont Aven group, the Nabis, the Symbolists and the Fauves, all of which, it is stated, made contributions to Post-Impressionism. Illustrations from the exhibition are accompainied by commentaries on the artists' careers and significance within the Post-Impressionist movement. Artists exhibited include Moret, Loiseau, Lebourg, Valtat, and Camoin.
1983, 4 June- 2 October	Martigny, Fondation Pierre Gianadda. *Manguin marmi les Fauves.* Textes de Lucile Manguin, Pierre Gassier, M. Hahnloser. 175 p., 107 illus.

Catalogue to an exhibition of paints and drawings by Henri Manguin (1874-1949) and ten Fauve painters: Braque, Charles Camoin, Dufy, Emile-Othon Friesz, Albert Marquet, Matisse, JeanPuy, Louis Valtat, Kees van Dongen, and Maurice de Vlaminck. In his essay Gassier gives and account of Fauvism from its origins in a meeting of Manguin, Matisse, and Marquet in the studio of Gustave Moreau, to its "official" birth at the Salon d'Automne in 1905, tracing the interest of its members in Cézanne and the decline of the movement as Cézanne's work became more widely known. Hahnloser describes the importance for Manguin of his visits to Switzerland, especially Lausanne, Manguin's daughter gives her recollections of his personality. The exhibits are divided into Fauvist works and works by Manguin from the post-Fauvist period (1908-49).

1985-86,
17 November-
2 February

New Brunswick, NJ, Jane Voorhees Zimmerli Art Museum. *The Circle of Toulouse-Lautrec: An Exhibition of the Work of the Artist and of his Close Associates.* Sponsored by National Endowment for the Arts, Washingtion, D.C. Catalogue by Phillip Dennis Cate and Patricia Eckert Boyer. 203 p., 258 illus., 36 col.

1989

Paris, Galerie Berggruen. *Gravures Fauves et expressionnistes.* Préface de Fabrice Hergott. 11 p., 45 pl. 52 works shown.
Included works from Valtat to Kirchner.

Art Works Index

Includes the titles of art works in all media, as referred to in the entries and annotations.

Georges Braque
Grand nu 2225

Charles Camoin
La Jeune Marseillaise 2930
Nature morte aux fleurs 2997
Nu à la chemise mauve 2947
Portrait de Marquet 2949, 2952, 2953

André Derain
Arlequin et Pierrot 2305
At the Suresnes Ball 2304, 2306, 2307
Bagpiper 2322
The Barge: London 2333
Bâteaux dans le port 2349
Big Ben 2343
Blue Horse 2308
Bougival 1906, 2330
Buste de femme 2309
Composition (l'Age d'or) 121, 2023,
 2260, 2313, 2318, 2332, 2360
La Danse baigneuse I,II,III 2260, 2329,
 2345, 2360
Les Deux sœurs 2210
Femme au collier à 2 rangs 2324
Femme aux bras écartés (terra cotta)
 2354
Femme nu 2344, 2369
The Fountain 2325
La Gibecière 2328
Grapes 2331
Head of A Young Woman 2356
Interprétation des massacres de Scio
 2334
Kahnweiler 2337

Landscape 2338
London Bridge 2189
Madame Paul Guillaume 2342
The Painter and His Family (oil, 1939)
 2340, 2350
Le Parlement, la nuit (oil, 1905-06)
 2322
Paysage I (drawing) 2346
Paysage II (drawing) 2347, 2780
Paysage au bord d'une rivière 2348
Paysage du Midi 2310
Pierrot 2351
Le Pont de Chatou 2352
Portrait of an Englishwoman 2353
Portrait of Marie Harriman 2315
Portrait of Matisse 2210
Rue à Collioure 2355
Self-Portrait with a Cap (1904, 1906)
 2358
Le Sentier à Ollioules 2345
Set Table 2327
Sketchbooks 2320
St. Paul's from the Thames 2321
Stag Hunt 2311, 2359
Standing Nude (drawing) 2345
Still Life 2345
Still Life with Fruit (oil, 1938) 2339
Toilette 2260
Les Trois paniers 2312, 2314, 2357
The Turning Road 2361
The Two Barges 2333
View of Collioure 2127, 2303
Window on the Park 2362
Woman with Fan 2363

Personal Names Index

Names of the major Fauve artists covered in this sourcebook appear in bold type.

Abdul Hak, Andrée 739
Adam, Georgina 220, 1602
Adams, Doug 1511
Adams, Philip R. 221
Adrichem, Jan van 2415
Affleck, Gregor 272
Agorniak, Marek 3028
Agustoni, F. 1358, 1545, 1585
Ahlers-Hestemann, Friedrich 507
Ahmet, Seker 1616
Aisner, Robert 1964
Ajalbert, Jean 1009
Alauzen, André di Genova 2930
Alazard, Jean 2705, 2938
Alberti, Leone Battista 534
Alechinsky, Pierre 1543
Alexandre, Arsène 1017, 2995, 3079
Allan, Robert 3005
Allard, Roger 283, 634, 653, 773, 990,
 1779, 1945, 2421
Allemand, G. 2202
Alvard, Julien 2503
Alvarez, Pilar Vazquez 1616
Ambler, J. 2304
Anacreon 2385
André, Albert 3102
Andreae, Christopher 38
Angiolini, Gerard 2924
Anquetin, Louis 226
Anscombe, Isabelle 2185
Anthonioz, Marie Claire 1353
Apollinaire, Guillaume 70, 153, 203,
 257, 271, 284-287, 299, 454, 512,
 546, 628, 962, 966-967, 976, 988,
 994, 1036, 1047, 1396, 1397, 1598,

1907, 2144, 2367, 2372, 2422, 2504,
 2505
Apollonio, Umbro 1
Apostolos-Cappadona, Diane 1511
Aragon, Louis 259
Arber, A. J. N. 1398
Archipenko, Alexander 2199
Argan, Giulio Carlo 145, 288
Aristide 1863
Arland, Marcel 654, 1048, 1254, 1399-
 1401, 1571, 1577
Arnould, Reynold 737
Arp, Jean (Hans) 289
Artaud, Antonin 2379
Artigas, Llorens 708, 1027, 1033
Artioli, U. 2
Ascher, Lida 2171
Ascher, Zika 2171
Ashbery, John 774
Asselin, Maurice 1960
Assouline, Pierre 2145
Atget 1636
Attenborough, David 1965, 2146
Auberjonois, René 630
Aubert, Georges 989, 2254
Aubery, Pierre 508, 509
Aubry, Georges-Jean 1086, 2668
Ault, Lee 1507
Aust, Von Günter 39
Avery, Milton 1092
Aynaud 2412
Azarkovic, V. 2623
Azcoaga, Enrique 290
Azorin 1867

About the Author

RUSSELL T. CLEMENT is Fine Arts Librarian, Harold B. Lee Library, Brigham Young University. His Greenwood books include *Georges Braque: A Bio-Bibliography* (1994), *Henri Matisse: A Bio-Bibliography* (1993), and *Paul Gauguin: A Bio-Bibliography* (1991). His articles have appeared in *The Journal of American Folklore, The Hawaiian Journal of History, Library Journal,* and others. He is currently completing a research guide on the French Symbolist painters.

ISBN 0-313-28333-8

HARDCOVER BAR CODE